FINE ARTS

A Bibliographic Guide to
Basic Reference Works, Histories, and Handbooks

Third Edition

Donald L. Ehresmann

University of Illinois
Chicago

Libraries Unlimited, Inc. - Englewood, Colorado
1990

LIBRARIES UNLIMITED
P.O. Box 3988
Englewood, Colorado 80155-3988

Library of Congress Cataloging-in-Publication Data

Ehresmann, Donald L., 1937-
 Fine arts : a bibliographic guide to basic reference works, histories, and handbooks / Donald L. Ehresmann. -- 3rd ed.
 xvii, 373 p. 17x25 cm.
 ISBN 0-87287-640-3
 1. Art--Bibliography. I. Title.
Z5931.E47 1990
[N5300]
016.7--dc20
 90-34857
 CIP

*For Sibylle
and Amalia*

CONTENTS

PART I
REFERENCE WORKS

PART II
HISTORIES AND HANDBOOKS

x / CONTENTS

PREFACE

This third edition of *Fine Arts* is the first of five bibliographies on the literature of the history of art. *Applied and Decorative Arts: A Bibliographic Guide to Basic Reference Works, Histories, and Handbooks* (Libraries Unlimited, 1977; second edition in preparation) and *Architecture: A Bibliographic Guide to Basic Reference Works, Histories, and Handbooks* (Libraries Unlimited, 1984) are the second and third bibliographies. The fourth bibliography covering sculpture is in preparation and the fifth to cover painting and graphic arts is in the planning stage. The plan is for each bibliography to cover those major books written in Western European languages, published in the past one hundred years, and available in the major libraries of the United States.

For the third edition of *Fine Arts*, books published in the decade since the appearance of the second edition have been surveyed, and 258 titles have been added. The literature published before September 1, 1978 (the cut-off date for the second edition) has been reviewed afresh with the result that 72 titles have been added. Most of these are found in part I. To increase the usefulness of the bibliography a new chapter — chapter 7 — on the historiography of art history has been added to *Fine Arts*. The 67 titles in chapter 7 were assembled to help provide a guide for the current great interest in the methodologies and theories of art historical study. In all, 2,051 entries are now found here.

The additional titles are only a partial indication of the work of revision and updating in the third edition of *Fine Arts*. New editions and reprints of books listed in the second edition have been noted, and new titles in continuing series have been added. This has been a special task for the updating of the unique listings of topographical handbooks in chapter 9 and has resulted in the reorganization of the way the sub-volumes are listed for several of the larger series (see particularly 1602 and 1682). These reorganizations are designed to ease the task of determining the geographic coverage of the complex handbooks and to facilitate interlibrary loan.

BIBLIOGRAPHIC SCOPE OF THIS VOLUME

To be included in *Fine Arts*, a work must treat two or more of the major media: architecture, sculpture, and painting. The majority, in fact, treat all three, and often the applied and decorative arts as well. The exact coverage of each title is mentioned in the annotations. The scope of *Fine Arts* corresponds approximately to the "N" category of the Library of Congress classification system. The cutoff date for inclusion is September 1, 1988.

The reference works covered in part I include both periodical articles and books published after 1830, the *terminus ad quem* for the basic bibliography of early writings on the history of art, Julius von Schlosser's *Die Kunstliteratur* (23). Generally, coverage stops at the level of national and period works. However, a selection of titles dealing with the art of some provinces that have in themselves been important centers of European art is also included. With few exceptions, reference works that are not strictly art historical in nature have been excluded. The chief exceptions to this practice are in areas such as ancient art and pre-Columbian art, where archaeological and anthropological works, which are of special value to art historians, have been listed and described.

The general histories and handbooks in part II are books published after 1875. Histories and handbooks have been defined here to exclude very specialized and theoretical studies. As with reference works in part I, coverage stops at national and period, except for those multi-volume topographical handbooks of various European countries, which are broken out into individual volumes, and, thus, extend the coverage to the level of major provinces and regions. Subject access to that level is reached through the index. Dissertations and exhibition and museum catalogues are not included. Coverage is restricted to works in Western European languages; and where multi-lingual editions of the same work exist, preference is given first to the English, then to the French, and then to the German edition. If translation into English is anticipated, this is mentioned in the annotation.

Fine Arts and its companion bibliographies are designed to serve two principal users: librarians and college and university students. Expanded and revised, the third edition of *Fine Arts* improves on the second edition as a tool of collection development and evaluation. Improvements in the index and reorganization of the most complex entries are intended to enhance the bibliography as a reference guide. These features recommend *Fine Arts* to the undergraduate and graduate student of art history. But, in addition, the fully articulated classification system and the new chapter on historiography are intended to aid students in gaining an overall view of the discipline, a task that is increasingly frustrated by ever-increasing emphasis on narrow specialization.

CLASSIFICATION SYSTEM

Reference works are arranged according to publication type. Where works are used in a similar fashion but appear in different categories, cross-references are provided in the annotations and at the end of sections. Histories and handbooks are arranged by period and geographical areas. The history of Western art is classified by standard period and style designations. National histories and handbooks are grouped into four broad cultural areas: Europe, the Orient, the

New World, and Africa and Oceania. Topographical handbooks or inventories are given special attention and are further classified by province. Here, too, cross-references are used to provide access to related works in the period and geographical sections. It should be borne in mind, however, that cross-references are intended to refer the reader to similarly specific titles, not to more general works.

CITATIONS

The author's full last and first names are given, with initial(s) supplied for middle name(s). Full title is supplied together with publication data. Only numbered series are listed with the citation. Where pertinent to the description of a title, other non-numbered series are mentioned in the annotations. Although a separate search was not made for reprints, the major ones have been included. Library of Congress card numbers are provided for single titles published since 1957. For some recent titles that lack LC card numbers, ISBN numbers have been supplied. LC card numbers and ISBN numbers facilitate interlibrary loan as well as cataloging and acquisition procedures.

ANNOTATIONS

The annotations are intended to be descriptive and, where warranted, critical comments appear. The repetitive and often redundant nature of many titles in the category of period histories is reflected in the equally repetitive annotations for those titles. Works of unusual completeness or approach have been accorded fuller annotation, some with a list of their contents. This is especially the case with the titles in the new chapter (7) on historiography. Particular attention has been given to the description of special features, such as glossaries, chronological charts, especially good illustrations, and bibliographies.

INDEX

Besides authors, editors, and titles, the index includes numbered series titles. The subject index provides access to the broad and specific divisions of the classification system and to other subjects taken from the annotations — in particular, the subdivisions of the complex national art inventories. Thus, it is possible to use the index to locate, for instance, books on the art and architecture of Bavaria or Westmoreland. Ascending references have been kept to a minimum and descending references have, wherever possible, been accomplished by *See also* references.

ACKNOWLEDGMENTS

Numerous colleagues in the academic and museum worlds in the United States and in Europe have assisted the author with generously given advice. The author wishes to recognize the assistance of Suzanne Meier whose labor as my graduate assistant in the history of art at the University of Illinois at Chicago made it possible for me to accomplish this revision of *Fine Arts*.

D.L.E.

REFERENCE WORKS

1
BIBLIOGRAPHIES

RESEARCH AND LIBRARY MANUALS

1 Carrick, Neville. **How to Find Out about the Arts: A Guide to Sources of Information.** Oxford, Pergamon, 1965. 164p. illus. index. LC 65-19834.

Guide for the general reader and the undergraduate student in how to use basic reference tools in the fine arts. Chapter on tracing art information has illustrations of actual pages from reference works like Bénézit (352) and Thieme-Becker (362). Chapters with introductory essays cover the major reference tools and basic histories by period, nation, and media. Includes chapters on theater and photography.

2 Goldman, Bernard. **Reading and Writing in the Arts: A Handbook.** Rev. ed. Detroit, Wayne State University Press, 1978. 163p. index. LC 77-27856.

Guide for undergraduate students to researching and writing papers. Part 1 is a reference key by subject that serves as an index to the classified bibliography of 403 reference works, general books, and periodicals listed in part 3. The major entries in part 3 have descriptive annotations. Part 4 provides guidance to writers of research papers and brief section on writing for publication.

3 Jones, Lois S. **Art Research Methods and Resources: A Guide to Finding Art Information. 2d ed.** Dubuque, Iowa, Kendall/Hunt, 1984. 332p. illus. index. LC 83-03049.

Comprehensive guide for the student and librarian in the use of fine arts reference works. Part I deals with research methods; part II surveys the basic sources. Part III gives practical advice on obtaining reference materials. Emphasis is on English-language materials, but a French, German, and Italian dictionary of art terms is provided. Treats how-to-do materials as well as art history reference tools. Useful feature is the use of facsimiles of pages from major reference sources as guides to their use.

4 Jones, Lois S., and Sarah Scott Gibson. **Art Libraries and Information Services.** Orlando, Fla. Academic Press, 1986. 343p. index. LC 85-28598.

Comprehensive handbook for art librarians with useful sections on the use of reference tools in the fine arts. Contents: I, Art Libraries as Information Centers; II, The Library Collection; III, Information Services; IV, Collection Development and Library Management; V, Appendices. Bibliographical footnotes.

5 Kleinbauer, Eugene, and Thomas Slaven. **Research Guide to the History of Western Art.** Chicago, American Library Association, 1982. 229p. index. LC 82-0867.

Two-part introduction to study and research in the history of art. First part written by Kleinbauer is a good survey of the various methodological and theoretical approaches to art history; the second part is a short, annotated bibliography of basic reference books. The first part offers a valuable overview of the historicity of art history, with thorough bibliographical references.

6 Muehsam, Gerd. **Guide to Basic Information in the Visual Arts.** Santa Barbara, Calif., ABC-Clio, 1978. 266p. index. LC 77-17430.

A reader's and librarian's guide to basic literature on the history of Western art and architecture. Divided into four major sections: "Core Materials," "Periods of Western Art," "Art Forms and Techniques," "National Schools of Art." Each discusses English-language works in essay form. Bibliography (pp. 199-247) lists 1,045 titles discussed in alphabetical order. Because of language restrictions, this guide concentrates on general works, but it is effective in demonstrating how much information can be obtained from these relatively accessible works.

7 Pacey, Philip, ed. **Art Library Manual. A Guide to Resources and Practice.** New York, R. R. Bowker, 1977. 423p. index.

Collection of essays by 21 experts (mostly British) in the field of art librarianship on such topics as: art bibliographies, museum and gallery publications, exhibition catalogs, sales catalogs, periodicals and serials, abstracts and indices, microforms, slides, film strips, and photographs. Each chapter is provided with a bibliography. Although the emphasis is chiefly on the technical handling of the materials from the librarian's standpoint, in earlier chapters there is much valuable information on the use of reference materials.

8 Pollard, Elizabeth B. **Visual Arts Research. A Handbook.** Westport, Conn. Greenwood Press, 1986. 165p. index. LC 86-375.

Research handbook designed to assist general readers, undergraduate students, and librarians. Also covers art education. Has a useful table comparing Library of Congress and Dewey classifications for fine arts and a section on computerized reference services.

GENERAL SYSTEMATIC BIBLIOGRAPHIES

9 Arntzen, Etta, and Robert Rainwater, eds. **Guide to the Literature of Art History.** Chicago, American Library Association, 1980. 616p. index. LC 78-31711.

Comprehensive classified and annotated bibliography of books on all aspects of art history published in Western languages before 1978. Does not include artists' monographs. Annotations give the table of contents and quotes from reviews for many entries. Although now ten years out of date, Arntzen and Rainwater is still the most complete single-volume fine arts bibliography.

10 **Art Books 1876-1949. Including an International Index of Current Serial Publications.** New York, R. R. Bowker, 1981. 780p. index. ISBN 0-8352-1370-6.

Classified bibliography of approximately 21,000 books in English that were published or distributed in the United States between 1876 and 1949. The books are cataloged in Library of Congress format and are classified using LC subject headings. The entries are not annotated. Additional volumes include: *Art Books 1950-1979. Including an International Directory of Museum Permanent Collection Catalogs* (New York, R. R. Bowker, 1979. 1500p. ISBN 0-8352-1189-4) and *Art Books 1980-1984. Including an International Index of Current and Ceased Serial Publications* (New York, R. R. Bowker, 1985. 571p. index. ISBN 0-8332-1819-8).

11 Bachmann, Donna G., and Sherry Piland. **Women Artists: An Historical, Contemporary and Feminist Bibliography.** Metuchen, N.J., Scarecrow Press, 1978. 323p. illus. LC 78-19182.

Annotated bibliography of women painters, sculptors, photographers, and architects from the Middle Ages through the twentieth century. A 46-page section on general works—which includes slide sets and microfilm collections, dissertations, and exhibition catalogs—precedes literature on 167 individual women artists, 69 of whom are twentieth-century figures. A brief biographical sketch opens each individual entry.

12 Besterman, Theodore. **Art and Architecture: A Bibliography of Bibliographies.** Totowa, N.J., Rowman and Littlefield, 1971. 216p. LC 74-29568.

Reissue of the sections on art and architecture in the author's *World Bibliography of Bibliographies*, 4th ed. (1965-1966). Classified bibliography of bibliographies.

13 Chamberlin, Mary W. **Guide to Art Reference Books.** Chicago, American Library Association, 1959. 418p. index. LC 59-10457.

Classified and annotated bibliography of 2,489 books on the fine arts. Covers reference tools, basic histories and handbooks, periodicals, documents and sources, and series publications. Includes only books written in Western languages. General index. Although no longer up to date, it is still an indispensable reference tool for students and librarians. A useful feature is the appendix, with a descriptive list of art reference libraries in the United States and Europe.

14 Crouslé, Maurice, comp. **L'art et les artistes.** 2d ed. Paris, Hachette, 1961. 343p. illus. index. LC 63-20786.

Classified trade bibliography of some 5,000 books in French on the fine arts. Lists chiefly general and popular books; gives a physical description of the book, place of publication, publisher (but not date of publication), and price. Although it is now out of date, it is still a useful compilation for the reference librarian.

15 Dove, Jack. **Fine Arts.** London, Clive Bingley, 1966. 88p. index. LC 64-27927.

Classified and annotated bibliography of a small selected group of books. Title and subject index. Good basic bibliography for the general reader and the art collector. In "The Readers Guide Series."

16 Duplessis, Georges. **Essai d'une bibliographie générale des beaux-arts; biographies individuelles, monographies, biographies, générales.** Paris, Rapilly, 1866. 144p.

List of early artists' biographies and monographs. Contents: section I, Biographies individuelles, Monographies (alphabetically by artist's name); section II, Biographies générales (chronologically by date of publication). No indexes.

17 Freitag, Wolfgang. **Art Books: A Basic Bibliography of Monographs on Artists.** New York, Garland, 1985. 370p. index. LC 85-15943.

Bibliography of 10,543 monographs on 1,870 artists. Arranged by name of artist. No annotations, although the monographs that have catalogues raisonnés are marked by a "CR." A very useful reference work as artists' monographs are not included in the standard comprehensive fine arts bibliographies.

18 Lucas, Edna Louise. **Art Books: A Basic Bibliography of the Fine Arts.** Greenwich, Conn., New York Graphic Society, 1968. 245p. index. LC 68-12364.

Classified bibliography of fine arts books covering basic reference tools, period and medium histories, and monographs on artists. Author, artist, and title index. Based on the author's *Harvard List of Books on Art* (last published in 1952) and designed as a selection guide for college libraries. As such, it includes only the books then readily obtainable, so there are many important omissions, particularly in reference categories. Its most useful feature is its bibliography of artist monographs.

19 Lucas, Edna Louise. **Guides to the Harvard Libraries, No. 2: Fine Arts.** Cambridge, Mass., Harvard University Library, 1949. 54p.

Guide to the fine arts collections of the Harvard libraries. Useful list of basic reference tools in the appendix.

20 Mayer, Leo A. **Bibliography of Jewish Art.** Ed. by Otto Kurz. Jerusalem, Hebrew University Press, 1967. 374p. index. LC B 67-14948.

Bibliography of books and periodical articles that treat art by Jews between 70 and 1830 A.D. and that were published up to 1965. The 3,016 entries are arranged alphabetically. Subject, artist, and author index.

21 Podszus, Carl O. **Art: A Selected Annotated Art Bibliography.** New York, n.p., 1960. 111p. LC 60-1621.

General bibliography of approximately 1,000 items covering all aspects of the visual arts, with particular emphasis on studio practice. Small section on history of art. Intended for schools, it should be useful for beginning students interested in the practice and the history of the fine arts.

22 Reisner, Robert G. **Fakes and Forgeries in the Fine Arts: A Bibliography.** New York, Special Libraries Association, 1950. 58p. index.

Bibliography of books and periodical articles on fine arts fakes and forgeries published from 1848 to 1948. Special feature is the list of articles on fakes published in the *New York Times* from 1897 to 1950.

23 Schlosser, Julius von. **La littérature artistique. Manuel des sources de l'histoire de l'art moderne.** Ed. by André Chastel. Paris, Flammarion, 1984. 741p. index. ISBN 2080126024.

Expanded, French edition of the third Italian edition edited by Otto Kurz (*La letteratura artistica: Manuale delle fonti della storia dell'arte moderna,* Florence, "La Nuova Italia," 1964. 766p. Reprint: 1977). Originally published as *Die Kunstliteratur* (Vienna, Schroll, 1924). Scholarly biblio-history of the literature of art history from late antiquity to the early nineteenth century. Emphasis on the Italian Renaissance. A classic in the field of art bibliography and an invaluable guide to the sources of Renaissance art and architecture.

24 Timmling, Walter. **Kunstgeschichte und Kunstwissenschaft: Kleine Literaturführer.** Leipzig, Koehler & Volckmar, 1923. 303p.

Classified and annotated bibliography of German books and periodical articles on all aspects of art history. The annotations are directed to the needs of the student. At the time it was published, it was most useful. A supplement, *Die Kunstliteratur der neuesten Zeit*, was published in Leipzig in 1928.

25 Vinet, Ernest. **Bibliographie méthodique et raisonnée des beaux-arts....** Paris, Firmin-Didot, 1874-1877. 2v. Reprint: Hildesheim, Olms, 1967. 288p.

Classified and annotated bibliography of books published before 1870 on all aspects of the fine and applied arts. Although the classification system is rather broad, the descriptive annotations make Vinet's one of the most useful of the nineteenth-century bibliographies. Based on Brunet's *Manual du libraire et de l'amateur de livres.*

See also: Indexes 253-272.

GENERAL SERIES BIBLIOGRAPHIES

26 **Art/Kunst: International Bibliography of Art Book[s].** 1972- . Basel, Helbing & Lichtenhahn, 1973- . index.

Classified list of in-print art books submitted by major art book publishers. As a trade list, it is useful for the librarian and the beginning student.

27 Bibliographie zur kunstgeschichtlichen Literatur in Ost und Südösteuropaischen Zeitschriften. 1960- . Munich, Zentralinstitut für Kunstgeschichte, 1964- . LC 72-623917.

Classified annual bibliography of articles in Slavic-language periodicals on the history of art. From 1960 to 1971, titled *Bibliographie zur kunstgeschichtlichen Literatur in slawischen Zeitschriften*. Titles are translated into German, and annotations indicate which articles have summaries in Western European languages. Extremely useful guide to much otherwise inaccessible material in Eastern European periodicals.

28 Cataloghi d'arte: Bolletino primario. Art catalogues: Primary Bulletin. Florence, Centro Di, 1971- .

A bimonthly listing of exhibition catalogs in Italian and English. Divided into ancient and modern art. Entries give name of museum or private collection, publication date, author or authors of text, references to subjects and artists, language or languages of text, number of pages, and illustrations.

29 Delogu, Giuseppe, comp. Essai d'une bibliographie internationale d'histoire de l'art, 1934/35. Bergamo, Ist. Ital. d'Arti Grafiche, 1936. 176p. index.

Published by the Comité Internationale d'Histoire de l'Art. Defunct. Intended to be a classified bibliography of books on art and music published in German, French, English, Spanish, Italian, Polish, Czech, Romanian, Swedish, and Hungarian. Thorough coverage of exhibition and sales catalogs. Author index.

30 Internationale Bibliographie der Kunstwissenschaft. 1902-1917/1918. Berlin, Behr, 1903-1920. 15v. in 14. index.

Classified bibliography of books, periodical articles, and book reviews published in all major languages. Outline of classification given at the beginning. Although defunct, it is a most thorough and comprehensive bibliography of the period 1903 to 1918. Author and subject indexes.

31 Kunstgeschichtliche Anzeigen. Neue Folge, Jahrg. 1-7, 1955-1960. Graz, Böhlaus, 1955-1960.

Continues *Kunstgeschichtliche Anzeigen* (Innsbruck, 1904-1913) and *Kritische Berichte zur kunstgeschichtlichen Literatur* (Leipzig, 1927-1938). Published by the Kunsthistorisches Institut der Universtät Wien. This was a periodical devoted to the scholarly criticism of art historical literature. Each issue was devoted to one or more periods or fields of art historical research. The important issues are listed in this bibliography under the appropriate period and civilization headings in the section "Specialized Bibliographies" in chapter 1.

32 Répertoire d'art et d'archéologie; dépouillement des périodiques et des catalogues de ventes, bibliographie des ouvrages d'art français et étrangers. T. 1- . 1910- . Paris, Morancé, 1910- . index.

Since 1965, there has been a Nouvelle Série with the title *Répertoire d'art et d'archéologie (de l'époque paléochrétienne à 1939)*. Classified and annotated annual bibliography of books and periodical articles on all aspects of Western art. In the original series—that is, until 1965—antiquity was covered. In the new series, the bibliography begins with Early Christian art. The material is arranged in large categories subdivided by nation. An outline of classification and a list of serials consulted are given at the beginning of each volume. A basic reference tool for serious study in the history of Western art. The most comprehensive international series bibliography that attempts to cover both periodical articles and books as well as exhibition and museum catalogs. Coverage has varied over the long history of this work. Up to 1945, it included aesthetics, folk art, prehistoric art, primitive art, and pre-Columbian art. Islamic, Far Eastern art, and ancient art were covered until 1964. The coverage of these areas was taken over by *Bulletin signalétique*, Nrs. 521, 525, and 526 (entries 44, 39, and 158) in 1970. In 1972, coverage of artists born after 1920 and works of art produced after 1940 were dropped. Since 1973, the *Répertoire*

has been computer assisted, and a new, highly detailed subject index has been added. Unfortunately this has been accompanied by a significant reduction in the number of periodicals covered. Nonetheless, the *Répertoire* still indexes more periodicals than RILA (33) and, except for American art, than the *Art Index* (254). The standard bibliographic tool for art history. Beginning with 1973 the *Répertoire* is accessible through the FrancisH Database of QUESTEL.

33 **RILA. Répertoire international de la littérature de l'art. International Repertory of the Literature of Art.** v. 1- . Williamstown, Mass., RILA Abstracts, 1975- .

A new, international, computer-assisted series bibliography covering books and periodical literature on post-classical European art and post-conquest American art. Coverage includes museum and exhibition catalogs, congress papers, Festschriften and dissertations. Appears twice a year. The bibliographic scope, classification system, and indexes are similar to the *Répertoire d'art et d'archéologie* (RAA; see no. 32) since 1973. Unlike RAA, RILA provides lengthy abstracts, many written by the authors, for most entries. Excellent computer-assisted subject indexing. Titles of foreign entries are translated. At present, RILA indexes some 190 periodicals, a fraction of the number indexed by RAA and the *Art Index* (254), but it indexes some not indexed by RAA, notably, American periodicals and newspapers. Since it greatly depends on author abstracting, RILA's coverage of books is slower and less complete than RAA's. Should be used together with RAA and *Art Index* for any comprehensive bibliographic search. Beginning with 1974 RILA is accessible through DIALOG as: Art Literature International (RILA) Database.

34 **The Worldwide Art Book Syllabus: A Select List of In-Print Books on the History of Art and Archaeology.** v. 1- . New York, Worldwide Books, 1966- .

Classified and annotated bibliography of fine arts books available from Worldwide Books. Gives book reviews and prices. Trade list useful to the librarian and general student.

35 **The Worldwide Art Catalogue Bulletin.** v. 1- . New York, Worldwide Books, 1963- .

List of museum and exhibition catalogs, annotated and listed by country. Prices are given. Useful trade list of art catalogs available through Worldwide Books.

36 "Literaturbericht zur Kunstgeschichte," in: **Zeitschrift für Kunstgeschichte.** Bd. 1- . Munich, Deutscher Kunstverlag, 1932- .

Beginning with vol. 12, this periodical publishes in its August issue a classified bibliography of books and periodical articles on art published in the previous year, covering all major Western languages. A most useful and thorough current bibliography.

See also: Indexes 253-272.

SPECIALIZED BIBLIOGRAPHIES

Prehistoric

37 **Bibliographie annuelle de l'âge de la pierre taillée (paléolithique et mésolithique).** No. 1- . 1955/1956- . Paris, Bureau de Recherches Géologiques et Minières, 1958- .

Annual bibliography of books and periodical articles on all aspects of prehistoric civilization including prehistoric art. Succeeds *Old World Bibliography* (42).

38 Bonser, Wilfrid. **A Prehistoric Bibliography.** Extended and ed. by June Troy. Oxford, Blackwell, 1976. 425p. index.

Comprehensive, classified bibliography covering books and periodical articles on all aspects of prehistoric culture in Great Britain published before 1973. Section on art, pp. 330-35. Brief descriptive annotations.

39 **Bulletin Signalétique. Série 525: Préhistoire.** v. 24- . Paris, Centre National de la Recherche Scientifique, 1970- . LC 74-263853.

Annual bibliography of books and periodical articles on all aspects of prehistory, including prehistoric art. Titles are translated into French and abstracts in French are provided for the more complex entries. A valuable reference work for advanced students and scholars of prehistoric art.

40 Eppel, Franz. "In den Jahren 1954 bis 1959 erschienene Werke zur urgeschichtlichen Kunst," in **Kunstgeschichtliche Anzeigen,** Neue Folge, Jahrg. 4, 1959/1960, pp. 57-105.

Critical examination of the major publications on prehistoric art published between 1954 and 1959. The works discussed are listed at the beginning of the article. See (31) for series annotation.

41 Michaelis, Helen, and Catherine Weinerth. **UCLA Rock Art Archive. Unpublished Documents. A Catalog.** Los Angeles, Institute of Archaeology, University of California—Los Angeles, 1984. 55p. index. (Institute of Archaeology, University of California—Los Angeles, Occasional Paper 12).

Alphabetical list of unpublished material (excavation reports, video tapes, films, slides, etc.) on all aspects of prehistoric and historic rock art in the Rock Art Archive. Emphasis is on California, the Great Basin, and the Southwest.

42 **Old World Bibliography: Recent Publications Mainly in Old World Palaeolithic Archaeology and Palaeo-Anthropology.** v. 1-8. Cambridge, Mass., Peabody Museum, American School of Prehistoric Research, 1948-1955.

Annual bibliography of books and periodical articles on all aspects of prehistoric archaeology and anthropology including prehistoric art. Defunct; succeeded by *Bibliographie annuelle de l'âge de la pierre taillée* (37).

43 **Tribal and Ethnic Art.** Santa Barbara, Calif., ABC-Clio, 1982. 99p. index. (Modern Art Bibliographical Series, v. 1). LC 82-152085.

Classified bibliography of books and periodical literature on the traditional arts of the non-Western cultures of Africa, the Americas, Australia, Asia, and Oceania published between 1972 and 1979 and culled from the database of *Artbibliographies Modern* (94). Approximately 900 entries.

Primitive

44 **Bulletin Signalétique. Série 521: Sociologie-Ethnologie.** v. 21- . Paris, Centre National de la Recherche Scientifique, 1967- .

Annual bibliography of books and periodical articles on all aspects of sociology and ethnology, including the arts of primitive peoples throughout the world. A valuable reference work for advanced students and scholars of primitive art.

45 Haselberger, Herta. "In den Jahre 1961 bis 1964 erschienene Werke zur ethnologischen Kunstforschung," in: **Kunstgeschichtliche Anzeigen,** Neue Folge, Jahrg. 7, 1965/1966, pp. 62-92.

Critical examination of the major works on primitive art published between 1961 and 1964. The works discussed are listed at the beginning of the article. See (31) for series annotation.

46 New York City. Museum of Primitive Art. Library. **Primitive Art Bibliographies.**
New York, Museum of Primitive Art, 1963- .
Series of separate classified bibliographies of books and periodical articles on the art
of various primitive cultures. To date, they include:
No. 1, Douglas Fraser, *Bibliography of Torres Strait Art* (New York, 1963. 6p.)
No. 2, Julie Jones, *Bibliography of Olmec Sculpture* (New York, 1963. 8p.)
No. 3, Herbert M. Cole and Robert F. Thompson, *Bibliography of Yoruba Sculpture* (New York, 1964. 11p.)
No. 4, Douglas Newton, *Bibliography of Sepik District Art, Annotated for Illustrations, Part 1* (New York, 1965. 20p.)
No. 6, Paula Ben-Amos, *Bibliography of Benin Art* (New York, 1968. 17p.)
No. 8, Allen Wardwell and Lois Lebov, *Annotated Bibliography of Northwest Coast Indian Art* (New York, 1970. 25p.)
No. 9, Valerie Chevrette, *Annotated Bibliography of the Pre-Columbian Art and Archaeology of the West Indies* (New York, 1971. 18p.).

Europe

PERIODS OF WESTERN ART HISTORY

Ancient

47 **L'année philologique: bibliographie critique et analytique del antiquité gréco-latine.**
Paris, Soc. d'édit. "Les Belles-Lettres," 1928- . Annual.
A current bibliography of the literature on Greek and Roman antiquity. Encompasses all regions which had trade and cultural relations with Greece and Rome. Also lists relevant publications on prehistory and the medieval period in the East and West, as well as references to the survival of antiquity in later periods. Divided into an author and a subject section. Subjects are further subdivided; part IV, Antiquités, is most valuable for archaeologists and art historians.

48 **Annual Egyptological Bibliography.** 1947- . Leiden, Brill, 1948- .
Bibliography of books and periodical articles on all aspects of ancient Egyptian civilization including the fine arts. Straight alphabetical listing. Entries have full annotations, some by leading specialists. Standard reference work for all serious study of ancient Egyptian art and architecture. Indexes 1947-1956 (1960).

49 **Archäologische Bibliographie: Beilage zum Jahrbuch des Deutschen Archäologischen Instituts.** v. 1- . 1932- . Berlin, de Gruyter, 1932- .
Preceded by *Bibliographie zum Jahrbuch des Archäologischen Instituts* (Berlin, 1913-1931) and *Archäologischer Anzeiger zum Jahrbuch des Archäologischen Instituts* (Berlin, 1889-1912). Classified bibliography of books and periodical articles on all aspects of classical archaeology, including art. With its predecessor series, the *Archäologische Bibliographie* is the most important bibliographical tool for specialists in the history of ancient art.

50 Berghe, Louis van den. **Bibliographie analytique de l'Assyriologie et de l'archéologie du Proche-Orient.** v. 1- . Leiden, Brill, 1956- .
Comprehensive, classified, and annotated bibliography of books and periodical articles on all aspects of the ancient civilizations of the Near East. Does not cover Egypt. Contains a valuable section on art and architecture. Basic reference tool for advanced students and scholars of Ancient Near Eastern art and archaeology.

51 Coulson, William D. **An Annotated Bibliography of Greek and Roman Art, Architecture and Archaeology.** New York, Garland, 1975. 135p. (Garland Reference Library of the Humanities, 28). LC 75-24081.

Annotated and classified bibliography of basic books on the subject. Would be most useful for students and instructors at the undergraduate level. All were in print at the time of publication, and most are paperbacks. Arranged in two main groups: books useful as texts or supplementary reading; additional books costing under $10.00. Appendices list major books in German and French then in print.

52 Defosse, Pol. **Bibliographie étrusque.** Brussels, Latomus, 1976- . (Collection Latomus, 144). LC 76-457244.

A planned three-volume retrospective bibliography of books and periodical literature on all aspects of Etruscan civilization. To date, Tome II, covering the period 1927 to 1950, has been published. Contains extensive coverage of fine and applied arts in addition to history, language, religion, and geophysical matters. Thoroughly indexed. Standard reference work for Etruscan art history.

53 Ellis, Richard S. **A Bibliography of Mesopotamian Archaeological Sites.** Wiesbaden, Harrassowitz, 1972. 113p. index. LC 72-170748.

Bibliography of books and periodical literature on ancient sites in pre-Islamic Mesopotamia. Provides quick access to basic archaeological literature on many sites important to the history of ancient art.

54 **Fasti Archaeologici ... Annual Bulletin of Classical Archaeology.** v. 1- . 1946- . Florence, Sansoni, 1948- .

Published by the International Association of Classical Archaeology. Issued annually. Classified bibliography of books and periodical articles on all aspects of classical archaeology, including art, from prehistoric to Early Christian times; includes works in English, French, German, and Italian. Also contains bulletins of archaeological discoveries throughout the ancient classical world. A basic reference tool for specialists in ancient art. Author index at the end of each volume.

55 Kenner, Hedwig. "In den Jahren 1957 bis 1959 erschienene Werke zur griechischen Kunst," in: **Kunstgeschichtliche Anzeigen,** Neue Folge, Jahrg. 4, 1959/1960, pp. 140-59.

Critical examination of the major works on Greek art published between 1957 and 1959. The works discussed are listed at the beginning of the article. See (31) for series annotation.

56 Kenner, Hedwig. "In den Jahren 1957 bis 1959 erschienene Werke zur keltischen und etruskischen Kunst," in: **Kunstgeschichtliche Anzeigen,** Neue Folge, Jahrg. 4, 1959/1960, pp. 160-64.

Critical examination of the major works on Celtic and Etruscan art published from 1957 to 1959. The works discussed are listed at the beginning of the article. See (31) for series annotation.

57 Kenner, Hedwig. "In den Jahren 1957 bis 1959 erschienene Werke zur provinzial-römischen Kunst," in: **Kunstgeschichtliche Anzeigen,** Neue Folge, Jahrg. 4, 1959/1960, pp. 178-84.

Critical examination of the major works on Roman provincial art published from 1957 to 1959. The works discussed are listed at the beginning of the article. See (31) for series annotation.

58 Kenner, Hedwig. "In den Jahren 1957 bis 1959 erschienene Werke zur römischen Kunst," in: **Kunstgeschichtliche Anzeigen,** Neue Folge, Jahrg. 4, 1959/1960, pp. 165-77.
Critical examination of the important publications on Roman art appearing from 1957 to 1959. The works discussed are listed at the beginning of the article. See (31) for series annotation.

59 Kenner, Hedwig. "In den Jahren 1957 bis 1959 erschienene Werke zur spätantiken Kunst," in: **Kunstgeschichtliche Anzeigen,** Neue Folge, Jahrg. 4, 1959/1960, pp. 185-94.
Critical examination of the major works on late Roman art published from 1957 to 1959. The works discussed are listed at the beginning of the article. See (31) for series annotation.

60 Lopez Pegna, Mario. **Saggio di bibliografia etrusca.** Florence, Sansoni, 1953.
Classified bibliography of books and periodical articles on all aspects of Etruscan art.

61 Moon, Brenda E. **Mycenaean Civilization Publications since 1935; A Bibliography.** London, University of London Institute of Classical Studies, 1957. 77p. (Bulletin of the Institute of Classical Studies, University of London, Supplement, no. 3).
Unclassified bibliography of books and periodical articles on all aspects of Minoan Crete published between January 1936 and June 1956. Subject index, pp. 68-77.

62 Porter, Bertha, and Rosalind L. B. Moss. **Topographical Bibliography of Ancient Egyptian Hieroglyphic Texts, Reliefs and Paintings.** 2d ed. Oxford, Clarendon Press, 1960. 7v. LC 60-1989.
Comprehensive classified bibliography of books and periodical articles dealing with ancient Egyptian hieroglyphic inscriptions, reliefs, and paintings. Does not cover architecture or free-standing sculpture. Contents:
I. *Theban Necropolis*
II. *Theban Temples*
III. *Memphis*
IV. *Lower and Middle Egypt*
V. *Upper Egypt: Sites*
VI. *Upper Egypt: Temples*
VII. *Nubia, the Deserts and Outside Egypt.*
A basic reference tool for advanced study in ancient Egyptian painting and relief sculpture.

63 Rounds, Dorothy. **Articles on Antiquity in Festschriften, an Index: The Ancient Near East, the Old Testament, Greece, Rome, Roman Law, Byzantium.** Cambridge, Mass., Harvard University Press, 1962. 560p. LC 62-7193.
An index to articles on all aspects of ancient and Byzantine civilizations including art and architecture published in festschriften.

64 Sarne, Berta. "In den Jahren 1955 bis 1961 erschienene Werke zur kretisch-mykenischen Kunst," in: **Kunstgeschichtliche Anzeigen,** Neue Folge, Jahrg. 7, 1965/1966, pp. 7-61.
Critical examination of the major works on Aegean art published from 1955 to 1961. The works discussed are listed at the beginning of the article. See (31) for series annotation.

65 **Swedish Archaeological Bibliography.** v. 1- . 1939-1948- . Stockholm, Almquist Wiksell, 1951- . LC 53-19073.
English edition of annual Swedish archaeology bibliography. Each issue has essays by Swedish scholars on current research and a classified bibliography of archaeological literature including art and architecture.

66 Swoboda, K. M. "In den Jahren 1950 bis 1954 erschienene Werke zur Kunst der prähistorie und alten Orients," in: **Kunstgeschichtliche Anzeigen,** Neue Folge, Jahrg. 1, 1955/1956, pp. 3-77.
 Critical examination of the major works on prehistoric art and the art of the Ancient Near East published from 1950 to 1954. The works discussed are listed at the beginning of the article. See (31) for series annotation.

67 Swoboda, K. M. "In den Jahren 1950 bis 1956 erschienene Werke zur griechischen Kunst," in: **Kunstgeschichtliche Anzeigen,** Neue Folge, Jahrg. 3, 1958, pp. 9-44.
 Critical examination of the major works on ancient Greek art published from 1950 to 1956. The works discussed are listed at the beginning of the article. See (31) for series annotation.

68 Swoboda, K. M. "In den Jahren 1950 bis 1957 erschienene Werke zur Kunst der Spätantike," in: **Kunstgeschichtliche Anzeigen,** Neue Folge, Jahrg. 3, 1958, pp. 80-137.
 Critical examination of the major works on late Roman art published from 1950 to 1957. The works discussed are listed at the beginning of the article. See (31) for series annotation.

69 Swoboda, K. M. "In den Jahren 1950 bis 1957 erschienene Werke zur römischen Kunst," in: **Kunstgeschichtliche Anzeigen,** Neue Folge, Jahrg. 3, 1958, pp. 57-59.
 Critical examination of the major literature on Roman art published from 1950 to 1957. The works discussed are listed at the beginning of the article. See (31) for series annotation.

Medieval and Byzantine

70 **Bibliographie de l'art byzantin et post-byzantin, 1945-1969.** Athens, Comité National Hellenique de l'Association Internationale d'Etudes du Sud-Est Européen, 1970. 115p. LC 72-318821.
 Classified bibliography of books and periodical articles on all aspects of Byzantine and derivative art forms in Eastern Europe published between 1945 and 1969. Brings up to date the various special bibliographies published in *Orient et Byzance* and *Byzantion* in the 1930s and 1940s.

71 Bonser, Wilfrid. **An Anglo-Saxon and Celtic Bibliography (405-1087).** Berkeley and Los Angeles, University of California Press, 1957. 2v. index.
 A general classified bibliography of Anglo-Saxon and Celtic culture. Includes a good section (pp. 480-574) on art, which includes books and periodical articles published up to 1953. Author and subject indexes in volume 2.

72 Chapman, Gretel. **Mosan Art: An Annotated Bibliography.** Boston, G. K. Hall, 1988. 392p. index. LC 87-26611.
 Comprehensive classified and annotated bibliography of the literature on the art and architecture of the various centers of the Mosan Valley during the Romanesque period (eleventh through the early thirteenth centuries). Includes literature on the history of the Mosan region during the Romanesque period.

73 Curcic, Slobodan. **Art and Architecture in the Balkans.** Boston, G. K. Hall, 1984. 427p. index. LC 83-18392.
 Comprehensive classified and annotated bibliography of the literature on art and architecture of Albania, Bulgaria, and Yugoslavia from the ninth through the nineteenth centuries with emphasis on the Middle Ages.

74 Deshman, Robert. **Anglo-Saxon and Anglo-Scandinavian Art: an Annotated Bibliography.** Boston, G. K. Hall, 1984. 125p. LC 84-10797.
Comprehensive classified and annotated bibliography of the literature on the art of England, excluding architecture, from the last third of the ninth century to the first quarter of the twelfth century.

75 **Dumbarton Oaks Bibliographies Based on Byzantinische Zeitschrift. Series I: Literature on Byzantine Art 1892-1967. Volume I: By Location. Volume 2: By Categories.** Ed. by Jelisaveta S. Allen. London, Mansell, 1973, 1976.
Classified and annotated bibliography of books and periodical articles on all aspects of Byzantine art. The entries are derived from the annual bibliography published since 1892 in the periodical *Byzantinische Zeitschrift*, the leading scholarly journal for Byzantine studies.

76 Filov, B. "Die Erforschung der altbulgarischen Kunst seit 1914," in: **Zeitschrift für slavische Philologie,** VII, 1931, pp. 131-43.
Critically annotated bibliography of scholarly literature on the history of medieval Bulgarian art which appeared between 1914 and 1930. Of interest to students of Byzantine art.

77 Grabar, André, and K. Mijatev. "Bibliographie de l'art byzantin: Bulgarie," in: **Orient et Byzance,** IV, 2, 1930, pp. 417-26.
Classified bibliography of books and periodical articles on the Byzantine phase of art in Bulgaria. Part of a series of bibliographies in this periodical covering most Slavic schools of Byzantine art.

78 Lord, Carla. **Royal French Patronage in the Fourteenth Century: An Annotated Bibliography.** Boston, G. K. Hall, 1985. 240p. LC 85-7621.
Comprehensive bibliography of the literature relating to the patronage of art and architecture by the French crown from the end of the thirteenth to the early fifteenth centuries.

79 Millet, Gabriel, and N. A. Il'in. "Bibliographie de l'art byzantin chez les Russes," in: **Orient et Byzance,** V, 1932, pp. 439-90.
Classified bibliography of books and periodical articles on the Byzantine phase of Russian art. Part of a series of specialized bibliographies in this periodical covering the major Slavic schools of Byzantine art.

80 Monneret de Villard, U. "Saggi di una bibliografia dell'arte cristiana in Egitto," in: **Rivista dell'Istituto d'Archeologia e Storia dell'Arte,** I, 1922, pp. 20-34.
Classified and annotated bibliography of books and periodical articles on Coptic art and architecture published before 1920.

81 Nees, Lawrence P. **From Justinian to Charlemagne, European Art, 567-787: An Annotated Bibliography.** Boston, G. K. Hall, 1985. 296p. LC 84-19762.
Comprehensive classified and annotated bibliography of the literature on art and architecture in Europe from 565 to 787. Covers both early Byzantine and "Dark Ages" art and architecture.

82 Sotiriou, G. A. "Bibliographie de l'art byzantin; Bulgarie, Serbie, Roumanie," in: **Orient et Byzance,** IV, 1930, pp. 417-54.
Classified bibliography of books and periodical articles on the Byzantine phase of art in Bulgaria, Serbia, and Romania. Part of a series of specialized bibliographies in this periodical covering the major Slavic schools of Byzantine art.

83 Stein, Frauke. "In den Jahren 1957 bis 1962 erschienene Werke zur Kunst der frühen Mittelalters," in: **Kunstgeschichtliche Anzeigen,** Neue Folge, Jahrg. 6, 1963/1964, pp. 105-133.
 Critical examination of the major works on early medieval art published from 1957 to 1962. The works discussed are listed at the beginning of the article. See (31) for series annotation.

84 Swoboda, K. M. "In den Jahren 1950 bis 1956 erschienene Werke zur Kunst des frühen Mittelalters," in: **Kunstgeschichtliche Anzeigen,** Neue Folge, Jahrg. 3, 1958, pp. 138-94.
 Critical examination of the major works on early medieval art (i.e., pre-Carolingian) published from 1950 to 1956. The works discussed are listed at the beginning of the article. See (31) for series annotation.

85 Swoboda, K. M. "In den Jahren 1950 bis 1957 erschienene Werke zur byzantin-ischen und weiteren ostchristlichen Kunst-Architektur," in: **Kunstgeschichtliche Anzeigen,** Neue Folge, Jahrg. 4, 1959/1960, pp. 34-56.
 Critical examination of the major works on Byzantine and East Christian architec-ture published from 1950 to 1957. The works discussed are listed at the beginning of the article. See (31) for series annotation.

86 Swoboda, K. M. "In den Jahren 1950 bis 1957 erschienene Werke zur Kunst der karolingische Zeit," in: **Kunstgeschichtliche Anzeigen,** Neue Folge, Jahrg. 4, 1959/1960, pp. 1-33.
 Critical examination of the important literature on Carolingian art published from 1950 to 1957. The works discussed are listed at the beginning of the article. See (31) for series annotation.

87 Swoboda, K. M. "In den Jahren 1950 bis 1961 erschienene Werke zur byzantin-ischen und weiteren ostchristlichen Kunst-Figurenkunst," in: **Kunstgeschichtliche Anzeigen,** Neue Folge, Jahrg. 5, 1961/1962, pp. 9-183.
 Critical examination of the major works on Byzantine art exclusive of architecture published from 1950 to 1961. The works discussed are listed at the beginning of the article. See (31) for series annotation.

88 Werner, Martin. **Insular Art: An Annotated Bibliography.** Boston, G. K. Hall, 1984. 432p. LC 84-10914.
 Comprehensive classified and annotated bibliography of the literature (to 1979) on the art and architecture of the British Isles from the early fifth century to 871 (to 1017 in Ireland). In addition there are sections covering general history, language, literature, learn-ing, exegesis, and liturgy.

89 Wulff, Oscar K. **Bibliographisch-Kritischer Nachtrag zu altchristliche und byzan-tinische Kunst.** Potsdam, Athenaion, 1937. 88p.
 Classified bibliography of books and periodical articles on all aspects of early Christian and Byzantine art. Supplement to the author's *Altchristliche und byzantinische Kunst ...* (Berlin, Athenaion, 1918) in the series "Handbuch der Kunstwissenschaft."

Renaissance and Baroque

90 Kaufmann, Thomas D. **Art and Architecture in Central Europe, 1550-1620: An Annotated Bibliography.** Boston, G. K. Hall, 1988. 360p. index. LC 88-1816.
 Comprehensive classified and annotated bibliography of the literature on the archi-tecture and art in the German speaking territories, Hungary, Bohemia, and Poland during the period 1550-1620. Geographical arrangement. Includes dissertations and exhibition catalogs.

91 Parshall, Linda B., and Peter W. Parshall. **Art and the Reformation. An Annotated Bibliography.** Boston, G. K. Hall, 1986. 282p. index. LC 85-27176.
Comprehensive classified and annotated bibliography of the literature on the relationship between art and architecture and the Reformation in Western Europe during the sixteenth century. Arranged by topics: The Image Controversy; Iconoclasm; The Reformation Period and Art; Text Illustration and Printed Propaganda; Reformation Religious Iconography; Artists of the Reformation; Architecture, Architectural Decoration and Furnishing; Decorative and Minor Arts; Iconography and the Reformers.

Modern (19th and 20th Centuries)

92 Anderson, David L., ed. **Symbolism: A Bibliography of Symbolism as an International and Multi-disciplinary Movement.** New York, New York University Press, 1975. 160p. index. LC 74-17460.
Classified bibliography on all aspects of symbolism including art, literature, music, and philosophy. Covers the literature from 1880 to 1973. Divided into four parts: general and miscellaneous; national and international movements; forms and genres; individual. No annotations.

93 Andreoli-de Villers, Jean-Pierre. **Futurism and the Arts: A Bibliography. 1959-1973.** Toronto, University of Toronto Press, 1975. 189p. index.
Chronologically arranged bibliography of 1,895 books, catalogs, and periodical articles on all aspects of Futurism. Introduction lists eighteen locations in Italy, France, and North America with collections of documents relating to Futurism. Section on periodicals of Futurism.

94 **Arntz-Bulletin; Dokumentation der Kunst des 20. Jahrhunderts.** v. 1- . Haag, Arntz-Winter, 1968- .
Annual bibliography that aims at covering all the oeuvre catalogs of major twentieth century artists. Arranged more or less alphabetically, the entries are annotated, and corrections and additions to the catalogs are presented by the compiler. In 1975, a Sonderband, *Werkkataloge zur Kunst des 20. Jahrhunderts,* appeared. It lists catalogues raisonnées printed since 1945, without annotations. Emphasis is on major European painters, sculptors, and graphic artists.

95 **Art Bibliographies Modern.** v. 1- . Santa Barbara, Calif., ABC-Clio, 1969- .
Annual bibliography of books and periodical articles on twentieth century art. Volume 1 was titled *L.O.M.A. Literature on Modern Art*; it was published in London by Lund and Humphries and was based on material in the Victoria and Albert Museum Library, Courtauld Institute Library, and the Library of the Lanchester Polytech. Subsequent volumes have been generally expanded. First section is arranged alphabetically by artist, second section by subject. A valuable bibliographical tool for modern art. Beginning with 1973 *Art Bibliographies Modern* is accessible through DIALOG database.

96 Bell, Doris L. **Contemporary Art Trends 1960-1980: A Guide to Sources.** Metuchen, N.J., Scarecrow Press, 1981. 171p. LC 81-5668.
Bibliographic guide to information in books and exhibition catalogs on trends in world art between 1960 and 1980. Arranged by trends and countries, the information is provided in descriptive paragraphs which define the trends and include bibliographical references. Useful annotated list of contemporary art journals.

97 **Bibliographie 1925: Cinquantenaire de l'exposition de 1925.** Paris, Société des Amis de la Bibliotheque Forney, 1976. 166p. index.
Comprehensive bibliography of 1,494 books, exhibition and museum catalogs and periodical literature on all aspects of the 1925 Art Deco exposition. Classified by media. Includes theater and the decorative arts.

98 Dobai, Johannes. **Die Kunstliteratur des Klassizismus und der Romantik in England.** Bern, Benetli, 1974-1977. 3v. LC 75-552831.

Comprehensive, critical bibliographical study of eighteenth and nineteenth century literature on art in England. Contents: Volume 1, 1700-1750: (I) Allgemeine Kunstlehre; (II) Architektur; (III) Gartenkunst; (IV) Malerei; (V) Kunstgeschichte; (VI) Auslandreisen. Abkürzungen von Zeitschriften und Nachschlagewerken, p. 15; Bibliographien, p. 15-22; Gekürzt zitierte Literatur, pp. 22-43; Volume 2, 1750-1790: (I) Allgemeine Kunstlehre; (II) Architektur; (III) Malerei; (IV) Gartenkunst; (V) Kunstleben und seine institutionellen Formen; (VI) Kunstgeschichte; (VII) Auslandreisen; Volume 3, 1790-1840: (I) Allgemeine Kunstlehre und Quellen; (II) Architektur; (III) Malerei und Skulptur; (IV) Gartenkunst; (V) Kunstgeschichte; (VI) Auslandreisen; (VII) Urteile von Ausländern über die englische Kunst. Bibliographies are at the end of each section.

99 Edwards, Hugh. **Surrealism and Its Affinities: The Mary Reynolds Collection. A Bibliography.** 2d ed. Chicago, The Art Institute of Chicago, 1973. 147p. illus. index.

Annotated bibliography of works by Surrealist artists and writers assembled by patroness Mary Reynolds: a bibliography of source materials rather than of literature on Surrealism. Includes books and monographs, Surrealist periodicals, and such miscellanea as catalogs, posters, and broadsides.

100 Falqui, Enrico. **Bibliografia e iconografia del Futurismo.** Florence, Sansoni, 1959. 239p. illus. index. LC 59-33638.

Bibliography of books and periodical literature on all aspects of Italian Futurism including art. Entries are unannotated and arranged alphabetically by author's last name. Useful collection of portraits of major personalities in the Futurism movement.

101 Gershman, Herbert. **A Bibliography of the Surrealist Revolution in France.** Ann Arbor, University of Michigan Press, 1969. 57p. LC 68-31128.

Unannotated and unclassified list of books and periodical articles on all aspects of Surrealism in France, meant as a companion to the author's *The Surrealist Revolution in France* (Ann Arbor, University of Michigan Press, 1969).

102 Grady, James. "Bibliography of Art Nouveau," in: **Journal of the Society of Architectural Historians**, XIV, 1955, pp. 18-27.

Classified and annotated bibliography of books and periodicals in all languages on Art Nouveau, with particular emphasis on architecture. Sections are devoted to literature on major Art Nouveau architects.

103 **Index Expressionismus: Bibliographie der Beiträge in den Zeitschriften und Jahrbüchern zu literarischen Expressionismus, 1910-1925.** Im Auftrage des Seminars für deutsche Philologie der Universität Göttingen und in Zusammenarbeit mit dem Deutschen Rechenzentrum Darmstadt. Herausgegeben von Paul Raabe. Nendeln, Liechtenstein, Kraus-Thomson, 1972. 18v.

A bibliography of contributions to 103 Expressionist literary magazines during the period 1910-1925. Includes numerous references to art and artist. In five parts: Index A, Alphabetical name index (4v.); Index B, Systematic (or subject) index (5v.); Index C, Index to individual magazines (5v.); Index D, Alphabetical title list (2v.); Index E, Classified index (2v.)

104 Kempton, Richard. **Art Nouveau: An Annotated Bibliography.** Los Angeles, Hennessey & Ingalls, 1977. 303p. index. (Art and Architecture Bibliographies, 4).

Classified bibliography of books and periodical articles on all aspects of Art Nouveau in continental Europe. Major entries are annotated.

105 Lietzmann, Hilda. **Bibliographie zur Kunstgeschichte des 19. Jahrhunderts: Publikationen der Jahre 1940-1966.** Munich, Prestel, 1968. 234p. index. (Studien zur Kunst des neunzehnten Jahrhunderts, Bd. 4). LC 68-133420. Marianne Prause, **Bibliographie zur Kunstgeschichte des 19. Jahrhunderts: Publikationen der Jahre 1967-1979 mit Nachträgen zu den Jahren 1940-1966.** Munich, Prestel, 1984. 1019p. index. (Materialen zur Kunst des neunzehnten Jahrhunderts, Bd. 31) ISBN 3791306375.

Comprehensive, classified bibliography of books and periodical articles on all aspects of nineteenth-century art published between 1940 and 1979. A thorough bibliography basic to serious research in European art and architecture of the nineteenth century.

106 Spalek, John M. **German Expressionism in the Fine Arts: A Bibliography.** Los Angeles, Hennessey & Ingalls, 1977. 272p. (Art and Architecture Bibliographies, 3). LC 72-188987.

Classified bibliography of some 400 books published before 1972 on German expressionism. Includes books by and illustrated by artists. Concentration is on painting and graphic work.

EUROPEAN NATIONAL AND AREA BIBLIOGRAPHIES

Baltic Countries

107 Böckler, Erich, and Henrik Fischer. **Bibliographie zur baltischer Bau- und Kunstgeschichte, 1939-1981.** Berlin, Deutscher Kunstverlag, 1984. 56p. index. (Sonderheft: Schrifttum zur Deutschen Kunst). ISBN 3871570982.

Classified bibliography of books and periodical literature on all aspects of art and architecture in Estonia, Latvia, Lithuania, and former German provinces of East and West Prussia. Covers the literature published between 1939 and 1981. For the earlier literature see: Niels von Holst, *Die deutsche Kunst des Baltenlandes im Lichte neuer Forschung. Berichte über das gesamte Schrifttum seit dem Weltkrieg 1919-1939* (Munich, 1942. 160p. Schriften der Deutschen Akademie, Nr. 31) and Peter Kügler, *Schrifttum zur Deutsch-Baltischen Kunst* (Berlin, 1939. 42p. Sonderheft: *Schrifttum zur Deutschen Kunst*).

108 Reklaitis, Paul. **Einführung in die Kunstgeschichtsforschung des Grossfürstentums Litauen: mit Bibliographie und Sachregister.** Marbur, Herder-Institut, 1962. 217p. map. (Wissenschaftliche Beiträge zur Geschichte und Landeskunde Ost-Mitteleuropas. 59).

Bibliography of 944 books and articles on all aspects of Lithuanian art arranged alphabetically by author.

Belgium

109 "Bibliographie de l'histoire de l'art national. Bibliografie van de nationale Kunstgeschiedenis," 1973- , in: **Revue belge d'archéologie et d'histoire de l'art,** XLIII, 1974- .

Annual classified bibliography of books and periodical articles on all aspects of art and architecture in Belgium. Appears at the end of the last number in each year. Long-awaited companion to the annual bibliography on Dutch art and architecture published in *Simiolus* (140).

Denmark

110 **Bibliografi over Dansk Kunst.** 1971- . Copenhagen, Kunstakademiets Bibliotek, 1972- .

Annual, classified bibliography of books and periodical articles on all aspects of Danish fine arts. Includes foreign-language literature as well as literature in Danish. Does

not include works on archaeology, folk art, costume, numismatics, or photography. A retrospective bibliography covering the literature on Danish art published between 1933 and 1970 is planned to fill the gap between the *Bibliografi over Dansk Kunst* and Bodelsen and Marcus (110). A basic reference tool for any serious study of Danish art.

111 Bodelsen, Merete, and Aage Marcus. **Dansk Kunsthistorisk Bibliografi.** Copenhagen, Reitzel, 1935. 503p.
 Classified bibliography of books and periodical articles on Danish art. Includes both Danish and foreign-language publications.

France

112 France. Archives Nationales. **Les sources de l'histoire de l'art aux Archives Nationales, par Mireille Rambaud, conservateur-adjoint aux Archives Nationales. Avec une étude sur les sources de l'histoire de l'art aux Archives de la Seine, par Georges Bailhache et Michel Fleury, archivistes-adjoints du département de la Seune et de la ville de Paris.** Avant-propos de Charles Braivant. Paris, Impr. Nationale, 1955. 173p. From 1970 supplemented in **Société de l'Histoire de l'Art Française. Bulletin.**
 Guide to the art resources in the national archives of France. Bibliographical footnotes. Contents: Tableau méthodique des séries; Table chronologique des séries; Instruments généraux de recherches: part 1, Documents écrits; part 2, Documents iconographiques; part 3, Les sources de l'histoire de l'art aux Archives de la Seine. Index.

113 Lasteyrie de Saillant, Robert C., et al. **Bibliographie générale des travaux historiques et archéologiques publiés par les sociétés savantes de la France, dressée sous les auspices du Ministère de l'instruction publique.** Paris, Impr. Nationale, 1888-1918. 6v. Reprint: New York, Burt Franklin, 1972. LC 66-20686.
 Volumes 1-4 cover the literature published to the year 1885; volumes 5-6 cover 1886-1900. Supplemented for the literature published after 1900 by *Bibliographie annuelle des travaux historiques et archéologiques publiés*, by the Sociétés Savantes de la France (t.1- . années 1901-1904. 1906- .) Contents: t.1 Ain-Gironde. 1888; t.2. Hérault-Haute-Savoie. 1893; t.3. Seine: Paris, 1 ptie. 1901; t.4. Seine: Paris (suite), Seine-et-Marne-Yonne, Colonies, Instituts français à l'étranger. Supplément, index des volumes analysés dans les tomes I à VI. Bibliography of the publications of French historical and archaeological societies (includes all artistic societies and local historical societies). Arranged alphabetically by title of society and then by publication. Basic to scholarly research in French art, architecture, and archaeology.

114 Lebel, Gustave. **Bibliographie des revues et périodiques d'art parus en France de 1746 à 1914.** Paris, Gazette des Beaux-Arts, 1951. (Gazette des Beaux-Arts, janv.-mars 1951, 6e per. t. 38). Reprint: Nendelen, Kraus, 1976.
 List of periodicals of art published in France between 1746 and 1914, by title. Gives date of first issue, frequency, editors, and the location of copies (either Bibliothèque Nationale or University of Paris Libraries). Some are annotated. Chronological index. Useful tool for students of eighteenth and nineteenth-century French art history. See *Répertoire d'art....* (32).

115 Marquet de Vasselot, Jean J. **Répertoire des publications de la Société de l'Histoire de l'Art Français (1851-1927).** Paris, Colin, 1930. xxxii, 219p.
 An index of nearly 2,400 books, articles, documents, sources, etc., published by the Société de l'histoire de l'art français from 1851-1927. Especially valuable as a key to the various documents and sources published in *Archives de l'art français, Nouvelles archives de l'art français, Mémoires inédits sur la vie et les ouvrages des membres de l'Académie Royale de Peinture et de Sculpture, Bulletin de la Société de l'Histoire de l'Art Français,* and *Revue de l'art français.*

German-speaking Countries

GENERAL WORKS

116 **Literaturbericht zur Kunstgeschichte: deutschsprachige Periodika. 1971.** Berlin, Mann and Deutscher Verein für Kunstwissenschaft, 1975. 186p. index.

Very comprehensive classified bibliography of articles on all aspects of art history published in German-language periodicals during 1971. The 2,546 articles are provided with abstracts, many written by the authors. Excellent author, artist, topographical, and subject index. Since German scholarship is central to many areas of art historical research, this work (assuming that subsequent volumes can appear at reasonable intervals) is potentially one of the major bibliographical reference tools for art history.

117 **Schrifttum zur deutschen Kunst.** Jahrg. 1- . Berlin, Deutscher Verein für Kunstwissenschaft, 1934- .

Published by the Deutscher Verein für Kunstwissenschaft and, since 1961, "zusammengestellt von der Bibliothek des Germanischen Nationalmuseums" in Nuremberg. One of the most thorough and comprehensive of national art bibliographies. Classified and annotated bibliography of books, periodical articles, exhibition catalogs, and book reviews on all aspects of art in German-speaking countries. Author, artist, and place indexes.

AUSTRIA

118 **Bibliographie zur Kunstgeschichte Österreichs.** Zusammengestellt im Kunsthistorischen Institut der Universität Wien. Lehrkanzel für Österreichische Kunstgeschichte, 1965- . Vienna, Schroll, 1966- .

Classified bibliography of books and periodical articles on all aspects of Austrian art. Issued as a supplement to *Österreichische Zeitschrift für Kunst und Denkmalpflege,* XX-XXV (1966-1971). Continues the bibliographic coverage of Austrian art in *Mitteilungen der Gesellschaft für vergleichende Kunstforschung in Wien,* I (1948)-XV (1963).

GERMANY

119 Beyrodt, Wolfgang. **Westfälische Kunst bis zum Barock: Ein Literaturverzeichnis.** Bielefeld, Stadtbibliothek Bielefeld, 1970. 63p.

Classified bibliography of books and periodical articles on all aspects of art in Westphalia from the early Middle Ages through the baroque.

120 Deutsche Akademie der Wissenschaft zu Berlin, Arbeitsstelle für Kunstgeschichte. **Schriften zur Kunstgeschichte.** Berlin, Akademie-Verlag, 1960-1974. 6v.

Bibliography of books and periodical articles on all aspects of art in the German Democratic Republic (East Germany). Issued in volumes devoted to separate regions: No. 4, *Bibliographie zur sächsischen Kunstgeschichte,* by Walter Hentschel (1960. 273p.); No. 7, *Bibliographie zur brandenburgischen Kunstgeschichte,* by Edith Neubauer and Gerda Schlegelmilch (1961. 231p.); No. 8, *Bibliographie zur Kunstgeschichte Mecklenburg und Vorpommern,* by Edith Fründt (1962. 123p.); No. 9, *Bibliographie zur Kunstgeschichte von Sachsen-Anhalt,* by Sibylle Harksen (1966. 431p.); No. 13, *Bibliographie zur Kunstgeschichte von Berlin und Potsdam,* by Sibylle Badstübner-Groger (1968. 320p.); and No. 16, *Bibliographie zur thüringischen Kunstgeschichte,* by Helga Mobius (1974. 227p.).

121 Deutscher Kunstrat. **Schrifttum zur deutschen Kunst des 20. Jahrhunderts: eine Bibliographie des deutschen Kunstrates e. V.** v. 1- . Bearb. von Ernst Thiele. Cologne, Oda 1960- . LC 61-47348

Classified and annotated bibliography of books, periodical articles, exhibition catalogs, and book reviews published in Germany on German art of the twentieth century. Supplements *Schrifttum zur deutschen Kunst* (116), which does not include art after Art Nouveau.

122 Gruhn, Herbert. **Bibliographie der schlesischen Kunstgeschichte.** Breslau, Korn, 1933. 357p. (Schlesische Bibliographie, 6, 1).
Classified bibliography of books and periodical articles on all aspects of art and architecture in the former German province of Silesia.

123 Krienke, Gisela. **Bibliographie zu Kunst und Kunstgeschichte: Veröffenlichungen im Gebiet der Deutschen Demokratischen Republik.** V. 1, 1935-1945; V. 2, 1945-1957. Berlin, VEB, 1956, 1961. index.
Classified bibliography of books and periodical articles published in the German Democratic Republic (East Germany). Includes unpublished dissertations. Volume 2 has supplement to volume 1. Indexes by periodical, artist, place, names, subjects, and authors.

124 Kügler, Hans Peter. **Schrifttum zur deutsch-baltischen Kunst.** Berlin, Deutscher Verein für Kunstwissenschaft, 1939. 42p.
Issued as a supplement to the *Schrifttum zur deutschen Kunst* (116). Classified bibliography of books and periodicals on German art in the former German Baltic provinces.

125 **Schrifttum zur rheinischen Kunst von den Anfängen bis 1935.** Berlin, Deutscher Verein für Kunstwissenschaft, 1949. 284p.
Classified and annotated bibliography of books and periodical articles on all aspects of the fine arts in the Rhineland. Covers material published up to 1935, when the *Schrifttum zur deutschen Kunst* (116) takes over the indexing of literature on Rhenish art.

126 Sepp, Hermann. **Bibliographie der bayerischen Kunstgeschichte bis Ende 1905.** Strasbourg, Heitz, 1906. 345p. index. (Studien zur deutschen Kunstgeschichte, Bd. 67). **Nachtrag für 1906-1910.** Strasbourg, Heitz, 1912. 208p. index. (Studien zur deutschen Kunstgeschichte, Bd. 67/155).
Classified and annotated bibliography of books and periodical articles on all aspects of art in Bavaria. Covers material published up to 1905, with the Nachtrag treating the literature between 1906 and 1910. Continued by Wichmann (127); together, they ensure that Bavaria is the most thoroughly bibliographized fine arts region in the world.

127 Wichmann, Hans. **Bibliographie der Kunst in Bayern.** Wiesbaden, Harrassowitz, 1961-1973. 4v. LC 63-59310.
Classified and annotated bibliography of books and periodical articles on all aspects of art in Bavaria. Covers only works published in the twentieth century, hence it complements Sepp (126). The most thorough of regional bibliographies thus far produced for the fine arts; includes nearly 70,000 items. Matthias Mende's *Sonderband: Dürer-Bibliographie* (Wiesbaden, Harrassowitz, 1971) classifies and annotates over 10,000 items dealing with the art of Albrecht Dürer and is also a model of an exhaustive artist bibliography.

Great Britain

128 London University. Courtauld Institute of Art. **Annual Bibliography of the History of British Art.** v. 1-6. 1934-1948. Cambridge, Cambridge University Press, 1936-1957. index.
Classified bibliography of books and periodical articles. Includes Celtic and Viking but not Roman art. Index in each volume. Useful tool for the study of British art, unfortunately discontinued.

129 **Archaeological Bibliography for Great Britain and Ireland, 1950/1951- .** London, Council for British Archaeology, 1949- . Annual. (1940/1946-1948/1949 **Archaeological bulletin for the British Isles**).
A classified index of book and periodical literature on English and Irish archaeology (including art history) from the earliest times to 1600 A.D., with few entries for literature on monuments of the seventeenth century.

130　**British archaeological abstracts.** v. 1- . London, Council for British Archaeology, 1968- . v. 1, no. 1 preceded by an introductory issue (1967). Published twice a year in Apr. and Oct. Ed. by Cherry Lavell.

Abstracts of articles on all aspects of archaeology in Britain from earliest times to 1600 A.D. Should be used together with *Archaeological Bibliography of Great Britain and Ireland* (128).

Hungary

131　Boskovits, Miklos, ed. **L'art du gothique et la Renaissance, 1300-1500: Bibliographie raisonnée des ouvrages publiées en Hongrie.** Budapest, Comité National Hongrois d'Histoire de l'Art, 1965. 2v. index. LC 68-37621.

Classified and annotated bibliography of books and periodical articles on Gothic and Renaissance art published in Hungary. Contains 2,858 entries. Author index.

Italy

132　"Bibliografia dell'arte veneta," in: **Arte Veneta**, Anno I, 1947- .

Classified bibliography of books and periodical articles appearing annually on all aspects of art and architecture in Venice and its environs.

133　**Bibliografia del libro d'arte italiano.** v.1- . 1940- . Rome, Bestetti, 1952- . LC A-53-9809 rev.

Classified bibliography of books on Italian art including congresses, catalogs, and guides. Volume 1, *Cura die Erardo Aeschlimann.* Author, title, artist indexes.

134　"Bollettino bibliografico," in: **Commentari: Rivista di Critica e Storia dell'Arte,** Anno 2- , 1951- .

Loosely classified list of books and periodical articles on Italian art and architecture appearing in each quarterly issue. By no means an exhaustive bibliography, it is useful in catching major current publications.

135　Borroni, Fabia. **"Il Cicognara": Bibliografia dell'archeologia classica e dell'arte italiana.** v. 1, t. l-v. 2, t. 7- . Florence, Sansoni, 1954-1967. (Biblioteca Bibliografica Italica, v. 6-).

Classified and annotated bibligraphy of books on classical and Italian art. Arranged in classes and listed chronologically. Illustrates the title pages of earlier works. A basic reference tool for students of classical and Italian art.

136　Ceci, Giuseppe. **Bibliografia per la storia delle arti figurative nell'Italia meridonale....** Naples, Presso la R. Deputazione, 1937. 2v. index.

Comprehensive classified bibliography of books and periodical articles on south Italian art. Arranged chronologically, volume 1 lists works published before 1742; volume 2, those published after that date. Material is best located by means of the author, artist, and place indexes in volume 2. An excellent regional fine arts bibliography.

137　Geck, Francis J. **Bibliography of Italian Art....** v. 5-10. Boulder, Colo., University of Colorado Book Store, 1932-1941.

Volumes 1-4 were never published. Classified bibliography of books on Italian history, customs, and literature as well as art and architecture. Emphasis is on books in English. Contents:

Volume 5	*Italian Gothic Art 1200-1420*
Volume 6	*Italian Early Renaissance Art—Quattrocento*
Volume 7	*Italian High Renaissance Art—Cinquecento*

Volume 8 *Italian Late Renaissance Art—Cinquecento*
Volume 9 *Italian Baroque Art—Il Seicento*
Volume 10 *Italian Rococo Art*
Popular work for the general reader and beginning student.

138 Instituto Nazionale per le Relazioni Culturali con l'Estero. **Archeologia, arti figura-
tive, musica.** Rome, I.R.C.E., 1941. 498p. index.
 Classified bibliography covering archaeology, art, theater, cinema, and music in
Italy. Books and exhibition catalogs published between 1922 and 1941. Author index. Sup-
plements *Bibliografia del libro d'arte italiano.* In the series "Bibliografie del Ventennio."

139 Lozzi, Carlo. **Biblioteca istorica della antica e nuova italia. Saggio di bibliografia
analitico, comparato e critico sulla propria collezione con un discorso proemiale.** Imola,
Galeati, 1886-1887. 2v. Reprint: Bologna, Forni, 1963.
 An annotated bibliography of Italy, most valuable to art historians for the location
of documentary material and the specialized literature on local artists. Contents: volume 1,
*Letteratura e parte generale degli statuti; Statuti de' municipii italiani e relativi o affini
ordinamenti; Storia d'Italia in generale; Storia de' municipii e di luoghi e cose particolari
d'Italia; A-O.* volume 2, *P-Z.*

140 Schudt, Ludwig. **Le guide di Roma: Materialien zu einer Geschichte der römischen
Topographie, unter Benützung des handschriftlichen Nachlasses von Oskar Pollak.** Wien,
Filser, 1930. 544p. (Quellenschriften zur Geschichte der Barockkunst in Rom....). Reprint:
Farnborough, Gregg, 1971.
 Comprehensive guide to the guidebooks of Rome. Part 1, (pp. 5-180) is a docu-
mented history of guidebooks to Rome; Part 2, (pp. 185-518) is the bibliography, arranged
chronologically. Index of names and titles, table of publication dates, index of places of
publication.

Netherlands

141 "Bibliografisch Overzicht van in Nederland in 1966-verschenen Publicaties op het
Gebied van de Kunstgeschiedenis en Enkele Aanverwante Wetenschappen," in: **Simiolus,**
Jaargang 1- , 1966/1967- .
 Annual, classified bibliography of books and periodical literature published in the
Netherlands on all aspects of the history of art.

142 Hall, H. van. **Repertorium voor de Geschiedenis der Nederlandsche Schilder- en
Graveerkunst sedert het Begin der 12de Eeuw....** 's Gravenhage, Nijhoff, 1936-1949. 2v.
index.
 Classified bibliography of books and periodical articles on Dutch painting and
engraving from the twelfth century to 1946. Belgian painting and engraving until 1500
included. Author index.

143 Netherlands. Rijksbureau voor Kunsthistorische Documentatie. **Bibliography of the
Netherlands Institute for Art History.** v. 1- . 1943- . The Hague, Rijksbureau, 1943- .
 Classified bibliography of books and periodical articles on Dutch painting and
graphic arts. Continuation of Hall (142).

144 **Repertorium betreffende Nederlandse Monumenten van Geschiedenis en Kunst.**
The Hague, Nederlandsch Oudheidkundige Bond, 1940-1962. 3v. index.
 Classified bibliography of periodical articles on all aspects of art and architecture in
the Netherlands from the early Middle Ages to the present. The period from 1901 to 1940 is
covered in the first two volumes; the period 1941 to 1950 is in the last volume. Subsequent
volumes are planned. A basic reference tool for all serious study of Dutch art and
architecture.

145 **Repertorium van Boekwerken betreffende Nederlandse Monumenten van Geschiedenis en Kunst.** The Hague, Nederlandsch Oudheidkundige Bond, 1950. 169p. index.
Classified bibliography of books on all aspects of art and architecture in the Netherlands from the early Middle Ages to the present. Entries are short and give neither the place of publication, number of pages, nor illustrations. Edited by the Koninklijke Nederlandse Oudheidkundige Bond. Includes books published to 1940. Periodical literature is treated in (144). A basic reference tool for any serious study of Dutch art and architecture.

Norway

146 Langballe, Anne M. Hasund, and Gunnar Danbolt. **Norsk Kunsthistorisk Bibliografi. Skrifter om Norsk Kunst utgitt til og med 1970. Bibliography of Norwegian Art History. Literature on Norwegian Art Published up the End of 1970.** Oslo, Universitetsforlaget, 1976. 390p. index. (Norsk Bibliografisk Bibliotek, Band 51). LC 77-563498.
Comprehensive, classified bibliography of the literature on all aspects of Norwegian art and architecture from 1000 to 1970. Coverage reaches back to 1737 and encompasses periodical literature as well as books. Preface and table of contents in English as well as Norwegian. Supplement: Ketil Falck, *Norsk Kunsthistorisk Bibliografi: Skrifter om Norsk Kunst utgitt fra og med 1971 og med 1985* is in preparation.

Russia

147 Alpatov, Mikhail V., and Nikolai I. Brunov. "Die altrussische Kunst in der wissenschaftlichen Forschung seit 1914," in: **Zeitschrift für slavische Philologie**, II, 1925, pp. 474-505; III, 1926/1927, pp. 387-408.
Classified bibliographies of books and periodical articles on Russian medieval art, published between 1914 and 1925.

Spain and Portugal

148 "Aportaciones recientes a la historia del arte español," in: **Archivo español del Arte**, Tomo 22- , 1949- .
Annual, classified bibliography of books and periodical articles on all aspects of Spanish art. Appears at the end of the "Bibliografia" section in last number in each year. The basic bibliographical tool for the study of Spanish art.

149 **El Libro de arte en España: catalogo de la exposicion celebrada en el Hospital Real de Granada: XXIII Congresso Internacional de Historia de Arte, 3-8 de setiembre de 1973.** Granada, Secretariado de Publicaciones de la Universidad de Granada, 1975. 285p. illus. index. LC 76-458114.
Bibliography of Spanish books on art and architecture printed in the eighteenth and nineteenth centuries arranged by author. Illustrations of title pages and selected plates from major examples. Based on an exhibition for the twenty-third international art history congress.

150 López Serrano, Mathilde. **Bibliografía de arte español y americano 1936-1940....** Madrid, Gráficas Uguina, 1942. 243p. index.
Classified bibliography of books and periodical articles on art and archaeology of Spain, Latin America, and the Philippines published from 1936 to 1940.

151 Oliveira, Arnaldo Henriques de. **Bibliografia artistia portuguesa.** Lisbon, 1944. 320p.
Classified bibliography of books on all aspects of Portuguese art in the library of Luiz Xavier da Costa. Lists 2,930 titles.

152 Paz Aguilo, Maria, Amelia Lopez-Yarto, and Maria Luisa Tarraga. **Bibliografía del arte en españa. Articulos de revistas ordenados por autores.** Madrid, Consejo superior de investigaciones cientificas, Instituto Diego Velazquez, 1978. 664p. LC 78-350600.
Unannotated list of periodical literature on the history of Spanish art and architecture from prehistoric times to the present arranged alphabetically by author's last name.

153 Zamora Lucas, Florentino, and Eduardo Ponce de Leon. **Bibliografía española der arquitectura (1526-1850)....** Madrid, Asoc. de Libreros y Amigos del Libro, 1947. 205p. illus. index.
Classified bibliography of books on Spanish architecture from the period 1526 to 1850. Arranged chronologically by centuries.

Sweden

154 Lundqvist, Maja. **Svensk Konsthistorisk Bibliografi: Sammanställd ur den Tryckta Litteraturen till och med år 1950. Bibliography to Swedish History of Art: Literature Issued up to and including 1950.** Stockholm, Almqvist and Wiksell, 1967. 432p. index. (Stockholm Studies in History of Art, 12). LC 67-103402.
Classified bibliography of books and periodical articles on Swedish art and writings on art history in Swedish. Preface and table of contents in Swedish, and English index.

155 "Svensk Konsthistorisk Bibliografi," 1959- . in: **Konsthistorisk Tidskrift,** XXIX, 1960.
Classified bibliography of books and periodical articles on Swedish art and writings in Swedish on art history in general. Compiled by Gunhild Osterman and Karin Melin-Fravolini. With (154), the standard bibliographical tool for study of Swedish art history.

Switzerland

156 Haendcke, Berthold. **Architecture, sculpture et peinture....** Berne, Wyss, 1892. 100p. index. (Bibliographie nationale suisse, fasc. 6^{a-c}).
Classified bibliography of books and periodical literature on the history of Swiss art. Index is an alphabetical list of artists' monographs.

Orient

GENERAL WORKS

157 "Bibliography," in: **Oriental Art,** XVI, 3, Autumn, 1970- .
Classified bibliography of books and periodical articles on all aspects of Oriental art and architecture. Divided into sections (Islamic and India, China and Japan) that reflect separate quarterly issues. Not annotated and not classified within the subsections. A valuable serial bibliography for students of Oriental art and architecture. For serious study, it should be used with *Bulletin Signalétique, Série 526* (159).

158 "Bibliography of Asian Studies," in: **Journal of Asian Studies.** 1956- . Ann Arbor, Mich., Association for Asian Studies, 1957- . LC 43-14717. (Continues the "Far Eastern Bibliography" included in the *Far Eastern Quarterly*, 1941-1955, which superseded the *Bulletin of Far Eastern Bibliography*, 1936-1940.

Comprehensive, classified bibliography of books and periodical articles in European languages on all aspects of the culture (including art history) of the Far East. Appears in the September number. No annotations. These annual bibliographies are published cumulatively under the same general classification system in: *Cumulative Bibliography of Asian Studies, 1941-1965. Author Bibliography*, and *Subject Bibliography* (Boston, G. K. Hall, 1969, 1970); *Cumulative Bibliography of Asian Studies, 1967-1970. Author Bibliography* (3v.), and *Subject Bibliography* (Boston, G. K. Hall, 1972, 1973. 3v.).

159 **Bulletin Signalétique. Série 526: Art et Archéologie: Proche-Orient, Asie, Amérique.** v. 25- . Paris, Centre National de la Recherche Scientifique, 1971- . LC 70-287578.

Annual bibliography of books and periodical articles on all aspects of the art and archaeology of the Near East, Asia, and the Americas. Covers those areas not treated in the *Répertoire* (32). Most entries have annotations or abstracts in French. A valuable reference work for all serious study of Oriental art and architecture.

160 Kyoto. Imperial University. Research Institute for Humanistic Science. **Bibliography of Oriental Studies.** 1946/1950- . Kyoto, Toho Bunka Kenykyujo, 1952- . Annual (irregular). LC 64-1528.

A classified bibliography of books and periodical articles on all aspects of the culture (including art history) of Japan, China, and Korea in Japanese and Western languages (including Russian). No annotations but occasional references to reviews.

161 Rowland, Benjamin, Jr. **The Harvard Outline and Reading Lists for Oriental Art.** 3d ed. Cambridge, Mass., Harvard University Press, 1967. 77p. LC 67-22872.

Classified bibliography of books on Oriental art. Periodical articles included when no books on a particular subject exist. Useful to the beginning student of Oriental art.

ISLAMIC WORLD

162 Creswell, Keppel A. C. **A Bibliography of the Architecture, Arts and Crafts of Islam to 1st Jan. 1960.** New York, Oxford University Press, 1961. 1330 columns. LC 62-3352. Reprint: Vaduz, Quarto Press, 1978. **Supplement: Jan. 1960 to Jan. 1972.** Cairo, American University in Cairo Press, 1973. 336 columns. **Second Supplement, Jan. 1972 to Dec. 1980.** by J. D. Pearson; assisted by Michael Meinecke, George T. Scanlon. Cairo, American University in Cairo Press, 1984. 578 columns. ISBN 9774240529.

Classified bibliography of books and periodical articles on all aspects of Islamic art with the exception of numismatics. Part 1 lists works on architecture classified by country; part 2 treats arts and crafts, each subdivided by country. A very thorough bibliography kept up-to-date with excellent supplements; basic tool for any serious study of Islamic art and architecture. Incorporates material in the author's *A Provisional Bibliography of Mohammadan Architecture in India* (1922) and *A Bibliography of Painting in Islam* (1953).

163 Ettinghausen, Richard, ed. **A Selected and Annotated Bibliography of Books and Periodicals in Western Languages Dealing with the Near and Middle East with Special Emphasis on Medieval and Modern Times.** Washington, D.C., Middle East Institute, 1952. 111p.

General classified and annotated bibliography on the Islamic world with a section on art and archaeology. Useful to the beginning student and general reader.

164 Kühnel, Ernst. "Kritische Bibliographie islamischer Kunst. 1914-1927," in: **Der Islam**, XVII, 1928, pp. 133-248.
One of the greatest scholars of Islamic art discusses the major publications on Islamic art published between 1914 and 1927.

165 Mayer, L. A. **Annual Bibliography of Islamic Art and Archaeology, India Excepted....** v. 1-3. Jerusalem, Divan Pub. House, 1935-1937.
Classified bibliography of books and periodical articles on all aspects of Islamic art, with the exception of Islamic art in India.

166 Swoboda, K. M. "In den Jahren 1950 bis 1955 erschienene Werke zur Kunst Asiens vor den Islam," in: **Kunstgeschichtliche Anzeigen**, Neue Folge, Jahrg. 1, 1955/1956, pp. 81-142.
Critical examination of the major works on Near and Middle Eastern art before the time of Islam published from 1950 to 1955. The works discussed are listed at the beginning of the article. See (31) for series annotation.

167 Swoboda, K. M. "In den Jahren 1950 bis 1956 erschienene Werke zur Kunst Islams," in: **Kunstgeschichtliche Anzeigen**, Neue Folge, Jahrg. 2, 1957, pp. 63-112
Critical examination of the major works on Islamic art published from 1950 to 1956. The works discussed are listed at the beginning of the article. See (31) for series annotation.

INDIA AND CEYLON

168 **Annual Bibliography of Indian Archaeology....** 1926- . Leiden, Brill, 1928- . illus.
Classified and annotated bibliography of books and periodical articles on all aspects of Indian archaeology, including art. Each volume has a useful introduction describing recent excavations. Basic reference tool for students of Indian art.

169 Chandra, Jagdish. **A Bibliography of Indian Art, History & Archaeology.** Delhi, Delhi Printers Prakashan, 1978- . illus.
Comprehensive bibliography of books and periodical articles on all aspects of the art of the Indian subcontinent. Volume 1, subtitled "Dr. Anand K. Coomaraswamy Memorial Volume" covers Indian art. Particularly useful for works published in Indian. For a classified bibliography of writings in Sanskrit see: Haridas Mitra, *Contribution to a Bibliography of Indian Art and Aesthetics.* 2d ed. Santiniketan, Visva-Bharati, 1951. 237p. LC 80-904584.

170 Coomaraswamy, Ananda K. **Bibliographies of Indian Art.** Boston, Museum of Fine Arts, 1952. 54p.
Classified bibliography of books on Indian art drawn from the catalog of the Indian collection of the Museum of Fine Arts; 1,250 entries. Useful to the beginning student and the general reader.

171 Pearson, J. D. **South Asian Bibliography: A Handbook and Guide.** Atlantic Highlands, N.J., Humanities Press, 1979. 381p. index. LC 77-16651.
General bibliography on the literature on the civilizations in India, Pakistan, Bangladesh, Sri Lanka, the Maldives, Burma, Tibet, and Afghanistan. Has valuable bibliographic essay "Art and Archaeology" by Graham Shaw, pp. 143-58.

172 Rau, Heimo. "In den Jahren 1960 bis 1965 erschienene Werke zur indischen Kunst," in: **Kunstgeschichtliche Anzeigen**, Neue Folge, Jahrg. 7, 1965/1966, pp. 93-108.
Critical examination of the major works on Indian art published from 1960 to 1965. The works discussed are listed at the beginning of the article. See (31) for series annotation.

CENTRAL ASIA

173 Bernier, Ronald M. **A Bibliography of Nepalese Art.** Khatmandu, Voice of Nepal, 1970. 46p. LC 74-915230.
 Classified bibliography of books and periodical articles on art of Tibet, Sikkim, Bhutan, and Nepal.

174 Jagdish, Chandra. **Bibliography of Nepalese Art.** New Delhi, Delhi Printers, 1980. 152p. index. LC 80-903293.
 Classified bibliography of 1,173 books and periodical articles on all aspects of the art and architecture. Also includes general sections on general history and culture of Nepal.

175 Jettmar, Karl. "In den Jahren 1955 bis 1962 erschienene Werke zur frühen nomaden Kunst der asiatischen Steppen," in: **Kunstgeschichtliche Anzeigen,** Neue Folge, Jahrg. 5, 1961/1962, pp. 184-97.
 Critical examination of the major works on Central Asiatic nomadic art published from 1955 to 1962. The works discussed are listed at the beginning of the article. See (31) for series annotation.

176 Rau, Heimo. "In den Jahren 1955 bis 1960 erschienene Werke zur Kunst Indiens und Zentralasiens," in: **Kunstgeschichtliche Anzeigen,** Neue Folge, Jahrg. 4, 1959/1960, pp. 122-39.
 Critical examination of the major literature on the art of India and Central Asia published between 1955 and 1960. Works discussed are listed at the beginning of the article. See (31) for annotation of the series.

FAR EAST

177 Borton, Hugh, comp. **A Selected List of Books and Articles on Japan in English, French and German.** Rev. and enl. ed. Cambridge, Mass., Harvard-Yenching Institute, 1954. 272p. index.
 Books and periodical articles on art are listed on pages 195 and 222. Classified bibliography. Author, title, and subject indexes.

178 Chen, C. M., and Richard B. Stamps. **An Index to Chinese Archaeological Works Published in the People's Republic of China, 1949-1965.** East Lansing, Asian Studies Center, Michigan State University, 1972. 75p. (East Asia Series, no. 3). LC 73-622188.
 A classified bibliography of books and articles on Chinese archaeological subjects published in the People's Republic of China from 1949 to 1965. Titles are translated from the Chinese into English and are arranged chronologically, then geographically, and finally by date of publication. No annotations.

179 Dittich, Edith. "In den Jahren 1956 bis 1964 erschienene Werke zur Kunst Ostasiens/Japan," in: **Kunstgeschichtliche Anzeigen,** Neue Folge, Jahrg. 6, 1963/1964, pp. 61-82.
 Critical examination of the major works on Japanese art published between 1956 to 1964. The works discussed are listed at the beginning of the article. See (31) for series annotation.

180 Dittich, Edith. "In den Jahren 1957 bis 1962 erschienene Werke zur Kunst Ostasiens/China," in: **Kunstgeschichtliche Anzeigen,** Neue Folge, Jahrg. 6, 1963/1964, pp. 1-37.

Critical examination of the major works on Chinese art published from 1957 to 1962. The works discussed are listed at the beginning of the article. See (31) for series annotation.

181 Kokusai Bunka Shinkokai, ed. **K.B.S. Bibliography of Standard Reference Books of Japanese Studies with Descriptive Notes.** Tokyo, Japan Foundation, 1959. Volume 3, A: Arts and Crafts.
Volume on the fine arts in a ten-volume guide to reference works on Japanese studies. A classified and annotated retrospective bibliography of major works on Japanese fine arts and crafts. The titles are romanized and the annotations are in English. Useful guide to major works in Japanese and other languages on Japanese art and architecture for the advanced student.

182 **Revue bibliographique de sinologie.** v. 1- . 1955- . Paris, Mouton, 1957- . LC 58-23000.
An annual, general bibliography on Chinese studies. Each volume contains a section on "Archéologie, art et épigraphie." Includes literature in Western and Oriental languages. Each entry includes a signed, analytical annotation in French, English, or German.

183 Swoboda, K. M. "In den Jahren 1950 bis 1956 erschienene Werke zur Kunst Ostasiens," in: **Kunstgeschichtliche Anzeigen,** Neue Folge, Jahrg. 2, 1957, pp. 5-46.
Critical examination of the major literature on the art of East Asia published from 1950 to 1956. The works discussed are listed at the beginning of the article. See (31) for series annotation.

184 Vanderstappen, Harrie, ed. **The T. L. Yuan Bibliography of Western Writings on Chinese Art and Archaeology.** London, Mansell, 1975. 606p. index. LC 76-356246.
Comprehensive, thoroughly classified bibliography of over 15,000 items written in English, German, Dutch, Scandinavian languages, Slavic languages, and Romance languages on all aspects of the art and archaeology of China. Covers material published between 1920 and 1965. Books are listed separately from periodical articles. A reference tool of major importance to the history of Far Eastern art as it covers material not found in any other bibliography.

New World

PRE-COLUMBIAN AMERICA

185 Berlo, Janet C. **The Art of Pre-Hispanic Mesoamerica: An Annotated Bibliography.** Boston, G. K. Hall, 1985. 288p. index. LC 85-21940.
Comprehensive, annotated bibliography of the literature on the art and architecture of Pre-Columbian Mexico, Guatemala, Belize, El Salvador, and Honduras. An historiographic essay on the major trends in the art history of Mesoamerica precedes the bibliography of 1,533 entries, which are arranged alphabetically by author.

186 Bernal, Ignacio. **Bibliografía de arqueologia y etografia: Mesoamérica y Norte de Mexico.** Mexico City, Instituto Nacional de Antropologia e Historia, 1962. 634p. LC 63-39894.
Comprehensive, retrospective bibliography of books and periodical articles on all aspects of the archaeology and ethnology of Central America and Mexico, including art and architecture. Covers material published between 1514 and 1960. Standard reference tool for the serious student of pre-Columbian art and architecture.

187 Kendall, Aubyn. **The Art and Archaeology of Pre-Columbian Middle America: An Annotated Bibliography of Works in English.** Boston, G. K. Hall, 1977. 334p. index. LC 77-14146.

Comprehensive bibliography of books and periodical literature on all aspects of the art, architecture, and archaeology of Mexico, Guatemala, El Salvador, Honduras, Belize (British Honduras), Costa Rica, Nicaragua, and Panama. Books and periodical articles are listed alphabetically in separate sections. Subject access index is inadequate. Good descriptive annotations. Appendix with list of doctoral dissertations. Use together with Bernal (186) and Valle (189).

188 Kendall, Aubyn. **The Art of Pre-Columbian Mexico: An Annotated Bibliography of Works in English.** Austin, University of Texas at Austin Press, 1973. 115p.

Selected bibliography of basic books and periodical articles on pre-Columbian art and architecture of Mexico. Books and periodical articles listed alphabetically in separate sections. Descriptive and occasionally critical annotations.

189 Valle, Rafael H. **Bibliografía maya.** Mexico City, D. F., 1937-1941. 404p. LC 46-42185. Reprint: New York, Burt Franklin, 1971. 404p. (Burt Franklin Bibliography and Reference Series, 436). LC 75-144831.

Comprehensive bibliography of books and periodical literature in all languages and on all aspects of ancient Mayan culture. Issued as an appendix to the *Boletin bibliográfico de antropologia americana* (v. 1-5. 1937-1941). Many entries have extensive descriptive annotations. Contains much material on Mayan art and architecture. However, the work is an unclassified alphabetical list, and there is no index to facilitate access to specific subject material.

See also: **Bulletin Signalétique. Serie 526.** (159).

NORTH AMERICAN INDIAN

190 Dawdy, Doris O. **Annotated Bibliography of American Indian Painting.** New York, Museum of the American Indian, 1968. 27p. (Contributions from the Museums of the American Indian Heye Foundation, vol. 21, pt. 2). LC 78-8195.

A useful bibliography of books and periodical articles on North American Indian painting.

191 Harding, Anne, and Patricia Bolling. **Bibliography of Articles and Papers on North American Indian Art.** Washington, D.C., Department of the Interior, 1938. 365p. Reprint: New York: Kraus, 1969. LC 39-26510.

Classified bibliography of periodical articles and scholarly papers on North American Indian art, with 1,500 entries. An important source for the early scholarly literature on this field.

192 Murdock, George Peter. **Ethnographic Bibliography of North America.** 3d ed. New Haven, Conn., Human Relations Area Files, 1960. xxiii, 393p. maps. LC 41-4723. (1st ed. 1941).

Comprehensive bibliography of approximately 17,000 books and articles on all ethnographical subjects relating to indigenous peoples of North America including archaeology and art. Arranged by geographical areas and within each area by tribal groups in alphabetical order. No annotations. In the series "Behavior science bibliographies."

See also: **Bulletin Signalétique. Série 521** (44); **Primitive Art Bibliographies** (46).

LATIN AMERICA

General Works

193 Bailey, Joyce W., ed. **Handbook of Latin American Art. Manual de Arte Latino-americo. A Bibliographical Compilation.** v. 1- . Santa Barbara, Calif., ABC-Clio, 1984- . LC 83-26656.
Comprehensive bibliography of books and periodical articles in all languages on Latin American art and architecture from ancient times to the present. The citations are taken from the fine arts section of the *Handbook of Latin Studies* (Cambridge, Mass., Harvard University Press, 1936-). To date the following have appeared: Volume I (in 2 volumes: *General References and Art of the Nineteenth & Twentieth Centuries*; Volume II: *Art of the Colonial Period.* Could be an important reference work if the material was rearranged in a consistent manner with adequate cross-references.

194 Findlay, James A. **Modern Latin American Art: A Bibliography.** Westport, Conn., Greenwood Press, 1983. 301p. index. (Art Reference Collection, Number 3). LC 83-10743.
Classified bibliography of books on twentieth century art and architecture of Latin America. Latin American periodical titles are cited but individual articles are not included. Brief annotations.

195 **Handbook of Latin American Studies.** v. 1- . Cambridge, Mass., Harvard University Press, 1936- .
Each volume contains a classified and annotated bibliography of books on Latin American art compiled by a specialist in the field.

196 Kupfer, Monica E. **A Bibliography of Art in Latin America.** New Orleans, Center for Latin America Studies and Howard-Tilton Memorial Library, Tulane University, 1983. 97p. index. LC 84-128276.
Classified, unannotated bibliography of books and periodical literature on art, excluding architecture, from Latin America since 1950. Based on the holdings of the Howard-Tilton Memorial Library at Tulane University.

197 O'Leary, Timothy J. **Ethnographic Bibliography of South America.** New Haven, Conn., Human Relations Area Files, 1963, 389p. LC 75-17091.
Equivalent of Murdock (192) for South America. Has approximately 24,000 entries. Includes entries on archaeology and art. Covers the literature through 1961. No annotations. In the series "Behavior science bibliographies."

198 Smith, Robert C., and Elizabeth Wilder. **A Guide to the Art of Latin America....** Washington, D.C., U.S. Government Printing Office, 1948. 480p. (U.S. Library of Congress Latin American Series, No. 21).
Classified and annotated bibliography of a selective list of books and periodical articles on Latin American art published before 1943. Source library given for each entry. Although old, it is still a valuable reference tool for the study of Latin American art.

Argentina

199 Buschiazzo, Mario José. **Bibliografía de arte colonial argentino.** Buenos Aires, Instituto de Arte Americano e Investigaciones Esteticas, 1947. 150p. LC 48-10865.
Classified and annotated bibliography of the colonial arts in Argentina. Entries for 843 books.

Brazil

200 Valladares, José. **Estudos de arte Brasileira publicações de 1943-1958: Bibliografia selectiva e comentada.** Salvador, Museo do Estado da Bahia, 1960. 193p. (Museo do Estado da Bahia. Publicação No. 15). LC 64-43893.
Classified and annotated bibliography of books on Brazilian art published from 1943 to 1958. 693 entries.

Colombia

201 Giraldo Jaramillo, Gabriel. **Bibliografía selecta del arte en Colombia.** Bogotá, Editorial A B C, 1956. 147p.
Classified and annotated bibliography of books on art in Colombia.

Dominican Republic

202 Florén Lozano, Luis. **Bibliografía de las bellas artes en Santo Domingo.** Bogotá, Antares, 1956. 53p.
Classified bibliography of books and periodical articles on the art of Santo Domingo (Dominican Republic).

Mexico

203 Ocampo, María Luisa, and María Mediz Bolio. **Apuntes para una bibliografía del arte en Mexico.** Mexico, Secretaria de Educacion Publica, 1957. 194p. LC 68-43120.
Classified bibliography of books on Mexican art, with 1,031 entries.

UNITED STATES

204 Bronner, Simon J. **American Folk Art: A Guide to Sources.** New York, Garland, 1984. 313p. index. LC 83-49308.
Bibliographical guide to folk art in the United States in the form of essays on various aspects: art criticism, genres (media), biographies, regions, ethnicity and religion, Afro-Americans, workers and trades, symbolism, collectors and museums, educators and classrooms, films, topics on the horizon written and compiled by various experts.

205 Chase, Frank H. **A Bibliography of American Art and Artists Before 1835.** Boston, 1918. 32p.
Short bibliography of 600 titles, chiefly periodical articles on the colonial and federal periods of art in the United States. Still useful to the specialist.

206 Davis, Lenwood A., and Janet L. Sims. **Black Artists in the United States: An Annotated Bibliography of Books, Articles and Dissertations on Black Artists, 1779-1979.** Westport, Conn., Greenwood Press, 1980. 138p. index. LC 79-8576.
Classified and annotated bibliography of 476 entries with an appendix of black artworks at the National Archives.

207 Garrett, Wendell D., and Jane N. Garrett. **The Arts in Early American History.** Chapel Hill, University of North Carolina Press, 1965. 170p. index. LC 65-53132.
Classified and annotated bibliography of books and periodical articles on American art up to 1826. Introductory essay, "An Unexploited Historical Resource," by Walter Muir Whitehill.

208 Igoe, Lynn M., and James Igoe. **250 Years of Afro-American Art; an Annotated Bibliography.** New York: R. R. Bowker, 1981. 1226p. index. LC 81-12226.

Comprehensive bibliography of approximately 25,000 citations on all aspects of Afro-American art. First part covers general literature; second is a selective bibliography of references to subjects in Afro-American art, such as "African Influence and Survivals." Third part is a bibliography of 3,900 Afro-American titles.

209 Karpel, Bernard. **Arts in America: A Bibliography.** Washington, D.C., Smithsonian Institution Press, 1979. 4v. LC 79-15321.

Comprehensive bibliography covering all aspects of art and architecture in America including photography, film, theater, dance, and music. The various subdivisions are the work of specialists and the degree of annotation to the entries varies. Contents: Volume 1: *Art of the Native Americans, Architecture, Decorative Arts, Design, Sculpture, Art of the West*; Volume 2: *Painting and Graphic Arts*; Volume 3: *Photography, Film, Theater, Dance, Music, Serials and Periodicals, Dissertations and Theses, Visual Resources*; Volume 4: *General Index*. Standard reference tool for research in American art history.

210 Keaveney, Sydney S., ed. **Art and Architecture Information Guide Series.** Detroit, Gale Research, 1974- .

Series of annotated bibliographies dedicated to a variety of subjects in the fine and applied arts. Thus far, among others, four volumes treating the history of American art have appeared: volume 1: *American Painting*, by Sydney S. Keaveney (1974); volume 3: *American Architects from the Civil War to the First World War*, by Lawrence Wodehouse (1976); volume 4: *American Architects from the First World War to the Present*, by Lawrence Wodehouse (1977); volume 5: *American Sculpture*, by Janis Ekdahl (1977). Although coverage in these four volumes is somewhat uneven and the information provided by the annotations is not consistent, the Keaveney series begins to fill the need for bibliographical guidance to the history of American art.

211 McCausland, Elizabeth. "A Selected Bibliography on American Painting and Sculpture from Colonial Times to the Present," in: **American Art Journal**, 36, 1947, pp. 611-53.

Classified bibliography of books and periodical articles on American painting and sculpture. Most useful for access to artist monographs.

212 Sokol, David M. **American Architecture and Art. A Guide to Information Sources.** Detroit, Gale Research, 1976. 341p. index. LC 73-17563.

Classified and annotated bibliography of 1,590 books and periodical articles on all aspects of American art and architecture. Ranges from general histories to articles on individual artists. More complete coverage is provided by Keaveney (210).

213 Tufts, Eleanor. **American Women Artists: A Selective Bibliographical Guide.** New York, Garland, 1984. 340p. illus. index. LC 83-48201.

Unannotated bibliography of books and periodical literature on women artists active in America from early colonial times to artists born before 1949. Does not include architects or artists working most of the applied media. Arrangement is by artist's name.

Africa and Oceania

214 Biebuyck, Daniel P. **The Arts of Central Africa: An Annotated Bibliography.** Boston, G. K. Hall, 1987. 304p. LC 79-15321.

Comprehensive, classified and annotated bibliography of the literature on the traditional native arts of Zaire and the immediate surrounding territory.

215 Burt, Eugene C. **An Annotated Bibliography of the Visual Art of East Africa.** Bloomington, Indiana University Press, 1980. 371p. index. LC 80-7805.

Comprehensive, classified, and annotated bibliography of books and periodical literature on all aspects of the art and architecture of the indigenous peoples of Kenya, Tanzania, and Uganda. Includes literature published before July 1979. Has 2,028 entries.

216 Gaskin, Guy. **A Bibliography of African Art Compiled at the International African Institute.** London, International African Institute, 1965. 120p. index. LC 66-70409

Classified bibliography of 4,827 books on African art, arranged by region. Author, geographical, ethnic, and subject indexes.

217 Hanson, Louise, and F. Allan Hanson. **The Art of Oceania: A Bibliography.** Boston, G. K. Hall, 1984. 560p. index. LC 84-10778.

Comprehensive classified and annotated bibliography of the literature (to 1984) on the native arts of Australia, Polynesia, Micronesia, and Melanesia. Classification system does not extend beyond the broadest geographical areas. Brief annotations.

218 Hassel, Herta. "In den Jahren 1954 bis 1960 erschienene Werke zur Kunst der ethnologischen Völker, besonders Negerafrikas," in: **Kunstgeschichtliche Anzeigen**, Neue Folge, Jahrg. 4, 1959/1960, pp. 106-121.

Critical examination of the major works on primitive art, particularly the art of black Africa. The works discussed are listed at the beginning of the article. See (31) for series annotation.

219 Mirvish, Doreen Belle. **South African Artists, 1900-1958: Bibliography.** Cape Town, University of Cape Town, 1959. 41p. LC 61-21936.

Bibliography of books and periodical articles on South African artists published between 1900 and 1958.

220 Taylor, Clyde Romer Hughes. **A Pacific Bibliography: Printed Matter Relating to the Native Peoples of Polynesia, Melanesia and Micronesia.** 2d ed. Oxford, Clarendon Press, 1965. xxx, 692p. illus. index. LC 66-1568.

A classified bibliography on all aspects of the culture of the native peoples of Oceania. The main area subdivisions are further divided into categorical sections, including arts, archaeology, dress, ornament, artefacts, and handicrafts. No annotations. Appendix: Principal islands and groups as arranged in the bibliography, pp. 589-91.

221 Western, Dominique C. **A Bibliography of the Arts of Africa.** Waltham, Mass., African Studies Association, Brandeis University, 1975. 123p. index.

Classified bibliography of books and periodical articles published in Western European languages before 1974 on sub-Saharan African art, architecture, oral literature, drama, and music. Major entries are annotated. Section on art and architecture, pp. 1-49, is classified by region and tribal group.

2
LIBRARY CATALOGS

GENERAL FINE ARTS LIBRARIES

North America

222 Cambridge, Mass. Harvard University. **Catalogue of the Harvard University Fine Arts Library.** The Fogg Art Museum. Boston, G. K. Hall, 1971. 16v.
Photomechanical reproduction of the author-subject card catalog of the combined holdings in the fine arts of the Widener Library and the Fogg Museum Library. Volume 16 is a separate catalog of the collection of sales catalogs. Harvard has one of the largest fine arts libraries in the United States; consequently, this reproduction of the card catalog with its thorough subject classification is a basic bibliographical tool.

223 New York City. Columbia University. Avery Architectural Library. **Catalog of the Avery Memorial Architectural Library of Columbia University.** 2d ed., enl. Boston, G. K. Hall, 1977. 19v. First Supplement. 1978. 4v. Second Supplement. 1980. Third Supplement. 1982. Fourth Supplement. 1983. Fifth Supplement. 1985. 4v.
A union list of books and periodical titles on art and architecture in the extensive Columbia University Library system, as well as 10,000 original drawings in library collections. The catalog of an important American art library, especially strong in architecture.

224 New York City. Metropolitan Museum of Art. Library. **Library Catalog.** 2d ed., rev. and enl. Boston, G. K. Hall, 1980. ISBN 0816114706. First Supplement. 2d ed., rev. 1981. Second Supplement. 1985. Third Supplement. 1987.
Microfilm edition of the photomechanical reproduction of the dictionary card catalog of this important collection (over 200,000 volumes). Volumes 1-23: books and periodical holdings; Volumes 24-25: sales catalogs. This microfilm edition replaces the printed first edition in 25 volumes. (Boston, G. K. Hall, 1960) plus the accessions since 1960 published in supplements.

225 New York City. New York Public Library. Research Libraries. **A Dictionary Catalogue of the Art and Architecture Division.** Boston, G. K. Hall, 1975. 30v. Supplement. 1974, (1976).
Photomechanical reproduction of the author, title, and subject card catalogs of all material cataloged through 1971 in the NYPL Art and Architecture Division; plus material in the General Research and Humanities Division; Cyrillic, Oriental and Hebraic material in the Language Divisions; source material in the Rare Book Division; and important architectural books in the Spencer Collection. Important catalog of one of America's largest art libraries (over 100,000 volumes). Very valuable supplements have been published since 1974 (226).

226 New York City. New York Public Library. Research Libraries. Art and Architecture Division. **Bibliographic Guide to Art and Architecture.** 1975- . Boston, G. K. Hall, 1976- .
 A volume for 1974 was published under the title, *Art and Architecture Book Guide* (Boston, G. K. Hall, 1975). Comprehensive listing of all material cataloged during the year by the Art and Architecture Division of the New York Public Library, with additional titles from the Library of Congress MARC tapes. Multiple access points through main entries, added entries, titles, series, and subject headings. Serves to update the *Dictionary Catalogue of the Art and Architecture Division* (225) and because of the Library of Congress entries, is a valuable series bibliography.

227 Ottawa, Ontario. National Gallery of Canada. **Catalogue of the Library of the National Gallery of Canada, Ottawa.** Boston, G. K. Hall, 1973. 8v.
 Photomechanical reproduction of the author-subject card catalog of the more than 35,000 volumes in the Canadian National Gallery Library. Useful tool for research into the visual arts in Canada.

228 Santa Barbara, University of California at Santa Barbara. Arts Library. **Catalogs of the Art Exhibition Catalog Collection of the Arts Library.** Teaneck, N.J., Somerset House, 1977.
 Microfiche reproduction of the 20,000 art exhibition catalogs in the Arts Library at the University of California at Santa Barbara. Cataloged by agency (location or publisher of the exhibition catalog) and subject. Updates are twice yearly. The Santa Barbara collection is complete for all major museums and galleries in North America and has excellent collections of foreign, particularly European, exhibition catalogs.

Europe

229 Amsterdam. Rijksmuseum. Kunsthistorische Bibliotheek. **Catalogus der Kunsthistorische Bibliotheek in het Rijksmuseum te Amsterdam.** Amsterdam, Dept. van Onderwijs, 1934-1936. 4v.
 A classified list of the books and periodicals in this important center for the research of Dutch art history. Outline of the classification at the beginning of each volume. Volume 4 contains author, artists, subject, place, collectors, and dealers indexes.

230 Brussels. Académie Royale des Beaux-Arts et École des Arts Décoratifs. **Catalogue annoté de la Bibliothèque artistique et littéraire.** Brussels, Guyot, 1903. 1170p. index.
 Thoroughly classified and annotated catalog of books. Author and title index. Particularly useful for the history of Flemish art.

231 Hague. Koninklijke Bibliotheek. **Catalogus van schoone kunsten en kunstnijverheid.** The Hague, Belinfante, 1905. 986p. index.
 Classified bibliography of the holdings on fine arts in this great Dutch central library. Thoroughly indexed by author, artists, subjects, and locations.

232 Leipzig. Anstalt für Kunst und Literatur. **Kunstkatalog....** By Rudolf Weigel. Leipzig, Weigel, 1837-1866. 35 parts in 5v.
 Classified catalog of books and prints in the Anstalt für Kunst und Literatur, listing over 25,000 titles and 3,832 prints (mostly portraits of artists). Index at end of each volume and general index at end of volume five. A standard reference tool for nineteenth century literature on the fine arts.

233 London. Royal Institute of British Architects. Library. **Catalogue of the Library.**
London, Royal Institute of British Architects, 1937-1938. 2v.
 Volume 1 (1,138p.) is an author catalog of books and manuscripts in the collection. Volume 2 (514p.) contains a classified index and an alphabetical subject index.

234 London. University. Library. **Catalogue of Books on Archaeology and Art and Cognate Works Belonging to the Preedy Memorial Library and Other Collections in the University Library....** London, University of London Press, 1935-1937. 2v. Supplement. 1937. 25p.
 Classified bibliography of some 3,000 books covering all aspects of archaeology and the history of art in all languages. Index by author.

235 London. Victoria and Albert Museum. **National Art Library Catalogue.** Boston, G. K. Hall, 1972. 11v. LC 73-153208.
 The author catalog of a great art reference library. Volume 10 lists titles written before 1890; volume 11 lists 50,000 exhibition catalogs.

236 Modena. **Annuario bibliografico di storia dell'arte.** Anno 1- . 1952- . Modena, Soc. Tipo. Modenese, 1952- . index.
 A classified list of the books and periodicals acquired by the Biblioteca dell'Instituto Nazionale d'Archeologia e Storia dell'Arte in Rome. Short abstracts are given for most entries. Index of names. Very useful bibliographical tool for the study of Italian art. Material arranged in three chief classes: I, Arte; II, Artisti; III, Paesi.

237 Paris. Bibliothèque Forney. **Catalogue des catalogues de ventes d'art. Bibliothèque Forney, Paris.** Boston, G. K. Hall, 1972. 2v. LC 72-226228.
 Photomechanical reproduction of the card catalog of the important collection of sales catalogs in the Bibliothèque Forney in Paris.

238 Paris. Bibliothèque Forney. **Catalogue matières: arts decoratifs, beaux-arts métier, techniques.** Paris, Société des Amis de la Bibliothèque Forney, 1970-1974. 4v. LC 75-574191. Supplement, 1979-1980. 2v. **Index alphabetique des auteurs.** 1983.
 Photomechanical reproduction of the subject catalog of this famous French library of nearly 100,000 volumes and 1,350 periodicals devoted to the applied arts. Particularly valuable for bibliographical information on art techniques.

238a Rome. Bibliotheca Hertziana (Max-Planck-Institut). **Kataloge der Bibliotheca Hertziana in Rome.** Wiesbaden, Reichert, 1985- . ISBN 3882263008.
 Catalog of the Hertziana Library of the Max-Planck-Institut in Rome specializing in the history of Italian art in particular Rome founded by Henriette Hertz in 1913. To date the systematic shelflist catalog has appeared (13v.).

239 Vienna. Österreichisches Museum für Kunst und Industrie. Bibliothek. **Katalog....** Vienna, n.p., 1902-1904. 5v.
 Classified catalog of books; especially rich in material on applied and decorative arts.

SPECIALIZED ART LIBRARIES

Primitive

240 New York City. Metropolitan Museum of Art. Robert Goldwater Library. **Catalog of the Robert Goldwater Library.** Boston, G. K. Hall, 1982. 4v. LC 82-220606.
Photomechanical reproduction of the dictionary catalog of the Robert Goldwater Library, a collection specializing in Primitive art.

Ancient

241 Athens. American School of Classical Studies at Athens. Genadius Library. **Catalogue.** Boston, G. K. Hall, 1968. 7v. LC 70-3154.
Photomechanical reproduction of the author and subject card catalog of the Genadius Library at the American School of Classical Studies at Athens, a library of some 50,000 volumes devoted to the history of Greek culture from earliest times to the present.

242 Rome. Deutsches Archäologisches Institut. **Kataloge der Bibliothek des Deutschen Archäologischen Instituts, Rom.** Boston, G. K. Hall, 1969. 13v.
Photomechanical reproduction of the card catalogs of books and card index to periodical articles in the German Archaeological Institute in Rome. Part one is author and periodical title catalog; part two, the subject catalog; part three, the special author index to periodical articles, begun in 1956. The holdings of this famous archaeological library cover the ancient civilizations of the entire Mediterranean basin from prehistory through the early Christian period.

Byzantine

243 Washington. Dumbarton Oaks Research Library. Harvard University. **Dictionary Catalogue of the Byzantine Collection of the Dumbarton Oaks Research Library.** Boston, G. K. Hall, 1975. 12v.
Photomechanical reproduction of the author, title, and subject card catalog of an 82,000-volume library dedicated to research on all aspects of Byzantine civilization. See also the *Dumbarton Oaks Byzantine Bibliographies* (74) and *Catalogue* of the Genadius Library (241).

Renaissance

244 Florence. Harvard University Center for Italian Renaissance Studies. **Catalogues of the Berenson Library of the Harvard University Center for Italian Renaissance Studies at Villa I Tatti, Florence, Italy.** Boston, G. K. Hall, 1972. 4v.
The total holdings of about 70,000 volumes are disposed in a two-volume author catalog and a two-volume subject catalog. The photomechanically reproduced cards are old and lack reliable orthography.

245 Florence. Kunsthistorisches Institut. Bibliothek. **Catalog of the Institute for the History of Art, Florence, Italy. Katalog des Kunsthistorischen Instituts in Florenz.** Boston, G. K. Hall, 1964. 9v. First Supplement. 1968. 2v. Second Supplement. 1972. 2v. Third Supplement. 1977. 2v.

Photomechanical reproduction of the alphabetical catalog (author and key word). The Institut is the most important center for Italian Renaissance studies in Europe. Thus, the holdings of its library are of great interest to students of Italian Renaissance art. The handwritten cards are a formidable obstacle to its use by the inexperienced.

246 London. Warburg Institute. **Catalogue of the Warburg Institute Library.** 2d ed. Boston, G. K. Hall, 1967. 12v. First Supplement. 1971.
Photomechanical reproduction of the author and subject card catalog of a collection of over 100,000 volumes, with special emphasis on the survival of the classical tradition. Particularly valuable for research into classical iconography in medieval, Renaissance, and Baroque art.

Modern

247 Amsterdam. Stedelijk Museum. Bibliotheek. **Catalogus.** Amsterdam, n.p., 1957. 179p. index.
Classified catalog of the holdings, as of 1956, of the Library of Modern Art in the Municipal Museum of Amsterdam. Introductory text in English as well as Dutch, German, and French. Thorough indexes.

248 New York City. Museum of Modern Art. **Catalog of the Library of the Museum of Modern Art.** Boston, G. K. Hall, 1976. 14v.
Photomechanical reproduction of the author, title, and subject card catalogs of 30,000 books and 700 periodical titles covering all aspects of twentieth century art. Particularly valuable is the indexing of periodical articles, many not in *Art Index* (254) or *Répértoire* (32). Includes material in the Latin American Archives and the exhibition and artists files.

249 New York City. Museum of Modern Art, Library. **Annual Bibliography of Modern Art.** Boston, G. K. Hall, 1986- .
A computer-derived bibliography of the acquisitions cataloged in the previous year by the MOMA Library. Contains extensive material from around the world, with emphasis on the United States, Western and Eastern Europe, and Japan. Includes books, periodicals, exhibition catalogs, photographs, and manuscripts. Dictionary format with access by author, title, and subject.

Oriental

250 Washington. Smithsonian Institution, Freer Gallery of Art. **Dictionary Catalogue of the Library of the Freer Gallery of Art, Smithsonian Institution, Washington, D.C.** Boston, G. K. Hall, 1967. 6v.
Photomechanical reproduction of the dictionary catalog of books, pamphlets, and periodicals in this important research library (40,000 volumes) devoted to Far Eastern art. Part one lists works in Western languages; part two, works in Chinese and Japanese.

American

251 Archives of American Art. **The Card Catalogue of the Manuscript Collection of the Archives of American Art.** Wilmington, Del., Scholarly Resources Inc., 1980. 10v. LC 80-53039.

Photomechanical reproduction of the card catalog of the collection of manuscript materials on the history of American Art and architecture in the Archives of American Art in the Smithsonian Institution, Washington, D.C. The collection now covers 5,000 collections or 6 million items. The collections of the archives are available through microfilm reproductions in various centers around the United States (presently New York, Boston, and San Francisco), and individual rolls of microfilm reproductions of specific collections can be obtained through interlibrary loan.

252 Winterthur, Delaware. Winterthur Museum Libraries. **The Winterthur Museum Libraries Collection of Printed Books and Periodicals.** Wilmington, Del., Scholarly Resources Inc., 1974. 9v. LC 73-88753.

Photomechanical reproduction of the card catalog of the Winterthur Museum Library, an outstanding reference collection devoted to early American civilization and to American art to 1913. Particularly good for primary source material. Contains the general author, title, and subject catalog, the rare book catalog, auction catalog, and Shaker collection.

3

INDEXES

PERIODICAL LITERATURE

253 **Art Bibliographies Current Titles.** v. 1- . Santa Barbara, Calif., ABC-Clio, 1972- .
Monthly index to the articles in approximately 250 current fine arts periodicals. Consists of photomechanical reproductions of the periodicals' tables of contents. Since 1973, it no longer appears in July and August. List of periodicals indexed is given in each number, and a complete list is published twice a year. The selection of periodicals is international and includes some museum bulletins and annuals. A useful index for keeping up with current periodical literature. Produced by the American Bibliographical Center in Santa Barbara. Unfortunately, does not index articles by subject.

254 **Art Index: A Cumulative Author and Subject Index to a Selected List of Fine Arts Periodicals and Museum Bulletins.** v. 1- . 1929- . New York, Wilson, 1933- .
Issued quarterly with annual and three-year cumulations. Classified bibliography of periodical articles and articles in museum bulletins. Coverage varies; museum bulletins included only through 1957. Periodical articles are listed under author and subject, book reviews under the author reviewed and subject, exhibitions under artist. A basic reference tool, especially for material in English-language periodicals. Should be supplemented with the Ryerson index (256) for more complete coverage. Beginning in September 1984, Art Index is accessible through *WILSONLINE*.

255 **Arts and Humanities Citation Index.** Philadelphia, Institute for Scientific Information, 1976- .
Quarterly, computer-driven index to periodical literature in the humanities, include the fine arts. The Arts and Humanities Index has been steadily increasing its coverage of fine arts, particularly, art historical, periodical literature, and at present it is comparable to the *Art Index* (254), *RAA* (32), and *RILA* (33) in usefulness for serious research. Since the four tools do not cover the same list of periodicals, all four should be used in making a comprehensive search.

256 Chicago. Art Institute, Ryerson Library. **Index to Art Periodicals.** Boston, G. K. Hall, 1962. 11v. First Supplement. 1974.
Photomechanical reproduction of the library's card file, which was begun in 1907. Over 300 periodicals are indexed, covering serial titles not indexed in Wilson's *Art Index* (254). Arranged by subject and artist.

257 New York City. Columbia University. Avery Architectural Library. **Avery Index to Architectural Periods.** 2d ed. Boston, G. K. Hall, 1973. First Supplement. 1975. Second Supplement. 1977. LC 74-152756.
 Photomechanical reproduction of the card index to articles in the architectural periodicals held by the Avery Library. The index, begun in 1934, covers architecture in the widest sense so as to include interior decoration, city planning, housing, etc. Articles are listed by subject. Supplements were issued yearly from 1965 to 1968, every two years since then. The Avery index is the most comprehensive index to periodical literature on architecture.

258 Paris. Bibliothèque Forney. **Catalogue d'articles des périodiques—arts décoratifs et beaux-arts. Catalog of Periodical Articles—Decorative and Fine Arts.** Boston, G. K. Hall, 1972. 4v. LC 72-221666.
 Photomechanical reproduction of the card index to articles dealing with the decorative arts in the Bibliothèque Forney in Paris. Articles are arranged by subject. Analyzes the articles on the decorative arts in 1,347 periodicals, 325 of them current. The most comprehensive index of its kind; supplements the other major periodical indexes (254, 256).

259 Prause, Marianne. **Verzeichnis der Zeitschriftbestände in den kunstwissenschaft-lichen Spezialbibliotheken der Bundesrepublik Deutschland und West-Berlin.** Berlin, Mann, 1973. 621p. LC 74-350376.
 Comprehensive list of the art and cultural historical periodicals held by art libraries in West Germany, West Berlin, the Biblioteca Hertziana, Rome, and the Kunsthistorisches Institut, Florence. Arranged by periodical title, the entries give the runs held by the various libraries. General bibliography of periodical reference works (pp. 613-21).

MUSEUM PUBLICATIONS

260 **The Bibliography of Museum and Art Gallery Publications and Audio-Visual Aids in Great Britain and Ireland.** Teaneck, N.J., Somerset House, 1978- . ISBN 0914146610.
 Biennial index of the publications of all major museums and art galleries in Great Britain and Ireland arranged by name of the museum or gallery. Includes museum catalogs, exhibition catalogs, guides, slides, postcards, and other information made available to the public. Includes prices. List of museums and galleries included, indexes by title, author, and subject.

261 **Catalog of Museum Publications and Media.** 2d ed. Detroit, Gale Research, 1980- . LC 79-22633.
 Editors: Paul Wasserman, Esther Herman. First published as: *Museum Media. A Biennial Directory and Index of Publications and Audiovisuals Available from United States and Canadian Institutions* (Detroit, Gale Research, 1973. LC 73-16335). Alphabetical listing of museums of all kinds in the United States and Canada, with the publications and audiovisual materials currently available from them. Gives full citations and prices for publications. Good title and keyword index.

262 Clapp, Jane. **Museum Publications. Part I: Anthropology, Archaeology and Art.** New York, Scarecrow Press, 1962. 434p. LC 62-10120.
 A classified list of publications available from 276 museums in the United States and Canada, including books, pamphlets, and other monographs and some serial reprints. Now out of date.

263 Tümmers, Horst-Johs. **Kataloge und Führer der Berliner Museen**. Berlin, Mann, 1975. 189p. index. (Verzeichnes der Kataloge und Führer Kunst- und Kulturgeschichtlicher Museen in der Bundesrepublik Deutschland und in Berlin [West], Band 1).

Comprehensive, retrospective bibliography of catalogs and guides published by the art and cultural museums of West Berlin before 1971. Two introductory chapters treat works published before 1918. Those published between 1918 and 1971 are arranged alphabetically by institution. The contents of the major catalogs are provided in annotations. First in a series that will eventually cover all of West Germany and provide that country with fine bibliographical coverage of its art catalogs.

264 Tümmers, Horst-Johs. **Kataloge und Führer der Münchner Museen**. Berlin, Mann, 1979. 194p. index. (Verzeichnis der Kataloge und Führer kunst- und kulturgeschichtlicher Museen in der Bundesrepublik Deutschland und Berlin [West], Band 2) ISBN 3786112207.

Comprehensive retrospective bibliography of catalogs and guides published by art and cultural museums in Munich before 1975. In the same series and follows the same format as Band 1 on Berlin (263).

265 **World Museum Publications 1982. A Directory of Art and Cultural Museums, their Publications and Audio-Visual Materials**. New York, R. R. Bowker, 1982. 711p. index. LC 82-646913.

Index of the publications and audio-visual materials available from museums around the world. Data was gathered by questionnaire and the list of museums was derived from *Art Books 1950-1977* (10, *see annotation*). Although the scope is broad, coverage is uneven.

SPECIALIZED INDEXES

266 Clapp, Jane. **Art Censorship: A Chronology of Proscribed and Prescribed Art**. Metuchen, N.J., Scarecrow Press, 1972. 582p. illus. LC 76-172789.

An index to acts of censorship against art, recorded in 641 selected sources. The acts of censorship are arranged chronologically; each entry gives the date of the incident, reference to one of the sources, and a brief quotation from the source. General index (pp. 425-582).

267 Havlice, Patricia P. **Index to Artistic Biography**. Metuchen, N.J., Scarecrow Press, 1974. 2v. Supplement. 1981. LC 81-5713.

Index of biographies of major artists in 611 reference works, mainly readily available titles in English. However, a rather capricious selection of foreign-language works is also indexed, but not the standard works by Bénézit (352) or Thieme-Becker (362). Entries give basic biographical data, nationality, and media for each artist.

268 Lincoln, Betty Woelk. **Festschriften in Art History, 1960-1975**. New York, Garland, 1988. 220p. (Garland Reference Library of the Humanities, v. 745). LC 87-22767.

Bibliography of literature on the history of art and architecture from the beginning of the Christian era to the present that appeared in Festschriften published between 1960 and 1975. Intended to fill the gap between Rave's Festschriften bibliography (271) and the beginning of RILA (33). The Festschriften are arranged by name of the dedicatee and are accompanied by complete bibliographical information including a list of the contributors and the titles of their essays. Author index, index of dedicatees, and thorough subject index to the contents of the festschriften.

269 Lugt, Frits. **Répertoire des catalogues de ventes publiques intéressant d'art ou la curiousité....** v. 1- . The Hague, Nijhoff, 1938- .

Chronological list of catalogs of art sales held throughout Europe from circa 1600 to 1900. Each entry gives date of the sale; place of sale; name of the collector, artist, or

merchant; the contents of the sale; number of lots; names of auctioneers; number of pages in the sales catalog; and library source for copies of the catalog. Volume 1 covers period from 1600 to 1825; volume 2, 1826 to 1860; volume 3, 1861 to 1900. Index of collectors and names of collections. Basic reference work for the history of art sales.

270 New York City. Columbia University. Avery Memorial Architectural Library. **Avery Obituary Index of Architects and Artists.** Boston, G. K. Hall, 1963. 338p. LC 64-7017.
 Photomechanical reproduction of the card index to obituaries of architects and artists published in periodicals and newspapers. A valuable source for biographical material on many lesser-known architects.

271 Rave, Paul O. **Kunstgeschichte in Festschriften.** Berlin, Mann, 1962. 314p. LC 63-43690.
 Classified index of art historical essays that appear in festschriften published up to 1960. Thoroughly indexed by title, author, artist, and place. For serious students of art history, an extremely valuable reference tool to give access to important material not usually included in other bibliographies. Access to more recent festschriften is through Otto Leistner, *Internationale Bibliographie der Festschriften* (International Bibliography of Festschriften; Osnabrück, 1976).

272 Robertson, Jack. **Twentieth Century Artists on Art: An Index to Artists' Writings, Statements and Interviews.** Boston, G. K. Hall, 1985. 512p. LC 85-21895.
 Index to writings by over 5,000 artists and architects active in the twentieth century. The citations are derived from a collection of 495 sources.

INDEXES TO ILLUSTRATIONS

273 **A.L.A. Portrait Index to Portraits in Printed Books and Periodicals....** Washington, D.C., Library of Congress, 1906. 1601p.
 An index to portraits illustrated in a large set of books and periodicals published before 1905. Arranged by subject. 120,000 portraits of nearly 45,000 persons. Entries give dates of the subject, name of artist and/or engraver, and source for illustrations.

274 **The Alinari Photo Archive.** Zug, Switzerland, Inter Documentation, 1982- . ISBN 3385750057.
 Microfiche reproduction of part of the famous Italian collection of photographs. The Alinari photo archive contains over 220,000 photographs, mostly of works of art and architecture in Italy. Some of the photographs date from before 1900. An invaluable research tool.

275 Bertran, Margaret. **A Guide to Color Reproductions.** 2d ed. Metuchen, N.J., Scarecrow Press, 1971. 625p.
 Index of separate-sheet color reproductions of works of art. Lists only those available in the United States, giving the source and price. Part I lists the reproductions by artist; part II, by title or subject.

276 Cirker, Hayward, and Blanche Cirker. **Dictionary of American Portraits: 4045 Pictures of Important Americans from Earliest Times to the Beginning of the Twentieth Century.** New York, Dover, 1967. 756p. illus. LC 66-30514.
 An illustrated index of portraits of Americans, arranged by subject. A short caption to each illustration gives artist and/or source. Index by profession.

277 Clapp, Jane. **Art in Life.** New York, Scarecrow Press, 1959. 504p. LC 65-13552.
Index to pictures of art published in *Life* magazine from 1936 to 1956. Arranged by artist, title, and/or subject. Supplement (covering years 1957 to 1963) published in 1965.

278 Clapp, Jane. **Art Reproductions.** New York, Scarecrow Press, 1961. 350p. LC 61-8714.
Index to art reproductions available from 95 sources in the United States and Canada. Arranged by medium. Entries give the dates of the artist, subject, dimensions, price, and source. Useful source for popular and easily accessible fine art reproductions.

279 Ellis, Jessie Croft. **Index to Illustrations.** Boston, F. W. Faxon, 1966. 682p. LC 66-11619.
General index to illustrations of almost everything except nature. Uses a small group of illustration sources, mostly popular magazines.

280 **Fine Art Reproductions, Old and Modern Masters.** 9th ed. Greenwich, Conn., New York Graphic Society, 1972. 550p. illus. index. LC 72-85864.
Index of the reproductions marketed by the New York Graphic Society, one of the largest manufacturers of fine art reproductions in the United States. Each entry is illustrated and has a caption giving size, reproduction medium, and price.

281 Havlice, Patricia P. **Art in Time.** Metuchen, N.J., Scarecrow Press, 1970. 350p. illus. LC 76-14885.
Index to all pictures in the art section of *Time* magazine, arranged by artist, title and/or subject. Entries give the dates of the artist, the medium of the work, whether the illustration is in black and white or color, and the source in *Time*. Useful for ready access to important reviews and criticisms of modern art.

282 Hewett-Woodmere Public Library. **Index to Art Reproductions in Books.** Metuchen, N.J., Scarecrow Press, 1974. 322p. LC 74-1286.
Index to reproductions in a selected group of books published between 1950 and 1971. Two-part index: one under the name of the artist, the other by title of the work of art. Good for the small library, as the 65 books indexed are readily available.

283 Lee, Cathbert. **Portrait Register.** v. 1- . Asheville, N.C., Biltmore Press, 1968- . LC 73-3014.
Index to some 8,000 painted portraits in private and public collections in the United States. Listed by subject and painter.

284 London University. Courtauld Institute of Art. **The Conway Library, the Courtauld Institute of Art Microform.** Haslemer, Surrey, Emmett Publishing, 1987- . ISBN 1868834008.
Microfiche reproduction of the collection of photographs begun by Sir William Conway (1856-1937), which is the major part of the famous Courtauld Institute photo archives. To date the following have appeared: Part 1: *Architecture, France, Italy*; Part 3: *Architectural Drawings*; Part 4: *Sculpture.*

285 London University. Courtauld Institute of Art. **Courtauld Institute Illustration Archives.** London, Miller, 1976- .
Quarterly publication of loose-leaf photographic reproductions of works of architecture and sculpture in Great Britain and Western Europe. The photographs are selected from the unparalled collections of the Witt and Conway Libraries of the Courtauld Institute, London. The photographs on a particular site or building are gathered together and issued under a broader archive designation (Archive 1. Cathedrals and Monastic Buildings in the British Isles; Archive 2. Fifteenth- and Sixteenth-Century Sculpture in Italy; Archive 3. Medieval Architecture and Sculpture in Europe; Archive 4. Late Eighteenth- and Nineteenth-Century Sculpture in the British Isles). For a complete reproduction of the Courtauld photographic archives see (284).

286　**Marburger Index: Bilddokumentation zur Kunst in Deutschland.** Munich, Verlag Dokumentation, 1977-1981.
　　Microfiche publication of the collections of photographs in the Bildarchiv Foto Marburg and the Rheinisches Bildarchiv Köln. The collections have together over 500,000 photographs of works of art and architecture from prehistoric times to the present. The collections concentrate on art and architecture in Germany but also include important holdings of non-German material.

287　Morse, John D. **Old Masters in America: A Comprehensive Guide; More Than Two-Thousand Paintings in the United States and Canada by Forty Famous Artists.** Chicago, Rand McNally, 1955. 192p.
　　Index of paintings by forty famous "old masters" in American collections, arranged by artist. A short biographical note is given with each entry. Index by state and city. Handy tool for quick location of famous paintings.

288　Munro, Isabel Stevenson, and Kate M. Munro. **Index of American Paintings.** New York, Wilson, 1948. 731p. First Supplement. 1964. 480p.
　　Index to illustrations of American paintings in a group of easily accessible books and periodicals; indexed by artist, title, and subject. Basic biographical data and location of the paintings are given.

289　Munro, Isabel Stevenson, and Kate M. Munro. **Index to Reproductions of European Paintings.** New York, Wilson, 1956. 668p. LC 55-6803.
　　Index to illustrations in 328 books and periodicals by artist, title, and subject. Entries give the dates of artists and the locations of the paintings. A valuable reference tool for easy access to illustrations of major European paintings. The sources used are generally available in small libraries.

290　Reinach, Salomon. **Répertoire de la statuaire grecque et romaine....** Paris, Leroux, 1897-1930. 6v. in 8. illus.
　　An illustrated index to ancient Greek and Roman statues, arranged by subject. Index at end of each volume and general index in volume 5. Still a useful tool for the study of classical iconography.

291　Reinach, Salomon. **Répertoire de reliefs grecs et romains....** Paris, Leroux, 1909-1912. 3v. illus.
　　An illustrated index to ancient Greek and Roman reliefs, arranged by subject. General index in volume 3. Still a useful tool for the study of classical iconography.

292　Singer, Hans W. **Allgemeiner Bildniskatalog.** Leipzig, Hiersemann, 1930-1936. 14v. LC 31-15244. **Neuer Bildniskatalog....** Leipzig, Hiersemann, 1937-1938. 5v. index. LC AC 37-1659 rev.
　　Index to engraved portraits of all times and countries represented in seventeen public collections in Germany. The approximately 180,000 portraits, arranged by subject, give the name of the artist, medium, and location. Separate artist and profession indexes in each volume, general index in volume 14. The *Neuer Bildniskatalog* is an index to painted and sculptured portraits and some early photographic portraits. Same format as the earlier index. Volume 1 has list of sources, and volume 5 has general index by artist and profession. These two Singer indexes are the most comprehensive guides to portraits made up to 1929.

4
DIRECTORIES

293 **American Architects Directory.** 3d ed. New York, R. R. Bowker, 1970. 1126p.
Directory of registered architects in the United States, listed alphabetically and by state and city. Also gives the membership of the American Institute of Architects and an appendix listing the National Council of Architectural Registration Boards.

294 **American Art Directory.** 51st ed. New York, R. R. Bowker, 1986. 765p. LC 99-1016.
Directory of American art organizations covering museums, foundations, organizations, university and college art departments, and art schools. Revised biennially.

295 Art Libraries Society of North America. **Directory of Art Libraries and Visual Resource Collections in North America.** Santa Barbara, Calif., ABC-Clio, 1978. 298p. index. LC 78-61628. Addendum. 1979. 36p. ISBN 0918212057.
Directory, arranged by state, of art libraries and special collections of visual materials such as photographs and slides. Information provided is similar to that given in *American Art Directory* (294), but coverage is much more extensive for smaller libraries and collections. Thoroughly indexed by institution and subject.

296 Hudson, Kenneth, and Ann Nichols, eds. **The Directory of World Museums.** New York, Columbia University Press, 1975. 864p. index. LC 74-21772.
Directory of approximately 25,000 museums around the world. Excluded are zoos and botanical gardens as well as museums and galleries without permanent collections. Arrangement is by country and place, with place names most often entered in anglicized form. Names of museums are also anglicized, which leads to some confusion. Entries provide addresses, guide to the collections, and opening times. There is a classified list of collections within major museums, glossary of museum terms, and a selected bibliography of museum directories. Does not provide as much information, nor is it as easy to use, as *Museums of the World* (302).

297 International Federation of Library Associations. **The IFLA Directory of Art Libraries.** New York, Garland, 1984. 512p. LC 84-48057.
Directory of the libraries outside of North America with holdings in the fine arts. Arrangement is by country and place. Entries give a brief description of the libraries which includes the size and nature of their holdings, hours, access, readers' services, catalog, and other activities. For art libraries in North America see (295).

298 **International Who's Who in Art and Antiques.** Cambridge, Melrose Press Ltd., 1972. 679p. illus. LC 79-189269.

Directory of artists, art educators, gallery and museum directors, heads of art associations, art and antique dealers, auctioneers, art publishers, and restorers in 58 countries. Five appendices list art schools, museums and galleries, art publishers, art associations, and art scholarships and grants by country. Not as thorough as (299), but it has the advantage of a single alphabetical list of persons.

299 **Internationales Kunst-Adressbuch. International Directory of Arts. Annuaire international des beaux-arts.** 18th ed. 1987/1988. Berlin, Deutsche Zentraldruckerei, 1988. 2v.

Directory of addresses of museums, art galleries, art libraries, art associations, universities, colleges and art academies, auctioneers, restorers, art dealers, booksellers, art publishers, and collectors. Arranged by country. The standard address directory for the fine arts.

300 Kloster, Gudrun B. **Handbook of Museums: Germany, Austria, Switzerland.** Munich, Verlag Dokumentation, 1972. 2v. index.

Comprehensive directory of some 3,050 museums in Germany, Austria, and Switzerland. Entries give address, telephone numbers, names of the professional staff, hours of opening, entrance fees, summary history of the museum, description of the buildings, collections, archives, and library, and sketch of the future plans of development and bibliography. Introduction in German and English; entries in German. Very thorough and useful directory.

301 Morgan, Ann. **International Contemporary Arts Directory.** New York, St. Martin's, 1986. 393p. LC 84-40122.

Directory of museums, libraries, galleries, periodicals, associations, grants, and writers associated with contemporary art. Includes performance art and various mixed media but does not include architecture. Designed to provide practical information for artists and based on questionnaires.

302 **Museums of the World/Museen der Welt: A Directory of 17,000 Museums in 148 Countries, Including a Subject Index.** 3d ed. Eleanor Braun, comp. New York, K. G. Saur, 1981. 623p. index. LC 75-508774.

A geographically arranged listing of all kinds of museums. Contains a useful classified subject index and an alphabetical listing by name.

303 **Official Museum Directory 1977: United States and Canada.** New York, National Register, 1977. 1173p. index. LC 79-144808.

Lists, by state and province, over 6,000 museums of all kinds in the United States and Canada. Gives names and specialties of museum curatorial staff, address of the museum, and a list of the museum's publications. Thorough alphabetical index. Standard American museum directory. Revised every two years.

304 Ploetz, Gerhard. **Bildquellen-Handbuch; der Wegweiser für Bildsuchende.** Wiesbaden, Chmielorz, 1961. 611p. illus. index. LC 61-49194.

Directory of photographic illustrations and their sources. Part I is an index of photographs by subject, country, place, persons, artists, etc., giving reference to sources in the approximately 4,000 photographic archives listed by country in parts II-V. A useful directory with emphasis on sources of original photographs.

305 UNESCO. **Répertoire international des archives photographiques d'oeuvres d'art. International Directory of Photographic Archives of Works of Art.** Paris, UNESCO, 1950-1954. 2v.

Directory of photographic archives throughout the world. The archives are arranged by place; descriptions include subject specialty, if any; size of the collection; nature or purpose of the archive; hours of opening; and the price charged for copies. Useful, although no longer current.

306 **Who's Who in American Art.** v. 1- . New York, R. R. Bowker, 1936- .
Issued by the American Federation of Arts. Directory of artists, art historians, art critics, art editors, museum personnel, art educators, and lecturers in the United States and Canada. Gives short biography and address. Geographical index and necrology at end of each volume. Standard directory for fine arts in America. Back issues are useful source for biographical information of lesser American modern artists.

307 **Who's Who in Art.** v. 1- . London, Art Trade Press, 1927- .
Directory of artists, designers, craftsmen, critics, writers, teachers, collectors, and museum personnel. Appendices with necrology and list of artists' marks and signatures. Useful chiefly for Great Britain.

5
DICTIONARIES AND ENCYCLOPEDIAS

GENERAL DICTIONARIES AND ENCYCLOPEDIAS

308 **Das Atlantisbuch der Kunst; eine Enzyklopädie der bildenden Künste.** Zürich, Atlantis, 1952. 897p. illus. index.

One-volume encyclopedia of the visual arts; articles are signed and include bibliographies. Arranged by broad subject areas: 1, Vom Wesen der Kunst; 2, Die Künstlerischen Techniken und ihre Anwendung; 3, Epochen der Kunst in Europa; 4, Die Kunst der aussereuropäischen Völker; 5, Kunstpflege. Well illustrated. Particularly useful are the sections devoted to European styles and periods and to the art of non-Western peoples.

309 Demmin, Auguste F. **Encyclopédie historique, archéologique, biographique, chronologique et monogrammatique des beaux-arts plastiques, architecture et mosaïque, céramique, scuplture, peinture et graveur....** Paris, Jouvet, 1873-1874. 3v. in 5. illus.

One of the most comprehensive nineteenth-century fine arts encyclopedias. Arranged in broad categories with lists of artists in each. Numerous engraved illustrations. General index at end of volume 3.

310 **Encyclopedia of World Art.** New York, McGraw-Hill, 1959-1968. 15v. illus. index (v. 15). LC 59-134333. Supplement: **World Art in Our Time** (v. 16). 1983.

Comprehensive encyclopedia of the art and architecture of all peoples and periods. Signed articles cover major artists, styles, periods, countries, civilizations, and media. Articles range in length from moderately long biographies of major artists to long articles on civilizations, countries, and periods. All have extensive bibliographies, classified and arranged by date of publication, covering books and periodical articles in all languages. Each volume has a corpus of excellent plates, and the articles are liberally provided with plans and diagrams. First appeared in an Italian edition (Florence, Sansoni), which has adversely affected the alphabetical arrangement in the English edition. In compensation, it is necessary to use the index volume. Only major artists are included; for secondary artists consult Thieme-Becker (362) or Myers (317). A standard reference work in the fine arts, although the quality of the entries varies with the contributor. The bibliographies are excellent guides to further study.

311 **Harper's Encyclopedia of Art: Architecture, Sculpture, Painting, Decorative Arts....** New York, Harper, 1937. 2v. illus.

Short-entry encyclopedia of the visual arts covering artists, styles, and periods. Some entries have short bibliographies. Based on the French encyclopedia of Louis Hourticq (Paris, 1925). Older, popular art encyclopedia.

312 **Herder Lexikon: Kunst.** Ed. by Ursula Böing-Häusgen. Freiburg im Breisgau, Herder, 1974. 238p. illus. LC 75-527557.
Comprehensive dictionary of world art containing 2,200 entries of various lengths covering major artists, periods, styles, media, techniques, and general terminology. Selected bibliography of basic works, chiefly in German (p. 239).

313 Jahn, Johannes. **Wörterbuch der Kunst.** 6th ed., rev. and enl. Stuttgart, Kröner, 1962. 749p. illus. LC A45-4462.
General fine arts dictionary of artists, terms, styles, periods, and civilizations. Illustrated with line drawings. Short but excellent bibliographies given at the end of the larger entries. Thoroughly cross referenced. One of the best one-volume art dictionaries.

314 **Lexikon der Kunst. Architektur, bildende Kunst, angewandte Kunst, Industrieformgestaltung, Kunsttheorie.** Ed. by Ludger Alscher, et al. Leipzig, Seemann, 1968- . Band I- . LC 78-423729.
Comprehensive encyclopedia covering the fine arts, applied and decorative arts, industrial design, and art theory. Entries are written by various German specialists; some, particularly those dealing with the philosophy of art, show Marxist bias. Major entries have good bibliographies of specialized literature. Particularly useful for technical aspects of art.

315 **Lexikon der Kunst. Malerei, Architektur, Bildhauerkunst.** Freiburg, Herder, 1987-1988. v. 1-6. illus.
Comprehensive encyclopedia covering architecture, painting, and sculpture from all periods and all parts of the world. Illustrated with numerous color plates. Entries cover major artists, styles, movements, countries, major places, media, subjects, and objects. Most entries have bibliographies at the end.

316 Murray, Peter, and Linda Murray. **Dictionary of Art and Artists.** 3d ed. Harmondsworth, Penguin, 1972. 467p. illus. LC 73-154752.
General fine arts dictionary containing artist biographies, definitions of terms and techniques, and articles on styles, periods, and schools of art. Excellent illustrations, but no bibliographies. Good general dictionary for the beginning student and general reader. Particularly useful for terms and techniques. Does not deal with non-Western art.

317 Myers, Bernard S., and Shirley D. Myers, eds. **McGraw-Hill Dictionary of Art.** New York, McGraw-Hill, 1969. 5v. illus. LC 68-26314.
Comprehensive dictionary of the visual arts covering artists, periods, styles, terms, monuments, museums, places, and countries. Articles range in length from short entries defining terms to long articles on major artists, styles, periods, etc. Larger articles are signed. The larger entries have separate bibliographies. Well illustrated. One of the best all-purpose art encyclopedias in English for the general reader and beginning student.

318 **New International Illustrated Encyclopedia of Art.** New York, Greystone, 1967-1971. 23v. illus. LC 67-24201.
Pictorial dictionary of the art and architecture of all peoples and periods. Entries cover artists, countries, media, and such subjects as urban planning. All illustrations are in color. No bibliography. For the general reader.

319 Osborne, Harold. **The Oxford Companion to Art.** New York, Oxford University Press, 1970. 1277p. illus. LC 71-526168.
A comprehensive general dictionary of the visual arts. Articles range in size from short definitions of terms and brief biographies of major artists to lengthy articles on periods, styles, civilizations, and special aspects of the study of the fine arts (such as preservation and conservation). Also includes places, major buildings, and museums. Entries have bibliographical references to the nearly 3,000 items in the general bibliography at the end of the volume. The best all-around fine arts dictionary in English.

320 The Oxford Dictionary of Art. Oxford, Oxford University Press, 1988. 548p. illus. LC 88-5138.

General dictionary of Western art from antiquity to the present. Entries cover major artist, styles, techniques, movements, objects, countries, regions, areas, etc. Many of the entries have come from The Oxford Companion series (319).

321 Parow, Rolf, and H. E. Pappenheim. **Kunststile: Lexikon der Stil Begriffe.** 2d ed. Munich, Kunst und Technik. 1958. 332p. illus. LC 58-19045.

General dictionary of art styles, schools, movements, and forms. Second part is a polyglot dictionary of the terms in German, English, and French. Bibliography (pp. 149-50). Useful dictionary for students confronted with the task of reading German art historical literature.

322 Phaidon Encyclopedia of Art and Artists. Oxford, Phaidon; New York, Dutton, 1978. 704p. illus. LC 77-89312.

One-volume condensation of the *Praeger Encyclopedia of Art* (325). Entries have been abbreviated and the bibliographies eliminated.

323 Pierce, James S. **From Abacus to Zeus: A Handbook of Art History.** 3d ed. Englewood Cliffs, N.J., Prentice-Hall, 1987. 183p. illus. ISBN 0133317943.

Pocket-size dictionary of general art terminology and iconography intended as a companion to H. W. Janson's *A History of Art*, a standard American college text book. Illustrated with line drawings and provided with maps locating major art centers of the world. References are made to illustrations in Janson's text.

324 Piper, David, ed. **The Illustrated Dictionary of Art and Artists.** New York, Random House, 1984. 448p. illus. LC 84-42655.

General dictionary of art excluding architecture. Entries cover major artists, art movements, style, groups, techniques, patrons, and writers on art. Emphasis is on Western European art. Useful feature is the good number of portraits of artists.

325 Praeger Encyclopedia of Art. New York, Praeger, 1971. 5v. illus. index. LC 75-122093.

Comprehensive encyclopedia-dictionary covering the art and architecture of all nations, civilizations, and periods. Covers artists, styles, schools, movements, and some terms. Most entries are short, but there are some 1,000 longer survey articles that cover major styles and periods. Based on the *Dictionnaire universel de l'art et des artistes* published by Hazan in Paris (1967), the work of a number of Continental specialists. A good reference work for the general reader and student with useful bibliographies attached to the major entries.

326 Runes, Dagobert, and Harry G. Schrickel, eds. **Encyclopedia of the Arts.** New York, Philosophical Library, 1946. 1064p. Reprint: Detroit, Gale Research, 1982. LC 82-20932.

An old standard dictionary of the fine and performing arts. Covers terms, techniques, movements, schools, and styles. Does not include artists. Major entries have short bibliographical references.

327 Schaffran, Emerich. **Dictionary of European Art.** New York, Philosophical Library, 1958. 283p.

General fine arts dictionary of artists, terms, techniques, periods, styles, etc. No bibliographies. Popular dictionary with very short entries, uneven in coverage. Restricted to European art.

328 Sormani, Giuseppe. **Dizionario delle arti.** 2d ed., rev. and enl. Milan, Sormani, c. 1953. 974p. illus.
 General fine arts dictionary with entries arranged under broad subjects and movements. Index of names. The unusual arrangement is advantageous for quick reference to styles, schools and movements, particularly in Italian and modern art.

329 **The Thames and Hudson Dictionary of Art and Artists.** Ed. by Herbert Read. Rev. ed., ed. by Nikos Stavgos. London, Thames and Hudson, 1985. 352p. illus. LC 84-50342.
 General, popular dictionary of art covering major artists, styles, movements, schools, materials, techniques, and general terminology. Much of the material was first published in the *Encyclopaedia of the Arts* (London, Thames and Hudson, 1966).

330 Thomas, Denis. **Dictionary of Fine Arts.** London, Hamlyn, 1981. 200p. illus. LC 82-181318.
 Popular dictionary with brief entries covering terms, techniques, schools, style, movements, and major artists and architects. No bibliography.

331 **Visual Dictionary of Art.** General editor, Ann Hill. Greenwich, Conn., New York Graphic Society, 1973. 640p. illus. index. LC 73-76181.
 General dictionary of art, both Eastern and Western, covering civilizations, periods, styles, schools, movements, and artists as well as terms, techniques, and materials. Thoroughly illustrated. An unusual and useful feature is the collection of short essays on major periods and civilizations preceding the alphabetical entries. The brevity of the entries and the limited bibliography restrict its usefulness to the general reader.

DICTIONARIES OF TERMINOLOGY

332 Adeline, Jules. **Adeline's Art Dictionary.** New York, Appleton, 1927. Reprint: Ann Arbor, Mich., Edwards, 1953. 422p.
 General fine arts dictionary with short definitions of terms, techniques, materials, subjects, and objects. Illustrated with line drawings. Although old, it is still useful for definitions of many terms, especially those encountered in antiquarian literature.

333 Bilzer, Bert. **Begriffslexikon der bildenden Künste. Die Fachbegriffe der Baukunst, Plastik, Malerei, Graphik und des Kunsthandwerks.** Reinbek bei Hamburg, Rororo, 1971. 2v. illus. LC 78-596414.
 Dictionary of terms used in architecture, sculpture, painting, graphic arts, and the applied and decorative arts. Covers stylistic and iconographical terms, objects, structures, techniques, style, and movements. Well illustrated with black and white and color plates plus line drawings. No bibliography.

334 Ehresmann, Julia M. **Pocket Dictionary of Art Terms.** 3d ed., rev. and enl. by James Hall. London, J. Murray, 1980. 128p. illus. ISBN 0719537517.
 Concise dictionary of terminology of the fine and decorative arts, photography, and some architecture. Includes media, techniques, and styles but not artists. Selected bibliography of standard, available books on art, pp. 118-28.

335 Elspass, Margy Lee. **Illustrated Dictionary of Art Terms.** London, Batsford, 1984. 220p. illus. LC 88-42535.
 Popular dictionary with brief definition of art terms. Has some useful definitions of contemporary art terms.

336 Fairholt, Frederick W. **A Dictionary of Terms in Art....** London, Virtue, Hall & Virtue, 1854. 474p. illus.

Covers terms used in sculpture, painting, graphic arts, and applied and decorative arts. Used in the preparation of the English translation of Adeline (332).

337 **Glossarium Artis. Deutsch-Französisches Wörterbuch zur Kunst.** fasc. 1- . Tübingen, Niemeyer, 1972- . Munich, K. G. Saur, 1982- . illus.

German-French, and beginning with fasc. 7, German-French-English, dictionary of art terms arranged by types or classes of works of art and architecture. To date the following have appeared:

1. *Burgen and feste Plätze: der Wehrbau vor Einführung der Feuerwaffen. L'architecture militaire avant l'introduction des armes a feu* (2d ed. 1977. 280p.)
2. *Liturgische Geräte, Kreuze und Reliquaire der christlichen Kirchen. Objets liturgiques, croix et reliquaires des églises chrétiennes* (2d ed. 1982)
3. *Bogen and Arkaden. Arcs et arcades.* (2d ed. 1982. 166p.)
4. *Paramente und Bücher der christlichen Kirchen. Parements et livres des églises chrétiennes* (2d ed. 1982. 202p.)
5. *Treppen. Escaliers.* (2d ed. 1985. 278p.)
6. *Gewölbe und Kuppeln. Voutes et coupoles* (2d ed. 1982. 249p.)
7. *Festungen: der Wehrbau nach Einführung der Feuerwaffen. Fortresses: l'architecture militaire apres l'introduction des armes a feu. Fortresses: Military Architecture after the Introduction of Firearms* (1979. 298p.)
8. *Das Baudenkmal: zu Denkmalschutz und Denkmalpflege. Le monument historique: termes concernant la protection et la conservation des monuments historiques. The Historic Monument: Terminology connected with the Protection and Preservation of Historic Monuments* (1981. 326p.)
9. *Städte: Stadtplane, Plätze, Strassen, Brücken. Villes: Plans, places, voies, ponts. Towns: Plans, Squares, Roads, Bridges* (1987. 407p.)

Each term is illustrated by a line drawing and briefly defined. Arranged under the German name with the French (and English in later fascicles and 2nd edition) equivalent at the end of each entry. Synonyms and homonyms given as well. Each fascicle contains a comprehensive bibliography of the subject. General indexes are planned. The most scholarly and comprehensive dictionary of art terms. When complete, it will be the standard work in the field.

338 Haggar, Reginald G. **Dictionary of Art Terms.** New York, Hawthorn Books, 1962. 415p. illus. LC 62-8288. Reprint: Poole, Dorset, England, New Orchard Editions, 1984. 416p.

General dictionary of art terms. Illustrated with line drawings. General bibliography (pp. 411-15). Chiefly useful for succinct definitions of art techniques, styles, and subjects.

339 Lemke, Antje B., and Ruth Pleiss. **Museum Companion: A Dictionary of Art Terms and Subjects.** New York: Hippocrene, 1974. 211p. illus. index. LC 73-76377.

Defines some 700 movements, styles, subjects, and techniques of Western Art. Provides pronunciations of terms, a list of major museums in Europe and North America, and a classified bibliography of selected books.

340 Linnenkamp, Rolf. **Begriffe der modernen Kunst.** Munich, Heyne, 1974. 203p. illus. index. (Heyne Bücher, 4431). LC 74-342487.

Dictionary of some 1,300 entries, covering all aspects of twentieth-century art. Part one covers terms and subjects, and part two, short biographies of major artists. Consult Walker (351) also.

341 Lucie-Smith, Edward. **Thames and Hudson Dictionary of Art Terms.** London, Thames and Hudson, 1984. 208p. illus. LC 83-51331.
General dictionary of art terms with particular attention to the terms applicable to modern and contemporary art. Good selection of illustrations. No bibliography.

342 Lützeler, Heinrich. **Bildwörterbuch der Kunst.** Bonn, Dummer, n.d. (c. 1950). 626p. illus.
Comprehensive dictionary covering terms from all aspects of art history, together with a few major biographies. Illustrated with line drawings.

343 Masciotta, Michelangelo. **Dizionario di termini artistici.** Florence, Le Monnier, 1967. 269p. LC 68-100571.
General Italian dictionary of art terms consisting of brief definitions. No bibliography. Useful tool for students who are reading extensively in Italian art historical literature.

344 Mayer, Ralph. **A Dictionary of Art Terms and Techniques.** New York, Crowell, 1969. 447p. illus. index. LC 69-15414. Reprint: New York, Barnes and Noble, 1981. ISBN 0064635317.
General fine arts dictionary of terms and techniques, intended chiefly for the practicing artist and general reader. Particularly useful for definitions of materials and techniques.

345 Mollett, John W. **An Illustrated Dictionary of Words Used in Art and Archaeology....** Boston, Houghton Mifflin, 1883. 350p. illus. Reprint: New York, American Archives of World Art, 1966.
Well-illustrated nineteenth century dictionary covering architecture, sculpture, painting, graphic arts, and applied and decorative arts. Includes a few Far Eastern terms.

346 Müller, Christian. **Das grosse Fachwörterbuch für Kunst und Antiquitäten: Band 1 Englisch-Französisch-Deutsch. The Art and Antiques Dictionary. Grand Dictionaire Technique d'Art et d'Antiquités.** Munich, Weltkunstverlag, 1982. 376p. illus. ISBN 3921669006.
English, French, German dictionary of terms used in the fields of fine arts (excluding photography) and antiques (excluding musical instruments). More up-to-date than Reau (348) but can not easily be used to determine the English equivalent of a French or German term.

347 O'Dwyer, John, and Raymond Le Mage. **A Glossary of Art Terms.** London, Nevill, 1950, 148p.
Popular dictionary of terms, techniques, styles, and schools of Western art. Includes some foreign terms with English translations. For the general reader.

348 Réau, Louis. **Dictionnaire polyglotte des termes d'art et d'archéologie.** Paris, Presses Universitaires de France, 1953. Reprint: Osnabrück, Ohms, 1974. 247p. 2d ed., Osnabrück, Ohms, 1977. 961p.
Polyglot dictionary of fine arts terms, consisting of one alphabetical listing under the French name of the term. Equivalents are given in Greek, Latin, Italian, Spanish, Portuguese, Romanian, English, German, Dutch, Swedish, Czech, Polish, and Russian. Greek and Russian names are transliterated into Latin alphabet. Second edition has additions to German, English, and Italian terminologies.

349 Reynolds, Kimberley, and Richard Seddon. **Illustrated Dictionary of Art Terms: A Handbook for the Artist and Art Lover.** London, Ebury Press, 1981. 190p. illus. ISBN 0852232071.
General and popular dictionary of approximately 10,000 art terms covering techniques, materials, periods, schools, etc. A good pocket-size dictionary for the general reader and beginning student.

350 Urdang, Laurence, and Frank R. Abate. **Fine and Applied Arts Terms Index.** Detroit, Gale Research, 1983. 773p. index. LC 83-16532.

Index to some 45,000 art terms with references to sources of information in 23 standard reference books and articles in Christie's and Sotheby Parke Bernet catalogs.

351 Walker, John A. **Glossary of Art, Architecture and Design since 1945.** 2d ed. London, Linnet Books, 1977. 352p.

Dictionary of terms relating to the fine arts since 1945. Brief entries give definition and source when known. General bibliography useful for definitions of the most avant-garde art terms. See Linnenkamp (340) as well.

See also: General Dictionaries.

GENERAL BIOGRAPHICAL DICTIONARIES

352 Bénézit, Emmanuel. **Dictionnaire critique et documentaire des peintres, sculpteurs, dessinateurs et graveurs....** Paris, Gründ, 1948-1955. Reprint: Paris, 1957. 8v. illus. index. Nouv.éd., Paris, 1976. 10v. illus. index. ISBN 2700001494.

Dictionary of painters, sculptors, and graphic artists of all times and nations. Entries vary from a few lines to several paragraphs. In addition to the basic biographical data, longer entries list prizes won by the artist and the museums where his works can be found. Facsimiles of signatures are given and monograms are listed at the end of each letter of the alphabet. Author index and general bibliography in final volume. Directed to the general reader and collector rather than the scholar.

353 Darmstaedter, Robert. **Reclams Künstlerlexikon.** Stuttgart, Reclam, 1979. 788p. illus. LC 79-395839.

First published in 1961 as *Künstlerlexikon: Maler, Bildhauer, Architekten.* (Bern, Francke). General biographical dictionary of architects, sculptors, and painters from all countries and periods. Each entry gives basic biography, characterization of the artist's style, list of major works, and a separate bibliography. The most comprehensive and reliable one-volume dictionary of artists.

354 Kaltenbach, Gustave E. **Dictionary of Pronunciation of Artists' Names.** 2d ed. Chicago, The Art Institute of Chicago, 1938. 74p.

Alphabetical list of 1,500 artists' names with their birth and death dates, national-ity, and pronunciation of their names. A useful and reliable guide.

355 Lodovici, Sergio. **Storici, teorici e critici delle arti figurative (1800-1940).** Rome, E.B.B.I., Istituto Editoriale Italiano, 1942. 412p. illus. (Enciclopedia Biografia e Biblio-graphica "Italiana," ser. IV).

Dictionary of art historians, theoreticians, and critics active between 1800 and 1940. Each biography gives a list of the writer's major works and a discussion of that person's theories; a portrait of the writer is often included.

356 Meissner, Gunter. **Allgemeines Künstler-Lexikon die bildenden Künstler aller Zeiten und Völker.** Band 1- . Leipzig, Seemann, 1983- . LC 84-192545.

Revision of Thieme-Becker (362). The signed articles are written by an international team of specialists and follow the scheme in Thieme-Becker: biography, work, museum holdings, bibliography. Over twice the number of artists are to be included in this revision.

357 Meyer, Julius, ed. **Allgemeines Künstler-Lexikon....** Leipzig, Engelmann, 1872-1885. 3v.

Planned revision and expansion of Nagler's *Neues allgemeines Künstler-Lexikon* (359), which reached only as far as "Bezzuoli." Excellent signed entries by leading German scholars of the last quarter of the nineteenth century.

358 Müller, Hermann A., and Hans W. Singer. **Allgemeines Künstler-Lexikon. Leben und Werke der berühmtesten bildenden Künstler.** 5th ed. Frankfurt am Main, Rütten & Loening, 1921-1922. 6v.

Unrevised reprint of the third edition, published in 1891-1901, with a supplement and corrections in the sixth volume. Short, unsigned biographical entries cover major artists of all periods and countries. No bibliographies.

359 Nagler, Georg K. **Neues allgemeines Künstler-Lexikon....** Leipzig, Schwarzenberg & Schumann, 1924. 25v.

Reprint of the first edition, published 1835-1852. Comprehensive dictionary of fine and applied artists of all periods and countries. Entries discuss both the life and work of the artist but give no bibliographies or references to sources. The most important of the early nineteenth-century artists' dictionaries, it laid the foundation for, and was superseded by, Thieme-Becker (362).

360 Pettys, Chris. **Dictionary of Women Artists: An International Dictionary of Women Artists Born before 1900.** Boston, G. K. Hall, 1985. 851p. illus. LC 84-22511.

Popular dictionary of women artists born before 1900. Brief entries have references to other reference works and general books. Emphasis is on lesser-known women artists with over 21,000 entries for women painters, sculptors, printmakers, and illustrators. Does not include architects.

361 Spooner, Shearjashub. **A Biographical History of the Fine Arts; or, Memoirs of the Lives and Works of Eminent Painters, Engravers, Sculptors, and Architects....** New York, Bouton, 1865. 2v. illus.

First published in 1853 as a dictionary of painters and engravers. Brief biographical entries on major artists of all periods and countries. Section devoted to major copyists and imitators, arranged under the master whose works they copied. Together with Bryan's *Dictionary of Painters and Engravers* (London, 1816), the chief English nineteenth-century artists dictionary.

362 Thieme, Ulrich, and Felix Becker. **Allgemeines Lexikon der bildenden Künstler von der Antike bis zur Gegenwart....** Leipzig, Seemann, 1907-1950. 37v.

The most comprehensive biographical dictionary of artists from antiquity to the present. Entries are signed and vary in length depending on the artist. All have separate bibliographies. Larger entries have thorough discussions of the stylistic development of the artist and lists of works with locations. Volume 37, entitled *Meister mit Notnamen und Monogrammisten*, contains biographies of anonymous artists known by substitute names or monograms. Artists active chiefly in the twentieth century are not included; equivalent biographies of these are found in Vollmer (410). A reference work of outstanding scope and scholarship. The standard biographical source for the fine arts. For successor see Meissner (356).

363 Waters, Clara Erskine Clement. **Women in the Fine Arts: From the Seventh Century B.C. to the Twentieth Century A.D.** Cambridge, Mass., Houghton Mifflin, 1904. 395p. illus. Reprint: New York: Hacker, 1974. LC 73-92107.

Biographical dictionary of female artists in all media. Brief entries give biographical data together with list of major works. Bibliographical references to a list of basic reference works.

See also: Havlice, **Index to Artistic Biography** (267).

DICTIONARIES OF MARKS AND SIGNATURES

364 Brulliot, Franz. **Dictionnaire des monogrammes, marques figurées, lettres, initiales, noms abrégés etc....** Nouv. éd. Munich, Cotta, 1832-1834. 3v. illus. index. Reprint: Farnborough, Gregg, 1969.

Comprehensive dictionary of marks, monograms, and initials of artists of all schools and periods, illustrated with facsimiles. Figurative marks appear as appendices in the first two volumes. Indexes of artists' names in each volume; general index at end of last volume. Superseded by Nagler (369).

365 Caplan, H. H. **The Classified Directory of Artists' Signatures, Symbols and Monograms.** Enl. rev. ed. Detroit, Gale Research, 1982. 873p. LC 83-10587.

General dictionary of marks and signatures, with emphasis on European painters and graphic artists (and a few Far Eastern or American artists). Arranged in four sections: alphabetical by artist's name, monograms by first letter, illegible or misleading signatures by first legible letter, and symbols classified by shape. Entries give facsimiles of the marks and signatures plus basic biographical data for the artist. No bibliography.

366 Goldstein, Franz. **Monogrammlexikon: Internationales Verzeichnis der Monogramme bildender Künstler seit 1850.** Berlin, de Gruyter, 1964. 931p. LC 65-47949.

Dictionary of the monograms of artists active since 1850, arranged alphabetically by the initial letters. Entries give the dates of the artist, media worked in, and bibliographical reference to either Thieme-Becker, Vollmer, Bénézit or *Dresslers Kunsthandbuch*. The standard reference tool for the monograms of modern artists. Complements Nagler (369).

367 Haslam, Malcolm. **Marks and Monograms of the Modern Movement 1875-1930.** New York, Scribner's, 1977. 192p. illus. index. LC 76-26189.

Dictionary of marks and monograms of modern artists working in the graphic, applied, and decorative arts. Arrangement is by media: ceramics, glass, metalwork and jewelry, graphics, furniture, and textiles. Entries provide a facsimile of the mark and basic biographical data for the artist.

368 Lampe, Louis. **Signature et monogrammes des peintres de toutes les écoles; guide monogrammiste....** Brussels, Castaign, 1895-1898. 3v.

Dictionary of signatures and monograms of Western painters of all periods and schools. Arranged by the subject depicted and then alphabetically by artists. Short biographical entries with facsimiles of signatures and monograms. Still a useful dictionary.

369 Nagler, Georg Kaspar. **Die Monogrammisten und diejenigen bekannten und unbekannten Künstler aller Schulen....** Munich, Franz, 1858-1879. 5v. illus. index. **General-Index zu G. K. Nagler die Monogrammisten....** Munich, Hirth, 1920. 109p. Reprint: Nieuwkoop, De Graaf, 1966. 6v. illus. index.

Comprehensive dictionary of the monograms of artists in all media and from all periods. In addition, it includes printers' and collectors' marks and marks on metalwork and ceramics. Arranged by the chief initials in the monogram. Facsimiles of the marks are given, with a short biography of the artist and a discussion of where the mark is found. Each volume has a supplement (Nachtrag) and index at the end. Volume six contains a general index and bibliography. The standard work on monograms. For the monograms of modern artists – i.e., active since 1870 – see Goldstein (366).

370 Ris-Paquot, Oscar E. **Dictionnaire encyclopédique des marques et monogrammes, chiffres, lettres, initiales, signes figuratifs....** Paris, Laurens, 1893. 2v. illus. index. Reprint: New York, Burt Franklin, 1964.

Comprehensive dictionary of artist's marks, initials, monograms, and signs, with particular attention to those found in various works of applied and decorative arts.

Arranged by broad classes and illustrated with facsimiles. General index of artists' names (pp. 579-609) in volume two. Useful inclusion of marks of collectors, museums and libraries.

SPECIALIZED DICTIONARIES AND ENCYCLOPEDIAS

Prehistoric

371 Ebert, Max, ed. **Reallexikon der Vorgeschichte.** Berlin, de Gruyter, 1924-1932. 15v. in 16. illus. index.

Comprehensive and scholarly encyclopedia of signed articles covering all aspects of prehistoric archaeology. The long articles are accompanied by separate and extensive bibliographies and many excellent illustrations. The standard reference tool for prehistoric archaeology.

372 Filip, Jan, ed. **Enzyklopädisches Handbuch zur Ur- und Frühgeschichte Europas.** Stuttgart, Kohlhammer, 1966-1969. 2v. illus. LC 67-101201.

Encyclopedia covering all aspects of European civilization during prehistoric and early historic times. Articles cover objects, sites, regions, and styles that are directly related to the study of prehistoric, Germanic, and Celtic art. Articles are occasionally illustrated with line drawings and plans; each major article is accompanied with an extensive bibliography of specialized literature. A standard reference tool for all serious study of early European art.

Europe

PERIODS OF WESTERN ART HISTORY

Ancient

373 Avery, Catherine B., ed. **The New Century Handbook of Greek Art and Architecture.** New York, Appleton-Century-Crofts, 1972. 213p. illus. LC 72-187738.

Dictionary of ancient Greek art and architecture covering artists, objects, monuments, places, styles, and schools. The entries are derived from the *New Century Classical Dictionary* and in some instances have been expanded to reflect more recent archaeological findings. For the general reader and beginning student.

374 Bianchi Bandinelli, Ranuccio, ed. **Enciclopedia dell'arte antica; classica e orientale.** Rome, Istit. della Enciclopedia Italiana, 1958-1973. 8v. illus. index. LC 58-37080.

Comprehensive encyclopedia of ancient art covering the period from prehistory to 500 A.D. Long, signed articles by specialists with separate bibliographies and good illustrations. Treats classical antiquity including the ancient civilizations of the Near East, Egypt, and the prehistoric cultures of Northern Europe. Volume 8 contains an atlas. Excellent reference tool for ancient art. A 951-page supplement was published in 1973.

375 Daremberg, Charles V., and Edmond Saglio. **Dictionnaire des antiquités grecques et romaines d'après les textes et les monuments.** Paris, Hachette, 1873-1919. 5v. illus. index. Reprint: Graz, Akademische Druck und Verlagsanstalt, 1962-1963. 5v. in 10. LC 64-44287.

Scholarly encyclopedia covering all aspects of classical culture including the visual arts. Long, signed articles by recognized specialists with separate bibliographical references. Does not include biography. One of the standard reference tools for classical studies. For greater depth and for classical biography and literature see Pauly-Wissowa (382).

376 **Dictionary of Ancient Greek Civilization.** London, Methuen, 1967. 491p. illus.
General dictionary covering all aspects of ancient Greek civilization, with articles on artists, art centers, major buildings, and subjects.

377 Ebeling, Erich, and Bruno Meissner, eds. **Reallexikon der Assyriologie.** v. 1- . ("A" through "Hazazu"). Berlin, de Gruyter, 1928- . illus.
Comprehensive encyclopedia covering all aspects of the ancient civilizations of the ancient Near East. Long, signed articles illustrated with line drawings and plans, plus extensive bibliographies. Most of the entries are in German, but some are in French and English. A standard reference work for the advanced student and scholar of ancient Near Eastern art and architecture.

378 Hammond, N. G. L., and H. H. Scullard, eds. **The Oxford Classical Dictionary.** 2d ed. Oxford, Clarendon Press, 1970. 1176p. LC 73-18819.
Comprehensive dictionary of all aspects of classical Greek and Roman civilizations. Entries are signed and supply separate bibliographies. Useful for students of ancient art for quick reference on places, major artists, religious and mythological subjects, and literary subjects. The standard classical dictionary in English.

379 Helck, Wolfgang, and Eberhard Otto, eds. **Lexikon der Ägyptologie.** Bd. I- . Wiesbaden, Harrassowitz, 1972- .
The first volume of a comprehensive encyclopedia covering all aspects of ancient Egyptian civilization. Six volumes are planned. Entries are signed and provide excellent bibliographies. Should become a standard reference work for advanced students and scholars of ancient Egyptian art and architecture.

380 Lamer, Hans. **Wörterbuch der Antike mit Berücksichtigung ihres Fortwirkens.** 8th ed. expanded and improved by P. Kroh. Stuttgart, Kröner, 1976. 832p. illus.
General dictionary of Greek and Roman civilization covering terms, persons, places, objects, and subjects. Major entries have separate bibliographies. One of the best pocket-sized classical dictionaries; particularly useful for its attention to the continuation of classical traditions in later periods.

381 **Lexikon der alten Welt.** Zürich, Artemis, 1965. 3524 columns. LC 67-105898.
Comprehensive dictionary covering all aspects of ancient civilization. Long, signed articles cover places, persons, objects, and subjects. There are excellent separate bibliographies. An excellent classical dictionary.

382 Pauly, August Friedrich von. **Pauly's Real-Encyclopädie der classischen Altertumswissenschaft; neue Bearbeitung begonnen von Georg Wissowa, unter Mitwirkung zahlreicher Fachgenossen, Herausgegeben von Wilhelm Kroll und Karl Mittelhaus.** Stuttgart, Metzler, 1894-1973. v. 1-24. 2. Reihe v. 1-10A and Supplement 1-13. Reprint: Stuttgart, Druckenmüller, 1967-1987.
Appeared in two series of 44 volumes and eleven volumes of supplements. Additional supplements are planned. Scholarly encyclopedia covering all aspects of classical civilization. Long, signed articles, with separate bibliographies, cover biography, antiquities, literature, mythology, religion, sites, and historical events. The standard classical encyclopedia and a paradigm of a reference work for historical studies. In English usually referred to as "Pauly-Wissowa"; sometimes cited in German as "R. E." Contents: Bd. 1-24: A-Quosenus; 2. Reihe Bd. 1-10A: R-Zythos. A useful guide to this complex work is: John P. Murphy, *Index to the Supplements and Supp. Volumes of Pauly-Wissowa's R. E.: Index to the Nachträge and Berichtungen in vols. I-XXIV of the first Series, vols. I-X of the second Series, and Supplementary vols. I-XIV of Pauly-Wissowa-Kroll's Realenzyklopadie.* 2d ed. (Chicago, Ares, 1980. 144p. ISBN 0890051747.)

383 **Der Kleine Pauly: Lexikon der Antike.** Ed. by Konrat Ziegler and Walther Sontheimer. Stuttgart, Druckenmüller, 1964-1975. 5v.
Abridged version of Pauly (382) but with updated material and bibliographies. Nachträge (supplement) volumes appear at regular intervals.

384 **Praeger Encyclopedia of Ancient Greek Civilization.** New York, Praeger, 1967. 491p. illus. LC 67-25162.
General dictionary with brief signed articles covering all aspects of ancient Greek civilization, including art and architecture. A useful reference work for the general reader and the beginning student.

385 Stillwell, Richard, ed. **The Princeton Encyclopedia of Classical Sites.** Princeton, Princeton University Press, 1976. 1019p. LC 75-30210.
Dictionary of basic information on sites important during classical antiquity, i.e., between the eighth century B.C. and the sixth century A.D. Does not include Early Christian sites. Entries describe the locations and their material remains and include valuable bibliographies of specialized literature that often note art historical references.

Medieval and Byzantine

386 Aressy, Pierre. **Abrégé de l'art roman, suivi d'un lexique des termes employés en art roman.** Montpellier, Causse et Castelnau, 1967. 143p. illus. LC 68-76605.
Part II (pp. 85-121) is a dictionary of terms used in the history of Romanesque art. Part I gives a short but useful history of Romanesque art in France. Useful handbook for the student of medieval art.

387 Cabrol, Fernand. **Dictionnaire d'archéologie chrétienne et de liturgie....** Paris, Letouzey et Ané, 1907-1953, 15v. illus.
Volumes 3-14 "publié par le Rme. dom Fernand Cabrol ... et le R. P. dom Henri Leclercq." Illustrated with line drawings. Scholarly encyclopedia covering all aspects of Christian culture of the period from the early Christians through the Carolingians. The long, signed articles have separate bibliographies and are of particular importance to students of Christian art seeking information on sites, archaeological and liturgical artifacts, and iconographical subjects. In the latter category, the work's usefulness extends far beyond its period of specialty.

388 Gay, Victor, and Henri Stein. **Glossaire archéologique du moyen-âge et de la Renaissance.** Paris, Société Bibliographique, 1887-1928. Reprint: Nendeln, Kraus, 1967. 2v. illus. LC 68-100435.
Dictionary of terms encountered in the study of medieval and Renaissance art. Major entries give quotations from literary or documentary sources. Illustrated with line drawings.

389 Guénebault, Louis J. **Dictionnaire iconographique des monuments de l'antiquité chrétienne et du moyen âge depuis le bas-empire jusqu'a la fin du seizième siècle indiquant l'état de l'art et de la civilisation a ces diverses époques.** Paris, Leleux, 1843-1845. 2v.
Comprehensive dictionary of the art and architecture of the Early Christian period and the Middle Ages. Entries treat countries, provinces, sites, objects, structures, techniques, and iconographic subjects. For an old book, information supplied is impressive. The extensive references to early literature make it a useful special tool.

390 Klauser, Theodor. **Reallexikon für Antike und Christentum; Sachwörterbuch zur Auseinandersetzung des Christentums mit der Antiken Welt....** Bd. I- . Stuttgart, Hiersemann, 1950- . illus.
Scholarly encyclopedia covering all aspects of the culture of the late Roman and Early Christian period. It is designed to investigate the interrelationship between

Christianity and late antiquity. Consists of long, signed articles with separate and exhaustive bibliographies on a broad variety of subjects, many of which are of direct interest to art historians of the period. Particularly valuable for information on iconography, architecture, sites, and personalities of the Early Christian period. Each volume has a table of contents in German, English, French, and Italian.

391 Laag, D. Heinrich. **Wörterbuch der altchristlichen Kunst.** Kassel, Stauda, 1959. 166p. illus. LC A66-3623.
General dictionary of terms, persons, subjects, and places encountered in the study of Early Christian art and architecture. Illustrated with line drawings. A very useful, pocket-sized dictionary for the student of Early Christian art.

392 **Lexikon des Mittelalters.** Band I- . Munich, Artemis Verlag, 1977- . LC 79-390542.
Planned five-volume encyclopedia covering all aspects of medieval civilization, including art and architecture. Entries are written by experts from various countries, are illustrated, and include valuable bibliographies of specialized literature. Of particular interest to art historians are the articles on major works of art, artistic personalities, and iconographical subjects.

393 Vogüe, Melchior de, Jean Neufville, and Wenceslas Bugara. **Glossaire de terms techniques à l'usage des lecteurs de "La Nuit des Temps."** Paris, Zodiaque, 1965. 473p. illus. index. LC 67-81381.
Dictionary of art and architectural terms used in the study of Romanesque and Gothic art. Very thorough dictionary is accompanied by numerous plates, plans, and diagrams, many with the terms included. An excellent dictionary of French terms for the advanced student of medieval art and architecture.

394 Wessel, Klaus, ed. **Reallexikon zur byzantinischen Kunst.** v. 1- . Stuttgart, Hiersemann, 1966- . illus. LC 76-446105.
Comprehensive and scholarly encyclopedia of all aspects of Byzantine art and architecture. Recognized specialists prepared the lengthy articles, which are well illustrated with plans and drawings and which have extensive separate bibliographies. Standard reference tool for the study of Byzantine art.

Renaissance

395 Avery, Catherine B., ed. **The New Century Italian Renaissance Encyclopedia.** New York, Appleton-Century-Crofts, 1972. 978p. illus. LC 76-81735.
Comprehensive dictionary of all aspects of the Italian Renaissance, including articles on artists and writers, résumés of literary works, subjects, and some terms dealing with the fine arts. The entries are brief, without bibliographies. Useful reference work for the general reader and the beginning student.

396 Earls, Irene. **Renaissance Art: A Topical Dictionary.** Westport, Conn., Greenwood Press, 1987. 345p. LC 87-250.
Dictionary of some 800 entries on topics related to European art, excluding architecture, from 1305 to 1576. Includes subjects, material and techniques, types of art objects, and stylistic terms. The longer entries have references to specific works of Renaissance art. Bibliography (pp. 323-27) is list by author of basic books.

397 Hale, J. R., ed. **A Concise Encyclopaedia of the Italian Renaissance.** New York, Oxford University Press, 1982. 360p. illus. LC 81-81905.
Comprehensive dictionary covering all aspects of the Italian Renaissance including art and architecture. Signed entries have bibliographical references. Good selection of illustrations. Informative reference tool directed to the undergraduate student.

Modern (19th and 20th Centuries)

398 Babington Smith, V., ed. **Dictionary of Contemporary Artists.** Santa Barbara, Calif., ABC-Clio, 1981. 451p. illus. LC 81-643135.
 Comprehensive dictionary of artists, excluding architects, who were alive and their work had been exhibited during 1979 and 1980. The media included are: ceramics, conceptual art, drawing, environmental art, glass, jewelry, painting, metalwork, performance art, photography, graphic arts, sculpture, textile, and video. Entries provide basic biographical data and reference to the most recent exhibition(s).

399 Busse, Joachim. **Internationales Handbuch aller Maler und Bildhauer des 19. Jahrhunderts.** Wiesbaden, Busse Verlag, 1977. 1200p. illus. LC 77-481499.
 Comprehensive, computer-assisted index of 89,000 painters, sculptors, and graphic artists still alive after 1806 or born before 1880. Emphasis is on European artists. Arranged alphabetically by artist's name and set in table form, the following information is provided chiefly through abbreviations: birth and death dates, nationality, place of work, techniques used and subjects most often represented, and reference to twelve reference sources, including sales catalogs. The work is designed for quick reference by collectors and others seeking basic information on less well-known artists of the nineteenth century, particularly Continental.

400 Charmet, Raymond. **Dictionnaire de l'art contemporain.** Paris, Larousse, 1965. 320p. illus. LC 66-72421.
 This pocket-sized dictionary of twentieth century art and architecture provides brief biographies of artists and architects, with entries on schools, styles, terms, and places relative to modern art. No bibliography.

401 Du Peloux de Saint Romain, Charles. **Répertoire biographique et bibliographique des artistes de XVIIIᵉ siècle français....** Paris, Champion, 1930-1941. 2v.
 Biographical dictionary and bibliography on French artists of the eighteenth century. Volume 1 contains the dictionary; volume 2, the bibliography of about 4,000 titles of books and periodical articles published in the decade between 1930 and 1940.

402 Edouard-Joseph, René. **Dictionnaire biographique des artistes contemporains, 1910-1930....** Paris, Art et Edition, 1930-1934. 3v. illus. index. Supplément. Paris, 1936. 162p. illus.
 Dictionary of artists active in France from 1910 to 1930. In addition to basic biographical data, it also lists when and where the artist exhibited and the awards won by each artist. List of important works given for major artists. Index of monograms at end of volume 3.

403 Maillard, Robert, ed. **New Dictionary of Modern Sculpture.** New York, Tudor, 1971. 328p. illus. LC 70-153118.
 Biographical dictionary of modern sculptors. Signed entries with illustrations, no bibliographies. Index of photographers.

404 Marks, Claude. **World Artists 1930-1980.** New York, Wilson, 1984. 912p. illus. LC 84-13152.
 Comprehensive dictionary of artists (excluding architects) from around the world who were active and were influential during the period 1930 to 1980. Biographies have list of exhibitions and bibliography of specialized literature.

405 Myers, Bernard S., and Shirley D. Myers. **Dictionary of 20th Century Art.** New York, McGraw-Hill, 1974. 440p. illus. LC 74-4200.
 Entries on twentieth century art and architecture from the *McGraw-Hill Dictionary of Art* (317). Bibliography (pp. 435-40) lists basic books in English.

406 Naylor, Colin, and Genesis P-Orridge, eds. **Contemporary Artists.** 2d ed. New York, St. James Press, 1983. 1041p. illus. LC 82-25048.
Dictionary of some 1,300 internationally known artists who were alive in 1930. For inclusion, an artist has to have had at least five years as a career professional, one-person shows, participation in a large-scale museum-type survey show, and have works in the permanent collections of major museums. Entries are quite comprehensive, giving biographical data, list of one-person and group exhibitions, collections possessing the artist's work, publications on and by the artist, and a brief statement (sometimes by the artist) of the character and intention of the artist's work. Most entries have illustrations. Partially fills the need for a dictionary of contemporary artists that includes the less well-known.

407 Osborne, Harold. **The Oxford Companion to Twentieth-Century Art.** New York, Oxford University Press, 1981. 656p. illus. LC 82-126560.
Dictionary covering all aspects of art (excluding architecture) of the twentieth century but with particular emphasis on Western European developments. Entries cover major artists, collectors, critics and other personalities, styles, movements, organizations, countries, areas, techniques, and media. Bibliographical references by abbreviations to works listed in the extensive bibliography, pp. 601-48.

408 **Phaidon Dictionary of Twentieth-Century Art.** 2d ed. London, Phaidon, 1977. 420p. illus. LC 77-81957.
General dictionary of twentieth century art, including artists' biographies, artists' groups, schools, styles, and a few terms. There are short bibliographies for most entries. Particularly useful for quick reference to modern art styles and movements.

409 Smith, Veronica B. **International Directory of Exhibiting Artists.** Santa Barbara, Calif., ABC-Clio, 1983. 2v. LC 82-646020.
Biographical dictionary of contemporary artists who have exhibited between 1972 and 1982. Entries are short biographical sketches with information as to where the artist studied and has exhibited. Artists can be contacted through the galleries whose addresses are provided at the end of the volume. Volume one covers painters, printmakers, and draftsmen; volume two covers sculptors, ceramicists, photographers, textile artists and artists working in other media. Does not include architects.

410 Vollmer, Hans. **Allgemeines Lexikon der bildenden Künstler des XX. Jahrhunderts.** Leipzig, Seemann, 1953-1962. 6v. LC 54-19064.
Biographical dictionary of twentieth century artists in all media. Conceived as a supplement to Thieme-Becker (362), it emphasizes artists born after 1870. In the case of those artists that are also treated in Thieme-Becker, Vollmer gives additional information. Volumes 5 and 6 are supplement volumes; additional supplement volumes are planned. The entries vary in length, are signed, and have separate bibliographies. The standard biographical dictionary for twentieth century artists.

411 Waters, Clara E., and Laurence Hutton. **Artists of the 19th Century and Their Works....** 3d ed. Boston, Osgood, 1885. 2v. in 1. index.
First published in 1870. Brief biographical entries of some 2,050 American and European artists active in the nineteenth century. Useful feature is the inclusion of quotations from contemporary critics.

See also: **Avery Obituary Index** (270).

EUROPEAN NATIONAL DICTIONARIES AND ENCYCLOPEDIAS

Austria

412 Schmidt, Rudolf. **Österreichisches Künstlerlexikon. Von den Anfängen bis zur Gegenwart.** Band 1- . Vienna, Tusch, 1975- . LC 75-566515.
Comprehensive dictionary of Austrian artists of all media and from earliest times to the present. In progress, the most recent volume (III) has reached "Buzzi-Quattrini." Entries are very thorough, giving full biographies, a list of major works, and a bibliography of specialized literature.

413 Wastler, Josef. **Steirisches Künstler-Lexikon.** Graz, "Leykam," 1883. 198p. index.
Biographical dictionary of artists born in or active in the Austrian province of Styria. Major entries have references to sources listed on p. ix. Geographical index.

Baltic Countries

414 Neumann, Wilhelm. **Lexikon baltischer Künstler.** Riga, Jonck and Poliewsky, 1908. 171p. Reprint: Hannover-Dühren, Hirschheydt, 1972. LC 72-366260.
General biographical dictionary of artists excluding architects who were born in or worked in the Baltic countries of Estonia, Latvia, and Lithuania.

Czechoslovakia

415 Dlabač, Jan B. **Allgemeines historisches Künstler-Lexikon für Böhmen und zum Teil auch für Mähren und Schlesien.** Prague, Hasse, 1815. 3v. in 1.
Comprehensive dictionary of artists, architects, and musicians in Bohemia from the Middle Ages to the end of the eighteenth century. Entries include references to archival material. Also includes some artists active in Moravia and Silesia.

Denmark

416 Gelsted, Otto. **Kunstner Leksikon, med 1100 biografier af Danske Billedhuggere, Malere, Grafikere og Dekorative Kunstnere fra 1900-1942.** Copenhagen, Jensen, 1942. 197p.
Short-entry biographical dictionary of Danish artists active between 1900 and 1942.

417 Weilbach, Philip. **Kunstnerleksikon; udgivet af en Komite med Støtte af Carlsbergfondet.** Redaktion: Meret Bodelsen og Povl Engelstoft. Copenhagen, Aschehoug, 1947-1952. 3v. illus. index. LC 50-24719 rev.
Biographical dictionary of signed entries for Danish artists and foreign artists active in Denmark. Good bibliographies at the end of each entry. Supplement at end of volume 3. Indexes. Standard reference tool for Danish artists.

France

418 Audin, Marius, and Eugène Vial. **Dictionnaire des artistes et ouvriers d'art du Lyonnais.** Paris, Bibliothèque d'Art et d'Archéologie, 1918, 1919. 2v.
Comprehensive biographical dictionary of artists working in the Lyonnais (the departments of Rhone and Loire) from the earliest time to end of the nineteenth century. Bibliographical references in each entry. General bibliography in volume 2, pp. 325-46.

419 Bellier de Chavignerie, Émile. **Dictionnaire général des artistes de l'école française depuis l'origine des arts du dessin jusqu'à nos jours....** Paris, Renouard, 1882-1885. 2v.
Biographical dictionary of artists who were admitted three times to the French Salon. Includes architects, painters, sculptors, and graphic artists. Entries list the works and dates exhibited. Supplement published in 1887 brought the information up to the 1882 Salon. Useful "Table topographique des artistes français" listing artists by province and city of birth in the supplement.

420 Bérard, André. **Dictionnaire biographique des artistes français du XI^e au XVII^e siècle, suivi d'une table chronologique et alphabétique comprenant en vingt classes les arts mentionnés dans l'ouvrage....** Paris, Dumoulin, 1872. 864 columns.
Limited-edition dictionary of French painters, sculptors, graphic, and applied artists. Reference is made to 206 sources listed at the beginning. Chronological list of artists at end.

421 Brune, Paul. **Dictionnaire des artistes et ouvriers d'art de la Franche-Comté.** Paris, Bibliothèque d'Art et d'Archéologie, 1912. 337p.
Biographical dictionary of artists born in or working in the region of Franche-Comté. Sources of information, pp. xiii-xxviii.

422 Camard, Jean P., and Anne M. Belfort. **Dictionnaire des peintres et sculpteurs provencaux, 1880-1950.** IIe de Bendor, Éditions Bendor, n.d. (1975?). 444p. LC 75-504752.
Biographical dictionary of some 700 painters and sculptors active in Provence between 1880 and 1950. Entries give basic biographical data, where the artist exhibited and locations of works.

423 **Dictionnaire des artistes et ouvriers d'art de la France.** Paris, Bibliothèque d'Art et d'Archéologie, 1912-1919. 3v. illus. index.
Unfinished series of biographical dictionaries intended to cover all the provinces of France. Each volume has an introduction outlining the art history of the region, a biographical dictionary of artists of the region who died before 1900, and a bibliography. Contents: *Franche-Comté*, par l'Abbé Paul Brune (1912); *Lyonnais* par M. Audin et E. Vial (1918-1919; 2v.).

424 Du Peloux de Saint Romain, Charles, Vicomte. **Répertoire biographique et bibliographique des artistes du XVIII^e siècle français....** Paris, Champion, 1930-1941. 2v.
Dictionary of French artists of the eighteenth century arranged by media in the first volume. Second volume contains: "notices historiques sur l'art français dans les pays scandinaves, les manufactures particulières de faïence, de porcelaine et de tapisseries." Comprehensive bibliography of books and periodical articles in all languages and on all aspects of eighteenth century French art published before 1940 is found both in first volume (pp. 329-449) and in second volume (pp. 38-97). Valuable list of art societies, collectors and public auctions in the eighteenth century (volume 1, pp. 288-328). A standard reference tool for eighteenth-century French art.

425 Dussieux, Louis E. **Les artistes français à l'étranger....** 3d ed. Paris, Lecoffre, 1876. 643p.
First published in 1852. Comprehensive dictionary of French artists and foreign artists active in France, arranged by country, then province. Brief biographical entries. No bibliographies.

426 Gabet, Charles H. J. **Dictionnaire des artistes de lécole française au XIX^e siècle. Peinture, sculpture, architecture, gravure, dessin, lithographie et composition musicale....** Paris, Vergne, 1831. 709p. illus.
Biographical dictionary of French artists, architects, and musicians to the end of the eighteenth century. Some references to sources listed on page two. Engraved illustrations.

427 Gérard, Charles. **Les artistes de l'Alsace pendant le moyen âge.** Paris, Berger-Levrault, 1872-1873. 2v. index.
Dictionary of artists born and active in Alsace from the seventh through the sixteenth centuries. Arrangement is by centuries, then alphabetically by artist's name. No bibliographies.

428 Giraudet, Eugène. **Les artistes tourangeaux: architects, armuriers, brodeurs, émail-leurs, graveurs, orfèvres, peintres, sculpteurs, tapissiers de haute lisse....** Tours, Rouillé-Ladevèze, 1885. 419p. illus. index.
Dictionary of artists active in the Tours region of France. Entries have bibliographical footnotes referring to documentary and other source material. Introduction sketches the history of the fine arts in the Touraine.

429 Leblond, Victor. **Les artistes de Beauvais et du Beauvaisis au XVIe siècle et leurs oeuvres.** Beauvais, Imprimerie Départmentale de l'Oise, 1922. 56p.
Handbook of architects and sculptors in Beauvais and vicinity during the sixteenth century. Includes chapter on glass-workers. List of families of artists (pp. 49-51) and "contracts d'apprentissage" (pp. 51-56).

430 Port, Célestin. **Les artistes angevins, peintres, sculpteurs, maîtres d'oeuvre, architects, graveurs, musiciens, d'après les archives angevins....** Paris, Baur, 1881. 334p.
Alphabetically arranged dictionary of artists active in the Angevin region of France, with references to archival material.

431 Portal, Charles. **Dictionnaire des artistes et ouvriers d'art du Tarn du XIIIe au XXe siècle.** Albi, Chez L'Auteur, 1925. 332p. illus. index.
Biographical dictionary of artists of the Tarn region, covering the period from the thirteenth to the twentieth centuries. Introduction gives the sources for the work.

Germany

432 Merlo, Johann J. **Kölnische Künstler in alter und neuer Zeit.** Rev. and exp. ed., ed. by Eduard Firmenich-Richartz and Hermann Keussen. Düsseldorf, Schwann, 1895. 1206 columns. illus. (Publikationen der Gesellschaft für Rheinische Geschichtskunde, IX).
First published in 1950. Dictionary of architects, sculptors, painters, and graphic artists active in Cologne. Alphabetically arranged, the entries for the major artists contain references to documentary sources and additional bibliography. One of the most comprehensive dictionaries of regional artists.

433 Mithoff, H. Wilhelm H. **Mittelalterliche Künstler und Werkmeister Niedersachsens und Westfalens....** 2d ed. Hannover, Helwing, 1885. 462p.
Comprehensive dictionary of artists and architects active in Lower Saxony and Westphalia up to 1600. Following the alphabetical artist list are sections on organizations of artists and architects, "Rolle der Maler und Glaseramts zu Lüneburg," artists' coats of arms, handling of artists and architects in the documents, "Morgensprache," patron saints of artists and artisans, and glossary of Lower German words used in medieval documents pertaining to artists.

434 Müller, Hermann A., and Oskar Mothes. **Illustriertes archäologisches Wörterbuch der Kunst des germanischen Altertums, des Mittelalters und der Renaissance....** Leipzig, Spamer, 1877. 2v. illus.
Comprehensive dictionary of terms in German, English, and French applicable to the study of the art history of antiquity, the Middle Ages, and the Renaissance. Covers stylistic terms, techniques for both the fine and applied arts, heraldry, epigraphy, and iconography. Illustrated with line drawings. The German equivalent to Adeline's dictionary (332) but more complete.

435 Nagel, Gert K. **Schwäbische Maler, Bildhauer und andere Künstler; ein illustriertes Lexikon von Künstler der letzten 200 Jahre.** Stuttgart, Kunsthaus Fritz Vogel, 1975. 176p. illus. LC 76-460749.
 Biographical dictionary of some 1,600 artists active in Swabia during the last 200 years. Bibliographies provided for the major entries.

436 Schmitt, Otto, ed. **Reallexikon zur deutschen Kunstgeschichte.** Bd. 1- .Stuttgart, Metzler, 1937- . illus.
 Comprehensive and scholarly encyclopedia of German art history. Long, signed articles by leading specialists are accompanied by many illustrations and extensive bibliographies. Covers all aspects except biography. Many subjects not covered in other reference tools are treated with impressive scholarly thoroughness. This is especially true in the areas of iconography, materials, structures, and objects. Although the work is progressing slowly (at present, only the letter "F" has been reached) and is technically limited to German art, the *Reallexikon* is of almost universal value. Information and bibliography on subjects that cut across periods (such as apse, altarpiece, and brick architecture) can be quickly and confidently obtained from this work. One of the finest reference tools in the field of art history.

437 Zülch, Walther K. **Frankfurter Künstler, 1223-1700.** Frankfurt am Main, Diesterweg, 1935. 670p. index.
 Biographical handbook of artists active in Frankfurt am Main from 1223 to 1700. Arranged chronologically, entries give archival sources as well as thorough reference to recent literature. List of artists by media (pp. 601-29); alphabetical list of artists (pp. 629-54). An excellent regional biographical dictionary.

Great Britain

438 Bindman, David. **The Thames and Hudson Encyclopaedia of British Art.** London, Thames and Hudson, 1985. 320p. illus. LC 84-51499.
 Popular dictionary covering art and architecture in Great Britain from early Middle Ages to the present. Bibliography of general works (pp. 297-99), and gazetteer of museums and galleries around the world with important collections of British art.

439 Cunningham, Allan. **The Lives of the Most Eminent British Painters, Sculptors, and Architects....** London, Murray, 1830-1833. 6v. illus.
 Biographical essays on 47 major British artists. Engraved portrait of the artist precedes each chapter.

440 **Dictionary of British Artists 1880-1940.** An Antique Collectors' Club Research **Project.** London, Antique Collectors' Club, 1976. 567p.
 Short-entry dictionary of some 4,000 British artists active 1880 to 1940. Starred entries are artists whose work sold for more than 100 pounds at auctions 1970-1975. Selected book list (p. 16).

441 Graves, Algernon. **Dictionary of Artists Who Have Exhibited in the Principal London Exhibitions from 1760 to 1893.** 3d ed. London, Graves, 1901. Reprint: Bath, Kingsmead, 1973. 314p.
 List of over 16,000 painters, graphic artists, medalists, sculptors, and architects in tabular form, giving the town from which the artist came, dates of first and last exhibits, specialty, and symbols indicating to which societies the artist belonged.

442 Hall, Henry C. **Artists and Sculptors of Nottingham and Nottinghamshire, 1750-1950.** Nottingham, H. Jones, 1953. 95p.
 Biographical dictionary of artists in Nottingham and surrounding region, arranged in three parts: Artists of the past (pp. 11-67); Contemporary artists (pp. 71-85); Sculptors (pp. 89-95). Brief biographical notes, bibliography.

443 Redgrave, Samuel. **A Dictionary of Artists of the British School: Painters, Sculptors, Architects, Engravers and Ornamentists; with Notices of Their Lives and Work....** 2d ed. London, Bell, 1878. 497p. Reprint: Amsterdam, Hissink, 1970. LC 76-519615.
 Dictionary of artists and architects born in and active in the British Isles. For major artists, brief biographical entries supply list of chief works. No bibliography.

444 Rees, Thomas M. **Welsh Painters, Engravers, Sculptors (1527-1911)....** Carnarvon, Welsh Publishing Co., 191?. 188p. illus.
 Brief biographical entries with reference to list of standard sources.

445 Strickland, Walter G. **A Dictionary of Irish Artists....** Dublin, Maunsel, 1913. 2v. illus. index. Reprint: New York, Hacker, 1968.
 Comprehensive dictionary of artists born and active in Ireland from the earliest times to the twentieth century. Appendix to second volume provides a discussion of Irish artists' societies and art institutions.

446 Waters, Grant M. **Dictionary of British Artists Working 1900-1950.** Eastbourne, Eastbourne Fine Arts, 1975. 368p. illus. LC 75-325140.
 Dictionary of some 5,500 British artists active between 1900 and 1950. Entries provide brief biography, list of works, and society affiliation. Good for secondary artists.

Italy

447 Alizeri, Federigo. **Notizie dei professori del disegno in Liguria dalla Fondazione dell' Accademia.** Genoa, Tip. Luigi Sambolino, 1864-1866. 3v. illus. index.
 Dictionary of painters, sculptors, and graphic artists in the Italian province of Liguria during the eighteenth and nineteenth centuries. Artists are listed by media. Introduction sketches the history of art in Liguria.

448 Bessone-Aurelj, Antonietta M. **Dizionario degli scultori e architetti italiani.** Genoa, Dante Alighieri, 1947. 523p.
 General biographical dictionary of Italian sculptors and architects. Complements the author's dictionary of Italian painters. Very short entries. No bibliographies.

449 Bindi, Vincenzo. **Artisti abruzzesi....** Napoli, G. de Angelis, 1883. 300p. Reprint: Bologna, Forni, 1970.
 Biographical dictionary of artists and architects as well as musicians of the Abruzzi region.

450 Bolognini Amorini, Antonio. **Vite dei pittori ed artefici bolognesi.** Bologna, Tip. Governativi alla Volpe, 1848. 5v. illus.
 Collection of lives of major Bolognese artists and architects; intended as an expansion of the work by Carlo Cesare Malvasia, *Felsina pittrice; vite pittori bolognesi alla measta christianissima di Lvigi XIII....* (Bologna, Barbieri, 1678). Lists of artists covered at the end of each volume.

451 Brenzoni, Raffaello. **Dizionario di artisti Veneti.** Florence, Olschki, 1972. 304p. LC 72-336512.
 Comprehensive dictionary of artists of all periods who were active in Venice and the surrounding province of the Veneto. Entries provide an extensive vita including a discussion of the artist's major work. Each entry is provided with a thorough, chronologically arranged bibliography. Standard dictionary of Venetian artists.

452 Calvi, Girolamo L. **Architetti, scultori e pittori che fiorirono in Milano durante il governo dei Visconti e degli Sforza.** Milan, Ronchetti, 1859-1869. 3v. index. Reprint: Bologna, Forni, 1975.
Collection of biographies of major artists and architects active in Milan during the Visconti and Sforza periods. Bibliographical references and references to sources in the footnotes.

453 Campori, Giuseppe, ed. **Gli artisti italiani e stranieri negli stati estensi....** Modena, Camera, 1855. 537p. Reprint: Rome, Multigrafica Editrice, 1969.
Comprehensive dictionary of artists working in all media and active in the former territory of the Este family. Entries are extensive; many have excerpts from archival material. Bibliographical footnotes.

454 Campori, Giuseppe. **Memorie biografiche degli scultori, architetti, pittori, ec. nativi de Carrara....** Modena, Vincenzi, 1873. 466p. Reprint: Bologna, Forni, 1969.
Dictionary of artists active in Carrara and the surrounding province of Massa as well as artists from elsewhere who came to Carrara to select marble for their work. Bibliography of sources (pp. 375-430). Thoroughly indexed.

455 Centofanti, L. Tanfani. **Notizie di artisti tratte dai documenti pisani.** Pisa, Spoerri, 1897. 583p. index. Reprint: Bologna, Forni, 1972.
Comprehensive dictionary of artists in all media active in Pisa from the Middle Ages to the middle of the nineteenth century. Occasional bibliographical footnotes; frequent reference to archival material.

456 Coddé, Pasquale. **Memorie biografiche posté in forma di dizionario dei pittori, scultori, architetti e incisori mantovani.** Mantua, Negretti, 1837. 174p. index. Reprint: Bologna, Forni, 1972.
Dictionary of painters, sculptors, architects, and graphic artists born or active in Mantua from earliest times to the end of the eighteenth century. Reference is made to appendix with excerpts from original documents.

457 Corna, Andrea. **Dizionario della storia dell'arte in Italia con duecento illustrazioni....** 2d ed. Piacenza, Tarantola, 1930. 2v. illus.
First published in 1919. Biographical dictionary of Italian architects, sculptors, painters, graphic artists, and applied artists.

458 Fenaroli, Stefano. **Dizionario degli artisti bresciani.** Brescia, Tip. Editrice del Pio Istituto Pavoni, 1877. 317p. index.
Dictionary of architects, sculptors, painters, and some applied and decorative artists active in Brescia. List of sources (pp. 263-89).

459 Giannelli, Enrico. **Artisti napoletani viventi....** Naples, Melfi and Joele, 1916. 749p. illus.
Biographical dictionary of architects, sculptors, and painters living in Naples around 1916.

460 Grasselli, Giuseppe. **Abecedario biografico dei pittori, scultori ed architetti cremonesi....** Milan, Manini, 1827. 290p.
Biographical dictionary of artists and architects of Cremona. Introductory essay outlines the history of art in Cremona.

461 Gubernatis, Angelo de, Conte. **Dizionario degli artisti italiani viventi, pittori, scultori e architetti....** Florence, Le Monnier, 1889. 640p.
Biographical dictionary of Italian artists and architects living in 1888.

462 Monteverdi, Mario. **Dizionario critico Monteverdi. Pittori e scultori italiani contemporanei.** Milan, Editrice Selearte Moderna, 1975. 852p. illus.
Dictionary of twentieth-century Italian artists. Brief biography is followed by a critical description of the artist's work. No bibliography.

463 Padovano, Ettore. **Dizionario degli artisti contemporanei.** Milan, Istituto Tip. Editoriale, 1951. 403p. illus. index.
Dictionary of twentieth-century Italian artists and architects. Uneven coverage, no bibliography: superseded by Monteverdi (462).

464 Pietrucci, Napoleone. **Biografia degli artisti padovani.** Padua, Bianchi, 1858. 295p. Reprint: Bologna, Forni, 1970.
Biographical dictionary of artists excluding architects active in Padua from the fourteenth to the nineteenth centuries. Bibliographical notes with references to archival sources.

465 **Schede Vesme. L'arte in Piemonte dal XVI al XVIII sécolo.** Turin, Società Piemontese di Archeologia e Belle Arte, 1963. 3v. index.
Comprehensive dictionary of artists working in all media and active in Piedmont from the sixteenth through the eighteenth centuries. Entries refer to, and often give excerpts from, documentary sources.

466 Valgimigli, Gian M. **Dei pittori e degli artisti Faentini de'secoli XV. e XVI.** 2d ed. Faenza, Conti, 1871. 186p. Reprint: Bologna, Forni, 1976. LC 78-353004.
Collection of biographical sketches on individual painters, and four sculptors, active in Faenza in the fifteenth and sixteenth centuries. Life and works are discussed, with occasional bibliographic references in the footnotes. Chiefly of historical interest, the work contains neither illustrations nor index.

467 Zannandreis, Diego. **Le vite dei pittori, scultori e architetti veronese....** Verona, Franchini, 1891. 559p. Reprint: Bologna, Forni, 1968.
Comprehensive dictionary of artists working in all media and active in Verona. Entries emphasize documentary sources, which are summarized (pp. xxvii-xxxv).

Low Countries

468 **Dictionnaire biographique des artistes belges de 1830 à 1970.** Brussels, Arto, 1978. 602p. LC 80-468145.
Biographical dictionary of Belgian painters, sculptors and graphic artists active between 1830 and 1970. Entries give basic biographical data but not bibliographical references. Bibliography (pp. 597-602) is a list of general works.

469 Duverger, Jozef. **De Brusselsche steenbikkeleren: Beeldhouwers, bouwmeesters, metselaars enz. der XIVe en XVe eeuw met een aanhangsel over Klaas Sluter en zijn Brusselsche medewerkers te Dijon.** Ghent, Vyncke, 1933. 134p. index.
Dictionary of architects, sculptors, and stonemasons active in Brussels during the fourteenth and fifteenth centuries. Chapter on primary documents and on the work of Claus Sluter in Brussels. Index of names (pp. 77-130).

470 Immerzeel, Johannes, Jr. **De levens en werken der hollandsche en vlaamsche kunstschilders, beeldhouwers, graveurs en bouwmeesters....** Amsterdam, van Kestern, 1842-1843. 3v. illus. Reprint: Amsterdam, B. M. Israël, 1974. 305p.
Dictionary of Dutch and Flemish painters, sculptors, graphic artists, and architects active between 1400 and 1840. Short biographies are usually followed by list of major works. Dictionary of monograms (pp. 265-307). No bibliographies.

471 Kramm, Christiaan. **De levens en werken der Hollandsche en Vlaamsche kunst-schilders, beeldhouwers, graveurs en bouwmeesters, van den vroegsten tot op onzen tijd....** Amsterdam, Diederichs, 1857-1864. 6 parts and supplement in 3v.

Biographical dictionary of Dutch and Flemish painters, sculptors, graphic artists, and architects from the earliest then known to the date of publication. The work is based on Immerzeel (470). Supplement is a separate list of additional masters.

472 Lerius, Théodore F. X. van. **Biographies d'artistes anversois.** Antwerp, Kockx, 1880-1881. 2v. (Maatschappij der Antwerpsche Bibliophilen, uitgave, 8, 11).

Comprehensive dictionary of artists of all media active in Antwerp. Entries on major personalities contain excerpts from documents. Bibliographical footnotes.

473 Scheen, Pieter. **Lexicon nederlandse beeldende Kunstenaars, 1750-1950.** 's Graven-hage, Scheen, 1969-1970. 2v. illus.

Biographical dictionary of Dutch painters active between 1750 and 1950. Expansion of the same author's *Honderd Jaren Nederlandsche Shilder- en Teekenkunst 1750-1850* (The Hague, 1946). Separate bibliographies after each entry; general bibliography at end of volume 2. Supplement in volume 2. Illustrations arranged by subject.

474 Wurzbach, Alfred. **Niederländisches Künstler Lexikon....** Vienna, Halm, 1906-1911. 3v. Reprint: Amsterdam, B. M. Israël, 1968.

Biographical dictionary of Dutch and Flemish artists. Biographies give facsimiles of signatures, lists of major works, and separate bibliographies. Volume 3 is devoted to anonymous artists and monogrammists. Standard reference tool for artists from the Netherlands.

Norway

475 **Norsk Kunstner Leksikon.** Oslo, Universitesforlaget, 1982-1986, 4v.

Comprehensive dictionary of Norwegian artists and architects. Covers artists of all periods and media, but the majority are from the nineteenth and twentieth centuries. Entries give summary of the artist's life, list of major works, locations (museums) of his/her work and bibliographical references to specialized literature. Major entries are signed. Note: Nordic practice places those artists whose name begin with A and O at the end of the alphabet. Standard biographical dictionary of Norwegian artists.

Portugal

476 Andrade, Arsénio S. de. **Dicionário histórico e biografico de artistas e technicos portugueses.** Lisbon, Minerva, 1959. 278p. illus. index.

Concise dictionary of artists and architects, critics of art, engineers, musicians, and composers in Portugal from the fourteenth century to the middle of the twentieth century. Emphasis on modern. Bibliography of basic works in Portuguese (pp. 273-76).

477 Machado, Cyrillo V. **Collecção de memorias relativa as vidas dos pintores, e escultores, architetos, e gravadores portuguese e dos estrangeiros, que estiverão em Portugal....** Coimbra, Imprensa da Universidade, 1922. 295p. (Subsidios para a historia da arte portuguesa, 5). Reprint of first edition, Lisbon, 1823.

Biographical dictionary of Portuguese architects, sculptors, painters, and graphic artists.

478 Pamplona, Fernando de. **Dicionário de pintores e escultores Portugueses ou que trabalharam em Portugal.** Lisbon, Santo Silva, 1954-1959. 4v. illus. LC 55-28095 rev.
 Biographical dictionary of Portuguese painters and sculptors. Entries include facsimiles of signatures and separate bibliographies for major artists. Basic reference tool for Portuguese artists.

479 Raczyński, Atanazy. **Dictionnaire historico artistique du Portugal, pour faire suite à l'ouvrage ayant pour titre: Les arts en Portugal, lettres adressées à la Société artistique et scientifique de Berlin et accompagnées de documens....** Paris, Renouard, 1847. 306p. illus.
 Biographical dictionary of artists and architects active in Portugal from the late Middle Ages through the early nineteenth century. Entries are brief but contain references to sources. Companion to the author's *Les arts en Portugal* (Paris, Renouard, 1846).

480 Tannock, Michael. **Portuguese 20th Century Artists. A Biographical Dictionary.** Chichester, Phillimore, 1978. 188p. illus. LC 79-306871.
 Dictionary of 2,150 artists (excluding architects) who were active between 1900 and 1974. Entries give basic biographical data, lists of exhibitions, prizes and museums which own works by the artist. No bibliographical references. Good collection of plates.

Spain

481 Alcahali y de Mosquera, José Maria Ruiz de Lihori y Pardines. **Diccionario biográfico de artista valencianos....** Valencia, F. Domenech, 1897. 443p.
 Biographical dictionary of the artists of the province of Valencia based on archival research. Excerpts from documents included in the entries.

482 Aldana Fernández, Salvador. **Guia abreviada de artistas valencianos.** Valencia, Ayuntamiento de Valencia, 1970. 382p. (Publicationes del Archivo municipal de Valencia. Seria primera. Catálogos guias y repertorios, 3).
 Biographical dictionary of the artists and architects of Valencia. Bibliographical references.

483 Campoy, Antonio M. **Diccionario critico del Arte Español contemporaneo.** Madrid, Iberico Europea de Ediciones, 1973. 489p. illus.
 Dictionary of Spanish twentieth-century architects, sculptors, painters, and graphic artists. Entries are in the form of narrative biographies. No bibliography.

484 Ceán, Bermúdez, Juan A. **Diccionario histórico de los más ilustres professores de las bellas artes en España....** Madrid, Ibarra, 1800. 6v. Reprint: New York, Kraus, 1965.
 Biographical dictionary of Spanish artists, architects, and applied artists. Last volume contains a supplement (pp. 55-91) and index tables by chronology, media, and geography. A standard early dictionary of Spanish artists. See Viñaza (494) for continuation and supplement.

485 Elias de Molins, Antonio. **Diccionario biográfico y bibliográfico de escritores y artistas catalanes del siglo XIX.** Barcelona, Administración, 1889. 2v. illus.
 Comprehensive dictionary of Catalan writers and artists active during the nineteenth century. Bibliographical references are supplied for the larger entries.

486 Furió, Antonio. **Diccionario histórico de los ilustres professores de las bellas artes en Mallorca.** Palma, Mallorquina, 1946. 337p. (Biblioteco Balear, 10).
 Biographical dictionary of painters, sculptors, and architects in Majorca from the thirteenth century to the nineteenth century. Introduction (pp. 13-84) is a history of art of the Balearic Islands. Occasional bibliographical references in the footnotes to the dictionary entries.

487 Gestoso y Pérez, José. **Ensayo de un diccionario de los artifices qui florecieron en Sevilla desde el siglo XIII al XVIII inclusive....** Seville, Oficina de la Andalucio Moderna, 1899-1909. 3v. illus. index.

Biographical dictionary of artists active in Seville from the thirteenth through the eighteenth centuries. Alphabetical arrangement; facsimiles of twenty signatures in third volume.

488 Orellana, Marcos A. de. **Biografia pictória valentina....** 2d ed., prepared by Xavier de Salas. Valencia, Ayuntamiento de Valencia, 1967. 654p. index. LC 76-277651.

Biographical dictionary, in chronological order, of Valencian painters, sculptors, graphic artists, and architects from the fourteenth through eighteenth centuries. Entries treat life and works, with bibliographical references in the footnotes to individual entries.

489 Ossorio y Bernard, Manuel. **Galeria biografica de artistas espagnoles del siglo XIX.** Madrid, Gaudi, 1975. 749p. illus.

Reprint of work originally published in 1883. Dictionary of some 3,000 Spanish nineteenth century painters, sculptors, and graphic artists. Illustrated with line drawings. No bibliography.

490 Ráfols, José F., ed. **Diccionario biográfico de artistas de Cataluna desde la epoca romana hasta nuestros dias....** 2d ed. Barcelona, Vasca, 1980-1981. 5v. illus. index.

Comprehensive dictionary of architects and artists working in all media and active in the province of Catalonia from the Romanesque to the mid-twentieth century. No bibliography. Index of artists by media.

491 Ramiréz de Arellano, Rafael. **Diccionario biográfico de artistas de la provincia de Córdoba.** Madrid, Perales y Matinez, 1893. 535p. (Colección de documentos inéditos para la historia España ... t. CVII).

Biographical dictionary of artists and architects active in the Spanish province of Córdoba. Alphabetical arrangement with tables indexing the entries by time and media. Appendix with documents pertaining to artists in Córdoba.

492 Saltillo, Miguel Lasso de la Vega, y Marqués del López de Tejada. **Artistas y artífices sorianos de los siglos XVI y XVII (1509-1699).** Madrid, Editorial Maestre, 1948. 476p. illus. index.

Biographical dictionary of artists, architects, and musicians in the Spanish province of Soria during the sixteenth and seventeenth centuries.

493 Stirling-Maxwell, William. **Annals of the Artists of Spain....** 2d ed. London, Nimmo, 1891. 4v. illus. index.

Biographies of major Spanish artists, arranged in the form of a narrative history. Covers from the Romanesque to 1800. Material on anonymous figures is included in the chapters treating various sites. Bibliographical footnotes. Anecdotal in style.

494 Viñaza, Cipriano Muñoz, y Conde de la Manzano. **Adiciones al Diccionario histórico de los más ilustres professores de las bellas artes en España de D. Juan Augustín Ceán Bermúdez....** Madrid, Tip. de los Huérfanos, 1889-1894. 4v. in 2.

Supplement to Ceán Bermúdez (484). Contents: tomo 1, Edad media...; tomos 2-4, Siglos XVI, XVII y XVIII. Within the volumes, arrangement is alphabetical by name of artist. Covers artists and architects. References to sources.

Sweden

495 Engman, Bo, ed. **Konstlexikon. Svensk konst under 100 år. 2500 konstnärer, 1500 konsttermer.** Stockholm, Natur och Kultur, 1972. 379p. illus. LC 73-318300.

Comprehensive dictionary of Swedish art history, covering artists, styles, periods, and general terminology.

496 **Svensk konstnärs lexikon.** Malmö, Allhems, 1952-1967. 5v. illus.
Comprehensive biographical dictionary of Swedish artists. Larger entries are signed
and have separate bibliographies. Standard reference guide to Swedish artists.

497 **Svenska konstnärer; biografisk handbok.** New ed. Stockholm, Eden, 1974. 561p.
illus. LC 75-410307.
Biographical dictionary of Swedish artists and architects. Bibliographical referen-
ces provided for the major entries.

Switzerland

498 Brun, Carl. **Schweizerisches Künstler Lexikon; Dictionnaire des artistes suisses.**
Frauenfeld, Huber, 1905-1917. 4v. Reprint: Nendeln, Kraus, 1967.
Biographical dictionary of Swiss artists of all periods and all media as well as for-
eign artists active in Switzerland. Articles are signed, and longer entries have separate bib-
liographies. Volume 4 contains a supplement. A standard reference work on Swiss artists.
For the twentieth century, see Plüss (500).

499 **Lexikon der zeitgenössischen Schweizer Künstler. Dictionnaire des artistes suisses
contemporains. Catalogo degli artisti svizzeri contemporanei.** Frauenfeld, Huber, 1981.
539p. index. LC 81-201982.
Comprehensive biographical dictionary of approximately 5,000 living Swiss artists
and artists of other nationalities working in Switzerland in the 1970s. Does not include
architects or applied and decorative artists. Designed as a supplement to Plüss (500).
Entries provide short biographies with list of prizes, awards, professional memberships,
location of principle works, list of major exhibitions, and bibliographical references.

500 Plüss, Eduard, and Hans C. von Tavel. **Künstler Lexikon der Schweiz XX. Jahr-
hundert.** Frauenfeld, Huber, 1958-1967. 2v.
Comprehensive and scholarly dictionary of Swiss artists of the twentieth century.
Thorough biographies include lists of exhibitions and works in museums, and very good
separate bibliographies. Standard reference tool for modern Swiss artists.

Orient

501 **Encyclopaedia of Islam.** v. 1- . New ed. Leiden, Brill, 1960- .
Comprehensive encyclopedia of long, signed articles covering all aspects of Islamic
civilization both past and present. Articles have thorough bibliographies of specialized
literature. Entries cover places, persons, objects, and subjects. Of great value to the
advanced student and scholar of Islamic art and architecture.

502 Hansford, Sidney Howard. **A Glossary of Chinese Art and Archaeology. 2d rev.**
ed. London, China Society, 1961. 104p. illus. (China Society Sinological Series, No. 4).
A general dictionary of terms pertaining to most media; particularly useful for
technical terms related to ceramics, lacquer, and other minor arts. Terms are given in Chi-
nese characters, with transliteration and English translation.

503 Roberts, Laurence P. **A Dictionary of Japanese Artists: Painting, Sculpture, Cera-
mics, Prints, Lacquer.** London, Weatherhill, 1976. 330p. illus. LC 76-885.
Comprehensive dictionary of Japanese pictorial artists who were either born before
1900 or who died before 1972. The 3,000 entries provide biographical data, summary of the
artist's career, list of major works, characterization of style, and bibliographical references
to works in English and Japanese. There is an index to alternate names and an index of the

artists in Kanji characters. Additional aids include: glossary of Japanese art terms; list of art organizations and institutions; chronological table of art periods of Japan, Korea, and China; and directory of Japanese provinces and prefectures. An excellent, long-awaited reference work on Japanese art.

504 Seymour, Nancy N. **An Index-Dictionary of Chinese Artists, Collectors, and Connoisseurs with Character Identification by Modified Stroke Count.** Metuchen, N.J., Scarecrow Press, 1988. 987p. LC 87-28704.
 Biographical dictionary of Chinese artists in all media with a special index of their names in Chinese characters. Designed to help those without knowledge of Chinese to decipher the names of Chinese artists found on works of art. Biographical entries provide only a few facts. No bibliography.

505 Tazawa, Yutaka, ed. **Biographical Dictionary of Japanese Art.** Tokyo, Kodansha, 1981. 825p. illus. index. LC 81-82717.
 Comprehensive biographical dictionary covering architects, artists in all media, scholars, and patrons. Arranged by media. Classified bibliography (pp. 720-84), includes monographic literature on the various artists and general works.

New World

PRE-COLUMBIAN

506 Muser, Carl. **Facts and Artifacts of Ancient Middle America: A Glossary of Terms and Words Used in the Archaeology and Art History of Pre-Columbian Mexico and Central America.** New York, Dutton, 1978. 212p. illus. LC 77-79799.
 Popular but useful dictionary covering terms relating to pre-Columbian art and architecture. Covers objects, subjects, places, and styles and is illustrated with drawings and a few plates. Good maps that show locations of ancient sites, chronological tables, and bibliography, by Allan Chapman (pp. 207-12) provides an annotated list of basic works in English.

LATIN AMERICA

507 Cavalcanti, Carlos, ed. **Dicionário Brasileiro de artistas plásticos.** v. 1- . Brasilia, Ministerio da Educação e Cultura, 1973- . LC 74-219639.
 Comprehensive dictionary of Brazilian painters, sculptors, and graphic artists, with emphasis on modern. Numerous illustrations but no bibliography.

508 **Enciclopedia de arte en América.** Buenos Aires, Bibliographica OMEBA, 1969. 5v illus. LC 72-236036.
 General encyclopedia of Latin American art and architecture, edited by Vicente Gesauldo. Volumes 1 and 2 provide a general history of Latin American art and architecture. Volumes 3 to 5 comprise a biographical dictionary of Latin American artists. Brief bibliographies given at the end of the major entries. A standard but popular encyclopedia of Latin American art and architecture.

509 Merlino, Adrián. **Diccionario de artistas plasticos de la Argentina, siglos XVIII-XIX-XX.** Buenos Aires, Instituciones de la Argentina vinculadas a las artes plasticas, 1954. 433p. illus.
 Biographical dictionary of artists in Argentina, covering the period from the beginning of the eighteenth to the middle of the twentieth centuries. Each entry gives basic biographical data, list of prizes and exhibitions, and a list of museums owning the artist's work. Provides a general bibliography (pp. 408-14).

510 Ortega Ricaurte, Carmen. **Diccionario de artistas en Colombia.** Bogotá, Plaza and James, 1979. 542p. illus. index. LC 66-56385.
 Biographical dictionary of painters, sculptors, graphic artists, architects, caricaturists, and metalsmiths of Colombia to the present. Entries give outline of artist's life works, and bibliographic citations.

511 Pontual, Roberto. **Dicionário das artes plasticas no Brasil.** Rio de Janeiro, Civilização Brasileira, 1969. 559p. illus. LC 76-464169.
 General biograpical dictionary of Brazilian artists. Most entries are short and have abbreviated bibliographies. Illustrations are given for the most important artists. Basic reference tool for Brazilian art.

512 Vargas, Ugarte R. **Ensayo de un diccionario de artifices coloniales de la America meridional.** Lima, Baiocco, 1947. 391p. index. **Apendice.** Lima, Baiocco, 1955. 118p.
 Biographical dictionary of Latin American artists arranged by centuries. No bibliography.

UNITED STATES AND CANADA

513 Baigell, Matthew. **Dictionary of American Art.** New York, Harper & Row, 1979. 390p. LC 78-24824.
 Popular dictionary of American art covering artists, styles, and media. Major entries have brief bibliographies.

514 **Britannica Encyclopedia of American Art.** Chicago, Encyclopedia Britannica Educational Corp., 1973; distr. New York, Simon and Schuster. 669p. illus. LC 73-6527.
 Dictionary covering architecture and all the arts in America from pre-Colonial times to the present. Respected specialists prepared the articles, which are signed. Numerous color and black and white illustrations. A list of entries according to the various arts (pp. 622-27), is an effective index by media. Contains a guide to major American museums and collections, a four-page glossary of terms, and a two-part bibliography (pp. 638-68): part I, a good general classified bibliography of American arts; and part II, a bibliography according to entries in the main body of the work. A sound reference tool in the field of American art.

515 Cederholm, Theresa D., ed. **Afro-American Artists: A Bio-Bibliographical Directory.** Boston, Boston Public Library, 1973. 348p. LC 73-84951.
 Biographical dictionary of some 2,000 Afro-American artists. Gives basic biographical data, education, exhibition awards, and bibliographical references. A very useful tool for an otherwise neglected area of art biography.

516 Collins, Jim, and Glenn B. Opitz. **Women Artists in America: 18th Century to the Present (1790-1980).** Poughkeepsie, N.Y., Apollo, 1980. c.1000p. illus. LC 81-186014.
 Dictionary of American women artists excluding architects. Brief biographical entries with list of prizes and awards. No bibliography.

517 **Creative Canada: A Biographical Dictionary of Twentieth-Century Creative and Performing Artists.** v. 1- . Toronto, University of Toronto Press, 1971- .
 Biographical dictionary of performing and visual artists in Canada in the twentieth century. Does not include architects and designers. Each volume covers about 500 visual artists, chiefly painters and sculptors. Uneven coverage.

518 Cummings, Paul. **Dictionary of Contemporary American Artists.** 3d ed. New York, St. Martin's, 1977. 545p. illus.
 Biographical dictionary of short entries. In addition to basic biographical data, it tells where the artist taught, his one-man and group shows, and the collections owning works. Good general bibliography (pp. 315-31). The best reference tool for prominent modern American artists.

519 Dawdy, Doris O. **Artists of the American West: A Biographical Dictionary.** Chicago, Swallow Press, 1974. 275p. LC 72-91919.

Dictionary of 1,300 pictorial artists born before 1900 who depicted subjects or scenes from the West (the sixteen states roughly west of the 95th meridian). Most entries are very brief, but 300 artists have been selected — somewhat arbitrarily — for longer narrative description of their careers. Bibliographical references are made to a very basic list of books; only an occasional monograph is noted.

520 **Dictionary of American Artists 19th & 20th Century.** Ed. by Alice C. McGlaufin. Poughkeepsie, N.Y., Apollo, 1982. 372p. ISBN 0938290010.

Reprint of material printed in volume 26 (1929) of the *American Art Annual*, predecessor of the *American Art Directory* (294). Brief entry biographical dictionary covering American artists active up to 1925.

521 Fielding, Mantle. **Dictionary of American Painters, Sculptors and Engravers....** Enl. ed., Green Farms, Conn., Modern Books and Crafts, 1975. 455p.

Reprint of 1926 edition with addendum containing corrections and additional material. Short biographies of approximately 10,500 American artists. Bibliography.

522 Groce, George C., and David H. Wallace. **The New York Historical Society's Dictionary of Artists in America, 1564-1860.** New Haven, Yale University Press, 1957. 759p.

Biographical dictionary of approximately 10,000 artists (professional and amateur, native or foreign-born) active in the present continental limits of the United States between 1564 and 1860. Key to sources (pp. 713-59). Standard reference guide to early American artists.

523 Macdonald, Colin. **A Dictionary of Canadian Artists.** v. 1- . Ottawa, Canadian Paperbacks, 1967- . LC 67-8044.

Comprehensive dictionary of Canadian artists and architects. Concise biographies give list of major works and reference to specialized literature.

524 Mallett, Daniel T. **Mallett's Index of Artists: International and Biographical....** New York, R. R. Bowker, 1935. 493p. Supplement. 1940. 319p. Reprint: New York, Smith, 1948. 2v.; Bath, England, 1976. Supplement. 1977.

Index to biographical information on painters, sculptors, and graphic artists in 24 standard reference books and 957 additional sources. Entries give nationality, birth and death dates, medium, residence (if artist was then living), and reference to sources for further information. Supplement concentrates on contemporary artists. Useful index for the general reader seeking further information on major artists and lesser-known American artists of the first half of the present century. Inaccuracies severely limit its value as a source for biographical data.

525 Samuels, Peggy, and Harold Samuels. **The Illustrated Biographical Encyclopedia of Artists of the American West.** Garden City, N.Y., Doubleday, 1976. 580p. illus. LC 76-2816.

Dictionary of artists of all nationalities who depicted subjects and scenes of the West, both in the United States and Canada. The 1,700 entries provide basic biographical data, brief sketch of the artist's career, and his relationship to the West. Bibliographical references are given to a list of basic books, and note is made of recent auction records. More complete and accurate than Dawdy (519).

526 Schwab, Arnold T. **A Matter of Life and Death: Vital Facts About Selected American Artists.** New York, Garland, 1977. 64p. LC 76-52694. (Garland Reference Library of the Humanities, v. 90).

About 580 artists active in the United States in the twentieth century are listed in tabular form, together with basic biographical data. Most of those included appear to be associated with the MacDowell Colony or mentioned by James Gibbon Huneker.

527 Smith, Ralph C. **A Biographical Index of American Artists....** Baltimore, Williams & Wilkins, 1930. 102p. Reprint: Detroit, Gale Research, 1976. LC 79-167186.
 Alphabetical index of about 4,700 American artists giving basic biographical data and reference to a collection (listed on p. ix) of basic reference works. Useful for lesser-known American artists established before 1929.

528 Soria, Regina. **Dictionary of Nineteenth Century American Artists in Italy 1760-1914.** Rutherford, N.J., Fairleigh Dickinson University, 1981. 332p. illus. LC 74-4986.
 Dictionary of artists and architects as well as art patrons, art historians, poets, writers, and other Americans who lived in Italy between 1760 and 1914. Entries include the location of personal papers and bibliographical references.

529 Young, William, ed. **A Dictionary of American Artists, Sculptors and Engravers from the Beginnings to the Turn of the Twentieth Century.** Cambridge, Mass., Young, 1968. 515p. illus. LC 68-37333.
 Short biographical entries covering native-born painters, sculptors, and graphic artists. Does not provide information concerning the artist's training. No bibliography.

530 **Who Was Who in American Art.** Ed. by Peter Hastings Falk. Madison, Conn., Sound View Press, 1985. 707p. LC 85-50119.
 Biographical dictionary of American artists compiled mainly from the *American Art Annual/Who's Who in Art* series published from 1898 through 1947. Covers nearly 25,000 artists. Particular value is in the information which was supplied by the artists themselves. The entries have references to the last issue of *American Art Annual* in which the artist appeared.

Africa

531 **Dictionnaire des civilizations africaines.** Paris, Hazan, 1968. 448p. illus.
 General dictionary covering all aspects of sub-Saharan African civilization, including useful articles on places, media, objects, and subjects of importance to the study of African art. Thoroughly illustrated with plates of African art. No bibliography.

Australia and Oceania

532 Germaine, Max. **Artists and Galleries of Australia and New Zealand.** Sydney, Landsdowne Editions, 1979. 646p. index LC 81-129382.
 Biographical dictionary of contemporary artists in Australia and New Zealand with entries describing the major galleries in the two countries.

533 McCulloch, Alan. **Encyclopedia of Australian Art.** New York, Praeger. 1969. 668p. illus. LC 69-17079.
 One-volume encyclopedia of Australian art from 1770 to the present. Covers all aspects including biography. The majority of entries give separate bibliographies.

534 Platts, Una. **Nineteenth Century New Zealand Artists: A Guide and Handbook.** Christchurch, Avon Fine Prints, 1980. 272p. illus. index. bibliography. LC 80-152051.
 Biographical dictionary of artists (excluding architects) who were either born in New Zealand or who worked there. Entries indicate the locations of the artists' works. General bibliography on New Zealand art, pp. 265-68.

6

ICONOGRAPHY

BIBLIOGRAPHIES

535 **Iconclass, an Iconographic Classification System.** Devised by H. van de Waal, completed and ed. by L. D. Couprie with R. H. Fuchs and E. Tholen. Amsterdam, North-Holland Publishing Co. for the Royal Netherlands Academy of Arts and Sciences, 1973- . LC 73-85996.

A system of classification of works of art by subject matter with accompanying bibliographies. The bibliographies cover both books and periodical articles in Western languages. The classification system is of interest to archivists and slide librarians and others compiling list of works of art by subject. The bibliographies are valuable to all advanced students and scholars interested in iconography. To date the following have appeared: volume 1, *Supernatural*; volume 2, *Nature, Man*; volumes 3,4, *Society*; volume 5, *Abstracts, History*; volume 6, *The Bible*; volume 7, *Sagas, Legends and Tales, Classical Mythology and Antiquities*. For each volume of the classification there is a bibliography volume. Two index volumes are planned.

536 Lurker, Manfred, ed. **Bibliographie zur Symbolik, Ikonographie und Mythologie.** Jahrg. 1- . Baden-Baden, Heitz, 1968- .

Classified and annotated bibliography of books and periodical articles on all aspects of symbolism, iconography, and mythology, including their manifestation in the visual arts. Each entry has a descriptive annotation in the language of the entry.

537 Lurker, Manfred. **Bibliographie zur Symbolkunde.** Baden-Baden, Heitz, 1964-1968. 3v. index. (Bibliotheca Bibliographica Aureliana, XII-XIV). LC 67-100109.

Classified and annotated retrospective bibliography of books and periodical articles on all aspects of symbolism, including the representation of symbols and subjects in the fine arts of all periods, nations, and cultures. Literature published since 1964 is indexed in the same author's annual bibliography on symbolism (536). Standard reference tool for all serious students and scholars of iconography. A work of amazing scope, containing more than 11,000 entries. Indexes by subject and author.

538 Pöschl, Viktor. **Bibliographie zur Antiken Bildersprache.** Heidelberg, C. Winter, 1964. 674p. (Heidelberger Akademie der Wissenschaften, Bibliothek der klassischen Altertumswissenschaften, N.F. 1. Reihe). LC 66-55568.

Classified bibliography of special studies of imagery in classical literature. Part I lists the studies by author; part II is an index to the first part arranged according to imagery of themes. This will be of direct value to classicists and art historians who wish to find the literary sources for images that are common in classical art.

539 Warburg Institute. **A Bibliography of the Survival of the Classics.** London, Cassell, 1934-1938. 2v.

Classified and descriptively annotated bibliography of books dealing with all aspects of the survival of the classics in European civilization after antiquity. Continues Richard Newald's bibliography, "Nachleben der Antike," in *Jahresbericht über die Fortschritte der klassischen Altertumswissenschaft* 232 (1931) and 250 (1935). Valuable bibliography for the specialist.

GENERAL DICTIONARIES

540 Bernen, Satia, and Robert Bernen. **Myth and Religion in European Painting 1270-1700: The Stories As the Artists Knew Them.** New York, Braziller, 1973. 280p. illus. LC 72-96070.

Dictionary of short entries covering religious subject matter in European painting. A popular dictionary with very brief bibliography of sources and no reference to special iconographic literature.

541 Chevalier, Jean. **Dictionnaire des symboles: mythes, rêves, coutumes, gestes, formes, figures, couleurs, nombres, sous la direction de Jean Chevalier, avec la collaboration d'Alain Gheerbrant.** 2d ed. Dessins de Bernard Gandet. Paris, Seghers, 1973. 4v. illus.

General dictionary of some 1,000 symbols and signs. Signed articles. Emphasis is on the allegorical meaning of symbols in particular as it relates to literary allegory (excerpts are given in most entries). Bibliographical references to list of basic reference works.

542 Cirlot, Juan E. **A Dictionary of Symbols.** New York, Philosophical Library, 1962. 400p. illus. LC A63-289.

General dictionary of sacred and profane symbols. Does not include narrative subjects. Bibliographical references are made to a list of 61 reference books. A popular work for the general reader and beginning student.

543 Cooper, J. C. **An Illustrated Encyclopedia of Traditional Symbols.** London, Thames and Hudson, 1978. 207p. illus. LC 78-55429.

General dictionary of world symbolism in the visual arts. Entries give the meaning of common symbols in the various cultures. No reference to sources or specialized bibliography. Glossary of terms and bibliography (pp. 203-207) listing books in all languages.

544 Daniel, Howard. **Encyclopedia of Themes and Subjects in Painting.** New York, Abrams, 1971. 252p. illus. LC 74-153493.

Dictionary of short entries covering all aspects of subject matter in Western painting. A well-illustrated, popular iconographic dictionary. Of limited usefulness to advanced students because it lacks bibliography and specific reference to literary sources.

545 Droulers, Eugene, pseud. Seyn, Eugéne. **Dictionnaire des attributs, allégories, emblèmes, et symboles.** Turnhout, Brepols, 1948. 281p. illus.

Dictionary of symbols, including symbolic objects and personages, in a single alphabetical listing. Brief definitions with no references to sources. However, a chronological list of sources and works of scholarship on symbolism is provided (pp. 276-81). Illustrated with engravings and line drawings.

546 Errera, Isabelle. **Répertoire abrégé d' iconographie....** Wetteren, de Meester, 1929-1938. 3v.

Completed only through letter "C." Attempts to provide a dictionary of Christian, classical, and profane iconography in Western art. Entries give brief definition together with list of major works of art in which symbol of the personage is depicted. Bibliography (pp. ix-xxiv) lists basic books in all languages.

547 Garnier, Francois. **Thesaurus iconographique. Systeme descriptif des representa-**
tions. Paris, Le Leopard d'Or, 1984. 239p. illus. LC 84-239484.
 Systematic classification of terms used to describe all manner of subjects represented
in art. Produced as an adjunct to the *Inventaire général des monuments et des richesses
artistiques de la France* (1523) and for the Musees de France in an effort to standardize
iconographic terminology.

548 Hall, James. **Dictionary of Subjects and Symbols in Art.** New York, Harper &
Row, 1974. 345p. illus. LC 74-186426.
 Comprehensive dictionary of sacred and profane iconography of Western art.
Treated in a single alphabetical list are: signs, attributes, symbols, narrative subjects, and
allegories. Major literary sources are both referred to in the entries and listed (pp. xix-xxiv).
Only occasional reference to actual works of art. The best modern single-volume dic-
tionary of iconography in English.

549 Hall, James. **A History of Ideas and Images in Italian Art.** New York, Harper &
Row, 1983. 415p. illus. index. LC 82-48154.
 Handbook of iconography found in art of Italy from Etruscan times to the neo-
classical period. The various subjects are discussed as features of broader ideas. There are
sufficient bibliographical references to guide the reader to further information, a useful
glossary, a general index, and indexes of primary sources, artists, and subjects.

550 Henkel, Arthur, and Albrecht Schöne. **Emblemata: Handbuch zur Sinnbildkunst**
des XVI. und XVII. Jahrhunderts. 2d ed. Stuttgart, Metzler, 1976. 2196 cols. illus.
 Comprehensive dictionary of sixteenth and seventeenth century emblems and their
meanings. Classified by groups, illustrated with facsimiles of engraved emblems. There is a
list of the emblem books used and an excellent bibliography. The standard scholarly
reference work on emblems. First edition (1967) has been updated to equal second edition
by a supplement volume (1976), which contains a much enlarged bibliography.

551 Jobes, Gertrude. **Dictionary of Mythology, Folklore and Symbols.** New York,
Scarecrow Press, 1962. 3v. index. LC 61-860.
 Short definitions of a comprehensive range of symbolic figures, objects, and con-
cepts. Third volume is an index in two parts. Part A is a tabular index of deities, heroes,
and personalities; part B is a tabular index of mythological affiliations, supernatural
forms, values, and objects. A long but unclassified and unannotated bibliography at the
end of volume 2 (pp. 1736-59).

552 Koch, Willi A. **Musisches Lexikon: Künstler, Kunstwerke und Motive aus Dich-**
tung, Musik und bildender Kunst. 2d ed. Stuttgart, Kröner, 1964. 1250p. illus. index. LC
65-69991.
 Dictionary of music, literature, and the fine arts, covering biography and works of
literature, music, and art, as well as the subjects depicted in the three arts. Most useful for
tracing parallel treatments of some major subjects in literature, music, and the fine arts.

553 Lanoe-Viellene, Georges. **Le livre des symboles; dictionnaire de symbolique et de**
mythologie. Paris, Bossard, 1927-1933. 5v.
 Dictionary of symbols and mythology; contains many extensive articles. Includes
literary references and quotations. Index. Bibliographical references contained in
footnotes.

554 Pigler, Andor. **Barockthemen, eine Auswahl von Verzeichnissen zur Ikonographie**
des 17. und 18. Jahrhunderts. 2d ed. Budapest, Akadémiai Kiadó, 1974. 3v. illus. index.
 A classified list of subjects, both secular and religious, depicted in seventeenth-
and eighteenth-century art. Volume one lists religious subjects; volume two, secular sub-
jects. Useful for tracing and comparing baroque iconography.

555 Ronchetti, Giuseppe. **Dizionario illustrato dei simboli, emblemi, attributi, alle-gorie, immagini degli dei ecc.** Milan, Hoepli, 1922. 1009p. illus.
Comprehensive dictionary of signs, emblems, attributes, and symbols in all aspects of iconography. Although individuals are included as simple symbols, narrative subjects are not covered. Illustrated with line drawings. Unfortunately, no bibliography or references to sources.

556 Todd, Alden, and Dorothy Weisbord. **Favorite Subjects of Western Art.** New York, Dutton, 1969. 224p. illus. LC 68-55032.
Short-entry dictionary of secular and religious subjects commonly depicted in Western art. This popular work is of little use to the advanced student, since it lacks reference to literary sources and to further literature.

557 Waters, Clara (Erskine) Clement. **A Handbook of Legendary and Mythological Art....** Boston, Houghton Mifflin, 1892. 23d ed. 575p. illus. index. Reprint: Detroit, Gale Research, 1969. LC 68-26616.
First published in 1871. Popular handbook of classical and Christian iconography. Contents: Symbolism in Art; Legends and stories illustrated in art; Legends of Place; Ancient Myths which have been Illustrated in Art. Appendix with supplementary material and list of paintings mentioned in the text.

558 Whittlesey, E. S. **Symbols and Legends in Western Art: A Museum Guide.** New York, Scribner's, 1972. 367p. illus. LC 71-162764.
Dictionary of short entries covering religious and non-religious subject matter in Western art. Reference is made to works of art in collections in the United States. An inadequate one-page bibliography limits its usefulness to advanced students.

CHRISTIAN ICONOGRAPHY

General Works

559 Aurenhammer, Hans. **Lexikon der christlichen Ikonographie.** v. 1- . Vienna, Hollinek, 1959- .
Comprehensive dictionary of Christian iconography, arranged alphabetically by subject; to date, it has reached the entry "Christus und die vierundzwanzig Ältesten." Each entry gives a thorough description of the subject, discussion of the literary sources, a sketch of the development of the subject, and a thorough bibliography of specialized literature. No illustrations. A valuable, scholarly dictionary of Christian iconography. Unfortunately, it is progressing very slowly. For the advanced student and scholar.

560 Barbier de Montault, Xavier. **Traité d'iconographie chrétienne....** Paris, Vivès, 1890. 2v. illus. index.
General handbook of Christian iconography. Contents: I, Les anges et les démons; II, Dieu; III, L'ancien testament; IV, Le monde païen; V, Le Christ; VI, La Sainte vierge; VII, Les apôtres; VIII, Les evangélistes et les docteurs; IX, Les saints; X, Les erreurs contre la foi catholique. No bibliography. Illustrated with line drawings by Henri Nodet.

561 Champeaux, Gérard de. **Introduction au monde des symboles.** Paris, Zodiaque, 1966. 470p. illus. (Introductions à la nuit des temps, 3),
General handbook of broad aspects of Christian iconography common in early medieval art. Contents: 1, Le ciel; 2, Figures simples; 3, Temple et cosmos; 4, L'ascension et les hauteurs; 5, L'homme; 6, L'arbre; 7, Le tetramorphie. Bibliographical footnotes.

562 Child, Heather, and Dorothy Colles. **Christian Symbols, Ancient and Modern: A Handbook for Students.** New York, Scribner's, 1972. 270p. illus. index. LC 72-2769.
 Popular handbook of Christian iconography. Subjects are arranged in broad categories, such as the cross, trinity, images of Christ, etc. Bibliography (pp. 256-259) is an inadequate list of very general and many obsolete works.

563 Detzel, Heinrich. **Christliche Ikonographie.** Freiburg im Breisgau, Herder, 1894-1896. 2v. illus. index.
 Comprehensive handbook of Christian iconography. First volume covers the iconography of God, trinity, Mary, good and evil, the life of Christ, death of Mary, and the Last Judgment. Second volume is devoted to the iconography of the saints. Bibliographical footnotes.

564 Didron, Adolphe N. **Christian Iconography; or, the History of Christian Art in the Middle Ages....** London, Bell, 1886. 2v. illus. index. Reprint: New York, Ungar, 1963. LC 65-23577.
 Contents: Part I: Nimbus or Glory; II, History of God; III, Trinity, Angels, Devils, Death, The Soul, The Christian Scheme. Appendix has useful translation of the late Byzantine *Guide to Painting* and the text of the *Biblia pauperum.* First published in 1845 as *Manuel d'iconographie chrétienne, grecque et latine.*

565 Doering, Oskar. **Christliche Symbole.** 2d ed. Freiburg im Breisgau, Herder, 1940. 147p. illus. index.
 Pocket-size handbook of Christian iconography covering symbolism of the trinity, heaven, the cross, Mary, angels, evangelists, the church, the mass, seven sacraments, virtues and vices, the Last Judgment, the devil, numbers, colors, flowers, the liberal arts, the elements, time. Bibliographical footnotes.

566 Ferguson, George W. **Signs and Symbols in Christian Art, with Illustrations from Paintings of the Renaissance.** New York, Oxford University Press, 1954. 346p. illus. index.
 Handbook of Christian symbols and subjects in classified arrangement. Illustrations of works of Renaissance painting in American museums. Popular work with no bibliography and few references to specific literary sources.

567 Forstner, Dorothea. **Die Welt der Symbole.** 3d ed. Innsbruck, Tyrolia, 1977. 456p. illus. index.
 Handbook of Christian symbolism in the fine arts. Subjects are arranged in broad classes and the entries refer to literary and biblical sources as well as to specialized iconographical literature. General bibliography. Indexed by subject. An excellent one-volume handbook of Christian symbols. More useful for information on small subjects and symbols than for its complicated biblical narratives.

568 Goldsmith, Elizabeth E. **Sacred Symbols in Art.** 2d ed. New York, Putnam, 1912. 296p. illus. index.
 Popular handbook of Christian iconography based on the works of Jameson (570), Didron (564), and with additional material from the *Golden Legends.* Chapters cover: emblems of the saints, color and number symbolism, trinity, angels and archangels, Virgin Mary, St. John the Baptist, the four evangelists, apostles, the Last Supper, Mary Magdalen, Latin fathers, patron saints, legends of the saints, and the monastic orders.

569 Hulme, Frederick E. **The History, Principles and Practice of Symbolism in Christian Art.** 6th ed. New York, Macmillan, 1910. 234p. illus. index. (The Antiquarian Library, 2).
 First published in 1891. Contents: Introduction; II, Number and Color Symbolism; III, The Trinity; IV, Sacred Monograms and Other Attributes of God; V, The Cross; VI, Soul of Man. Reference to literary sources in text and footnotes.

570 Jameson, Anna Brownell (Murphy). **The History of Our Lord as Exemplified in Works of Art....** 4th ed. London, Longmans, Green, 1881. 2v. illus. index. Reprint: Detroit, Gale Research, 1976. LC 72-167006.

Older, popular handbook of the iconography of the life of Christ and the principal Old and New Testament types. Volume one covers Old Testament figures, the childhood and ministry of Christ; volume two, the Passion and the Last Judgment. Inadequate bibliography and reference to sources. Superseded by first three volumes of Schiller (588).

571 Jameson, Anna Brownell (Murphy). **Legends of the Madonna As Represented in the Fine Arts....** Cor. and enl. ed. Boston, Houghton Mifflin, 1891. 483p. illus. index. Reprint: Detroit, Gale Research, 1972. LC 70-89273.

First published in 1848. Forms third series to her *Sacred and Legendary Art* (573). Popular handbook of the iconography of the Virgin Mary. Contents: Introduction, Virgin without the Child, Virgin with the Child, Symbols and Attributes of the Virgin, Life of the Virgin. Illustrated with line drawings. Inadequate bibliography and reference to sources.

572 Jameson, Anna Brownell (Murphy). **Legends of the Monastic Orders as Represented in the Fine Arts....** 6th ed. London, Longmans, Green, 1880. 461p. illus. index.

First published in 1850. Forms second series to her *Sacred and Legendary Art* (573). Chapters devoted to the various religious orders of Western Christendom, describing the history, habits, attributes, chief churches, and legends of the various saints associated with each order. Includes the Jesuits. As with all the works of Mrs. Jameson, inadequate references to literary sources.

573 Jameson, Anna Brownell (Murphy). **Sacred and Legendary Art....** Ed. with additional notes by Estelle M. Hurll. Boston, Houghton Mifflin, 1896. 2v. illus. index. Reprint: New York, AMS Press, 1970. LC 71-12594.

First published in 1848. Popular handbook of the iconography of Christian saints and other holy personages. First volume covers angels, archangels, apostles, doctors of the church, the three Marys, Lazarus, Maximin, Marcella, Mary of Egypt, and the Holy Penitents. Second volume covers patron saints, virgin patronesses, martyrs, bishops, and hermits. As with all work by Mrs. Jameson, inadequate attention was paid to accurately documenting the information and ideas.

574 Keller, Hiltgart I. **Reclams Lexikon der heiligen und der biblischen Gestalten.** Stuttgart, Reclam, 1968. 571p. illus. LC 76-393012.

Dictionary of short entries covering Christian subject matter, with special emphasis on the iconography of the saints. A good one-volume dictionary-handbook of Christian iconography. Its valuable appendixes include attributes of the saints, glossary of terms dealing with costume, a calendar of saints' days, and a good representative bibliography.

575 Kirschbaum, Englebert, ed. **Lexikon der christlichen Ikonographie.** Freiburg im Breisgau, Herder, 1968-1976. 8v. illus. index. LC 71-386111.

Comprehensive encyclopedia covering all aspects of Christian iconography. Signed entries, arranged alphabetically, range in size from short entries on simple symbols to lengthy and exhaustive articles on major subjects. All entries give a list of literary sources, description of the subject, history of the representation in Christian art, and a thorough bibliography listing special iconographical literature. Volume four gives a list of entries for the entire work in English and French with the German equivalents. Volumes 5 through 8 comprise a comprehensive dictionary of iconography of Christian saints. This is now the standard work on Christian iconography.

576 Knipping, John B. **Iconography of the Counter Reformation in the Netherlands.** Nieuwkoop, de Graaf, 1974. 2v. illus. index. LC 73-85234.

Comprehensive, scholarly study of the effect of the Counter Reformation on the iconography of art in the Catholic Netherlands. Expanded translation of *De iconographie van de contra-reformatie in de Nederlanden....* (Hilversum, Brand, 1939-1940). Contents:

I, Netherlands and the Counter Reformation; II, Humanism and the Counter Reformation; III, The New Asceticism; IV, New Devotions; V, The Bible; VI, The Saint in Cult and Culture; VII, Christian Love as Life; VIII, The Militant Church; IX, Form and Content; X, The Great Stream of Tradition. Comprehensive list of books and periodical articles in all languages (pp. 497-503).

577 Künstle, Karl. **Ikonographie der christlichen Kunst....** Freiburg im Breisgau, Herder, 1926-1928. 2v. illus. index.
A comprehensive handbook of Christian iconography. Volume two covers the iconography of the saints in dictionary form; all other Christian subjects are covered in volume one, where they are arranged in classes. Each chapter has a separate bibliography with many references to specific literature. A standard handbook on Christian iconography, although it is somewhat out-of-date in certain areas.

578 Lipffert, Klementine. **Symbol-Fibel: Eine Hilfe zum Betrachten und Deuten mittelalterlicher Bildwerke.** 4th ed. Kassel, Stauda, 1964. 159p. illus. index. LC 65-106537.
Handbook of Christian symbolism arranged by classes (i.e., animals, plants, colors, persons, inanimate objects, initials). Bibliography (pp. 158-60). Useful for quick reference on simple Christian symbols.

579 Lurker, Manfred. **Wörterbuch biblischer Bilder und Symbole.** Munich, Kösel, 1973. 434p. index.
Dictionary of biblical subjects and symbols. The thorough entries discuss the meaning of the subject with references to scriptural passages. Very useful bibliographies citing specialized literature follow each entry. General bibliography (pp. 386-91). Provides a comprehensive index of meanings and scriptural passages. A valuable tool for anyone seeking the meaning of biblical subjects found in the fine arts.

580 Metford, J. C. J. **Dictionary of Christian Lore and Legend.** London, Thames and Hudson, 1983. 272p. illus. LC 82-50815.
General dictionary covering all aspects of Christian culture including the visual arts. In addition to brief entries on the more common symbols and subjects in Christian art there are useful ones on objects, parts of church buildings, and liturgical practice. Unfortunately the entries have no bibliographical references.

581 Molsdorf, Wilhelm. **Christliche Symbolik der mittelalterlichen Kunst.** 2d. ed. rev. and enl. Leipzig, Hiersemann, 1926. Reprint: Graz, Akademischen Druck-und Verlagsanstalt, 1969. Rev. ed., 1984. 284p. illus. index. LC 73-390272.
Handbook of Christian subject matter found in medieval art, arranged by classes. Entries have reference to further illustrations and to specific literature. Still a useful one-volume handbook to Christian iconography. Well indexed.

582 Réau, Louis. **Iconographie de l'art chrétien....** Paris, Presses Universitaires de France, 1955-1959. 3v. in 6. illus. Reprint: Nendeln, Kraus, 1974.
Comprehensive handbook of Christian iconography covering both Eastern and Western traditions. Arranged by classes. Volume one gives a general introduction; volume two covers biblical subjects; volume three, the iconography of the saints. A general bibliography is given (pp. 21-26 in volume one), and separate bibliographies follow each chapter. A particularly useful feature is the list of examples at the end of each chapter or class of subject. A standard handbook; Schiller (588) and Kirschbaum (578) are now more thorough.

583 Rohault de Fleury, Charles. **L'évangile; études iconographiques et archéologiques....** Tours, Mame, 1874. 2v. illus. index.
Guide to the iconography of the life of Christ, arranged according to the texts of the Gospels. Major passages of scripture are followed by section on iconography and archaeology that discusses the visualization of the text in art and the physical evidence associated with the original event. Bibliographical footnotes; illustrated with engravings.

584 Rohault de Fleury, Charles. **La messe: études archéologiques sur ses monuments continuées par son fils....** Paris, Morel, 1882-1889. 8v. illus.
Iconographical and archaeological history of the Mass from Early Christian times to the end of the Middle Ages. Illustrated with line drawings. Occasional bibliographical footnotes. Still an important work in a neglected area of Christian iconography.

585 Sachs, Hannelore, Ernst Badstübner, and Helga Neumann. **Christliche Ikonographie im Stichworten.** Leipzig, Koehler und Amelang, 1973. 371p. illus.
Comprehensive dictionary covering all aspects of Christian iconography from broad narrative subjects to simple symbols.

586 Schiller, Gertrud. **Ikonographie der christlichen Kunst.** Gutersloh, Mohn, 1966-1988. 6v. LC 66-25808.
Comprehensive handbook of Christian iconography, arranged by broad categories. Within the broad categories the individual subjects are arranged in chronological order (the life of Christ) or by sub-subject. The emphasis in Schiller, therefore, is on narrative or allegorical subjects. Although there is much information on smaller subjects and symbols, those must be approached through the index, or, better yet, by consulting Kirschbaum (578). Contents:
 Band 1, *Inkarnation, Kindheit Christi* (3d. ed. 1981)
 Band 2, *Passion Christi* (2d ed. 1983)
 Band 3, *Auferstehung Christi* (2d ed. 1986)
 Band 4, 1, *Die Kirche* (2d ed. 1988)
 Band 4, 2, *Maria* (1980)
 Registerbeiheft zu den Bänden 1 bis 4, 2. bearbeitet von Rupert Schreiner (1980. Reprint: 1985). Band 1 and Band 2 have been translated into English as: *Iconography of Christian Art* (Greenwich, Conn., New York Graphic Society, 1969, 1971. 2v. LC 76-132965). *Ikonographie der christlichen Kunst* is the standard handbook for Christian iconography. The corpi of plates at the end of each volume are major resources in their own right.

587 Seibert, Jutta. **Lexikon christlicher Kunst: Themen, Gestalten, Symbole.** Freiburg, Herder, 1982. 352p. LC 80-137893.
General, popular dictionary of Christian iconography. Brief entries define the subject and give references to biblical sources. No bibliographical references in the entries; brief list of basic reference works, p. 347.

588 Sill, Gertrude G. **A Handbook of Symbols in Christian Art.** New York, Macmillan, 1975. 241p. illus. index. LC 75-26557.
Popular handbook covering signs, symbols, narrative subjects, and allegories of Christian art. Arrangement is not strictly alphabetical; instead, subjects are grouped under broad categories like angels, beasts, initials, etc. Except for occasional scriptural quotes, literary sources are not given. No references to specialized literature. Inadequate one-page bibliography of popular works in English.

589 Spitzing, Gunter. **Lexikon byzantinisch-christlicher Symbole: Die Bilderwelt Griechlands und Kleinasiens.** Munich, Diedrichs, 1989. 344p. illus.
Comprehensive dictionary of subjects and symbols found in Byzantine art. Emphasis is on works of art in Greece and Turkey. Bibliographical references included in major entries.

590 Timmers, J. J. M. **Symboliek en Iconographie der Christelijke Kunst....** Roermond-Maaseik, Romen & Zonen, 1947. 1125p. illus. index.
Comprehensive handbook of Christian iconography. Subjects are arranged in broad classes similar to Künstle (457). Bibliography (pp. 1015-30). Indexed by subjects, people, and places. Excellent Dutch handbook of iconography, with a good, concise history of Christian symbolism as an introduction.

591 Urech, Édouard. **Dictionnaire des symbols chrétiens.** Neuchâtel, Delachaux & Nestlé, 1972. 192p. illus. LC 72-368448.
 Concise dictionary of Christian symbols. Bibliographical references are to a list of basic works (p. 187).

592 Webber, Frederick R. **Church Symbolism: An Explanation of the More Important Symbols of the Old and New Testament, the Primitive, the Mediaeval and the Modern Church....** 2d ed. rev. Cleveland, Jansen, 1938. 413p. illus. index. Reprint: Detroit, Gale Research, 1971.
 First published in 1927. Popular handbook of Christian iconography covering: Old Testament figures, trinity, sacred monogram, cross, nimbus, and emblems of the saints. Does not cover narrative subjects. No bibliography.

593 Whone, Herbert. **Church, Monastery, Cathedral. A Guide to the Symbolism of Christian Tradition.** Tisbury, Wiltshire, Compton Russell, 1977. 180p. LC 77-357904.
 General dictionary covering all aspects of Christian art and architecture but with special emphasis on the English Middle Ages. Brief entries define structural and decorative features, common symbols and subjects, church furniture and liturgical objects. Illustrated with line drawings. No bibliography.

594 Woodruff, Helen. **The Index of Christian Art at Princeton University: a Handbook.** Princeton, Princeton University Press, 1942. 83p. LC 42-21166.
 Description of the unique index of Christian iconography begun at Princeton University in 1917. The Princeton index is a card index of subjects depicted in Christian art from the beginnings to 1400. All media are included. The card index is supplemented by a large collection of illustrations of works of art in which the subjects are depicted. There are copies of the card index in the Dumbarton Oaks Research Library of Harvard University in Washington, D.C., in the Metropolitan Museum of Art Library in New York (has not been kept up-to-date), and in the Pontifical Institute for Christian Archaeology in the Vatican. For a small fee scholars may search the index for specific subjects by writing to the Princeton index.

 See also: Mâle (1151, 1152, 1251), Weisbach (1263).

Dictionaries of Saints

595 Braun, Joseph. **Tracht und Attribute der Heiligen in der deutschen Kunst.** Stuttgart, Metzler, 1943. Reprint: Stuttgart, Druckenmüller, 1964. 854p. illus. index. LC 65-16573.
 Dictionary of the saints found in German art. First part lists the saints alphabetically; each entry gives a short life of the saint and a thorough description of how the saint is represented in art, with reference to and occasional illustrations of works of German art. Excellent references to literary sources and specific iconographical literature. Second part deals with the costume and attributes of the saints. One of the finest iconographical dictionaries of the saints.

596 Cahier, Charles. **Caractéristiques des saints dans l'art populaire enumerées et expliquées....** Paris, Poussielgue, 1867. 2v. illus. index.
 Older, comprehensive dictionary of the saints and their attributes. Arrangement is alphabetical, with saints, their attributes, and their symbols listed together. Entries under each saint's name give quite thorough descriptions of the chief legends. Bibliographical footnotes.

597 Drake, Maurice, and Wilfred Drake. **Saints and Their Emblems....** London, Laurie, 1916. Reprint: New York, Franklin, 1971. 235p. illus.
 General dictionary of saints and their attributes. Part one is a dictionary of saints, with brief biographies; part two is a list of their attributes; part three lists and describes other religious personages. An excellent general dictionary of the saints.

598 Ferrando Roig, Juan. **Iconografia de los santos.** Barcelona, Omega, 1950. 302p. illus. index.

Dictionary of saints valuable for its emphasis on Spanish saints. Illustrated with saints in Spanish art. List of attributes of the saints and index of the patronage of Spanish saints.

599 Guénebault, Louis J. **Dictionnaire iconographique des figures, légendes et actes des saints, tant de l'ancienne que de la nouvelle loi, et répertoire alphabétique des attributs....** Paris, Chez l'Éditeur, 1850. 1232 columns. (Encyclopédie théologique, tome 45).

Early dictionary of saints and their attributes. First part is an alphabetically arranged dictionary of the lives of the saints; second part is a dictionary of saints' attributes. Bibliographical references to list of sources (cols. 1070-1220).

600 Holweck, Frederick G. **A Biographical Dictionary of the Saints, with a General Introduction on Hagiology....** St. Louis, Herder, 1924. 1053p. Reprint: Detroit, Gale Research, 1969. LC 68-30625.

Comprehensive dictionary of the saints, with occasional reference to their attributes.

601 Husenbeth, Frederick C. **Emblems of Saints: By Which They Are Distinguished in Works of Art....** 3d ed. Norwich, Norfolk and Norwich Archaeological Society, 1882. 426p. illus. index.

Divided into two parts. First lists saints and their emblems together with sources, i.e., usually works of art depicting the saint. In the second part, emblems are listed first. Also includes patron saints of various trades and professions, countries and cities. Appendix discusses the iconography of the sibyls and sacred heraldry.

602 Kaftal, George. **Iconography of the Saints in Central and South Italian Painting.** Florence, Sansoni, 1965. illus. index. LC 67-42343.

Specialized dictionary of saints found in Central and South Italian painting of the fourteenth and fifteenth centuries. Follows the plan of the author's dictionary of Tuscan saints (603). Scholarly reference tool for the specialist.

603 Kaftal, George. **Iconography of the Saints in Tuscan Painting.** Florence, Sansoni, 1952. 1274p. illus. index. LC A53-2358.

Specialized dictionary of saints found in Tuscan painting of the fourteenth and fifteenth centuries. Each entry gives short life and a description of how the saint is represented, with reference to specific works of Tuscan painting, literary sources, and special bibliography. Thoroughly indexed by attribute, painters, place, and saints. A scholarly dictionary of amazing thoroughness. A basic reference tool for the study of Italian painting.

604 Kaftal, George, and Fabio Bisogni. **Iconography of the Saints in the Painting of North East Italy.** Florence, Sansoni, 1978. 1342 cols. illus. index.

Specialized dictionary of saints found in paintings of the schools of Romagna, Emilia, and the Veneto from the fifth to the early sixteenth centuries. Follows the plan of the author's dictionary of Tuscan saints (603). Scholarly reference tool for the specialist.

605 Kaftal, George, and Fabio Bisogni. **Iconography of the Saints in the Painting of North West Italy.** Florence, Casa Editrice le Lettere, 1985. 818 cols. illus. index. LC 85-202410.

Specialized dictionary of saints found in paintings of the schools of Lombardy, Piedmont, Savoy, and Liguria from the beginning to the early sixteenth century. Follows the plan of the author's dictionary of Tuscan saints (603). This volume concludes the series dedicated to the iconography of the saints in early Italian painting. Scholarly reference tool for the specialist.

606 Menzies, Lucy. **The Saints in Italy: A Book of Reference to the Saints in Italian Art and Decoration....** London, Medici Society, 1924. 496p.

Dictionary of saints found in Italian art. Entries give dates, short life, and description of how the saint is represented in art. List of attributes and description of the habits of the monastic orders (pp. 465-96). This popular dictionary is still useful for quick reference, but it lacks sources and bibliography as well as reference to specific works of art.

607 Ricci, Elisa. **Mille santi dell'arte....** Milan, Hoepli, 1931. 734p. illus. index.

A general dictionary of saints in art. Brief entries give description of the saint and reference to works of art in which the saint is depicted. Index of attributes (pp. 687-99). A good, well-illustrated dictionary of the saints in art.

608 Roeder, Helen. **Saints and Their Attributes: With a Guide to Localities and Patronage.** London, Longmans, Green, 1955. 391p. illus. index.

General dictionary of saints arranged by their attributes. Death date, main locality of veneration, and day of commemoration are given for each saint. Indexed by saints and by localities. A good general dictionary of saints, but it lacks specific bibliography and reference to works of art.

609 Rohault de Fleury, Charles. **Archéologie chrétienne. Les saints de la messe et leurs monuments....** Paris, Libraires Impremeries Réunies, 1893-1900. 10v. illus.

Older handbook of the iconography of major Christian saints. Entries give basic biographical facts and list of works of art and architecture associated with each saint. Illustrated with line drawings, plans, and elevations. Contents: I, *Les vierges*; II, *Vierges et martyrs*; III, *Papes*; IV, *Ministres sacrés*; V, *Diacres, médecins*; VI, *Saint Pierre*; VII, *Saint Pierre, Saint Paul, Saint Philippe, Saint Jacques Mineur*; VIII, *Saint Jean Évangéliste, Saint Jacques-le-Majeur*; IX, *Saint Barthélemy, Saint Matthieu, Saint Thomas*; X, *Saint André, Saint Simon et Saint Jude, Saint Mathias, Saint Barnabé, Saint Jean-Baptiste, Agneau de Dieu.* Bibliographical footnotes. Useful chiefly for its information on early cult associations of the saints.

610 Waters, Clara (Erskine) Clement. **Saints in Art.** Boston, Houghton Mifflin, 1907. 428p. illus. index. Reprint: Detroit, Gale Research, 1974. LC 77-89303.

Popular old handbook of the iconography of the saints. Covers the four evangelists, twelve apostles, fathers of the church, patron saints, virgin saints, and other saints. No bibliography.

611 Wimmer, Otto. **Die Attribute der Heiligen.** 3d ed. Innsbruck, Tyrolia, 1975. 185p. LC 75-507508.

Dictionary of the saints in art, arranged in two lists: by the name of the saint, and by the attribute of the saint. Gives a brief life of each saint. Popular pocket dictionary of the saints in art.

WESTERN PROFANE ICONOGRAPHY

612 Marle, Raimond van. **Iconographie de l'art profane au moyen-âge et à la Renaissance, et la décoration des demeures....** The Hague, Nijhoff, 1931-1932. 2v. illus.

Comprehensive handbook of secular iconography in the art of the Middle Ages and the Renaissance. Arranged in broad classes; entries relating to everyday life are grouped in volume one, while volume two covers secular allegories and symbols. A standard work on secular subject matter. Lack of an index makes it difficult to use for quick reference.

613 Tervarent, Guy de. **Attributs et symboles dans l'art profane, 1450-1600.** Geneva, Droz, 1958-1964. 3v. LC 60-32005.

Dictionary of symbols and subjects found in works of non-religious art between 1450 and 1600. Entries give literary sources for the subject and references to specific works of art that depict the symbol or subject. Although restricted essentially to the Renaissance period, many of the secular subjects treated in this dictionary occur in earlier and later periods. Should be consulted by any serious student pursuing a secular subject.

CLASSICAL MYTHOLOGY AND ICONOGRAPHY

614 Brommer, Frank. **Denkmälerlisten zur griechischen Heldensage.** Marburg, Elwert, 1971-1976. 4v. index.

Alphabetical list of personages, objects, and subjects from ancient Greek mythology, with references to works of ancient Greek and Roman art that depict the subjects. Gives location of the works, short description of the object, and references to sources of illustrations and further information. Does not include works of ancient vase painting, which are indexed in a separate list (615). A very useful index for advanced students interested in classical iconography.

615 Brommer, Frank. **Vasenlisten zur griechischen Heldensage.** 3rd ed. Marburg, Elwert, 1973. 646p. LC 74-305619.

Index to subjects from Greek mythology depicted in works of ancient Greek vase painting. Follows the arrangement of (614). A very useful index for advanced students interested in classical iconography.

616 Goldsmith, Elisabeth. **Ancient Pagan Symbols.** New York, Putnam, 1929. 220p. illus. index. Reprint: Detroit, Gale Research, 1976. LC 68-18025.

Popular dictionary of subjects found in ancient Egyptian, Near Eastern, Buddhist, Hindu, Chinese, and Japanese art. Arrangement is by broad subject category, such as: "The Elements," "The Serpent," etc. No bibliography.

617 Grant, Michael, and John Hazel. **Who's Who in Classical Mythology.** London, Wiedenfeld & Nicolson. 1973. 447p. illus. LC 73-177715.

Dictionary of classical mythology; well-illustrated with works of art. Entries give concise summaries of the lives and exploits of the chief mythological figures, with referen-concise summaries of the lives and exploits of the chief mythological figures, with references to major Green and Latin authors. The entries do not, however, refer specifically to sources.

618 Grimal, Pierre. **Dictionnaire de la mythologie grecque et romaine.** 3d ed. Paris, Presses Universitaires de France, 1963. 578p. illus. index. LC 64-22572.

Dictionary of ancient Greek and Roman mythology. Each entry has a collection of bibliographical footnotes that refer chiefly to source material. A competent classical mythology dictionary, though it does not refer specifically to depiction of the subjects in the fine arts.

619 Hunger, Herbert. **Lexikon der griechischen und römischen Mythologie: Mit Hinweisen auf des Fortwirken antiker Stoffe und Motive in der bildenden Kunst, Literatur und Musik des Abendlandes bis zur Gegenwart.** 5th ed. Vienna, Hollinek, 1959. 387p. illus. LC 59-33741. Reprint: Reinbek bei Hamburg, Rororo, 1974. (Rororo Handbuch, 6178).

Comprehensive dictionary of ancient Greek and Roman mythological subjects in Western art, literature, and music to the present day. Each entry provides numerous bibliographical references, a short account of the subject according to original sources, a discussion of the meaning of the subject, and a description of the subject's use in later Western art, literature, and music. Excellent general bibliography (pp. 383-87) with section on classical iconography. Very useful tool for students interested in classical mythology.

620 **Lexicon iconographicum mythologiae classicae.** Zürich, Artemis, 1981- (1986). v. 1- (v. III). ISBN 3760887511.
Comprehensive encyclopedia of subjects from classical mythology. For each volume of text there is a corresponding volume of plates. An exhaustive work, volume III covers subjects Atherion to Eros. Entries are written by experts and appear in their native languages (mostly German, English, French, and Italian) and include thorough description of the literary sources, detailed catalogs of works of art that depict the subject(s), and thorough specialized bibliographies. When completed the *Lexicon iconographicum mythologiae* will be the definitive reference tool for research work on classical iconography.

621 Mackenzie, Donald A. **The Migration of Symbols and Their Relations to Beliefs and Customs.** New York, Knopf, 1926. 219p. illus. index. Reprint: New York, AMS, 1970.
Study of four major classes of ancient symbols: the swastika, the spiral, ear symbols, tree symbols.

622 Preston, Percy. **A Dictionary of Pictorial Subjects from Classical Literature: A Guide to Their Identification in Works of Art.** New York, Scribner's, 1983. 309p. illus. index. LC 83-4470.
Dictionary of subjects derived from classical mythology and literature found in works of art from all periods. Alphabetical arrangement of subjects which include objects, persons, themes, etc. Entries give references to literary sources but no bibliographical references to the specialized iconographical literature. Bibliography, p. 311, is a list of general reference works.

623 Overbeck, Johannes. **Griechische Kunstmythologie.** Leipzig, Engelmann, 1871-1889. 3v. illus. index. Reprint: Osnabrück, Biblio Verlag, 1964. LC NUC 71-49134.
Detailed examination of the major deities in ancient Greek art. Contents: Band 1: *Zeus*; Band 2: *Hera, Poseidon, Demeter und Kora*; Band 3, *Apollon*. Bibliographical footnotes. Still valuable for its thorough treatment of literary sources.

624 Roscher, Wilhelm H. **Ausführliches Lexikon der griechischen und römischen Mythologie.** Leipzig, Teubner, 1884-1927. 6v. plus Supplements (3v. in 5). illus.
Comprehensive dictionary of ancient Greek and Roman mythology. The entries give very thorough discussions of the myths, their literary sources and cult significance, and their representation in the fine arts. A standard dictionary of classical mythology; basic to all serious research on classical iconography.

625 Tripp, Edward. **Crowell's Handbook of Classical Mythology.** New York, Crowell, 1970. 631p. index. LC 74-127614.
Comprehensive dictionary of Greek and Roman mythology. Entries are fuller than in Grant (617) and give more comprehensive reference to literary sources. No references to art. Pronouncing index.

NON-WESTERN MYTHOLOGY AND ICONOGRAPHY

626 Banerjea, Jitendra N. **The Development of Hindu Iconography.** 2d. rev. and enl. ed. Calcutta, University of Calcutta, 1956. 653p. illus. index.
Scholarly history of the early development of Hindu iconography in Indian art, chiefly sculpture. Contents: I, Study of Hindu Iconography; II, The Antiquity of Image-Worship in India; III, The Origin and Development of Image-Worship in India; IV, Brahmanical Divinities and Their Emblems on Early Indian Coins; V, Deities and Their Emblems

on Early Indian Seals; VI, Iconoplastic Art in India—Factors Contributing to Its Development; VII, Iconographic Terminology; VIII, Canons of Iconometry; IX, Cult Icons-Vyantara Devatas; X, Cult Icons—Visnu and Surya; XI, Cult Icons—Siva and Sakti; XII, Miscellaneous and Syncretistic Icons. Selected bibliography (pp. 627-32).

627 Bhattacharyya, Benoytosh. **The Indian Buddhist Iconography, Mainly Based on the Sādhanamālā and Other Cognate Tāntric Texts of Rituals....** London, Oxford University Press, 1924. 220p. illus. index. 2d. rev. ed. Calcutta, Mukhopadhyay, 1958. 478p. illus. index.
 Scholarly, comprehensive handbook of Buddhist iconography in India. Chapters treat various classes of symbols and emphasis is placed on textual sources. Glossary of terms, selected bibliography of books and articles in all languages (pp. xxx-xxxiii). A standard work.

628 Bonnet, Hans. **Reallexikon der ägyptischen Religionsgeschichte.** Berlin, de Gruyter, 1952. 883p. illus. LC A52-9962.
 Comprehensive dictionary of ancient Egyptian religion. Covers deities and other personages, places, objects, and subjects. Each entry has a separate bibliography of specialized works. Standard reference work on ancient Egyptian religion. Invaluable for all serious study of ancient Egyptian iconography.

629 Coomaraswamy, Ananda K. **Elements of Buddhist Iconography.** Cambridge, Mass., Harvard University Press, 1935. 95p. text, 15 plates.
 Handbook of basic Buddhist symbolism. Contents: Part I, Tree of Life, Earth-Lotus, Word-Wheel; Part II, The Place of the Lotus-Throne. Plates have descriptive notes with bibliographical footnotes.

630 Cummings, Mary. **The Lives of the Buddha in the Art and Literature of Asia.** Ann Arbor, University of Michigan, 1982. 225p. illus. index. (The University of Michigan Center for South and Southeast Asian Studies, Michigan Papers on South and Southeast Asia, No. 20). LC 80-67341.
 Handbok of the major subjects in the lives of the Buddha as they are described in the texts (the *Jatakas*, the *Buddhacarita*, and *Lalitavistara*) and represented in the visual arts. Arrangement follows the narrative of the texts. Bibliographical footnotes and alphabetical list of works cited, pp. 213-25.

631 Getty, Alice. **The Gods of Northern Buddhism; Their History, Iconography and Progressive Evolution through the Northern Buddhist Countries.** 2d ed. rev. Oxford, Clarendon Press, 1928. 220p. illus. index.
 Introduction sketches the development of Buddhism and Buddhist art. Subsequent chapters deal with a major deity. Glossary of Oriental terms used in the text (pp. 183-203). Bibliography of books and periodical articles in all languages (pp. 203-207).

632 Gopinātha Rau, T. A. **Elements of Hindu Iconography....** Madras, Law Printing House, 1914-1916. 2v. in 4. illus. index. Reprint: New York, Paragon, 1968.
 Scholarly, comprehensive handbook of Hindu iconography, with emphasis on textual sources. Literary sources in Sanskrit and English translation provided throughout. Thoroughly indexed and good corpus of plates. A standard work.

633 Gordon, Antoinette K. **The Iconography of Tibetan Lamaism.** 2d ed. New York, Paragon, 1967. 131p. illus. index. LC 67-711.
 Little changed from first edition of 1938. Dictionary of subjects of Tibetan Lamaism. Arranged in classes with descriptions and illustrations. General bibliography (pp. 111-18). Popular work, yet still important to serious student.

634 Grey, Louis H., and John A. MacCulloch, eds. **Mythology of All Races.** Boston, Jones, 1916-1932. 13v. illus. index.
Comprehensive handbook of world mythology. Arranged by broad cultures with subject index in vol. 13. Good bibliographies at the end of each volume. The most comprehensive dictionary of mythology in English. A valuable aid to the study of non-Western iconography.

635 Gupte, Ramesh. **Iconography of the Hindus, Buddhists, and Jains.** Bombay, Taraporevala, 1972. 201p. illus. LC 72-907859.
Comprehensive handbook of the iconography of traditional Indian art. The basic subjects of Hindu, Buddhist, and Jainistic art are discussed, together with the relevant literary texts.

636 Hackin, Joseph, et al. **Asiatic Mythology.** London, Harrap, 1932. Reprint: New York, Crowell, 1963. 459p. illus. index. LC 63-20021.
A collection of articles by specialists on the mythology of Persia, the Kafirs, Buddhism, Lamaism, Indochina, Central Asia, modern China, and Japan. Responsible collection of myths found in Oriental art, but the lack of bibliography and specific references to literary sources limits its usefulness for the serious student.

637 Haussig, Hans Wilhelm, ed. **Wörterbuch der Mythologie. I. Abteilung: Die Mythologie der alten Kulturvölker.** Lieferung 1- . Stuttgart, E. Klett, 1961- . illus. index.
Comprehensive dictionary of the mythology of all ancient cultures of the world. Consists of a series of separate dictionaries of the mythologies, in five categories: Ancient Near East (includes Egypt), Ancient Europe, the Iranian Peoples, Central and East Asia, and Ancient America. Thus far, the first and second parts have been published. A second section, covering the mythology of primitive peoples, is being planned. Each dictionary has a valuable introduction with an historical survey of the mythology concerned. The entries cover gods, ideas, cults, etc., and have thorough cross references and excellent separate bibliographies attached to the major entries. A collection of plates, maps, and chronological tables is provided. The basic, scholarly reference tool for the study of mythology. Essential for any serious study of non-Christian iconography; of special value to the specialist in non-classical archaeology.

638 Joly, Henri L. **Legend in Japanese Art: A Description of Historical Episodes, Legendary Characters, Folk-Lore, Myths, Religious Symbolism Illustrated in the Arts of Old Japan.** Rutland, Vt., Tuttle, 1967. 623p. illus. LC 67-16411.
Reissue of 1908 edition. This dictionary of Japanese iconography explains the mythology, but without specific reference to literary sources or specialized literature. Bibliography (pp. 596-609) lists, for the most part, works that are older and that are in Japanese.

639 Jouveau-Dubreuil, G. **Hindu Iconography of Southern India.** Delhi, Bharatiya Publishing House, 1978. 135p. illus. LC 78-913194.
First published in 1928. Study of the iconography of Hindu temples in Tamil-speaking part of southern India. Contents: Sivaite Iconography; Vishnuvite Iconography; Brahma and Secondary Divinities; History of Religion According to Iconography; Costumes, Statues, Cars, etc. Bibliographical footnotes.

640 Kirfel, Willibald. **Symbolik des Buddhismus.** Stuttgart, Hiersemann, 1959. 128p. illus. index. (Symbolik der Religionen, 5).
Concise survey of Buddhist symbolism, with particular reference to the visual arts. Bibliographical footnotes.

641 Kirfel, Willibald. **Symbolik des Hinduismus und des Jinismus.** Stuttgart, Hiersemann, 1959. 167p. illus. index. (Symbolik der Religionen, 4).
Concise survey of Hindu and Jain symbolism, with reference to literature and visual arts. Bibliographical footnotes.

642 Lauf, Detlef I. **Eine Ikonographie des tibetischen Buddhismus.** Graz, Akademische Druck-und-Verlagsanstalt, 1979. 204p. illus. LC 80-513765.
 Illustrated handbook of the major subjects depicted in the Buddhist art of Tibet. Introductory essay gives the outlines of Tibetan Buddhist iconography with reference to the religious texts. Collection of plates arranged by broad subject categories is accompanied by descriptive notes with bibliographical references. Bibliography of general works, pp. 203-204.

643 Liebert, Gösta. **Iconographic Dictionary of Indian Religions: Hinduism, Buddhism, Jainism.** Leiden, Brill, 1976. 377p. illus. index. (Studies in South Asian Culture, v. 5) ISBN 900404557.
 Important reference tool to the iconography of the art of India and Tibet. Entries define the subject, make reference to literary sources, often with translations of key passages, and provide bibliographical references to specialized iconographical literature and to books with illustrations of the subject. Index is subdivided by classes of subject matter: *Vahanas*, Attitudes, *Mudras*, Attributes, and other terms.

644 Lurker, Manfred. **Symbole der alten Ägypter: Einführung und kleines Wörterbuch.** Weilheim, O. W. Barth, 1964. 152p. illus. LC 66-93601.
 Dictionary of ancient Egyptian symbols. The alphabetical part, covering signs, signets, gods, and goddesses, is preceded by a brief account of ancient Egyptian mythology and its representation in the visual arts. A useful dictionary for the advanced student.

645 Moor, Edward. **The Hindu Pantheon.** London, J. Johnson, 1810. 467p. illus. index. Reprint: New York, Garland, 1984. LC 78-60887.
 The first reliable systematic treatment of Hindu mythology still useful for the study of Hindu iconography. Bibliographical footnotes.

646 Ross, Nancy Wilson. **Three Ways of Asian Wisdom: Hinduism, Buddhism, Zen and Their Significance for the West.** New York, Simon and Schuster, 1966. 222p. illus. index. LC 66-11065.
 British edition titled *Hinduism, Buddhism, Zen: An Introduction to Their Meaning and Their Arts* (London, Faber, 1968). A handbook of the subject matter of Hinduism, Buddhism, and Zen religions. There are separate chapters for each religion, with sub-sections on the representation of their subjects in the fine arts. Adequate illustrations, with descriptive captions. Bibliography (pp. 199-207) lists chiefly works on religion. A general and popular treatment, it is still useful because of the lack of other substantial works in the field.

647 Sahai, Bhagwant. **Iconography of Minor Hindu and Buddhist Deities.** New Delhi, Abhinav Publications, 1975. 295p. illus. index.
 Scholarly handbook, arranged by type, i.e., Vedic, Saiva deities, etc. Thorough reference to textual sources and good use of works of art as examples of the various subjects. Extensive bibliographical footnotes. Emphasis on Indian material. Supplements Bhattacharyya (627) and Gopinātha Rau (632).

648 Stutley, Margaret. **The Illustrated Dictionary of Hindu Iconography.** London, Routledge & Kegan Paul, 1985. 175p. illus. LC 84-6861.
 Dictionary of subjects depicted in Hindu art of all periods. Major entries have references to short list of basic books and Hindu art, mythology, and religion. List of English subjects and Sanskrit equivalents.

649 Stutley, Margaret, and James Stutley. **A Dictionary of Hinduism: Its Mythology, Folklore and Development 1500 B.C.-A.D. 1500.** New York, Harper, 1977. 372p. LC 76-9999.

Comprehensive dictionary of Hinduism, with particular reference to literary sources. Although few references to visual arts are made, this work is very useful to the study of Hindu iconography. Bibliography (pp. 353-68) lists books and periodical articles in all languages.

650 Werner, Edward T. C. **A Dictionary of Chinese Mythology.** New York, Julian Press, 1961. 627p. illus. LC 61-17239.
Reprint of 1932 edition. Comprehensive dictionary of characters, objects, and subjects of Chinese mythology. Longer entries have references to sources and occasionally to specialized literature. Bibliography (pp. 625-27) lists books in Chinese and Western languages. A standard dictionary of Chinese mythology. Essential for all serious study of Chinese pictorial art.

651 Williams, Charles Alfred S. **Encyclopedia of Chinese Symbolism and Art Motives: An Alphabetical Compendium of Legends and Beliefs as Reflected in the Manners and Customs of the Chinese Throughout History.** New York, Julian, 1960. 468p. illus. index. Reprint: Rutland, Vt., Tuttle, 1974. LC 73-90237.
Reissue of *Outlines of Chinese Symbolism and Art* (1931). Dictionary of Chinese iconography. Chinese characters are given after the main English heading. Very useful dictionary. Longer entries have bibliographies of specialized literature.

7
HISTORIOGRAPHY OF ART HISTORY

Included here are bibliographies, dictionaries, general handbooks and histories of art historiography, anthologies of art historiographical writings, and major studies in the historiography of art history. To be included in the last group a work must deal explicitly or implicitly with art history as a whole.

BIBLIOGRAPHIES AND DICTIONARIES

652 Brazier, Paul. **Art History in Education; an Annotated Bibliography and History.** London, Heinemann, 1985. 72p. index. ISBN 0435808818.
A biblio-history of the teaching of art history in Great Britain and the United States with emphasis on the penetration of art history into the field of art education.

653 Lodovici, Sergio. **Storici, teorici e critici delle arti figurative (1800-1940).** Roma, E.B.B.I., Istituto editoriale italiano B.C. Tosi, 1942. 412p. illus. (Enciclopedia biografica e bibliografica "Italiana," ser. IV).
Dictionary of biographies of Italian art historians and critics from 1800-1940. Lists of Italian periodicals, pp. 389-412.

654 Piel, Friedrich. "Sachliteratur zur Kunstwissenschaft und Kunstgeschichte," in: R. Radler, ed. **Die deutschsprachige Sachliteratur. Kindlers Literaturgeschichte der Gegenwart,** Band V. Munich, Kindler, 1977, pp. 472-504.
Bibliographical essay on the literature in German on art historiography.

655 Waetzoldt, Wilhelm. **Deutscher Kunsthistoriker.** Leipzig, Seemann, 1921-1924. 2v. index.
Biographies and analysis of the writings of major German art historians from the seventeenth century to the early twentieth century. Contents: volume 1, *Von Sandrart bis Rumohr*; volume 2, *Von Passavant bis Justi*. Bibliographies at the end of both volumes.

HANDBOOKS AND HISTORIES

656 Barasch, Moshe. **Theories of Art from Plato to Winckelmann.** New York, New York University Press, 1985. 394p. index. LC 84-19006.
 History of the attitudes towards art from antiquity to the beginning of the nineteenth century. Bibliographical footnotes.

657 Bazin, Germain. **Histoire de l'histoire de l'art de Vasari a nos jours.** Paris, Albin Michel, 1986. 653p. index. ISBN 2226027874.
 Comprehensive history of art history from Vasari to the present. Contents: I, Les prolégomènes; II, De l'histoire de l'art a la science d l'art; III, Voies et moyen; IV, Territoires; Au fil du temps. Bibliographical footnotes.

658 Dilly, Heinrich. **Kunstgeschichte als Institute. Studien zur Geschichte einer Disziplin.** Frankfurt am Main, Suhrkamp, 1979. 200p. index. LC 80-454053.
 History of the institutional aspects of art history in the German-speaking countries from the early nineteenth century to the 1970s. Contents: I, Geschichte der Kunstgeschichtsschreibung und neuere Wissenschaftsforschung; II, Kunstgeschichte: Geschichte der Kunst—Kunst in der Geschichte; III, Institutionalisierte Wissenschaft—kunstwissenschaftliche Institutionen. Bibliographical footnotes and selected bibliography, pp. 266-91.

659 Dittman, Lorenz. **Stil, Symbol, Struktur. Studien zu Kategorien der Kunstgeschichte.** Munich, Fink, 1967. 243p. LC 68-70543.
 Critical study of the methods and theories of stylistic, iconographic, and structural analysis. Contents: Stil: Riegl, Wölfflin; Symbol: Panofsky; Struktur: Sedlmayr; Susammenfassung und Ausblick. Extensive bibliography in the footnotes and selected bibliography, pp. 238-42.

660 Grinten, Evert van. **Enquiries into the History of Art-historical Writing; Studies of Art-historical Functions and Terms up to 1850.** Venlo, 1952. 152p. LC 53-31720.
 History of early writing on art history. First part presents quotations and excerpts with commentary: "in light of art historical functions and terms." Second part is an outline of the development of those functions and terms from the Middle Ages to 1850. Bibliographical index, pp. 131-50.

661 Hedicke, Robert. **Methodelehre der Kunstgeschichte, ein Handbuch für Studierende.** Strasbourg, Heitz, 1924. 301p. index.
 Comprehensive handbook on the methods of art historical research. Contents: Grundbegriffe und Grundsteinstellungen; Kunstgeschichte und Logik; Kunstgeschichtliche Methoden; Forschung und Darstellug; Denkmalgeschichtliche Methode; Bildkünstlerische Methode; Technische Methode; Geistesgeschichtliche Methode; Darstellung; Bildungsgang des Kunsthistorikers; Konservator und Museumbeamter; Kenner, Sammler, Künstler; Händler, Journalist; Geschichte der Kunstgeschichte; Allgemeine Kunstgeschichte; Ornamentgeschichte. Bibliography, pp. 277-92.

662 Heidrich, Ernst. **Beiträge zur Geschichte und Methode der Kunstgeschichte.** Basel, B. Schwabe, 1917. 109p. Reprint: Hildesheim, Olms, 1968.
 Early attempt to formulate a general methodology for art history, especially important for its criticism of the structuralist analysis of style by Alois Riegl (710).

663 Kultermann, Udo. **Geschichte der Kunstgeschichte. Der Weg einer Wissenschaft.** Vienna, Econ, 1966. 477p. illus. LC 67-7513.
 Survey history of art history from Vasari to the 1960s. Portraits of many major art historians. Bibliographical footnotes.

664 Lützeler, Heinrich. **Kunsterfahrung und Kunstwissenschaft. Systematische und entwicklungsgeschichtliche Darstellung und Dokumentation des Umgangs mit der bildenden Kunst.** Freiburg, K. Alber, 1975. 3v. illus. index. (Orbis Academicus, Problemgeschichte der Wissenschaft in Dokumenten und Darstellungen, Band 1/15. LC 76-455638.
By far the most comprehensive and perceptive study of art historiography. Excerpts from a vast spectrum of opinion in art history and theory are analyzed in detail with close references to criticism and opposing views. Volumes one and two contain the text, volume three bibliography, indexes and plates. Contents: I, Die Ausserwissenschaftliche Kunsterfahrung (1, Die unmittelbare Erfahrung von Kunst; 2, Die dichterische Erfahrung von Kunst; 3, Die Kunstkritik); II, Die Vorwissenschafliche Kunsterfahrung (1, Reisebücher; 2, Künstlerviten; 3, Chroniken); III, Künstler über Kunst (1, Praxis; 2, Theoria; 3, Selbstbildnis); IV, Kunsterfahrung in der Wissenschaft Überblicke (1, Methode; 2, Systeme der Kunstwissenschaft; 3, Geschichte der Kunstwissenschaft; 4, Selbstdarstellung von Kunsthistorikern; 5, Entwürfe zur Kunstwissenschaft); V, Grundlagen der Kunstwissenschaft (1, Kunstwissenschaft als Kennen; 2, Kunstwissenschaft als Erklären; 3, Kunstwissenschaft als Verstehen; 4, Die Beschreibung von Kunstwerken; 5, Die Bewertung von Kunstwerken); VI, Die Heteronome Grundlegung der Kunstwissenschaft (1, Theologie; 2, Philosophie; 3, Pyschologie; 4, Pyschologie des Unbewussten; 5, Soziologische Kunstgeschichte; 6, Mathematik und Naturwissenschaften); VII, Die Autonome Grundlegung der Kunstwissenschaft (1, Motiv; 2, Zwischen Motiv und Form; 3, Form; 4, Werkstoff; 5, Das Kunstwerk als Einheit und Ganzheit); VIII, Die Offenheit des Kunstwerkes (1, Bezugssysteme; 2, Die Unabgeschlossenheit des Kunstwerkes; 3, Kunstgeschichte als Geistesgeschichte; 4, Kunstwissenschaft und Geschichtswissenschaft; 5, Kunstwissenschaft und Sozologie; 6, Der grosse Künstler; 7, Landschaft und Stamm/Volk und Nation; 8, Die Kunst der Welt).

665 Podro, Michael. **The Critical Historian of Art.** New Haven, Yale University Press, 1982. 257p. illus. index. LC 82-4934.
History and analysis of the development of German theory of art history from 1827 to 1927. Contents: I, The Project; II, Hegel; III, Schnaase's Prototype of Critical History; IV, From Semper to Göller; V, Riegl; VI, Wölfflin and Classic Art; VII, The *Principles* and its Problems; VIII, From Springer to Warburg; IX, Panofsky; X, The Tradition Reviewed. Bibliographical footnotes and select bibliography, pp. 251-54.

666 Roskill, Mark. **What Is Art History?** New York, Harper, 1976. 192p. illus. index. LC 75-34872.
Introduction to art historical methods using examples from the history of painting to demonstrate the tasks confronting stylistic analysis. Contents: The Attribution of Paintings: Some Case Histories; Collaboration between Two Artists: Masaccio and Masolino; Deciding the Limits of an Artist's Work: Piero della Francesca; Cutting through Mystery and Legend: Giogione; Reconstructuring How Works Were Displayed: Raphael's Tapestries in the Sistine Chapel; A Forgotten Artist Rediscovered: Georges de la Tour; Disguised Meaning in Pictures: Vermeer and Velasquez; Forgery and Its Detection: the Hand of Hans van Meegeren; Understanding a Modern Picture: Picasso's Guernica; Epilogue: the Art Historian Today. Bibliography, pp. 183-88.

667 Salerno, Luigi. "Historiography" in: **Encyclopedia of World Art.** New York, McGraw-Hill, 1959-1968, v. 7, pp. 507-59.
Survey of the history of the methods and theories of art history from antiquity to modern times.

668 Tietze, Hans. **Die Methode der Kunstgeschichte, ein Versuch.** Leipzig, Seemann, 1913. 489p. illus. index.
Comprehensive handbook of art historical methods reflecting the *Geistesgeschichte* of the great Viennese school of art history. Bibliographical footnotes.

ANTHOLOGIES

669 Broude, Norma, and Mary D. Garrard. **Feminism and Art History; Questioning the Litany.** New York, Harper & Row, 1982. 358p. illus. index. LC 81-48062.
 Selected essays on the role of women in the history of art and on the Feministic critique of art history. Notes on the contributors, pp. 347-50

670 Bryson, Norman, ed. **Calligram: Essays in New Art History from France.** New York, Cambridge University Press, 1988. 183p. illus. index. LC 87-21814.
 Collected essays by French scholars, most applying the theories of semiology to various topics in art history. Contents: 1, Art as Semiological Fact by Jan Mukarovsky; 2, Time and the Timeless in Quattrocento Painting by Yves Bonnefoy; 3, Giotto's Joy by Julia Kristeva; 4, The Trompe-l'oeil by Jean Badrillard; 5, Towards a Theory of Reading in the Visual Arts; Poussin's *The Arcadian Shepards*; 6, *Las Meninas* by Michel Foucault; 7, The World as Object by Roland Barthes; 8, Ambrosia and Gold by Michel Serres; 9, In Black and White by Jean-Claude Lebensztejn; 10, Turner Translates Carnot by Michel Serres; 11, The Wisdom of Art by Roland Barthes. Not every essay is new; Foucault's essay was published in 1932 and Roland Barthes, the Dean of French New Art History, has been dead for nearly a decade.

671 Kleinbauer, W. Eugene. **Modern Perspectives in Western Art History. An Anthology of 20th-century Writings on the Visual Arts.** New York, Holt, Rinehart and Winston, 1971. 528p. illus. LC 73-153995.
 Anthology of writings by twentieth-century art historians which express a distinctive theory or method of research. Contents: Introduction: What is Art History?, Determinants of Art Historical Investigation, Genres of Modern Scholarship; Intrinsic Perspectives: Connoisseurship, Syntactical Analysis, Formal Change, Period Distinctions, Documentary Studies in Architectural History, Iconography and Iconology; Extrinsic Perspectives: Art History and Psychology, Art History, Society, and Culture, Art History and the History of Ideas. Writings included are by R. Ofner, A. Riegl, H. Focillon, H. Wölfflin, R. Wittkower, E. Panofsky, K. Weitzmann, K. Lehmann, E. H. Gombrich, E. Kris, F. Hartt, D. D. Egbert, F. Antal, R. Krautheimer, M. Dvorak, and G. Ladner. Each text is preceded by a descriptive and analytical essay. See also the author's *Research Guide to the History of Western Art* (5) for a more comprehensive analysis of the trends in art historical research.

672 Rees, A. L., and Frances Borzello, eds. **The New Art History.** Atlantic Highlands, N.J., Humanities Press, 1988. 173p. LC 87-2997.
 Collected essays by a group of British scholars (most trained in or working in the newer universities and polytechnical schools in Britain) that purport to challenge and discredit "traditional" art history which the authors see as expressions of cultural elitism. Most of the essays are concerned with new methodologies based on psychology (post-Freudian psychoanalysis of Jacques Lacan), linguistic theories (semiotics theories of Saussure), Feminism, and Marxist concepts of social change. Bibliographical footnotes accompany the essays.

673 Sypher, Wylie, ed. **Art History: An Anthology of Modern Criticism.** New York, Random House, 1963. 428p. LC 63-15044. Reprint: Gloucester, Mass., Peter Smith, 1975.
 Excerpts from the following: Franz Boas, *Primitive Art*; Waldemar Deonna, *Primitivism and Classicism*; Rhys Carpenter, *Greek Sculpture*; Erwin Panofsky, *History of the Theory of Human Proportions*; Ernest Will, *Greco-Roman Cult-relief*; Otto Demus, *The Methods of the Byzantine Artist*; Jurgis Baltrusaitis, *Ornamental Stylistic in Romanesque Sculpture*; Wolfgang Schoene, *On Light in Painting*; Dagobert Frey, *Gothic and Renaissance*; Bernard Berenson, *Italian Painters of the Renaissance*; John White, *The Birth and Rebirth of Pictorial Space*; R. Wittkower, *Architectural Principles in the Age of*

Humanism; Heinrich Wölfflin, *Classic Art* and *Principles of Art History*; Walter Fried-länder, *Mannerism and Antimannerism in Italian Painting*; Henri Focillon, *The Life of Forms in Art*; Ernst Kris, *Psychoanalytic Exploration in Art*; Anton Ehrenzweig, *The Psychoanalysis of Artistic Vision and Hearing*; Francis Klingender. *Art and the Industrial Revolution*; Nikolaus Pevsner, *Academies of Art Past and Present*; Pierre Francastel, *The Destruction of a Plastic Space*; Jean Cassou, *The Nostalgia for a Métier*; Rudolf Arnheim, *Accident and the Necessity of Art.*

MAJOR STUDIES IN ART HISTORIOGRAPHY

674 Ackerman, James S., and Rhys Carpenter. **Art and Archaeology.** Englewood Cliffs, N.J. Prentice-Hall, 1963. 241p. LC 63-12267. (In the series "The Princeton Studies: Humanistic Scholarship in America.")
 Essay evaluating the methods, progress and present state (1960) of art history (Ackerman) and archaeology (Carpenter) in America. Bibliography, pp. 230-31.

675 Arnheim, Rudolf. **Visual Thinking.** Berkeley, University of California Press, 1969. 345p. illus. index. LC 71-76335.
 Analysis of visual perception based on the Gestalt psychology of Wolfgang Köhler. Author tries to establish the unity of thought and perception. Bibliographical footnotes.

676 Badt, Kurt. **Kunsttheoretische Versuche. Ausgewählte Aufsätze.** Cologne, DuMont Schauberg, 1968. 180p. illus. index.
 Contents: Einfachheit in der Malerei; Artifex vates und Artifex rhetor; Der Gott und der Künstler; Feiern durch Rühmung; Der kunstgeschichtliche Zusammenhang. For a study of Badt's position in art historiography see L. Dittmann, "Die Kunsttheorie Kurt Badts," in: *Zeitschrift für Asthetik und Allgemeine Kunstwissenschaft* 16 (1971).

677 Bätschmann, Oskar. **Einführungen in die kunstgeschichtliche Hermeneutik.** Darmstadt, Wissenschaftliche Buchgesellschaft, 1984. 185p. illus. index.
 Attempt to establish the outlines of an holistic approach to the interpretation of art history. Emphasis is on painting and the relationship between earlier (Renaissance and Baroque) works and works of twentieth century art. Bibliographical footnotes.

678 Baxandall, Michael. **Pattern of Intention.** New Haven, Yale University Press, 1985. 147p. LC 85-27621.
 Based on lecturers at the University of California, Berkeley, in 1982. Study of the mental assumptions made in the description of works of art. Contents: Language and Explanation; The Historical Object: Benjamin Baker's Forth Bridge; Intentional Visual Interest: Picasso's Portrait of Kahnweiler; Pictures and Ideas: Chardin's A Lady Taking Tea; Truth and Other Cultures: Piero della Francesca's Baptism of Christ. Bibliographical footnotes.

679 Berenson, Bernard. **Rudiments of Connoisseurship. Study and Criticism of Italian Art.** New York, Schocken, 1962. 152p. illus. index. LC 62-18157.
 Eight articles by Berenson chosen by the author to best represent his methods of attribution and dating of works of Italian Renaissance painting. Appended is an essay: "Rudiments of Connoisseurship" in which Berenson summarizes his methods under headings: Contemporary Documents—the Document of Art; Tradition; The Works of Art—Selection, Isolation of Characteristics, Morphology (Cranium, Eyes, Ears, Mouth, the Nude, Hands, Drapery, Animals, Landscape, Colours, Light and Shade, Time Limit of Tests, Test versus Quality). See also the author's *Aesthetics and the History in the Visual Arts* (New York, Pantheon, 1948. 260p. Reprint: St. Clair Shores, Mich., Scholarly Press, 1979).

680 Bernheimer, Richard. **Nature of Representation: A Phenomenological Inquiry.** New York, New York University Press, 1961. 249p. LC 61-8057.
Important investigation of the nature of representation in the visual arts. Bernheimer sets out to prove that representation is governed by an inner structure based on the idea of substitution. Contents: The Problem; Theories of Representation; Representation and Sign Function; Substitution, Vectoral and Adaptive Substitutes; Replicas; Categorical Representation; Legal Representation; Mimetic Representation; The Rationale of Mimetic Representation; Subjects and Motifs; Subject Functions: Allusion, Description, Explanation, Commentary; Substitution in Art; Similarity and Recognition.

681 Bialostocki, Jan. **Stil und Ikonographie. Studien zur Kunstwissenschaft.** Dresden, VEB Verlag der Kunst, 1966. 237p. illus. (Fundusbücher, 18). Reprinted: Cologne, DuMont, 1981 (Dumont Taschenbücher, 113). LC 67-113863.
Essays by a leading Polish art historian on the methods of stylistic and iconographic analysis in the history of art. Contents: Das Modusproblem in den bildenden Künsten; Manierismus und Volkssprache in der polnischen Kunst; Der Manierismus zwischen Triumph und Dämmerung; Barock: Stil, Epoche, Haltung; Die Rahmenthemen und die archetypischen Bilder; Ikonographie Forschungen zu Rembrandt's Werk; Romantische Ikonographie; Van Goghs Symbolik; Kunst and Vanitas.

682 Buschor, Ernst. **On the Meaning of Greek Statues.** Amherst, University of Massachusetts Press, 1980. 95p. illus. LC 79-4697.
Translation of *Vom Sinn der griechischen Standbilder* (Berlin, Mann, 1977). Major contribution to the theory of periodicity. Basing his analysis on the evolution of ancient Greek sculpture, Buschor postulates six stages in the development of art.

683 Dvorák, Max. **Kunstgeschichte als Geistesgeschichte; Studien zur abendländischen Kunstentwicklung.** Munich, Piper, 1924. 276p. illus. English translation: **The History of Art as the History of Ideas.** London, Routledge & Kegan Paul, 1984. 114p. illus. ISBN 071009969X.
Essays and lectures from the last years of Max Dvorák's (1874-1921) influential career as the leader of the Viennese school of art history. Although they focus on particular topics, these works together give a full exposition of Dvorák's method of interpreting art history in light of the history of ideas (*Geistesgeschichte*). Content: Katakombenmalerei. Die Anfänge der christlichen Kunst; Idealismus und Naturalismus in der gotischen Skulptur and Malerei; Schongauer und die Niederländische Malerei; Dürers Apokalypse; Über die Geschichtlichen Voraussetzungen des niederländischen Romanismus; Pieter Bruegel d. A.; Über Greco und den Manierismus. Bibliographical footnotes. For a study of Dvorák's position in art historiography see: D. Frey, "Max Dvorák's Stellung in der Kunstgeschichte," in: *Jahrbuch für Kunstwissenschaft* (Vienna, 1921) and Sedlmayr (714).

684 Ettlinger, Leopold D. **Art History Today.** London, H. K. Lewis, 1961. 22p.
Lecture delivered at the University College London. Brief history of art history from Vasari to 1960. The author recommends the integration of art history with history of ideas and the pursuit of deeper understanding of the language of visual forms after the manner of Gombrich (691).

685 Fischer, Ernst. **The Necessity of Art, a Marxist Approach.** Baltimore, Pelican, 1963. 234p. illus. index.
Marxist interpretation of the history of art with emphasis on the modern period and with the interrelationship between art and poetry. Contents: The Function of Art; The Origins of Origins; Art and Capitalism; Content and Form; The Loss and Discovery of Reality.

686 Focillon, Henri. **The Life of Forms in Art.** 2d English ed. New York, Wittenborn, 1948. 94p. illus. LC 48-5278.
The most important French contribution to the historiography of art history. Focillon presents a formalistic interpretation of artistic change that puts emphasis on the

influence of materials and techniques. Contents: The World of Forms; Forms in the Realm of Space; Forms in the Realm of Matter; Forms in the Realm of Mind; Forms in the Realm of Time; In Praise of Hands. Focillon applied his idea of change most fully in the history of medieval art and architecture, see his *Art of the West in the Middle Ages* (968) with informative introduction by Jean Bony.

687 Frankl, Paul. **Das System der Kunstwissenschaft.** Brünn, Rohrer, 1938. 1063p. illus. index.
Important attempt to formulate a comprehensive system for interpretation of art history. Product of the influential Viennese school of art history.

688 Frey, Dagobert. **Die Entwicklung nationaler Stile in der mittelalterlichen Kunst des Abendlandes.** Darmstadt, Wissenschaftliche Buchgesellschaft, 1970. 74p.
Reprint of article that appeared in *Deutsche Vierteljahrsschrift für Literaturwissenschaft und Geistesgeschichte* 16 (1938), pp. 1-74. Important study of the development of national styles in Western European art and architecture during the Middle Ages. For an application of the author's ideas to the development of a single national style see *Englisches Wesen in der bildenden Kunst* (1613).

689 Friedländer, Max J. **On Art and Connoisseurship.** London, Cassirer, 1942. 284p. illus. index. Reprint: New York, Beacon Hill, 1960.
Collection of essays by a master connoisseur. An excellent complement to Berenson, for Friedländer specialized in northern European art of the fifteenth and sixteenth centuries. Topics covered include: formal qualities of color, light, size and scale, perspective, questions associated with authorship, such as individuality and type, genius and talent, copies and forgeries, and issues of technique and materials, such as study of drawings, use of photography, and restorations, and questions peculiar to special types, such as genre, still life, landscape, and portraiture. See also the author's: *Reminiscences and Reflections* (Greenwich, Conn., New York Graphic Society, 1969. 109p. illus. LC 68-25741).

690 Gablik, Suzi. **Progress in Art.** New York, Rizzoli, 1976. 192p. illus. index. LC 76-62549.
Study of process of change in art as a problem in cultural dynamics that combines elements of the concepts of human development of Jean Piaget, cultural development of Claude Levi-Strauss and theories of visual perception of Ernst Gombrich. Bibliography, pp. 180-82.

691 Gombrich, Ernst H. **Art and Illusion: A Study in the Psychology of Pictorial Representation.** 5th ed. New York, Pantheon, 1977. (Bollingen Series XXXV, 5). LC 78-303279.
Major study of the relationship between art history and psychology. The author maintains that all art is conceptual and is based on the artist's experience of other works of art. Change in art is the result of interaction between the artist's conception of past traditions of art and nature. Contents: The Limits of Likeness: From Light into Painting, Truth and the Stereotype; Function and Form: Pygmalion's Power, Reflections on the Greek Revolution, Formula and Experience; The Beholder's Share: The Image in the Clouds, Conditions of Illusion, Ambiguities of the Third Dimension; Invention and Discovery: The Analysis of Vision in Art, The Experiment of Caricature, From Representation to Expression. Bibliographical footnotes.

692 Grinten, E. F. van der. **Elements of Art Historiography in Medieval Texts.** The Hague, Nijhoff, 1969. 152p.
Study of the language used in the Middle Ages to describe works of art and architecture. Contents: Approaches of the Concept of Style; The Hand of the Artist; Personality and Work of the Artist; Awareness of the History of Art; The Idea of Progress; The Concepts Old and New; Seeing and Describing Works of Art; Comparisons. Appendix has 302 quotes from medieval Latin texts referred to in the text.

693 Hadjinicolaou, Nicos. **Art History and Class Struggle.** London, Pluto Press, 1978. 206p. illus. index.

Published in 1973 as *Histoire de l'art et lutte des classes* (Paris, Maspero). Extreme Marxist interpretation of the history of art. Using the concepts of Louis Althusser, the author attempts to prove that the history of art is the history of the visualization of ideology. Bibliographical footnotes.

694 Hauser, Arnold. **The Philosophy of Art History.** New York, Knopf, 1959. 410p. LC 58-10966.

Discussion of the theoretic basis for art history from standpoint of the author's idea of the sociology of art history. Intended as a basis for his *Social History of Art* (New York, Knopf, 1951. 2v.) Contents: The Scope and Limitations of a Sociology of Art; The Sociological Approach: The Concept of Ideology in the History of Art; The Psychological Approach: Psychoanalysis and Art; The Philosophical Implications of Art History; Art History without Names; Educational Strata in the History of Art; Folk Art and Popular Art; Conflicting Forces in the History of Art: Originality and Conventions. See also the author's *The Sociology of Art* (Chicago: University of Chicago Press., 1982. 776p. illus. LC 81-13098).

695 Huber, Ernst W. **Ikonologie zur anthropologischen Grundlegung einer Kunstwissenschaftlichen Methode.** Mittenwald, Mäander Kunstverlag, 1978. 189p. index. (Studia Iconologia, Band 2). LC 80-488317.

Attempt to suggest an anthropological (representation as analogy to the human figure) dimension behind the subject matter of art. Contents: Einführung in das Leibproblem; Der handlungsbezogene Leib; Der anschauungsbezogene Leib; Der gefühlsbezogene Leib; Die Ganzheit des Leibes; Einführung des anthropologischen Raumes; Der Raum des handlungsbezogenen Leibes; Der Raum der gefühlsbezogenen Leibes; Der Raum des anschauungsbezogenen Leibes; Der anthropologische Raum des Kunstwerks; Wissenschaft als Konstruktion der Anschauung und Kunstgeschichte al Meta-Anschauung; Kriterien des Handlungsbezugs in der Kunstgeschichte; Kriterien des Gefühlsbezugs in der Kunstgeschichte; Kriterien des Anschauungsbezugs als Sinnmoment in der Kunstgeschichte; Kriterien des Anschauungsbezugs als Sinnganzheit in der Kunstgeschichte; Prospekt einer anthropologischen Ikonologie. Bibliography, pp. 175-89.

696 Kaemmerling, Ekkehard, ed. **Ikonographie und Ikonologie. Theorien-Entwicklung-Probleme.** 3d ed. Cologne, DuMont, 1984. 521p. illus.

Anthology of major texts on the theory of iconographical and iconological analysis. Authors included: Jan Bialostocki; Karl Künstle; G. J. Hoogewerff; William S. Heckscher; Edgar Wind; Erwin Panofsky; Rudolf Wittkower; Erik Forssman; Michael Biebmann; Lorenz Dittmann; Otto Pächt; Ernst Gombrich; David Manning; Oskar Bätschmann. Appendix: Die Grundlagenprobleme bei der ikonologischen Bedeutungsanalyse bildender Kunst; Die unterschiedlichen Bedeutungen des Begriffs "Ikonologie"; Panofskys Methode der Bedeutungsanalyse gegenständlicher Kunst im Aufbau und ihren Entwicklungsstadien. Bio-bibliographies of the authors.

697 Klingender, Francis D. **Marxism and Modern Art; An Approach to Social Realism.** London, 1943. 52p. Reprint: London, Lawrence and Wishart, 1975. LC 75-329995.

Marxist attack on the formalistic strain in modern art (Roger Fry) and advocate of social realism. Bibliography, pp. 50-52, with annotations.

698 Ladner, Gerhart. **Ad Imaginem Dei: The Image of Man in Mediaeval Art.** Latrobe, Pa., Archabbey Press, 1965. 165p. illus. LC 65-28205.

Study of the relationship between the depiction of the human figure in medieval art and development of the theological idea of man's image-likeness with God. Although a brief work, originally delivered as a lecture, *Ad Imaginem Dei* offers a good introduction to the methods of art history as *Geistesgeschichte* that characterized the Viennese school under Max Dvorák (683).

699 Lee, Rensselaer W. **Ut pictura poesis: The Humanistic Theory of Painting.** New York, Norton, 1967. 79p. illus.
 Reprinted from the *Art Bulletin* 22 (1940). Attempt to define a "humanistic theory of painting," which the author sees as the chief force behind the development of European painting from the fifteenth to the eighteenth centuries.

700 Morelli, Giovanni. **Italian Painters; Critical Studies of their Works.** London, John Murray, 1892-1893. 2v.
 One of the foundation stones in the method of connoisseurship. Morelli pursued the question of authorship and authenticity in Renaissance painting by careful examination and description of the forms of the figures. He is most famous for his emphasis on anatomical details as ears, nostrils, fingernails, etc., as important clues to authorship. But Morelli also developed a thorough method of investigating the characteristic appearance of basic forms such as composition, drapery and expression. Morelli's methods were refined and developed especially by Bernard Berenson (679).

701 Munro, Thomas. **Evolution in the Arts, and Other Theories of Cultural History.** Cleveland, Cleveland Museum of Art, 1963. 561p. index. LC 63-12488.
 Examination of the question of change in art from the standpoint of cultural history influenced by social and psychological forces. Index of concepts and writers in the field of the theory of cultural history. See also the author's "Style in the Arts: A Method of Stylistic Analysis" *Journal of Aesthetics and Art Criticism* V (1946), pp. 128-58.

702 Panofsky, Erwin. "The History of Art as a Humanistic Discipline," in: **Meaning in the Visual Arts: Papers in and on Art History.** New York, Overlook Press, 1974.
 First published in 1940 in T. M. Greene, ed., *The Meaning of the Humanities* (Princeton, Princeton University Press). Superb introduction to the author's humanistic approach to the theory of art history.

703 Panofsky, Erwin. **Idea; a Concept in Art Theory.** Columbia, University of South Carolina Press, 1968. 268p. illus. Reprint: New York, Harper, 1974. ISBN 0064300498.
 Translation of: *Idea: ein Beitrag zur Begriffsgeschichte der älteren Kunsttheorie*, 2d ed. (1960). Study of the "beautiful" from antiquity through the Renaissance. Contents: Antiquity; The Middle Ages; The Renaissance; Mannerism; Classicism; Michelangelo and Dürer. Appendices with excerpts from Lomazzo, Ficino, and Bellori. A classic study in the humanistic tradition of art historical theory. For the position of Panofsky in art historiography see: Renate Heidt, *Erwin Panofsky—Kunsttheorie und Einzelwerk* (Cologne, Vienna, Bohlaus, 1977) and Michael Ann Holly, *Panofsky and the Foundations of Art History* (Ithaca, N.Y., Cornell University Press, 1984. 267p. LC 84-45143).

704 Panofsky, Erwin. **Studies in Iconology. Humanistic Themes in the Art of the Renaissance.** New York, Harper, 1962. 262p. illus. index.
 First published in 1939 by Oxford University Press. Based on six Mary Flexner lectures. The introduction is a revised version of the author's article: "Zum Problem der Beschreibung und Inhaltsdeutung von Werken der bildenden Kunst," published in *Logos* 21 (1932), and it explains the author's method of iconological analysis. The remaining chapters are: The Early History of Man in Two Cycles of Paintings by Piero di Cosimo; Father Time; Blind Cupid; The Neoplatonic Movement in Florence and North Italy; The Neoplatonic Movement and Michelangelo. This edition is prefaced by notes by the author commenting on subsequent scholarship bearing up the subjects of the six lectures. Comprehensive bibliography, pp. 235-50.

705 Passarge, Walter. **Die Philosophie der Kunstgeschichte in der Gegenwart.** Berlin, Junker und Dünnhaupt, 1930. 127p. illus. Reprint: Mittenwald, Mäander Kunstverlag, 1981. ISBN 388219121X
 Important formalist interpretation of art historiography. Contents: I, Kunstgeschichte und Kunsttheorie; II, Kunstgeschichte als Formgeschichte und das Problem der

Grundbegriffe; III, Kunst und Weltanschauung; IV, Kunstgeschichte als Kultur- und Geistesgeschichte; V, Die Universalgeschichte des Stiles; VI, Der Rhythmus der Lebensalter und der Generationen. Reprint edition has a "Nachwort" by Ernst W. Huber that evaluates Passarge's place in the history of art historiography.

706 Pieper, Paul. **Kunstgeographie, Versuch einer Grundlegung.** Berlin, Triltsch and Huther, 1936. 116p. illus. (Neue deutsche Forschungen. Abt. Kunstwissenschaft und Kulturgeschichte, v. 1). LC 38-12182.

Based on the author's dissertation. First attempt to formulate the methods of art geography that sought to determine regional characteristics of art that persist in time and encompass differences between schools and individual artists. For a modern evaluation of art historical geography see R. Haussherr, "Überlegungen zum Stand der Kunstgeographie," *Rheinische Vierteljahrsblätter* 30 (1965).

707 Pinder, Wilhelm. **Das Problem der Generation in der Kunstgeschichte Europas.** Berlin, Frankfurter Verlags-Anstalt, 1926. 156p. illus.

Important study of the effect of generation on the history of art. The author demonstrates that at any given time there are several styles corresponding to the generation of the particular artists. Contents: Das Problem der geschichtlichen Gleichzeitigkeit; Entwurf einer Kunstgeschichte nach Generationen; Schlüsse aus der Kunstgeschichte nach Generationen; Künste als Generationen; Das Generalproblem in verschiedenen Künsten; Das Gesetz des Rhythmus und sein Sinn.

708 Plekhanov, Georgi. **Art and Society.** New York, Critics Group, 1937. 93p.

The first work of Marxist art history, first published in Russian in 1918. Concentrates on painting and drama in eighteenth century France. Bibliographical footnotes.

709 Praz, Mario. **Mnemosyne: The Parallel between Literature and the Visual Arts.** Princeton, Princeton University Press, 1970. 261p. illus. index. LC 68-20876.

Based on the A. W. Mellon lectures delivered at the National Gallery in Washington in 1967. Provocative study of the relationship between painting, sculpture, and architecture and literature. Although the author's scope ranges from antiquity to the early twentieth century, the focus is on the period between 1400 and 1800. Contents: Ut Pictura Poesis; Time Unveils Truth; Sameness of Structure in a Variety of Media; Harmony and the Serpentine Line; The Curve and the Shell; Telescopic and Photoscopic Structure; Spatial and Temporal Interpenetration. Bibliographical footnotes.

710 Riegl, Alois. **Historische Grammatik der bildenden Künste.** Graz, Böhlaus, 1966. 317p. illus. index.

Riegl's theory of art history as the unfolding of innate forces which he called *Kunstwollen* is, perhaps, the single most important influence in the historiography of art history. However, he exercised this influence through published works of a specialized nature (e.g., *Spatrömische Kunstindustrie*, entry 944) and lectures at the University of Vienna. Published here are the detailed notes by Riegl to the lectures he delivered in 1899 and a booklength manuscript written by Riegl on the same theme in 1897/1898. Both provide a synthesis and elaboration of Riegl's approach to art history. For analysis and critique of Riegl see Dittmann (659), Heidrich (662), Podro (665), and Sedlmayr (714).

711 Schapiro, Meyer. "Style," in: **Anthropology Today: An Encyclopedic Inventory.** Chicago, University of Chicago Press, 1953, pp. 287-312.

Important essay on the problems of style history.

712 Schapiro, Meyer. **Words and Pictures: On the Literal and the Symbolic in the Illustration of a Text.** The Hague, Mouton, 1973. (Approaches to Semiotics, 11). LC 73-176481.

Study of mostly Old Testament illustrations using the methods of semiotics. Contents: The Artist's Reading of a Text; Theme of State and Theme of Action; Frontal and Profile as Symbolic Forms. Bibliographical footnotes.

713 Sedlmayr, Hans. **Art in Crisis.** Chicago, Henry Regnery Co., 1958. 266p. illus. index.
Translation of: *Verlust der Mitte—Die bildende Kunst des 19. und 20. Jahrhunderts als Symptom und Symbol der Zeit.* (Salzburg, Müller, 1948). Important analysis of western European art of the nineteenth and twentieth centuries using the structuralist model used by the author in his earlier works: *Die Architektur Borrominis* (Berlin, 1930) and *Die Entstehung der Kathedrale* (ARCH. 453). The author expresses a severe judgment against modern art for exercising a dehumanizing effect on culture.

714 Sedlmayr, Hans. **Kunst und Wahrheit. Zur Theorie und Methode der Kunstgeschichte.** Hamburg, Rowohlt, 1958. 211p. illus. index. Reprint: Mittenwald, Mäander Verlag, 1978.
Essays on the theory and methods of art history by the most prolific and controversial exponents of the Viennese school. Contents: Die Kunstgeschichte auf neuen Wegen; Kunstgeschichte als Stilgeschichte—Die Quintessenz der Lehren Riegls; Kunstgeschichte als Kunstgeschichte—Zur einer strengen Kunstwissenschaft; Kunstgeschichte als Geistesgeschichte; Probleme der Intepretation—Kunstwerk und Kunstgeschichte; Das Problem der Wahrheit—Bild und Wahrheit; Das Problem der Zeit—Die wahre und die falsche Gegenwart; Anhang: Zwei Beispiele zur Interpretation (Jan Vermeer, Johann Bernhard Fischer von Erlach); Über den Verfasser. Bibliography, pp. 204-05, lists major works in German.

715 Tietze, Hans. **Die Methode der Kunstgeschichte, ein Versuch.** Leipzig, Seemann, 1913. 489p. illus. index.
Comprehensive handbook of art historical methods marked by overemphasis on the importance of documentary evidence. Contents: I, Begriff und Wesen der Kunstgeschichte; II, Methodologie; III, Quellenkunde; IV, Kritik der mittelbaren Quellen und der Denkmäler nach Echtheit, Enstehungsort und Bestimmung des Urhebers; V, Affasung. Bibliographical footnotes.

716 Venturi, Lionello. **History of Art Criticism.** New York, Dutton, 1936. 345p. Reprint: New York, Dutton, 1964.
A standard history of art criticism from antiquity to the 1930s. Bibliography, pp. 355-83.

717 Wind, Edgar. **The Eloquence of Symbols: Studies in Humanist Art.** Ed. by Jaynie Anderson with a biographical memoir by Hugh Lloyd-Jones. Oxford, Oxford University Press, 1984. 135p. illus. index. LC 81-18719.
Collected essays, some published for the first time in English, by one of the chief spokesmen of Aby Warburg's iconological approach to meaning in art history. Contents: I, On Plato's Philosophy of Art; II, Warburg's Concept of *Kulturwissenschaft* and its Meaning for Aesthetics; III, Donatello's *Judith*. A Symbol of Sanctimonia; IV, The Subject of Botticelli's *Derelitta*; V, The Revival of Origen; VI, Platonic Justice designed by Raphael; VII, An Allegorical Portrait by Grünewald. Albrecht von Brandenburg as St. Erasmus; VIII, Aenigma termini. The Emblem of Erasmus of Rotterdam; IX, The Christian Democritus; X, Platonic Tyranny and the Renaissance Fortuna. On Ficino's Reading of *Laws*, IV, 709a-712A; XI, Traditional Religion and Modern Art. Rouault and Matisse; XII, Yeats and Raphael. The Dead Child on a Dolphin; Appendix: On a Recent Biography of Warburg; The Published Writings of Edgar Wind.

718 Wölfflin, Heinrich. **Principles of Art History; the Problem of the Development of Style in Later Art.** London, Bell, 1932. Reprint: New York, Dover, 1950. LC 50-4154.
One of the most influential works on the theory of artistic change. Sets out in integrated and slightly revised form the author's theory of inexorable movement of style from classic to baroque, which he introduced in *Renaissance und Barock* (Munich, Ackermann, 1888); translated as *Renaissance and Baroque* (London, Collins, 1964) and *Classic Art* (1213). Wölfflin also applied his theory of stylistic change to the differences in geography

in his: *The Sense of Form in Art* (1214). For insight into the personality of Wölfflin see: *Heinrich Wölfflin 1864-1945. Autobiographie, Tagebücher und Briefe.* (2d ed. Basel, Schwabe, 1984. 513p. illus. index. ISBN 3796508189). The literature on Wölfflin is large. For a recent appraisal with bibliography of the earlier literature see Joan Hart, *Heinrich Wölfflin, An Intellectual Biography* (Berkeley, University of California Press, 1981).

719 Worringer, Wilhelm. **Abstraction and Empathy: A Contribution to the Psychology of Style.** New York, International Universities Press, 1953. 144p. index.
 Translation of *Abstraktion und Einfühlung* (Munich, Piper, 1911). Fascinating study in the theory of artistic change which combines Riegl's idea of *Kunstwollen* with the psychological idea of empathy derived from Theodor Lipps, *Asthetische Faktoren der Raumanschauung* (Hamburg, Voss, 1891). Worringer sees two polar styles of geometrical/abstract and organic/empathetic in all of art history. In his *Form in Gothic* (1167) Worringer describes Gothic style as the product of the psychological *Kunstwollen* of Nordic man.

HISTORIES AND HANDBOOKS

8
PREHISTORIC AND PRIMITIVE ART

GENERAL WORKS

720 Adam, Leonhard. **Primitive Art.** New York, Barnes and Noble, 1963. 250p. illus. index. LC 64-6042.
Actually covers both prehistoric and primitive art of Africa, Asia, Oceania, Australia, and the arts of the American Indian. Introductory chapters cover primitive art and the artists of the West, primitive art and psychoanalysis, etc. Appendixes give a good annotated bibliography of general literature and a very useful section on primitive art in museums.

721 Christensen, Erwin O. **Primitive Art.** New York, Crowell, 1955. 384p. illus. index. LC 55-11109.
Survey of the arts of the primitive peoples of Africa and Alaska; the American Indian; the pre-Columbian societies of Central and South America, Oceania, and Australia; and the prehistoric art of Europe. Provides maps, a fair selection of plates, and a bibliography (pp. 367-76), which lists books and periodical articles chiefly in English.

722 Cossío, Manuel B., and José Pijoán y Soteras. **Arte de los pueblos aborigenes.** Bilbao, Spain, Espasa-Calpe, 1931. 526p. illus. index. (Summa Artis, Historia General del Arte, I).
Comprehensive survey of all of the arts of primitive peoples and certain prehistoric cultures, namely, pre-Columbian. Treats the art of children and the arts of Oceania, Melanesia, tribal Africa, and North American Indians—the last with special thoroughness. Brief bibliographies of books at the ends of chapters.

723 Kühn, Herbert. **Die Kunst der Primitiven....** Munich, Delphin, 1920. 240p. illus. index.
Survey of prehistoric and primitive art covering paleolithic and neolithic art of Europe, American rock pictures, European Bronze Age art, and the art of sub-Saharan Africa. Emphasis is on socioeconomic relationship between art and society. Bibliography of basic works in all languages (pp. 178-222).

724 Lommel, Andreas. **Prehistoric and Primitive Man.** New York, McGraw-Hill, 1966. 176p. illus. index. LC 66-15836.
Concise survey of the arts of prehistoric and primitive cultures in Europe, Asia, Indonesia, Oceania, the Americas, and Africa. Includes maps and a general reading list (pp. 171-72).

725 Pericot-Garcia, Luis, John Galloway, and Andreas Lommel. **Prehistoric and Primitive Art.** New York, Abrams, 1968. 340p. illus. index. LC 68-26827.

Handbook of European prehistoric art to the Bronze Age and the arts of the primitive societies of Africa, Oceania, and the American Indian. Excellent bibliography (pp. 326-33), which covers the major general works; numerous footnotes give reference to more specialized literature. Well illustrated.

726 Sydow, Eckhart von. **Die Kunst der Naturvölker und der Vorzeit....** Berlin, Propyläen, 1923. 569p. illus. index.

Covers prehistoric art of Europe, primitive art of Africa and Oceania, art of ancient America, and Germanic art of the migrations and Viking periods. General bibliography (pp. 551-58). Still a useful one-volume handbook of primitive and prehistoric art.

PREHISTORIC

727 Bandi, H. G., et al. **The Art of the Stone Age.** London, World, 1961. 242p. illus. index. LC 52-13999.

Covers paleolithic art in Europe, north and south Africa, and Australia. Balanced bibliography of general works and glossary of terms.

728 Brown, Gerard B. **The Art of the Cave Dweller: A Study of the Earliest Artistic Activities of Man....** London, Murray, 1928. 280p. illus. index.

Comprehensive survey of prehistoric art of Europe, with good coverage of the major cave painting sites. Cultural-historical emphasis. Bibliographical footnotes.

729 Cossío, Manuel B., and José Pijoán y Soteras. **El arte prehistórico europeo.** Bilbao, Spain, Espasa-Calpe, 1935. 592p. illus. index. (Summa Artis, Historia General del Arte, VI).

Comprehensive survey of the arts and artifacts of prehistoric Western cultures, from Neolithic to Celtic, and including Mycenaean and Minoan art and architecture. Brief lists of books in Western languages at the ends of chapters.

730 Giedion, Siegried. **The Eternal Present: The Beginnings of Art.** New York, Bollingen, 1962. 588p. illus. index. (Bollingen Series, XXXV, 6.1). LC 62-7942.

Influential study of prehistoric art; first presented as the 1957 Mellon lectures at the National Gallery in Washington. Chapters extensively treat the formalistic and symbolic qualities of "primeval art." List of works cited (pp. 552-62) is a fairly extensive list of books and periodical articles in all languages.

731 Grand, Paule M. **Prehistoric Art: Paleolithic Painting and Sculpture.** Greenwich, Conn., New York Graphic Society, 1967. 103p. illus. index. (Pallas Library of Art, v. III). LC 67-28690.

Pictorial survey of paleolithic art in Europe, Africa, and Australia. Well illustrated with plates, line drawings, and diagrams; also included are a useful selection of maps and a select but well-chosen bibliography (p. 101) of basic books in all languages.

732 Graziosi, Paolo. **Palaeolithic Art.** New York, McGraw-Hill, 1960. 278p. (text); 306p. (illus.) index. LC 59-13435.

Comprehensive and scholarly study of European paleolithic sculpture and painting. One chapter is an excellent introduction to the study of paleolithic art. Excellent selection of plates. Bibliography (pp. 221-36) is unclassified but is a thorough list of books and periodical articles. A standard handbook.

733 Hoernes, Moritz, and Oswald Menghin. **Urgeschichte der bildenden Kunst.** 3d ed. Vienna, Schroll, 1925. 864p. illus. index.

Comprehensive handbook-history of prehistoric art, chiefly in Europe, from Neolithic through La Tène periods. Thorough reference to specialized literature in the footnotes. Illustrated chiefly with line drawings. An old but classic history of European prehistoric art.

734 Kühn, Herbert. **Die Kunst Alteuropas.** 3d ed. Stuttgart, Kohlhammer, 1958. 251p. illus. index. LC 59-52274.

Concise history of art of Europe from the Ice Age through the early Middle Ages. Attempts to trace a continuous stylistic development from prehistoric through ancient and medieval times. Most useful for the earlier chapters on art up to the first millenium. Good classified bibliography (pp. 235-42), with mention of additional literature in the notes to the plates.

735 Laming-Emperaire, Annette. **La signification de l'art rupestre paléolithique; methodes et applications.** Paris, Picard, 1962. 424p. illus. index.

Important scholarly study of paleolithic art in Europe, expressing an influential opinion on the function of prehistoric art. Contents: I, L'art rupestre paléolithique; II, Hypothèses et théories sur la signification de l'art rupestre paléolithique; III, Une methode d'etude de la signification de l'art rupestre paléolithique et ses applications; IV, Documents. The last chapter offers a complete catalog of the major cave sites in France. Excellent annotated bibliography (pp. 360-94). A standard work.

736 Leroi-Gourhan, André. **The Dawn of European Art: An Introduction to Paleolithic Cave Paintings.** New York, Cambridge University Press, 1982. 77p. LC 81-21715.

Survey of paleolithic cave art of Europe by a leading authority. Contents: Technique, Form, Space, Animation and Time, The Message, The Actors, The Content of the Message. Brief bibliography, p. 77.

737 Leroi-Gourhan, André. **Treasures of Prehistoric Art.** New York, Abrams, 1967. 543p. illus. index. LC 67-22851.

Comprehensive study of and handbook for paleolithic art. Provides chronological tables, maps, lists of works of art that are reliably dated, list of cave sites, analysis of cave art by style, etc. General bibliography (p. 527) is followed by specialized bibliography, arranged by site (pp. 528-37). A standard work on paleolithic art; fully documented.

738 Maringer, Johannes, and Hans Georg Bandi. **Art in the Ice Age.** London, Praeger, 1953. 167p. illus. index.

Concise survey of paleolithic art in Europe. Bibliography (pp. 164-65) of major works.

739 Mellink, Machteld J., and Jan Filip. **Frühe Stufen der Kunst.** Berlin, Propyläen, 1974. 371p. illus. index. (Propyläen Kunstgeschichte, 13).

Comprehensive illustrated scholarly handbook of prehistoric art in Europe through the La Tène period, and in the eastern Mediterranean and the Near East until the emergence of Sumerian civilization. Also includes prehistoric art of North Africa. Text consists of essays by various European scholars; detailed notes to the excellent corpus of plates, with special bibliographic references. Chronological table and excellent classified bibliography of books and periodical articles in all languages (pp. 349-62). A standard handbook for prehistoric art.

740 Müller-Karpe, Hermann. **Das Vorgeschichte Europa.** Baden-Baden, Holle, 1968. 223p. illus. index. LC 74-497422.

Concise history of European prehistoric art. Provides a glossary, a chronological table, and a good, classified bibliography (pp. 194-99), which lists books and periodical articles in all languages. German edition of the series "Art of the World."

741 Nougier, Louis. **L'art préhistorique.** Paris, Presses Universitaires de France, 1966. 186p. illus. LC 67-72072.
 Survey of prehistoric art in Europe with a brief chapter on America and Africa. Good selection of plates; bibliography (pp. 185-86) lists books in all languages.

742 Powell, Thomas George E. **Prehistoric Art.** New York, Praeger, 1966. 284p. illus. LC 66-12991.
 Treats the art of prehistoric Europe through La Tène Celtic. Bibliography (pp. 263-69) lists only recent publications, chiefly those in English. Popular work for the general reader and beginning student.

743 Sandars, Nancy K. **Prehistoric Art in Europe.** Harmondsworth, Penguin, 1968. 350p. illus. index. (Pelican History of Art, Z30). LC 79-352957.
 Art of prehistoric Europe through La Tène Celtic. Good bibliography of general works and extensive bibliographical footnotes to specialized literature. A standard work on prehistoric art.

744 Sieveking, Ann. **The Cave Artists.** London, Thames and Hudson, 1979. 221p. (Ancient Peoples and Places, 93). LC 80-473767.
 Good survey of paleolithic cave painting, engraving, and sculpture. Includes decorated shelters as well as the more well-known underground sanctuaries. Select bibliography (pp. 211-14) is a good, classified bibliography of the important modern literature.

745 Torbrügge, Walter. **Prehistoric European Art.** New York, Abrams, 1968. 260p. illus. index. LC 68-28390.
 Concise history of prehistoric art in Europe from paleolithic times through La Tène. Well illustrated; provided with useful maps, chronological tables, and a bibliography (pp. 255-56) that lists major books in all languages.

746 Ucko, Peter J., and Andrée Rosenfeld. **Palaeolithic Cave Art.** New York, McGraw-Hill, 1967. 256p. illus. index. LC 66-16481.
 Survey of European and African prehistoric cave art, concentrating on painting but also reviewing sculpture, with emphasis on the function of prehistoric art. Chapter three summarizes past interpretations of paleolithic art; chapter four postulates ethnographic explanation for the function of cave art, together with a critical evaluation of the ideas of Leroi-Gourhan (737) and Laming (735). General and specialized literature covered in the notes (pp. 240-51).

747 Waage, Frederick O. **Prehistoric Art.** Dubuque, Iowa, W. C. Brown, 1967. 113p. illus. index. LC 67-22709.
 Survey of prehistoric art from paleolithic times through the Levant style of Spanish rock art. Bibliography (pp. 109-10) provides a short list of books in English. Designed as an inexpensive text for the beginning student.

PRIMITIVE

748 Anton, Ferdinand, Frederick J. Dockstader, Margaret Trowell, and Hans Nevermann. **Primitive Art. Pre-Columbian, North American Indian, African, Oceanic.** New York, Abrams, 1979. 526p. illus. index. LC 78-12164.
 Well-illustrated survey of the art and architecture of native peoples of Africa, Oceania, North and South America. The chapters on pre-Columbian art of middle and South America and the art of Oceania were first published in German in 1967. Classified bibliography of basic books, pp. 509-20.

749 Batterberry, Michael, and Ariane Ruskin. **Primitive Art.** New York, McGraw-Hill, 1972. 192p. illus. index. LC 72-2295.
 Pictorial survey of the arts of primitive Africa, Oceania, Australia, and pre-Columbian America. No bibliography.

750 Boas, Franz. **Primitive Art.** New York, Dover, 1955. 372p. illus. index.
 Reprint of 1927 edition. Conceptual study of primitive art, with emphasis on the art of the Northwest Coast Indians of America. Bibliography in the footnotes. An old but classic study.

751 Fraser, Douglas. **Primitive Art.** Garden City, N.Y., Doubleday, 1962. 320p. illus. index. LC 62-13342.
 Survey of the arts of the primitive cultures of Africa, Asia, Oceania, and America. The American section covers both the pre-Columbian civilizations of Central and South America and the arts of the North American Indian. Bibliography (pp. 313-16) is a good selection of the major works in this broad field.

752 Layton, Robert. **The Anthropology of Art.** New York, Columbia University Press, 1981. 227p. illus. index. LC 80-39919.
 Important study of primitive art from the standpoint of Anthropology. Contents: 1, The Art of Other Cultures (Primitive Art?, The Definition of Art, Art in Small-scale Societies, Aesthetics, Art and Art Imagery, Anthropologists and Ritual); Art and Social Life (Uncentralized Societies in West Africa, Bwami, Genealogical Fictions, Realization of Ideals Concerning Leadership, Art in Traditional Kingdoms); Art and Visual Communication (Australian Religion, Art and Expression, Visual Signifiers, Composition and Grammar); Style (Limits of the Imitation of Nature, Evaluation of Styles, Correspondences between Style and Mental Schemata); Creativity of the Artist (Sources of Creativity, Incentives to Continuity and Change, Individual Creativity in a Conservative Context: the Asmat, Individual Creativity in an Innovative Context: Nubian House Decoration). References (pp. 213-19) is an alphabetical list of major books.

753 Wingert, Paul S. **Primitive Art: Its Traditions and Styles.** New York, Oxford University Press, 1962. 421p. illus. index. LC 62-20161.
 Treats the arts of the primitive societies of Africa, Oceania, and the American Indian. Illustrated in black and white, with a selection of maps. Selected bibliography (pp. 387-94). A workmanlike handbook on the main aspects of primitive art.

9

PERIODS OF WESTERN ART HISTORY

ANCIENT

General Works

754 Amiet, Pierre. **Art in the Ancient World: A Handbook of Styles and Forms.** New York, Rizzoli, 1981. 567p. illus. LC 80-54673.
Illustrated handbook of ancient art and architecture in the Near East, Egypt, Greece, Etruria, and Rome. Brief introductory essay followed by line drawings of major works chronologically arranged in groups by medium. Brief bibliographies and glossary. Useful tool for students in survey courses.

755 Byvanck, Alexander W. **De Kunst der Oudheid....** Leiden, Brill, 1946-1965. 5v. illus. index. LC 46-2532.
Comprehensive Dutch history of art and architecture in the ancient world from Egypt to Mesopotamia through Rome. Well illustrated with plates, plans, and diagrams and provided with good bibliographies at the end of each volume. A respected history of ancient art.

756 Curtius, Ludwig. **Die Antike Kunst.** Berlin, Athenaion, 1923, 1938. Reprint: Hildesheim, Olms, 1959. 2v. illus. index.
Comprehensive history of the art and architecture of ancient Egypt, the ancient Near East, ancient Greece and Rome. Bibliographies are given at the end of each chapter. Once a standard handbook-history, it is still valuable for the force of the author's language and ideas. Original series: "Handbuch der Kunstwissenschaft."

757 Groenewegen-Frankfort, Henriette A., and Bernard Ashmole. **Art of the Ancient World.** New York, Abrams, n.d. 529p. illus. index. LC 77-113722.
Survey history of the art and architecture of the major civilizations of the ancient Mediterranean from ancient Egypt and Mesopotamia through Roman civilization. Has a brief bibliography of selected English language works (pp. 509-14), and the extensive footnotes give access to more specialized literature. Well illustrated. One of the best histories of ancient art in English.

758 Hausmann, Ulrich. **Handbuch der Archäologie im Rahmen des Handbuchs der Altertumswissenschaft.** Munich, Beck, 1969- . ISBN 340601447X.
Continuation and revision of (761). Contents: *Allgemeine Grundlagen der Archäologie. Befriff und Methode* (1969); Barthel Hrouda, *Vorderasien: I, Mesopotamien, Babylonien, Iran und Arabien* (1971); Guntram Koch and Hellmut Sichtermann, *Romische Sarkophage* (1982); Peter Zazoff, *Die antiken Gemmen* (1983); Werner Fuchs and Josef Floren, *Die griechische Plastik. Band 1: Die geometrische und archaische Plastik* (1987).

759 Huyghe, René, ed. **Larousse Encyclopedia of Prehistoric and Ancient Art.** London, Hamlyn, 1966. 415p. illus. index. LC 67-85568.

Collection of essays by French experts on various aspects of the arts of prehistoric and primitive man, plus the art and architecture of ancient Egypt, the ancient Near East, and Asia to 1000 A.D. Historical summaries are given at the end of each major section. Provides maps and chronology but no bibliography. For the general reader and beginning student.

760 Leroy, Alfred. **Évolution de l'art antique....** Paris, Horizons de France, 1945. 316p. illus.

Concise survey of ancient art, exclusive of architecture, from ancient Egypt and the Near East through late Roman. Chronological table, maps of art centers, and bibliography of basic books in all languages (pp. 307-16).

761 Otto, Walter, ed. **Handbuch der Archäologie, im Rahmen des Handbuchs der Alter tumswissenschaft....** Munich, Beck, 1939-1953. 4v. illus. index. (Handbuch der Altertumswissenschaft, 6.Abt.).

Comprehensive handbook of ancient art and archaeology. Volume one covers the ancient civilizations of Egypt and the Near East; volume two, the Stone and Bronze Ages of Europe; volumes three and four the ancient civilizations of Greece and Rome. *Die griechische Plastik*, by G. Lippold (volume 3, part 1), and *Malerei und Zeichnung*, by A. Rumpf (volume 4, part 1), are classics in the field.

762 Perrot, Georges, and Charles Chipiez. **Histoire de l'art dans l'antiquité.** Paris, Hachette, 1882-1914. 10v. illus. index.

Old standard, comprehensive history of art and architecture in the ancient world. Contents: volume 1, L'Égypte; volume 2, Chaldée et Assyrie; volume 3, Phénicie, Cypre; volume 4, Judée, Sardaigne, Syrie, Cappadoce; volume 5, Perse, Phrygie, Lydie et Carie, Lycie; volume 6, La Grèce primitive: l'art mycénien; volume 7, La Grèce de l'épopée, la Grèce archaïque (le temple); volume 8, La Grèce archaïque, la sculpture; volume 9, La Grèce archaïque, la glyptique, la numismatique, la peinture, la céramique; volume 10, La Grèce archaïque, la céramique d'Athènes. An English translation of the first six volumes (issued in twelve volumes) was published in London by Chapman and Hall, 1883-1894.

763 Powell, Ann. **The Origins of Western Art.** New York, Harcourt, Brace, 1973. 224p. illus. index. LC 74-183245.

General survey history of art in Europe from the Stone Age through the late Roman Empire. Glossary, chronological table, and a bibliography (pp. 219-20) that lists recent books in English. For the general reader and the beginning student.

Egyptian

764 Aldred, Cyril. **The Development of Ancient Egyptian Art from 3200-1315 B.C.** New York, Transatlantic, 1952. 3v. LC 52-14926. One-volume ed.: London, Tiranti, 1962.

Survey history of the fine arts of ancient Egypt, excluding architecture, from pre-dynastic times through the eighteenth dynasty. Suggestions for further reading at the end of each volume. Informative notes on the black and white plates. For the general reader and beginning student.

765 Aldred, Cyril. **The Egyptians.** Rev. ed. London, Thames and Hudson, 1984. 216p. illus. index. LC 83-50637.

In the series *Ancient Peoples and Places*. Good cultural history of ancient Egyptian art and architecture. Chapters on the geography, economy, and sociology of ancient Egypt. The history of ancient Egypt is traced chiefly through its art and architecture. Brief, classified bibliography of books in all languages, pp. 206-207.

766 Capart, Jean. **Documents pour servir à l'étude de l'art égyptien....** Paris, Les Éditions du Pégase, 1927-1931. 2v. illus. index.
Collection of plates of major Egyptian works of art in various museums and collections around the world. Brief text accompanies each plate, and a selected bibliography is appended to each volume. General indexes in each volume.

767 Capart, Jean. **Egyptian Art: Introductory Studies....** New York, Stokes, 1923. 179p. illus. index.
Concise handbook of ancient Egyptian art, with bibliographies at the end of each chapter. Once a standard work for the beginning student, it is now obsolete; nevertheless, it is still worthwhile because of its organization and its succinct language.

768 Capart, Jean. **L'art égyptien.** Brussels, Vromant, 1909-1911. 2v.
An illustrated handbook of the art and architecture of ancient Egypt from predynastic times through the Greco-Roman period. The notes to the plates offer very thorough bibliographies. This old standard illustrated handbook is still useful to the advanced student because it provides access to older literature.

769 Cossío, Manuel B., and José Pijoán y Soteras. **El arte egipcio hasta la conquista romana.** Bilbao, Spain, Espasa-Calpe, 1932. 555p. illus. index. (Summa Artis, Historia General del Arte, III).
Comprehensive history of Egyptian art and architecture from predynastic times through the Roman conquest in the first century B.C. Brief bibliographies of books in all languages at the ends of chapters.

770 Driot, Étienne. **Egyptian Art.** New York, Arts, Inc., 1951. 161p. illus.
Brief survey of the fine arts in ancient Egypt from prehistoric times through the Greco-Roman period. A pictorial survey for the general reader.

771 Hamann, Richard. **Ägyptische Kunst, Wesen und Geschichte.** Berlin, T. Knaur, 1944. 314p. illus.
Well-written history of art and architecture in ancient Egypt from prehistoric times to the Ptolemaic period.

772 Lange, Kurt. **Egypt.** 4th ed., rev. and enl. Photographs by Max Hirmer. London, Phaidon, 1968. 559p. illus. index. 5th ed., in German, published by Hirmer, in 1975.
The brief introductory survey of ancient Egyptian art is followed by many excellent photographs and informative notes. General bibliography (pp. 548-49). A standard illustrated handbook for the beginning and advanced student.

773 Maspero, Gaston C. C. **Manual of Egyptian Archaeology and Guide to the Study of Antiquities in Egypt....** New York, Putnam, 1926. 385p. illus. index.
Translation of *L'archéologie égyptienne* (Paris, 1887). Survey of ancient Egyptian fine and applied arts. Media treated in separate chapters. Occasional bibliographic footnotes.

774 Michalowski, Kazimierz. **The Art of Ancient Egypt.** New York, Abrams, 1969. 600p. illus. index. LC 68-26865.
A comprehensive and richly illustrated history of the fine arts in ancient Egypt. Useful chronological tables, glossaries, and bibliography of general works. Most useful parts are the section on archaeological sites arranged by regions and the bibliographies of specialized literature given at the end of the various chapters. A standard handbook-history.

775 Poulsen, Vagn. **Egyptian Art.** Greenwich, Conn., New York Graphic Society, 1968. 184p. illus. index. LC 69-15492.
Pictorial survey of ancient Egyptian art and architecture. Brief bibliography. Excellent illustrations. For the general reader.

776 Rachewiltz, Boris de. **An Introduction to Egyptian Art.** New York, Viking, 1960. 255p. illus. index. LC 60-11232.

Concise survey of the history of art and architecture in ancient Egypt from predynastic times through the Roman period. Provides maps; a useful chapter on chronology; modest but intelligent selection of plates, diagrams, and plans; and a well-classified and selected bibliography of major books and periodical articles in all languages (pp. 233-50).

777 Schäfer, Heinrich. **Principles of Egyptian Art.** Oxford, Clarendon Press, 1974. 470p. illus. index. LC 75-000260.

Translation of fourth edition (Wiesbaden, Harrassowitz, 1963) of *Von ägyptischer Kunst: eine Grundlage,* edited with an epilogue by Emma Brunner-Traut. History of ancient Egyptian art and architecture from predynastic times through the New Kingdom. Good choice of illustrations and excellent bibliography (pp. 392-420), and additional references in the notes. A standard work especially important for its exploration of formal aspects of ancient Egyptian art.

778 Schäfer, Heinrich, and Walter Andrea. **Die Kunst des alten Orients.** 3d ed. Berlin, Propyläen, 1942. 686p. illus. index. (Propyläen Kunstgeschichte, II).

A pictorial handbook of the art and architecture of ancient Egypt and Mesopotamia, and the Hittite and Aramaic cultures. Brief introductory essays precede the large collection of plates. No bibliography. Still a useful collection of illustrations, although it is being superseded by volumes in the new *Propyläen Kunstgeschichte* (780, 798).

779 Smith, William S. **Art and Architecture of Ancient Egypt.** London, Penguin, 1958. 301p. illus. index. (Pelican History of Art, Z14). Rev. with additions, 1981. LC 79-24561.

Scholarly history of the fine arts in ancient Egypt from the predynastic period through the Saitic period. Bibliography of general works (pp. 289-90). Thorough coverage of specialized literature in the numerous footnotes. The standard history of Egyptian art and architecture in English.

780 Vandersleyen, Claude. **Das alte Ägypten.** Berlin, Propyläen, 1975. 457p. text, 440 plates. (Propyläen Kunstgeschichte, 15).

Comprehensive illustrated handbook on ancient Egyptian art and architecture from prehistoric times through the Roman period. Text consists of essays by European experts on various media and periods and detailed notes to the plates, which provide bibliographies of specialized literature. Chronological table. Excellent classified bibliography of books and periodical articles in all languages (pp. 436-45). A standard handbook.

781 Vandier, Jacques. **Manuel d'archéologie égyptienne.** Paris, Picard, 1952-1955. 6v. illus. index. LC 68-77571.

Handbook of ancient Egyptian art and architecture from predynastic times through the New Kingdom. Contents: Tome I, *Les époques de formation* (2v.); Tome II, *Les grandes époques: Ancien, Moyen et Nouvel Empire* (2v.); Tome III, *La statuaire* (2v.). Excellent bibliographies at the end of each tome and extensive bibliographical references in the text footnotes. A standard handbook of ancient Egyptian art and archaeology.

782 Westendorf, Wolfhart. **Painting, Sculpture and Architecture of Ancient Egypt.** New York, Abrams, 1969. 260p. illus. index. LC 68-2839.

Survey history of fine arts in ancient Egypt from prehistoric times through the Coptic (twelfth century A.D.). Chronological table and brief bibliography (pp. 255-56). Designed for the general reader, this work discusses literature, religions, and history as well as the fine arts.

783 Woldering, Irmgard. **The Art of Egypt: The Time of the Pharaohs.** New York, Crown, 1963. 260p. illus. index. LC 62-20055.

Survey history of ancient Egyptian art and architecture from prehistory through the Ptolemaic period. Each period has a separate chapter on history and culture. Chronological table, glossary, and brief bibliography of general works (pp. 248-49).

784 Woldering, Irmgard. **Gods, Men and Pharaohs: The Glory of Egyptian Art.** New York, Abrams, 1967. 275p. illus. index. LC 67-26468.

Survey of art and architecture in ancient Egypt from predynastic times to the end of the New Kingdom. Bibliography (pp. 247-50) lists major books in all languages. For the general reader and the beginning student.

785 Wolf, Walter. **The Origins of Western Art: Egypt, Mesopotamia, the Aegean.** New York, Universe, 1971. 207p. illus. index. LC 72-134760.

Survey history of ancient art and architecture in Egypt, Mesopotamia, and the Aegean Islands. Does not cover Iran or Asia Minor. Brief bibliography (pp. 202-203). Excellent condensation for the beginning student. There are many appropriate illustrations, with informative captions.

Ancient Near Eastern

GENERAL WORKS

786 Amiet, Pierre, et al. **Art in the Ancient World: A Handbook of Styles and Forms.** New York, Rizzoli, 1981. 567p. illus. LC 80-54673.

Pictorial handbook of the art and architecture of the ancient world from ancient Sumer to the late Roman Empire. Geographical-cultural arrangement. Brief introductory essay with concise bibliography is followed by collection of line drawings of major works grouped by media and then chronologically. Most useful for undergraduate teaching and study.

787 Bossert, Helmuth T. **Altsyrien: Kunst und Handwerk in Zypern, Syrien, Palästina, Transjordanien und Arabien von den Anfängen bis zum volligen Aufgehen in der griechisch-römischen Kultur.** Tübingen, Wasmuth, 1951. 407p. illus. index. LC A51-10617.

Illustrated handbook and history of the art and architecture of ancient Syria, Cyprus, Palestine, Jordan, and Arabia from prehistoric times to the second century B.C. Especially good coverage of the minor arts. A standard handbook and survey history concentrating on an area often slighted in other surveys of ancient Near Eastern art and architecture.

788 Burney, Charles. **The Ancient Near East.** Ithaca, N.Y., Cornell University Press, 1977. 224p. illus. index. LC 76-55483.

Survey of art and civilization in the ancient Near East from Neolithic times to the end of the Assyrian Empire. Bibliography of basic works in English is arranged by chapters of the text (pp. 205-12).

789 Christian, Viktor. **Altertumskunde des Zweistromlandes von der Vorzeit bis zum Ende der Achämenidenherrschaft....** v. 1- . Leipzig, Hiersemann, 1940- .

Comprehensive, scholarly handbook of archaeological sites in Mesopotamia. Planned to cover the period from prehistory to the end of the Achaemenian dynasty, but only first part appeared. Covers ancient Mesopotamia from prehistoric times through the third dynasty of Ur. Geographical arrangement with detailed descriptions of the finds at various levels at the major sites. Extensive bibliographical references throughout.

790 Contenau, Georges. **L'art de l'asie occidentale ancienne.** Paris, Van Oest, 1928. 119p. illus.

Concise survey of art and architecture in the ancient Near East from the beginnings to the third century A.D.

791 Contenau, Georges. **Arts et styles de l'asie antérieure (d'Alexandre le Grand a l'Islam).** Paris, Larousse, 1948. 125p. illus.

Survey history of ancient Near Eastern art and architecture under the Seleucid, Parthian, and Sassanian dynasties. Chronological table, map of chief archaeological sites, and classified bibliography of basic books in all languages (pp. 115-17).

792 Contenau, Georges. **Manuel d'archéologie orientale depuis les origines jusqua'à l'époque d'Alexandre.** Paris, Picard, 1927-1947. 4v. illus. index.

Volumes 1-3 trace the history of art and architecture in Mesopotamia, Iran, Anatolia, the Levant, and Arabia from prehistoric times to the time of Alexander the Great. Fourth volume discusses important archaeological discoveries made between 1930 and 1939 and relates these to the overall history of ancient Near Eastern art. Bibliographies for each chapter, plus general bibliographies at end of each volume.

793 Cossío, Manuel B., José Pijoán y Soteras. **Arte del Asia occidental.** Bilbao, Spain, Espasa-Calpe, 1931. 554p. illus. index. (Summa Artis, Historia General del Arte, II).

Comprehensive history of the arts of ancient Near Eastern cultures: Sumerian, Babylonian, Assyrian, Hittite, Phoenician, Persian, Parthian, Sassanian, and Scythian. Includes architecture, textiles, pottery, and other artifacts with sculpture and painting.

794 Frankfort, Henri. **The Art and Architecture of the Ancient Orient.** 4th rev. ed. Harmondsworth, Penguin, 1970. 465p. illus. (Pelican History of Art, PZ7). LC 70-128007. (Revised paperback edition of the 1954 hardcover edition.)

Comprehensive and scholarly history of art and architecture in the ancient Near East from Sumerian times to the end of the Achaemenian Empire. Covers Mesopotamia, Anatolia, Iran, and the Levant. Good selection of plates, many plans and diagrams. Bibliography (pp. 413-36) is an excellent classified list of books and periodical articles in all languages; it has been brought up to date by an additional bibliography edited by Helene Kanter. The standard history of ancient Near Eastern art and architecture.

795 Garbini, Giovanni. **The Ancient World.** New York, McGraw-Hill, 1966. 176p. illus. index. LC 66-19270.

Historical survey of the art of Mesopotamia (Sumeria, Akkadia, Neo-Sumeria, Babylonia, the Kassites, Assyria, Neo-Babylonia), Palestine, Anatolia, plus the Hittites, Syria, Persia, Phoenicia, Egypt (predynastic through Saite dynasty), Nubia, South Arabia, Ethiopia, and Carthage. Includes chronological tables, glossary, maps, and a general bibliography (p. 172).

796 Goossens, Godefroy. **L'art de l'asie antérieure dans l'antiquité; les époques.** Brussels, Office de Publicité, 1948. 90p. illus.

Brief survey of the history of ancient Near Eastern art and architecture from ancient Sumer to the advent of Islam. Occasional bibliographic footnotes.

797 Lloyd, Seton. **The Art of the Ancient Near East.** New York, Praeger, 1961. 303p. illus. index. LC 61-15605.

Survey of the art and architecture of the ancient Near East covering Mesopotamia, Egypt, and Iran from prehistoric times to the Persian Empire. Architecture is surveyed in a separate chapter. Brief bibliography (p. 283).

798 Orthmann, Winfried. **Der alte Orient.** Berlin, Propyläen, 1975. 520p. text, 480 plates. index. (Propyläen Kunstgeschichte, 14).

Comprehensive illustrated handbook of the art and architecture of the ancient Near East from the beginnings of Sumerian civilization through pre-Islamic Persian culture. Covers all major cultures of Mesopotamia, the Levant, and Cyprus. Text consists of essays by leading European scholars and detailed notes to the excellent corpus of plates. The notes to the plates have very useful bibliographies of specialized literature. Chronological table coordinates events in the various regions. Good classified bibliography of basic books and periodical articles in all languages (pp. 542-57).

799 Potratz, Johannes M. H. **Die Kunst des alten Orient: Babylonien und Assyrien, Alt-Syrien, Alt Anatolien und das Alten Persien.** Stuttgart, Kröner, 1961. 438p. illus. index. LC 67-55551.
 Concise history of the art and architecture of the ancient Near East including Mesopotamia, Iran, Syria, and Anatolia. Covers the period from circa 3100 B.C. to 330 B.C. Although it is a pocket-sized book, it is well provided with plates, plans, diagrams, a useful chronological table, and an excellent classified bibliography (pp. 404-17), which lists books and periodical articles in all languages. An excellent handbook-history of ancient Near Eastern art and architecture for the advanced student.

800 Ry van Beest Holle, Carel J. du. **Art of the Ancient Near and Middle East.** New York, Abrams, 1970. 264p. illus. index. LC 78-92910.
 Concise history of art and architecture in the Near and Middle East from 9000 B.C. to the third century A.D. Covers Mesopotamia, Anatolia, Iran, Syria, Jordan, Palestine, and Arabia. Good selection of color illustrations, maps, and chronological tables. Has a good chapter on the discovery of ancient Near Eastern civilization. Bibliography (pp. 258-60) lists major books in all languages.

801 Speiser, Werner. **Vorderasiatische Kunst.** Berlin, Safari-Verlag, 1952. 301p. illus. LC A53-2037.
 Survey history of art and architecture in the Near East from prehistoric times to the Parthians. Bibliography of basic books (p. 296).

802 Woolley, Charles L. **The Art of the Middle East Including Persia, Mesopotamia and Palestine.** New York, Crown, 1961. 259p. illus. index. LC 61-16972.
 A survey history of the fine arts in the ancient Near East from Elam and Sumeria to the Greco-Roman period covering Mesopotamia, Iran, Anatolia, Syria, and Palestine. Provides maps, chronological tables, glossary, and brief bibliography (pp. 247-50).

MESOPOTAMIA

803 Moortgart, Anton. **The Art of Ancient Mesopotamia: The Classical Art of the Near East.** London, Phaidon, 1969. 356p. illus. index. LC 69-12789.
 Comprehensive history of the art and architecture of ancient Mesopotamia from Sumerian through Neo-Babylonian times. General bibliography and notes (pp. 329-40). Survey with emphasis on stylistic development.

804 Parrot, André. **The Arts of Assyria.** New York, Golden Press, 1961. 380p. illus. index. (The Arts of Mankind, 2). LC 61-11170.
 Pictorial survey of the art and architecture of Mesopotamia and Iran from the Assyrian period through the Achaemenian period to the death of Alexander the Great. Part two has an interesting section on Mesopotamian techniques, literature, and music. Provides maps, glossary-index, and good bibliography (pp. 343-59). Informative notes to the plates. Sequel to (805).

805 Parrot, André. **Sumer, the Dawn of Art.** New York, Golden Press, 1961. 396p. illus. index. (The Arts of Mankind, 1). LC 61-6746.
 Pictorial survey of art and architecture in ancient Mesopotamia from prehistoric times through the Kassite and Elamite periods. Provides a glossary-index, maps, and good bibliography (pp. 361-70). Richly illustrated, there is often more information in the notes to the illustrations than in the overly condensed text. For the general reader and the beginning student.

806 Schmökel, Hartmut. **Ur, Assur und Babylon; Drei Jahrtausende im Zweistromland.**
Stuttgart, Kilpper, 1955. 301p. illus. index. (Grosse Kulturen der Frühzeit, Band 2). LC
A55-5641.
 Survey of Mesopotamian art and architecture from prehistoric times to the Neo-
Babylonians. Good selection of plates. Bibliography (pp. 291-94) lists books and periodical
articles in all languages.

807 Strommenger, Eva. **5000 Years of the Art of Mesopotamia.** New York, Abrams,
1964. 480p. illus. index. LC 64-15231.
 A comprehensive illustrated handbook of the art and architecture of ancient Meso-
potamia from the Sumerian through the late Babylonian periods. A concise and well-writ-
ten introduction is followed by a section of 280 superlative plates by Max Hirmer, and very
informative notes on the plates with references to specialized literature. Chronology pro-
posed is somewhat controversial. General bibliography (pp. 465-69) includes an excellent
section on excavation reports. Standard illustrated handbook for ancient Mesopotamian
art.

808 Unger, Eckhard. **Assyrische und Babylonische Kunst.** Breslau, F. Hirt, 1927. 140p.
illus.
 Concise survey of Assyrian and Babylonian art with particular emphasis on stele
sculpture. Bibliography (pp. 72-75).

809 Woolley, Charles L. **The Development of Sumerian Art....** London, Faber and
Faber, 1935. 140p. illus. index. LC 36-3991.
 Older survey history of Sumerian art and architecture from the Al Ubaid period
through the third dynasty of Ur, by famous excavator of the royal tombs of Ur. Biblio-
graphical note at the end of each chapter.

810 Zervos, Christian. **L'art de la Mésopotamie de la fin du quatrième millénaire au XVᵉ
siècle avant notre ère....** Paris, Cahiers d'Art, 1935. 264p. illus.
 Pictorial survey of the art and architecture of ancient Mesopotamia from Sumerian
through Akkadian times.

IRAN

811 Colledge, Malcom A. **Parthian Art.** Ithaca, N.Y., Cornell University Press, 1977.
200p. illus. index.
 Survey of ancient Parthian art and architecture. Introduction provides a history of
the Parthians. Special chapters on techniques, iconography, and style. Appendices with
principal scripts, chronological table of eras, list of kings. Bibliography (pp. 172-92) is an
unclassified list of basic books and periodical articles.

812 Dieulafoy, Marcel A. **L'art antique de la Perse.** Paris, Librairie Centrale d'Archi-
tecture, 1884-1889. 5v. illus.
 Collection of plates and accompanying descriptive text of major works and sites
of Achaemenian, Parthian, and Sassanian Persia. Partie 1: *Monuments de la Vallée de
Polvar-Roud*; 2: *Monuments de Persépolis*; 3: *La sculpture persépolitaine*; 4: *Les Monu-
ments vouté l'époque achéménide*; 5, *Monuments parthes et sassanides*. Bibliographic
footnotes.

813 Diez, Ernst. **Iranische Kunst.** Vienna, Andermann, 1944. 238p. illus. index.
 Survey history of art and architecture in Iran from prehistoric times through the
sixteenth century A.D. Bibliographical footnotes (pp. 233-35). Useful for the discussion of
transition from ancient to Islamic Persian art.

814 Ghirshman, Roman. **The Arts of Ancient Iran from Its Origins to the Time of Alexander the Great.** New York, Golden Press, 1964. 439p. illus. (The Arts of Mankind, 5). LC 64-13072.

History of art and architecture in Iran from the prehistoric period through Achaemenian times. In addition to Iranian art and architecture, it covers Irano-Urartian and Scythian art. Provides a glossary-index, maps, chronological table, and a good bibliography (pp. 405-17), which lists books and periodical articles in all languages. Well illustrated.

815 Ghirshman, Roman. **Persian Art: The Parthian and Sassanian Dynasties.** New York, Golden Press, 1962. 344p. illus. index. (The Arts of Mankind, 3). LC 62-19125.

Pictorial survey of the art and architecture of ancient Iran from 249 B.C. to 651 A.D. Provides a glossary-index, maps, and good annotated bibliography (pp. 369-77). Numerous plans, chronological tables, and reconstructions are used throughout.

816 Porada, Edith. **The Art of Ancient Iran: Pre-Islamic Cultures.** New York, Crown, 1965. 279p. illus. index. LC 65-15839.

Concise history of the art and architecture of ancient Iran from the Elamites through the Sassanians. Provides useful glossary of terms, maps, chronological table, and a good basic bibliography (pp. 262-67). An excellent survey history for the general reader as well as for the beginning and advanced student.

817 Sarre, Friedrich P. T. **Die Kunst des alten Persien.** Berlin, Cassirer, 1922. 150p. illus. (Die Kunst des ostens, Band V).

Survey history of Persian art and architecture from circa 550 B.C. to circa 636 A.D. Also includes material on the applied and decorative arts. Bibliography of basic books (pp. 57-59).

See also: Belloni (1793), Godard (1794), Pope (1976).

ANATOLIA

818 Akurgal, Ekrem. **The Art of the Hittites.** New York, Abrams, 1962. 315p. illus. index. LC 62-11624.

History of Hittite art and architecture from 2500 to 700 B.C. Excellent illustrations and a good, comprehensive bibliography (pp. 306-12) of books and periodical articles in all languages. A standard history of Hittite art and architecture. For the beginning and advanced student. The latter should be aware of translation errors and should consult the German original (Munich, 1961).

819 Akurgal, Ekrem. **Die Kunst Anatoliens von Homer bis Alexander.** Berlin, de Gruyter, 1961. 350p. illus. index.

Scholarly history of the art and architecture of the Greeks, Phrygians, Lydians, Urartians, Persians, and other societies in Anatolia from circa 1000 B.C. to the middle of the fourth century B.C. Extensive footnotes with reference to specialized literature. Informative notes to the black and white plates, with further bibliography. Standard history of one phase of ancient Anatolian art.

820 Bittel, Kurt. **Les Hittites.** Paris, Gallimard, 1976. 332p. illus. index. (L'Universe des Formes, 24). LC 76-489568.

Translation of *Die Hethiter* (Munich, Beck, 1976). Well-illustrated survey of the art and architecture of ancient Anatolia from the end of the third to the beginning of the first millenium B.C., with emphasis on Hittite civilization. Chronological table correlates events in Anatolia with those in other areas of the ancient Mediterranean. Maps and excellent classified bibliography of books and periodical articles in all languages (pp. 309-16).

821 Bossert, Helmuth T. **Altanatolien: Kunst und Handwerk in Kleinasien von den Anfängen bis zum volligen Aufgehen in der griechische Kunst.** Berlin, Wasmuth, 1942. 112p. (text); 160p. (illus.). index. LC A47-2988.

Illustrated handbook of the art and architecture of ancient Asia Minor from prehistoric times to the middle of the fourth century B.C. A standard survey and handbook with emphasis on the minor arts.

822 Vieyra, Maurice. **Hittite Art 2300-750 B.C.** London, Tiranti, 1955. 91p. illus. LC A55-10301.

Series: "Chapters in Art." Pictorial survey of Hittite art and architecture. Bibliography of basic works in all languages (pp. 55-58).

SCYTHIA

823 Artamonov, M. I. **The Splendor of Scythian Art.** New York, Praeger, 1966. 296p. illus. index. Lc 68-31440.

Pictorial survey of the arts of the ancient Scythians from the sixth through the fourth century B.C., with emphasis on the remains from Russian tombs. Bibliography is brief and listed by the various Russian barrows.

824 Borovka, Grigorii I. **Scythian Art....** New York, Stokes, 1928. 111p. illus. index.

Brief survey of Scythian art illustrated chiefly with examples in Soviet collections. Bibliography of basic books and articles (pp. 12-14). Once a standby, it is now superseded by Artamonov (823).

825 Charrière, Georges. **L'art barbare scythe.** Paris, Éditions Cercle d'Art, 1971. 263p. illus. LC 75-865997.

Pictorial survey of the arts of the ancient Scythians. Provides a glossary of terms, informative notes to the plates, and brief bibliography (p. 259).

826 Charrière, Georges. **Scythian Art. Crafts of the Early Eurasian Nomads.** New York, Alpine Fine Arts Collection, 1979. 268p. illus. ISBN 0933516053.

Ethnographic survey of ancient Scythian art with emphasis on the relationship between ancient Scythian art and later nomadic art in Russia and elsewhere. Inadequate bibliography, p. 268.

827 Jettmarr, Karl. **Art of the Steppes.** New York, Crown, 1967. 272p. illus. index. LC 67-17700.

Concise history of the art of the ancient peoples of the Russian steppes. Covers the Scythians, Sarmatians, and societies of Eastern and Central Soviet Union from circa 900 B.C. to 200 A.D. Provides a valuable chronological table, maps, good color plates, and an excellent classified bibliography of books in all languages (pp. 242-58). An excellent history of this complex and slighted area of ancient art history. For the beginning and advanced student.

828 Piotrovsky, Boris, Liudmila Galanina, and Nonna Grach. **Scythian Art.** Oxford, Phaidon, 1987. 183p. illus. LC 87-573.

Illustrated survey of the art, chiefly works in metal, of the ancient Scythians from the mid-seventh century B.C. to the end of the third century B.C. Brief introductory essays on the history and art history of the Scythians. Selected bibliography (pp. 179-83) lists only titles in Russian. Good quality illustrations.

829 Rice, Tamara T. **The Scythians.** London, Thames and Hudson, 1957. 255p. illus. index. LC A57-4905.

Concise survey of the arts of the ancient Scythians, with emphasis on their relationship to the general culture of the Scythians. Provides a chronological table, list of major burial sites, and a useful bibliography of books (pp. 201-208), arranged by language.

830 Rostov̂tsev, Mikhail I. **The Animal Style of South Russia and China....** Princeton, Princeton University Press, 1929. 112p. illus. (Princeton Monographs in Art and Archaeology, XIV).

A survey of the arts of the ancient Scythians and Sarmatians, with an exploration of the relationship of these arts to Chinese art of the Han and Chou dynasties. Bibliographical footnotes. An old but still influential study.

831 Rostov̂tsev, Mikhail I. **Iranians and Greeks in South Russia.** Oxford, Clarendon Press, 1922. 260p. illus. index.

History of the arts of the major ancient civilizations of Southern Russia including the Scythians, Cimmerians, Sarmatians, and Greeks from the eighth century B.C. through the Roman period. Good bibliography (pp. 223-38). A standard work.

Aegean

832 Boardman, John. **Pre-Classical: From Crete to Archaic Greece.** Harmondsworth, Penguin, 1967. 186p. illus. index. LC 67-99818.

Concise history of the art and architecture of the ancient Mediterranean from circa 3000 to 500 B.C. Covers the art of the Minoans, Mycenaeans, Etruscans, Scythians, and Greeks from the Geometric period through the Archaic period. Modest but well-chosen selection of plates. Bibliography (pp. 183-84) lists and annotates major books in English. Series: "Style and Civilization."

833 Bossert, Helmuth T. **The Art of Ancient Crete, from the Earliest Times to the Iron Age....** 3d ed. London, Zwemmer, 1937. 44p. text, 304 illus. LC 38-15038.

Illustrated survey with notes to the plates. Some bibliographical references in the notes; chronological table of ancient Aegean civilizations.

834 Buchholz, Hans-Günter, and Vassos Karageorghis. **Altägäis und Altkypros.** Tübingen, Wasmuth, 1971. 516p. illus.

Detailed survey of the archaeological finds of the past hundred years on Cyprus and the immediate area of the Aegean. Large corpus of nearly two thousand illustrations of artifacts and art works. Introductory essay surveys the ancient history of Cyprus. A standard reference tool.

835 Demargne, Pierre. **The Birth of Greek Art.** New York, Golden Press, 1964. 446p. illus. index. (The Arts of Mankind, 6). LC 64-21312.

Pictorial handbook-history of art and architecture in the Aegean including Minoan, Mycenaean, and Greek art of the early Archaic period. Richly illustrated and equipped with maps, plans, and reconstructions, plus a useful glossary-index and an extensive bibliography (pp. 421-30) with its own index.

836 Ekschmitt, Werner. **Kunst und Kultur der Kykladen.** Mainz am Rhein, Paul von Zabern, 1986. 2v. illus. index. (Kulturgeschichte der antiken Welt, Bd. 28). LC 87-121414.

Survey of the art of the Cycladic Islands from prehistoric times to the end of the Archaic period. Excellent plates, plans and drawings. Contents: Volume 1, *Neolithikum und Bronzezeit*; Volume 2, *Geometrische und Archaische Zeit*. Comprehensive, classified bibliographies at the end of each volume.

837 Hafner, German. **Art of Crete, Mycenae and Greece.** New York, Abrams, 1969. 264p. illus. index. LC 68-28392.

Concise history of art and architecture in the ancient Aegean area and Greece from circa 2800 B.C. to 146 B.C. Covers Helladic, Cretan-Mycenaean, and Greek art and architecture. The introduction, which traces the main outlines of the development, is followed by a good collection of illustrations, arranged chronologically, and a brief introduction to

the major periods. The illustrations have informative notes as well as captions. There are no plans for the architectural examples, but the work does provide a useful chronological table, a map, and a good, classified bibliography (pp. 258-60), which lists major books in all languages.

838 Hampe, Roland, and Erika Simon. **The Birth of Greek Art from the Mycenaean to the Archaic Period.** New York, Oxford University Press, 1981. 316p. illus. index. LC 81-81427.

Well-illustrated history of art and architecture in ancient Greece from circa 1600 to circa 600 B.C. with the aim of demonstrating the continuity of earlier Aegean and later Greek cultures. Arranged by media: architecture and painting; metalwork; weapons; stone vessels; pottery; engraving; jewelry and ornament; ivory, bone, and wood; sculpture. Good, classified bibliography with references to the literature on specific works, pp. 285-309.

839 Higgins, Reynold A. **Minoan and Mycenaean Art.** New York, Praeger, 1967. 216p. illus. index. LC 67-27569.

Survey history of the art and architecture of ancient Crete, the Cyclades, and mainland Greece to the late Bronze Age. Selected bibliography (pp. 195-96). A few brief bibliographical footnotes.

840 Karageorghis, Vassos. **The Ancient Civilization of Cyprus.** Geneva, Nagel, 1969. 259p. illus.

Survey of the archeological finds in Cyprus of the past century. Covers period from prehistoric through Roman times. Good collection of plates.

841 Marinatos, Spyridon. **Crete and Mycenae.** New York, Abrams, 1960. 177p. illus. index. LC 60-8399.

Survey history of the art and architecture of the ancient civilizations of Minoan Crete and Mycenaean Greece. Bibliography is found in notes to the plates and notes to the text. A good survey, with photographs by Max Hirmer.

842 Matz, Friedrich. **The Art of Crete and Early Greece: The Prelude to Greek Art.** New York, Crown, 1962. 260p. illus. index. LC 62-20056.

Survey history of art and architecture in the Aegean Islands and the Greek mainland from the Neolithic through the Mycenaean periods. Provides maps, glossary, chronological tables, and selected bibliography (pp. 248-50).

843 Mylonas, George E. **Mycenae and the Mycenaean Age.** Princeton, Princeton University Press, 1966. 215p. illus. index.

Survey of ancient Mycenean civilization from the end of the seventeenth century B.C. to the end of the twelfth century B.C. Contents: 1, Introduction; 2, Mycenaean Citadels; 3, Mycenean Palaces and Houses; 4, The Grave Circles of Mycenae; 5, Tholos and the Chamber Tombs; 6, Shrines and Divinities; 7, Ceremonial Equipment and the Cult of the Dead; 8, Some Aspects of Mycenaean Culture; 9, Epilogue. Bibliographical footnotes and select bibliography, pp. 239-41.

844 Snyder, Geerto A. S. **Minoische und Mykenische Kunst. Aussage und Deutung.** Zürich, Schnell & Steiner, 1980. 158p. illus. LC 80-507321.

Survey of ancient Minoan and Mycenean art and architecture with the aim of illuminating its "meaning" by relating its forms and subjects to contemporary art and culture. Bibliographical references in the footnotes.

845 Spiteris, Tony. **The Art of Cyprus.** New York, Reynal, 1970. 215p. illus. index. LC 75-128117.

Illustrated survey of art of ancient Crete from Neolithic times to circa 58 B.C. Good plates. Maps, chronological table, and selected list of books (p. 215).

846 Thimme, Jürgen, ed. **Art and Culture of the Cyclades in the Third Millenium B.C.** Chicago, University of Chicago Press, 1977. 617p. illus. index. LC 77-84340.

Comprehensive illustrated handbook of art, exclusive of architecture, of the Cyclades during the third millenium B.C. Based on an exhibition held in Karlsruhe. Consists of papers on various aspects of Cycladic art by internationally known experts, extensive catalogue to the excellent plates (with bibliographical references), glossary, maps, and good, classified bibliography of books and periodical articles in all languages (pp. 598-607). A standard work.

847 Zervos, Christian. **L'art de la Créte néolithique et minoenne.** Paris, Éditions Cahiers d'Art, 1956. 523p. illus. index.

Illustrated survey of the ancient art and architecture of Neolithic and Minoan Crete, with excellent corpus of plates. Brief introductory text with useful chapter on major excavations on Crete.

848 Zervos, Christian. **L'art des Cyclades du début à fin de l'âge du bronze....** Paris, Éditions Cahiers d'Art, 1957. 278p. illus. index.

Comprehensive survey of the art of the Cycladic Islands from circa 2500 B.C. to circa 100 B.C. Includes chapters on major excavations and religion. Brief list of basic books in all languages (p. 271). Further references to specialized literature in the footnotes.

See also: Cossío and Pijoán (729).

Classical

GENERAL WORKS

849 Becatti, Giovanni. **The Art of Ancient Greece and Rome: From the Rise of Greece to the Fall of Rome.** New York, Abrams, 1967. 441p. illus. index. LC 67-12684.

Comprehensive history of the art and architecture of ancient Greece and Rome from the Archaic period through the late Roman period. Well illustrated with plates, plans, and reconstructions. Provides a glossary of terms and an excellent comprehensive bibliography (pp. 401-23). A standard history of classical art.

850 Bohr, Russel LeRoi. **Classical Art.** Dubuque, Iowa, W. C. Brown, 1967. 158p. illus. index. LC 67-21302.

Survey history of art and architecture in ancient Greece and Rome from the Stone Age through Constantinian Roman art. Provides maps on the end papers, tables of major works of art (with phonetic spelling), and a brief bibliography of basic works in English (pp. 149-52). Designed for the beginning student.

851 Ducati, Pericle. **L'art classica.** 3d ed. Turin, Ed. Torinese, 1944. 829p. illus. index. (Storia dell'Arte Classica e Italiana, v. 1).

History of art and architecture in ancient Greece and Rome. Well illustrated, it provides a useful chronological table, list of major museums and collections of classical art, and a bibliography (pp. 789-802), which lists major works in all languages. A standard Italian history of classical art and architecture.

852 Kasper, Wilfried. **Bruckmann's Handbuch der antiken Kunst.** Munich, Bruckmann, 1976. 287p. illus. index. LC 77-456436.

Well-illustrated handbook of ancient Greek and Roman art and architecture. The text supplies a good summary of the main outlines in the development of classical art.

853 Kjellberg, Ernst, and Gosta Säfflund. **Greek and Roman Art, 3000 B.C. to A.D. 550.** New York, Crowell, 1968. 250p. illus. index. LC 68-20758.

A survey history of art and architecture from the Aegean period through late Roman. Chronological table, glossary, and bibliography of major works in English (pp. 222-28). A general history and guide to classical art for the general reader and tourist.

854 Rodenwaldt, Gerhart. **Die Kunst der Antike; Hellas und Rom.** 4th ed. Berlin, Propyläen, 1944. 770p. illus. index. (Propyläen Kunstgeschichte, III).

Comprehensive illustrated handbook of ancient Greek and Roman art and architecture. Introductory essays on the development of art in classical antiquity are followed by good corpus of plates with descriptive notes. Superseded by two volumes in the new Propyläen series (892, 942).

855 Rumpf, Andreas. **Die griechische und römische Kunst.** 4th ed. Leipzig, Teubner, 1931. 106p. (Einleitung in die Altertumswissenschaft, II, 3).

Survey history of the art and architecture of classical antiquity from Minoan Crete to the beginning of the fourth century A.D. Bibliographies at the end of each chapter. No illustrations.

856 Ruskin, Ariane. **Greek and Roman Art.** Adapted by Ariane Ruskin and Michael Batterberry. New York, McGraw-Hill, 1968. 192p. illus. index. LC 73-96242.

Pictorial survey of the architecture, sculpture, and painting of the ancient world, from Crete and Mycenae through the Roman Empire.

857 Strong, Donald E. **The Classical World.** New York, McGraw-Hill, 1965. 166p. illus. index. LC 65-21594.

Survey of the architecture, painting, sculpture, and minor arts of Greek and Roman civilizations, from Bronze Age Crete through late Roman art. Includes glossary, general bibliography (p. 169), and chronological table.

858 Woodford, Susan. **The Art of Greece and Rome.** New York, Cambridge University Press, 1981. 122p. illus. index. LC 81-10091.

Survey of art and architecture in ancient Greece and Rome from 1000 B.C. to end of the third century A.D. Designed as an introductory text for undergraduate students and has a few informative sketches and diagrams. Bibliography (p. 120) is a list of basic books in English.

859 Woodford, Susan. **An Introduction to Greek Art.** London, Duckworth, 1986. 186p. illus. index. LC 86-9012.

Survey history of ancient Greek sculpture and vase painting from the eighth to the fourth centuries B.C. Commissioned by the Joint Association of Classical Teachers, the work has many instructive diagrams, illustrations of major works from several angles, and glossary.

860 Zinserling, Gerhard. **Abriss der griechischen und römischen Kunst.** Leipzig, Reclam, 1970. 606p. illus. index. (Reclams Universal-Bibliothek, Band 435). LC 72-581110.

Concise history of art and architecture in ancient Greece and Rome from the second millennium B.C. to the middle of the fourth century A.D. A pocket-sized aid for students, it provides many useful assists: glossary of terms, chronological table, list of principal excavations, list of major museums of ancient art, and an excellent classified bibliography listing books and periodical articles. Additionally, there are special sections for periodicals and books of reference in fields relating to the study of ancient art and architecture.

GREEK

861 Akurgal, Ekrem. **The Art of Greece: Its Origins in the Mediterranean and the Near East.** New York, Crown, 1968. 258p. illus. index. LC 75-548860.
A survey of the art and architecture of Archaic Greece and the neighboring cultures (Neo-Assyrian, Babylonian, Aramaean, Neo-Hittite, Phoenician, and Syrian). Provides glossary of terms, chronological tables, maps, and general bibliography. Useful survey of this otherwise slighted group of Eastern cultures that influenced the early development of Greek art.

862 Arias, Paolo Enrico. **L'arte della Grecia.** Turin, Unione Torinese, 1967. 951p. illus. index. (Storia universale dell'Arte, v. 2, t. 1). LC 68-109179.
Comprehensive history of ancient Greek art and architecture from the Geometric period through the Hellenistic period. Well illustrated and provided with a good, classified bibliography (pp. 895-930) of books and periodical articles in all languages.

863 Beazley, John D., and Bernard Ashmole. **Greek Sculpture and Painting to the End of the Hellenistic Period....** 2d ed. Cambridge, Cambridge University Press, 1966. 111p. illus. index.
General survey first published in 1932, here accompanied with a two-page appendix that is inadequate to bring the excellent older work up to date.

864 Boardman, John. **Greek Art.** New rev. ed. New York, Thames and Hudson, 1985. 252p. illus. index. LC 83-50636.
Concise survey of art and architecture in ancient Greece from the Geometric period through the Hellenistic period. Chronological table and selected bibliography (pp. 271-72). Best for early periods, i.e., Geometric through Archaic.

865 Boardman, John, José Dörig, and Werner Fuchs. **The Art and Architecture of Ancient Greece.** New York, Abrams, 1967. 600p. illus. index. LC 67-22850.
Comprehensive, well-balanced handbook of the art and architecture of ancient Greece, richly illustrated with photographs by Max Hirmer and numerous plans, maps, and reconstructions. Selected, general bibliography (pp. 587-88), and extensive bibliographical references in the notes to the text.

866 Brilliant, Richard. **Arts of the Ancient Greeks.** New York, McGraw-Hill, 1973. 406p. illus. index. LC 72-14098.
Concise history of the art and architecture of ancient Greece from Mycenaean times through the Hellenistic period. Excellent selection of plates, plans, and diagrams. Bibliographies at the end of each chapter list major books and periodical articles in all languages.

867 Brunn, Heinrich. **Geschichte der griechischen Künstler.** Stuttgart, Ebner & Seubert, 1889. 2v. illus.
Important, early history of ancient Greek art and architecture from the Ancient period through the Hellenistic, with emphasis on major personalities. First volume covers sculptors; the second, painters, architects, and applied and decorative artists. Bibliographical footnotes.

868 Brunn, Heinrich. **Griechische Kunstgeschichte.** Munich, Bruckmann, 1893-1897. 2v. illus. index.
First parts of an uncompleted comprehensive history of ancient Greek art and architecture. Contents: Band I: *Die Anfänge und die älteste decorative Kunst*; Band II: *Die archäische Kunst*. Bibliographical footnotes.

869 Chamoux, François. **Greek Art.** Greenwich, Conn., New York Graphic Society, 1966. 97p. illus. index. LC 65-21746.

Pictorial survey of the art and architecture of ancient Greece from Mycenaean times through Hellenistic. Excellent plates. Brief bibliography of recent works in English. For the general reader.

870 Charbonneaux, Jean, Roland Martin, and François Villard. **Archaic Greek Art (620-480 B.C.).** New York, Braziller, 1971. 437p. illus. index. (The Arts of Mankind, 14). LC 78-13166.

Pictorial history of ancient Greek art and architecture during the Archaic period, particularly strong on influences of the ancient Near East. Provides a useful glossary-index, maps, plans, and reconstructions, and a very thorough bibliography (pp. 385-95) with its own index. With the sequel volumes (871 and 872) by the same authors, it forms a good pictorial handbook of ancient Greek art and architecture.

871 Charbonneaux, Jean, Roland Martin, and François Villard. **Classical Greek Art (480-330 B.C.).** New York, Braziller, 1972. 422p. illus. index. (The Arts of Mankind, 16). LC 72-80015.

Pictorial history of art and architecture in ancient Greece during the classical period. Richly illustrated. Provides useful chronological table, glossary-index, maps, and good bibliography (pp. 367-77). Sequel to (870). Together with other volumes in the series (870 and 872), it forms a valuable pictorial handbook.

872 Charbonneaux, Jean, Roland Martin, and François Villard. **Hellenistic Art (330-50 B.C.).** New York, Braziller, 1973. 421p. illus. index. (The Arts of Mankind, 18). LC 72-89850.

Excellent, well-balanced pictorial history of art and architecture in ancient Greece during the Hellenistic period. Richly illustrated. Provides chronological table, glossary-index, maps, and good bibliography (pp. 371-82). Sequel to (871). Together with other volumes in the series (870 and 871), it forms a valuable pictorial handbook for advanced students, while the texts are concise enough for the general reader and beginning student.

873 Carpenter, Rhys. **Greek Art: A Study of the Formal Evolution of Style.** Philadelphia, University of Pennsylvania Press, 1962. 256p. illus. index. LC 61-6619.

Survey of art and architecture in ancient Greece from the Archaic through Hellenistic periods, with an emphasis on stylistic development. No bibliography.

874 Cook, Robert M. **Greek Art: Its Development, Character and Influence.** New York, Farrar, Straus, Giroux, 1973. 277p. illus. LC 72-84781.

Handbook-history of ancient Greek art, arranged by media. Contains a brief but usefully annotated bibliography (pp. 261-66). Good glossary and useful section on Greek art in museums. Good, workmanlike handbook; similar to but more up-to-date than Richter (888). Lacks bibliographical references for more serious study.

875 Cossío, Manuel B., and José Pijoán y Soteras. **El arte griego hasta la toma de Corinto por los romanos (146 A.J.C.).** Bilbao, Spain, Espasa-Calpe, 1932. 591p. illus. index. (Summa Artis, Historia General del Arte, IV).

Comprehensive history of Greek art and architecture from the post-Mycenaean period to 146 B.C., when the Romans took Corinth. Brief bibliographies of books in all languages at the ends of chapters.

876 Ginouvés, René. **L'art grec.** Paris, Presses Universitaires de France, 1964. 184p. illus.

General history of ancient Greek art and architecture from the Geometric period to the end of the Hellenistic Age. Classified bibliography of books, pp. 182-84.

877 Hamann, Richard. **Griechische Kunst; Wesen und Geschichte.** Munich, Droemer-sche Verlagsanstalt, 1949. 459p. illus. index.
History of art and architecture in ancient Greece from Minoan times through the Hellenistic period. Combines stylistic history with form concept analysis. Bibliography (pp. 456-59) lists books in all languages.

878 Havelock, Christine M. **Hellenistic Art: The Art of the Classical World from the Death of Alexander to the Battle of Actium.** 2d ed. New York, Norton, 1970. 283p. illus. index. LC 81-167686.
Illustrated handbook of Hellenistic art and architecture. Introductory essay followed by notes to the plates with bibliographical references. Emphasizes sculpture.

879 Holloway, R. Ross. **A View of Greek Art.** Providence, R.I., Brown University Press, 1973. 213p. illus. index. LC 72-187947.
History of ancient Greek art and architecture, with an emphasis on the purpose or use. Covers the periods from Archaic through Hellenistic and deals chiefly with monumental art. A brief bibliographical note (p. 203), maps, and chronological table of the periods of ancient Greek art and architecture round it out.

880 Homann-Wedeking, Ernst. **The Art of Archaic Greece.** New York, Crown, 1968. 224p. illus. index. LC 68-16898.
Concise survey of the art and architecture of ancient Greece during the Archaic period, circa 600-480 B.C. Provides a useful glossary, map, and chronological table. General bibliography (pp. 209-11) and further bibliographical references in the notes to the text. Together with the sequel volumes in the same series (861, 891 and 898), it forms a good history of the art and architecture of ancient Greece.

881 Hurwit, Jeffrey M. **The Art and Culture of Early Greece 1100-480 B.C.** Ithaca, N.Y., Cornell University Press, 1985. 367p. illus. index. LC 85-4204.
History of art and architecture in ancient Greece during the Archaic Period. The author puts the visual arts within the overall cultural context with many quotes from and references to literary and historical works. Bibliographical footnotes.

882 Klein, Wilhelm. **Geschichte der griechischen Kunst.** Leipzig, Verlag von Veit & Comp., 1904-1907. 3v. illus. index.
Comprehensive history of ancient Greek art and architecture from the Archaic period through the first century B.C. Chapters are devoted to periods, regions, artists and architects, and major monuments. Extensive bibliographical footnotes. A standard, older work with thorough coverage of the earlier literature.

883 Lübke, Wilhelm, and Erich Pernice. **Die Kunst der Griechen....** 17th ed. Vienna, Neff, 1948. 464p. illus. index. (Grundriss der Kunstgeschichte, Band 1).
Latest edition, reworked by Berta Sarne, of the volume of ancient Greek art and architecture from the standard, older, multi-volume history of art. Contents: Vorgeschichte (Troja, Kykladen, Kreta, Mykenä); Die griechische Architektur; Plastik; Kunsthandwerk; Malerei. One-page bibliography of basic books in German. A good stylistic history.

884 Matz, Friedrich. **Geschichte der griechischen Kunst; I, Die geometrische und früharchaische Form.** Frankfurt/Main, Klostermann, 1949. 2v. illus. index.
The only volume to appear in a projected comprehensive history of ancient Greek art and architecture. Covers the Geometric and early Archaic periods. Volume one, text; volume two; plates (which are excellent). Thorough bibliography (pp. 511-38) lists books and periodical articles in all languages. Even though it is incomplete, it is a major work for the advanced student.

885　Onians, John. **Art and Thought in the Hellenistic Age. The Greek World View 350-50 B.C.** London, Thames and Hudson, 1979. 192p. illus. index. LC 78-63040.

　　History of art and architecture in ancient Greece from 350 to 50 B.C. with emphasis on the broader context. Chapters deal with the Hellenistic attitudes towards art, allegory, measure and scale, time and space. Brief bibliography, pp. 182-83.

886　Pollitt, J. J. **Art and Experience in Classical Greece.** London, Cambridge University Press, 1972. 205p. illus. index. LC 74-160094.

　　A history of art and architecture in ancient Greece from circa 480 to 323 B.C., with emphasis on the interrelationship of the fine arts and the general cultural climate. Bibliography (pp. 199-202) is a useful commentary on the major scholarly interpretations of classical Greek art.

887　Richter, Gisela M. A. **Archaic Greek Art against Its Historical Background; A Survey.** New York, Oxford University Press, 1949. 226p. illus. index.

　　History of Greek art from circa 650 to circa 480 B.C. Bibliography of books and periodical articles given with the abbreviations (pp. xiii-xviii). A standard work, but should be used together with Charbonneaux and Homann-Wedeking (870, 880).

888　Richter, Gisela M. A. **A Handbook of Greek Art: A Survey of the Visual Arts of Ancient Greece.** 6th ed. London, Phaidon, 1969. 431p. illus. index. LC 75-443770.

　　Handbook-history of ancient Greek art from the Archaic period through the Hellenistic period. Treats the various arts separately by type, with good attention to the minor arts. Provides glossary, maps, tentative chronology of Greek sculptural work, and a good bibliography of basic literature (pp. 399-410). Further reference to specialized literature in the notes. A standard handbook of Greek art and architecture that emphasizes sculpture.

889　Robertson, Martin. **A History of Greek Art.** Cambridge, Cambridge University Press, 1975. 2v. illus. index. LC 73-79317.

　　Comprehensive history of Greek art, excluding architecture, from Geometric and Orientalizing periods through the Hellenistic period. Volume of text and volume of plates. Written as a continuous history in which the various media are treated together. Reference to specialized literature in the notes; general, unclassified bibliography of basic works (pp. 740-59). An abbreviated version was published as: *A Shorter History of Greek Art* (New York, Cambridge University Press, 1981. 240p. illus. index. LC 80-41026).

890　Salis, Arnold von. **Die Kunst der Griechen....** 4th ed. Zurich, Artemis-Verlag, 1954. 328p. illus. index.

　　First published in 1919. Influential, formalistic history of ancient Greek art, exclusive of architecture, from the Geometric through the Hellenistic periods. Bibliography (p. 327) is a brief list of basic books in German.

891　Schefold, Karl. **The Art of Classical Greece.** New York, Crown, 1967. 294p. illus. index. LC 67-17705.

　　History of the art and architecture of ancient Greece during the Classical period, circa 480-330 B.C. Provides a useful glossary of terms, a map, and a chronological table. General bibliography (pp. 236-45) and further bibliography in the notes to text. Together with other volumes in the series (861, 880, 898), it forms a good history of art and architecture in ancient Greece.

892　Schefold, Karl. **Die Griechen und ihre Nachbarn.** Berlin, Propyläen, 1967. 372p. (text); 432p. (illus.). index. LC 67-109553.

　　Comprehensive illustrated handbook of the art and architecture of ancient Greece from the Geometric period through the Hellenistic period, and the art and architecture of the neighboring civilizations in the Near East (Phrygian, Lydian, Scythian, Iranian to the Seleucids) and the western Mediterranean (Phoenician and Iberian, and Italy before Rome). The introductory essay is by Schefold, and there are additional essays on the

development of the various arts by leading European specialists. Excellent illustrations, numerous plans and elevations in the notes. Long, very informative notes to the illustrations (with references to specialized literature) and a very good comprehensive bibliography (pp. 343-55). The finest handbook for ancient Greek art.

893 Schoder, Raymond V. **Masterpieces of Greek Art.** Greenwich, Conn., New York Graphic Society, 1965. 121p. illus. LC 65-6508.
 Brief pictorial survey of ancient Greek art and architecture. Excellent illustrations. For the general reader.

894 Schuchhardt, Walter H. **Greek Art.** New York, Universe, 1972. 189p. illus. index. LC 70-17860.
 Concise history of art and architecture in ancient Greece from the Archaic through the Hellenistic periods. Brief bibliography of major works (pp. 186-87). Excellent condensed history for the beginning student, with many well-chosen illustrations and informative captions.

895 Schweitzer, Bernard. **Greek Geometric Art.** New York, Phaidon, 1971. 352p. illus. index. LC 71-111066.
 Detailed examination of the history of ancient Greek art of the Proto- and Geometric periods. Chapters are devoted to individual media and major classes of art objects. Chapter on architecture is less comprehensive. Extensive bibliographic footnotes.

896 Seltman, Charles. **Approach to Greek Art.** New York, Dutton, 1960. 143p. illus. index.
 Unusual survey of ancient Greek art from Archaic times through the Hellenistic period. Emphasizes the dominant role of celature, i.e., the art of embossing on metal, most notably in the creation of coins. Brief bibliography of basic books (p. 122).

897 Vermeule, Emily. **Greece in the Bronze Age.** Chicago, University of Chicago Press, 1964. 406p. illus. index. LC 64-23427.
 Reprinted in 1972. Cultural history of ancient Greece from the end of the Stone Age to the end of Mycenaean and Minoan civilizations. Good bibliography of books and periodical articles in all languages (pp. 351-83). Glossary of terms.

898 Webster, Thomas Bertram L. **The Art of Greece: The Age of Hellenism.** New York, Crown, 1966. 243p. illus. index. LC 66-26188.
 Concise history of the art and architecture of ancient Greece during the Hellenistic period, circa 330-50 B.C. Provides a useful glossary of terms, a map, and a chronological table. General bibliography (pp. 224-32) and further bibliography in the notes to the text. Together with other volumes in the series (861, 880 and 891), it forms a good history of ancient Greek art.

ETRUSCAN

899 Banti, Luigi. **Etruscan Cities and Their Culture.** Trans. by Erica Bizzarri. Berkeley, University of California Press, 1973. 322p. illus. index. LC 74-145781.
 Comprehensive history/handbook of ancient Etruscan culture arranged by regions and cities with chapters on Etruscan art, religion, writing and language, history and government. Select bibliography (pp. 280-303) is a good classified bibliography of basic books and periodical articles.

900 Bianchi Bandinelli, Ranuccio, and Antonio Giuliano. **Etruschi e Italici prima del dominio di Roma.** Milan, Rizzoli, 1973. 437p. illus. index.
Pictorial history of the art and architecture of the Etruscan and ancient Italians. Richly illustrated. Provides useful chronological table, glossary-index, maps, and good, classified bibliography of books and periodical articles in all languages (pp. 389-98).

901 Bloch, Raymond. **Etruscan Art: A Study.** Greenwich, Conn., New York Graphic Society, 1966. 103p. illus. index. LC 65-22674.
Brief history of Etruscan art and architecture. Good illustrations.

902 Brendel, Otto J. **Etruscan Art.** Harmondsworth, Penguin, 1978. 507p. illus. index. (Pelican History of Art, Z43). LC 77-22662.
Comprehensive history of ancient Etruscan art excluding architecture (in the same series Etruscan architecture is treated in the volume by Axel Boëthius and John Ward-Perkins **Etruscan and Roman Architecture** [Harmondsworth, Penguin, 1970]). Bibliography (pp. 481-85) lists basic works, and there are specialized bibliographies in footnotes. A standard history of Etruscan art.

903 Busch, Harold, ed. **Etruskische Kunst.** Frankfurt am Main, Umschau Verlag, 1969. 59p. text, 134 plates. LC 71-579548.
Illustrated survey of Etruscan art and architecture. Introductory essay by W. Zchietzschmann traces the outlines of Etruscan art and architecture. A good corpus of black and white illustrations follows.

904 Cristofani, Mauro. **The Etruscans: A New Investigation.** London, Orbis, 1979. 128p. illus. index. LC 79-317873.
History of Etruscan art and architecture with emphasis on major issues such as: the influence of near eastern art on Etruscan art; the relationship between ancient Greece and Etruria; rural and urban in Etruscan art. Bibliographical footnotes.

905 Dohrn, Tobias. **Grundzüge etruskischer Kunst.** Baden-Baden, Grim 1958. 64p. illus. (Deutscher Beiträge zur Altertumswissenschaft, Heft 8).
Scholarly analysis of the basic stylistic character of ancient Etruscan art, exclusive of architecture. Important chapters on the process of absorption of Greek influences by Etruscan art and the Etruscan contribution to Roman art. Bibliographic footnotes.

906 Ducati, Pericle. **Storia dell'arte etrusca.** Florence, Rinascimento del Libro, 1927. 2v. illus. index.
Comprehensive history of Etruscan art and architecture. Volume one is text; volume two is plates. Good bibliographies given at the end of each chapter. Once a standard history, it is now out of date. Nevertheless, it is still useful to the advanced student for its plates and its bibliography of older literature.

907 Frova, Antonio. **L'arte etrusca.** Milan, Garzanti, 1957. 110p. illus. index.
Illustrated survey of Etruscan art and architecture. Selected bibliography of books in all languages (pp. 104-108).

908 Giglioli, Giulio Q. **Arte Etrusca.** Milan, Treves, 1935. 95p. illus. index. LC 36-14223.
Pictorial handbook to ancient Etruscan art and architecture. Still a valuable collection of illustrations for the beginning and advanced student.

909 Hess, Robert. **Das etruskische Italien; Entdeckungsfahrten zu den Kunststätten und Nekropolen der Etrusker.** Cologne, DuMont-Schauberg, 1974. 285p. illus. index. LC 73-345438.
Comprehensive, pocket-sized handbook to the major Etruscan archaeological sites. Introductory chapters survey Etruscan history and art and are followed by a geographically arranged description of the major sites. Bibliography (pp. 267-71) lists basic books in all languages.

910 Mansuelli, Guido A. **The Art of Etruria and Early Rome.** New York, Crown, 1965. 255p. illus. index. LC 65-24336.

Concise, well-illustrated history of Etruscan art and architecture and the art and architecture of the Republican period of Rome. Provides a useful glossary of terms, a map, a chronological table, and an appendix on the Etruscan tombs. General bibliography (pp. 240-46) is excellent except that it does not note English translations of certain key titles.

911 Martha, Jules. **L'art étrusque.** Paris, Firmin-Didot, 1889. 635p. illus. index. LC F-3664.

Older, once standard handbook of Etruscan art and architecture. Illustrated with line drawings. Bibliographical footnotes.

912 Matt, Leonard von. **The Art of the Etruscans.** Photos by Leonard von Matt. Text by Mario Moretti and Guglielmo Maetzke. New York, Abrams, 1970. 252p. illus. index. LC 70-125781.

Illustrated handbook of the art and architecture of the ancient Etruscans, arranged by place. For the general reader, the beginning student, and the tourist.

913 Mühlestein, Hans. **Die Etrusker im Spiegel ihrer Kunst.** Berlin, Deutscher Verlag der Wissenschaften, 1969. 324p. illus. LC 71-423275.

Part one covers Etruscan history; part two surveys the history of Etruscan art exclusive of architecture. Extensive bibliographic footnotes. One of the best cultural histories of the ancient Etruscans.

914 Pallottino, Massimo. **The Etruscans.** Baltimore, Penguin, 1956. 295p. illus. index. LC 56-53.

History of Etruscan civilization, with strong emphasis on its art and architecture. Good selection of plates. Brief bibliography (pp. 281-82) lists major books in all languages. A standard cultural history.

915 Pallottino, Massimo, and Martin Hürlimann. **Art of the Etruscans.** New York, Vanguard, 1955. 154p. illus. LC 56-39.

Pictorial survey of the art and architecture of the ancient Etruscans. Emphasis is on painting and sculpture; only tomb architecture is included. Brief but sensible text is followed by a fine collection of plates with informative notes. Provides a map, a chronological table, and a brief bibliography (p. 29) that lists major books in all languages.

916 Richardson, Emeline Hill. **The Etruscans, Their Art and Civilization.** Chicago, University of Chicago Press, 1964. 285p. illus. index. LC 64-15817. Reprint: University of Chicago Press, 1976. LC 76-381935.

History of the arts and civilization of the ancient Etruscans from the prehistoric period through the Hellenistic period. Good general bibliography (pp. 251-63) and further reference to specialized literature in the notes to the plates. One of the best surveys of Etruscan art, except for paucity of illustrations. Reprinted (1976) by publisher.

917 Riis, Poul J. **An Introduction to Etruscan Art.** Copenhagen, Munksgaard, 1941. 144p. illus. index.

Collection of lectures on various aspects of Etruscan art and architecture, some out of date, others still useful to the beginning student. Bibliographical references are given at the end of each chapter.

918 Sprenger, Maja, and Gilda Batolini. **The Etruscans.** New York, Abrams, 1983. 176p. text, 288p. plates. LC 83-3736.

Well-illustrated survey of ancient Etruscan art and architecture. Brief introductory essay followed by plates with descriptive notes. Reference to specialized literature in the notes to the plates; general bibliography, pp. 165-67.

919 Steingräber, Stephan. **Etrurien Städte, Heiligtümer, Nekropolen.** Munich, Hirmer, 1982. 480p. illus. LC 86-672388.
In the series: *Reise und Studium.* Comprehensive and scholarly handbook of the major archaeological sites of ancient Etruscan civilization. Introductory chapters on history, topography, domestic, funerary, and sacred architecture are followed by detailed descriptions of the major cities. Comprehensive bibliography (pp. 580-90) and specialized literature at the end of the sections on the sites.

See also: Cossío and Pijoán (930), Hafner (935), Kraus (942).

ROMAN

Andreae, Bernard. **The Art of Rome.** New York, Abrams, 1978. 656p. illus. index. LC 75-8855.
Sumptuously illustrated history and handbook of ancient Roman art and architecture. Part one, City to Empire to World Spirit, traces the development of art and architecture within the general cultural context. Part two, The Image as Document, provides an extensive collection of illustrations chronologically arranged to demonstrate the continuity and evolution of style. Part three is a catalog of descriptions of major archaeological sites, with bibliographies of specialized literature. Glossary of terms, genealogical tables of the Roman emperors, chronological table of major events in Roman history. Color plates of exceptional quality.

921 Becatti, Giovanni. **L'arte romana.** Milan, Garzanti, 1962. 139p. illus.
Concise history of ancient Roman art and architecture from its beginnings to the end of the fourth century A.D. Glossary of terms, brief bibliography of books in Italian.

922 Bertman, Stephen. **Art and the Romans. A Study of Roman Art as a Dynamic Expression of Roman Character.** Lawrence, Kansas, Coronado Press, 1975. 83p. illus. index.
Sketchy attempt to discern manifestations in Roman art and architecture of such broad themes as war and peace, conquest of space, and Rome and Jerusalem. Suggestions for further reading (pp. 75-81).

923 Bettini, Sergio. **L'arte alla fine del mondo antico.** Padua, Editorial Liviana, 1948. 139p. illus. index. LC 50-17294.
Concise history of Roman art and architecture of the third through the fifth centuries A.D. No bibliography.

924 Bianchi Bandinelli, Ranuccio. **Rome, the Center of Power: Roman Art to A.D. 200.** New York, Braziller, 1970. 455p. illus. index. (The Arts of Mankind, 15). LC 79-526920.
Illustrated history of Roman art and architecture from Republican times to 200 A.D. Provides excellent illustrations, numerous maps, plans, reconstructions, and chronological and genealogical tables. A good comprehensive bibliography (pp. 391-96). Together with volumes 16 and 17 in the series (by the same author), it forms a good pictorial handbook-history.

925 Bianchi Bandinelli, Ranuccio. **Rome, the Late Empire: Roman Art A.D. 200-400.** New York, Braziller, 1971. 463p. illus. index. (The Arts of Mankind, 16). LC 71-136167.
Illustrated history of the art and architecture of ancient Rome during the third and fourth centuries A.D. Provides a glossary-index, a chronological table, numerous plans and reconstructions, and a good bibliography (pp. 411-21). Together with another volume in the series (924), it forms a good pictorial handbook-history of ancient Roman art and architecture.

926 Brendel, Otto J. **Prolegomena to the Study of Roman Art.** New Haven, Yale University Press, 1979. 207p. illus. index. LC 78-24455.
First published in the *Memoir of the American Academy in Rome* in 1953. Important contribution to the study of basic issues in the history of ancient Roman art through an investigation of the definition of the "Roman" in Roman art. Bibliographical footnotes.

927 Brilliant, Richard. **Roman Art from the Republic to Constantine.** London, Phaidon, 1974. 288p. illus. index. LC 74-1527.
Well-illustrated survey of Roman art and architecture. Part one treats major themes in Roman art; part two, the history of period styles in Roman art. Chronological table and bibliography arranged by chapters (pp. 269-72) provides a good overview of the major books and articles in all languages.

928 Chapot, Victor. **Les styles du monde romain.** Paris, Larousse, 1943. 144p. illus. index.
Concise stylistic history of ancient Roman art and architecture from Republican times to the end of the Empire. Chapter on architectural construction. Glossary, topographic index with summaries of the monuments, and bibliography (pp. 139-40) listing basic books in all languages. Volume in the series, "Arts, Styles, et Techniques."

929 Charbonneaux, Jean. **L'art au siècle d'Auguste.** Lausanne, Guilde du Livre, 1948. 108p. text, 101 plates. LC 49-27633.
Survey of the art of ancient Rome from the middle of the first century B.C. to the middle of the first century A.D. Good collection of plates. Bibliographical footnotes.

930 Cossío, Manuel B., and José Pijoán y Soteras. **El arte romano hasta la muerte de Diocleciano. Arte etrusco y arte helenístico después de la toma de Corinto.** Bilbao, Spain, Espasa-Calpe, 1934. 591p. illus. index. (Summa Artis, Historia General del Arte, V).
Comprehensive survey of Roman art and architecture, including both Roman Hellenistic and Etruscan aspects. Brief lists of books at the end of chapters.

931 Ducati, Pericle. **L'arte in Roma dalle origini al sec. VIII....** Bologna, Cappelli, 1938. 500p. illus. index.
History of art and architecture in ancient Rome from early Republican times through the eighth century. Well illustrated and provided with a good annotated bibliography (pp. 421-36).

932 Essen, Carel C. van. **De kunst van het oude Rome.** The Hague, Servire, 1954. 105p. illus. index. LC A55-4049.
Concise history of Roman art by a leading Dutch scholar. Emphasis on contribution of Italy. Bibliography of basic books (p. 106).

933 Essen, Carel C. van. **Précis d'histoire de l'art antique en Italie.** Brussels, Latomus, 1960. 151p. index. (Collection Latomus, 42).
Unusual attempt to trace the history of art and architecture in Italy, as a regional phenomenon, from circa 900 B.C. to circa 700 A.D. Extensive bibliographic footnotes.

934 Frova, Antonio. **L'arte di Roma e del mondo romano.** Turin, Unione Torinese, 1961. 947p. illus. index. (Storia Universale dell'Arte, v. 2, t. 2). LC 61-49278.
Comprehensive history of Roman art and architecture from Etruscan times through the fourth century A.D. Well illustrated and provided with a good classified bibliography (pp. 839-93) that lists books and periodical articles in all languages.

935 Hafner, German. **Art of Rome, Etruria and Magna Graecia.** New York, Abrams, 1969. 264p. illus. index. LC 71-92911.
Concise history of the art and architecture of the Etruscans and ancient Romans from the eighth century B.C. through the fourth century A.D. An introduction sketching

the main outlines of the development is followed by a good selection of illustrations, arranged chronologically, and a brief introduction to the chief periods of ancient Etruscan and Roman art. The plates are accompanied by informative notes in addition to the captions. Unfortunately, there are no plans for the architectural examples. Does have a good chronological table, maps, and a good, classified bibliography (pp. 257-59) that lists books in all languages.

936 Hanfmann, George M. A. **Roman Art. A Modern Survey of the Art of Imperial Rome.** New York, New York Graphic Society, 1964. 328p. illus. index. Reprint: New York, Norton, 1975. LC 74-30063.

Pictorial survey arranged by media. Introductory essay and short essays on periods of Roman art. Notes to the plates give some references to specialized literature. Bibliography of basic books (pp. 53-55).

937 Heintze, Helga. **Roman Art.** New York, Universe, 1971. 200p. illus. index. LC 79-134759.

Concise history of the art and architecture of the ancient Romans from 600 B.C. to 500 A.D. Good selection of plates, plans, and diagrams. Succinct and informative text and illustration captions. Bibliography (pp. 193-95) lists major books in all languages. A good survey of Roman art and architecture for the beginning student.

938 Henig, Martin. **A Handbook of Roman Art: A Comprehensive Survey of All the Arts of the Roman World.** Ithaca, N.Y., Cornell University Press, 1983. 288p. illus. index. LC 82-71591.

Comprehensive survey of ancient Roman art and architecture from the eighth century B.C. to the sixth century A.D. Chapters are devoted to the various media and are written by a team of British scholars. Good, classified bibliography (pp. 271-80) and additional bibliography in the footnotes.

939 Kähler, Heinz. **The Art of Rome and Her Empire.** New York, Crown, 1963. 262p. illus. index. LC 63-14558.

Concise history of art and architecture in ancient Rome from the time of Augustus to that of Constantine. Provides a useful glossary of terms, a chronological table, a map, and a bibliography of basic works (pp. 216-24). Mansuelli's volume (910) in the same series treats earlier Roman art. Useful chapter on fundamental characteristics of Roman art.

940 Kaschnitz von Weinberg, Guido. **Römische Kunst.** Reinbek bei Hamburg, Rowohlt, 1961-1963. 4v. illus. index. LC NUC66-84856.

Comprehensive history of the art and architecture of ancient Rome, beginning with Republican times and ending with the fourth century. Volume one is a general introduction that explores the concept of Roman art, the problem of Roman art form, the origins of Roman art, and the general historical background to Roman art. Volume two is a history by types of Roman sculpture; volumes three and four cover the history of Roman architecture. Provides a chronological table, brief bibliography at the end of each volume, and an index at the end of volume four. A basic work for advanced students. Emphasizes form in the tradition of Alois Riegl.

941 Koch, Herbert. **Römische Kunst.** Weimar, Böhlaus, 1949. 160p. illus. index.

Concise history of art and architecture in ancient Rome from early Republican times through the fifth century. Chronological outline (pp. 151-54) and selected bibliography (pp. 145-50). A brief but well-written general history of Roman art and architecture.

942 Kraus, Theodor. **Das Römische Weitreich.** Berlin, Propyläen, 1967. 336p. (text); 414p. (illus). index. (Propyläen Kunstgeschichte, 2). LC 68-70295.

Comprehensive illustrated handbook of the art and architecture of ancient Rome and its dominions from late Etruscan times through the fifth century. Introductory essay is

followed by sections on the development of the various arts, written by a number of specialists. Excellent illustrations, numerous plans and elevations, and very informative notes to the illustrations, with references to specific bibliography. Good comprehensive bibliography (pp. 305-19). One of the finest handbooks of ancient Roman art.

943 Lübke, Wilhelm, and Ernst Pernice. **Die Kunst der Römer.** New ed. reworked by Berta Sarne. Vienna, Neff, 1958. 455p. illus. index. (Grundriss der Kunstgeschichte, Band 1). LC 59-5011.
 Comprehensive history of ancient Roman art and architecture from its beginnings to the end of the fourth century A.D. Chapter on architecture is particularly thorough, treating the basic systems of construction and the development of the major building types. Bibliography (pp. 450-54) provides a good, classified list of books and periodical articles in all languages. Latest edition of the volume on Rome in an older, standard multi-volume history of art.

944 Riegl, Alois. **Spätrömische Kunstindustrie.** 2d ed. Vienna, Österreichischen Staatsdruckerei, 1927. 422p. illus. index. Reprint: Darmstadt, Wissenschaftliche Buchgesellschaft, 1964.
 First published in 1901. Highly influential history and analysis of the art and architecture of the third through the sixth centuries A.D. Introduction examines the past attitudes to late Roman and Early Christian art. Separate chapters are devoted to the analysis of architecture, sculpture, painting, and the minor arts. Conclusion summarizes the basic qualities of late Roman art. Riegl's work was one of the first to seriously reevaluate a period that was previously seen only as one of artistic decline. Bibliographical footnotes. Classified bibliography of basic books and periodical articles (pp. 413-16). Appendix with important essay on Riegl by Otto Pächt.

945 Rumpf, Andreas. **Stilphasen der spätantiken Kunst; Ein Versuch.** Cologne, Westdeutsche Verlag, 1957. 52p. text, 40p. illus. (Arbeitsgemeinschaft für Forschung des Landes Nordrhein-Westfalen. Geisteswissenschaften. Abhandlung 44).
 Scholarly history of the development of late Roman art, exclusive of architecture, from the fourth through the sixth centuries. Based on lectures delivered in Copenhagen and Bonn in 1953. Extensive bibliographical footnotes. A standard work; see also Kitzinger (1040).

946 Strong, Donald. **Roman Art.** Harmondsworth, Penguin, 1976. 357p. illus. index. (Pelican History of Art, Z 39). Reprint, Baltimore, Penguin, 1980.
 Scholarly history of Roman art exclusive of architecture, which is treated in a separate volume in the same series, *Etruscan and Roman Architecture* by Axel Boëthius and J. B. Ward-Perkins (1970). Strong covers the period from early Republican times through the fourth century A.D. Lacks detailed footnotes due to author's death. Bibliography (pp. 175-84) compiled by Jocelyn Toynbee. Not as comprehensive a work as the companion volume on architecture, but still an important history.

947 Strong, Eugénie. **Art in Ancient Rome....** New York, Scribner's, 1928. 2v. illus. index. Reprint: Westport, Conn., Greenwood Press, 1970. 220p. illus. index. LC 72-109858.
 Handbook of ancient Roman art from the early Republican period through the fifth century A.D. Does not cover architecture. Once a standard history, it is still valuable for its succinct stylistic analysis and its organization.

948 Toynbee, Jocelyn M. C. **The Art of the Romans.** New York, Praeger, 1965. 271p. illus. index. (Ancient People and Places, v. 43). LC 65-20080.
 Concise history of the art but not the architecture of ancient Rome from the sixth century B.C. to the end of the fifth century A.D. General bibliography (pp. 183-89) and further references to specialized literature in the footnotes and notes to the plates. One of the best modern surveys of Roman art.

949 Wheeler, Robert Eric Mortimer. **Roman Art and Architecture.** New York, Praeger, 1964. 250p. illus. index. Reprint: London, Thames and Hudson, 1985. LC 84-51306.

Concise history of art and architecture in ancient Rome from Republican through late Roman times with emphasis on architecture. The arts are surveyed separately by medium. Short bibliography (p. 237).

950 Wickhoff, Franz. **Roman Art; Some of Its Principles and Their Application to Early Christian Painting....** New York, Macmillan, 1900. 198p. illus. index.

General survey history of Roman art as the background to the art of the Early Christian and Early Byzantine periods, with special reference to the "Vienna Genesis." An influential work in its time. Bibliographic footnotes.

Germanic and Celtic

951 Adama van Scheltema, F. **Die altnordische Kunst: Grundprobleme vorhistorischer Kunstentwicklung.** 2d ed. Berlin, Mauritius, 1924. 252p. illus. index.

Comprehensive history of the art of Europe from paleolithic times through the Iron Age of the Germanic peoples. Illustrated with line drawings and a few plates. Extensive bibliography in the footnotes. In many aspects, out of date and still controversial in approach, yet a classic study of the development and significance of prehistoric and migration art in Europe.

952 Allen, John R. **Celtic Art in Pagan and Christian Times.** 2d ed. London, Methuen, 1912. 315p. illus. index.

Survey of Celtic art, with emphasis on the British Isles, from the early Bronze Age to circa 1100 A.D. Bibliographic footnotes. For its time, a remarkably comprehensive and well-illustrated survey.

953 Déchelette, Joseph. **Manuel d'archéologie préhistorique celtique et gallo-romaine.** Paris, Picard, 1908-1934. 6v. illus. index. Reprint of first two volumes: Farnborough, Gregg, 1971.

Handbook of Celtic and Gallo-Roman archaeology. Useful information on the fine arts. Volume one covers prehistoric archaeology; volumes two through four, Celtic archaeology; the remaining volumes, Gallo-Roman archaeology. Each volume has extensive bibliographies. A standard handbook.

954 Duval, Paul-Marie. **Les Celtes.** Paris, Gallimard, 1977. 323p. illus. index.

Pictorial survey of Celtic art on the European continent and the British Isles from 450 B.C. to the fourth century A.D. Richly illustrated. Provides useful chronological table, maps, glossary-index, and excellent bibliography (pp. 299-307) listing 356 books and periodical articles in all languages. List of principal museums with collections of Celtic art.

955 Eggers, Hans J., et al. **Les Celtes et les Germains à l'époque paienne.** Paris, Michel, 1965. 263p. illus. index. LC 66-56194.

Concise history of the art of the ancient Celts and Germanic peoples from 500 B.C. through the fifth century A.D. Also covers provincial Roman art in Gaul. Provides excellent color plates, a supplementary collection of black and white plates, maps, diagrams, drawings, a chronological table, and a good classified bibliography of major works in all languages (pp. 241-49). This is the French edition of the "Art of the World Series." A good survey history of a period otherwise neglected in the general literature.

956 Fettich, Nándor. **Die altungarische Kunst.** Berlin, Kupferberg, 1942. 54p. text; 60p. illus. (Schriften zur Kunstgeschichte Südösteuropas, I).

Brief but still useful survey of the art of the migrations period in Hungary. Bibliography of books and periodical articles (pp. 53-54).

957 Finlay, Ian. **Celtic Art: An Introduction.** London, Faber and Faber, 1973. 183p. illus. index. LC 72-89198.

Concise history of Celtic art in Europe, exclusive of architecture, from the Hallstatt period through the fourteenth century. Good selection of plates and a brief, unclassified bibliography (pp. 174-75).

958 Grenier, Albert. **Manuel d'archéologie gallo-romaine.** v. 1- . Paris, Picard, 1931- . illus. index.

Comprehensive handbook of Gallo-Roman archaeology with much information on Celtic and Gallo-Roman art and architecture. Continues Déchelette (953). Contents: Tome 1, *Généralités: travaux militaires*; Tome 2, *Archéologie du sol*; Tome 3, *L'architecture*; Tome 4, *Les monuments des eaux* (2v.). A basic handbook.

959 Holmqvist, Wilhelm. **Germanic Art During the First Millenium A.D.** Stockholm, Almqvist & Wiksell, 1955. 89p. illus. (Kungl. Vitterhets Historie och Antikvitets Akadiemiens Handlingar, Del. 90).

Survey of Germanic art from late Roman times to the end of the Viking period. Bibliography (pp. 79-84) is an unclassified list of books and periodical articles in all languages. Further reference to specialized literature in the footnotes. A standard work on Germanic art.

960 Jacobsthal, Paul. **Early Celtic Art.** Oxford, Clarendon Press, 1970. 2v. illus. index. LC 73-16002.

Reissue of the 1944 edition. Comprehensive study of Celtic art of the third through the early second centuries B.C. Does not cover Celtic art in Spain and Portugal. The excellent selection of plates is accompanied by a catalog with reference to specialized literature. A standard history-handbook of Celtic art.

961 Jenny, Wilhelm Albert von. **Die Kunst der Germanen im frühen Mittelalter.** Berlin, Deutsche Kunstverlag, 1940. 151p. illus.

History of the arts of the Germanic peoples from the first through the tenth centuries. Covers the arts of the North Germans through the Viking period as well as the arts of the various migrating Germanic tribes. Well illustrated. Good bibliography (pp. 77-86), which lists books and periodical articles in all languages. A standard history of Germanic art.

962 Kühn, Herbert. **Die vorgeschichtliche Kunst Deutschlands.** Berlin, Propyläen, 1935. 611p. illus. index. (Propyläen-Kunstgeschichte, Ergänzungsband 8).

Comprehensive handbook of art in Germany from earliest times through the period of migrations. Introductory essay followed by good collection of plates with descriptive notes. Good classified bibliography of books and periodical articles (pp. 571-81).

963 László, Gyula. **The Art of the Migration Period.** Coral Gables, University of Florida Press, 1974. 135p. illus. LC 70-171454.

Pictorial survey of the arts of the pre-Christian Germans, Huns, Avars, Slavs, and Hungarians during the period of the migrations. Well illustrated. Brief bibliography (pp. 141-44) of books and periodical articles. One of the few recent surveys of the art of the migrations period.

964 Megaw, J. V. S. **Art of the European Iron Age.** New York, Harper, 1970. 195p. illus. index. LC 78-115868.

Concise history of the arts of barbarian Europe from the eighth century B.C. to the second century A.D. Concentrates chiefly on Celtic art but does not cover Celtic art in Iberia or the Iron Age cultures in the Balkans and East Hallstatt region. The catalog of plates provides excellent bibliographical references. A basic history.

965 Salin, Bernhard. **Die altgermanische Thierornamentik....** New ed. Stockholm, Wahlström, Wahlström & Widstrand, 1935. 387p. illus. index.

First published in Swedish in 1904. Detailed, scholarly study of the evolution of Germanic decorative style from the late Roman period through the Viking style. Salin describes a series of zoomorphic styles of ornament in Germanic art that form the basis (although controversy on the points exists) for all later study of Germanic art. Bibliography in the footnotes. A standard work.

MEDIEVAL AND BYZANTINE

General Works

966 Calkins, Robert G. **Monuments of Medieval Art.** Ithaca, Cornell University Press, 1979. 299p. illus. index. LC 84-21504.

Survey of the art and architecture of Europe from the Early Christian period to the early sixteenth century including Byzantium. The first six chapters constitute a chronological survey; the final two chapters concentrate on medieval manuscript illumination and medieval secular art. Bibliography (pp. 275-80) mostly lists works in English.

967 Duby, George. **History of Medieval Art.** New York, Rizzoli, 1986. 722p. illus. index. LC 85-43525.

Reissue with many new illustrations of a three-volume work first published in 1966-1967. A sweeping and engagingly written social history of medieval architecture and art from the beginning of the Romanesque to the late Gothic. No bibliography.

968 Focillon, Henri. **The Art of the West in the Middle Ages.** 2d ed. New York, Phaidon, 1963. 2v. illus. index. LC 63-4333.

Comprehensive survey of art and architecture in Western Europe during the Romanesque and Gothic periods. Good collection of black and white plates; emphasis is on architecture, with less on sculpture and little on painting. Good bibliographies are at the end of the chapters, with further bibliography in the informative footnotes, some brought up to date by editor Jean Bony. Not strictly a factual history, but a highly individualitic interpretation of medieval art that emphasizes the metamorphosis of forms.

969 Huyghe, René, ed. **Larousse Encyclopedia of Byzantine and Medieval Art.** New York, Prometheus, 1963. 416p. illus. index. LC 63-12755.

Collection of essays by French specialists on the art and architecture of the Early Christian through the Gothic periods. Includes Asian art and architecture of the same time span. No bibliography.

970 Kidson, Peter. **The Medieval World.** New York, McGraw-Hill, 1967. 176p. illus. index. LC 67-11796.

Pictorial survey of the art and architecture of the Western Middle Ages from Hiberno-Saxon and Carolingian times through the Gothic. Provides a glossary, chronological tables, maps, succinct captions to the illustrations, and a brief list of books for further reading.

971 Lethaby, William R. **Medieval Art, from the Peace of the Church to the Eve of the Renaissance, 312-1350.** Rev. by David T. Rice. New York, Philosophical Library, 1950. Reprint: New York, Greenwood Press, 1969. 223p. illus. index. LC 71-97315.

Survey history of the art and architecture of the Middle Ages from 312 to 1350. Also covers Byzantine art and architecture. Few bibliographical references in the footnotes. Originally published in 1904 and long a standard history, this useful work has been brought up to date by Rice, chiefly through the addition of supplementary footnotes.

972 Mâle, Émile. **Art et artistes du moyen âge.** 4th ed. Paris, A. Colin, 1947. 328p. illus. index.

Survey of Western medieval art and architecture from Early Christian through Gothic, consisting of chapters on major monuments such as Mont-Saint-Michel, Rheims, Córdoba; artists such as Jean Bourdichon; media such as French late Gothic ivories. Interesting chapter on Rodin and the French cathedrals. Bibliographical footnotes.

973 Morey, Charles R. **Medieval Art.** New York, Norton, 1942. 412p. illus. index.

Survey of art and architecture from the early Christian through the late Gothic periods. Brief reading list (p. 395). Illustrated with black and white plates and line drawings. Some bibliographical references given in footnotes. Once a standard history of medieval art, it is now out of date. Nevertheless, it is still useful to the general reader and beginning student for its effective organization and succinct language.

974 Schlosser, Julius von. **Die Kunst des Mittelalters.** Berlin, Neubabelsburg, 1923. Reprint: **L'arte del medioevo.** Turin, Einaudi, 1961. 134p. illus.

Survey of medieval art and architecture in Western Europe with emphasis on evolution of form within the overall cultural context. Still an influential interpretation of medieval art. No bibliography.

975 Shaver-Crandell, Anne. **The Middle Ages.** New York, Cambridge University Press, 1982. 122p. illus. index. (Cambridge Introduction to the History of Art, 2). LC 81-9989.

Concise survey of art and architecture in Western Europe from the second half of the eleventh century to the end of the fourteenth century, directed to the beginning student. Bibliography (p. 120) lists basic works in English.

976 Smith, Norris Kelly. **Medieval Art: An Introduction to the Art and Architecture of Europe, A.D. 300-A.D. 1300.** Dubuque, Iowa, W. C. Brown, 1967. 111p. illus. index. LC 67-22712.

Concise survey of the art and architecture of Eastern and Western Europe from 300 to 1300. Includes Byzantine art and architecture. General, unclassified bibliography (pp. 113-14).

977 Snyder, James. **Medieval Art: Painting, Sculpture, Architecture, 4th-14th Century.** New York, Abrams, 1988. 511p. illus. index. LC 88-9909.

Survey history of art and architecture from Early Christian times to the end of the fourteenth century. Includes Byzantine art and architecture. Good selection of plates. Bibliography (pp. 487-93) is a classified list of major books; more specialized literature is referenced in the footnotes.

978 Stokstad, Marilyn. **Medieval Art.** New York, Harper, 1983. 442p. illus. index. LC 84-48522.

Survey history of the art and architecture of Europe from the second to the fifteenth centuries. Covers Byzantine as well as Western medieval art. Designed to serve as a text for undergraduate students. Good, classified bibliography of basic books, pp. 413-23.

979 Strong, Donald E., et al. **Origins of Western Art.** New York, Franklin Watts, 1965. 246p. illus. index. LC 64-23542.

Pictorial survey of the art and architecture of Europe from late Roman times through the thirteenth century. Consists of essays on late Roman, early Christian, Byzantine, early Medieval, Romanesque, and Gothic art and architecture by specialists. Well illustrated. Provides brief bibliography (p. 15) of books in English.

980 Zarnecki, George. **Art of the Medieval World: Architecture, Sculpture, Painting, the Sacred Arts.** New York, Abrams, 1975. 476p. illus. index. LC 75-25576.

Survey history of art and architecture from the fourth century A.D. to the middle of the fourteenth century A.D. Includes Byzantine art and architecture. Chronological table

correlating persons and events with artists and their works. Glossary of terms and classified bibliography of basic books and periodical articles in all languages (pp. 462-67). Intended as a college text.

Austria

See: Feuchtmüller (1543), Ginhart (1544).

France

981 Evans, Joan. **Art in Medieval France, 987-1498.** 1st ed., 3d impression with additional bibliography. Oxford, Clarendon Press, 1969. 325p. illus. index. LC 70-430545.
 History of art and architecture in medieval France cast in the context of the cultural environment. Some bibliography in the text footnotes; unclassified bibliography (pp. 293-300). Useful and readable history of the arts and general culture of medieval France. Particularly valuable are the chapters on the monastic orders.

982 Réau, Louis, and Gustave Cohen. **L'art du moyen âge: art plastique, arts litteraires et la civilization française.** Paris, Albin Michel, 1935. 468p. illus. index. Reprint: Paris, Albin Michel, 1951.
 Survey history of French medieval literature and fine arts during the Middle Ages. The two art forms are treated in separate sections, but the text makes frequent cross references. Good classified bibliography of basic books (pp. 429-43).

983 Stoddard, Whitney S. **Monastery and Cathedral in France: Medieval Architecture, Sculpture, Stained Glass, Manuscripts, the Art of Church Treasuries.** Middletown, Conn., Wesleyan University Press, 1966. 412p. illus. index. LC 66-23923. Reprint: **Art and Architecture in Medieval France.** New York, Harper & Row, 1972.
 Good survey of medieval art and architecture in France from the eleventh to the early sixteenth centuries. Emphasis is on major buildings. Classified bibliography of major works, pp. 393-402.

 See also: Schneider (1532).

Germany

984 Mâle, Émile. **L'art allemand et l'art français du moyen âge.** 4th ed. Paris, Colin, 1922. 328p. illus. index. LC 17-28856.
 Survey of the art of France and Germany from Carolingian times through the Gothic, with emphasis on the interrelationships between the two countries. Bibliographic footnotes.

985 Schardt, Alois J. **Die Kunst des Mittelalters in Deutschland.** Berlin, Rembrandt-Verlag, 1943. 668p. illus. index. (Geschichte der Kunst, Band II, Teil 1). LC 46-2267.
 Comprehensive history of art and architecture in Germany from the time of Charlemagne to the end of the fifteenth century. No bibliography.

986 Schmitz, Hermann. **Die Kunst des frühen und hohen Mittelalters in Deutschland.** Munich, Bruckmann, 1924. 272p. illus.
 Concise survey of the history of art and architecture in the German-speaking countries from prehistoric times through the late Romanesque (mid-thirteenth century). Includes a brief, unclassified bibliography of German books (pp. 268-69). Although now out of date in the details, it is still a well-written survey of German medieval art.

 See also: Dehio (1593), Pinder (1596).

Great Britain

987 Denvir, Bernard. **From the Middle Ages to the Stuarts; Art, Design and Society before 1689.** London, Longmans, 1988. 280p. illus. index. LC 87-26249.
 In the series: "A Documentary History of Taste in Britain." Cultural history of art and architecture in Britain from the early Middle Ages to 1689. Valuable for the many excerpts from contemporary literary sources. Biographical index.

988 Saunders, O. Elfrida. **A History of English Art in the Middle Ages.** Oxford, Clarendon Press, 1932. Reprint: Freeport, N.Y., Books for Libraries, 1969. 272p. illus. index. LC 70-103658.
 Concise history of art (exclusive of architecture) in England, beginning with Saxon period and ending the late Gothic. General bibliography (pp. 260-62) in addition to the bibliographies at the ends of chapters. An old survey history that is still of interest to the general reader.

989 Stoll, Robert. **Architecture and Sculpture in Early Britain: Celtic, Saxon, Norman.** New York, Viking, 1967. 356p. illus. index. LC 67-7107.
 Pictorial survey of architecture and sculpture in Britain during the early Middle Ages, from the seventh century through the Romanesque. The short introductury essay is followed by a collection of black and white plates (chiefly of architecture) and notes to the plates. No bibliography.

 See also: Boase (1611).

Italy

990 Lavagnino, Emilio. **L'arte mediaevale.** 2d ed. Torino, Unione Tipografico Editrice Torinese, 1960. 942p. illus. index. (Storia dell'Arte Classica e Italiana, v. 2).
 Survey of art and architecture in Italy from the Early Christian through the Gothic periods. Gothic section includes the Trecento. Good annotated bibliography (pp. 880-89). First published in 1936; still a good, well-illustrated history of medieval art and architecture in Italy.

991 Vitzthum, Georg von, and Wolfgang F. Volbach. **Die Malerei und Plastik des Mittelalters in Italien.** Wildpark-Potsdam, Athenaion, 1924. 339p. illus. index.
 Older, comprehensive history of painting and sculpture in Italy from the seventh through the fourteenth centuries. Arrangement is chronological by region. Bibliographical references are provided at the beginning of each chapter.

 See also: Ancona (1625), Venturi (1635).

Scandinavia

992 Anker, Peter, and Aron Andersson. **The Art of Scandinavia.** London, Hamlyn, 1970. 2v. illus. index. LC 79-21555.
 Comprehensive history of art and architecture in Scandinavia during the Middle Ages. Well illustrated with plates, plans, and diagrams. Bibliographical footnotes. This is a translation of the French edition, titled *La Pierre-qui-vire* (Zodiaque, 1968-1969). An excellent history of Scandinavian medieval art and architecture. The first volume is especially valuable as a thorough treatment of Viking art.

993 Rácz, István. **Art Treasures of Medieval Finland.** New York, Praeger, 1967. 252p. illus. LC 67-15670.
 Pictorial survey of art and architecture in Finland during the fourteenth and fifteenth centuries. Introduction and notes on the plates by Riitta Pylkkänen. No bibliography.

994 Rácz, István. **Norsk Middelalderkunst.** Oslo, Cappeln, 1970. 224p. illus. index. LC 79-574133.

Survey history of medieval art and architecture in Norway. Well illustrated. No bibliography.

See also: Poulsen (1670).

Switzerland

See: Gantner (1603).

Eastern Europe

995 **L'art medieval Yougoslave.** Belgrade, Institute for the Promotion of Travel and Catering Industry, n.d. 47p. illus.

Survey of art and architecture in Yugoslavia from Early Christian times to the end of the fifteenth century. Introduction and descriptions of the plates are in English, French, and German. No bibliography.

996 Grabar, André. **L'art du moyen âge en Europe orientale.** Paris, Michel, 1968. 243p. illus. index. LC 71-363370.

Concise history of art and architecture in Eastern Europe, covering the Balkans, Romania, Russia, and Greece from the tenth to the seventeenth centuries. Provides maps, chronological tables, and a classified bibliography of books in all languages (pp. 229-31). A good survey history of a neglected area of medieval art history.

997 Millet, Gabriel, ed. **L'art byzantin chez les slaves; L'ancienne russie, les slaves catholiques.** Paris, Geuthner, 1932. 535p. illus. index.

Collection of scholarly essays on Slavic Byzantine art and architecture. Three parts: Monuments byzantins de Chersonèse; L'ancienne Russie; Les Slaves catholiques. Extensive bibliographical footnotes and excellent classified bibliography of basic books and periodical articles compiled by Millet (pp. 439-90). A standard work.

998 Tschilingirov, Assen. **Die Kunst des christlichen Mittelalters in Bulgarien 4. bis 18. Jahrhunderts.** Munich, Beck, 1979. 403p. illus. index. LC 80-24708.

Well-illustrated survey of art and architecture in Bulgaria from 681 to the end of the eighteenth century. Notes to the plates with references to specialized bibliography and general bibliography of works in all languages, pp. 380-91.

999 Voyce, Arthur. **The Art and Architecture of Medieval Russia.** Norman, University of Oklahoma Press, 1966. 432p. illus. index. LC 66-13433.

History of art and architecture in Russia from the pre-Christian era (Scythians, etc.) to 1600. Provides a chronological table, a useful glossary of Russian art terms, maps, and good bibliography of general works (pp. 405-16). A standard history of medieval Russian art and architecture.

See also: Alpatov (1746), Filov (1728), Radojčic (1768).

Early Christian

1000 Beckwith, John. **Early Christian and Byzantine Art.** Harmondsworth, Penguin, 1970. 211p. illus. index. (Pelican History of Art). LC 79-23592.

History of Early Christian art from the early third century and Byzantine art to the middle of the fifteenth century. Does not cover architecture, which is treated in the same

series by R. Krautheimer's *Early Christian and Byzantine Architecture*. Provides a glossary of terms, maps, and a brief bibliography of general works (pp. 191-92). Specialized literature is mentioned in the notes to the text. A basic history of Early Christian and Byzantine art.

1001 Brenk, Beat. **Spätantike und frühes Christentum.** Berlin, Propyläen, 1977. 351p. text, 400 plates. (Propyläen-Kunstgeschichte, Ergänzungsband I).
Comprehensive illustrated handbook of Early Christian art and architecture covering the third through the fifth centuries. Introductory essays by various European scholars discuss the evolution of Early Christian art. Excellent corpus of plates with detailed descriptive notes that include bibliographic references to specialized literature. Includes chronological table correlating political, religious, and artistic events. Good classified bibliography of books and periodical articles in all languages. A standard handbook.

1002 Cossío, Manuel B., and José Pijoán y Soteras. **Arte cristiano primitivo. Arte bizantino, hasta el saqueo de Constantinopla por los cruzados el año 1204.** Bilbao, Spain, Espasa-Calpe, 1935. 592p. illus. index. (Summa Artis, Historia General del Arte, VII).
Comprehensive survey of Early Christian art and architecture and also Byzantine art to 1204. Does not treat contemporary Germanic arts (these are given consideration in number 729). Brief lists of books at the ends of chapters.

1003 Du Bourguet, Pierre. **Early Christian Art.** New York, Reynal, 1971. 219p. illus. LC 77-151935.
Comprehensive history of Early Christian art and architecture from circa 200 to the end of the fourth century A.D. Excellent illustrations, useful plans and maps, and a good classified bibliography (pp. 216-17), which lists books and periodical articles in all languages. A good survey history.

1004 Francia, Ennio. **Storia dell'arte paleocristiana.** Milan, Martello, 1969. 209p. illus. index. LC 78-434554.
Concise history of early Christian art and architecture from the early second century A.D. through the fifth century. Good selection of plates. Bibliography (pp. 147-54) lists books and periodical articles in all languages.

1005 Garrucci, Raffaele. **Storia della arte cristiana nei primi otto secoli della chiesa....** Prato, Guasti, 1872-1881. 6v. illus.
Collection of line drawings illustrating Early Christian painting and sculpture, chiefly in Rome. Contents: volume 1, *Teorica, Annali*; volume 2, *Pitture cimiteriali*; volume 3, *Pitture non cimiteriali*; volume 4, *Musaici cimiteriali*; volume 5, *Sarcofagi ossia sculture cimiteriali*; volume 6, *Sculture non cimiteriali*. Still occasionally contulsted by the specialist scholar.

1006 Gerke, Friedrich. **Spätantike und frühes Christentum.** Baden-Baden, Holle, 1967. 279p. illus. index. LC 68-114559.
Concise history of Early Christian art and architecture from the pre-Constantinian art through the time of Heraclius. Provides a useful glossary of terms, a map, and a brief bibliography (pp. 251-52).

1007 Gough, Michael. **The Origins of Christian Art.** London, Thames and Hudson, 1973. 216p. illus. index. LC 73-8233.
Concise history of art and architecture in Europe from pre-Constantinian Christian art of the third century A.D. through Hiberno-Saxon art and architecture of the eighth century. Covers Byzantine art and architecture through the seventh century. Good choice of illustrations, plans, and diagrams. Bibliography (pp. 203-204) lists major books in Western languages.

1008 Grabar, André. **Early Christian Art: From the Rise of Christianity to the Death of Theodosius.** New York, Odyssey, 1969. 325p. illus. index. (The Arts of Mankind, 9). LC 68-110414.

British edition is *The Beginnings of Christian Art, 200-395*. This is an illustrated history of the art and architecture of the Early Christian period from circa 200 to 395 A.D. Provides chronological tables, maps, useful glossary, index, an excellent section on documents in translation, and good bibliography (pp. 307-313).

1009 Hutter, Irmgard. **Early Christian and Byzantine Art.** New York, Universe, 1971. 191p. illus. index. LC 75-122018.

Concise survey history of the art and architecture of the Early Christian and Byzantine periods beginning with the third century and ending with the thirteenth century. Balanced, well-chosen illustrations with informative captions. Brief bibliography (pp. 186-87).

1010 Kaufmann, Carl M. **Handbuch der christlichen Archäologie, Einführung in die Denkmälerwelt und Kunst des Urchristentums.** 3d ed. Paderborn, Schöningh, 1922. 683p. illus. index.

First published in 1905. Scholarly handbook of Early Christian art and architecture from the third century through the sixth century. Arranged by media, each chapter provides a bibliographical note at the beginning and bibliographical footnotes throughout the text. A once-standard handbook.

1011 Lassus, Jean. **The Early Christian and Byzantine World.** New York, McGraw-Hill, 1967. 176p. illus. index. LC 67-11797.

Survey of the architecture, mosaics, sculpture, and minor arts of these two epochs. Includes a chronological table, a glossary, maps, and a general bibliography (p. 172).

1012 Laurent, Marcel. **L'art chrétien primitif.** Brussels, Vromant, 1911. 2v. illus. index. LC 11-18988.

Contents: Tome 1, *L'art des catacombes, statues et sarcophages, églises et baptistères*; Tome 2, *la mosaïque, les arts industriels, l'art chrétien primitif en orient, Ravenne, l'art préroman*. Bibliographical footnotes. A standard, older history of Early Christian art by a leading Belgian scholar. Reissued as *L'art chrétien des origines à Justinien* (Brussels, Laclercq, 1957) in one volume.

1013 Leclercq, Henri. **Manuel d'archéologie chrétienne depuis les origines jusqu'au VIIIe siècle.** Paris, Letouzey et Anne, 1907. 2v. illus.

Older, comprehensive handbook of Early Christian art and architecture, illustrated with line drawings. Good coverage of the applied and decorative arts and considerable useful information on the techniques of Early Christian art and architecture. Bibliography at the end of each chapter.

1014 Leroy, Alfred. **Naissance de l'art chrétien des origines à l'an mil.** Paris, A. Fayard, 1956. 123p. illus. LC 57-30497.

Concise survey of Christian art and architecture from its beginnings to the year 1000, seen from the point of view of a clergyman. Bibliographical references at the end of each chapter.

1015 Lowrie, Walter. **Art in the Early Church.** 2d rev. ed. New York, Harper, 1965. 229p. illus. index. LC 67-11797.

Survey of Early Christian art and architecture, beginning with the pre-Constantinian art of the catacombs and ending with a discussion of the influence of Early Christian art on early medieval art. Provides a chronological table and a good selective, annotated bibliography of the older literature. An enthusiastic study and intepretation of Early Christian art for the general reader and the beginning student.

1016 Marucchi, Orazio. **Éléments d'archéologie chrétienne....** Paris, Lefebvre, 1899-1903. 3v. illus. index.

Older, comprehensive handbook of Early Christian art, chiefly that in Rome. First volume provides an overall sketch; second volume covers the catacombs of Rome and Naples; volume three treats the chief Early Christian basilicas of Rome. Illustrated with line drawings, maps, and plans.

1017 Meer, Frederik van der, ed. **Atlas of the Early Christian World.** By F. van der Meer and Christine Mohrmann. Trans. and ed. by Mary F. Hedlund and H. H. Rowley. London, Nelson, 1958. 215p. illus. maps. index. LC 58-7.

Contents: 1, The Church of the martyrs A.D. 30-313; 2, The Church of the empire A.D. 313-600; 3, The Fathers of the Church and early Christian literature. Valuable cultural atlas of the Early Christian period with 614 illustrations of works of art and architecture.

1018 Meer, Frederik van der. **Early Christian Art.** London, Faber, 1967. 149p. illus. index. LC 67-114396.

Concise survey of the art and architecture of the Early Christian period from the catacombs through the sixth century. Good chapter on the discovery of Early Christian art. No bibliography. Good appreciative survey of Early Christian art.

1019 Milburn, Robert. **Early Christian Art and Architecture.** Aldershot, Scholar Press, 1988. 318p. illus. index. LC 87-32261.

Comprehensive history of Early Christian art and architecture from the beginnings to the middle of the sixth century. Contents: Signs and Symbols; House-Churches; The Catacombs; Stone Carving; Church Buildings; Church Buildings in Asia; Egypt; Nubia and Ethiopia; the Churches of North Africa; Greece and the Balkans; Spain; Ravenna; The Foundations of Justinian; Fonts and Baptisteries; Mosaic; Carved Ivories; Arts and Crafts; Coins and Gems; Textiles; Writings and Illustrated Books. Good, classified bibliography of basic books (pp. 306-12) and specialized bibliography in the notes.

1020 Morey, Charles R. **Early Christian Art.** 2d ed. Princeton, Princeton University Press, 1953. 282p. illus. index.

History of Early Christian art, beginning with the Hellenistic background and ending with the eighth century. Does not cover architecture. Informative notes to the plates. Bibliography is included in the footnotes. Once a standard history, it is now out of date. Nevertheless, it is still useful to the advanced student because of the author's original approach in dealing with the origins of Early Christian art and because of its bibliographical footnotes.

1021 Neuss, Wilhelm. **Die Kunst der alten Christen.** Augsburg, Filser, 1926. 155p. illus.

An important survey of Early Christian art and architecture from the third to the sixth centuries with emphasis on the religious content and sacred function. Extensive bibliographical footnotes.

1022 Rice, David T. **The Beginnings of Christian Art.** London, Hodder and Stoughton, 1957. 223p. illus. index.

Concise survey of the development of Christian art and architecture from the third to the twelfth centuries, including Byzantine art and architecture. Brief bibliographies at the end of each chapter.

1023 Sas-Zaloziecky, Wilhelm. **Die altchristliche Kunst.** Frankfurt am Main, Ullstein, 1963. 157p. illus. index. (Ullstein Kunstgeschichte, 7).

Concise history of Early Christian art and architecture from the early third century to the end of the fifth century A.D. Bibliography of basic works in all languages (pp. 155-56).

1024 Stryzgowsky, Josef. **Orient oder Rom; Beiträge zur Geschichte der spätantiken und frühchristlichen Kunst.** Leipzig, Hinrich, 1901. 159p. illus. index.
 Influential and controversial study of the stylistic origins of Early Christian and late Roman art and architecture. Chapters treat individual monuments (like the tomb of ca. 259 in Palmyra and the sarcophagus from Sidamarra in Berlin) as well as broader topics like Coptic textiles and Constantinian building in the Holy Land. Bibliographical footnotes. Stryzgowsky's thesis is the preeminence of Near Eastern sources over Roman sources for the direction of Late Antique style.

1025 Sybel, Ludwig von. **Christliche Antike; Einführung in die altchristliche Kunst.** Marburg, Elwert, 1906-1909. 2v. illus. index. LC 24-28938.
 Older, scholarly handbook of Early Christian art and architecture. First volume examines the religious content with special emphasis on the subject matter of the Roman catacomb paintings. Here the examination of such subjects as the feast of the saints and the theme of salvation are classics of early scholarship in Christian antiquity. Second volume is a remarkably complete summary of what was then known about the development of architecture, sculpture, and painting in the Early Christian period.

1026 Sybel, Ludwig von. **Frühchristliche Kunst. Leitfaden ihrer Entwicklung.** Munich, Beck, 1920. 55p. illus. index.
 Concise history of Early Christian art and architecture from Hadrian to Theodosius. Bibliograpical footnotes.

1027 Syndicus, Eduard. **Early Christian Art.** New York, Hawthorn Books, 1962. 186p. illus. index. (Twentieth Century Encyclopedia of Catholicism, v. 121, Section 12; Catholicism and the Arts). LC 62-11412.
 Concise history of art and architecture from the early third century A.D. to the end of the Carolingian period. Emphasis is on the content of Early Christian art and its interrelationship with the world of late antiquity. The selection of plates is modest, but the book is liberally provided with plans and diagrams. Brief bibliography (pp. 187-88) lists major books in all languages. A good survey written from the standpoint of the church.

1028 Volbach, Wolfgang F. **Early Christian Art.** New York, Abrams, 1962. 363p. illus. index. LC 61-8333.
 Illustrated handbook of early Christian art and architecture. Short introductory essay is followed by 158 excellent plates (with informative notes), containing plans, elevations, reconstructions, and references to specialized literature. A basic handbook.

1029 Wulff, Oskar K. **Altchristliche und byzantinische Kunst.** Berlin, Athenaion, 1918. 2v. illus. index.
 Comprehensive history of the art and architecture of the Early Christian period of Byzantium. Volume one covers Early Christian art and architecture from pre-Constantinian times through the fifth century; volume two, Byzantine art and architecture from the sixth through the fourteenth centuries. Extensive bibliographies are given at the end of chapters. A third volume, containing a critical bibliography, appeared in 1939 and is annotated elsewhere in this bibliography (89). This old standard handbook is still useful to the advanced student and the scholar.

Byzantine

1030 Bayet, C. **L'art byzantin.** Paris, Quantin, n.d. 320p. illus.
 Older history of Byzantine art and architecture from the sixth through the fourteenth centuries. Engraved illustrations. Bibliographical footnotes.

1031 Beckwith, John. **The Art of Constantinople: An Introduction to Byzantine Art, 330-1453.** 2d ed. New York, Phaidon, 1968. 184p. illus. index. LC 68-18908.
 History of Byzantine art (but not architecture) from 330 to 1453, with emphasis on the contribution of Constantinople. Chronological table, glossary of terms, and thorough reference to and discussion of the literature of Byzantine art in the footnotes. Well-chosen illustrations.

1032 Bon, Antoine. **Byzantium.** London, Barrie and Jenkins, 1973. 222p. illus. index. LC 73-165988.
 Cultural history of the Byzantine Empire, with special emphasis on art and architecture of the period from the ninth through the middle of the fifteenth centuries. Chronological table; selected bibliography of books in all languages (pp. 193-202).

1033 Bréhier, Louis. **L'art byzantin....** Paris, Laurens, 1924. 203p. illus. index.
 Survey history of Byzantine art and architecture, with a useful chapter on the centers of Byzantine art (pp. 188-200). No bibliography.

1034 Dalton, Ormonde M. **Byzantine Art and Archaeology....** Oxford, Clarendon, 1911. 727p. illus. index.
 Older, comprehensive handbook of Byzantine art, but not including architecture. Introduction gives a geographical overview. Useful chapter on iconography with references to material illustrated elsewhere in the text. Thorough bibliographical references in the footnotes. Still a valuable guide to the older literature.

1035 Dalton, Ormonde M. **East Christian Art, a Survey of the Monuments.** Oxford, Clarendon, 1925. 396p. illus. index.
 Geographical survey of Byzantine art and architecture, a somewhat more popular version of the author's *Byzantine Art and Archaeology* (1034). Bibliographical footnotes.

1036 Delvoye, Charles. **L'art byzantin.** Paris, Arthaud, 1967. 462p. illus. index. (Collection Art et Paysages, 27). LC 68-80779.
 Well-illustrated survey of Byzantine art and architecture, with a good classified bibliography of books and periodical articles in all languages (pp. 407-426).

1037 Diehl, Charles. **Manuel d'art byzantin....** 2d ed. Paris, Picard, 1925-1926. 2v. illus. index.
 History of Byzantine art and architecture from the sixth century through the middle of the fifteenth century. Extensive references to specialized literature in the footnotes; bibliographical note (pp. xiii-xv) discusses major works in all languages. Has a useful iconographical index. An old but still useful handbook.

1038 Grabar, André. **The Art of the Byzantine Empire: Byzantine Art in the Middle Ages.** New York, Crown, 1966. 216p. illus. index. LC 66-21147.
 Survey history of the art and architecture of the Byzantine Empire from the Iconoclastic period (mid-eighth century) to the fifteenth century. Provides a chronological table and a brief, general bibliography (pp. 209-10). A good survey history of later Byzantine art for the beginning and advanced student.

1039 Grabar, André. **The Golden Age of Justinian, from the Death of Theodosius to the Rise of Islam.** New York, Odyssey, 1967. 408p. illus. index. (The Arts of Mankind, 10). LC 66-29363.
 British edition is titled *Byzantium, from the Death of Theodosius....* Illustrated history of the art and architecture of Byzantium from the early sixth through the fifteenth centuries. Treats the various arts separately by type. Provides plans, maps, chronological tables, informative notes to the plates, and a good bibliography (pp. 383-92).

1040 Kitzinger, Ernst. **Byzantine Art in the Making....** Cambridge, Mass., Harvard University Press, 1977. 175p. illus. index. LC 77-73578.
Scholarly study of the stylistic development of Early Christian and early Byzantine art from the late third through the seventh centuries. Emphasis is on the roles played by various centers and regions. Extensive bibliographical references in the notes (pp. 129-53).

1041 Lemerle, Paul. **Le style byzantin.** Paris, Larousse, 1943. 130p. illus.
Concise history of Byzantine art and architecture from the sixth through the middle of the fifteenth centuries. Introduction sketches the overall historical development and a concluding chapter summarizes the influence of Byzantine art on the West. Glossary of tems and topographical index with summaries of the major monuments. Bibliography (p. 127) lists French books. In the series, "Arts, Styles et Techniques."

1042 Mathew, Gervase. **Byzantine Aesthetics.** New York, Viking, 1963. 189p. illus. index. LC 64-12098.
History of Byzantine art and architecture from the third century to the middle of the fifteenth century, with emphasis on the record in contemporary documents. Thorough bibliographical coverage of primary sources in the notes; bibliography (pp. 179-80) lists only major books published since 1945. An important documentary history.

1043 Micheles, Panayotis A. **An Aesthetic Approach to Byzantine Art.** London, Batsford, 1955. 284p. illus. index.
Historical study of the distinctive character of Byzantine sacred art and architecture. Contents: Part one, The Aesthetic Character of Christian Art; part two, The Sublime in Byzantine Art; part three, The Aesthetic Approach to the History of Art. The latter part is a critique of Wöllflin's methodology. Bibliographical footnotes. Although not consistently convincing, this contains much valuable material, particularly in the liturgical use of Byzantine architecture and painting.

1044 Peirce, Hayford, and Royall Tyler. **L'art byzantin....** Paris, Libraire de France, 1932-1934. 4v. illus. index.
Illustrated handbook of Byzantine art, exclusive of architecture, from the fourth century through the sixth century. Each volume has a brief introductory essay sketching the development of the various media, followed by a good collection of plates with informative notes. No bibliography. Still valuable to the advanced student for its illustrations.

1045 Rice, David T. **The Art of Byzantium.** London, Thames and Hudson, 1959. 339p. illus. index. LC 60-1215.
Illustrated handbook of Byzantine art and architecture from the time of Justinian to the middle of the fifteenth century. Brief introductory survey is followed by an excellent collection of plates; the informative notes to the plates include bibliographical references. A standard illustrated handbook.

1046 Rice, David T. **The Art of the Byzantine Era.** New York, Praeger, 1963. 286p. illus. index. LC 63-16444.
Survey history of art and architecture in Byzantium from the early sixth to the mid-fifteenth centuries. Includes Coptic, Palestinian, and Syrian art. Provides maps, a chronological table, and a brief bibliography of major works (pp. 267-68).

1047 Rice, David T. **Byzantine Art.** Rev. and expanded ed. Harmondsworth, Penguin, 1968. 580p. illus. index. LC 75-356968.
Survey of the art and architecture of Byzantium from the early sixth century through the middle of the fifteenth century. The various arts are treated separately. Provides maps, an excellent selection of illustrations, and a good, annotated bibliography (pp. 563-70). An excellent survey for the general reader and the beginning student.

1048 Runciman, Steven. **Byzantine Style and Civilization.** Harmondsworth, Penguin, 1975. 238p. illus. index. LC 75-330373.

History of Byzantine civilization from the fourth to the middle of the fifteenth centuries, with emphasis on the art and architecture of Constantinople. Contents: The Triumph of the Cross; The Sixth-century Synthesis; The Triumph of the Image; The Full Programme; The Changing World; The Last Splendor; Conclusion. An annotated guide to further reading (pp. 227-29). Valuable bibliographical references to more specialized literature are contained in the catalog of illustrations (pp. 213-26). Series: "Style and Civilization."

1049 Sas-Zaloziecky, Wilhelm. **Die byzantinische Kunst.** Frankfurt am Main, Ullstein, 1963. 157p. illus. index. (Ullstein Kunstgeschichte, 8). LC 65-98284.

Concise history of Byzantine art and architecture, with a good chapter on the spread of Byzantine art to Slavic Europe. Bibliography (pp. 154-55) lists books in all languages.

1050 Schug-Wille, Christa. **The Art of the Byzantine World.** New York, Abrams, 1971. 263p. illus. index. LC 75-92912.

Concise history of art and architecture from pre-Constantinian times (circa 200 A.D.) through the art and architecture of Russia during the fifteenth and sixteenth centuries. Well-chosen illustrations and useful maps, but no plans for architectural examples. Provides a balanced bibliography (pp. 257-59) that lists books in all languages.

1051 Schweinfurth, Philipp. **Die byzantinische Form; Ihr Wesen und ihre Wirkung.** Berlin, Kupferberg, 1943. 162p. illus. index.

Stylistic history of Byzantine art and architecture from the sixth through the fourteenth centuries. Chapter on the importance of Byzantine art to the development of Western art. Bibliographical footnotes.

1052 Stern, Henri. **L'art byzantin.** Paris, Presses Universitaires de France, 1966. 186p. illus. index. LC 67-91757.

In the series, "Les Neuf Muses." Concise history of Byzantine art and architecture from the time of Justinian to the fall of Constantinople in 1453. Chapter on the influence of Byzantine art in Slavic Europe. Bibliography (pp. 183-86) lists books and periodical articles in all languages.

1053 Stryzgowsky, Josef. **L'ancien art chrétien de Syrie, son caractère et son évolution....** Paris, Boccard, 1936. 215p. illus. index.

History of art and architecture in Syria during the Early Christian period. A controversial work in its day, it is now out of date but the only general survey of the subject. Bibliographic footnotes.

1054 Volbach, Wolfgang F., and Jacqueline LaFontaine-Dosgne. **Byzanz und der christliche Osten.** Berlin, Propyläen, 1968. 366p. (text); 432p. (illus). index. (Propyläen Kunstgeschichte, Band 3). LC 70-377738.

Comprehensive illustrated handbook of the art and architecture of Byzantium and the Christian art and architecture of Syria, Egypt, Nubia, Ethiopia, Armenia, Georgia, Russia, Romania, Bulgaria, Yugoslavia, and Greece from the sixth through the fifteenth centuries. Introductory essay is followed by a corpus of excellent illustrations, essays on the development of the various arts and national subdivisions, extensive and informative notes to the plates, and plans and elevations. A chronological table comparing the artistic developments with political and religious developments is provided, and there is an excellent classified bibliography (pp. 380-98). Specialized literature is noted in the notes to the plates. A standard and basic illustrated handbook.

1055 Wharton, Annabel J. **Art of Empire. Painting and Architecture of the Byzantine Periphery. A Comparative Study of Four Provinces.** University Park, Pennsylvania State University Press, 1988. 198p. illus. index. LC 86-43039.

History of art and architecture from the ninth century to the beginning of the twelfth century in the Byzantine provinces of Cappadocia, Cyprus, Macedonia, and southern Italy. Bibliographical footnotes.

Coptic

1056 Badawy, Alexander. **Coptic Art and Archaeology: The Art of the Christian Egyptians from the Late Antique to the Middle Ages.** Cambridge, Mass., MIT Press, 1978. 416p. illus. index. LC 77-25101.

History of Coptic art and architecture. Chapters treat the historical-cultural background, the development of the major and minor art forms and significance and influences of Coptic art. Good bibliography of books and periodical articles (pp. 364-73).

1057 Du Bourguet, Pierre. **The Art of the Copts.** New York, Crown, 1971. 234p. illus. index. LC 78-147350.

Concise history of the art and architecture of the Copts from pre-Coptic times through the twelfth century. Provides maps, a chronological table, a good classified bibliography (pp. 224-27), and bibliographical footnotes to the text. Excellent history of Coptic art and architecture for the beginning and advanced student.

1058 Effenberger, Arne. **Koptische Kunst: Ägypten in spätantiker, byzantinischer und frühislamischer Zeit.** Leipzig, Koehler und Amelang, 1975. 277p. illus. index. LC 77-461908.

Well-illustrated survey of Coptic art and architecture from the fourth century through the eighth century A.D. Bibliography of basic books and periodical articles (pp. 251-59).

1059 Gayet, Albert J. **L'art copte: École d'Alexandrie — architecture monastique — sculpture — peinture — art somptuaire....** Paris, Leroux, 1902. 334p. illus.

Comprehensive history of Coptic art and architecture. Illustrated with line drawings. Bibliographical footnotes. An old, standard history of Coptic art; should be known by the advanced student.

1060 Grüneisen, Wladimir de. **Les caractéristiques de l'art copte.** Florence, Alinari, 1922. 193p. illus.

Illustrated survey of Coptic art and architecture. Good selection of plates. Provides a brief bibliography (pp. 27-29), with reference to more specialized literature in the footnotes. An older survey, still useful to the advanced student because of the plates.

1061 Wessel, Klaus. **Coptic Art.** New York, McGraw-Hill, 1965. 247p. illus. index. LC 65-19075.

Survey of the art of Early Christian Egypt. Does not include architecture. Maps, good selection of plates, and brief unclassified bibliography (pp. 238-37). A useful but controversial history of Coptic art.

1062 Zalosser, Hilde. **Die Kunst im christlichen Ägypten.** Vienna, Schroll, 1974. 191p. illus. index. LC 75-530475.

Concise survey of Coptic art and architecture from Hellenistic times to the advent of Islam. Bibliography of books and periodical articles in all languages (pp. 177-88).

Early Medieval

GENERAL WORKS

1063 Backes, Magnus, and Regine Dölling. **Art of the Dark Ages.** New York, Abrams, 1971. 263p. illus. index. LC 70-90886.
Concise survey of the art and architecture of the early Middle Ages from the period of the migrations through the Ottonian period. A short introduction is followed by explanations of the plates. Brief bibliography (pp. 258-59).

1064 Bréhier, Louis. **L'art en France des invasions barbares à l'époque romane....** Paris, La Renaissance du Livre, 1930. 210p. illus.
Concise history of the art and architecture of France in the Merovingian, Carolingian, and pre-Romanesque periods. Illustrated with facsimiles and rather weak plates. Bibliography (pp. 107-108) lists major works. An old, but still valuable study of a neglected period in French medieval art history.

1065 Busch, Harald, and Bernd Lohse. **Pre-Romanesque Art.** New York, Macmillan, 1966. 217p. illus. LC 66-16924.
Pictorial survey of the art and architecture of Western Europe from the fourth through the middle of the eleventh centuries. Introduction by Louis Grodecki; informative notes to the plates by Eva Wagner. No bibliography.

1066 Fillitz, Hermann. **Das Mittelalter, I.** Berlin, Propyläen, 1969. 350p. (text); 420p. (illus). index. (Propyläen Kunstgeschichte, Band 5). LC 71-484515.
Comprehensive illustrated handbook of the art and architecture of the early Middle Ages. Covers the period from the late eighth century through the Romanesque period (circa middle of the twelfth century). Introductory essay is followed by a corpus of excellent illustrations with extensive and highly informative notes and separate essays on the development of the various arts. There is a chronological table comparing the developments in the arts with those in political and religious history, and an excellent classified bibliography (pp. 292-327). Specialized literature is mentioned in the notes to the illustrations. A standard and basic illustrated handbook.

1067 Hautmann, Max. **Die Kunst des frühen Mittelalters.** Berlin, Propyläen, 1929. 756p. illus. index. (Propyläen-Kunstgeschichte, VI). LC 30-8339.
Comprehensive, illustrated handbook of the art and architecture of Western Europe and Byzantium from the time of Constantine through the twelfth century. Introductory essay followed by a good corpus of plates with descriptive notes. No bibliography. Superseded by a volume (1066) in the new Propyläen series.

1068 Henderson, George. **Early Medieval.** Harmondsworth, Penguin, 1972. 272p. illus. index. LC 72-171390.
Concise history of art and architecture in Western Europe from the eighth century through the middle of the eleventh century. Emphasis is placed on the relationship between the fine arts and the general culture of the early Middle Ages. Well-chosen illustrations with informative notes and some with bibliographical references. Bibliography (pp. 165-68) is a helpful annotated list of major literature in all languages. Contents: Introduction; The Barbarian Tradition; An Habitation of Dragons; The Uses of Antiquity; Story-telling; De Laudibus Sanctae Crucis.

1069 Holländer, Hans. **Early Medieval Art.** New York, Universe, 1974. 192p. illus. index. LC 72-91633.
Series: "Universe History of Art." Concise history of art and architecture in Western Europe from the seventh century to the middle of the eleventh century. Emphasis is on development of style. Brief text accompanied by good selection of plates of major works with informative captions. Bibliography (pp. 188-89) lists books in all languages.

1070 Hubert, Jean. **L'art pré-roman....** Paris, Éditions d'Art d'Histoire, 1938. 202p. illus. index. Reprint: Chartres, Laget, 1974. LC 76-471633.
Concise history of the art and architecture of France from the fifth to the tenth centuries. Bibliographical references in the footnotes. Illustrated with plates, plans, and diagrams. A standard history.

1071 Kayser, Felix. **Kreuz und Rune; langobardisch-romanische Kunst in Italien.** Stuttgart, Urachhaus, 1964. 2v. illus. index. LC 67-85057.
History of the art and architecture of the Lombards in Italy from the sixth century through the twelfth century. Good plates and plans. General bibliography (pp. 138-40) and further reference to more specialized literature in the footnotes. A standard history of Lombardic art and architecture.

1072 Lasko, Peter. **Ars Sacra: 800-1200.** Baltimore, Penguin, 1972. 338p. illus. index. (Pelican History of Art, Z36). LC 73-162318.
Comprehensive history of ivory carving, metalwork, enamels, and bronze sculpture from the Carolingian through the Romanesque periods. Good selection of plates. Bibliography (pp. 315-17) is a selected list of major works in all languages. Further reference to more specialized literature in the notes.

1073 Lantier, Raymond, and Jean Hubert. **Les origines de l'art français.** Paris, Le Prat, 1947. 180p. illus.
Concise history of art and architecture in France from prehistory through Carolingian era. Brief bibliography (p. 180). The good selection of plates makes this work invaluable for this neglected period of French art and architecture.

1074 Mahr, Adolf. **Christian Art in Ancient Ireland.** Dublin, Stationery Office, 1932-1941. 2v. illus. index. Reprint: New York, Hacker, 1977. LC 75-11058.
Concise history of art and architecture in Ireland from the seventh century to the time of the Anglo-Norman conquest. Bibliography (pp. 169-76) of books and periodical articles. An older, general history of Irish medieval art and architecture.

1075 Michel, André, ed. **Des débuts de l'art chrétien à la fin de la période romane.** Paris, Colin, 1905. 440p. illus. (Histoire de l'Art ... tome I).
Comprehensive history of art, architecture, and the applied arts in Europe from the third to the end of the twelfth centuries. Chapters are written by various French scholars. Bibliographies of basic literature at the end of each chapter.

1076 Palol Salellas, Pedro de. **Early Medieval Art in Spain.** New York, Abrams, 1967, 500p. illus. index. LC 66-26609.
Illustrated handbook of art and architecture in Spain from the Visigothic through the Romanesque periods. Genealogical tables, maps, and excellent plates. Bibliography in the notes to the plates.

1077 Picton, Harold W. **Early German Art and Its Origin from the Beginnings to About 1050.** London, Batsford, 1939. 148p. illus. index.
A survey of the development of the art and architecture of the Germanic peoples from neolithic times through the Ottoman period. A pan-Germanic survey that treats Germanic art of the migrations epoch and the early Middle Ages in Eastern Europe, Italy, Spain, France, and the British Isles, as well as Central Europe. This provocative work is out of date in many of its conclusions, but it is still valuable for the advanced student.

1078 Pijoán y Soteras, José. **Arte bárbaro y pre-románico desde el siglo IV hasta el año 1000.** Bilbao, Spain, Espasa-Calpe, 1942. 569p. illus. index. (Summa Artis, Historia General del Arte, VIII).
Comprehensive survey of Germanic art and the art and architecture of the Western Middle Ages to the year 1000. Conventional arrangement, but thorough treatment. Brief bibliographies at the end of chapters.

1079 Stryzgowski, Josef. **Die altslavische Kunst.** Augsburg, Filser, 1929. 296p. illus. index.

Scholarly history of the art and architecture of the Slavic peoples during the early Middle Ages. Excellent plans and diagrams, good illustrations of rarely reproduced works, and thorough reference to specialized literature in the footnotes. Like all works by Stryzgowski, this one is still controversial; but it remains one of the standard histories of early Slavic art and architecture.

PRE-CAROLINGIAN

1080 Brown, Gerard B. **The Arts in Early England....** London, Murray, 1903-1937. 6v. illus. index.

Contents: volume 1, *The Life of Saxon England in Its Relationship to the Arts*; volume 2, *Ecclesiastical Architecture in England from the Conversion of the Saxons to the Norman Conquest*; volumes 3-4, *Saxon Art and Industry in the Pagan Period*; volume 5, *The Ruthwell and Bewcastle Crosses, the Gospels of Lindesfarne and Other Christian Monuments in Northumbria*; volume 6, pt. 1, *Completion of the Study of the Monuments of the Great Period of the Art of Anglican Northumbria*; volume 6, pt. 2, *Anglo-Saxon Sculpture*. As a survey history of early medieval art in the British Isles superseded by Kendrick (1085). Volume 6, part 2, is still the basic history of Anglo-Saxon sculpture.

1081 Dodwell, C. R. **Anglo-Saxon Art, a New Perspective.** Ithaca, N.Y., Cornell University Press, 1982. 353p. illus. index. LC 82-71592.

Important history of art excluding architecture in Anglo-Saxon England from the sixth through the eleventh centuries with special attention to the evidence in written sources. Contents: 1, Art Survivals and Written Sources; II, Anglo-Saxon Taste; III, Artists and Craftsmen in Anglo-Saxon England; IV, Painting and Carving; V, Textiles; VI, Costume and Vestments; VII, Jewellery, Silver and Gold; VIII, Anglo-Saxon Art and the Conquest. Extensive bibliography in the notes.

1082 Henry, Françoise. **Irish Art in the Early Christian Period to 800 A.D.** 3d rev. enl. ed. Ithaca, N.Y., Cornell University Press, 1965. 256p. illus. index. LC 65-22854 rev.

Concise history of art and architecture in Ireland from the fifth century to 800 A.D. Good bibliographical footnotes in the text. A standard history of early medieval art and architecture in Ireland.

1083 Hubert, Jean, Jean Porcher, and W. F. Volbach. **Europe of the Invasions.** New York, Braziller, 1969. 387p. illus. (The Arts of Mankind, 12). LC 75-81858.

Illustrated history of art and architecture in Western Europe from the fifth through the eighth centuries. Covers the art of the migrating Germanic tribes, the last manifestations of Early Christian art in Italy, and the art and architecture of the established Germanic kingdoms in Western Europe and the British Isles. The arrangement by types of works of art does not give clarity to the complex history of art in this transitional time. Provides numerous plans, elevations, reconstructions, maps, notes to the plates, and a good but unclassified bibliography (pp. 331-35). One of the few books in English on this crucial period.

1084 Kendrick, Thomas D. **Anglo-Saxon Art to A.D. 900.** London, Methuen, 1938. 227p. illus. index.

Concise history of art and architecture in England from the Roman period to 900 A.D. Bibliographical references in the footnotes. A standard history.

1085 Kendrick, Thomas D. **Late Saxon and Viking Art.** London, Methuen, 1949. 152p. illus. index. Reprint: London, Barnes and Noble, 1974. LC 74-193181.

Concise history of the art and architecture of England in the tenth century and Scandinavian art of the ninth and tenth centuries. Bibliographical references in the

footnotes. This is a sequel to (1084); together they form a standard history of the arts of the early Middle Ages in England with reference to contemporary Scandinavian art.

1086 Klindt Jensen, Ole, and David Wilson. **Viking Art.** Ithaca, N.Y., Cornell University Press, 1966. 173p. illus. index. 2d ed. 1980. LC 79-26806.
Concise history of Scandinavian art of the Viking period, 800-1100. The chapter on Scandinavian art before the Vikings adds to the usefulness of this survey. A standard work in English.

1087 Kutzli, Rudolf. **Langobardische Kunst. Die Sprache der Flachbänder.** Stuttgart, Urachhaus, 1974. 256p. illus. index. LC 75-572228. 2d ed. 1981. ISBN 387838778.
History of art of the Lombards in Italy, with special emphasis on metalwork and relief sculpture. Well-illustrated.

1088 Palol Salellas, Pedro de. **Arte hispanico de la epoca Visigoda.** Barcelona, Ediciones Poligrafia, 1968. 237p. illus. LC 72-620.
Pictorial survey of Visigothic art and architecture in Spain. Text in Spanish, English, and French. Brief bibliography (p. 221). Useful pictorial survey for the general reader and beginning student.

1089 Puig y Cadafalch, José. **L'art wisigothique et ses survivances.** Paris, de Nobelle, 1961. 204p. illus. index. LC 64-36324.
History of art and architecture of the Visigoths in Spain with chapters on the survival and influence of Visigothic art and architecture in Carolingian art, Mozarabic art, and the early Romanesque in Spain. Excellent bibliography (pp. 189-98). Standard history of Visigothic art.

1090 Schaffran, Emerich. **Die Kunst der Langobarden in Italien.** Jena, Diederich, 1941. 196p. illus. index.
History of the art and architecture of the Lombards in Italy during the seventh and eighth centuries. Access to further literature through the numerous footnotes in the text.

1091 Schlunk, Helmut, and Theodor Haschild. **Die Denkmäler der frühchristlichen und westgotischen Zeit.** Mainz, Zabern, 1978. 245p. illus. index. LC 79-376632.
First volume in the series *Hispania antiqua* published by the Deutsches Archäologisches Institut in Madrid. Comprehensive history of architecture and art in Spain from the beginning of the fourth century to the end of the seventh century A.D. organized around major monuments and sites. Catalog of the large body of plates contains specialized bibliography. General bibliography, pp. 235-42. A major contribution to the history of early medieval art in Spain.

1092 Stokes, Margaret M. **Early Christian Art in Ireland....** Dublin, Stationery Office, 1928. 2v. illus. index.
First published in 1887 as a handbook for the South Kensington Museum. General survey of early medieval Irish architecture, sculpture, manuscript illumination, and metalwork. Chronological table, bibliographies in each chapter.

1093 Verzone, Paolo. **The Art of Europe: The Dark Ages from Theodoric to Charlemagne.** New York, Crown, 1968. 276p. illus. index. LC 68-9069.
Concise history of art and architecture in Western Europe from circa 425 to 800 A.D. Emphasis on Italian developments. Provides glossary of terms, chronological table, and brief bibliography (pp. 259-60). A useful, if somewhat complicated history of a period on which little has been written for the beginning student.

1094 Wilson, David M. **Anglo-Saxon Art from the Seventh Century to the Norman Conquest.** London, Thames and Hudson, 1984. 224p. illus. index. LC 84-4447.

Comprehensive history of art and architecture in England from the coming of the Anglo-Saxons to the Norman conquest. Good selection of illustrations. Classified bibliography, pp. 216-20. Updates the synthesis by Kendrick (1084).

See also: Kuhn (962).

CAROLINGIAN AND OTTONIAN

1095 Beckwith, John. **Early Medieval Art.** New York, Praeger, 1964. 270p. illus. index. LC 64-19953.

Concise history of the art and architecture of Western Europe from the early ninth through the middle of the twelfth centuries. Excellent critical bibliographical references in the notes to the text. Well-chosen illustrations.

1096 Braunfels, Wolfgang. **Die Welt der Karolinger und ihre Kunst.** Munich, Callwey, 1968. 402p. illus. index. LC 70-364845.

History of the art and architecture of the Carolingian period. Well illustrated; the descriptive notes to the plates contain bibliographical references to specialized literature. General bibliography (pp. 392-95).

1097 Grodecki, Louis, and Florentine Mütherich. **La siècle de l'an mil.** Paris, Gallimard, 1973. 442p. illus. index. (Univers des formes 20). LC 74-161053.

History of art and architecture in Europe during the Ottonian and early Romanesque period (tenth through middle of the eleventh centuries). Provides good selection of plates, plans, diagrams, a glossary-index, and a good comprehensive bibliography of books and periodical articles. German edition in the series, "The Arts of Mankind."

1098 Henry, Françoise. **Irish Art During the Viking Invasions, 800-1020.** Ithaca, N.Y., Cornell University Press, 1967. 236p. illus. index. LC 67-15300.

Concise history of the art and architecture in Ireland, 800-1020. Good selection of plates and maps. Bibliographical references in the footnotes to the text. Sequel to (1082); together with (1120), it is a standard history of Irish medieval art.

1099 Hinks, Roger P. **Carolingian Art.** Ann Arbor, University of Michigan Press, 1962. 226p. illus. index. LC 62-52487.

First published in 1935 (London, Sidgwick and Jackson). Survey of Carolingian art, excluding architecture. Adequate bibliographical references in the footnotes in the text, plus a general bibliography (pp. 215-18). Although it is very much out of date, the beginning student will find the section on form and structure of Carolingian art to be informative reading.

1100 Hubert, Jean, Jean Porcher, and W. F. Volbach. **The Carolingian Renaissance.** New York, Braziller, 1970. 381p. illus. (The Arts of Mankind, 13). LC 72-99513.

Illustrated handbook of Carolingian art and architecture. Provides chronological table, glossary-index, and good comprehensive bibliography (pp. 321-35) with its own index by subject. Collection of plans, elevations, reconstructions, and maps.

1101 Jantzen, Hans. **Ottonische Kunst.** Reinbek bei Hamburg, Rowohlt, 1959. 175p. illus. index. LC AF99-455.

First published in 1947 (Munich, Münchner Verlag). History of art and architecture in the Ottonian period covering the development within and outside Germanic lands. Separate chapters on the various arts. Unclassified bibliography of major works (pp. 166-67). A standard history of Ottonian art.

1102 Kubach, Hans Erich, and Victor Elbern. **Das frühmittelalterliche Imperium.** Baden-Baden, Holle, 1968. 308p. illus. index. LC 79-378251.
Concise history of the art and architecture of Carolingian and Ottonian periods. Treats the arts separately by type. Provides a chronological table, a map, and a good classified bibliography (pp. 280-93). An excellent history for the advanced student.

1103 Messerer, Wilhelm. **Karolingische Kunst.** Cologne, DuMont-Schauberg, 1973. 236p. illus. index. LC 73-342249.
Scholarly handbook of Carolingian art, architecture, and applied arts. Introductory chapter defines Late Antique, Germanic, Carolingian, and Ottonian styles by a comparison of four metal and ivory bookcovers. Subsequent chapters examine the state of research, the concept of *Renovatio*, styles and schools, iconographic development, architecture, and the influence of Carolingian art. Work concludes with a collection of excerpts from the work of major experts in the field (von den Steinen, Schnaase, Koehler, Otto, Schöne, and Porcher). Extensive bibliography in the notes.

Romanesque

1104 Aubert, Marcel. **L'art français à l'époque romane, architecture et sculpture.** Paris, Morancé, 1929-1951. 4v. illus. index.
Pictorial survey of Romanesque architecture and architectural sculpture in France. Volume one: *Ile-de-France, Champagne, Alsace, Normandie, Vallée de la Loire*; volume two: *Poitou, Saintonge, Angoumois, Périgord, Nivernais, Auvergne, Velay*; volume three: *Bourgogne*; and volume four: *Provence, Languedoc*. A collection of plates with short introductions but with useful bibliographies at the end of each volume. Basic compendium of illustrations for the advanced student.

1105 Aubert, Marcel, ed. **L'art roman en France....** Paris, Flammarion, 1961. 464p. illus. index. LC 62-32085.
History of the art and architecture of the Romanesque period in France. Consists of essays by specialists on the various regional styles. Well illustrated, but no bibliography.

1106 Baldass, Ludwig, Bruno Buchowiecki, and Wilhelm Mrazek. **Romanische Kunst in Österreich.** Vienna, Forum, 1962. 119p. (text); 96p. (illus.).
History of Romanesque art and architecture in Austria from the early eleventh century through the twelfth century. Well illustrated and provided with a good bibliography (pp. 115-16) that lists books and periodical articles.

1107 Barral i Altet, Xavier, Francoise Avril, and Danielle Gaborit-Chopin. **Romanische Kunst.** Munich, Beck, 1983. 2v. (Universum der Kunst, Bd. 29, 30). ISBN 3406030297.
History of art and architecture in Western Europe from 1060 to 1220. First volume covers middle and southern Europe; the second volume covers northern and western Europe. Provides a good selection of plates, plans, diagrams, a glossary-index, and a good comprehensive bibliography of books and periodical articles. German edition in the series: "The Arts of Mankind" and translation of the French edition: "Univers des Formes."

1108 Bonet, Blas. **El movimento románico en España. The Romanesque Movement in Spain....** Barcelona, Poligrafia, 1967. 307p. illus. LC 68-74678.
Survey history of art and architecture in Spain from the fifth through the twelfth centuries. Text in Spanish, French, English, and German. No bibliography.

1109 Brehier, Louis. **Le style roman.** Paris, Larousse, 1942. 125p. illus. index. LC 46-35343.
Concise survey history of Romanesque art and architecture. Emphasis is on France, with a final chapter that briefly outlines the development of the Romanesque in other

countries of Western Europe. Chapter on the applied and decorative arts. Glossary of terms and useful topographic index with brief descriptions of the major monuments. One-page bibliography of basic books.

1110 Busch, Harald. **Germania Romanica; die hohe Kunst der romanischen Epoche in mittleren Europa.** Vienna, Schroll, 1963. 316p. illus. LC 65-66409.
Pictorial survey of the art and architecture of the Romanesque period in the German-speaking countries, with emphasis on architecture. A brief introductory essay is followed by a selection of black and white plates, with notes to those plates. No bibliography. Selections from this work are found in (1122).

1111 Colas, René. **Le style roman en France dans l'architecture et la décoration des monuments.** Paris, Colas, 1927. 59p. text. 144 plates.
Pictorial survey of French Romanesque architecture, architectural sculpture, and painting. No bibliography.

1112 Collon-Gevaert, Suzanne, et al. **A Treasury of Romanesque Art: Metalwork, Illuminations and Sculpture from the Valley of the Meuse.** London, Phaidon, 1972. 327p. illus. index. LC 76-161220.
Translation of *Art roman dans la vallée de la Meuse aux XIe et XIIe siècles* (Brussels, 1962). Well-illustrated survey of the figurative arts of the eleventh and twelfth centuries in the Meuse region of Belgium and the Netherlands. Part one provides a historical background; part two discusses metalwork; and part three, works in other media. Good classified and annotated bibliography of books (pp. 309-16).

1113 Courtens, André. **Romanesque Art in Belgium: Architecture, Monumental Art.** Brussels, M. Vokaer, 1969. 111p. (text); 125p. (illus.). index. LC 75-572505.
Pictorial survey of architecture and monumental sculpture in Belgium of the Romanesque period. The short introductory essay is followed by a collection of black and white plates (chiefly of architecture), notes to the plates, and a classified bibliography of general works (pp. 104-106).

1114 Crozet, René. **L'art roman.** Paris, Presses Universitaires de France, 1962. 186p. illus. index. LC 63-38107.
Survey history of the art and architecture of the Romanesque period with an emphasis on France. A brief chapter called "Universalité de l'art Roman," sketches the history of Romanesque art and architecture outside France. Bibliography (pp. 185-86) lists chiefly books in French.

1115 Decker, Hans. **Romanesque Art in Italy.** New York, Abrams, 1959. 82p. (text); 240p. (illus.). LC 59-5999.
Pictorial survey of Romanesque art and architecture in Italy. Emphasis is on architecture and its decoration. Text discusses the material by region. Bibliography (p. 82) lists a few major works in all languages. Good collection of plates. Text is for the general reader and the beginning student; plates are useful to the advanced student as well.

1116 Durliat, Marcel. **L'art roman en Espagne.** Paris, Braun, 1962. 86p. (text); 248p. (illus.). LC 64-46252.
Pictorial survey of the art and architecture of Romanesque Spain, with the emphasis on architecture. The short introductory essay is followed by a good selection of black and white plates (also with emphasis on architecture), notes to the plates, and a brief, unclassified bibliography (pp. 88-89).

1117 Franz, Heinrich G. **Spätromanik und Frühgotik.** Baden-Baden, Holle, 1969. 283p. illus. index. LC 75-452952.
Concise history of the late Romanesque and early Gothic art and architecture. Good color plates with a modest supplement of black and white plates, plans, and diagrams,

plus a good classified bibliography (pp. 245-68) of major books and periodical articles in all languages. For the beginning and advanced student. German edition in the series "The Art of the World."

1118 Gantner, Joseph, and Marcel Pobé. **Romanesque Art in France.** London, Thames and Hudson, 1956. 80p. (text); 271p. (illus.). index. LC A57-3028.

Pictorial survey of Romanesque art and architecture in France. Chief emphasis is on architecture, with less on monumental sculpture and little on painting. Introductory essay, notes on the plates, and general bibliography (p. 78).

1119 Gomez Moreno, Manuel. **El arte románico español.** Madrid, Blass, 1934. 173p. illus. index.

Concise history of Romanesque art, architecture and applied arts in Spain from the late eleventh through the twelfth centuries. Good corpus of plates. Geographical arrangement. Bibliographical footnotes.

1120 Henry, Françoise. **Irish Art in the Romanesque Period, 1020-1170.** 3d rev. and enl. ed. Ithaca, N.Y., Cornell University Press, 1970. 240p. illus. index. LC 76-82117.

Concise history of art and architecture in Ireland, 1020-1170. Good selection of plates and maps. Bibliographical references in the footnotes to the text. Sequel to (1082) and (1083); together they form a standard history of Irish medieval art.

1121 Kubach, Hans E., and Peter Bloch. **L'art roman, de ses débuts à son apogée.** Paris, Michel, 1966. 297p. illus. index. LC 67-42768.

History of Romanesque art and architecture from the middle of the eleventh to the middle of the twelfth centuries. Good selection of color plates, modest but well-chosen supplement of black and white plates; liberally provided with plans and diagrams. Also provides map and chronological table and an excellent classified bibliography (pp. 245-68), which lists books and periodical articles in all languages. French edition of the series "The Art of the World." An excellent history of Romanesque art and architecture.

1122 Künstler, Gustav, comp. **Romanesque Art in Europe.** Greenwich, Conn., New York Graphic Society, 1969. 327p. illus. index. LC 69-18001.

Pictorial survey of the art and architecture of Romanesque Europe, consisting of a selection of text and illustrations from a six-volume series published between 1955 and 1968 by Schroll Verlag of Vienna. These volumes, three of which have been translated into English, are annotated separately in this bibliography (989, 1110, 1113, 1115, 1118, and 1134). Short introductory essays, selection of black and white plates (with emphasis on architecture), notes on the plates, and maps and plans; no bibliography.

1123 **La España romanica.** 2d ed. Madrid, Ediciones Encuentro, 1978-1979. 10v. illus. LC 80-130452.

Illustrated survey of early medieval and Romanesque architecture and art in Spain. Originally published in French (Zodiaque) as separate, regional volumes. Geographical arrangement in the regional volumes. Emphasis is on art *in situ* although major works of the applied and decorative arts that are known to have come from particular regions are included. Many excellent plates with descriptive notes. Bibliographies for each region. Contents: volume 1, *Castilla/1*; volume 2, *Galicia*; volume 3, *Castilla/2*; volume 4, *Aragon*; volume 5, *Leon y Asturias*; volume 6, *Cataluña/1*; volume 7, *Navarra*; volume 8, *El Preromanico*; volume 9, *Cataluña/2*; volume 10, *El Mozarbe*.

1124 Lefrançois, Louis Pillon. **L'art roman en France: architecture, sculpture, peinture, arts mineurs.** Paris, Le Prat, 1943. 118p. illus.

Concise history of art and architecture in France during the Romanesque period. No bibliography.

1125 Mâle, Émile. **Religious Art in France, the Twelfth Century: A Study of the Origins of Medieval Iconography.** Princeton, Princeton University Press, 1978. 460p. illus. index. (Bollingen Series, XC. 1).

Translation of the sixth edition (Paris, A. Colin, 1953) of *L'art religieux du XII*ᵉ *siècle en France; étude sur les origines de iconographie du moyen âge....* First published in 1922. Important scholarly study of the iconography of French figurative arts of the twelfth century. In this edition, supplemental material published as addenda in the 1953 edition has been incorporated into the text. Brought up-to-date through additions to the notes by Louis Grodecki. Introduction sketching and evaluating Mâle's career by Harry Bober. Contents: I, The Birth of Monumental Sculpture: the Influence of Manuscripts; II, The Complexity of Twelfth Century Iconography: Its Hellenistic, Syrian and Byzantine Origins; III, Eastern Iconography Modified by Our Artists; IV, Enrichment of Iconography: the Liturgy and Liturgical Drama; V, Suger and His Influence; VI, The Saints; VII, The Pilgrimage Road in Italy; VIII, The Pilgrimage Road in France and Spain; IX, Encyclopedic Trends in Art; X, The Monastic Imprint; and XI, Twelfth Century Historiated Portals: Their Iconography. Unclassified, but comprehensive, updated bibliography of books and periodical articles in all languages (pp. 517-46). A standard work.

1126 Merhautova-Livorova, Anezka. **Romanische Kunst in Polen, der Tschechoslovakei, Ungarn, Rumanien, Jugoslawien.** Vienna, Schroll, 1974. 318p. illus. index. LC 75-530497.

Concise survey of art and architecture in Eastern Europe during the Romanesque. Brief text summarizes the developments in each country, followed by good collection of plates.

1127 Pijoán y Soteras, José. **El arte románico. Siglo XI y XII.** Bilbao, Spain, Espasa-Calpe, 1944. 612p. illus. index. (Summa Artis, Historia General del Arte, IX).

Comprehensive survey of European Romanesque art and architecture. Brief lists of books at the ends of chapters.

1128 Rey, Raymond. **L'art roman et ses origines.** Paris, Didier, 1945. 511p. illus. index.

History of Romanesque art and architecture in France. Traces its origin back to Gallo-Roman and Germanic art. Bibliographical footnotes. A good survey of Romanesque art and architecture in France for the advanced student.

1129 Santos, Reynoldo dos. **O románico em Portugal.** Lisbon, Editorial SUL, 1955. 151p. text, 144 plates. index.

Concise history of Portuguese Romanesque architecture and architectural sculpture, arranged by place. Introductory chapter surveys the pre-Romanesque background. Occasional bibliographical footnotes.

1130 Souchal, François. **Art of the Early Middle Ages.** New York, Abrams, 1968. 263p. illus. index. LC 68-27428.

Brief survey of the art and architecture of the Romanesque period. A short introductory essay is followed by explanations of the plates. Provides chronological tables and a brief bibliography (pp. 258-59).

1131 Swarzenski, Hanns. **Monuments of Romanesque Art: The Art of Church Treasures in North-Western Europe.** 2d ed. Chicago, University of Chicago Press, 1967. 102p. (text); 238p. (illus.). index. LC 67-85931.

Comprehensive illustrated handbook of manuscript painting, metalwork, bronze sculpture, ivory carving, and enamels from France, Germany, the Low Countries, and England dating from the ninth century through the middle of the thirteenth century. The introduction, which traces the history of these arts, is followed by detailed notes on the plates with thorough reference to specialized literature. The excellent plates form an invaluable corpus of early medieval minor arts. A standard handbook.

1132 Swoboda, Karl M. **Die Epoche der Romanik.** Munich, Schroll, 1976. 236p. illus. index. (Geschichte der bildenden Kunst, Band 1). LC 77-480452.
 History of art and architecture in Western Europe from the fourth century through the twelfth century. Emphasis is on the evolution of early medieval form. Bibliographies of specialized literature at the beginning of each chapter and a classified bibliography of general works (pp. 226-27). A good, balanced modern survey.

1133 Timmers, J. J. M. **A Handbook of Romanesque Art.** London, Nelson, 1969. 240p. illus. index. LC 79-80800.
 Concise handbook of Romanesque art and architecture in Italy, France, Germany, Spain, British Isles, Scandinavia, the Low Countries, and Eastern Europe. After an introduction that traces its origins, Romanesque art is divided into national groupings. Excellent maps, good selection of plates, and general, unclassified bibliography (pp. 234-35). A good handbook for beginning and advanced students.

1134 Tuulse, Armin. **Scandinavia Romanica: Die hohe Kunst der romanischen Epoche in Dänemark, Norwegen, und Schweden.** Vienna, Schroll, 1968. 35p. (text); 96p. (illus.). LC 73-281685.
 Pictorial survey of Romanesque sculpture and architecture in Denmark, Norway, and Sweden. Short introductory essay is followed by a collection of black and white plates, with notes; emphasis is on architecture. There are a few ground plans and elevations. Selections from this work are contained in (1122).

1135 Zarnecki, George. **Romanesque Art.** New York, Universe, 1971. 196p. illus. index. LC 75-122322.
 Concise history of the art and architecture of the Romanesque period. Well-chosen illustrations with informative captions. Bibliography of general works (pp. 190-92). Series "Universe History of Art."

Gothic

1136 Aubert, Marcel. **The Art of the High Gothic Era.** New York, Crown, 1965. 227p. illus. index. LC 64-24750.
 "With the collaboration of J. A. Schmoll-gen. Eisenwerth and contributions by Hans H. Hofstätter." Concise history of art and architecture in Western Europe, 1220-1350. Provides maps, glossary, chronological tables, and good classified bibliography (pp. 196-207). A good survey history of the climax of Gothic art in France and its spread to the rest of Europe. Series: "Art of the World."

1137 Bachmann, Erich, ed. **Gothic Art in Bohemia.** New York, Praeger, 1977. 96p. text, 249 plates. index. LC 75-111067.
 Comprehensive, scholarly history of art and architecture in Bohemia from the thirteenth through the fifteenth centuries. Translation of *Gotik in Böhmen* (Munich, Prestel, 1969). Chapters treating the development of architecture, painting, and sculpture are written by German specialists. Bibliography of basic books and periodical articles (pp. 90-92).

1138 Bialostocki, Jan. **Spätmittelalter und beginnende Neuzeit.** Berlin, Propyläen, 1972. 474p. (text); 468p. (illus.). index. (Propyläen Kunstgeschichte, Band 7). LC 72-373268.
 Comprehensive illustrated handbook of Western European art and architecture of the fifteenth century. The introductory essay is followed by a body of excellent plates, essays by specialists on the development of the various arts, informative notes on the plates with additional plans and reconstructions, and valuable bibliographical references. Excellent, classified bibliography (pp. 430-52). A standard handbook.

1139　Bouffard, Pierre. **L'art gothique en Suisse.** Geneva, Mazenod, 1948. 90p. illus.
　　Illustrated survey of art and architecture throughout Switzerland during the thirteenth, fourteenth, and fifteenth centuries. Series: "Les Nouvelles Éditions d'Art."

1140　Busch, Harald. **Deutsche Gotik.** Vienna, Schroll, 1969. 124p. illus. LC 76-487048.
　　Pictorial survey of Gothic art and architecture in Germany. Emphasis is on architecture and its sculptural and painted decoration. Consists of brief introductory sketch followed by a good selection of plates with informative notes. No bibliography. Useful collection of plates.

1141　Decker, Heinrich. **Gotik in Italien.** Vienna, Schroll, 1964. 308p. illus. LC 65-66821.
　　Illustrated survey of Gothic art and architecture in Italy. Introductory essay discusses the development of Gothic in the various regions of Italy, followed by a good collection of plates with emphasis on architecture and its decoration. No bibliography.

1142　Deuchler, Florens. **Gothic Art.** New York, Universe, 1973. 184p. illus. index. LC 72-85081.
　　Concise history of Gothic art and architecture from the mid-twelfth century through the fifteenth century in Northern Europe. The treatment of the Italian development ends with the thirteenth century. Well-chosen illustrations, many plans and elevations, and a balanced bibliography of general works (pp. 178-80). A good survey history for beginning and advanced students. Series: "Universe History of Art."

1143　Fischer, Friedhelm W., and J. J. M. Timmers. **Spätgotik; zwischen Mystik und Reformation.** Baden-Baden, Holle, 1971. 283p. illus. index. LC 74-570646.
　　Concise and well-balanced history of the art and architecture of Germany, France, the Low Countries, and England during the fourteenth and fifteenth centuries. Provides a good selection of color plates, plans, and diagrams, a glossary of terms, and a classified bibliography of books in all languages (pp. 264-71). This work is part of the German edition of the series "The Art of the World," and may be translated in the near future.

1144　Harvey, John H. **The Gothic World, 1100-1600: A Survey of Architecture and Art.** New York, Harper & Row, 1969. 160p. illus. index. LC 69-12465.
　　Concise survey of art and architecture in Western Europe during the Gothic period. Sets the history of art within the general context of cultural history, with good chapters on the methods and techniques of the Gothic artists and architects. Chief attention is given to architecture. Brief classified bibliography (pp. 133-36) and further bibliography in the footnotes. Rather poor illustrations, but useful maps and plans.

1145　Henderson, George D. S. **Gothic.** Harmondsworth, Penguin, 1967. 223p. illus. index. (Style and Civilization). LC 67-9741.
　　An exploration of the factors that brought about the Gothic style in Europe, with chapters on the Gothic artists, the relation of theology to form, the development of Gothic style, and art and mysticism. Short but helpfully annotated bibliography (pp. 217-19).

1146　Hofstätter, Hans H. **Art of the Late Middle Ages.** New York, Abrams, 1968. 264p. illus. index. LC 68-18131.
　　Brief survey of the art and architecture of the thirteenth through the mid-sixteenth centuries. Provides chronological tables of painting, sculpture, and architecture and a brief general bibliography (p. 253).

1147　Jantzen, Hans. **Kunst der Gotik.** Reinbek bei Hamburg, Rowohlt, 1957. 174p. illus. index.
　　Scholarly history of French architecture, portal sculpture, and stained glass of the late twelfth and thirteenth centuries. Chapter on the rediscovery of the Middle Ages and the state of research into Gothic architecture. Glossary of terms and bibliography of basic books in all languages (pp. 166-67).

1148 Karlinger, Hans. **Die Kunst der Gotik.** 3d ed. Berlin, Propyläen, 1927. 726p. illus. index. (Propyläen Kunstgeschichte, VII).
Comprehensive illustrated handbook of Gothic art and architecture throughout Europe. Covers the period from the beginning of the Gothic style in France in the mid-twelfth century to the end of the fifteenth century. Includes the applied and decorative arts and graphic arts. Introductory essay surveys development, followed by a good corpus of plates with descriptive notes. No bibliography. Superseded by the new Propyläen series (1161).

1149 Lambert, Elie. **L'art gothique en Espagne.** Paris, Laurens, 1931. 314p. illus. index. Reprint: New York, B. Franklin, 1971. LC 72-156386.
Concise history of art and architecture in Spain during the twelfth and thirteenth centuries. Good selection of plates, plans, and diagrams. Annotated bibliography (pp. 291-98). Standard history of Spanish Gothic art.

1150 Lefrancois-Pillon, Louis, and Jean Lafond. **L'art du XIVe siècle en France.** Paris, Albin Michel, 1954. 254p. illus. index.
Comprehensive history of art and architecture in France during the fourteenth century. Chapters discuss the various media separately. Appendix with discussion of the iconography of fourteenth-century illuminated manuscripts. Bibliographical footnotes and brief list of basic books (p. 238).

1151 Mâle, Émile. **Religious Art in France. The Late Middle Ages. A Study of Medieval Iconography and Its Sources.** Princeton, Princeton University Press, 1986. 597p. illus. index. (Bollingen Series, XC. 3). LC 84-26359.
Translation of the fifth edition of *L'art religieux de la fin du moyen age en France. Étude sur l'iconographie du moyen age et sur ses sources d'inspiration.* (Paris, Colin, 1949). Contents: Part One: Narrative Art. I, French Iconography and Italian Art; II, Art and the Religious Theater; III, Religious Art Expresses New Feelings: Pathos; IV, Religious Art Expresses New Feelings: Human Tenderness; V, Religious Art Expresses New Feelings: New Aspects of the Cult of Saints; VI, The Old and New Symbolism. Part Two: Didactic Art. VII, Art and Human Destiny: Human Life, Vice and Virtue; VIII, Art and Human Destiny: Death; IX, Art and Human Destiny: The Tomb; X, Art and Human Destiny: The End of the World: The Last Judgment, Punishments and Rewards; XI, How the Art of the Middle Ages Came to an End. This translation edited by Harry Bober has updated bibliographical footnotes, bibliography, pp. 549-73, and new illustrations. A standard work, but less authoritative than the author's works on the twelfth and thirteenth centuries (1125 and 1152).

1152 Mâle, Émile. **Religious Art in France. The Thirteenth Century. A Study in Medieval Iconography and Its Sources.** Princeton, Princeton University Press, 1984. 564p. illus. index. (Bollingen Series, XC. 2). LC 82-11210.
Translation of the ninth edition of *L'art religieux du XIIIe siècle en France. Étude sur l'iconographie du moyen age et sur ses sources d'inspiration* (Paris, Colin, 1958). A translation of the third edition (Paris, 1898) was in 1913 by Dutton and reprinted as: *The Gothic Image: Religious Art in France of the Thirteenth Century* (New York, Harper, 1958. LC 58-10152). Scholarly study of the iconography of French figurative arts of the thirteenth century with emphasis on the sculpture and stained glass of the great cathedrals. Contents: I, General Character of Medieval Iconography; II, Method Used for the Study of Medieval Iconography, The *Speculum Majus* of Vincent of Beauvais; Book One, *Speculum Naturale*: The Mirror of Nature; Book Two, *Speculum Doctrinale*: The Mirror of Learning; Book Three, *Speculum Morale*: The Mirror of Morals; Book Four, *Speculum Historiale*: The Mirror of History: I, The Old Testament; II, The Gospels; III, The Traditional Legends Based on the Old and the New Testaments; IV, The Saints and the *Golden Legend*; V, Antiquity, Secular History; VI, The End of History. The Apocalypse. The Last Judgment; Conclusion. This translation edited by Harry Bober has updated bibliographical footnotes, bibliography (pp. 501-24), and new illustrations. A standard work.

1153 Martindale, Andrew. **Gothic Art.** New York, Praeger, 1967. 287p. illus. index. LC 67-28194.

Concise history of Gothic art and architecture from the twelfth to the fifteenth centuries. Includes Italian art and architecture of the fourteenth century. Provides a chronological table, a glossary of terms, and a select bibliography (pp. 272-73).

1154 Mayer, August L. **Gotik in Spanien.** Leipzig, Klinkhardt und Biermann, 1928. 299p. illus. index.

History of art and architecture in Spain from the early thirteenth century to the end of the fifteenth century. Chapters treat major monuments, artists, schools, and regions. Inadequate bibliographical footnotes.

1155 Michel, André, ed. **Formation, expansion et évolution de l'art gothique.** Paris, Colin, 1907. 2v. illus. (Histoire de l'Art...., tome II).

Comprehensive history of art, architecture, and the applied arts in Western Europe during the thirteenth and fourteenth centuries. Chapters written by various French scholars discuss the development of these media in the various countries with emphasis on France and Italy. Bibliographies on basic literature at the end of each chapter.

1156 Pijoán y Soteras, José. **Arte gótico de la Europa occidental, siglos XIII, XIV y XV.** Madrid, Espasa-Calpe, 1947. 615p. illus. index. (Summa Artis, Historia General del Arte, XI).

Comprehensive history of art and architecture in Western Europe during the thirteenth, fourteenth, and fifteenth centuries. Introductory chapters discuss the background and definition of Gothic style. Arrangement of the remaining chapters is by country, then chiefly by major building. Bibliography of general books (pp. 595-97).

1157 Réau, Louis. **L'art gothique en France: architecture, sculpture, peinture, arts appliqués.** Rev. and exp. ed. Paris, Le Prat, 1968. 170p. illus. LC 79-373657.

Concise history of art and architecture in France during the Gothic period. Provides a one-page glossary of terms and brief bibliography (p. 170).

1158 Salet, François. **L'art gothique.** Paris, Presses Universitaires de France, 1963. 186p. illus. LC 66-46706.

Concise history of Gothic art and architecture, chiefly in France, from 1125 to 1540. Bibliography (pp. 185-86) chiefly lists works in French.

1159 Scheffler, Karl. **Der Geist der Gotik.** Leipzig, Insel, 1917. 111p. illus.

Analysis of the development of form in medieval art. Contents: Die Lehre von Ideal; Die beiden Formenwelten der Kunst; Der Weg der Gotik. No bibliography. For a similar approach, see Worringer (1167).

1160 Schmarsow, August. **Italienische Kunst im Zeitalter Dantes.** Augsburg, Filser, 1928. 2v. illus.

Important, comprehensive history of Italian art and architecture during the thirteenth and fourteenth centuries. Contents: I, Niccolò Pisano; II, Giovanni Pisano; III, Die Gotik in Mittelitalien; IV, Rhythmik der Innenraum; V, Raumdarstellung der Maler; VI, Giotto in Padua und in Florenz; VII, Die Bronzetur des Andrea Pisano; VIII, Reliefskulpturen des Domfassade von Orvieto; IX, Sienesische Malerei; and X, Der Schrein des SS. Corporale in Orvieto. No bibliography.

1161 Simson, Otto von. **Das Mittelalter II: Das Hohe Mittelalter.** Berlin, Propyläen, 1972. 475p. (text); 472p. (illus.). index. (Propyläen Kunstgeschichte, Band 6). LC NUC73-87529.

Comprehensive illustrated handbook of art and architecture in Western Europe from the mid-twelfth century through the fourteenth century. Introductory essay by von Simson is followed by a corpus of excellent plates; essays by specialists on the development

of the various arts in France, Germany, England, and Italy; informative notes on the plates with valuable bibliographical references; and an excellent comprehensive and classified bibliography (pp. 437-56). A standard handbook.

1162 Stalley, R. A. **Architecture and Sculpture in Ireland, 1150-1350.** New York, Barnes and Noble, 1971. 149p. illus. LC 72-197179.

Well-illustrated survey of architecture and architectural sculpture in Ireland during the Gothic period. Introductory chapter on patrons and craftsmen is followed by chapters devoted to particular building types. Maps; no bibliography.

1163 Swaan, Wim. **The Late Middle Ages: Art and Architecture from 1350 to the Advent of the Renaissance.** Ithaca, N.Y., Cornell University Press, 1977. 232p. illus. index. LC 77-77552.

Well-illustrated survey of art and architecture outside Italy from 1350 to circa 1500. Introduction analyzes the "Tenor of the Age," and subsequent chapters concentrate on the development of art and architecture in the various nations. Excellent photographs by the author. Classified bibliography, chiefly of books (pp. 224-27).

1164 Swoboda, Karl M. **Die Gotik von 1150-1300.** Munich, Schroll, 1977. 234p. illus. index. (Geschichte der bildenden Kunst, Band 2).

History of Gothic art and architecture 1150 to 1300. Introductory chapters discuss the state of research on Gothic art and stylistic and formalistic ramifications of the Gothic mode. Subsequent chapters are devoted to the evolution of Gothic in the various nations of Western Europe. Specialized literature is contained in bibliographies at the beginning of each chapter, and general works are presented in a classified list (pp. 226-27). A good, balanced, modern stylistic survey.

1165 Swoboda, Karl M. **Die Spätgotik.** Munich, Schroll, 1978. 228p. illus. index. (Geschichte der bildenden Kunst, Band 3).

History of art and architecture in Italy during the fourteenth century and in the rest of Western Europe during the fourteenth and fifteenth centuries. Introduction analyzes the concept of Late Gothic, and subsequent chapters trace the evolution of style in the various countries. Bibliographies of specialized literature at the beginning of each chapter, and a classified bibliography of more general works (pp. 216-17). A good, balanced, modern stylistic survey.

1166 Walle, A. J. L. van de. **Gothic Art in Belgium.** Brussels, M. Vokaer, n.d. 239p. illus. index. LC 72-360090.

Pictorial survey of architecture and monumental sculpture from the Gothic period in Belgium. Includes examples from the thirteenth through the fifteenth centuries. Introductory essay is concerned chiefly with the history of architecture in Belgium during the Gothic period. Plates that follow include works of sculpture as well as architecture. Brief, unclassified bibliography (pp. 77-78). For the general reader and the beginning student; however, the introductory essay is sufficiently detailed to be of value to the advanced student of medieval architecture.

1167 Worringer, Wilhelm. **Form in Gothic.** Rev. ed. London, Tiranti, 1957. 180p. illus. Reprint: New York, Schocken, 1964. LC 63-22688.

First published in 1910 as *Formprobleme der Gotik.* Highly influential study of the psychology of Gothic art and architectural form. Based upon the ideas of the German aesthetician, Theodor Lipps, in analyzing aesthetic empathy (Einfühlung). Worringer sees Gothic form as a fundamental desire for abstraction derived from the spirituality of the age. A classic work in the psychology of art history.

RENAISSANCE (INCLUDING MANNERISM)

General Works

1168 Adama van Scheltema, Frederik. **Die Kunst der Renaissance.** Stuttgart, Kohlhammer, 1957. 210p. illus. index. (Die Kunst des Abendlandes, Band 3). LC A58-273.
Survey history of art and architecture of the fifteenth and sixteenth centuries in both Northern and Southern Europe. Bibliographical footnotes.

1169 Batterberry, Michael, adapter. **Art of the Early Renaissance.** New York, McGraw-Hill, c. 1968. 191p. illus. LC 79-115138.
Pictorial survey of the art and architecture of Northern and Southern Europe from Giotto to Botticelli and Van Eyck to Bosch. No bibliography. For the general reader.

1170 Battisti, Eugenio. **Rinascimento e Baròcco.** Turin, Einaudi, 1960. 328p. illus. LC 62-42100.
History of European art and architecture from the early fourteenth century through the middle of the eighteenth century. Emphasis is on Italian developments. Extensive bibliographical footnotes. A standard Italian history of Renaissance and Baroque art and architecture.

1171 Baumgart, Fritz-Erwin. **Renaissance und Kunst des Manierismus.** Cologne, DuMont Schauberg, 1963. 232p. illus. index. LC 64-43125.
History and investigation of the meaning of the High Renaissance and Mannerism in Western Europe. Provides a most useful collection of excerpts (translated into German) from documents relating to the Renaissance and Mannerism, from Serlio to Erwin Panofsky. Bibliography (pp. 217-22) lists major works on the period in chronological order. A scholarly definition and history of the High Renaissance and Mannerism.

1172 Gilbert, Creighton. **History of Renaissance Art: Painting, Sculpture, Architecture throughout Europe.** New York, Abrams, 1973. 460p. illus. index. LC 72-4791.
Concise history of art and architecture of the Renaissance in Western Europe. Emphasis is on painting, beginning with Cimabue and ending with the late sixteenth century. Chronological chart of artists and classified bibliography of works in English (pp. 423-36).

1173 Huyghe, René, ed. **Larousse Encyclopedia of Renaissance and Baroque Art.** New York, Prometheus, 1964. 444p. illus. index. LC 64-13787
Concise history composed of brief essays by specialists on the art and architecture of Western Europe from the end of the Middle Ages through the Baroque (actually nineteenth century). No bibliography.

1174 Kaufmann, Georg. **Die Kunst des 16. Jahrhunderts.** Berlin, Propyläen, 1970. 468p. (text); 408p (illus.). (Propyläen Kunstgeschichte, Band 8). LC 75-551182.
Comprehensive illustrated handbook of the art and architecture of Europe in the sixteenth century. The introductory essay by Kaufmann is followed by a body of excellent plates, essays by a number of specialists on the development of the various arts, informative notes to the plates (with plans and diagrams), and valuable references to specialized literature. Excellent classified bibliography of books and periodical articles (pp. 405-441). Chronological table provides synopsis of events in political history, the various arts, philosophy, literature, and cultural history. A standard handbook.

1175 Martindale, Andrew. **Man and the Renaissance.** New York, McGraw-Hill, 1966. 186p. illus. index. LC 66-15837.
Art historical survey of the Renaissance in Italy and Northern Europe in a cultural context. Treats architecture, sculpture, and painting. Enhanced by maps, a chronological table, brief biographical glossary and a general reading list (p. 167).

1176 Ruskin, Ariane. **Art of the High Renaissance.** New York, McGraw-Hill, 1968. 189p. illus. index. LC 76-110961.
Pictorial survey of art and architecture from Leonardo to El Greco. Covers both Northern and Southern Europe. No bibliography. For the general reader.

1177 Wolf, Robert E., and Ronald Millen. **Renaissance and Mannerist Art.** New York, Abrams, 1968. 263p. illus. index. LC 68-18132.
Concise survey of the art and architecture in Italy, Spain, Portugal, France, the Low Countries, Germany, and England during the fifteenth and sixteenth centuries. Well illustrated and with a brief, classified bibliography of books in English and foreign languages (pp. 258-60).

1178 Wundram, Manfred. **Art of the Renaissance.** New York, Universe, 1972. 196p. illus. LC 73-175861.
Concise history of art and architecture in all of Western Europe during the fifteenth and sixteenth centuries. Very good selection of plates with informative captions, liberally provided with plans and diagrams. Bibliography (pp. 190-92) lists major books in all languages. Concise but balanced and factual text with emphasis on the development of style in Renaissance art and architecture. A good survey for the general reader and the beginning student. Series: "Universe History of Art."

Mannerism

1179 Chastel, Andre. **The Crisis of the Renaissance, 1500-1600.** Trans. by Peter Price. Geneva, Skira, 1968. 217p. illus. index. LC 68-20498.
Survey of art and architecture during the sixteenth century with emphasis on mannerism. Contents: (I) Image and speech; (II) Unity of the divided west; (III) Naturalism and symbolism; (IV) Pageantry, court art and the marvelous.

1180 Hauser, Arnold. **Mannerism: The Crisis of the Renaissance and the Origin of Modern Art.** New York, Knopf, 1965. 2v. illus. index. LC 65-11130.
Volume one, text; volume two, plates. This scholarly study of the art and architecture of mannerism provides a good historical survey of the style and an investigation of the concept of mannerism and its relationship to contemporary culture. No separate bibliography, but the extensive footnotes provide thorough reference to literature on mannerism. A standard work.

1181 Hocke, Gustav R. **Die Welt als Labyrinth, Manier und Manie in der europäischen Kunst: Beiträge zur Ikonographie und Formgeschichte der europäischen Kunst von 1520 bis 1620.** Hamburg, Rowohlt, 1957. 252p. illus. index. LC 59-25248.
Five-part text discusses subject matter and style of European mannerism. Important theoretical analysis of manneristic spatial concepts. Classified bibliography of basic works in all languages (pp. 229-33).

1182 Nyholm, Esther. **Arte e teoria del Manierismo.** Odense, Odense University Press, 1971-1982. 2v. illus. index. (Odense University Studies in Art History, vol. 2, 3). LC 78-357661.
Major study of Italian mannerism based on the author's dissertation. Contents: Volume 1, *Ars Naturans*: La riscoperta del Manierismo; Il Manierismo comme periodo; La

letteratura artistica in Italia nel Cinquecento; La problematica dell'imitazione; Il "non finito" de Michelangelo, visto in relazione al principo dell'ars naturnas; Il "non finito" di Tiziano, visto in relazione a quello di Michelangelo; La letteratura d'arte nella meta del Cinquecento quale espressione della nova arte; Paolo Pino; Ludovico Dolce; Pietro Aretino; I primi artisti del Manierismo; Il Pontormo; Domenico Beccafumi; Il Russo Fiorentino; Il Parmigianino; Benvenuto Cellini; Giorgio Vasari. Volume 2, *Idea*: La reazione al primo Manierismo e il suo rapporto con la Controriforma; Bomarzo; Caprarola; Lo Studiolo; Il Buonatelenti; Cli ultimi critici del Manierismo; Giovanni Battista Armenini; Gian Paolo Lomazzo; Federico Zuccari; Gli ultimi artisti del Manierismo e il Manierismo fuori d'Italia; Il Manierismo e il Barocco. Bibliographical footnotes and general bibliography in each volume.

1183 Shearman, John K. G. **Mannerism.** Harmondsworth, Penguin, 1967. 216p. illus. index. LC 67-98470.

Handbook of the art and architecture of mannerism in both Northern and Southern Europe. Not a history of mannerist art but an investigation of the meaning of the style in relationship to other arts and cultural developments. Chapter five gives an excellent account of the term mannerism in art history. A brief but useful bibliography of books and periodical articles in all languages (pp. 207-208). Further literature is noted in the catalog of illustrations. For beginning and advanced students. This is one of the best analyses of the mannerist style in English.

1184 Weise, Georg. **Il manierismo. Bilancio critico del problema stilistico e culturale.** Florence, Olschki, 1971. 236p. illus. index. (Accademia Toscana di Scienze e Lettere "La Colombaria," Studi XX). LC 72-325759.

Collection of essays on the nature of mannerism. Part one treats formal problems in the development of manneristic style; part two examines broad ideas and cultural phenomena of mannerism. Unclassified list of books and periodical articles in all languages (pp. 213-19).

1185 Würtenberger, Fransepp. **Mannerism, the European Style of the Sixteenth Century.** New York, Holt, Rinehart and Winston, 1963. 246p. illus. index. LC 63-18066.

Comprehensive history of the art and architecture of mannerism in Western Europe. Treats art, architecture, and the minor arts. Excellent illustrations and a good classified bibliography (pp. 230-38), which lists books and periodical articles in all languages. A standard history and study of mannerism.

Italian Renaissance

1186 Battisti, Eugenio. **Hochrenaissance und Manierismus.** Baden-Baden, Holle, 1970. 255p. illus. index. LC 79-508918.

Concise history of Italian art and architecture of the High Renaissance and mannerism. Good selection of color plates, modest supplement of black and white illustrations. Bibliography (pp. 214-44) provides a good classified list of books and periodical articles in all languages. German edition of the series, "Art of the World."

1187 Bode, Wilhelm von. **Die Kunst der Frührenaissance in Italien.** Berlin, Propyläen, 1923. 624p. illus. index. (Propyläen Kunstgeschichte, VIII).

Illustrated survey of fifteenth-century art and architecture in Italy. Introduction discussing the fourteenth-century background is followed by chapters devoted to major regional schools. Superseded by a new Propyläen series volume (1138), but the text here, by one of the greatest experts on the Italian Renaissance, is still worth reading.

1188 Chastel, André. **The Flowering of the Italian Renaissance.** New York, Odyssey Press, 1965. 384p. illus. index. (The Arts of Mankind, 7). LC 65-27309.

History of art and architecture in Italy from circa 1460 to 1530 with a section on the spread of Italian Renaissance style to the rest of Europe. Provides maps and chronological tables; the bibliography of books in all languages (pp. 359-67) has its own subject index. With its companion volume (1189), it forms a useful pictorial handbook to Italian Renaissance art and architecture for the advanced student. The somewhat confused arrangement by schools, types, etc., will frustrate the beginning student, who would otherwise benefit most from the text.

1189 Chastel, André. **Studios and Styles of the Italian Renaissance.** New York, Odyssey Press, 1966. 417p. illus. index. (The Arts of Mankind, 8). LC 66-18997.

Survey history of the art and architecture of the fifteenth century in Italy, arranged by type, with an emphasis on workshops and local schools. Provides a glossary-index that treats artists, terms, and places; there are also maps and a good bibliography of books in all languages (pp. 387-98). See (1188) as well.

1190 Cole, Bruce. **The Renaissance Artist at Work: From Pisano to Titian.** New York, Harper & Row, 1983. 216p. index. LC 82-48102.

Survey of the Italian Renaissance artist, his place in society and his training, and the materials and types of Renaissance art. Extensive bibliography in the notes.

1191 Decker, Heinrich. **The Renaissance in Italy.** New York, Viking, 1969. 338p. illus. index. LC 68-23210.

Pictorial survey of the art and architecture of Italy in the fifteenth and sixteenth centuries. After a short introductory essay the plates are arranged by geographical region, with informative notes. No bibliography.

1192 Dvorák, Max. **Geschichte der italienischen Kunst im Zeitalter der Renaissance....** Munich, Piper, 1927-1928. 2v. illus. index.

Comprehensive and scholarly history of art and architecture in Italy during the fourteenth, fifteenth, and sixteenth centuries. Well-illustrated with plates and plans. Volume one covers the fourteenth and fifteenth centuries; volume two, the sixteenth century. Bibliography in the footnotes. An old but classic history of Italian Renaissance art by one of the greatest specialists.

1193 Eglinski, Edmund. **The Art of the Italian Renaissance.** Dubuque, Iowa, W. C. Brown, 1968. 104p. illus. index. LC 68-14576.

Brief survey of the art and architecture of Italy during the fifteenth and sixteenth centuries. Short bibliography of books in English (pp. 100-102). For the beginning student.

1194 Hartt, Frederick. **History of Italian Renaissance Art: Painting, Sculpture and Architecture.** 3d ed. New York, Abrams, 1987. 703p. LC 79-89044.

Comprehensive history of art and architecture in Italy from the late twelfth to the late sixteenth centuries. Excellent choice of illustrations, plans, and diagrams, very useful glossary of terms and subjects, chronological chart of artists and monuments, and classified bibliography of works in English. A standard history of Italian Renaissance art and architecture for beginning and advanced students.

1195 Heydenreich, Ludwig H. **Italie, 1400-1460: Éclosion de la Renaissance.** Paris, Gallimard, 1972. 452p. illus. index. LC NUC74-111761.

History of art and architecture in Italy from 1400 to 1460. Provides a good selection of plates, plans, and diagrams; a glossary-index; and a good comprehensive bibliography of books and periodical articles. French edition in the series "The Arts of Mankind."

1196 Heydenreich, Ludwig H., and Gunther Passavant. **Le temps des génies; Renaissance italienne 1500-1540.** Paris, Gallimard, 1974. 462p. illus. index. (L'Univers des Formes, 22). LC 74-759.

History of art and architecture in Italy during the High Renaissance. Provides good selection of plates, plans, and diagrams; a glossary-index; and a good comprehensive bibliography of books and periodical articles. French edition of the series "The Arts of Mankind."

1197 Hoffmann, Heinrich. **Hochrenaissance, Manierismus, Frühbarock. Die Italienische Kunst des 16. Jahrhunderts.** Zürich, Gebr. Leeman, 1938. 187p. illus.

Formalistic analysis and survey of art and architecture in Italy during the sixteenth century. One of the first books to recognize the intermediary role played by mannerism in the development from High Renaissance to Baroque. Classified bibliography of basic books in all languages (pp. 184-87).

1198 Keller, Harald. **The Renaissance in Italy: Painting, Sculpture, Architecture.** New York, Abrams, 1969. 394p. illus. index. LC 69-12485.

History of art and architecture in Italy from the early fourteenth century through mannerism. Good selection of black and white and color plates, plans, and diagrams, and a balanced, classified bibliography (pp. 375-79). An excellent history for beginning and advanced students.

1199 Letts, Rosa M. **The Renaissance.** Cambridge, Cambridge University Press., 1981. 106p. illus. index. LC 80-40357.

Concise history of art and architecture in Italy during the fifteenth century and the first quarter of the sixteenth century directed to the general reader and beginning student of art history.

1200 Levey, Michael. **Early Renaissance.** Harmondsworth, Penguin, 1967. 224p. illus. index. LC 68-88043.

History and analytical study of Italian art and architecture of the fifteenth century. Emphasis is on the idea of the Renaissance and the relationship of the fine arts to the general culture. Provides a good annotated bibliography (pp. 217-19) of books in English.

1201 Michel, André, ed. **La renaissance.** Paris, Colin, 1909-1911. 2v. illus. (Histoire de l'Art ..., tome IV).

Comprehensive history of art, architecture, and graphic and applied arts in Italy, France, Spain, and Portugal during the sixteenth century. Chapter on painting of the Low Countries at the end of the sixteenth century. Bibliographies of basic literature at the end of each chapter.

1202 Michel, André, ed. **Le réalisme les débuts de la renaissance.** Paris, Colin, 1907-1908. 2v. illus. (Histoire de l'Art ..., tome III).

Comprehensive history of art, architecture, and the graphic and applied arts in Italy and France during the fifteenth century. Chapters, written by various French scholars, sketch the development of the media. Concluding chapter: "L'art chrétien d'orient du milieu de XIIe au milieu du XVIe siècle," by G. Millet. Bibliography of basic literature at the end of each chapter.

1203 Murray, Linda. **The High Renaissance.** New York, Praeger, 1967. 213p. illus. index. LC 67-18404.

Concise survey of the art and architecture of Italy in the first three decades of the sixteenth century. Selected bibliography of books in English (pp. 195-97). Series "World of Art Library."

1204 Murray, Linda. **The Late Renaissance and Mannerism.** New York, Praeger, 1967. 215p. illus. index. LC 67-25566.
Concise survey of the art and architecture of Western Europe from circa 1530 to 1580. Short bibliography (pp. 200-202) of books in English. Series: "World of Art Library."

1205 Murray, Peter, and Linda Murray. **The Art of the Renaissance.** New York, Praeger, 1963. 286p. illus. index. LC 63-18834.
Survey history of the art and architecture of Western Europe of the fifteenth century. Good selection of illustrations and readable text, but no bibliography. Series: "World of Art Library."

1206 Paatz, Walter. **The Arts of the Italian Renaissance.** Englewood Cliffs, N.J., Prentice-Hall, 1974. 277p. illus. LC 73-21965.
Concise history-handbook of art and architecture in Italy from the beginning of the fifteenth century until 1530. Treats the various arts separately. Excellent introductory chapters on the concept and definition of the Renaissance. Thorough bibliographical references in the footnotes of the text.

1207 Pijoán y Soteras, José. **Renacimiento Romano y Veneciano siglo XVI.** Madrid, Espasa-Calpe, 1951. 711p. illus. index. (Summa Artis, Historia General del Arte, XIV).
Comprehensive history of Italian art and architecture of the sixteenth century with emphasis on Rome and Venice. Chapters are dedicated to major personalities, schools, and major buildings. Bibliography of general books (pp. 667-69).

1208 Pijoán y Soteras, José, and Juan A. Gaya Nuño. **Arte del periodo humanístico trecento y cuartrocento.** Madrid, Espasa-Calpe, 1950. 641p. illus. index. (Summa Artis, Historia General del Arte, XIII).
Comprehensive history of art and architecture in Italy during the fourteenth and fifteenth centuries. Chapters are chiefly dedicated to major personalities and schools. Bibliography (pp. 611-13) lists general books in all languages.

1209 Schubring, Paul. **Die Kunst der Hochrenaissance in Italien.** Berlin, Propyläen, 1926. 614p. illus. index. (Propyläen-Kunstgeschichte, IX).
Illustrated survey of Italian art and architecture of the first half of the sixteenth century. Brief introductory essay followed by corpus of plates. No bibliography. Superseded by new Propyläen series volume (1174).

1210 Smart, Alastair. **The Renaissance and Mannerism in Italy.** New York, Harcourt Brace Jovanovich, 1971. 252p. illus. index. LC 76-113711.
Survey of the art and architecture of Italy from the early fifteenth to the late sixteenth century. Emphasis is on painting and sculpture, although architecture is treated. Bibliography (pp. 245-46) lists only books in English.

1211 Stokes, Adrian D. **The Quattro Cento; A Different Conception of the Italian Renaissance.** New York, Schocken, 1968. 230p. illus. index. LC 68-28902.
First published in 1932. Collection of essays on various aspects of the fifteenth century in Italy, particularly the relationship between Verona and Florence. Eccentric. No bibliography.

1212 White, John. **Art and Architecture in Italy: 1250 to 1400.** Baltimore, Penguin, 1966. 449p. illus. index. (Pelican History of Art, Z28). LC 67-5664.
Comprehensive history of art and architecture in Italy from 1250 to 1400. Good selection of plates, plans, and diagrams; a good, classified bibliography (pp. 419-27) of books in English and foreign languages, with additional references to specialized literature in the notes to the text. A standard history.

1213 Wölfflin, Heinrich. **Classic Art, an Introduction to the Italian Renaissance.** 2d ed. New York, Phaidon, 1953. 297p. illus. index.

History of painting and sculpture in Italy during the period of the High Renaissance. A preliminary survey outlines the development of Italian art during the fifteenth century; this is followed by a detailed analysis of the artistic development of Leonardo, Michelangelo, Raphael, Fra Bartolommeo, and Andrea del Sarto. The work concludes with a formalistic investigation of the style of Italian Renaissance art. Bibliographical footnotes. A classic of art historical analysis, more important for its highly influential methodology than for its history of Italian Renaissance art.

1214 Wölfflin, Heinrich. **Die Kunst der Renaissance: Italien und das deutsche Formgefühl.** Munich, Bruckmann, 1931. English translation: **The Sense of Form in Art.** New York, Chelsea Publishing Co., 1958. 230p. illus. LC 57-12877.

Not a history of Renaissance art, but a detailed comparison of the formalistic qualities of Italian and German art and architecture of the sixteenth century. One of the most influential studies in contrasting national art styles. No bibliography.

See also: Alazard (1624), Bottari (1628), Venturi (1635).

Northern Renaissance

GENERAL WORKS

1215 Benesch, Otto. **The Art of the Renaissance in Northern Europe.** 2d ed. New York, Phaidon, 1965. 195p. illus. index. LC 64-13171.

History of art (exclusive of architecture) of Germany, France, and the Low Countries during the sixteenth century, with an emphasis on the interrelationship between the visual arts and the general intellectual climate of the times. Treats mannerist styles as well as Renaissance. Thorough bibliography of books and periodical articles in the notes to the text (pp. 169-85). A basis study for the advance student.

1216 Glück, Gustav. **Die Kunst der Renaissance in Deutschland, der Niederlanden, Frankreich....** 2d ed. Berlin, Propyläen, 1928. 657p. illus. index. (Propyläen-Kunstgeschichte, X).

Comprehensive illustrated handbook of art and architecture outside of Italy during the sixteenth and seventeenth centuries. Introductory essay outlining the development of style is followed by a good corpus of plates, with descriptive notes containing occasional bibliographical references. Superseded by new Propyläen series (1174).

1217 Michel, André, ed. **La renaissance dans les pays du nord; Formation de l'art classique moderne.** Paris, Colin, 1912-1915. 2v. illus. (Histoire de l'art..., tome V).

Comprehensive history of art, architecture, and the graphic and applied arts in Germany, the Low Countries, and England during the fifteenth and early sixteenth centuries. Chapters, written by various French scholars, trace the development of the media in the various countries. Concluding chapter on enamels by P. de Vasselot. Bibliographies of basic literature at the end of each chapter.

1218 Osten, Gert von der, and Horst Vey. **Painting and Sculpture in Germany and the Netherlands: 1500 to 1600.** Baltimore, Penguin, 1969. 403p. illus. index. (Pelican History of Art, Z31). LC 73-8246.

Comprehensive history of painting and sculpture in Germany and the Netherlands in the sixteenth century. Good selection of plates; an unclassified bibliography in the form of a list of abbreviations (pp. 375-78) is supplemented by reference to specific literature in the notes to the text. A standard history.

1219 Pijoán y Soteras, José. **El arte renacimiento en el norte y el centro de Europa.** Madrid, Espasa-Calpe, 1952. 696p. illus. index. (Summa Artis, Historia General del Arte, XV).

Comprehensive history of art and architecture in the Low Countries, Germany, Austria, and Switzerland during the fifteenth and sixteenth centuries. Chapters are chiefly devoted to the art of a major personality. Bibliography of general works (pp. 630-34).

1220 Smart, Alastair. **The Renaissance and Mannerism outside Italy.** New York, Harcourt Brace Jovanovich, 1972. 224p. illus. index. LC 70-165326.

Survey of art and architecture in France, Spain, the Low Countries, Portugal, and Germany from the early fifteenth century to the end of the sixteenth century. Emphasis is on painting and sculpture. Bibliography (pp. 218-20) is restricted to books in English.

1221 Snyder, James. **Northern Renaissance Art. Painting, Sculpture, the Graphic Arts from 1350 to 1575.** New York, Abrams, 1985. 559p. illus. index. LC 84-11435.

Survey of art, excluding architecture, in the Low Countries, Germany, and France from 1350 to 1575. Large number of well-selected illustrations. Good classified bibliography of basic works (pp. 534-37) and additional bibliography in the notes. Good history for the general reader and beginning student.

1222 Stokstad, Marilyn J. **Renaissance Art outside Italy.** Dubuque, Iowa, W. C. Brown, 1968. 113p. illus. index. LC 68-14577.

Survey of art and architecture in Spain, France, Germany, and the Low Countries during the Renaissance. Brief bibliography (pp. 107-108) lists major books in English. Designed as an inexpensive text for beginning students.

See also: Bialostocki (1138).

FRANCE

1223 Blunt, Anthony. **Art and Architecture in France: 1500-1700.** 4th ed. Harmondsworth, Penguin, 1981. 471p. illus. index. (Pelican History of Art, Z4). LC 81-189237.

Comprehensive history of art and architecture in France during the sixteenth and seventeenth centuries. Good selection of plates, plans, and diagrams. Bibliography (pp. 289-94), with further, more specialized literature mentioned in the extensive footnotes. A standard history.

1224 Du Colombier, Pierre. **L'art de la renaissance en France.** 2d ed. Paris, Le Prat, 1950. 133p. illus.

Brief survey of the art and architecture in France during the late fifteenth and sixteenth centuries. Text arranged by media. No bibliography.

1225 Du Colombier, Pierre. **Le style Henri IV et Louis XIII.** Paris, Larousse, 1941. 124p. illus. index.

In the series, "Arts, Styles et Techniques." Concise history of art, architecture, and the decorative arts in France during the reigns of Henry IV and Louis XIII. Bibliography of books and periodical articles (pp. 119-22) and index with artists' biographies.

1226 Gébelin, François. **Le style renaissance en France.** Paris, Larousse, 1942. 129p. illus.

Brief history of art and architecture in France during the sixteenth century. Brief bibliography (pp. 126-29) and an appendix of short biographies of artists.

1227 Weese, Arthur. **Skulptur und Malerei in Frankreich vom 15. bis 17. Jahrhundert.** Berlin, Athenaion, 1927. 220p. illus. index.

Comprehensive history of sculpture and painting in France from the early fifteenth through the seventeenth centuries. Some bibliographical references in the footnotes.

See also: Schneider (1532).

GERMANY AND AUSTRIA

1228 Baldass, Peter von, Ruppert Feuchtmüller, and Wilhelm Mrazek. **Renaissance in Österreich.** Vienna, Forum, 1966. 11p. (text); 96p. (illus.). index. LC 67-77758.

History of art and architecture in Austria during the sixteenth century. Chapters treat the major media of architecture, painting, and sculpture, as well as the minor arts. Well illustrated. Provides a good bibliography (pp. 107-109) that lists books and periodical articles.

1229 Christensen, Carl. **Art and Reformation in Germany.** Athens, Ohio University Press, 1979. 269p. LC 79-16006.

Study of the relationship between the Reformation and art in Germany. Contents: The Origins of Reformation Iconoclasm; Luther's Theology and Religious Art; Further Iconoclasm and Its Significance; Early Lutheran Art; The Reformation and the Decline of German Art; Excursus: Dürer's Four Apostles—A Reformation Painting. Select bibliography (pp. 255-62) and further bibliography in the footnotes.

1230 Jahn, Johannes. **Deutsche Renaissance: Architektur, Plastik, Malerei, Graphik, Kunsthandwerk.** Vienna, Schroll, 1969. 50p. (text); 158p. (illus.). LC 70-471461.

Pictorial survey of the art and architecture of the Renaissance in Germany, Austria, and Switzerland. Short essays on the development of the various arts are followed by a collection of good plates and descriptive notes. No bibliography.

1231 Ullman, Ernst. **Deutsche Architektur und Plastik 1470-1550.** Gütersloh, Prisma Verlag, 1984. 444p. illus. index. LC 85-201806. (Sonderband Geschichte der deutschen Kunst.)

Comprehensive history of German architecture, urban planning, and sculpture between 1470 and 1550 written from the standpoint of official Marxism of the German Democratic Republic. Classified bibliography of books, pp. 346-51.

See also: Pinder (1596).

LOW COUNTRIES

1232 Gaunt, William. **The Golden Age of Flemish Art.** New York, Crown, 1983. 160p. illus. index. LC 83-11713.

Originally published as *Flemish Cities*. Illustrated survey of art and architecture in Flanders from the beginning of the fifteenth century to the end of the seventeenth century. Many fine illustrations from photographs by Wim Swaan and others. Brief bibliography, p. 158.

SPAIN AND LATIN AMERICA

1233 Saló Marco, Antonio. **El estilo renacimiento español.** Barcelona, Serrahima y Urpi, n.d. (1931). 480p. illus.

Comprehensive handbook of Spanish Renaissance art, with emphasis on the applied and decorative arts. Contents: Mobiliario; Cerámica y vidrieras; Hierros forjados; Techos

artesonados, puertos labrados; Orfebreria, plateria, esmaltes; Bordados, tejidos, cueros repujados; Conjunto de interiores; Altares, retablos, púlpitos; Arquitectura; Patios, zaguanes y jardines. Each chapter ends with a summary. No bibliography.

1234 Tovar de Teresa, Guillermo. **Pintura y escultura del Renacimiento en Mexico.** Mexico City, Instituto Nacional de Antropologia y Historia, 1979. 570p. illus. index. LC 80-135814.
 Well-illustrated survey of sixteenth-century painting and sculpture in Mexico. Contents: Los artistos en la Nueva España; Los retablos renacentistes. Bibliography, pp. 529-33.

See also: Gudiol y Ricart (1710).

EASTERN EUROPE

1235 Bialostocki, Jan. **The Art of the Renaissance in Eastern Europe.** Ithaca, N.Y., Cornell University Press, 1976. 312p. illus. index. LC 75-38429.
 Based on the Wrightsman Lectures at the Institute of Fine Arts in New York in 1975. Themalogical survey of art in Poland, Czechoslovakia, and Hungary during the sixteenth century. Contents: Humanism and Early Patronage; the Castle; the Chapel; the Tomb; the Town; Classicism, Mannerism and Vernacular. Comprehensive but unclassified bibliography, with Slavic titles translated into English (pp. 281-306). Major work by a leading Polish art historian on a neglected area.

1236 Kozakiewiczowie, Helena, and Stefan Kozakiewiczowie. **The Renaissance in Poland.** Warsaw, Arkady, 1976. 330p. illus. index.
 Illustrated survey of art and architecture in Poland (including the former German territories presently under Polish administration) from 1545 to 1640. Selected bibliography (pp. 323-25) lists works in Polish.

1237 Lorentz, Stanislaw. **The Renaissance in Poland.** Warsaw, PRASA, 1955. 95p. illus.
 Collection of plates illustrating art and architecture in Poland during the sixteenth century. Brief introductory essay. No bibliography.

See also: Alpatov (1747), **Geschichte der russischen Kunst** (1753).

BAROQUE AND ROCOCO

General Works

1238 Andersen, Liselotte. **Baroque and Rococo Art.** New York, Abrams, 1969. 264p. illus. index. LC 79-75041.
 A survey history of painting, sculpture, architecture, and the decorative and minor arts of the Baroque and Rococo in Northern and Southern Europe. Includes chronological tables and a general bibliography (pp. 258-59).

1239 Bazin, Germain. **Baroque and Rococo.** New York, Praeger, 1964. 288p. illus. index. LC 64-22488.
 Survey history of the art and architecture of the seventeenth and eighteenth centuries in Italy, Spain, Portugal, France, the Low Countries, Germany, Austria, Scandinavia, Great Britain, and Eastern Europe. Brief, but annotated bibliography of books in all languages (pp. 273-75).

1240 Brinckmann, Albert E. **Die Kunst des Rokoko.** Berlin, Propyläen, 1940. 671p. illus. index. (Propyläen-Kunstgeschichte, XIII).

Comprehensive illustrated handbook of Rococo architecture, sculpture, and painting throughout Europe. Geographical survey introduces a good corpus of plates, with descriptive notes and some bibliographical references. First edition by Max Osborn (Berlin, Propyläen, 1929. 659p.). Superseded in function by the new Propyläen series (1246), but the introductory essay by one of the great experts on eighteenth-century art is still worth reading.

1241 Hausenstein, Wilhelm. **Vom Genie des Barock.** Munich, Prestel, 1962. 104p. illus. LC 57-2274.

Scholarly analysis of the Baroque style in European art and architecture. Particularly valuable for the text and illustrations examining the quality of space in Baroque painting and architecture. No bibliography.

1242 Hautecoeur, Louis. **L'art baroque.** Paris, Formes et Reflets, 1958. 146p. illus. index.

Illustrated survey of art and architecture of the seventeenth century in Western Europe. No bibliography.

1243 Held, Julius S., and Donald Posner. **17th and 18th Century Art: Baroque Painting, Sculpture, Architecture.** New York, Abrams, 1971. 439p. illus. index. LC 79-127417.

History of art and architecture in Italy, France, Spain, Portugal, the Low Countries, Germany, Austria, and England during the seventeenth and eighteenth centuries. Provides a chronological chart of artists and a brief selected bibliography of books chiefly in English (pp. 424-27). Reference to specialized literature is made in the notes to the text.

1244 Hubala, Erich. **Baroque and Rococo Art.** New York, Universe, 1976. 196p. illus. index. LC 73-88459.

Concise stylistic history of art and architecture in Western Europe during the seventeenth and eighteenth centuries. Good selection of plates with informative captions. Bibliography (pp. 192-93) offers a classified list of books in all languages. In the series, "Universe History of Art," and originally published in German as a volume in the "Belser Stilgeschichte."

1245 Hubala, Erich. **Die Kunst des 17. Jahrhunderts.** Berlin, Propyläen, 1970. 387p. (text); 408p. (illus.). (Propyläen Kunstgeschichte, Band 9). LC 79-518135.

Comprehensive illustrated handbook of the art and architecture of Europe in the seventeenth century. Introductory essay is followed by an excellent corpus of illustrations, specialists' commentaries on the development of the various arts, very informative notes to the plates (with plans, diagrams, and excellent bibliographies of specialized literature). Provides a very good classified bibliography (pp. 347-58) of books and periodical articles in all languages. A standard handbook.

1246 Keller, Harald. **Die Kunst des 18. Jahrhunderts.** Berlin, Propyläen, 1971. 479p. (text); 436p. (illus.). index. (Propyläen Kunstgeschichte, Band 10). LC 77-884403.

Comprehensive, illustrated handbook of the art and architecture of Europe and the New World in the eighteenth century. Introductory essay by Keller is followed by an excellent corpus of plates, short commentaries on the evolution of the arts in various countries, informative notes to the plates (with plans, diagrams, and very valuable bibliographies of specialized literature). An excellent, comprehensive, classified bibliography of books and periodical articles in all languages (pp. 446-56). A standard handbook.

1247 Kimball, S. Fiske. **The Creation of the Rococo.** New York, Norton, 1964. 242p. illus. index. Reprint New York: Dover, 1980. LC 79-55748.
Scholarly history of Rococo architecture and architectural decoration. Bibliographical references in the extensive footnotes; the numerous illustrations are poorly reproduced in this reprint. A standard work on Rococo architectural decoration for the advanced student.

1248 Kitson, Michael. **The Age of the Baroque.** New York, McGraw-Hill, 1966. 175p. illus. index. LC 65-21591.
Pictorial survey of the architecture, painting, sculpture, and decorative and minor arts in all of Europe in the seventeenth and eighteenth centuries. Includes maps, chronological tables, and short biographical notes on baroque artists and architects.

1249 Lübke, Wilhelm, and Max Semrau. **Die Kunst der Barockzeit und des Rokoko.** 4th ed. Stuttgart, Neff, 1921. 435p. illus. index. (Grundriss der Kunstgeschichte, IV).
Older, comprehensive history of art and architecture in Europe during the seventeenth and eighteenth centuries. Contents: Architektur des Barocks, Die bildenden Kunst im Zeitalter des Barocks; Die niederländische Malerei im 17. Jahrhundert; Die spanische Malerei und Plastik im 17. Jahrhundert; Die Kunst des Rokoko und des Klassismus. Bibliographical footnotes.

1250 Mainstone, Madeline, and M. Rowland. **The Seventeenth Century.** Cambridge, Cambridge University Press, 1981. 96p. illus. index. LC 80-40039.
Brief survey of European art and architecture of the seventeenth century intended as an introduction for undergraduate students and the general reader. Brief list of books for further reading, p. 92.

1251 Mâle, Émile. **L'art religieux de la fin du XVIe siècle; étude sur l'iconographie après le concile de Trente: Italie, France, Espagne, Flandres.** 2d ed. Rev. and corrected. Paris, Colin, 1951. 532p. illus. index. LC A51-5112.
First published in 1932 as *L'art religieux après le concile de Trente....* Scholarly study of the iconography of the figurative arts in Catholic Europe from the end of the sixteenth through the eighteenth centuries. Contents: I, L'art et les artistes après le concile de Trent; II, L'art et le Protestantisme; III, Le martyr; IV, V, La vision et l'extase; VI, L'iconographie nouvelle; VII, Les devotions nouvelles; VIII, Les survivances de passé, persistance de l'esprit du moyen âge; IX, Les survivances de passé, persistance de l'esprit du XVIe siècle, L'allegorie; X, La decoration des églises, les églises des ordres religieux. Extensive bibliographical footnotes. A standard work.

1252 Martin, John R. **Baroque.** New York, Harper & Row, 1977. 367p. illus. index. LC 76-12059.
Scholarly analysis of Baroque art and architecture. Contents: 1, The Question of Style; 2, Naturalism; 3, The Passions of the Soul; 4, The Transcendental View of Reality and the Allegorical Tradition; 5, Space; 6, Time; 7, Light; 8, Attitudes to Antiquity. Appendix with translations of documents pertaining to Rubens, Paul Fréart de Chatelon, Arnold Houbraken, Francisco Pacheo, and Philippe de Champaigne. Books for further reading (pp. 305-309) has a critical discussion of basic works.

1253 Michel, André, ed. **L'art en Europe au XVIIe siècle.** Paris, Colin, 1921-1922. 2v. illus. (Histoire de l'Art...., tome VI).
Comprehensive history of art and architecture in Europe during the seventeenth century. Chapters, written by various French scholars, sketch the development of the various media in the countries of Western Europe. Does not cover Eastern Europe. Bibliographies of basic literature at the end of each chapter.

1254 Michel, André, ed. **L'art en Europe au XVIIIᵉ siècle.** Paris, Colin, 1924-1925. 2v. illus. (Histoire de l'Art...., tome VII).

Comprehensive history of art, architecture, the graphic, applied and decorative arts in Europe during the eighteenth century. Chapters, written by various French scholars, cover the development of the various media in the countries of Western Europe. Bibliographies of basic literature at the end of each chapter.

1255 Pignatti, Terisio. **The Age of Rococo.** London, Hamlyn, 1969. 157p. illus. LC 76-434709.

Pictorial survey of art and architecture in Western Europe during the eighteenth century. Emphasis on the Italian scene. All illustrations in color. No bibliography.

1256 Pijoán y Soteras, José. **Arte barroco en Francia, Italia y Alemania.** Madrid, Espasa-Calpe, 1957. 578p. illus. index. (Summa Artis, Historia General del Arte, XVI).

Comprehensive history of art and architecture of the seventeenth and eighteenth centuries in Italy, France, and Germany. Chapters are arranged by countries, then by major personalities and schools. A few chapters are dedicated to major buildings, such as Versailles. Bibliography of general books (pp. 539-41).

1257 Rotenberg, Jewsej. **Die Kunst des 17. Jahrhundert in Europa.** Dresden, VEB Verlag, 1978. 307p.

First published in Russian in 1971. History of art and architecture throughout Europe during the seventeenth century. Introduction expounds a Marxist interpretation of history. Bibliography (pp. 287-95) is particularly useful for its listing of Eastern European publications.

1258 Ruskin, Ariane. **17th and 18th Century Art.** New York, McGraw-Hill, 1969. 191p. illus. index. LC 69-17190.

Pictorial survey of art and architecture in Italy, Spain, France, the Netherlands, and Germany during the seventeenth and eighteenth centuries. All illustrations are in color. No plans for the architectural examples. No bibliography. For the general reader.

1259 Sewter, A. C. **Baroque and Rococo.** New York, Harcourt Brace Jovanovich, 1972. 224p. illus. index. LC 73-152765.

Concise, popular survey of art and architecture in Europe during the seventeenth and eighteenth centuries. Bibliography (pp. 218-21) lists basic books in English and includes some artists' monographs.

1260 Soehner, Halldor, and Arno Schönberger. **The Rococo Age, Art and Civilization of the Eighteenth Century.** New York, McGraw-Hill, 1960. 394p. illus. index. LC 60-11310.

Survey of the art of Europe (exclusive of architecture) during the eighteenth century, with emphasis on the general cultural context. Informative notes to the plates, but no bibliography.

1261 Stinson, Robert E. **Seventeenth and Eighteenth Century Art: An Introduction to Baroque and Rococo Art in Europe from A.D. 1600 to A.D. 1800.** Dubuque, Iowa, W. C. Brown, 1969. 149p. illus. LC 68-14580.

Brief survey of the art and architecture of Western Europe from 1600 to 1800. Brief bibliography of books in English (pp. 143-44).

1262 Tapie, Victor Lucien. **The Age of Grandeur: Baroque Art and Architecture....** New York, Praeger, 1961. 305p. illus. index. LC 61-17028.

Survey of the art and architecture of the seventeenth century in Italy, Spain, Portugal, France, Germany and Austria, the Low Countries, Eastern Europe, and the New World colonies. Classified bibliography (pp. 285-97) of books in all languages; further literature is referred to in the notes to the text.

1263 Weisbach, Werner. **Der Barock als Kunst der Gegenreformation.** Berlin, Cassirer, 1921. 232p. illus. index.
　　Important, scholarly examination of the role of the Counter Reformation in the formation of the style of Baroque art and architecture in Catholic Europe, particularly in Italy and Spain. Contents: Historische und psychologische Grundlage; Elemente der gegenreformatorischen Kunst; Die gegenreformatorische Kunst und das Heilige. Bibliographical references in the footnotes.

1264 Weisbach, Werner. **Die Kunst des Barock in Italien, Frankreich, Deutschland und Spanien.** Berlin, Propyläen, 1924. 536p. illus. index. (Propyläen Kunstgeschichte, XI).
　　Comprehensive illustrated handbook of the art and architecture of the seventeenth century in Italy, France, Germany, and Spain. Concise historical sketch serves as an introduction to the good corpus of plates, with descriptive notes. No bibliography. Superseded by the new Propyläen series (1245, 1246).

France

1265 Boime, Albert. **Art in an Age of Revolution 1750-1800.** Chicago, University of Chicago Press, 1987. 521p. illus. index. LC 87-5944.
　　In the series: "A Social History of Modern Art." History of painting and sculpture in Western Europe and America from 1750 to 1800 from the standpoint of the social, political, and economical effects of the French Revolution and the Industrial Revolution. Bibliographical references in the footnotes.

1266 Hildebrandt, Edmund. **Malerei und Plastik des 18. Jahrhunderts in Frankreich.** Berlin, Athenaion, 1924. 212p. illus. index.
　　Comprehensive history of painting and sculpture in France during the eighteenth century. Extensive bibliographies of books and periodical articles given at the end of the sections. An old but standard treatment of the subject.

1267 Kalnein, Wend Graf, and Michael Levey. **Art and Architecture of the Eighteenth Century in France.** Harmondsworth, Penguin, 1972. 443p. illus. index. LC 73-167862
　　Comprehensive history of art and architecture in France during the eighteenth century. Part one, dealing with painting and sculpture, is by Levey; part two, on architecture by Graf Kalnein. Does not cover the minor arts. Good selection of plates. Bibliography (pp. 405-417) lists books in all languages. Further reference to more specialized literature is made in the extensive footnotes. A standard history of French eighteenth century art and architecture. In the "Pelican History of Art" series.

1268 Lévêque, Jean-Jacques. **L'art et la révolution française.** Neuchâtel, Editions Ides et Calendes, 1987. 328p. illus.
　　Well-illustrated survey of art and architecture in France from 1789 to 1804 with emphasis on painting. No bibliography.

1269 Mauricheau-Beaupré, Charles. **L'art au XVIIe siècle en France.** Paris, Le Prat, 1946-1947. 2v. illus. index.
　　History of architecture, sculpture, painting, and the applied arts in France during the seventeenth century. Tome 1: *Premiere période, 1594-1661*; tome 2: *Deuxieme période, 1661-1715*. No bibliography.

1270 Réau, Louis. **L'art au XVIIIe siècle en France: Style Louis XVI.** Paris, Le Prat, 1952. 2v. illus. LC 56-23929.
　　Illustrated survey of art and architecture in France during the reign of Louis XVI. Emphasis is on interior design and decorative arts.

1271 Verlet, Pierre. **Le style Louis XV.** Paris, Larousse, 1942. 154p. illus. index.
In the series, "Arts, Styles et Techniques." Concise history of art, architecture, and the applied and decorative arts during the reign of Louis XV. Introductory chapter sketches the historical background to and formulates a characterization of the Louis XV style. Bibliography of basic books and periodical articles (pp. 148-49).

1272 Weigert, Roger. **Le style Louis XIV.** Paris, Larousse, 1942. 127p. illus. index.
In the series, "Arts, Styles et Techniques." Concise history of art, architecture, and the decorative arts in France during the reign of Louis XIV. Introductory chapter examines the origins and character of the Louis XIV style. Concluding chapter on the importance of foreign artists then in France. Bibliography of books in all languages (pp. 120-23). Index with biographies of major artists.

See also: Du Colombier (1225), Mâle (1251), Weese (1227).

Germany and Austria

1273 Feulner, Adolf. **Skulptur und Malerei des 18. Jahrhunderts in Deutschland.** Wild-park-Potsdam, Athenaion, 1929. 268p. illus. index. LC 30-2560.
Volume in the series, "Handbuch der Kunstwissenschaft." Scholarly history of painting and sculpture in the German-speaking countries during the eighteenth century. The two media are treated in the chronological sequence of styles: Spätbarock, Rokoko, Louis XVI, übergang zum Klassismus. Bibliographical footnotes and general bibliography (p. 255). Although out of date in parts, still a standard work by one of the great experts.

1274 Grimschitz, Bruno, Wilhelm Mrazek, and Ruppert Feuchtmüller. **Barock in Öster-reich.** Vienna, Forum, 1960. 95p. (text); 92p. (plates). index.
History of art and architecture in Austria during the seventeenth and eighteenth centuries. Consists of essays on developments in the major media. No bibliography. Well illustrated.

1275 Hempel, Eberhard. **Baroque Art and Architecture in Central Europe.** Baltimore, Penguin, 1965. 370p. illus. index. (Pelican History of Art, Z22). LC 65-28970.
Comprehensive and scholarly history of art and architecture in Germany, Austria, Switzerland, Hungary, Czechoslovakia, and Poland. Painting and sculpture are treated from the early seventeenth through the eighteenth centuries; architecture, from the beginning of the sixteenth century through the eighteenth century. Excellent selection of plates, maps, plans, and diagrams. Good, well-classified bibliography of books and periodical articles in all languages (pp. 335-43). Further reference to specialized literature in the notes to the text. A standard history.

1276 Riesenhuber, Martin. **Die kirchliche Barockkunst in Österreich.** Linz, Verlag Christlichen Kunstblätter, 1924. 670p. illus. index.
Comprehensive and scholarly history of religious architecture, sculpture, painting, and the applied arts in Austria during the seventeenth and eighteenth centuries. Contents: I, Einleitung; II, Literatur; III, Allgemeines über die Barocke; IV, Die Ausstattung der Barockkirchen; VII, Baumeister und Bauten der Barockzeit; VIII, Die barocke Plastik; IX, Die Malerei des 17. und 18. Jahrhunderts; and X, Nachträge. Thoroughly indexed. Detailed, annotated bibliography of books and periodical articles (pp. 6-15).

1277 Schmitz, Hermann. **Kunst und Kultur des 18. Jahrhunderts in Deutschland.** Munich, Bruckmann, 1922. 379p. illus.
Comprehensive history of art, architecture, and culture in general in Germany and Austria during the eighteenth century. No bibliography.

Great Britain

1278 Denvir, Bernard. **The Eighteenth Century. Art, Design and Society 1689-1789.**
London, Longmans, 1983. 306p. illus. index. LC 82-16205.
 In the series: "A Documentary History of Taste in Britain." Cultural history of art
and architecture in Great Britain 1689 to 1789. Contents: A New Sense of Splendour; The
Rule of Taste; Fine Art and Its Institutions; the Arts of Manufacture; Man and Nature;
Biographical index.

Italy

1279 Golzio, Vincenzo. **Seicento e Settecento.** 3d ed. Turin, Unione Torinese, 1968.
2v. illus. index. (Storia dell'Arte Classica e Italiana, 4). LC 75-522328.
 Comprehensive history of art and architecture in Italy during the seventeenth and
eighteenth centuries. Well illustrated with good, selected bibliography of books (pp.
919-26). A standard and scholarly history for the advanced student.

1280 Griseri, Andreina. **Le metamorfosi del barocco.** Turin, Einaudi, 1967. 383p. illus.
index. LC 68-105433.
 History of Baroque art and architecture in Italy from its background in late man-
nerism to the mid-eighteenth century. Extensive bibliography in the footnotes. Good
selection of plates.

1281 Lees-Milne, James. **Baroque in Italy.** London, Batsford, 1959. 216p. illus. LC
60-20309.
 Concise history of art and architecture in Italy from mannerism through the late
baroque (circa 1775). Emphasis is on architecture and its decoration. Bibliography (pp.
205-209) lists books and periodical articles in all languages. For the general reader and the
beginning student.

1282 Wittkower, Rudolf. **Art and Architecture in Italy: 1600 to 1750.** 3d rev. ed. Har-
mondsworth, Penguin, 1973. 485p. illus. index. (Pelican History of Art, Z16). LC
75-128578. Reprinted with corrections and additional bibliography, 1980. LC 80-151645.
 Comprehensive history of art and architecture in Italy during the Baroque period.
Good selection of plates, plans, and diagrams. Excellent bibliography (pp. 415-52) and fur-
ther references to specialized literature in the extensive footnotes. A standard work.

Low Countries

1283 Ackere, Jules van. **Baroque & Classic Art in Belgium (1600-1789).** Brussels, Marc
Vokaer, 1972. 244p. illus. index. LC 73-167677.
 Illustrated survey of architecture and monumental sculpture in Belgium, 1600-1789.
Chapter on interior decoration. Well illustrated. Specialized literature in the notes; list of
general books (p. 238).

1284 Gerson, Horst, and E. H. ter Kuile. **Art and Architecture in Belgium: 1600 to
1800.** Baltimore, Penguin, 1960. 236p. illus. index. (Pelican History of Art, Z18). LC
60-3193.
 Comprehensive history of art and architecture in Belgium from 1600 to 1800. Excel-
lent selection of plates, plans, diagrams, and maps. Provides a good, classified bibliog-
raphy of major works (pp. 197-217) and thorough reference to specialized literature in the
extensive footnotes. The standard history of Flemish art in the Baroque and Rococo
periods.

1285 Rosenberg, Jakob, and Seymour Slive. **Dutch Art and Architecture: 1600 to 1800.** London, Penguin, 1966. 330p. illus. index. (Pelican History of Art, Z27). Rev. paperback ed. Harmondsworth, Penguin, 1972.

Comprehensive history of art and architecture in the United Netherlands from 1600 to 1800. Contains an excellent selection of illustrations (though they are poorly reproduced), useful plans, diagrams, and maps. A good, classified bibliography (pp. 279-308) lists references to more specialized literature in the extensive footnotes. The standard history of Dutch Baroque and eighteenth century art and architecture.

Spain, Portugal, and Latin America

1286 Bonet Correa, Antonio, and Victor M. Villegas. **El barroco en España y en Mexico.** Mexico City, M. Porrúa, 1967. 244p. illus. index. LC 78-321763.

Popular, illustrated survey of Spanish and Mexican Baroque art, with emphasis on architecture. Chapter on Baroque *retablos.* Introduction by George Kubler and René Taylor. Bibliography of Spanish books (p. 247).

1287 Lees-Milne, James. **Baroque in Spain and Portugal, and Its Antecedents.** London, Batsford, 1960. 224p. illus. index. LC 61-1109.

Pictorial survey of the architecture and art of the Baroque in Spain and Portugal, with emphasis on architecture and its decoration. For the general reader and the beginning student.

1288 Tovar de Teresa, Guillermo. **Mexico barroco.** Mexico City, Instituto Nacional de Antropologia y Historia, 1981. 332p. illus. index.

Well-illustrated survey of seventeenth century art and architecture in Mexico. Bibliography of basic books and articles, pp. 323-28.

1289 Weisbach, Werner. **Spanish Baroque Art.** Cambridge, Cambridge University Press, 1941. 65p. illus.

Series of three lectures on Spanish Baroque architecture, painting, and sculpture. Concentrates on the chief artistic personalities. No bibliography.

Eastern Europe

1290 Angyal, Endre. **Die slawische Barockwelt.** Leipzig, Seemann, 1961. 321p. illus. LC 61-37650.

Concise history of the art and architecture of the Baroque in the Slavic countries. Good chapter treating the research on Slavic Baroque. Bibliographical footnotes.

1291 Blažiček, Oldřich J. **Baroque Art in Bohemia.** Feltham, England, Hamlyn, 1968. 195p. illus. LC 77-370432.

Pictorial survey of art and architecture in Bohemia from the middle of the seventeenth to the end of the eighteenth centuries. Specialized literature in the footnotes; bibliography (p. 181) lists basic books and articles in all languages.

1292 Swoboda, Karl M., ed. **Barock im Böhmen.** Munich, Prestel, 1964. 359p. illus. index.

Comprehensive, scholarly history of art, architecture, and the applied arts in Bohemia from the early seventeenth to the late eighteenth centuries. Chapters on the individual media are written by various Austrian scholars. Well illustrated. Extensive bibliographical coverage in the notes.

See also: Alpatov (1747), **Geschichte der russischen Kunst** (1753).

MODERN (19th AND 20th CENTURIES)

General Works

1293 Arnason, H. H. **History of Modern Art: Painting, Sculpture, Architecture.** 3d. ed. Englewood Cliffs, N.J., Prentice-Hall; New York, Abrams, 1986. 749p. illus. index. LC 86-1167.

Comprehensive history of art and architecture in Europe and America from the Impressionists through the many movements of the 1960s. Arranged according to movements, the text centers on important artists, using their lives and art as distillations of the movements and periods covered. With copious black and white and color illustrations. Good classified bibliography of books (pp. 631-43). A standard history.

1294 Bowness, Alan. **Modern European Art.** New York, Harcourt Brace Jovanovich, 1972. 224p. illus. index. LC 77-183243.

Concise history of art in Europe from Manet to the inheritors of abstract expressionism. Emphasis is on painting; arrangement is by movements. Separate chapters are devoted to modern European sculpture and architecture. Illustrated in black and white, with some color plates. Classified bibliography of books (pp. 217-20).

1295 Brizio, Anna M. **Ottocento; Novecento.** Turin, Unione Torinese, 1939. 571p. illus. index. (Storia Universale dell'Arte, vol. 6).

Comprehensive history of art and architecture in the West from Neoclassicism to circa 1930. Bibliography (pp. 549-58) lists books and periodical articles in all languages. A standard Italian history of nineteenth-century art and architecture.

1296 Canaday, John. **Mainstreams of Modern Art.** New York, Holt, Rinehart and Winston, 1959. 576p. illus. index. LC 59-8693.

Comprehensive history of Western painting, graphics, and sculpture from David to Surrealism. An appendix gives a short history of modern architecture. No bibliography. A good survey history for the general reader.

1297 Evers, Hans Gerhard. **The Art of the Modern Age.** New York, Crown, 1970. 270p. illus. index. LC 72-125038. British title: **The Modern Age: Historicism and Functionalism** (1970).

Concise history of painting, sculpture, and architecture in Europe and America from the late nineteenth century to the mid-twentieth century. Chronological table of political history, art, literature, and science and technology, but no bibliography. A good, balanced survey.

1298 Galloway, John C. **Modern Art: The Nineteenth and Twentieth Centuries.** Dubuque, Iowa, W. C. Brown, 1967. 149p. illus. index. LC 67-22713.

Survey of painting and sculpture in Europe and America during the nineteenth and twentieth centuries (only twentieth century American art is covered). Bibliography (pp. 131-39) lists major books and periodical articles chiefly in English.

1299 Hamilton, George H. **19th and 20th Century Art: Painting, Sculpture, Architecture.** New York, Abrams, 1970. 583p. illus. index. LC 70-100401.

Comprehensive history of art and architecture in Europe and America during the nineteenth and twentieth centuries. Good selection of plates, diagrams, and plans. Bibliography (pp. 459-64) lists books in English.

1300 Hamilton, George H. **Painting and Sculpture in Europe, 1880 to 1940.** Rev. and corrected ed. Baltimore, Penguin, 1972. 624p. illus. index. (Pelican History of Art, Z29). LC 71-128577.

Comprehensive and scholarly history of painting and sculpture in Europe from 1880 to 1940. Excellent choice of illustrations. Provides a good, classified bibliography (pp. 391-419) that lists books in all languages. Further bibliographical references are to be found in the extensive footnotes. A standard history.

1301 Hildebrandt, Hans. **Die Kunst des 19. und 20. Jahrhunderts.** Berlin, Athenaion, 1924. 460p. illus. index.

Comprehensive history of art and architecture in Europe from 1800 to 1920. The scholarly text is amplified by a large selection of plates and plans, but there is no bibliography. A volume in the series, "Handbuch der Kunstwissenschaft." An older, but classic history of nineteenth-century and early twentieth-century art and architecture.

1302 Huyghe, René, ed. **Larousse Encyclopedia of Modern Art, from 1800 to the Present Day.** New York, Prometheus, 1965. 444p. illus. index. LC 65-19759.

Not a true encyclopedia, but a general survey of modern painting, sculpture, and architecture amplified by summary discussions of parallel developments in history, literature, and music. Written by a variety of specialists, the sections cover a range of subjects from Classicism and Romanticism to action painting and abstract expressionism. Includes a large section on "Later Eastern Arts" (Oriental art from 1200 onward), which treats periods that are judged to have been influential on modern art.

1303 Huyghe, René, and Jean Rudel, eds. **L'art et le monde moderne.** Paris, Larousse, 1969-1970. 2v. illus. index. LC 75-518560.

Comprehensive history of modern art and architecture from 1880 to the present. Includes the minor arts and the cinema. Consists of a group of essays by French specialists. Well illustrated and provided with a useful chronological table, but no bibliography. A useful illustrated survey for the beginning and advanced student.

1304 Lübke, Wilhelm, and Friedrich Haack. **Die Kunst des XIX. Jahrhunderts und der Gegenwart.** 6th ed. Stuttgart, Neff, 1922-1925. 2v. illus. index. (Grundriss der Kunstgeschichte, Bände 5-6).

Comprehensive history of art and architecture in Western Europe during the nineteenth and early twentieth centuries. Text is divided into four major divisions: Klassizismus, Romantik, Renaissancismus, and Moderne. Bibliographical footnotes.

1305 Lynton, Norbert. **The Modern World.** New York, McGraw-Hill, 1965. 175p. illus. index. LC 65-21593.

The text of this pictorial survey covers painting, sculpture, and architecture from the first half of the nineteenth century to just after 1940. Includes a glossary of terms, a chronological table (inside the covers), and a general bibliography (pp. 170-71).

1306 Meier-Graefe, Julius. **Entwicklungsgeschichte der modernen Kunst.** 3d ed. Munich, Piper, 1966. 2v. illus. index. LC 67-81601.

Comprehensive history of modern European art, chiefly painting, from Neoclassicism through Les Fauves and German Expressionists. No bibliography. A recent edition of an old, but classic study of the development of modern art.

1307 Michel, André, ed. **L'art en Europe et en Amerique au XIX^e siècle et au début du XX^e siècle.** Paris, Colin, 1925-1929. 3v. illus. (Histoire de l'Art...., tome VII).

Comprehensive history of art, architecture, and the graphic, applied, and decorative arts in Europe and America during the nineteenth and early twentieth centuries. Chapters are written by various French scholars and cover the development of the various media in the countries of Western Europe, Hungary, the Balkan countries, Poland, Russia,

Latin America, the United States, and Canada. Concluding chapter by Louis Réau discusses the development of the decorative arts at the end of the nineteenth century. Bibliographies of basic literature at the end of each chapter.

1308 Pijoán y Soteras, José. **Arte europeo de los siglos XIX y XX.** Madrid, Espasa-Calpe, 1967. 591p. illus. index. (Summa Artis, Historia General del Arte, XXIII).
Comprehensive history of art and architecture in Europe during the nineteenth and first half of the twentieth centuries. Chapters treat the various styles from Neoclassicism to abstract expressionism. Bibliography (pp. 553-56) lists basic books in all languages.

1309 Wilenski, Reginald H. **The Modern Movement in Art.** London, Faber and Faber, 1945. 210p. illus.
Critical examination of the development of European art and architecture in the late nineteenth and early twentieth centuries. Contents: I, Character of the Movement; II, Degenerate Nineteenth Century Art; III, Technique of the Movement; IV, Relative Values. Bibliographical footnotes.

1310 Zervos, Christian. **Histoire de l'art contemporain.** Paris, Cahiers d'Art, 1938. 498p. illus.
Comprehensive history of modern European painting and sculpture from Les Fauves to the Dadaists. Numerous but poorly reproduced illustrations and no bibliography. An older history of European Post-Impressionist art.

Austria

1311 Feuchtmüller, Ruppert, and Wilhelm Mrazek. **Kunst in Österreich, 1860-1918.** Vienna, Forum, 1964. 130p. (text); 100p. (plates). index.
History of art and architecture from 1860 to 1918. Consists of essays on the development of various media. Well illustrated, with a good bibliography (pp. 123-26) that lists general studies, artist monographs, and periodicals. A standard history of Austrian art and architecture of the late nineteenth century.

1312 Karpfen, Fritz. **Österreichische Kunst.** Leipzig, Literaria Verlag, 1923. 212p. illus. index. (Gegenwarts Kunst, III).
Journalistic treatment of Austrian painting, sculpture, and graphic arts of the late nineteenth and early twentieth centuries. No bibliography.

1313 Sotriffer, Kristian. **Modern Austrian Art: A Concise History.** New York, Praeger, 1965. 140p. illus. index. LC 65-25389.
Concise history of Austrian painting, sculpture, and graphic art from the late nineteenth century to the 1960s. Includes two biographical dictionaries: the first is of sixty artists mentioned in the text, with literature citations; and the second is of fifty artists not mentioned. Includes a short, selective bibliography (pp. 136-37).

Belgium

1314 Fontaine, André. **L'art belge depuis 1830; art et esthétique.** Paris, Felix Alcan, 1925. 168p. illus.
Survey history of Belgian art and architecture from Neoclassicism through Art Nouveau. Occasional bibliographical footnotes.

1315 Lambotte, Paul, et al. **Histoire de la peinture et de la sculpture en Belgique, 1830-1930.** Brussels, Van Oest, 1930. 203p. illus.
 Contents: I, La Renaissance de l'art Belge apres 1830; II, Le Romantisme; III, L'epoque de la societé libre des Beaux-Arts; IV, Les peintres de genre et d'intérieurs; V, Les paysagistes; VI, Les marinistes; VII, Les animaliers; VIII, Les graveurs; IX, Les peintres actuels; and X, Les sculptures. No bibliography.

France

1316 Fontainas, André, et al. **Histoire générale de l'art français de la révolution à nos jours.** Paris, Librarie de France, 1922. 3v. illus.
 Concise history of French art and architecture from the Revolution to the early twentieth century. Volume 1 covers painting and graphic arts; volume 2, architecture and sculpture; volume 3, decorative arts. No bibliography.

See also: Schneider (1532).

Germany

1317 Gurlitt, Cornelius. **Die deutsche Kunst seit 1800. Ihre Ziele und Taten.** 4th ed. Berlin, Bondi, 1924. 535p. illus. index.
 Comprehensive history of German art, exclusive of architecture, from Neoclassicism through Expressionism. Contents: I, Das Erbe; II, Die Klassiker; III, Die alten Schulen; IV, Die Landschaft; V, Die Romantiker; VI, Die Historische Schule; VII, Das Streben nach Wahrheit; VIII, Die Kunst aus Eigenem; IX, Der Kampf um den Stil; X, Der Realismus und Impressionismus; and XI, Der Expressionismus. No bibliography.

See also: Dehio (1593).

Italy

1318 Argan, Giulio Carlo. **L'arte moderna, 1770/1970.** Florence, Sansoni, 1970. 774p. illus. index. LC 79-564092.
 Comprehensive history of art and architecture of Italy from 1770 to 1970. Well illustrated; has some bibliographical footnotes.

1319 Carrieri, Raffaele. **Avant-Garde Painting and Sculpture (1890-1955) in Italy.** Milan, Domus, 1955. 318p. illus. index.
 History of Italian painting and sculpture from 1890 to 1955. Consists of chapters on movements and major artists. No bibliography.

1320 Lavagnino, Emilio. **L'arte moderna dai neoclassici ai contemporaei.** Turin, Edit. Torinese, 1956. 2v. illus. index. (Storia dell'Arte Classica e Italiana, 5).
 Comprehensive history of art and architecture in Italy from the nineteenth century to the middle of the twentieth century. Well illustrated with plates plans, and diagrams. Bibliography (pp. 1263-78) is a balanced list of books and periodical articles. The standard history of Italian nineteenth- and twentieth-century art.

1321 Maltese, Corrado. **Storia dell'arte in Italia, 1785-1943.** Turin, Einaudi, 1960. 471p. illus. index. LC A61-5671.
 History of art and architecture in Italy from Neoclassicism to mid-twentieth century abstraction. Well illustrated, but no bibliography.

Japan

1322 Munsterberg, Hugo. **The Art of Modern Japan: From the Meiji Restoration to the Present.** New York, Hacker, 1978. 159p. illus. index.
Popular pictorial survey of Japanese art and architecture from 1868 to 1968. Bibliography of basic books (pp. 153-54).

Mexico

1323 Fernández, Justino. **El arte moderno y contemporaneo en Mexico.** Mexico City, Imprenta Universitaria, 1952. 522p. illus. index.
Comprehensive history of art and architecture in Mexico from the early nineteenth century to the middle of the twentieth century. Numerous but poor illustrations; good but unclassified bibliography (pp. 505-512). A standard history of modern Mexican art and architecture.

Romania

1324 Oprescu, George. **Rumanian Art 1800 to Our Days.** Malmö, Malmö Ljustrycksanstalt, 1935. 192p. illus. index.
Concise history of Romanian art of the nineteenth and early twentieth centuries. No bibliography.

Russia

1325 Gray, Camilla. **The Russian Experiment in Art, 1863-1922.** New York, Abrams, c. 1962; reissued in new format, 1970. 296p. illus. index. LC 76-106290.
Concise history of painting and sculpture in Russia from the 1860s to 1922. Bibliography (pp. 280-82).

1326 Lozowick, Louis. **Modern Russian Art.** New York, Museum of Modern Art, 1925. 60p. illus.
Concise history of Russian art, exclusive of architecture, in the late nineteenth and early twentieth centuries. Contents: Introduction; The First Moderns; The Cubists; The Suprematists; The Constructivists; The Expressionist Strain; Others; Art Criticism; Present Standing. No bibliography.

Sweden

1327 Strömböm, Sixten G. M. **Konstnärsförbundets historia: Med företal av Prins Eugen.** Stockholm, Bonnier, 1945-1965. 2v. illus. index.
Comprehensive, scholarly history of Swedish painting and sculpture, with emphasis on artists' associations and academies. Volume one: *Till och med 1890;* volume two: *Nationalromantik och radikalism* (to circa 1920). Extensive bibliography in footnotes. A standard work.

United States

1328 Cahill, Holger, and Alfred H. Barr, Jr. **Art in America in Modern Times.** Freeport, N.Y., Books for Libraries, 1969. 110p. illus. LC 69-17569. Reprint of 1934 edition.
 Survey history of art and architecture in America from 1865 to 1934. Covers photography, film, and stage design as well as architecture, painting, and sculpture. Brief bibliographies (pp. 107-110) list major books.

1329 Myron, Robert, and Abner Sundell. **Modern Art in America.** New York, Crowell-Collier, 1971. 218p. illus. index. LC 76-153760.
 Survey of art and architecture in America from circa 1870 to 1970. Modest selection of black and white plates and brief bibliography of popular books (p. 214).

19th Century

GENERAL WORKS

1330 Hansen, Hans Jürgen. **Late Nineteenth Century Art: Architecture and Applied Art of the "Pompous Age."** New York, McGraw-Hill, 1972. 264p. illus. index. LC 72-148989.
 Pictorial survey of art and architecture in Europe and the United States during the second half of the nineteenth century. Emphasis is on Victorian art and architecture and its equivalents in Germany and France. Consists of essays on the various arts, written by specialists. Provides a bibliography (pp. 257-60) that lists major books in all languages.

1331 Hofmann, Werner. **Art in the Nineteenth Century.** London, Faber and Faber, 1960. 435p. illus. index.
 History of art and architecture in Europe and America, with an emphasis on the relationship between the fine arts and the general culture. Bibliographical references in the footnotes. An important study of nineteenth-century art for beginning and advanced students.

1332 Lankheit, Klaus. **Révolution et Restauration.** Paris, Michel, 1966. 286p. illus. index. LC 66-51780.
 Concise history of art and architecture in Europe and America from Neoclassicism through Realism. Good selection of color plates, modest supplement of black and white illustrations, plans, and diagrams. Provides a good bibliography (pp. 253-63) that lists books and periodical articles in all languages. French edition in the series "Art of the World."

1333 Novotny, Fritz. **Painting and Sculpture in Europe: 1780 to 1880.** Baltimore, Penguin, 1960. 288p. illus. index. (Pelican History of Art, Z20). LC 60-51441.
 Comprehensive history of painting and sculpture in Europe from Neoclassicism through Impressionism. Good selection of plates and good classified bibliography (pp. 253-69), which lists books and periodical articles in all languages. Further reference to specialized literature can be found in the extensive footnotes. A standard history of nineteenth-century painting and sculpture.

1334 Rosenblum, Robert, and H. W. Janson. **Nineteenth Century Art, Painting and Sculpture.** New York, Abrams, 1984. 527p. illus. index. LC 83-3882.
 Comprehensive history of painting and sculpture in Europe and the United States during the nineteenth century. The two media are treated separately, painting by stylistic phases and sculpture by countries. Good, classified bibliography, pp. 506-14.

1335 Scheffler, Karl. **Die europäische Kunst im neunzehnten Jahrhundert.** Berlin, Cassirer, 1926-1927. 2v. illus. index.
Important, comprehensive history of painting and sculpture in Western Europe during the nineteenth century and early twentieth century. Band 1: *Geschichte der europäische Malerei von Klassizismus bis zum Impressionismus*; Band 2: *Geschichte der europäischen Malerei vom Impressionismus bis zur Gegenwart, Geschichte der europäischen Plastik in neunzehnten und zwanzigsten Jahrhundert.* No bibliography.

1336 Schultze, Jürgen. **Art of Nineteenth Century Europe.** New York, Abrams, 1972. 264p. illus. index. LC 79-92913.
Concise history of art and architecture in Europe during the nineteenth century. Begins with Neoclassicism and hence reaches back into the mid-eighteenth century. Good selection of illustrations, mostly in color. No plans are given for the architecture. Provides a useful chronological table that coordinates events in the fine arts with events in literature, music, politics, and science and technology. Good bibliography (pp. 253-55) lists books in all languages. A good survey of nineteenth-century art and architecture for the general reader.

1337 Vogt, Adolf M. **Art of the Nineteenth Century.** New York, Universe, 1973. 189p. illus. index. LC 72-85082.
Concise history of art and architecture in Europe during the nineteenth century. A concluding chapter treats the influence of foreign cultures on nineteenth-century Western art. Good selection of plates, informative captions, and a good, balanced bibliography (pp. 184-86) of books and periodical articles in all languages.

1338 Zeitler, Rudolf W. **Die Kunst des 19. Jahrhunderts.** Berlin, Propyläen, 1967. 411p. (text); 440p. (illus.). index. (Propyläen Kunstgeschichte, Band 11). LC 67-104178.
Comprehensive illustrated handbook of the art and architecture of the nineteenth century in Europe and America. The introductory essay by Zeitler is followed by essays on various styles and media by different specialists, an excellent corpus of plates, very informative notes to the plates with reference to specialized literature, and a very good, comprehensive, and classified bibliography (pp. 373-83) of books and periodical articles in all languages. A standard handbook of nineteenth-century art and architecture.

Austria

1339 Hevesi, Ludwig. **Österreichische Kunst im 19. Jahrhundert.** Leipzig, Seemann, 1903. 2v. illus. index. (Geschichte der Modernen Kunst, II).
Older, comprehensive history of art and architecture in the Austro-Hungarian Empire from 1800 to 1900. No bibliography.

Belgium

1340 Hymans, Henri S. **Belgische Kunst des 19. Jahrhunderts.** Leipzig, Seemann, 1906. 253p. illus. index.
General history of art and architecture in Belgium during the nineteenth century. No bibliography. Still valuable for illustrations.

1341 Vanzype, Gustave. **L'art belge du XIXᵉ siècle.** Brussels, Van Oest, 1923. 2v. illus. index.
Illustrated survey of Belgian painting and sculpture during the nineteenth century; based upon an exhibition held in Brussels in 1922. Chapters are dedicated to major artists. No bibliography.

DENMARK

1342 Hannover, Emil. **Dänische Kunst des 19. Jahrhunderts.** Leipzig, Seemann, 1970. 168p. illus. index.
General history of art and architecture in Denmark during the nineteenth century. No bibliography. Still valuable for illustrations.

GERMANY

1343 Beenken, Hermann T. **Das neunzehnte Jahrhundert in der deutschen Kunst.** Munich, Bruckmann, 1944. 563p. illus. index. LC 46-12460.
A comprehensive history of art and architecture in Germany during the nineteenth century. Bibliographical references in the footnotes. A standard history.

GREAT BRITAIN

1344 Denvir, Bernard. **The Early Nineteenth Century: Art, Design and Society 1789-1852.** London, Longmans, 1984. 316p. illus. index. LC 83-25546.
In the series: "A Documentary History of Taste in Britain." A cultural history of art in Britain from 1789 to 1852. Contents: The Picturesque and the Past; Improving Public Taste; The World of the Artist; Patronage, Public and Private; Art, Design and the Machine. Biographical index with brief biographies of major personalities. Occasional bibliographical footnotes and references to sources in the text.

1345 Denvir, Bernard. **The Late Victorians: Art, Design and Society 1852-1910.** London, Longmans, 1986. 269p. illus. index. LC 85-4289.
In the series: "A Documentary History of Taste in Britain." A cultural history of art in Britain from 1852 to 1910. Contents: The State of Art; The Relationship between Art and High Victorian Life; Buying and Selling: The State of the Art Market; Architectural Alternatives: Stylistic Pressures on Architects; Virtuous Design: Design and Ornament Take on a New Complexion; Divisions of Taste: Opposing Factions in Art; Aestheticism, Impressionism and After. Biographical index with brief biographies of major personalities. Occasional bibliographical footnotes and references to sources in the text.

ITALY

1346 Willard, Ashton R. **History of Modern Italian Art....** 2d. ed. New York, Longmans, Green, 1900. 713p. illus. index.
Older, popular history of Italian art and architecture from Canova to the end of the nineteenth century. No bibliography.

MEXICO

1347 Fernández, Justino. **El arte siglo XIX en México.** Mexico City, Imprenta Universitaria, 1967. 256p. text, 343 illus., 23 color plates. index.
History of painting, sculpture, architecture, graphic arts, and popular graphics from Colonial Baroque times to the mid-twentieth century. Bibliography (pp. 228-32) is a selected, unclassified list of books and periodical articles, mostly in Spanish.

PORTUGAL

1348 Franca, José-Augusto. **A Arte em Portugal no século XIX**. 2d ed. Lisbon, Bertrand Editora, 1981. LC 82-148437.
 Comprehensive history of painting, sculpture, and the graphic arts in Portugal during the nineteenth century. Detailed chronological table and extensive bibliographical footnotes.

SWEDEN

1349 Nordensvan, Georg G. **Schwedische Kunst des 19. Jahrhunderts**. Leipzig, Seemann, 1904. 140p. illus.
 General survey of art and architecture in Sweden in the nineteenth century. No bibliography. Still valuable for illustrations.

1350 Nordensvan, Georg G. **Svensk konst och svenska konstnärer i nittonde århundradet....** Stockholm, Bonnier, 1925-1928. 2v. illus. index.
 Scholarly history of Swedish art from the late eighteenth through the nineteenth centuries. Contents: Volume 1, *Från Gustav III till Karl XV*; volume 2, *Från Karl XV till sekelslutel*. Bibliography of books and periodical articles (volume 2, pp. 511-13). A standard work.

UNITED STATES

1351 Garrett, Wendell D., et al. **The Arts in America: The Nineteenth Century**. New York, Scribner's, 1969. 412p. illus. index. LC 78-852.
 History of art and architecture in the United States during the nineteenth century. Good coverage of the minor and decorative arts. Bibliography (pp. 385-90) lists major books. A good survey of nineteenth-century American art and architecture for the general reader.

1352 Harris, Neil. **The Artist in American Society: The Formative Years, 1790-1860**. Chicago, University of Chicago Press, 1982. 432p. illus. index. LC 81-19752.
 First published in 1966. History of the social position of artists in American society from Federal times to the Civil War. Contents: To Aid of Necessity; The Perils of Vision; Art, Luxury and Republicanism; The Burden of Portraiture; Professional Communities: Growing Pains; European Travel: The Immediate Experience; European Travel: From Perceptions to Conceptions; Art and Transcendentalism: Beauty and Self-Fulfillment; Crusades for Beauty; Artist Images: Types and Tensions; The Pattern of Artistic Community; The Artists' Dreams and European Realities; The Final Tribute. Bibliographical footnotes.

1353 Lynes, Russell. **The Art-Makers. An Informal History of Painting, Sculpture and Architecture in Nineteenth-Century America**. New York, Atheneum, 1970. 514p. illus. index. Reprint: New York, Dover, 1982. LC 81-17359.
 History of American nineteenth-century art from standpoint of taste. Bibliography, pp. 494-96.

1354 Lynes, Russell. **The Tastemakers. The Shaping of American Popular Taste**. New York, Harper & Brothers, 1955. 372p. illus. index. Reprint: New York, Dover, 1980. LC 80-65770.
 History of taste in the United States from the Federal period to the end of World War II. Emphasis is on the differences between strata of popular taste. Plates with works of art illustrating highbrow, middlebrow, and lowbrow taste at given times between 1850 and 1950. Brief bibliography, pp. 355-56.

NEOCLASSICISM

1355 Benoit, François. **L'art français sous la révolution et l'empire.** Paris, L.-H. May, 1897. 458p. illus. index. Reprint: Geneva, Slatkine-Megariotis, 1975.
History of French painting, sculpture, and architecture from the beginning of the French Revolution to the end of the Empire (1789-1815). Part 1 deals with influences of theory, of traditional art, and of the government and public. Part 2 treats artists both as a class and as individual masters. Classified bibliography of books, mostly French (pp. 441-46).

1356 Dreyfous, Maurice. **Les arts et les artistes pendant la période révolutionnaire (1789-1795.** Paris, Paclot, 1906. 471p. illus.
Comprehensive history of the visual and performing arts in France during the Revolution. Contents: I, Le vandalisme révolutionnaire; II, Les foundations artistiques; III, Les travaux et les projets artistiques; IV, Les arts plastiques; V, Les arts du théatre; VI, La musique révolutionnaire; VII, L'art des corteges. Bibliography of books and periodical articles (pp. 467-71).

1357 Francastel, Pierre. **Le style empire.** Paris, Larousse, 1944. 104p. illus. index.
In the series, "Arts, Styles et Techniques." Concise history of French art and architecture of the Empire style. Includes chapter on applied and decorative arts and the role of foreigners in French Empire style. Bibliography (pp. 99-100) lists basic works in French.

1358 Hautecoeur, Louis. **L'art sous la révolution et l'empire en France, 1789-1815.** Paris, Le Prat, 1953. 130p. illus.
Pictorial survey of art, architecture, and applied arts in France from 1789 to 1815. No bibliography.

1359 Honour, Hugh. **Neo-classicism.** Harmondsworth, Penguin, 1968. 221p. illus. index. LC 71-384062.
In the series, "Style and Civilization." History of Neoclassical art and architecture in Europe, with special reference to the general cultural context of the style. Bibliographical footnotes and critically annotated bibliography of basic works (pp. 209-212).

1360 Irwin, David. **English Neoclassical Art: Studies in Inspiration and Taste.** London, Faber, 1966. 230p. illus. index. LC 68-10513.
History of British art, exclusive of architecture, in the Neoclassical style. Contents: Introduction; II, The Antique: Leaders of Taste; III, The Antique: A Fashionable Phase or Imagination Supreme; IV, The Gothic Muse; V, 'Sublime' and 'Wicked' in Renaissance and Baroque Art; VI, Poetry and Further Romantic Tendencies; VII, The Contemporary Scene; VIII, Conclusion. Good bibliography of books and periodical articles and including source material (pp. 171-212).

1361 Landsberger, Franz. **Die Kunst der Goethezeit: Kunst und Kunstanschauung von 1750 bis 1830.** Leipzig, Insel-Verlag, 1931. 319p. illus. index.
History of Realism, Neoclassicism, and Romanticism, with their antecedents in Germany from 1750 to about 1830. Arranged by chronological periods and treating painting, sculpture, and architecture. Good classified bibliography (pp. 304-15) and a name index.

1362 Pariset, François G. **L'art néo-classique.** Paris, Presses Universitaires de France, 1974. 184p. illus. index. LC 74-178185.
Concise history of art and architecture in Europe from 1780 to 1820. Contents: I, L'Italie jusque vers 1800; II, Le néo-classicisme Anglo-Saxon jusque vers 1780; III, La France; IV, L'Italie néo-classique aprés 1800; V, Le néo-classicisme anglais; VI, L'Europe centrale; VII, Le néo-classicisme slave. Bibliography (pp. 180-84) provides a good classified list of books in all languages. In the series, "Les neuf muses."

1363 Pauli, Gustav. **Die Kunst des Klassizismus und des Romantik.** Berlin, Propyläen, 1925. 527p. illus. index. (Propyläen Kunstgeschichte, XIV).

Comprehensive illustrated handbook of European Neoclassical and Romantic art and architecture. Introductory essay sketches the development of the various media and is followed by a good corpus of plates with descriptive notes. No bibliography. Superseded by the new Propyläen series (1338).

1364 Praz, Mario. **On Neoclassicism.** London, Thames and Hudson, 1969. 400p. illus. index. LC 70-386455.

First published as *Gusto neoclassico* (Florence, Sansoni, 1940). Translation of the second revised edition (1959). Important, scholarly, and controversial analysis of neoclassical art and architecture. Chapters treat major literary and artistic figures, national manifestations of neoclassicism and major works of art and architecture. Extensive bibliography in the notes.

1365 Pückler-Limpurg, Siegfried L. J. **Der Klassizismus in der deutschen Kunst.** Munich, Heimatbucher-Verlag, 1929. 261p. illus. index.

History of Neoclassicism in the art and architecture of German-speaking countries. Includes the applied and decorative arts. Bibliographical footnotes.

1366 Rosenblum, Robert. **Transformations in Late Eighteenth Century Art.** Princeton, Princeton University Press, 1967. 203p. illus. index. LC 66-21841.

Scholarly examination of the development of Neoclassical art and architecture in Europe. Contents: I, Neoclassicism: Some Problems of Definition; II, The Exemplum Virtutis; III, Aspects of Neoclassic Architecture; IV, Toward the Tabula Rasa. Extensive bibliographical footnotes. A major work on the development of early Neoclassicism.

1367 Sydow, Eckart von. **Die Kultur des deutschen Klassizismus. Leben/Kunst/Weltanschauung.** Berlin, Grote, 1926. 264p. illus. index.

Comprehensive history and analysis of Classicism in Germany, with particular emphasis on art and architecture. First chapter summarizes the political background, the second describes the general cultural life, the third provides an expansive examination of Neoclassical art and architecture, and the fourth presents an influential analysis of "die klassizistische Weltauffassung." Bibliography (pp. 262-64) lists books in German. The standard work on German Neoclassicism.

ROMANTICISM

1368 Brion, Marcel. **Art of the Romantic Era: Romanticism, Classicism, Realism.** New York, Praeger, 1966. 285p. illus. index. LC 65-20070.

Concise history of art and architecture in Europe and the United States during the period 1750-1850 (American art and architecture to circa 1900). Good selection of illustrations. Bibliography (pp. 267-68) lists major books in all languages.

1369 Brion, Marcel. **Romantic Art.** New York, McGraw-Hill, 1960. 239p. illus. index. LC 60-12761.

Pictorial history of Romantic art and architecture in Western Europe and the United States. Architecture and sculpture are treated in a brief chapter; the rest of the book consists of essays and notes, with plates of Romantic painting in the various countries. No bibliography.

1370 Clay, Jean. **Romanticism.** New York, Vendome Press, 1981. 320p. illus. index. LC 81-7555.

Richly illustrated survey of European Romanticism with emphasis on painting. Reference to basic works in the notes.

1371 Hautecoeur, Louis, et al. **Le romantisme et l'art.** Paris, Laurens, 1928. 320p. illus.
Collection of essays on various aspects of French Romantic art and literature. Contents: Les origines du romantisme (Louis Hautecoeur); La sculpture romantique (Paul Vitry); Le romantisme et le moyen age (Marcel Aubert); Gros-Géricault (Robert Rey); Delacroix (Paul Jamot); Les manuscrits d'Eugene Delacroix (André Joubin); Chassériau ou les deux romantismes (Henri Focillion); Le paysage romantique (René Schneider); Les peintres romantiques et la peinture étrangére (M. Rouches); La gravure romantique (Léon Rosenthal); L'orient romantique (René Lanson); Berlioz et le romantisme (Adolphe Boschot); and Le livre, l'illustration et la relieure a l'époque romantique (Henri Girard). Bibliographical footnotes.

1372 Honour, Hugh. **Romanticism.** New York, Harper & Row, 1979. 415p. illus. index. LC 78-2146.
Important history of Romantic painting and sculpture. Contents: For Lack of a Better Name; The Morality of Landscape; Frozen Music; The Last Enchantments of the Middle Age; The Sense of the Past; The Cause of Liberty; The Artist's Life; The Mysterious Way; Epilogue. Excellent annotated bibliography (pp. 366-71) and additional bibliographical references in the notes.

1373 Husarski, Vaslav. **Le style romantique.** Paris, Éditions du Trianon, 1931. 145p. illus. index.
Concise history of European art and architecture in the period of Romanticism. No bibliography.

1374 La Bris, Michel. **Romantics and Romanticism.** New York, Rizzoli, 1981. 215p. illus. index. LC 80-54677.
Popular, richly illustrated survey of European Romantic art with emphasis on painting. No bibliography.

1375 Newton, Eric. **The Romantic Rebellion.** New York, St. Martin's, 1962. 224p. illus. index. Reprint: New York, Schocken, 1964. LC 63-9417.
Examination of the history of Romanticism, with particular emphasis on the visual arts. Contents: I, Romanticism in the Visual Arts; 2, Central and Centrifugal; 3, Distance and Direction; 4, Romantic States of Mind; 5, Romanticism of Mystery—Pre-Nineteenth Century Romantics; 6, Romanticism of Mystery, the Nineteenth Century; 7, The Pre-Raphaelite Brotherhood; 8, The Romanticism of the Abnormal; 9, Conflict; 10, Romanticism in the Twentieth Century—Picasso; 11, Romanticism in the Twentieth Century—Paul Klee; Conclusion. No bibliography.

1376 Ráfols, José F. **El arte romántico en España.** Barcelona, Juventud, 1954. 284p. illus. index.
Comprehensive history of Spanish Romantic art and architecture, with chapter on the literary background. Brief biographies of major personalities (pp. 245-80).

1377 Réau, Louis. **L'art romantique.** Paris, Garnier, 1930. 228p. illus.
General history of the painting and sculpture of the Romantic movement, mostly in France, which concentrates on individual masters and some general phenomena like landscape and the decorative arts. General, classified bibliography of mostly French books (pp. 220-23).

1378 Réau, Louis. **L'ére romantique: Les arts plastiques.** Paris, Michel, 1949. 301p. illus. index.
Written in conjunction with two other volumes (by other authors) treating the literature and music of the Romantic movement. Contents: Introduction; part I, Preromanticism in northern and southern Europe; part II, Romanticism in France—painting, sculpture, architecture and decorative arts; part III, Romanticism in England, the United States, Germany, Latin countries, Scandinavia, and Slavic countries; Epilogue, Postromanticism. Classified bibliography (pp. 277-87) and index of artists.

1379 Vaughan, William. **Romanticism.** New York, Oxford University Press, 1978. 288p. illus. index.
 Series: "World of Art Library." Comprehensive history of European art and architecture in the Romantic style, with emphasis on the general cultural context. Contents: I, Attitudes and Ambiguities; 2, Hope and Fear; 3, The Heroic Era; 4, The Medieval Revival; 5, Transcendent Landscapes; 6, "Natural peinture"; 7, Sensation; 8, Romanticizing the World. Brief list of sources and bibliography of basic books, chiefly in English (pp. 281-82).

REALISM

1380 Needham, Gerald. **19th Century Realist Art.** New York, Harper & Row, 1988. 350p. illus. index. LC 86-46092.
 History of the tradition of realism in Western European and American painting, graphic arts, and photography during the nineteenth century. Contents: The Dilemmas of Realism; The Origins of Realism; The Desire to Record the World, 1830-1850; The Situation of Art in 1848; The First Generation of Realist Painters; Realism throughout Europe; Changing Ideas and the Early Work of Manet; Impressionism; The End of Realism. Classified and annotated bibliography, pp. 334-39.

1381 Nochlin, Linda. **Realism.** Baltimore, Penguin, 1971. 283p. illus. index.
 Study of Realist art and architecture of the nineteenth century. Emphasis is on the relationship of Realism to contemporary culture and the nature of Realist style rather than its historical development. Provides a good annotated bibliography (pp. 271-74) that lists books and periodical articles in all languages.

1382 Waldmann, Emil. **Die Kunst des Realismus und des Impressionismus im 19. Jahrhundert.** Berlin, Propyläen, 1927. 652p. illus. index. (Propyläen Kunstgeschichte, 15).
 Comprehensive, illustrated handbook of European painting, sculpture, and graphic arts in the second half of the nineteenth century. Introductory essay outlines the development of Realism and Impressionism and is followed by a good corpus of plates with descriptive notes. No bibliography. Superseded by new Propyläen series (1338), but Waldmann's text is still a valuable introduction.

IMPRESSIONISM, POST-IMPRESSIONISM, AND NEO-IMPRESSIONISM

1383 Bowness, Alan, ed. **Impressionists and Post-Impressionists.** New York, Franklin Watts, 1965. 296p. illus. index. LC 65-10269.
 Pictorial history of painting and sculpture in Europe and America in the second half of the nineteenth century, with an emphasis on the Impressionist and Post-Impressionist phases. The brief introduction, which sketches the chief characteristics of the period, is followed by a substantial section devoted to artists' biographies. The work concludes with a succinct historical sketch of the development of late nineteenth-century art. Well illustrated, with portraits of most of the artists discussed. Brief and inadequate bibliographies at the end of the introduction and in some of the biographies. Although it is awkwardly arranged, its numerous illustrations and its responsible (if too brief) text make it a useful survey for the general reader and the beginning student.

1384 Clay, Jean. **De l'impressionisme à l'art moderne.** Paris, Hachette Réalités, 1975. 318p. index. illus. LC 76-478369.
 History of painting and sculpture from Impressionism to the present. Contents: Avant-Propos; Les signes et les hommes; I, La couleur; II, La deformation; III, L'objet pulvérisé; IV, La frontalité; V, L'objet réel; VI, Le mouvement. No bibliography.

1385 Courthion, Pierre. **Impressionism**. New York, Abrams, 1983. 160p. illus. index. LC 83-9939.
 Survey of French Impressionism. Introduction tracing the history of Impressionism is followed by plates of major work with descriptive captions. Bibliography (pp. 156-57) is an unclassified list of basic books.

1386 Hamann, Richard, and Jost Hermand. **Impressionismus**. Berlin, Akademie-Verlag, 1960. 414p. illus. index. (Deutsche Kunst und Kultur von der Gründerzeit bis zum Expressionism, Band III). LC 61-40068.
 Comprehensive history of German art and architecture during the last decade of the nineteenth and first decade of the twentieth centuries, with emphasis on the general cultural context. Brief bibliographical note (p. 406). Together with other volumes in the series, it forms a good history of German art for the period 1870 to 1930.

1387 Hamann, Richard, and Jost Hermand. **Naturalismus**. Berlin, Akademie-Verlag, 1959. 336p. illus. index. (Deutsche Kunst und Kultur von der Gründerzeit bis zum Expressionismus, Band II). LC 60-2589.
 Comprehensive history and analysis of German art and architecture in the 1880s with an emphasis on the general cultural context. Excellent chapter on Naturalism as a stylistic principle in nineteenth century art history. Brief bibliographial note (p. 330). Together with other volumes in the series, it forms a good history of German art for the period 1870 to 1930.

1388 Leymarie, Jean. **Impressionism**. Cleveland, World; Geneva, Skira, 1955. 2v. illus. index. LC 55-7701.
 Survey history of French Impressionist painting. Handsomely illustrated. The bibliography in volume 1 (pp. 127-29) lists books and periodical articles in all languages.

1389 Lucie-Smith, Edward. **Symbolist Art**. New York, Praeger, 1972. 216p. illus. index. LC 72-77068.
 Concise history of Symbolist art since its origin in the Symbolist movement of the late nineteenth century through its heirs in the twentieth century. Illustrated in black and white, with some color plates. Brief bibliography (p. 209). For the general reader and the beginning student, a good survey of the subject.

1390 Mathey, François. **The Impressionists**. New York, Praeger, 1961. 289p. illus. index. LC 61-5759.
 Pictorial survey of French Impressionist painting. Good selection of illustrations.

1391 Pool, Phoebe. **Impressionism**. New York, Praeger, 1967. 282p. illus. index. LC 67-25263.
 Concise history of Impressionistic painting in Europe and America. Good selection of plates. Bibliography (pp. 270-72) lists major books in all languages. For the general reader.

1392 Rewald, John. **The History of Impressionism**. 4th ed. Greenwich, Conn., New York Graphic Society, 1973. 672p. illus. index. LC 68-17468.
 Comprehensive history of French Impressionist painting. Thoroughly illustrated and provided with a useful chronological table of events and an excellent annotated bibliography (pp. 608-52) of books and periodical articles in all languages. A standard history of impressionism.

1393 Rewald, John. **Post-Impressionism, from Van Gogh to Gauguin**. New York, Museum of Modern Art, 1956. 614p. illus. index. LC 56-14105.
 History of French Post-Impressionist painting from 1886 to 1893. Well illustrated; the good bibliography (pp. 551-95) lists books and periodical articles in all languages. A standard history of the early phase of Post-Impressionism in France.

20th Century

GENERAL WORKS

1394 Argan, Giulio C., ed. **Die Kunst des 20. Jahrhunderts 1880-1940.** Berlin, Propyläen, 1977. 420p. text, 400 plates. index. (Propyläen Kunstgeschichte, XII).
Comprehensive illustrated handbook of the art and architecture of Europe and America from 1880 to 1940. Introductory essays by various scholars are followed by excellent corpus of plates, with descriptive notes provided with good bibliographies of specialized literature. Chronological table, and classified bibliography of basic works (pp. 415-19).

1395 Batterberry, Michael. **Twentieth Century Art.** New York, McGraw-Hill, 1969. 191p. illus. index. LC 70-76821.
A pictorial survey of modern painting and sculpture beginning with Matisse and Les Fauves and ending with the New York School of the 1950s. No bibliography.

1396 Carroll, Donald, and Edward Lucie-Smith. **Movements in Modern Art.** New York, Horizon Press, 1973. 208p. illus. index. LC 73-77640.
History of the art and architecture of Europe and America in the twentieth century. Text takes the form of a conversation between the two authors. Contents: I, Cubism/Futurism; II, Surrealism/Dadaism; III, The Rise of Abstract Art; IV, Abstract Expressionism; V, Pop Art; and VI, The Contemporary Avant-Garde. No bibliography.

1397 Cirlot, Juan E. **Arte de siglo XX.** Barcelona, Labor, 1972. 2v. illus. index. LC 72-334275.
Concise survey of European art and architecture during the twentieth century, with emphasis on Spain. Volume one covers architecture and sculpture; volume two, painting. Bibliography of general books (volume 2, p. 645).

1398 Delevoy, Robert L. **Dimensions of the 20th Century: 1900-1945.** Geneva, Skira, 1965. 223p. illus. index. LC 65-24417.
A conceptually treated survey of modern art, demonstrated by examples of painting, sculpture, and architecture. Exceptionally good tipped-in color plates. Indexed by names of artists. Includes a general bibliography (pp. 215-16).

1399 Einstein, Carl. **Die Kunst des 20. Jahrhunderts.** 3d̄ ed. Berlin, Propyläen, 1951. 575p. illus. index.
Illustrated handbook of painting and sculpture during the first half of the twentieth century. Excellent collection of plates, brief text, and informative notes to the plates. No bibliography. Even with the new "Propyläen Kunstgeschichte" volume covering the twentieth century (1394), this is still a useful handbook for beginning and advanced students.

1400 Grohmann, Will. **Bildende Kunst und Architektur.** Berlin, Suhrkamp, 1953. 551p. illus. index. (Zwischen den Beiden Kriegen, Dritter Band).
Comprehensive history of European and American art and architecture between the two world wars. Provides a useful chronological table of events from 1890 to 1950 and a good classified bibliography (pp. 521-26) of books and periodical articles. A good history of art and architecture of the 1920s and 1930s for the advanced student.

1401 Haack, Friedrich. **Die Kunst des XX. Jahrhunderts und der Gegenwart.** 6th ed. Esslingen, Neff, 1922-1925. 2v. illus.
Comprehensive history of European art and architecture of the nineteenth and early twentieth centuries. First published in 1905, it was one of the first attempts to trace systematically the stylistic development of nineteenth-century art and architecture. Despite its age, it should be known by the advanced student.

1402 Heise, Carl G., ed. **Die Kunst des 20. Jahrhunderts.** Munich, Piper, 1957. 3v. illus. LC 57-38885 rev.
Comprehensive history of art, architecture, and the applied arts from 1900 to 1950. Contents: Band 1, *Malerei*, by H. Platte; Band 2, *Plastik*, by H. Platte; Band 3, *Bau, Raum, Gerät*, by W. Fischer. Bibliography (volume 3, pp. 287-88) is chiefly a list of German books.

1403 Hunter, Sam, and John Jacobus. **Modern Art; From Post-Impressionism to the Present: Painting, Sculpture, Architecture.** New York, Abrams, 1977. 400p. illus. index. Rev. ed. 1985. LC 84-24198.
Survey history of European and American art and architecture from the late nineteenth century to the present. Good, classified bibliography of books in English (pp. 397-99).

1404 Langui, Emile. **50 Years of Modern Art.** New York, Praeger, 1959. 335p. illus. LC 59-7300.
Illustrated survey of painting and sculpture from Fauvism to non-representational art. Good collection of illustrations and useful section of artists' biographies. No bibliography.

1405 Lucie-Smith, Edward. **Art Now: From Abstract Expressionism to Superrealism.** New York, Morrow, 1977. 504p. illus. index. LC 77-76724.
Comprehensive, well-illustrated history of American and European art, exclusive of architecture, from the 1930s to the present. Contents: Birth of Modernism; Abstract Expressionism; Postwar Europe; Assemblage and Neo-Dadaism; Pop Art in America; Pop Art as an International Style; Op Art and Kinetic Art; Post-Painterly Abstraction; Sculpture in the Post-war Period; Happenings and Environments; Earth Art and Concept Art; Superrealism. The bibliography (p. 501) lists books in English.

1406 Lynton, Norbert. **The Story of Modern Art.** Ithaca, N.Y., Cornell University Press, 1980. 382p. illus. index. LC 80-67606.
General survey of twentieth-century painting and sculpture in Europe and America directed to students in art schools and the general reader. Classified bibliography of basic works (pp. 377-78) and additional bibliography in the biographical notes.

1407 Richardson, Tony, and Nikos Stangos, eds. **Concepts of Modern Art.** Rev. and enl. ed. New York, Harper & Row, 1981. 384p. LC 80-8704.
Concise history of modern art, exclusive of architecture, from 1900 to the present. Consists of essays by specialists on the various "isms" of modern art, beginning with Fauvism and ending with minimal art. Provides a good classified bibliography of major literature in all languages.

1408 Rowland, Kurt. **A History of the Modern Movement: Art, Architecture, Design.** New York, Van Nostrand-Reinhold, 1973. 240p. illus. index. LC 73-7117.
Contents: Arts & Crafts; The New Art; The New World; The Periphery; Expressions; The New Reality; Art and Industry; The Machine; Anti-Art; The Machine (2); The New Style; The New Society; The New Education. No bibliography.

1409 Schug, Albert. **Art of the Twentieth Century.** New York, Abrams, 1972. 264p. illus. index.
Concise history of twentieth-century European and American painting, sculpture, architecture, and graphic arts, arranged according to movements. Illustrated with black and white and color plates. Includes a chronological table of the arts, political history, and science and technology. There is a general bibliography (pp. 258-60), which is heavily European in the citations.

1410 Selz, Peter. **Art in Our Times: A Pictorial History 1890-1980.** New York, Abrams, 1981. 590p. illus. index. LC 80-15710.
Well-illustrated history of art and architecture in the West from Art Nouveau to 1980. Designed as a textbook. Good, classified bibliography, pp. 559-65.

1411 Sylvester, David, ed. **Modern Art, from Fauvism to Abstract Expressionism.** New York, Franklin Watts, 1965. 296p. illus. index. LC 65-10270.
Survey history of modern painting, drawing, graphic art, and sculpture, from Matisse to the abstract Expressionists. Following a succinct introduction, a biographical section treats the lives and works of important modern artists, with brief literature citations. Illustrated with color and black and white plates.

1412 Thomas, Karin. **Bis Heute: Stilgeschichte der bildenden Kunst im 20. Jahrhundert.** 3d ed. Cologne, DuMont-Schauberg, 1975. 384p. illus. index. LC 76-457921.
Survey of art, exclusive of architecture, in Western Europe and America from 1885 to 1971. Chapters are devoted to the major styles: Expressionism, Cubism, Dada, Surrealism, Abstract. Concluding chapter treats trends since mid-century. Selected bibliography of books in German (pp. 374-75).

AFRICA

1413 Beier, Ulli. **Contemporary Art in Africa.** New York, Praeger, 1968. 173p. illus. index. LC 68-19432.
Survey of mid-century painting and sculpture in black Africa, with an emphasis on West African artists. Well illustrated. No bibliography.

AUSTRIA

1414 Feuerstein, Günther, et al. **Moderne Kunst in Österreich.** Vienna, Forum, 1965. 119p (text); 114p. (illus.). index.
History of art and architecture in Austria from 1918 to 1964. Consists of essays on the development of the various media. Well illustrated. The good bibliography (pp. 120-23) lists books and periodical articles.

CHINA

1415 Sullivan, Michael. **Chinese Art in the Twentieth Century.** Berkeley and Los Angeles, University of California Press, 1959. 110p. illus. index.
History of Chinese art, exclusive of architecture, from 1912 to 1950. Provides a good selection of plates, a biographical index of modern Chinese artists, and a bibliography (p. 98), which lists books and periodicals in Chinese and Western languages. A good survey of modern Chinese art.

CZECHOSLOVAKIA

1416 Nebeskýi, Václav. **L'art moderne tschécoslovaque.** Paris, Alcan, 1937. 186p. illus.
Illustrated survey of painting and sculpture in Czechoslovakia from 1905 to 1933. Chapters concentrate on major personalities. No bibliography.

GERMANY

1417 Feist, Peter H. **Geschichte der deutschen Kunst 1848-1890.** Leipzig, Seemann, 1987. 490p. illus. index. ISBN 3363000502.
Comprehensive history of German art and architecture between 1848 and 1890 written from the standpoint of the official Marxism of the German Democratic Republic. Good, classified bibliography of books and periodical articles, pp. 415-48.

1418 Haftmann, Werner, et al. **German Art of the Twentieth Century.** New York, Museum of Modern Art, 1957. 240p. illus. index. Reprint: New York, Arno Press, 1972. LC 78-169303.
History of painting, sculpture, and the graphic arts in German-speaking countries during the twentieth century. Good bibliography (pp. 227-35) by Nancy Riegen lists books, catalogs, and periodical articles.

1419 Roh, Franz. **German Art in the 20th Century.** Greenwich, Conn., New York Graphic Society, 1968. 516p. illus. index. LC 12367.
Comprehensive history of art and architecture in Germany from Jugendstil to the present. Additional chapters on developments since 1955 have been written by Juliane Roh. Good selection of plates. No bibliography.

1420 Thoene, Peter. **Modern German Art.** Harmondsworth, Penguin, 1938. 108p. illus.
Survey history of German painting and sculpture from Impressionism through the abstract styles of the 1930s. No bibliography. An older survey, still valuable for the advanced student because of its comments on the state of German modern art at the time of the Nazi campaign on "degenerate" art.

GREAT BRITAIN

1421 Knowles, Roderic, ed. **Contemporary Irish Art.** Dublin, Wolfhound Press, 1982. 232p. illus. index. LC 83-142344.
Collection of essays on Irish artists (excluding architects) active in the 1970s. The essays are critical rather than historical in focus. Directory of contemporary artists (pp. 216-29) provides bibliographical references together with biographical data.

1422 Read, Herbert. **Contemporary British Art.** Harmondsworth, Penguin, 1957. 46p. text, 64 plates.
Concise survey of painting and sculpture in Britain during the 1940s and 1950s by a major critic. List of books (pp. 45-46).

1423 Rothenstein, John K. M. **British Art Since 1900, an Anthology.** London, Phaidon, 1962. 181p. illus. LC 62-51567.
Pictorial survey of painting and sculpture in Britain from 1900 to 1955. Brief introductory essay and biographical notes to the plates. No bibliography.

1424 Spalding, Frances. **British Art Since 1900.** London, Thames and Hudson, 1986. 252p. illus. index. LC 87-9782.
Survey history of art with the exception of architecture in Britain from Post-Impressionism to Post-Modernism. Emphasis is on painting. Classified bibliography, pp. 240-45.

HUNGARY

1425 Németh, Lajos. **Modern Art in Hungary.** Budapest, Corvina, 1969. 187p. illus. LC 72-9780.
Concise survey of painting, sculpture, and the graphic arts in Hungary from 1900 to 1965. Bibliography (pp. 171-72) lists books and periodical articles in all languages.

JAPAN

1426 Kung, D. **The Contemporary Artist in Japan.** Honolulu, East-West Center Press, 1966. 187p. illus. LC 66-31499.
Survey of Japanese painting and sculpture since the last war. Introduction on the development of modern Japanese art is followed by biographies of leading artists. No bibliography.

MEXICO

1427 Schmeckebier, Laurence E. **Modern Mexican Art.** Westport, Conn., Greenwood Press, 1971. 191p. illus. index. LC 70-141418.
Reprint of 1939 edition. Survey history of painting and sculpture in Mexico during the first three decades of the twentieth century. Poor illustrations. Provides a section of artists' biographies and a brief selected bibliography (pp. 181-83).

NETHERLANDS

1428 Kersten, Wim. **Moderne Kunst in Nederland.** Amsterdam, de Bussy, 1969. 140p. illus. index. LC 76-485611.
Survey of modern art and architecture in the Netherlands from the early twentieth century to the present. No bibliography.

1429 Loosjes-Terpstra, Aleide B. **Moderne Kunst in Nederland, 1900-1914.** Utrecht, Dekker & Gambert, 1959. 352p. illus. index. (Orbis Artium, Utrechtse Kunsthistorische Studiën, 3). LC 61-34142.
Comprehensive study of art and architecture in the Netherlands from 1900 to 1914. Bibliographical footnotes. A good study.

PORTUGAL

1430 França, José-Augusto. **A Arte em Portugal no sécolo XX.** 2d ed. Lisbon, Livraria Bertrand, Sarl, 1986. 661p. illus. index. LC 86-169368.
Comprehensive history of painting, sculpture, and the graphic arts in Portugal from 1911 to 1961. Detailed chronological table and extensive bibliographical footnotes.

RUSSIA

1431 Gassner, Hubertus, and Eckart Gillen, eds. **Zwischen Revolutionskunst und sozialistischen Realismus.** Cologne, DuMont, 1979. 560p. illus. index. LC 80-470226.
Comprehensive study of the debate over art in the Soviet Union between 1917 and 1934. Numerous excerpts from documents. Bibliography (pp. 513-46) contains biographies of major personalities with references to the specialized literature.

SWITZERLAND

1432 Lüthy, Hans, and Hans-Jörg Heusser. **Kunst in der Schweiz 1890-1980.** Zurich, Füssli, 1983. 295p. LC 84-109632.
 History of art and architecture in Switzerland from 1890 to 1980. Divided into two parts: 1890-1945 by H. Lüthy; 1945-1980 by H. Heusser. Bibliographical footnotes.

UNITED STATES

1433 Baur, John I. H. **Revolution and Tradition in Modern American Art.** Cambridge, Mass., Harvard University Press, 1958. 170p. illus. index.
 Survey of painting and sculpture in the United States during the first half of the twentieth century. The introductory chapter, which traces the main outlines of the development of modern American art, is followed by chapters investigating the various movements. Concluding chapters discuss the position of the artist in modern society and attempt to characterize what is American in contemporary art. Bibliographical references in the footnotes. A standard study of modern American art.

1434 Goodrich, Lloyd, and John I. H. Baur. **American Art of Our Century.** New York, Praeger, 1961. 309p. illus. index.
 Concise history of painting and sculpture in the United States from 1900 to 1960. Consists of short essays on the major phases. Designed as a guide to the collections in the Whitney Museum of American Art; thus, all examples illustrated are from that collection. Provides a catalog of the Whitney Collection and a list of the exhibitions and books published by the Museum.

1435 Hunter, Sam. **American Art of the 20th Century.** New York, Abrams, 1972. 487p. illus. index. LC 72-3634.
 Comprehensive history of American painting and sculpture of the twentieth century. Copiously illustrated with black and white and color illustrations. The excellent classified bibliography (pp. 437-70) is in two sections: literature to 1959, by Bernard Karpel; and literature since 1959, by Roberta Smith and Nicole Metzner. A standard history suitable for all levels.

1436 Rose, Barbara. **American Art Since 1900: A Critical History.** 2d ed. New York, Praeger, 1975. 320p. illus. index. LC 72-83563.
 This concise history of modern American art centers on painting but includes a chapter each for sculpture and architecture. Illustrated in black and white, with some color plates. General bibliography (pp. 289-92) is supplemented by the notes to the text.

1437 Sandler, Irving. **American Art of the 1960's.** New York, Harper & Row, 1988. 412p. illus. index. LC 87-45662.
 Comprehensive history of painting and sculpture in the United States during the 1960s. Emphasis is on developments in New York City. Third volume of the author's history of American art since 1945. First volume: *The Triumph of American Painting: A History of Abstract Expressionism* (New York, Harper & Row, 1970); second volume: *The New York School: Painters and Sculptors of the Fifties* (New York, Harper & Row, 1978). Comprehensive, classified bibliography, pp. 365-99.

ART NOUVEAU

1438 Abbate, Francesco, ed. **Art Nouveau: The Style of the 1890's.** London, Octopus, 1972. 158p. illus.
 Pictorial survey of the art and architecture of Art Nouveau. All illustrations are in color; brief popular text. Inadequate one-page bibliography.

1439 Ahlers-Hestermann, Friedrich. **Stilwende: Aufbruch der Jugend um 1900.** 2d ed. Berlin, Mann, 1956. 116p. illus. LC 57-44770.
History of Art Nouveau art and architecture throughout Europe. Contents: Einleitung; Das neunzehnte Jahrhundert; England: Art Nouveau; Deutschland: Die Münchener Gruppe; Henry van de Velde, kritische und wegweisende Stimmen; Ausbreitung der Bewegung; Buchkunst; Wien und Darmstadt: Das Folkwang-Museum, Die Schotten; Wendung zur Sachlichkeit; Traditions-und Neuform; Malerei und Plastik. No bibliography.

1440 Amaya, Mario. **Art Nouveau.** New York, Dutton, 1966. 168p. illus. index.
Brief history of Art Nouveau art and architecture in Britain, America, Spain, Belgium, Holland, France, Germany, and Austria. No bibliography.

1441 Barilli, Renato. **Art Nouveau.** London, Hamlyn, 1969. 157p. illus.
Pictorial survey of Art Nouveau art and architecture. All illustrations are in color. Popular text. No bibliography.

1442 Bouillon, Jean-Paul. **Art Nouveau 1870-1914.** New York, Rizzoli, 1985. 247p. illus. index. LC 85-42919.
Well-illustrated survey of Art Nouveau art and architecture. Bibliography (pp. 233-35) is a chronological list of basic works.

1443 Champigneulle, B. **L'art nouveau.** Paris, Somogy, 1972. 288p. illus. index.
Surveys Art Nouveau art and architecture in all countries. Poor illustrations. No bibliography.

1444 Cremona, Italo. **Il tempo dell'arte nouveau.** Florence, Vallecchi, 1964. 230p. illus. index.
Survey of Art Nouveau art and architecture throughout Europe. Provides a biographical dictionary of major Art Nouveau artists and architects, but no bibliography.

1445 Johnson, Diane Chalmers. **American Art Nouveau.** New York, Abrams, 1979. 311p. illus. index. LC 78-31815.
Well-illustrated survey of Art Nouveau art and architecture in the United States. Classified bibliography (pp. 299-304) and further bibliography in the footnotes.

1446 Lenning, Henry F. **The Art Nouveau.** The Hague, Nijhoff, 1951. 142p. illus. index.
History of Art Nouveau art and architecture in Europe, with special emphasis on Belgium. Contents: I, The Art Nouveau; II, Henry van de Velde—1; III, Henry van de Velde—2; IV, Expositions and Salons; V, Architecture; VI, Interiors and Furnishings; VII, The Art Nouveau—the Style. Bibliography (pp. 131-35) lists books and periodical articles, including source material, in all languages.

1447 Madsen, S. Tschudi. **Art Nouveau.** New York, McGraw-Hill, 1967. 256p. illus. index. LC 66-24159.
Concise history of Art Nouveau art and architecture in Europe and America. Brief bibliography (pp. 247-48) and further reference to specialized literature in the footnotes.

1448 Masini, Larra-Vinca. **Art Nouveau.** London, Thames and Hudson, 1984. 414p. illus. index. LC 86-136033.
Well-illustrated survey of Art Nouveau art and architecture in Europe and America. Introductory chapters discussing the precedents and characteristics of Art Nouveau are followed by chapters on individual countries. Biographies of major artists. Bibliography is most useful for list of contemporary publications.

1449 Rheims, Maurice. **The Age of Art Nouveau.** London, Thames and Hudson, 1966. 450p. illus. index. LC 66-66903.
 First published as *L'art 1900* (Paris, 1965). Well-illustrated history of art and architecture in the Art Nouveau style throughout Europe.

1450 Schmutzler, Robert. **Art Nouveau.** New York, Abrams, 1964. 322p. illus. index. LC 64-10765. Abridged edition, 1978. 224p. LC 78-8781.
 Comprehensive history of Art Nouveau art and architecture. Traces the origin of the style to proto-Art Nouveau art of the earlier nineteenth century and its development to late Art Nouveau of the 1920s. Good selection of plates, and excellent bibliography (pp. 299-307), which lists books and periodical articles in all languages. There are special sections on literary sources. A standard history of Art Nouveau.

1451 Seling, Helmut. **Jugendstil: Der Weg ins 20. Jahrhundert.** Heidelberg, Keyser, 1959. 459p. illus. index.
 Comprehensive history of Art Nouveau art and architecture, consisting of essays by German specialists on the development of the various arts. Good coverage of the minor arts. Good bibliographies at the end of each chapter. Also provides a useful dictionary of artists' biographies. A standard work for the advanced student.

1452 Selz, Peter. **Art Nouveau: Art and Design at the Turn of the Century.** New York, Doubleday, 1960. 192p. illus. index. LC 60-11987.
 Survey of Art Nouveau art and architecture, consisting of a group of essays by various specialists. Designed to accompany an exhibition formed by the Museum of Modern Art in New York. Provides an excellent bibliography (pp. 152-61), compiled by James Grady.

1453 Sterner, Gabrielle. **Art Nouveau.** Woodbury, N.Y., Barron's, 1979. 192p. illus. index. LC 79-17025.
 Survey of Art Nouveau art and architecture in Europe and America. Contents: Stylistic Analysis: Entrances to the Paris Métro; The Problematic Aspects of Art Nouveau: Theory and Practice Exemplified by Henry van de Velde; The Schools, Communal Workshops, and Centers of Art Nouveau; Painting and Sculpture at the Turn of the Century and Their Relationship to Art Nouveau; Art Nouveau Glass; Conclusion; The Most Important Art Nouveau Architects and Their Principal Works. Bibliography of basic books, pp. 170-73.

 See also: Grady (101), Kempton (103).

FAUVISM

1454 Crespelle, Jean-Paul. **The Fauves.** Greenwich, Conn., New York Graphic Society, 1962. 351p. illus. index.
 Illustrated survey of the painting and graphics of the Fauves. Well illustrated and provided with a bibliography (pp. 349-51) that lists books and periodical articles.

1455 Leymarie, Jean. **Fauvism, Biographical and Critical Study.** Paris, Skira, 1959. 163p. illus. index. LC 59-7255.
 Survey of the painting of the Fauves with emphasis on the major personalities. Bibliography (pp. 149-52) lists major books and periodical articles in English and French.

1456 Muller, Joseph E. **Fauvism.** New York, Praeger, 1967. 260p. illus. index.
 History of French Fauves, with emphasis on the movement's influence on such major painters as Matisse and Dufy. Well illustrated. A good survey for the general reader and the beginning student.

1457 Rewald, John. **Les Fauves.** New York, Museum of Modern Art, 1952. illus. index.
Survey of Fauvism designed to accompany an exhibition at the Museum of Modern Art in New York. Good selection of illustrations and good bibliography.

CUBISM

1458 Barr, Alfred H. **Cubism and Abstract Art.** New York, Museum of Modern Art, 1936. 250p. illus. index.
Survey of the history of Cubist painting and sculpture in Europe and America. Good selection of illustrations and good bibliography (pp. 234-49) of books and periodical articles, compiled by B. Newhall.

1459 Daix, Pierre. **Cubist and Cubism.** New York, Rizzoli, 1982. 170p. illus. index. LC 82-600070.
Survey of the development of Cubism in Western Europe and the United States from 1906 to the 1920s. Brief bibliography, p. 159.

1460 Fry, Edward. **Cubism.** New York, McGraw-Hill, 1966. 200p. illus. index.
This study consists of a history of Cubism and an extensive collection of documentary texts related to Cubism. Provides an excellent bibliography (pp. 176-83), which lists books and periodical articles in all languages, and a useful listing of Cubist exhibitions. A standard work on Cubism.

1461 Golding, John. **Cubism: A History and an Analysis.** New York, Wittenborn, 1959. 207p. illus. index. LC 59-4201.
Important, scholarly history and analysis of Cubism. Contents: The History and Chronology of Cubism; II, Picasso and Braque 1907-1912; III, Picasso, Braque and Gris, 1912-1914; IV, The Influence of Cubism in France, 1910-1914. Bibliography covers sources, books, and periodical literature. A standard work on Cubism.

1462 Green, Christopher. **Cubism and Its Enemies. Modern Movements and Reaction in French Art, 1916-1928.** New Haven, Yale University Press, 1987. 325p. illus. index. LC 87-2154.
Important history of French Cubist art during its late and final stages of development. Contents: Late Cubism in France, 1916-1928: A Narrative; Art Worlds; Cubism and the Conservative Opposition; Radical Alternatives. Extensive bibliographic footnotes.

1463 Habasque, Guy. **Cubism: Biographical and Critical Study.** Paris, Skira, 1959. 170p. illus. index.
Survey of Cubist painting in Europe. Color illustrations. Provides a good bibliography (pp. 154-57), which lists books on and sources for Cubism in all languages.

1464 Kozloff, Max. **Cubism/Futurism.** New York, Charterhouse, 1973. 243p. illus. LC 72-84221.
Study and concise history of Cubism and Futurism. Bibliography (pp. 221-22) provides a selected list of books in English.

1465 Pierre, José. **Cubism.** London, Heron, 1970. 207p. illus. LC 70-598812.
Survey of Cubism with emphasis on French Cubist painting. Bibliography (p. 204) lists major books in French and English.

1466 Rosenblum, Robert. **Cubism and Twentieth Century Art.** 3d ed. New York, Abrams, 1976. 347p. illus. index.
History and analysis of Cubism from Picasso and Braque to circa 1939. Emphasis is on painting. Provides a chronological table and a good critical bibliography (pp. 312-17). A good scholarly study of Cubism for beginning and advanced students.

1467 Schwartz, Paul W. **Cubism.** New York, Praeger, 1971. 216p. illus. index. LC 70-100034.

Survey of Cubist painting and sculpture, along with literature and theater. Brief, selected bibliography (pp. 203-204) of books in all languages.

EXPRESSIONISM

1468 Cardinal, Roger. **Expressionism.** London, Paladin, 1984. 151p. illus. index. LC 85-223253.

In the series: "Paladin Movements and Ideas." History and analysis of Expressionism in painting, the graphic arts, and literature. Contents: I, Expression and Expressionism; II, The Expressionist Project; III, The Spiritual Impulse; IV, Style and Response. Select bibliography, pp. 143-45.

1469 Cheney, Sheldon. **Expressionism in Art.** Rev. ed. New York, Boni, 1958. 415p. illus. index.

Survey of Expressionist elements in European and American art of the nineteenth and twentieth centuries. Bibliographical footnotes.

1470 Dube, Wolf D. **Expressionism.** New York, Praeger, 1973. 215p. illus. index. LC 72-79505.

Concise history of German Expressionist painting and graphic arts from their origins to the late 1920s. Provides a section (pp. 208-13) of artists' biographies, with bibliographies of major monographs. A good survey of Expressionism for the general reader and the beginning student.

1471 Kuhn, Charles L. **German Expressionism and Abstract Art: The Harvard Collections.** Cambridge, Mass., Harvard University Press, 1957. illus. index.

History of German Expressionist painting and sculpture, with emphasis on the pieces in the Harvard University Collections.

1472 Myers, Bernard S. **The German Expressionists: A Generation in Revolt.** New York, Praeger, 1957. 401p.

Survey history of German Expressionist painting and graphic arts. Good selection of illustrations. Bibliography provides a good list of major books in all languages.

1473 Willett, John. **Expressionism.** New York, McGraw-Hill, 1970. 256p. illus. index. LC 70-96434.

Survey history of Expressionist art and literature from its beginnings to 1945. Good selection of illustrations and a useful, annotated bibliography (pp. 248-52), which lists books in all languages. For the general reader and the beginning student.

CONSTRUCTIVISM AND ABSTRACTION

1474 Blok, Cor. **Geschichte der abstrakten Kunst 1900-1960.** Cologne, DuMont-Schauberg, 1975. 190p. illus. LC 76-472868.

Comprehensive handbook of American and European abstract painting and sculpture. Contents: I, Von den Anfängen bis 1944; II, Die Nachkriegszeit; III, Abstrakte Kunst in der Perspektive. Specialized literature in the notes; selected bibliography of books in all languages (pp. 177-78). Useful chronological list of styles with brief summaries. In the series, "DuMont Dokumente."

1475 Brion, Marcel. **Art Abstrait.** Paris, Albin Michel, 1956. 315p. illus.
Survey of twentieth-century abstract art in Europe and America. Bibliographical footnotes.

1476 Lodder, Christina. **Russian Constructivism.** New Haven, Yale University Press, 1983. 328p. illus. index. LC 83-40002.
Important history of Russian Constructivism with a postscript on influence in Western Europe. Appendix with biographical sketches of the major personalities; excellent classified bibliography (pp. 305-17) and further bibliography in the footnotes.

1477 Osborne, Harold. **Abstraction and Artifice in Twentieth Century Art.** Oxford, Clarendon Press, 1979. 192p. illus. index. LC 79-25009.
History of abstraction in the art of the twentieth century from 1910 to 1970. Contents: Part One: Modes of Abstraction; Part Two: Abstraction from Nature; Part Three: Constructivist Abstraction. Bibliographical references in the text and footnotes.

1478 Poensgen, Georg, and Leopold Zahn. **Abstrakte Kunst: Eine Weltsprache.** Baden-Baden, Woldemar, 1958. 224p. illus.
Survey of painting and scuplture in the abstract style throughout the world. Introductory essay on the nature and development of abstract art is followed by a series of artists' biographies, which are accompanied by excellent illustrations and short bibliographies. The bibliography (p. 125) deals with the documentary sources of abstract art in the twentieth century.

1479 Rickey, George. **Constructivism: Origins and Evolution.** New York, Braziller, 1967. 305p. illus. index. LC 67-24210.
Concise history of the Constructivist movement from its origins in the early twentieth century to movements and persons still working under Constructivist influence. Black and white illustrations. Includes a chronology of Constructivist events, a table of museum holdings of major artists, and a good classified, annotated bibliography (pp. 247-301).

1480 Vallier, Dora. **Abstract Art.** New York, Orion, 1970. 342p. illus. index. LC 75-86121.
Translated from the French *L'art abstrait* (1967). Concise history of abstract sculpture and painting, beginning with Kandinsky and including abstract art after 1945. The idea of abstraction is discussed at length in the introduction. In addition to a chronology of events, there is a good general bibliography (pp. 322-30). A straightforward and responsible work.

FUTURISM

1481 Baumgarth, Christa. **Geschichte des Futurismus.** Reinbek bei Hamburg, Rowohlt, 1966. 313p. illus. index.
Comprehensive history of Futurism, covering the period from 1905 to the influence of Futurist art in the mid-twentieth century. Covers art and architecture. Provides a collection of documents (translated into German), a section of further source material, and a good bibliography (pp. 299-306) of books and periodical articles in all languages.

1482 Carrieri, Raffaele. **Futurism.** Milan, Milione, 1963. 183p. (text); 163p. (illus.).
Concise history of Futurism in Italian art and literature. Provides a good bibliography (pp. 171-77), which lists books and periodical articles on Futurism; there is also a list of writings, manifestoes, and exhibitions of Futurism. A definitive work.

1483 Clough, Rosa T. **Futurism, the Story of a Modern Art Movement: A New Appraisal.** New York, Philosophical Library, 1961. 297p. illus. index. LC 60-15952.
Reprint of (1484), with the addition of part II: *A New Appraisal.* Updated bibliography (pp. 283-90).

1484 Clough, Rosa T. **Looking Back at Futurism.** New York, Philosophical Library, 1942. 297p. illus.
Based on dissertation at Columbia University, this is a history of Futurism. Contents: Revolt Against the Past; Literature; Painting; Sculpture; Architecture; Post-War Futurism. Bibliographical footnotes and selected works (pp. 205-207). See also (1483).

1485 Lista, Giovanni. **Futurism.** New York, Universe, 1986. 120p. illus. LC 86-40210.
Survey history of Futurism covering painting, graphic arts, literature, and theater. Bibliography, pp. 114-17.

1486 Lista, Giovanni. **Le livre futuriste de la libération du mot au poèm tactile.** Modena, Panini, 1984, 158p. illus. LC 86-40210.
Text in French and Italian. Well-illustrated survey of Futurism. Comprehensive bibliography (pp. 142-58) includes biographies of major personalities.

1487 Martin, Marianne W. **Futurist Art and Theory. 1909-1915.** Oxford, Clarendon Press, 1968. 228p. illus. index. Reprint: New York, Hacker, 1978. LC 75-44910.
History of Futurist sculpture and painting from 1909 to 1915, with special reference to the literature of Futurist theory. Appendix on Futurists' controversies. Bibliography (pp. 207-13) is an unclassified but comprehensive list of books and articles in all languages. Reprint has new introduction by the author.

1488 Rye, Jane. **Futurism.** London, Studio Vista, 1972. 159p. illus. index. LC 72-170798.
Survey of Futurist literature, art, and architecture in and outside Italy. Brief bibliography (p. 156). For the general reader.

1489 Taylor, Joshua. **Futurism.** New York, Museum of Modern Art, 1961. 153p. illus.
Survey of Futurist painting and graphics. Provides a collection of excerpts from Futurist writings and a useful chronology of events in the Futurist movement. Good bibliography (pp. 148-51).

1490 Tisdall, Caroline, and Angelo Bozzella. **Futurism.** New York, Oxford University Press, 1978. 216p. illus. index. LC 77-76819.
Comprehensive history of Futurism, covering literature, theater, and music as well as painting and sculpture. Contents: 1, The Means of Futurism; 2, The Roots of Futurism; 3, Painting and Sculpture up to 1913; 4, Literature and Theatre; 5, Futuristic Music; 6, The Futuristic City; 7, Photodynamism and Futurist Cinema; 8, Futurism and Women; 9, Lacerba; 10, Art of the War Years and After; 11, Futurism and Fascism. Brief bibliography and list of sources (p. 210).

DE STIJL

1491 Blotkamp, Carel, et al. **De beginjaren van De Stijl. 1917-1922.** Utrecht, Reflex, 1982. 295p. illus. index. LC 82-227184.
History of the early stage from 1917 to 1922 of the De Stijl movement, through essays on individual personalities: Theo van Doesburg, Piet Mondriaan, Vilmos Huszár, J. J. P. Oud, Bart van der Leck, Jan Wils, Robert van't Hoff, Georges Vantongerloo, Gerrit Rietveld, Bibliographical footnotes.

1492 Jaffe, Hans. **De Stijl, 1917-1931.** Amsterdam, Meulenhoff, 1956. 293p. illus.
Comprehensive history of Dutch art and architecture from 1917 to 1931. Discusses the origin, character, and influence of De Stijl. Good selection of plates and excellent bibliography (pp. 269-91). A standard work on De Stijl.

1493 Overy, Paul. **De Stijl.** New York, Dutton, 1969. 167p. illus. index.
Brief history of modern Dutch art and architecture from 1895 to 1930. Provides a short bibliography (p. 164) of books in all languages. For the general reader.

DADA AND SURREALISM

1494 Abastado, Claude. **Introduction au surréalisme.** Paris, Bordas, 1971. index. LC 72-316405. 2d ed. Paris, Bordas, 1986. 251p. illus. index. ISBN 204015778.
Concise history of many aspects of Surrealism, including the visual arts. Part one treats the causes of the Surrealist revolt; part two discusses philosophical and intellectual expressions; part three covers literature, painting, sculpture, cinema and theater; part four, "Vision du monde," thematically treats "Le moi," "L'amour," and "Le monde." Includes a good chronological table of events and creations; lists of source materials, exhibitions and revues; Surrealist films; and a concise biographical dictionary of personalities. Excellent classified bibliography (pp. 203-260).

1495 Abastado, Claude. **Le surréalisme.** Paris, Hachette, 1975. 320p. illus.
Comprehensive handbook of Surrealist art and literature. Contents: I, L'action; II, Théorie de la connaissance; III, Les oeuvres; IV, Surréalisme sans frontiéres. Bibliographical footnotes and excellent classified bibliography of sources and critical studies (pp. 269-314).

1496 Barr, Alfred H. **Fantastic Art: Dada, Surrealism.** 2d ed. New York, Museum of Modern Art, 1937. 271p. illus. index.
Collection of essays on fantastic art, Dada, and Surrealism; designed to accompany an exhibition at the Museum of Modern Art. Well illustrated and provided with a good bibliography (pp. 263-67) of books and periodical articles.

1497 Gascoyne, David. **A Short Survey of Surrealism.** London, Cass, 1970. 162p. illus. index. LC 77-571396. 2d ed. San Francisco, City Lights Books, 1982. 162p. LC 82-12898.
Brief survey of Surrealism, with a section containing translations of major works of Surrealist poetry. Poor illustrations and no bibliography.

1498 Gaunt, William. **The Surrealists.** London, Thames and Hudson, 1972. 272p. illus. index. LC 72-75027.
Survey of Surrealist painting in Europe. Well illustrated and provided with a bibliography listing major books and periodical articles in all languages.

1499 Haslam, Malcolm. **The Real World of the Surrealists.** London, Weidenfeld and Nicolson, 1977. 272p. illus. index. LC 78-102303.
Journalistic account of the lives and times of major Surrealist artists. Many contemporary photographs, together with good illustrations on major works of art and a useful chronology of Surrealist events from 1917 to 1939. One-page bibliography of basic works.

1500 Matthews, J. H. **The Imagery of Surrealism.** Syracuse, Syracuse University Press, 1982. 262p. illus. index. LC 82-10801.
Collection of essays on various aspects of Surrealistic art and literature. Contents: Surrealists' Image-Making; Grammar, Prosody, and French Surrealist Poetry; Jean-Pierre Duprey; André Breton and Joan Miró: *Constellations*; Painting, Poetry, and Surrealist's

"Underlying Ambition"; Language and Play: le cadavre exquis; Collage; The Language of Desire; The Language of Objects; The Visual Language of Film; Sound in Surrealist Cinema. Bibliographical notes.

1501 Nadeau, Maurice. **The History of Surrealism.** New York, Macmillan, 1965. 351p. illus. index. LC 65-23834.
 Translation of second edition of *Histoire du surréalism* (Paris, Éditions du Seuil, 1964). First published in 1945. Important early history of Surrealist art, including theater and literature. Contents: I, The Elaboration; II, The Heroic Period, 1923-1925; III, The Analytical Period, 1925-1930; IV, The Period of Autonomy, 1930-1939; V, Epilogue; VI, Famous Manifestos and Documents. Bibliography (pp. 319-35) lists sources and a classified list of books and periodical articles on Surrealism. Short biographical notes to the principal artists (pp. 337-43).

1502 Oesterreicher-Mollwo, Marianne. **Surrealism and Dadaism.** Oxford, Phaidon, 1979. 104p. LC 79-83785.
 General survey of Surrealism and Dadaism. Contents: The Contemporary Situation; Dadaism: Clean Slate or How Far Does Absolute Nonsense Go?; Surrealism: The Attempt at a Creative Reconciliation of Pure Subjectivity and General Consciousness; The Consequences on the International Art Scene Up to the Present Day; Irritation and Fascination – The Viewer's Reaction; Short Biographies. Bibliography of basic books, p. 4.

1503 Passeron, René. **Encyclopédie du surréalisme.** New ed. Paris, Somogy, 1977. 288p. illus. index. LC 76-459040.
 Contents: Introduction; Les précurseurs; Les surréalistes; Index conceptuel et technique; Les groupes; Les revues; Les expositions. Dictionary arrangement followed in each section. Bibliography (pp. 274-76) is an unclassified list of books and articles in all languages.

1504 Picon, Gäetan. **Surrealists and Surrealism, 1919-1939.** New York, Rizzoli, 1977. 231p. illus. index. LC 76-62889. Reprint: New York, Rizzoli, 1983. LC 83-156698.
 Sumptuously illustrated history of European Surrealism from 1919 to 1939. Contents: 1, 1919, The Discovery; 2, 1920-1924, From Dada to Surrealism; 3, 1924, The Year 1; 4, 1925-1929, The Surrealist Revolution; 5, 1930, Back to First Principles; 6, 1931-1939, Dream and Revolution. Bibliography (pp. 193-206) provides a comprehensive list of books and periodical articles, including artist monographs and sources.

1505 Pierre, José. **A Dictionary of Surrealism.** London, Methuen, 1974. 168p. illus. LC 74-183172.
 Covers personalities, concepts, major works of art, and techniques of Surrealism. No bibliography.

1506 Read, Herbert. **Surrealism....** New York, Harcourt, Brace, 1936. 251p. illus.
 Survey history and conceptual study of Surrealist art. Contents: Introduction, by Herbert Read; "Limits Not Frontiers of Surrealism," by André Breton; "Surrealism at This Time and Place," by Hugh S. Davies; "Poetic Evidence," by Paul Éluard; "1870-1936," by George Hugnet. A standard collection of essays on Surrealism.

1507 Richter, Hans. **Dada: Art and Anti-Art.** New York, McGraw-Hill, 1965. 246p. illus. index. LC 65-19077.
 History of Dada in Europe and America. Divided into "schools" of Dada (Zurich Dada, New York Dada, etc.), with a chapter on Dada's influence on art since 1923. Appendix provides a translation of the Zurich Dada *Chronicle.* Good bibliography (pp. 229-37) lists works on Dada as well as literary works by major Dada figures. A standard history of Dada.

1508 Rubin, William S. **Dada and Surrealist Art.** New York, Abrams, [1968]. 525p. illus. index. LC 68-13064.

Comprehensive history of Dada and Surrealist art in Europe and America. Excellent selection of plates, thorough and scholarly text. Provides a comprehensive chronology (pp. 453-72) by Irene Gordon and an excellent bibliography (pp. 492-512) listing books, periodical articles, and editions of writings by Dada and Surrealist artists and writers. A standard study.

1509 Schneede, Uwe M. **Surrealism.** New York, Abrams, 1975. 144p. illus. index. LC 74-2302.

Pictorial survey of Surrealist painting, sculpture, and film. Contents: Dada—"A Mental Attitude"; Proto-Surrealism; Breton's 1924 Manifesto; Activities and Disagreements 1924-1929; The Second Manifesto 1929; Unconscious Notation—The Principle of Metamorphosis; the Verism of the Impossible; Max Ernst the Individualist; Films; The Situation between 1930 and 1939; Surrealism in Exile; Chronology. Good classified bibliography includes monographs on artists.

1510 Verkauf, Willy, ed. **Dada: Monograph of a Movement.** New York, Wittenborn, 1957. 188p. illus. index.

Collection of essays on various aspects, phases, and media of Dada. Provides a useful bibliography (pp. 176-83) arranged by artists. A standard work on Dada.

1511 Waldberg, Patrick. **Surrealism.** Cleveland, Skira-World, 1962. 140p. illus. index. LC 62-10989.

Brief history of Surrealism. Good color plates. Select bibliography (p. 135) lists major works in all languages. Also has a useful chronological survey of events in Surrealism and a list of the major writings by Surrealist authors. For the beginning student.

See also: Edwards (98), Gershman (100).

ART DECO

1512 Arwas, Victor. **Art Deco.** New York, Abrams, 1980. 315p. illus. index. LC 80-12363.

Well-illustrated history of Art Deco art of all media excluding architecture. Biographies of major Art Deco artists and bibliography of books and exhibition catalogs, pp. 306-309.

1513 Duncan, Alistair. **American Art Deco.** New York, Abrams, 1986. 285p. illus. index. LC 86-3561.

Survey of American Art Deco architecture and art. Bibliographical footnotes.

ART IN MID-CENTURY

1514 Ashton, Dore. **American Art Since 1945.** New York, Oxford University Press, 1982. 224p. illus. index. LC 81-83435.

Survey of painting and sculpture in the United States from 1945 to 1980. No bibliography.

1515 Brion, Marcel, et al. **Art Since 1945.** New York, Washington Square Press, 1962. 336p. illus.

This survey history of modern art since 1945 comprises essays by ten specialists on painting and sculpture in the following countries: France, Spain, Italy, Yugoslavia, Poland, Germany, Austria, Switzerland, Great Britain, Holland, Scandinavia, and the United States. No bibliography and no index. A regional approach for the beginning student.

1516 Granath, Olle. **Another Light: Swedish Art Since 1945.** 2d ed. No place, The Swedish Institute, 1982. 223p. illus. index. LC 83-215886.

Survey history of art excluding architecture in Sweden between 1945 and 1980. No bibliography.

1517 Haftmann, Werner, et al. **Art Since Mid-Century: The New Internationalism.** Greenwich, Conn., New York Graphic Society, 1971. 2v. illus. index. LC 70-154332.

Collection of essays by various experts; covers the development of European and American painting and sculpture since the end of World War II. First volume covers abstract styles; second volume, figurative styles. Each volume concludes with short statements by the artists considered. No bibliography.

1518 Hunter Sam, et al. **New Art around the World: Painting and Sculpture.** New York, Abrams, 1966. 509p. illus. index. LC 66-29665.

History of painting and sculpture in the major art-generating centers around the world between 1945 and 1965. Consists of essays by various specialists on the art of the United States, Paris, Great Britain, Italy, Spain, The Netherlands, Scandinavia, Belgium, Japan, South America, Greece, Israel, Poland, Czechoslovakia, Yugoslavia, Germany, Austria, and Switzerland. No bibliography.

1519 Lucie-Smith, Edward. **American Art Now.** Oxford, Phaidon, 1985. 160p. illus. index. LC 85-23261.

Survey of painting and sculpture in the United States in the first half of the 1980s. Contents: The Old Masters; The Fate of Abstraction; New Figuration; American Expressionism; Two New York Styles; Pop Survival and Pop Revival; Neo-Surrealism; From Mock-Architecture to Mock-Science; Replication, Trompe-L'Oeil and the Mural Movement; American Realism: The Genres; Figuration and Style; Causes; Chicago and the Southeast; New Art in Texas; The West Coast. Biographical dictionary of artists. No bibliography.

1520 Lucie-Smith, Edward. **Late Modern: The Visual Arts since 1945.** New York, Praeger, 1969. 288p. illus. index. LC 74-92585.

Survey history of painting and sculpture since 1945 with sections on abstract Expressionism, the European scene, Pop Art, Op Art, kinetic art, sculpture, and environments. General reading list (p. 275).

10
NATIONAL HISTORIES AND HANDBOOKS
OF EUROPEAN ART

WESTERN EUROPE

France

TOPOGRAPHIC HANDBOOKS

1521 **Dictionnaire des églises de France.** Paris, Laffont, 1966-1971. 5v. illus. index. LC 67-73940.
Topographical guide to the art and architecture of the churches of France, Belgium, Luxembourg, and French Switzerland. Volume 1 is a history of church art and architecture in these countries with bibliographies at the end of sections and a glossary of terms at the end of the volume. Volumes two through five treat the churches (by region and place), giving attention to the art contents along with the architecture of the major buildings. Contents: volume 2, Centre et Sud-Est; volume 3, Sud-Ouest; volume 4, Ouest et Ile-de-France; volume 5, Nord et Est, Belgique, Luxembourg, Suisse. The entry for each church has a brief bibliography. Although not the in-depth coverage of an official inventory, this is still a valuable reference work for beginning and advanced students.

1522 **Guide artistique de France.** Paris, Hachette, 1968. 1240p. index. LC 68-122321.
Pocket-size guide to the art and architecture of France, including collections of major museums. Geographical arrangement. Good classified bibliography of books in French (pp. 1023-45).

1523 **Inventaire général des monuments et des richesses artistiques de la France.** Paris, Imprimerie Nationale, 1969- .
Published by the Ministère des Affaires Culturelles. Official inventory of the art and architecture in France, arranged by region. To date, the following have appeared:
Finistère: Canton Carhaix-Plouguer (2v. 1969)
Haut-Rhin: Canton Guebwiller (2v. 1972)
Landes: Canton Peyrehorade (2v. 1973)
Gard: Canton Aigues-Mortres (2v. 1973)
Morbihan: Cantons Le Faouet et Gourin (1975)
Eure: Canton Lyon-la-Forêt (1976)
Cote d'Or: Canton Sombernon (1977)

Morbihan: Canton Belle-Ile-en-Mer (1978)
Bas-Rhin: Canton de Saverne (1978)
Charente-Maritime: Canton Ile de Ré (2v. 1979)
Haut-Rhin: Canton Thann (1980)
Vauclause: Cantons Cadenet et Pertuis, Pays d'Aigues (1981)
Meuse: Canton Gondrecourt-le-Chateau (1981)
Sarthe: Canton La Ferté-Bernard (1983)
Cantal: Canton Vic-sur-Ceré (1984)

Each section is introduced with a chapter on the pertinent archival sources and a sketch of the local history and art history. The inventory of the monuments and their contents is arranged by place. For each section, a volume of plates accompanies the inventory text. Two sub-series are attached to the *Inventaire*: the first is "Répertoire des inventaires," 1970- , which is a series of bibliographies on the art and architecture of the major regions of France. To date, the following volumes have appeared: *Région Nord* (1970), *Limousin* (1970), *Languedoc-Roussillon* (1970), *Lorraine* (1973), *Poitou-Charentes* (1975), and *Auvergne* (1977), *Aquitaine* (1978), *Franche-Comté* (1978), *Bourgogne* (1979), *Haute-Normandie* (1975), *Basse-Normandie, Calvados, Marche, Orne* (1982), *Ile-de-France, Essone, Hauts-de-Seine, Seine-et-Marne, Seine-Saint-Denis, Val-de-Marne, Val-d'Oise, Yuelines* (1983). The other sub-series is "Principes d'analyse scientifique," 1971- , which consists of illustrated glossaries of the terminology used in the description of the various arts. Volumes that have appeared to date are: *Tapisserie* (1971), *Architecture* (1972; 2v.). *La sculpture: methode et vocabulaire* (1978); *Objets civils domestiques: vocabulaire* (1984). The *Inventaire* and its sub-series are intended, when complete, to replace the old and incomplete inventory. They will fill a long-standing gap in the information on art and architecture *in situ* in France. The volumes of the sub-series deserve to be better known as reference tools in their own right. The "Répertoire des inventaires" has the potential of becoming the long-needed retrospective bibliography on French art and architecture. The volumes of the "Principes d'analyse scientifique" are excellent dictionaries of art terminology.

1524 Olivier-Michel, Françoise, et al. **A Guide to the Art Treasures of France.** London, Methuen, 1966. 555p. illus. index. LC 66-74412.

Topographical guide to the art and architecture of France. Arrangement is by region, then by place. Includes art in museums as well as *in situ*. Text consists of brief descriptions accompanied by numerous small illustrations. No bibliography. Too large to be used in the field, but it can be used for quick reference to illustrations of the major works.

1525 Keller, Harald. **Die Kunstlandschaften Frankreichs.** Weisbaden, F. Steiner, 1963. 100p. illus. index. LC 64-44002.

Handbook of the regional styles of French art and architecture on the model of the same author's work on Italian art (1621). Modest selection of plates, good maps, and extensive bibliographical footnotes. For the advanced student.

1526 **Reclams Kunstführer Frankreich.** Herausgegeben von Manfred Wundram. Stuttgart, Reclam, 1967- . illus. index. LC 78-413637.

Topographical guide to the art and architecture of France, including all major works from prehistoric times to the present. The volumes that have appeared to date are: Band I, *Paris and Versailles* (rev. 1979); Band II, *Elsass* (1980); Band III, *Lothringen, Ardennen, Ostchampagne* (1983); Band IV, *Provence; Cote d'Azur; Dauphine, Rhone-Tal* (1975). Within the volumes, arrangement is by place and in the case of Paris, by city quarter. Each place is introduced by a historical sketch, followed by a thorough description of the major buildings, their art contents and decoration, sites and monuments. Major museums and their buildings and collections are also included. Modestly illustrated with plates; liberally provided with plans and diagrams. No bibliography. Designed as pocket guides for the serious tourist, the thoroughness of the Reclam guides makes them valuable reference tools.

HISTORIES

1527 **Art Treasures in France: Monuments, Masterpieces, Commissions, and Collections.** General eds., Bernard S. Myers and Trewin Copplestone. New York, McGraw-Hill, 1969. 176p. illus. index. LC 69-13326.
Pictorial survey of the architecture, painting, sculpture, and decorative and minor arts in France from prehistory to the present. Written by a variety of period specialists. Contains maps and a glossary-index of museums and monuments in France, but no bibliography.

1528 Hourticq, Louis. **Histoire générale d l'art—France.** Paris, Hachette, n.d. (1912). 476p. illus.
Survey of art and architecture in France from Gallo-Roman times to the end of the nineteenth century. No bibliography. Series: "Ars Una; Species-Mille."

1529 Laclotte, Michel. **French Art from 1350 to 1850.** New York, Franklin Watts, 1965. 249p. illus. index. LC 65-10267.
Pictorial survey of art and architecture in France from 1350 to 1850, with an emphasis on painting and sculpture. The introduction, which outlines the chief characteristics, schools, and artists of France, is followed by a substantial section devoted to artists' biographies. The work concludes with a brief historical sketch of the development of art and architecture in France. Well illustrated. Brief and inadequate bibliographies are found at the end of the introduction and in some of the biographies. It is awkwardly arranged, but its numerous illustrations and responsible, if too brief, text make it a useful survey for the general reader.

1530 Mâle, Émile. **Religious Art from the Twelfth to the Eighteenth Century.** New York, Pantheon, 1949. 208p. illus. index. Reprint: New York, Noonday, 1958. LC 49-10882.
Translation of the second edition (Paris, A. Colin, 1946) of *L'art religieux du XIIᵉ au XVIIIᵉ siècle: etraits choisis par l'auteur.* Collection of passages, chosen by the author, from his four-volume history of the iconography of French art (1125, 1151, 1251). No bibliography.

1531 Réau, Louis. **Histoire de l'expansion de l'art français....** Paris, Laurens, 1924-1933. 3v. illus. index.
History of French art and architecture in other countries and the influence of French art and architecture in other countries. Contents: volume 1, *Le monde latin-Italie, Espagne, Portugal, Roumanie, Amérique du Sud*; volume 2, part 1, *Belgique et Hollande, Suisse, Allemagne et Autriche, Bohème et Hongrie*; volume 2, part 2, *Pays scandinaves, Angleterre, Amérique du Nord*; volume 3, *Le Monde slave et l'Orient.* Each volume provides a list of documents and bibliography.

1532 Schneider, René. **L'art français....** Paris, Laurens, 1925-1930. 6v. illus. index.
General history of art and architecture in France from the early Middle Ages to the early twentieth century. Popular text, but there are good bibliographies at the end of each volume.

1533 Smith, Bradley. **France. A History in Art.** Garden City, N.Y., Doubleday, 1984. 296p. illus. index. LC 84-5932.
Survey of the history of art and architecture in France from 1500 B.C. to 1968. All illustrations are in color. Bibliography, pp. 289-92, is a list of basic books on France in English.

German-Speaking Countries

GENERAL WORKS

1534 Braunfels, Wolfgang. **Die Kunst im Heiligen Romischen Reich Deutscher Nation.** v. I, Munich, C. H. Beck, 1979- . illus. index.

Comprehensive history of art and architecture in territories of the Holy Roman Empire from Carolingian times to the end of the eighteenth century. Although the German-speaking territories are at the center, the border regions in the west and east are examined in their own volumes. This remarkably wide-reaching work is unusual among the many national histories of art for the thoroughness of its exploration of the geographic manifestation of art history. To date the following volumes have appeared: Band 1, *Die weltlichen Fürstentumer.* Band 2, *Die geistlichen Fürstentumer.* Band 3, *Reichsstädte, Grafschaften, Reichsklöster.* Band 4, *Grenzstaaten im Westen und Suden, deutsche und romanische Kultur.* Band 5, *Grenzstaaten im Osten und Norden, deutsche und slawische Kultur.* Bibliographical footnotes.

1535 **Deutsche Kunstgeschichte.** Munich, Bruckmann, 1942-1956. 6v. illus. index.

Comprehensive history of art and architecture in the German-speaking countries from Carolingian times through the twentieth century. Band I, *Baukunst*, by Eberhard Hempel; Band II, *Plastik*, by Adolf Feulner and Theodor Müller; Band III, *Malerei*, by Otto Fischer; Band IV, *Zeichnung und Graphik*, by Otto Fischer; Band V, *Kunstgewerbe*, by Heinrich Kohlhaussen; Band VI, *Die Kunst des 20. Jahrhunderts*, by Franz Roh. Good, classified bibliographies at the end of each volume. Excellent illustrations. A standard history of German art and architecture.

1536 **Geschichte der deutschen Kunst....** Berlin, Grote, 1887-1891. 5v. illus. index.

Comprehensive history of art and architecture in German-speaking countries. Contents: Band 1, Robert Dohme, *Geschichte der deutschen Baukunst*; Band 2, Wilhelm Bode, *Geschichte der deutschen Plastik*; Band 3, Heinrich Janitschek, *Geschichte der deutschen Malerei*; Band 4, Carl von Lützow, *Geschichte des deutschen Kupferstiches und Holzschittes*; Band 5, Jakob von Falke, *Geschichte des deutschen Kunstgewerbes.* Only occasional footnotes. An old, standard history; superseded by Bruckmann's *Deutsche Kunstgeschichte* (1535).

1537 Grisebach, August. **Die Kunst der deutschen Stämme und Landschaften.** Vienna, Neff, 1946. 367p. illus. index. LC A49-92.

Important attempt to delineate the various regional styles in the art and architecture of the German-speaking countries. Contents: Einleitung; Franken; Schwaben; Die Alemannen am Oberrhein; Bayern und Österreich; Köln und der Niederrhein; Westfalen und Niedersachsen; Lübeck und die Kunst an der Ostsee; Thüringen und Sachsen; Schlesien und der Nordosten; Berlin; Schlusswort. Artists index. No bibliography.

AUSTRIA

Topographic Handbooks

1538 **Dehio-Handbuch: Die Kunstdenkmäler Österreich.** Ed. by the Bundesdenkmalamt and Institut für Österreichische Kunstforschung. Vienna, Schroll, 1953- . illus. index.

This is the fourth and fifth editions of the original work by Georg Dehio, *Handbuch der deutschen Kunstdenkmaler ... 2. Abteilung: Österreich....* (Berlin 1933-1935), expanded, rearranged, and rewritten by a team of specialists. List of volumes to date: *Wien*, by Justus Schmidt and Hans Tietze (rev. 1973), *Niederösterreich*, by Richard Kurt Donin (rev. 1976), *Oberösterreich*, by Erwin Hainisch (rev. 1977), *Salzburg*, by Franz

Martin (rev. 1986), *Steiermark*, by Eduard Andorfer (rev. 1982), *Kärnten*, by Karl Ginhart (rev. 1981), *Tirol*, by Heinrich Hammer, (1980), *Burgenland*, by Adelheid Schneller-Kitt (2v. 1980), *Vorarlberg*, by Gert Amman and Martin Bitschnau (1983). Topographical handbook of the art and architecture of Austria, divided by province and arranged by place. A short history of the place with reference to documents is followed by a thorough description and discussion of the major architectural monuments of Austria. Does not include works in museums. Intended as a field guide, it is also a major reference tool for the advanced student.

1539 Hootz, Reinhardt. **Kunstdenkmäler in Österreich: Ein Bildhandbuch.** Munich, Berlin, Deutscher Kunstverlag, 1965-1968. 4v. illus. index. LC 67-96968. 2d ed. 1968-78.

Illustrated handbook of the art and architecture of Austria. Volume one covers the provinces of Salzburg, Tirol, and Vorarlberg; volume two, Carinthia and Styria; volume three, Upper and Lower Austria and Burgenland; volume four, the city and county of Vienna. Each volume has an introductory essay on the history of art and architecture in the particular regions, followed by an excellent collection of plates arranged by place. Informative notes to the plates give dates, attribution, plans, etc. There is a chronological listing of the works illustrated. A standard handbook for beginning and advanced students.

1540 **Österreichische Kunsttopographie.** Band 1- . Vienna, Schroll, 1907- . illus. index.

Official inventory of art and architecture in Austria. After 1918 it was published by Deutschösterreiches Staatsdenkmalamt, and after 1924 by Bundesdenkmalamt. Between 1937 and 1945 the name changed to *Ostmärkische Kunsttopographie*. In progress. To date the following volumes have appeared:

Band I, *Bezirk Krems* (1970)
Band II, *Stadt-Wien (XI-XXI Bezirk)* (1908)
Band III, *Bezirk Melk* (1909)
Band IV, *Pöggstall* (1910)
Band V, *Bezirk Horn* (1911)
Band VI, *Bezirk Waidhofen a.d. Thaya* (1911)
Band VII, *Benediktiner-Frauen-Stift Nonnberg in Salzburg* (1911)
Band VIII, *Bezirk Zwettl (ohne Stift Zwettl)* (1911)
Band IX, *Stadt Salzburg-Kirchliche Denkmale der Stadt Salzburg* (1912)
Band X, *Bezirk Salzburg* (1913)
Band XI, *Bezirk Salzburg* (1916)
Band XII, *Stift St. Peter in Salzburg* (1913)
Band XIII, *Profanen Denkmale der Stadt Salzburg* (1914)
Band XIV, *Hofburg in Wien* (1914)
Band XV, *Kunsthistorischer Atlas Wien* (1916)
Band XVI, *Die Kunstsammlungen der Stadt Salzburg* (1919)
Band XVII, *Urgeschichte des Kronlandes Salzburg* (1918)
Band XVIII, *Bezirk Baden* (1924)
Band XIX, *Stift Heiligenkreuz* (1926)
Band XX, *Bezirk Hallein* (1927)
Band XXI, *Bezirk Schärding* (1927)
Band XXII, *Bezirk Tamsweg* (1929)
Band XXIII, *St. Stephansdom in Wien* (1931)
Band XXIV, *Bezirk und Städte Eisenstadt und Rust* (1932)
Band XXV, *Bezirk Zell am See* (1933)
Band XXVI, *Volkskunde des Burgenlandes* (1935)
Band XXVII, *Vorgeschichtlichen Vorarlbergs* (1937)
Band XVIII, *Landkreise Bischofshofen* (1940)
Band XXIX, *Zisterzienserkloster Zwettl* (1940)
Band XXX, *Bezirk Braunau* (1947)
Band XXXI, *Benediktinerstift St. Lambert* (1971)
Band XXXII, *Bezirk Feldkirch* (1958)

Band XXXIV, *Bezirk Lambach* (1959)
Band XXXV, *Bezirk Murau* (1964)
Band XXXVI, *Die Linzer Kirchen* (1964)
Band XXXVII, *Benediktinerstift St. Paul im Lavanttal* (1969)
Band XXXVIII, *Die Profanen Kunstdenkmäler der Stadt Innsbruck* (1972)
Band XXXIX, *Gerichtsbezirk Oberwölz* (1973)
Band XL, *Bezirk Oberwalt* (1974)
Band XLI, *Wien, Die Kirche des III. Bezirks* (1974)
Band XLII, *Die profanen Bau- und Kunstdenkmäler der Stadt Linz. Die Altstadt* (1977)
Band XLIII, *Benediktinerstiftes Kremsmünster* (2v. 1977)
Band XLIV, *Wien, Die Profanenbauten des III. IV. und V. Bezirkes* (1980)
Band XLV, *Stadt Innsbruck. II. Teil: Die Profanenbauten.* (1981).
Band XLVI. *Stadt Graz. Die profanenbauten des IV. und V. Bezirkes.* (1984)
Band XLVII, *Stadt Innsbruck. Die Hofbauten.* (1986)
Band XLVIII, *Die Kunstsammlungen des Augustinerschorherrenstiftes St. Florian.* (1987)
Band L, *Die Profanen Bau- und Kunstdenkmäler der Stadt Linz. Die Landstrasse. Obere und Untere Vorstadt.* (1986)

Each volume devoted to a region is introduced by an historical sketch of the area followed by a description of major buildings (including their art contents and decoration), monuments, archaeological sites, and other *in situ* remains. The history of major places and monuments is discussed in detail, with thorough reference to documentary sources and to specialized literature in the footnotes. Well and extensively illustrated with plates, plans, and diagrams.

1541 **Reclams Kunstführer Österreich.** Stuttgart, Reclam, 1974. 2v. illus. index. LC 78-407658.

Topographical guide to the art and architecture of Austria. Divided into regions and arranged by place. Band I, *Wien, Niederösterreich, Oberösterreich, Burgenland* (5th ed., 1981; 703p.); Band II, *Salzburg, Tirol, Vorarlberg, Kärnten, Steiermark* (4th ed., 1974; 911p.). Each place is introduced with a historical sketch, followed by a description and discussion of the major buildings. Although emphasis is on architecture, the art contents of the buildings are briefly discussed. Illustrated with plates and plans of the major buildings. Volume one has a useful glossary of terms; each volume has an index by place and by artist-architect. Designed as a comprehensive, pocket-sized field guide, this work is remarkably thorough, but not as detailed as the Dehio-Handbuch (1538) or as definitive as the official inventories (1540).

Histories

1542 Benesch, Otto. **Kleine Geschichte der Kunst in Österreich.** Vienna, Globus, 1950. 65p. illus. LC A51-2497.

Concise history of Austrian art and architecture from the earliest times to the middle of the twentieth century. No bibliography.

1543 Feuchtmüller, Ruppert. **Kunst in Österreich vom frühen Mittelalters bis zur Gegenwart.** v. 1- . Vienna, Forum, 1972- . illus. index. LC 75-315996.

Comprehensive history of art and architecture in Austria from the early Middle Ages to the present. Volume one covers the Middle Ages. Bibliographical references are given at the end of each section. Well illustrated with plates, plans, and diagrams.

1544 Ginhart, Karl, ed. **Die bildende Kunst in Österreich.** Baden bei Wien, R. M. Rohrer, 1936-1943. 6v. illus. index. LC 39-10657.

Comprehensive and scholarly history of art and architecture in Austria from prehistoric times to the 1940s. Contents: Band 1, *Voraussetzungen und Anfänge (von der Urzeit bis zum 600 N.Chr.)*; Band 2, *Vorromanische und Romanische Zeit (von etwa 600 bis zum 1250)*; Band 3, *Gotische Zeit (von etwa 1250 bis zum 1530)*; Band 4, *"Renaissance" und Barock (von etwa 1530 bis zum 1690)*; Band 5, *Barock und Rokoko (von etwa 1690 bis zum 1780)*; Band 6, *Vom Ausgang des 18. Jahrhunderts bis zur Gegenwart.* Bibliographies at end of each chapter. The standard history of Austrian art.

1545 Grimschitz, Bruno. **Ars Austriae.** Vienna, Wolfrum. 1960. 60p. (text); 244p. (illus.). index. LC A61-5108.

Pictorial survey of the art and architecture of Austria from the seventh century B.C. through the twentieth century. Introductory essay provides a brief historical survey supplemented by more detailed information in the notes to the plates. No bibliography. Popular survey in English for the general reader.

1546 Neuwirth, Josef. **Bildende Kunst in Österreich.** Vienna, C. Fromme, 1918. 2v. illus. index.

Comprehensive history of art, exclusive of architecture, in Austria from prehistoric times to the early twentieth century. Contents: Band 1, *Von der Urzeit bis zum Ausgange des Mittelalters*; Band 2, *Von der Renaissance bis zum Beginne des zwanzigsten Jahrhunderts.* Occasional bibliographical footnotes.

1547 Schaffran, Emerich. **Kunstgeschichte Österreichs.** Vienna, Hollinek, 1948. 443p. illus. (Bücherreihe Österreichische-Heimat, Band 11). LC 49-18170.

Concise history of art and architecture in Austria from the early Middle Ages to the early twentieth century. "Lexikon der wichtigen bildenden Künstler Österreich" (pp. 353-423). Good classified bibliography of books and periodical articles (pp. 425-32).

GERMANY

Topographic Handbooks

1548 Dehio, Georg. **Handbuch der deutschen Kunstdenkmäler.** New ed. by the Vereinigung zur Herausgabe des Dehio-Handbuches. Munich, Deutscher Kunstverlag, 1964- . illus. index.

New, expanded, and rewritten edition of the original five-volume work published from 1900 to 1906. Comprehensive topographical handbook of the art and architecture of Germany from prehistoric times to the present. To date the following volumes have appeared: *Baden-Württemberg*, by Friedrich Piel (1964. Reprint: 1979); *Bremen, Niedersachsen*, by Gottfried Kiesow (1977); *Franken, Die Regierungsbezirke OberMittel- und Unterfranken*, by Tilmann Breuer, et al. (1979); *Hamburg; Schleswig-Holstein*, by Johannes Habich (1971); *Hessen*, by Magnus Backes (2d ed. 1982); *Nordrhein-Westfalen, Teil 1: Rheinland*, by Ruth Schmidt-Ehmke (1977); *Nordrhein-Westfalen, Teil 2: Westfalen*, by Dorothea Kluge, et al. (2d ed. 1986); *Rheinland-Pfalz, Saarland*, by Hans Caspary, et al. (2d ed. 1984); *Die Bezirke Berlin/DDR und Potsdam* (1983); *Die Bezirke Cottbus und Frankfurt/Oder*, by Ernst Badstübner, et al. (1986); *Der Bezirk Halle* (1976); *Der Bezirk Magdeburg* (1974); *Die Bezirke Neubrandenburg, Rostock, Schwerin* (2d ed. 1980). Arranged by place, each volume provides an historical sketch of the place and a detailed description of the important buildings and their contents. Illustrated only with ground plans. No bibliography. A standard topographical handbook of German art and architecture.

1549 Hootz, Reinhardt. **Deutsche Kunstdenkmäler: Ein Bildhandbuch.** Munich, Deutscher Kunstverlag, 1966-1974. Rev. 1977-1983. 14v. illus. index.

Illustrated handbook of the art and architecture of Germany consisting of separate volumes for each of the present states of both East and West Germany. Consists of the following volumes:

Baden-Württemberg (3d ed. 1977)
Bayern nördlich der Donau (3d ed. 1977)
Bayern südlich der Donau (2d ed. 1967)
Bremen; Niedersachsen (2d ed. 1974)
Hamburg; Schleswig-Holstein (2d ed. 1968)
Hessen (2d ed. 1974)
Niederrhein (2d ed. 1974)
Rheinland-Pfalz und Saar (2d ed. 1969)
Westfalen (2d ed. 1972)
Thüringen (Bezirke Erfurt, Suhl, Gera) (1968)
Provinz Sachsen und Land Anhalt (Bezirke Halle, Magdeburg) (1968)
Sachsen (Bezirke Leipzig, Dresden, Karl-Marx-Stadt) (1968)
Mecklenburg (Bezirke Schwerin, Rostock, Neu-Brandenburg) (1971)
Mark Brandenburg und Berlin (Bezirke Potsdam, Frankfurt an der Oder, Cottbus, Berlin) (1983)

Each volume has an introductory essay that surveys the art history of the region, followed by an excellent collection of plates arranged by place, notes to the plates with plans and basic historical data, a chronological list of the works of art illustrated, and maps indicating the locations of the places. No bibliography. Although they do not substitute for the more intensive and extensive treatment of art and architectural monuments in the numerous official inventories, these volumes are handy, competent reference tools to the major works of art and architecture in situ in Germany. Their small size permits their use as field guides for intensive art travel.

1550 **Reclams Kunstführer Deutschland.** Stuttgart, Reclam, 1971- . illus. index. LC 68-110831.

Topographical guide to the art and architecture of West Germany and Berlin. Volumes covering East Germany are planned. To date, the following have appeared:

Band I, 1, *Bayern Süd* (9th ed. 1983)
Band I, 2, *Bayern Nord* (9th ed. 1983)
Band II, *Baden-Württemberg* (7th ed. 1979)
Band III, *Nordrhein-Westfalen* (6th ed. 1982)
Band IV, *Hessen* (5th ed. 1978)
Band V, *Niedersachsen, Hansestädte, Schleswig-Holstein* (6th ed. 1984)
Band VI, *Rheinland-Pfalz, Saarland* (7th ed. 1980)
Band VII, *Berlin* (3d ed. 1980)

Arranged by place or site. Each place is introduced by a brief historical sketch that precedes a thorough description of the major buildings and monuments, including their art contents and decoration. Modestly illustrated with plates, liberally provided with plans and diagrams, and well indexed. No bibliography.

Inventories of Art and Architecture

German art and architecture inventories present a complex bibliographical problem. Territorial changes after the two wars have broken the continuity of earlier series, changing their titles and scope, and have brought new series into being. To facilitate the use of these extremely valuable reference works for advanced study in German art history, they are arranged here under headings corresponding to major regions in Germany. The present-day territorial equivalents are given in parentheses.

All of the inventories are thoroughly illustrated with plates, diagrams, and plans. Many provide old views of places and buildings. All follow a geographical arrangement by place within counties (*Kriese*). And all provide invaluable bibliographical references either in the form of footnotes or as separate bibliographies at the end of sections or volumes.

BAVARIA (LAND BAYERN)

1551 **Die Kunstdenkmäler Bayerns.** Munich, Oldenbourg, 1895- . illus. index. Reprint: Munich, Oldenbourg, 1981-1983.

Official inventory of art and architecture in Bavaria. The series is divided by the eight *Regierungsbezirke* and then by *Kreise.* To date, the following have appeared:

I, *Oberbayern*
1) *Ingolstadt, Pfaffenhofen, Schrobenhausen, Aichach, Friedberg, Dachau, Freising, Bruck, Landsberg, Schongau, Garmisch, Tölz, Weilheim, München, I und II* (1895); 2) *München Stadt, Erding, Ebersberg, Miesbach, Rosenheim, Traunstein, Wasserburg* (1895); 3) *Mühldorf, Alt-Ötting, Laufen, Berchtesgaden, Register zu Teil 1* [Index to section I] (1908).

II, *Oberpfalz und Regensburg*
1) *Roding* (1905); 2) *Neuburg v. W.* (1906); 3) *Waldmünchen* (1906); 4) *Parsberg* (1906); 5) *Burglengenfeld* (1906); 6) *Cham* (1906); 7) *Oberviechtach* (1906); 8) *Vohenstrauss* (1907); 9) *Neustadt a. W.* (1907); 10) *Kemnath* (1907); 11) *Eschenbach* (1909); 12) *AG. Beilngries* (1908); 13) *AG. Riedenburg* (1908); 14) *Tirschenreuth* (1908); 15) *BA. Amberg* (1909); 16) *Stadt Amberg* (1909); 17) *Neumarkt* (1909); 18) *Nabburg* (1910); 19) *Sulzbach* (1910); 20) *Stadtamhof* (1914); 21) *BA. Regensburg* (1910); 22) *Stadt Regensburg* (3v.; 1933).

III, *Unterfranken und Aschaffenburg*
1) *Ochsenfurt* (1911); 2) *Kitzingen* (1911); 3) *Würzburg* (1911); 4) *Hassfurt* (1912); 5) *Hofheim* (1212); 6) *Karlstadt* (1912); 7) *Marktheidenfeld* (1913); 8) *Gerolzhofen* (1913); 9) *Lohr* (1914); 10) *Kissingen* (1914); 11) *Brückenau* (1914); 12) *Stadt Würzburg* (1915); 13) *Königshofen* (1915); 14) *Hammelburg* (1915); 15) *Ebern* (1916); 16) *Alzenau* (1916); 17) *BA. Schweinfurt* (1917); 18) *Miltenberg* (1917); 19) *Stadt Aschaffenburg* (1918); 20) *Gemünden* (1920); 21) *Mellrichstadt* (1921); 22) *Neustadt a. S.* (1922); 23) *Obernburg* (1925); 24) *BA. Aschaffenburg* (1927).

IV, *Niederbayern*
1) *Dingolfing* (1912); 2) *BA. Landshut* (1914); 3) *Stadt Passau* (1919); 4) *BA. Passau* (1920); 5) *Vilsbiburg* (1921); 6) *Stadt Straubing* (1921); 7) *Kelheim* (1922); 8) *Eggenfelden* (1923); 9) *Kötzting* (1922); 10) *Pfarrkirchen* (1923); 11) *Wegscheid* (1924); 12) *BA. Straubing* (1925); 13) *Landau a. I.* (1926); 14) *Vilshofen* (1926); 15) *Viechtach* (1926); 16) *Stadt Landshut* (1927); 17) *Deggendorf* (1928); 18) *Mainburg* (1928); 19) *Regen* (1928); 20) *Bogen* (1929); 21) *Griesbach* (1929); 22) *Rottenburg* (1930); 23) *Wolfstein* (1931); 24) *Grafenau* (1933); 25) *Mallersdorf* (1936).

V, *Mittelfranken*
1) *Stadt Eichstätt* (1924); 2) *BA. Eichstätt* (1928); 3) *Hilpoltstein* (1929); 4) *Stadt Dinkelsbühl* (1931); 5) *Weissenburg* (1932); 6) *Gunzenhausen* (1937); 7) *Schwabach* (1939); 8) *Rothenburg o. T. kirchl. Bauten* (1959); 10) *Hersbruck* (1959); 11) *Landkreis Lauf an der Pegnitz* (1966).

VII, *Schwaben und Neuburg*
1) *BA. Nördlingen* (1938); 2) *Stadt Nördlingen* (1940); 3) *LK. Donauwörth* 1951); 4) *Lindau* (1954); 5) *Neuburg/Donau* (1958); 6) *Stadt Dillingen* (1964); 7) *LK. Dillingen* (1972); 8) *LK. Sonthofen* (1964).

VIII,*Oberfranken*
1) *Wundsiedel und Stadt Marktredwitz* (1954); 2) *Pegnitz* (1961).

BADEN-WÜRTTEMBERG (LAND BADEN-WÜRTTEMBERG)

1552 **Die Kunstdenkmäler Badens.** Various places and publishers. Presently: Munich, Deutscher Kunstverlag. 1887- . illus. index. LC 53-23592.
Official inventory of art and architecture in Baden. Until 1933, it was titled *Die Kunstdenkmäler des Grossherzogthums Baden.* To date, the following volumes have appeared: Band 1: *Kreis Konstanz*; Band 2: *Kreis Villingen*; Band 3: *Kreis Waldshut*; Band 4, 1: *Kreis Mosbach. Amtsbezirk Wertheim*; Band 4, 2: *Kreis Mosbach. Amtsbezirk Tauberbischofsheim*; Band 4, 3: *Kreis Mosbach. Amtsbezirke Buchen und Adelsheim*; Band 4, 4: *Kreis Mosbach. Amtsbezirke Mosbach und Eberbach*; Band 5: *Kreis Lörrach*; Band 6, 1: *Kreis Freiburg. Amtsbezirke Breisach, Emmendingen, Ettenheim, Freiburg Land, Neustadt, Staufen und Waldkirch*; Band 7: *Kreis Offenburg*; Band 8, 1: *Kreis Heidelberg. Amtsbezirke Sinsheim, Eppingen und Weisloch*; Band 8, 2: *Kreis Heidelberg. Amtsbezirk Heidelberg*; Band 9, 1: *Kreis Karlsruhe. Amtsbezirk Bretten*; Band 9, 2: *Kreis Karlsruhe. Amtsbezirk Bruchsal*; Band 9, 3: *Kreis Karlsruhe. Amtsbezirk Ettlingen*; Band 9, 5: *Kreis Karlsruhe. Amtsbezirk Karlsruhe Land*; Band 9, 6: *Kreis Karlsruhe. Amtsbezirk Pforzheim Stadt*; Band 9, 7: *Kreis Karlsruhe. Amtsbezirk Pforzheim Land*; Band 10, 2: *Kreis Mannheim. Stadt Schwetzingen*; Band 10, 3: *Kreis Mannheim. Landkreis Mannheim*; Band 11, 1: *Kreis Baden-Baden. Stadt Baden-Baden*; Band 12, 1: *Kreis Rastatt. Landkreis Rastatt.*

1553 **Die Kunstdenkmäler in Baden-Württemberg.** Munich, Deutscher Kunstverlag, 1978- . illus. index.
Official inventory of art and architecture in the German Federal State of Baden-Württemberg. To date the following volumes have appeared;
Oberamts Ulm (1978)
Stadtkreis Mannheim (1982)
Rems-Murr-Kreis (2v. 1983)

1554 **Die Kunstdenkmäler Hohenzollerns.** Stuttgart, Spemann, 1939-1948. 2v. illus. index.
Official inventory of art and architecture in the former province of Hohenzollern. Contents: Band 1, *Kreis Hechingen* (1939); Band 2, *Kreis Sigmaringen* (1948).

1555 **Die Kunst- und Altertumsdenkmale im Königreich Württemberg.** Stuttgart, Deutsche Verlags-Anstalt, 1897-1914. 4v. illus. index.
Official inventory of art and architecture in the former kingdom of Württemberg. Succeeded by *Die Kunst- und Altertumsdenkmale in Württemberg* (1556). Contents: Band 1, *Schwarzwaldkreis* (1897); Band 2, *Neckarkreis* (1889); Band 3, *Jagstkreis* (2v. 1907-1913); Band 4, *Donaukreis I* (1914).

1556 **Die Kunst- und Altertumsdenkmale in Württemberg.** Stuttgart, Deutsche Verlags-Anstalt, 1924-1936. 4v. illus. index.
Official inventory of art and architecture in Württemberg. Succeeds *Die Kunst- und Altertumsdenkmale im Königreich Württemberg* (1555) and is succeeded by *Die Kunstdenkmäler in Württemberg* (1557). Contents: Band 1, *Donaukreis II* (1924); Band 2, *Oberamt Münsingen* (1926); Band 3, *Oberamt Ravensburg* (1931); Band 4, *Kreis Riedlingen* (1936).

1557 **Die Kunstdenkmäler in Württemberg.** Stuttgart, Deutsche Verlags-Anstalt, 1937- .
illus. index. LC 38-8276 rev. 2.
Official inventory of art and architecture in the German Federal State of
Württemberg. Succeeds *Die Kunst- und Altertumsdenkmale in Württemberg* (1556). To
date the following volumes have appeared:
Band 1, *Kreis Tettnang* (1937)
Band 2, *Kreis Saulgau* (1938
Band 3, *Ehemaliger Kreis Waldsee* (1943)
Band 4, *Ehemaliger Kreis Wangen* (1954)
Band 5, *Ehemaliges Oberamt Künzelsau* (1962. Reprint: Frankfurt am Main,
Weidlich, 1983).

HESSE (LAND HESSEN)

1558 **Die Kunstdenkmäler im Grossherzogtums Hesse.** Darmstadt, Bergsträsser, 1885-
1934. 9v. illus. index.
Official inventory of art and architecture in the former grand duchy of Hesse. In
1919, the title changed to *Die Kunstdenkmäler im Freistaat Hessen*; in 1933, to *Die
Kunstdenkmäler im Volkstaat Hessen.* Succeeded by *Bau- und Kunstdenkmäler des Landes
Hessen* (1559). Contents:
Provinz Starkenburg: Kreis Bensheim (1914)
Provinz Starkenburg: Kreis Offenbach (1885)
Provinz Starkenburg: Kreis Wimpfen (1898)
Provinz Starkenburg: Kreis Erbach (1891)
Provinz Oberhessen: Kreis Friedberg (1895)
Provinz Oberhessen: Kreis Büdingen (1890)
Provinz Oberhessen: Kreis Giessen. Band II (1919)
Provinz Rheinhessen: Stadt und Kreis Mainz (1919)
Provinz Rheinhessen: Kreis Bingen (1934)

1559 **Die Bau- und Kunstdenkmäler des Landes Hessen.** Munich, Berlin, Deutscher
Kunstverlag, 1958- . illus. index.
Official inventory of art and architecture in the German Federal State of Hessen.
Succeeds *Die Kunstdenkmäler im Grossherzogtums Hessen* (1558). To date, the following
volumes have appeared:
Regierungsbezirk Darmstadt, Stadt Darmstadt (195?); *Regierungsbezirk Kassel,
Kreis der Eder* (1960); *Regierungsbezirk Wiesbaden, Landkreis Biedenkopf* (1958).
Series title changed to Kunstdenkmäler des Landes Hessen. *Rheingau Kreis* (1965);
Kreis Bergstrasse (2v. 1969).

1560 **Die Bau- und Kunstdenkmäler im Regierungsbezirk Cassel.** Marburg, Kassel, Bar-
enreiter-verlag, 1901-1939. 10v. illus. index. LC 49-35172.
Official inventory of art and architecture in the former Prussian Regierungsbezirk
Cassel. Today the territory is part of the German Federal State of Hessen. In 1937 it began
a new series (Neue Folge) with its own volume numbers. Contents:
Band I, *Kreis Gelnhausen* (1901)
Band II, *Kreis Fritzlar* (1909)
Band III, *Kreis Grafschaft Schaumburg* (1907)
Band IV, *Kreis Cassel-Land* (1910)
Band VI, *Kreis Cassel-Stadt* (1923)
Band VII, *Kreis Hofgeismar* (1926)
Band VIII, *Kreis Marburg-Stadt* (1934)

Neue Folge (published in Kassel):
Band 1, *Kreis Wolfhagen* (1937)
Band 2, *Kreis der Twiste* (1938)
Band 3, *Kreis des Eisenberges* (1939)

1561 **Die Bau- und Kunstdenkmäler des Regierungsbezirks Wiesbaden.** 2d ed. Frankfurt am Main, H. Keller, 1907-1921. 6v. illus. index. LC 14-7041. Reprint: Walluf, Sandig, 1973. 5v.

Official inventory of art and architecture in the former Prussian Regierungsbezirk Wiesbaden. The territory is today part of the German Federal State of Hessen. Contents:

Band I, *Der Rheingau* (1907)
Band II, *Der östliche Taunus* (1907)
Band III, *Lahngebiet* (1908)
Band IV, *Die Kreise Biedenkopf* (1910)
Band V, *Die Kreise Unter-Westerburg, St. Goarshausen, Untertaunus und Wiesbaden Stadt und Land* (1914)
Band VI, *Nachlese zu Band I bis V* (1921)

1562 **Die Baudenkmäler in Frankfurt am Main.** Frankfurt/Main, Architeken-und Ingenieur-Verein, 1896-1914. 3v. illus. index.

Official inventory of art and architecture in the city of Frankfurt am Main.

RHINELAND (LAND RHEINLAND-PFALZ, LAND NORDRHEIN)

1563 **Die Kunstdenkmäler der Pfalz.** Munich, Oldenbourg, 1926-1939. 8v. illus. index. Reprint: Munich, Oldenbourg, 1974-1982.

Official inventory of the art and architecture in the former Bavarian province of the Palatinate. Series consists of:

Band 1, *Stadt und Bezirksamt Neustadt (Haardt)* (1926)
Band 2, *Stadt und Bezirksamt Landau* (1928)
Band 3, *Stadt und Bezirksamt Speyer* (1934)
Band 4, *Bezirksamt Bergzabern* (1935)
Band 5, *Bezirksamt Germersheim* (1927)
Band 6, *Stadt und Bezirksamt Ludwigshafen* (1936)
Band 7, *Bezirksamt Kircheimbolanden* (1938)
Band 8, *Stadt und Landkreis Frankenthal* (1939)

1564 **Die Kunstdenkmäler der Rheinprovinz.** Düsseldorf, Schwann, 1891-1944. 19v. in 41. illus. index. Reprint: Düsseldorf, Schwann, 1980-1985.

Official inventory of art and architecture in the former Prussian province of the Rhineland, which is today divided between the German Federal States of Nordrhein-Westfalen and Rheinland-Pfalz. For successor series, see (1264). The following volumes appeared:

Band 1, *Kreis Kempen, Geldern, Moers, Kleve*
Band 2, *Kreis Rees, Duisburg, Mülheim, Ruhrort, Essen*
Band 3, *Kreis Düsseldorf, Barmen, Elberfeld, Remscheid, Lennep, Mettmann, Solingen, Neuss, M-Gladbach, Krefeld, Grevenbroich*
Band 4, *Landkreis Köln, Kreis Rheinbach, Bergheim, Euskirchen*
Band 5, 1, *Kreis Gummersbach, Waldrael, Wipperfurth*
Band 5, 2, *Kreis Mülheim am Rhein*
Band 5, 3, *Stadtkreis Bonn*
Band 6, *Stadt Köln* (4v.)
Band 7, *Stadt Köln* (4v.)
Band 8, 1, *Kreis Jülich*
Band 8, 2, *Kreis Erkeleuz und Geilenkirchen*
Band 8, 3, *Kreis Heinsburg*
Band 9, 1, *Kreis Düren*
Band 9, 2, *Landkreis Aachen und Eupen*
Band 10, *Stadt Aachen* (3v.)
Band 11, *Monschau*

Band 12, 1, *Kreis Bitburg* (1927)
Band 12, 2, *Kreis Prüm* (1927)
Band 12, 3, *Kreis Daun* (1928)
Band 12, 4, *Kreis Wittlich* (1934)
Band 13, *Stadt Trier* (2v. 1938)
Band 15, 1, *Kreis Bernkastel* (1935)
Band 15, 2, *Landkreis Trier* (1936)
Band 15, 3, *Kreis Saarburg* (1939)
Band 16, 1, *Kreis Altenkirchen* (1935)
Band 16, 2, *Kreis Neuwied* (1940)
Band 16, 3, *Landkreis Koblenz* (1944)
Band 17, 1, *Kreis Ahrweiler* (1938)
Band 17, 2, *Kreis Mayen* (1941)
Band 18, 1, *Kreis Kreuznach* (1935)
Band 19, 3, *Kreis Zell an der Mosel* (1938)
Band 20, 1, *Die kirchlichen Denkmäler der Stadt Koblenz* (1937)

1565 **Die Kunstdenkmäler von Rheinland-Pfalz.** Munich, Deutscher Kunstverlag, 1954- .
illus. index.
Official inventory of art and architecture in the German Federal State of Rhein-
land-Pfalz. In part, successor to the series *Die Kunstdenkmäler der Rheinprovinz* (1564)
and *Die Kunstdenkmäler der Pfalz* (1563). To date, the following volumes have appeared:
Band 1: *Stadt Koblenz: Die Profanen Denkmäler und Vororte.* (1954. Reprint:
1986)
Band 2: *Stadt und Landkreis Pirmasens* (1957. Reprint: 1974)
Band 3: *Kreis Cochem.* (1959. Reprint: 1984)
Band 4: *Stadt Mainz, Teil 1: Kirchen St. Agnes bis H. Kreuz* (1961)
Band 5: *Der Dom zu Speyer* (3v. 1973)
Band 6: *Kreis Simmern* (1977)
Band 7: *Stadt und Landkreis Zweibrücken* (1981)

1566 **Die Bau- und Kunstdenkmäler von Nordrhein-Westfalen.** Berlin, Mann, 1977- .
illus. index.
Official inventory of art and architecture in the German Federal State of Nord-
rhein-Westfalen. In part, successor to the series *Die Kunstdenkmäler der Rheinprovinz*
(1564) and *Die Bau- und Kunstdenkmäler von Westfalen* (1567). To date, the following
volumes have appeared:
Abt. 1: *Rheinland.* Band 7: *Erftkreise, Teil 3: Stadt Brühl* (1977)
Abt. 1: *Rheinland.* Band 9: *Kreis Euskirche, Teil 1: Stadt Bad Münstereifel.* (1985)
Abt. 1: *Rheinland.* Band 11: *Kreis Kleve, Teil 7: Gemeinde Kerke* (1983)
Abt. 1: *Rheinland.* Band 11: *Kreis Kleve, Teil 13: Stadt Straelen.* (1987)

WESTPHALIA (LAND WESTFALEN)

1567 **Die Bau- und Kunstdenkmäler von Westfalen.** Münster, Aschendorff, 1893- . illus.
index. Reprint with summaries of war damage: Münster, Aschendorff, 1975-1981.
Official inventory of art and architecture in Westphalia. Contents:

Kreis Ahaus (1900)	*Kreis Bochum-Land* (1907)
Kreis Altena (1911)	*Kreis Borken* (1954)
Kreis Arnsberg (1906)	*Kreis Brilon* (1952)
Kreis Beckum (1897)	*Kreis Büren* (1926
Bielefeld-Stadt (1906)	*Kreis Coesfeld* (1913)
Kreis Bielefeld-Land (1906)	*Dortmund-Stadt* (n.d.)
Stadt Bocholt (1931)	*Kreis Dortmund-Land* (1895)
Bochum-Stadt (1906)	*Gelsenkirchen-Stadt* (1908)

Hagen-Stadt (1910)
Kreis Hagen-Land (1910)
Stadt Hamm (1936)
Kreis Halle (1908)
Kreis Hattingen (1909)
Kreis Herford (1908)
Kreis Hörde (1895)
Kreis Höxter (1914)
Kreis Iserlohn (1900)
Stadt Lemgo (1983)
Kreis Lippstadt (1911)
Kreis Lübbecke (1907)
Kreis Lüdinghausen (1893)
Kreis Meschede (1908)
Kreis Minden (1902)

Stadt Münster (7v.; 1932-62)
Kreis Münster-Land (1897)
Kreis Olpe (1903)
Kreis Paderborn (1899)
Kreis Recklinghausen (1929)
Kreis Schwelm (1910)
Kreis Siegen (1903)
Kreis Soest (1905)
Kreis Steinfurt (1904)
Kreis Tecklenburg (1907)
Kreis Unna (1959)
Kreis Warburg (1939)
Kreis Warendorf (1936)
Kreis Wiedenbrück (1901)
Witten-Stadt (1910)
Kreis Wittgenstein (1903)

LOWER SAXONY (LAND NIEDERSACHSEN, LAND BREMEN)

1568 **Die Kunstdenkmäler der Provinz Hannover.** Hanover, Provinzialverwaltung, 1899-1941. 25v. illus. index. LC 53-34984. Reprint: Leer, Schuster, 1975-1979.

Official inventory of the art and architecture of the former province of Hanover, territory now part of the German Federal State of Niedersachsen. Succeeded by *Die Kunstdenkmäler des Landes Niedersachsen* (1571). Contents:

Band I, 1, *Landkreise Hannover und Linden* (1899)
Band I, 2, *Stadt Hannover* (in two parts; 1932)
Band I, 3, *Kreis Springe* (1941)
Band II, 1, *Stadt Goslar* (1901)
Band II, 2, *Stadt Goslar* (1901)
Band II, 3, *Kreis Marienburg* (1910)
Band II, 4, *Stadt Hildesheim* (in two parts; 1912)
Band II, 6, *Kreis Alfeld* (1929)
Band II, 7, *Landkreis Goslar* (1937)
Band II, 8, *Kreis Peine* (1938)
Band II, 9, *Landkreis Hildesheim* (1938)
Band II, 10, *Kreis Alfeld II* (1939)
Band III, 1, *Kreise Burgdorf und Fallingbostel* (1902)
Band III, 2, *Stadt Lüneburg* (n.d.)
Band III, 4, *Kreis Gifhorn* (1931)
Band III, 5, *Stadt Celle* (1937)
Band III, 6, *Kreis Soltau* (1939)
Band IV, 1, *Stadt Osnabrück* (1907)
Band IV, 2, *Stadt Osnabrück* (1907)
Band IV, 3, *Kreise Wittlage und Bersenbrück* (1915)
Band IV, 4, *Kreise Lingen und Grafschaft Bentheim* (1919)
Band V, 1, *Kreise Verden, Rotenburg und Zeven* (1908)
Band VI, 1, *Stadt Emden* (1927)
Band VI, 2, *Stadt Emden* (1927)

In 1939, two volumes not numbered with the above numbers appeared: *Die Kunstdenkmäler des Kreises Wesermünde. I: Die ehemalige Kreis Lehe* and *II: Der frühere Kreis Geestemünde.*

1569 **Die Bau- und Kunstdenkmäler des Herzogtums Braunschweig.** Wölfenbüttel, various publishers, 1896-1922. 7v. illus. index. Reprint: Osnabrück, Wenner, 1978.

Official inventory of art and architecture in the former duchy of Braunschweig, which is now part of the German Federal State of Niedersachsen. See (1571) for successor series. Contents:

Band I, *Kreis Helmstedt* (1896)
Band II, *Kreis Braunschweig mit Ausschluss der Stadt Braunschweig* (1900)
Band III, 1, *Stadt Wölfenbüttel* (1904)
Band III, 2, *Die Ortschaften des Kreises Wölfenbüttel* (1906)
Band IV, *Kreis Holzminden* (1907)
Band V, *Kreis Gandersheim* (1910)
Band VI, *Kreis Blankenburg* (1922)

1570 **Die Bau- und Kunstdenkmäler des Herzogtums Oldenburg.** Oldenburg, G. Stalling, 1896-1909. 5v. illus. index. Reprint: Osnabrück, Wenner, 1976).

Official inventory of the art and architecture of the former Duchy of Oldenburg. Contents:

Heft 1. *Amt Wildeshausen* (1896)
Heft 2. *Amt Vechta* (1900)
Heft 3. *Amt Cloppenburg und Amt Friesoythe* (1903)
Heft 4. *Die ämter Öldenburg, Delmenhorst, Elsfleth und Westerstede* (1907)
Heft 5. *Die ämter Brake, Butjadingen, Varel, Jever und Rüstringen* (1909)

1571 **Die Kunstdenkmäler des Landes Niedersachsens.** Berlin, Deutscher Kunstverlag, 1956- . illus. index.

Official inventory of art and architecture in the German Federal State of Niedersachsen. Successor to: *Die Kunstdenkmäler der Provinz Hannover* (1568), *Die Bau- und Kunstdenkmäler des Herzogtums Braunschweig* (1569), and *Die Bau- und Kunstdenkmäler des Herzogtums Oldenburg* (1570). To date the following volumes have appeared:

Band I, 1, *Land Hadeln und der Stadt Cuxhaven* (2v.; 1956)
Band I, 2, *Stadt Stade* (1960)
Band I, 3, *Landkreis Stade* (2v. 1965)
Band II, 1, *Kreis Neustadt am Rübenberge* (2v.; 1958)
Band II, 2, *Landkreis Hamel-Pyrmont* (1975)
Band III, 1, *Stadt Bodenwerder und Gemeinde Pegestorf* (1976)

The above listed volumes together with the volumes in the predecessor series have been reprinted and renumbered as: *Kunstdenkmälerinventare Niedersachsens.* Osnabrück, Wenner, 1978-1980.

SCHLESWIG-HOLSTEIN (LAND SCHLESWIG-HOLSTEIN, LAND HAMBURG)

1572 **Die Kunstdenkmäler der Provinz Schleswig-Holstein.** Berlin, Deutscher Kunstverlag, 1939. 4v. illus. index.

Official inventory of art and architecture in the former province of Schleswig-Holstein. Succeeded by *Die Kunstdenkmäler des Landes Schleswig-Holstein* (1573). Contents: Band 1, *Kreis Husum* (1939); Band 2, *Kreis Eiderstedt* (1939); Band 3, *Kreis Pinneberg* (1939); Band 4, *Kreis Südtondern* (1939).

1573 **Die Kunstdenkmäler des Landes Schleswig-Holstein.** Munich, Berlin, Deutscher Kunstverlag, 1950- . illus. index.

Official inventory of art and architecture in the Federal German State of Schleswig-Holstein. Successor to *Die Kunstdenkmäler der Provinz Schleswig-Holstein* (1572), numbering its volumes together with the older series. To date, the following volumes have appeared: Band 5, *Kreis Eckenförde* (1950); Band 6, *Landkreis Flensburg* (1952); Band 7, *Stadt Flensburg* (1955); Band 8, *Landkreis Schleswig* (1957); Band 9, *Kreis Pinneberg* (1961); Band 10, 2, *Stadt Schleswig. Der Dom und ehemalige Dombezirk* (1966). Band 11, 3, *Stadt Schleswig: Kirchen Klöster und Hospitaler* (1985).

1574 **Die Bau- und Kunstdenkmäler der Freien und Hansestadt Hamburg.** Hamburg, Wegner, 1953- . illus. index.
Official inventory of art and architecture in the German Federal State of Hamburg. To date, the following have appeared:
Band 1: *Bergedorf, Vierlande, Marschelande.* (1953).
Band 2: *Altona, Elbvororte* (1959; 2d ed. 1970).
Band 3: *Innenstadt. Die Häuptkirchen St. Petri, St. Katharinen, St. Jacobi* (1968).

1575 **Die Bau- und Kunstdenkmäler der Hansestadt Lübeck.** Lübeck, B. Nohring, 1906-1939. 6v. illus. index. Reprint: Lübeck, Schmidt-Römhild, 1974. LC 14-15842.
Official inventory of art and architecture in the city and county of Lübeck.
Contents:
Band I, *Profane Denkmäler* (1939)
Band II, *Petrikirche, Marienkirche, Heilig-Geist Kirche* (1906)
Band III, *Der Dom* (1919)
Band III, 2, *Dom, Jakobikirche, Ägidienkirche* (1920)
Band IV, 1, *Die Klöster* (1926)
Band IV, 2, *Aussengebieten* (1928)
New Series, Band 1, *Rathaus und öffentliche Gebäude der Stadt Lübeck* (1974)

GERMAN DEMOCRATIC REPUBLIC (EAST GERMANY)

1576 **Die Bau- und Kunstdenkmale in der DDR.** Heraugegeben vom Institut für Denkmalpflege der DDR. Munich, Beck, 1978- .
Concise illustrated topographical handbook of art and architecture in situ in the German Democratic Republic intended as a popular adjunct to the comprehensive inventories on the individual regions (Bezirke). To date the following have appeared:
Bezirk Frankfurt/Oder. H. Trost, et al., eds. (1980)
Bezirk Neubrandenburg. G. Baier, et al., eds. (1982)
Bezirk Potsdam. H. Drescher, et al., eds. (2d ed. 1979)
Hauptstadt Berlin. H. Trost, ed. (1983)

MECKLENBURG (BEZIRKE NEUBRANDENBURG, ROSTOCK, SCHWERIN)

1577 **Die Kunst- und Geschichtsdenkmäler des Grossherzogtums Mecklenburg-Schwerin.** Schwerin, Barensprung, 1896-1902. 5v. illus. index.
Official inventory of art and architecture in the former grand duchy of Mecklenburg-Schwerin. The following volumes have appeared:
Band I, *Amtsgerichtsbezirke Rostock, Ribnitz, Sülze-Marlow, Tessin, Laage, Gnoien, Dargun, Neukalen* (1896)
Band II, *Amtsgerichtsbezirke, Wismar, Grevesmühlen, Rehna, Gadebusch, Schwerin* (1899)
Band III, *Amtsgerichtsbezirke Hagenow, Wittenburg, Boizenburg, Lübtheen, Dömitz, Grabow, Ludwigslust, Neustadt, Crivitz, Brüel, Warin, Neubukow, Kröpelin, Doberan* (1900)
Band IV, *Amtsgerichtsbezirke Schwaan, Bützow, Sternberg, Güstrow, Krakow, Goldberg, Parchim, Lübz, Plau* (1901)
Band V, *Amtsgerichtsbezirke Teterow, Malchin, Stavenhagen, Penzlin, Waren, Malchow, Röbel* (1902).

1578 **Kunst- und Geschichtsdenkmäler des Freistaates Mecklenburg-Strelitz.** Neubrandenburg, various publishers, 1921-1934. 4v. illus. index.
Official inventory of art and architecture in the former state of Mecklenburg-Strelitz. Successor to *Die Kunst- und Geschichtsdenkmäler des Grossherzogtums Mecklenburg-Schwerin.* Contents:

Band I, 1, *Amtsgerichtsbezirke Neustrelitz, Strelitz, Mirow* (1921)
Band I, 2, *Amtsgerichtsbezirke Fürtenberg, Feldberg, Woldegk, Friedland (Des Land Stargard)* (1925)
Band I, 3, *Amtsgerichtsbezirke Friedland, Stargard, Neubrandenburg* (1929)
Band II, *Das Land Ratzeburg* (1934)

1579 **Die Kunstdenkmäler im Bezirk Rostock.** Leipzig, Seemann, 1963- . illus. index.
Official inventory of art and architecture in the Bezirk Rostock of the German Democratic Republic (East Germany). To date, one volume has appeared: Band 1, *Kreis Rügen* (1963).

THURINGIA (BEZIRKE ERFURT, GERA, SUHL, HALLE, MAGDEBURG)

1580 **Die Bau- und Kunstdenkmäler der Provinz Sachsen.** Halle, Historische Commission der Provinz Sachsen, 1879-1911. 29v. illus. index.
Official inventory of art and architecture in the former Prussian province of Saxony. Succeeded by *Die Kunstdenkmäler der Provinz Sachsen* (1581). Contents:
Band 1, *Kreis Zeitz* (1879)
Band 2, *Kreis Langensalza* (1879)
Band 3, *Kreis Weissenfels* (1880)
Band 4, *Kreis Mühlhausen* (1881)
Band 5, *Kreis Sangerhausen* (1881)
Band 6, *Kreis Weisensee* (1882)
Band 7, *Grafschaft Wernigerode* (1883)
Band 8, *Kreis Merseburg* (1883)
Band 9, *Kreis Eckartsberga* (1883)
Band 10, *Kreis Calbe* (1885)
Band 11, *Stadt Nordhausen* (1888)
Band 12, *Grafschaft Hohenstein* (1889)
Band 13, *Stadt Erfurt und des Erfurter Landkreis* (1890)
Band 14, *Kreis Oschersleben* (1891)
Band 15, *Kreis Schweinitz* (1891)
Band 16, *Kreis Delitzsch* (1892)
Band 17, *Kreis Bitterfeld* (1893)
Band 18, *Mansfelder Gebirgskreises* (1893)
Band 19, *Mansfelder Seekreis* (1895)
Band 20, *Kreis Gardelegen* (1897)
Band 21, *Kreis Jerichow* (1898)
Band 22, *Kreis Ziegenrück und Schleusingen* (1901)
Band 23, *Halberstadt Land und Stadt* (1902)
Band 24, *Stadt Naumburg* (1903)
Band 25, *Stadt Aschersleben* (1904)
Band 26, *Kreis Naumburg (Land)* (1905)
Band 27, *Kreis Querfurt* (1909)
Band 28, *Kreis Heiligenstadt* (1909)
Band 29, *Kreis Wolmirstadt* (1911)

1581 **Die Kunstdenkmäler der Provinz Sachsen.** Burg, Hopfer, 1929-1938. 5v. illus. index. LC 50-47346.
Official inventory of art and architecture in the former province of Saxony (Provinz Sachsen). Succeeds *Die Bau- und Kunstdenkmäler der Provinz Sachsen* (1580). Contents:
Band 1, *Die Stadt Erfurt* (1929)
Band 2, *Die Stadt Efurt* (1931)
Band 2, 2, *Die Stadt Erfurt* (1932)
Band 3, *Kreis Stendal Land* (1933)
Band 4, *Kreis Osterburg* (1938)

1582 **Die Kunstdenkmäler im Bezirk Magdeburg.** Halle, Leipzig, Seemann, 1961- . illus index.

Official inventory of art and architecture in the Bezirk Magdeburg in the German Democratic Republic (East Germany). Bezirk Magdeburg is part of the old Freistaat and Königreich Sachsen. Successor to the series (1580 and 1581). To date, one volume has appeared: Band 1, *Kreis Haldensleben* (1961).

SAXONY (BEZIRKE DRESDEN, KARL-MARX-STADT, LEIPZIG)

1583 **Beschreibende Darstellung der älteren Bau- und Kunstdenkmäler des Königreichs Sachsen.** Dresden, various publishers, 1882-1923. 42v. illus. index.

Official inventory of art and architecture in the former kingdom of Saxony. Succeeded in 1929 by the series *Die Kunstdenkmäler des Freistaates Sachsen* (1584). Contents:

Heft 1, *Amtshauptmannschaft Pirna* (1882)
Heft 2, *Amtshauptmannschaft Dippoldiswalde* (1883)
Heft 3, *Amtshauptmannschaft Freiberg* (1884)
Heft 4, *Amtshauptmannschaft Annaberg* (1885)
Heft 5, *Amtshauptmannschaft Marienberg* (1886)
Heft 6, *Amtshauptmannschaft Flöha* (1886)
Heft 7, *Amtshauptmannschaft Chemnitz* (1886)
Heft 8, *Amtshauptmannschaft Schwarzenberg* (1887)
Heft 9, *Amtshauptmannschaft Auerbach* (1888)
Heft 10, *Amtshauptmannschaft Oelnitz* (1888)
Heft 11, *Amtshauptmannschaft Plauen* (1888)
Heft 12, *Amtshauptmannschaft Zwickau* (1889)
Heft 13, *Amtshauptmannschaft Glauchau* (1890)
Heft 14, *Amtshauptmannschaft Rochlitz* (1890)
Heft 15, *Amtshauptmannschaft Borna* (1891)
Heft 16, *Amtshauptmannschaft Leipzig* (1894)
Heft 17, *Amtshauptmannschaft Stadt Leipzig* (1895)
Heft 18, *Amtshauptmannschaft Stadt Leipzig* (1896)
Heft 19/20 *Amtshauptmannschaft Grimma (1897)*
Heft 21, *Stadt Dresden* (1909)
Heft 22, *Stadt Dresden* (1901)
Heft 23, *Stadt Dresden* (1903)
Heft 24, *Amtshauptmannschaft Dresden-Alstadt* (1904)
Heft 25, *Amtshauptmannschaft Döbeln* (1903)
Heft 26, *Amtshauptmannschaft Dresden-Neustadt* (1904)
Heft 27/28, *Amtshauptmannschaft Oschatz* (1905)
Heft 29, *Amtshauptmannschaft Zittau* (1906)
Heft 30, *Stadt Zittau* (1907)
Heft 31/32, *Amtshauptmannschaft Bautzen* (1908)
Heft 33, *Stadt Bautzen* (1909)
Heft 34, *Amtshauptmannschaft Löbau* (1910)
Heft 35, *Amtshauptmannschaft Kamenz* (1912)
Heft 36, *Städte Kamenz und Pulsnitz* (1912)
Heft 37, *Amtshauptmannschaft Grossenhain* (1914)
Heft 38, *Städte Grossenhain, Radeburg und Riesa* (1914)
Heft 39, *Meissen* (1917)
Heft 40, *Meissen (Burgberge)* (1919)
Heft 41, *Meissen-Land* (1923)
 Erganzungsheft-Altenzella (1922)

1584 **Die Kunstdenkmäler des Freistaates Sachsen.** Dresden, W. Bachman, 1929. illus. index.

Official inventory of art and architecture in the former free state of Sachsen (successor state to the kingdom of Saxony). Only one volume appeared: Band I, *Die Stadt Pirna* (Dresden, 1929).

BRANDENBURG (BEZIRKE POTSDAM, FRANKFURT AN DER ODER, COTTBUS)

1585 **Die Kunstdenkmäler der Provinz Mark Brandenburg.** Berlin, Deutscher Kunstverlag, 1907-1960. 21v. illus. index. LC 50-49544.

Official inventory of art and architecture in the former province of Brandenburg.
Contents:

Band I, 1, *Kreis Westpriegnitz* (1909)
Band I, 2, *Kreis Ostpriegnitz* (1907)
Band I, 3, *Kreis Ruppin* (1914)
Band II, 1, *Kreis Westhavelland* (1913)
Band II, 3, *Stadt und Dom Brandenburg* (1912)
Band III, 1, *Kreis Prenzlau* (1921)
Band III, 2, *Kreis Templin* (1937)
Band III, 3, *Kreis Angermünde* (1934)
Band III, 4, *Kreis Niederbarnim* (1939)
Band IV, 1, *Kreis Teltow* (1941)
Band V, 1, *Kreis Luckau* (1917)
Band VI, 1, *Kreis Lebus* (1909)
Band VI, 2, *Stadt Frankfurt a. Oder* (1912)
Band VI, 3, *Kreis Weststernberg* (1913)
Band VI, 4, *Kreis Oststernberg* (1960)
Band VI, 6, *Kreis Crossen* (1921)
Band VII, 1, *Kreis Königsberg* (1928)
Band VIII, 3, *Kreis Landsberg* (1937)

SILESIA (NOW UNDER POLISH ADMINISTRATION)

1586 **Verzeichnis der Kunstdenkmäler der Provinz Schlesien.** Breslau, Wilh. Gottl. Korn, 1886-1903. 5v. illus. index.

Official inventory of art and architecture in the former German province of Silesia.
Contents:

Band I, *Die Stadt Breslau* (1886)
Band II, *Die Landkreis des Reg. Bezirks Breslau* (1889)
Band III, *Reg. Bezirk Liegnitz* (1891)
Band IV, *Reg. Bezirk Oppeln* (1894)
Band V, *Register* [Index] (1903)

1587 **Die Bau- und Kunstdenkmäler Schlesiens.** Breslau, Wilh. Gottl. Korn, 1939-1943. 3v. illus. index.

Official inventory of the former German province of Silesia. Succeeded by *Bau- und Kunstdenkmäler des deutschen Ostens* (1588). Contents: Band II, *Kreis Namslau* (1939); Band IV, *Stadtkreis Oppeln* (1939); Band V, *Kreis Tost-Gleiwitz* (1943).

See also: (1588), (1589).

EAST AND WEST PRUSSIA

1588 **Die Bau- und Kunstdenkmäler des deutschen Ostens.** Stuttgart, Kohlhammer, 1957- . illus. index.
Inventory of art and architecture in the former German territories in Eastern Europe. To date, the following have appeared.
Reihe A. *Stadt Danzig*
 Band I, *Sankt Johann* (1957)
 Band II, *Sankt Katharinen* (1958)
 Band III, *Sankt Nikolai und andere Kirchen in Danzig* (1959)
 Band IV, *Marienkirche* (1963)
 Band V, *Kunstdenkmäler der Stadt Danzig* (1972)
Reihe B. *Ostpreussen*
 Band I: *Das Königsberger Schloss* (1956)
 Band II: *Goldschmiedekunst in Königsberg* (1959)
 Band III: *Kreis Oststernberg* (1960)
 Band IV: *Die mittelalterlichen Kirchenstühle in Westpreussen und Danzig* (1961)
 Band V: *Das Dohnasche Schloss Schlobitten in Ostpreussen* (1962)
 Band VI: *Stadt Elbing* (1964)
Reihe C. *Schlesien*
 Band I: *Landkreis Breslau* (1965)
 Band II: *Schlesische Malerei der Biedermeierzeit* (1965)
 Band III: *Der Orgelbau in Schlesien*

1589 **Bau- und Kunstdenkmäler im östlichen Mitteleuropa.** Frankfurt am Main, Weidlich, 1982- .
Collection of topographical handbooks and histories on art and architecture in the former German territories of Silesia, West and East Prussia. Successor to (1588). Contents:
 Band 1: Günther Grundmann, *Burgen, Schlösser und Gutshäuser in Schlesien I: Die mittelalterlichen Burgruinen, Burgen und Wohntürme* (1982)
 Band 2: Werner Renkewitz, *Geschichte der Orgelbaukunst in Ost- und Westpreussen von 1333 bis 1444 (I)* (1984)
 Band 3: Günther Grundmann, *Burgen, Schlösser und Guthäuser in Schlesien II: Schlösser und feste Häuser der Renaissance* (1987)

1590 **Die Bau- und Kunstdenkmäler der Provinz Westpreussen.** Danzig, Provinzial-Landtag, 1884-1919. 14v. illus. index.
Official inventory of art and architecture of the former German province of West Prussia. Contents:
 Band I, 1, *Kreis Carthaus, Berent und Neustadt* (1885)
 Band I, 2, *Landkreis Danzig* (1885)
 Band I, 3, *Kreis Pr. Stargard* (1885)
 Band I, 4, *Kreis Marienwerder westl. der Weichsel, Schwetz, Konitz, Schlochau, Tuchel, Flatow, Deutsch Krone* (1887)
 Band II, 5, *Kreis Kulm* (1887)
 Band II, 6, *Kreis Thorn* (1889)
 Band II, 7, *Stadt Thorn* (1889)
 Band II, 8, *Kreis Strasburg* (1891)
 Band II, 9, *Kreis Graudenz* (1894)
 Band II, 10, *Kreis Löbau* (1895)
 Band III, 11, *Kreis Marienwerder östl. der Weichsel* (1898)
 Band III, 12, *Kreis Rosenberg* (1906)
 Band III, 13, *Kreis Stuhm* (1909)
 Band IV, 14, *Neuteich, Tiegenort und die ländlichen Ortschaften* (1919)

WEST BERLIN

1591 **Die Bauwerke und Kunstdenkmäler von Berlin.** Berlin, Mann, 1961- .
Topographical inventory of the architecture and art of West Berlin. Thorough
bibliographical references in the footnotes and introductions to the major buildings and
monuments. Covers the art contents of buildings but not museums. To date, the following
have appeared:
Bezirk Charlottenburg (2v. 1961)
Schloss Charlottenburg (2v. 1970)
Stadt und Bezirk Spandau (1971)

Histories

1592 **Art Treasures in Germany: Monuments, Masterpieces, Commissions, and Collec-
tions.** General eds., Bernard S. Myers and Trewin Copplestone. New York, McGraw-Hill,
1970. 196p. illus. index. LC 73-76759.
Pictorial survey of architecture, painting, sculpture, and the decorative and minor
arts in Germany from the time of the Celts (550 B.C.) to the present. Periods are treated by
a variety of specialists. Contains maps and a glossary-index of museums and monuments,
but no bibliograpy. For the general reader.

1593 Dehio, Georg. **Geschichte der deutschen Kunst....** 3d ed. Berlin, de Gruyter, 1923-
1934. 4v. and atlas of plates. illus. index.
Comprehensive history of art and architecture in Germany from time of the Ger-
manic migrations through the early twentieth century. Volume four, covering nineteenth-
and twentieth-century art and architecture is written by Gustav Pauli. Separate volume of
plates for each volume of text. No bibliography. An old, but classic history of German art.

1594 Günther, Hubertus. **Bruckmann's Handbuch der deutschen Kunst.** Munich, Bruck-
mann, 1975. 336p. illus. index. LC 75-507632.
Concise history of German art and architecture from Germanic times to the present.
Chapters summarize the chief styles and periods of German art. Glossary of technical
terms, chronological table and bibliography (pp. 329-34) of basic works in German.

1595 Lindemann, Gottfried. **History of German Art: Painting, Sculpture, Architecture.**
New York, Praeger, 1971. 228p. illus. index. LC 79-89605.
Survey history of art and architecture in Germany from the Carolingian period
through the first half of the twentieth century. No bibliography.

1596 Pinder, Wilhelm. **Von Wesen und Werden deutscher Formen....** Leipzig, Seemann,
1937-1951. 4v. in 5. illus. index.
A new edition, edited by Georg Scheja, was published in 1957 (Frankfurt am Main,
Menck) with four volumes of text and three volumes of illustrations. Comprehensive his-
tory of art and architecture in Germany from the Carolingian period through the middle of
the sixteenth century. No bibliography. A standard history of German medieval and Ren-
aissance art and architecture.

1597 Vey, Horst, and Xavier de Salas. **German and Spanish Art to 1900.** New York,
Franklin Watts, 1965. 307p. illus. index. LC 64-23687.
Pictorial survey of art and architecture in Germany and Spain from Carolingian
times to 1900. Emphasis is on painting and sculpture. The introduction, which outlines the
chief characteristics, schools, and artists of Germany and Spain, is followed by a substan-
tial section devoted to artists' biographies. The work concludes with a brief historical
sketch of the development of art and architecture in Germany and Spain. Well-illustrated.
Brief and inadequate bibliographies of books in English are given at the end of the intro-
duction and in some of the biographies. Awkwardly arranged, but the numerous illustra-
tions and responsible, if too brief, text make it a useful survey for the general reader.

1598 Weigert, Hans. **Geschichte der deutschen Kunst.** 2d ed. Frankfurt am Main, Umschau, 1963. 2v. illus. index. LC 63-36375.

Concise history of art and architecture in Germany from paleolithic times through the early twentieth century. Selected bibliography (pp. 951-58). Reissue of an older, popular history of Germany art and architecture.

SWITZERLAND

Topographic Handbooks

1599 Deuchler, Florens. **Reclams Kunstführer: Schweiz und Liechtenstein.** 3d ed. Stuttgart, Reclam, 1979. 949p. illus. index. LC 70-355052.

Topographical guide to the art and architecture in Switzerland and Liechtenstein. Arranged alphabetically by place. Each city, town, or village is introduced with a historical sketch; for the major places, there are city plans, aerial views, and old views. Following the introduction, the various buildings and their artistic contents are thoroughly discussed. The major works of art and architecture are illustrated by interspersed plates. The entries for the major cities provide a brief description of the art museums. Excellent glossary of terms; indexed by place and artists. Designed as a pocket-sized field guide, this work is remarkably thorough. As a ready source for information on Swiss art and architecture, its coverage is exceeded only by the official inventories (1601).

1600 Hootz, Reinhardt. **Kunstdenkmäler in der Schweiz: Ein Bildhandbuch.** Munich, Deutscher Kunstverlag, 1969-1970. 2v. illus. index. LC 70-469028.

Comprehensive illustrated handbook of the art and architecture in Switzerland arranged by canton then by location. Erster Band, *Mit den Kantonen Aargau, Appenzell, Graubünden, Glarus, Luzern, St. Gallen, Schaffhausen, Schwyz, Thurgau, Unterwalden, Uri, Zürich, Zug;* Zweiter Band, *Mit den Kantonen Basel, Bern, Freiburg, Genf, Neuenburg, Solothurn, Tessin, Waadt, Wallis.* Each volume provides an introductory essay that briefly sketches the history of art and architecture in the particular region. This is followed by a collection of excellent plates; concise and factual notes to the plates, with plans (but no bibliography); and a chronological list of the works illustrated at the end. Does not include works in museums. Although no substitute for the official inventory of art and architecture in Switzerland (1601), these volumes are a handy and competent reference tool to works of art *in situ*; their small size permits their use as field guides for intensive art travel.

1601 **Die Kunstdenkmäler der Schweiz. Les monuments d'art et d'histoire de la Suisse.** Basel, Birkhäuser, 1927- . illus. index.

Official topographical inventory of the art and architecture in Switzerland and Liechtenstein. To date, the following have appeared:

Aargau, 1: Bezirke Aargau, Kulm, Zofingen (1948. Reprint: 1982) volume 21.
Aargau, 2: Bezirke Lenzburg und Brugg (1953) volume 29.
Aargau, 3: Kloster Königsfelden (1954) volume 32.
Aargau, 4: Bezirk Bremgarten (1967) volume 54.
Aargau, 5: Bezirk Muri (1967) volume 55.
Aargau, 6: Baden, Ennetbaden und oberen Reusstalgemeinden (1976) volume 63.
Appenzell Ausserhoden, 1: Bezirk Hinterland (1973) volume 61.
Appenzell Ausserhoden, 2: Bezirk Mittelland (1980) volume 70.
Appenzell Ausserhoden, 3: Bezirk Vorderland (1981) volume 72.
Appenzell Innerrhoden (1985) volume 74.
Basel-Landschaft, 1: Bezirk Arlesheim (1969) volume 57.
Basel-Landschaft, Band 2: Der Bezirk Liestal (1974) volume 62.
Basel Landschaft, Band 3: Bezirk Sissach (1986) volume 77.

Basel-Stadt, 1: Vorgeschichte, römische und fränkische Zeit; Geschichte und Stadt-bild; Befestigungen, Areal und Rheinbrücke, Rathaus und Staatsarchiv (1932. Reprint: 1971) volume 3.

Basel-Stadt, 2: Der Baseler Münsterschatz (1933. Reprint: 1982) volume 4.

Basel-Stadt, 3: Die Kirchen, Kloster und Kapellen, Teil 1. St. Alban bis Kartause (1941. Reprint: 1982) volume 12.

Basel-Stadt, 4: Kirchen, Kloster und Kapellen II: S. Katharina bis St. Niklaus (1961) volume 46.

Basel-Stadt, 5: Kirchen, Kloster und Kapellen III: S. Pter bis Ulrichskirche (1966) volume 52.

Bern 1: Stadt Bern. Stadtbild, Wehrbauten, Stadttore, Anlagen, Dankmäler, Brücken, Stadtbrunnen, Spitäler, Waisenhäuser (1952) volume 28.

Bern, 2: Gesellschaftshäuser und Wohnbauten (1959) volume 40.

Bern, Band 3: Die Staatsbauten der Stadt Bern (1947. Reprint: 1982) volume 19.

Bern, 4: Das Berner Münster (1960) volume 44.

Bern, 5: Die Kirchen der Stadt Bern: Antonierkirche, Französische Kirche, Heilig-geistkirche und Nydeggkirche (1969) volume 58.

Bern, Landband 1: Die Stadt Burgdorf (1985) volume 75.

Fribourg, 1: La ville de Fribourg: Introduction, plan de la ville, fortifications, pro-menades, ponts, fontaines, et édifices publics (1964) volume 50.

Fribourg, 2: La ville de Fribourg (1956) volume 36.

Fribourg, 3: La ville de Fribourg: les monuments religieux (1959) volume 41.

Fürstentums Liechtenstein (1950) volume 24.

Graubünden, 1: Die Kunst in Graubünden: eine Überblick (1975) volume 8.

Graubünden, 4: Die Täler am Vorderrhein, 1: Das Gebiet von Tamins bis Somvix (2d ed. 1975) volume 13.

Graubünden, 5: Die Täler am Vorderrhein II (1941, Reprint: 1961) volume 14.

Graubünden, 5: Herrschaft, Davos, Schnafigg, Churwalden, Albulatal (1937. Reprint: 1957) volume 9.

Graubünden, 6: Misox und Calanca (2d ed. 1975) volume 17.

Graubunden, 7: Chur und der Kreis Fünf Dörfer (2d ed. 1975) volume 20.

Graubünden, 11: Räzünser Boden, Domleschg, Heinzenberg, Oberhalbstein, Ober-und Unterengadin (2d ed. 1975) volume 11.

Luzern, 1: ämter Entlebuch und Luzern-Land (1946) volume 18.

Luzern, 2: Stadt Luzern I (1953) volume 30.

Luzern, 3: Stadt Luzern II (1954) volume 31.

Luzern, 4: Amt Sursee (1956) volume 35.

Luzern, 5: Amt Willisau mit St. Urban (1959) volume 42.

Luzern, 6: Amt Hochdorf (1963) volume 47.

Neuchatel, Band 1: La ville de Neuchatel (1955) volume 33.

Neuchatel, 2: Les districts de Neuchatel et de Baudry (1963) volume 49.

Neuchatel, 3: Les districts du Val-de Travers, du Val-de-Ruz, du locle et de La Chaux-de-Fonds (1968) volume 56.

Schaffhausen, 1: Stadt Schaffhausen (1951) volume 26.

Schaffhausen, 2: Bezirk Stein am Rhein (1943) volume 39.

Schaffhausen, 3: Kanton Schaffhausen ohne Stadt Schaffhausen (1960) volume 43.

Schwyz, 1: Der Bezirk Schwyz, Teil 1. Der Flecken Schwyz und das übrige Gemein-degebiet (1978) volume 65.

Schwyz, 1: Einsiedln, Höfe und March (1927) volume 1.

Schwyz, 2: Gersau, Küssnach und Schwyz (1930) volume 2.

Solothurn, 3: Bezirke Thal, Thierstein und Dorneck (1957) volume 38.

St. Gallen, 1: Bezirk Sargans (1951) volume 25.

St. Gallen, 2: Die Stadt St. Gallen I (1957) volume 37.

St. Gallen, 3: Stadt St. Gallen II (1961) volume 45.

St. Gallen, 4: Der Seebezirk (1966) volume 53.

St. Gallen, 5: Bezirk Gaster (1970) volume 59.

Thurgau, 1: Bezirk Frauenfeld (1950) volume 23.
Thurgau, 2: Bezirk Münchwilen (1955) volume 34.
Thurgau, 3: Bezirk Bischofszell (1962) volume 48.
Ticino, 1: Locarno e ils suo circolo (1972) volume 60.
Ticino, 2: L'Alto Verbano: Il circolo delle Isole (1979) volume 68.
Ticino, 3: L'Alto Verbano: Il circolo del Gambarogno e della Navegna (1983) volume 73.
Uri, 2: Die Seegemeinden (1986) volume 78.
Vaud, 1: La cathedrale de Lausanne (1944) volume 16.
Vaud, 1: La ville de Lausanne: Introduction édifices religieux (sans la cathedrale) (1965) volume 51.
Vaud, 3: La ville de Lausanne: édifices publics II. (1979) volume 69.
Vaud, 4: Villes, hameaux et maison de l'ancienne campagne Lausannoise (1981) volume 71.
Wallis, 1: Das Obergoms: die ehemalige Grosspfarrei Münster (1976) volume 64.
Wallis, 2: Das Ostergoms: die ehemalige Grosspfarrei Ernen (1979) volume 67.
Zug, 1: (1933. Reprint: 1959) volume 5.
Zug, 2: Die Stadt Zug: Kunststatische Kunst und Kultur im Zugerland (1935. Reprint: 1959) volume 6.
Zürich, 1: Bezirk Affoltern und Andelfingen (1935) volume 7.
Zürich, 2: Bülach, Diesdorf, Hinwil, Horgen und Meilen (193?) volume 10.
Zürich, Band 3: Die Bezirke Phäffikon und Uster (1978) volume 66.
Zürich, 4: Stadt Zürich I (194?) volume 15.
Zürich, 5: Stadt Zürich II (1949) volume 22.
Zürich, 6: Stadt Winterthur (1952) volume 27.
Zürich, 7: Bezirk Winterthur, südlicher Teil (1986) volume 76.
Zürich, Band 8: Der Bezirk Winterthur, nördlicher Teil (1986) volume 79.

Within the volumes, material is arranged by place. A thorough history of the place, with maps and old views, serves as an introduction. The important buildings and sites are thoroughly described and discussed, with footnotes referring to specialized literature. The art contents and decoration of the monuments are given extensive coverage. Well-illustrated. The epitome of a comprehensive and scholarly inventory of art and architecture. A basic reference and research tool.

1602 **Kunstführer durch die Schweiz.** Bern, Bühler, 1968-1982. 3v. illus. ISBN 3717001659.

First published as Hans Jenny, *Kunstführer der Schweiz* (1961). Pocket-sized guide to the architecture and art of Switzerland. Geographical arrangement.

Histories

1603 Gantner, Joseph, and Adolf Reinle. **Kunstgeschichte der Schweiz von den Anfängen bis zum Beginn des 20. Jahrhunderts.** Frauenfeld, Huber, 1936-1962. 4v. illus. index. LC 38-8266 rev.

A second edition of volume I, completely rewritten by Adolf Reinle, appeared in 1968 (Huber). Comprehensive history of art and architecture in Switzerland from ancient Roman times to the end of the eighteenth century. Very well illustrated with plates, plans, and diagrams. Excellent bibliographies are given at the end of each chapter and throughout the text in footnotes. The standard history of Swiss art and architecture.

1604 Ganz, Paul. **Geschichte der Kunst in der Schweiz von den Anfängen bis zur Mitte des 17. Jahrhunderts.** Basel, B. Schwabe,1960. 646p. illus. index. LC A61-1709.

History of art and architecture in Switzerland from prehistoric times through the Renaissance. The minor arts are given particularly good treatment. Excellent selection of plates and good, classified bibliography (pp. 613-16). A standard history of old Swiss art and architecture.

1605 Meyer, Peter. **Schweizerische Stilkunde.** 6th ed. Zürich, Spiegel, 1969. 288p. illus. index. LC 79-593833.

Concise history of art and architecture in Switzerland from prehistoric times to the present, with emphasis on the development of style. Well illustrated and provided with a bibliography (pp. 267-69) that lists major books in both German and French.

Great Britain and Ireland

TOPOGRAPHIC HANDBOOKS

1606 Royal Commission on the Ancient and Historical Monuments in Scotland. **An Inventory of Ancient Monuments.** Edinburgh, H. M. Stationery Office, 1933- . illus. index.

Official inventory of art and architecture in Scotland. To date, the following have appeared:
> *Argyll*
>> Volume 1: *Kintyre* (1971)
>> Volume 2: *Lorn* (1975)
>> Volume 3: *Mull, Tiree, Coll and Northern Argyll* (1980)
>> Volume 4: *Iona* (1982)
>> Volume 5: *Islay, Jura, Colonsay and Oronsay* (1984)
> *County Berwick* (1915)
> *Caithness* (1911)
> *County Dumfries* (1920)
> *East Lothian* (1924)
> *City of Edinburgh* (1951)
> *Eife, Kinross and Clackmannan* (1933)
> *Galloway* (2v. 1912-1914)
> *Lanarkshire: An Inventory of the Prehistoric and Roman Monuments* (1978)
> *Midlothian and West Lothian* (1929)
> *Orkney and Shetland* (3v. 1946)
> *Outer Hebrides, Skye and the Small Isles* (1928)
> *Peebleshire* (2v. 1967)
> *Roxburgshire* (2v. 1956)
> *Selkirkshire* (1957)
> *Stirlingshire* (2v. 193?)
> *Sutherland* (1911)

Within the volumes, the material is arranged by place. Following a history of the place are descriptions and discussions of the major buildings, their art contents, and their decoration. Archaeological sites are also covered. Specialized literature is referred to in the footnotes. Well illustrated with plates, maps, plans, and diagrams. Many volumes also provide a glossary of terms. Standard reference tool.

1607 Royal Commission on the Ancient and Historical Monuments of England. **An Inventory of Ancient Monuments.** London, H. M. Stationery Office, 1910- . illus. index.

Official inventory of art and architecture in England. Covers all major works from prehistory to the present. To date, the following have appeared:
> *Buckinghamshire*
>> Volume 1: *Buckinghamshire (South)* (1912)
>> Volume 2: *Buckinghamshire (North)* (1913)
> *Cambridgeshire*
>> Volume 1: *West Cambridgeshire* (1968)
>> Volume 2: *Northeast Cambridgeshire* (1972)
> *City of Cambridge* (2v. 1959)

Dorset
 Volume 1: *West Dorset* (1952)
 Volume 2: *South-East Dorset* (1970)
 Volume 3: *Central Dorset* (1971)
 Volume 4: *North Dorset* (1972)
 Volume 5: *East Dorset* (1975)
Essex
 Volume 1: *North-West Essex* (1916)
 Volume 2: *Central and South-West Essex* (1921)
 Volume 3: *North-East Essex* (1922)
 Volume 4: *South-East Essex* (1923)
Gloucestershire
 Volume 1: *Iron Age and Romano British Monuments* (1976)
Herefordshire
 Volume 1: *South-East Herefordshire* (1931)
 Volume 2: *East Herefordshire* (1932)
 Volume 3: *North-West Herefordshire* (1934)
Hertfordshire (1910)
Huntingdonshire (1926. Reprint: 1952)
London
 Volume 1: *Westminster Abbey* (1924)
 Volume 2: *West London excluding Westminster Abbey* (1925)
 Volume 3: *Roman London* (1928)
 Volume 4: *The City* (1929)
 Volume 5: *East London* (1930)
Middlesex (1937)
County of Northampton
 Volume 1: *Archaeological Sites in North-East Northamptonshire* (1975)
 Volume 2: *Archaeological Sites in Central Northamptonshire* (1979)
 Volume 3: *Archaeological Sites in North-West Northamptonshire* (1981)
 Volume 4: *Archaeological Sites in South-West Northamptonshire* (1982)
 Volume 5: *Archaeological Sites and Church in Northampton* (1985)
 Volume 6: *Architectural Monuments in North Northamptonshire* (1984)
City of Oxford (1939)
City of Salisbury (1977)
Town of Stanford (1977)
Westmorland (1936)
City of York
 Volume 1: *Eburacum, Roman York* (1962)
 Volume 2: *The Defences* (19??)
 Volume 3: *South-West of the Ouse* (1972)
 Volume 4: *Outside the City Walls; East of the Ouse* (1975)
 Volume 5: *The Central Area* (1981)

Within the volumes, the material is arranged by place. Following a brief history of the place, the major buildings, sites, monuments, etc., are described and discussed. Thorough reference to specialized literature is provided in the footnotes. Well illustrated with plates, maps, plans, and diagrams. Standard reference tool.

1608 Royal Commission on the Ancient and Historical Monuments of Wales. **An Inventory of Ancient Monuments.** London, H. M. Stationery Office, 1911- . illus. index.
 Official inventory of art and architecture in Wales. Covers all major works from prehistory to the present. To date, the following have appeared:
Anglesey (1937)
Caernarvonshire
 Volume 1: *East* (1956)
 Volume 2: *Central* (1960)

Volume 3: *West* (1964)
Carmarthen (1917)
Clamorgan
Volume 1: *Pre-Norman, Part 1: The Stone and Bronze Ages* (1976)
Volume 1: *Pre-Norman, Part 2: The Iron Age and the Roman Occupation* (1976)
Volume 1: *Pre-Norman, Part 3: The Early Christian Period* (1976)
Volume 3: *Medieval Secular Monuments, Part 2: Non-defensive* (1976)
Volume 4: *Domestic Architecture from the Reformation to the Industrial Revolution, Part 1: The Great Houses* (1976)
Denbigh (1914)
Flint (1912)
Merioneth (1921)
Montgomery (1911)
Pembroke (1925)
Radnor (1913)

Within the volumes, material is arranged by place. Following a brief history of each place, its major buildings, sites, monuments, etc., are described and discussed. Thorough reference to specialized literature is provided in the footnotes. Well-illustrated with plates, maps, plans, and diagrams. Standard reference tool.

HISTORIES

1609 Arnold, Bruce. **A Concise History of Irish Art.** Rev. ed. New York, Oxford University Press, 1977. 180p. illus. index.
Survey history of art and architecture in Ireland from the early Bronze Age through the twentieth century. Brief bibliography (pp. 206-207). A good survey history for the general reader.

1610 **Art Treasures in the British Isles: Monuments, Masterpieces, Commissions, and Collections.** General eds., Bernard S. Myers and Trewin Copplestone. New York, McGraw-Hill, 1969. 176p. illus. index. LC 76-76757.
Pictorial survey of English painting, sculpture, architecture, and minor arts from prehistory to the present. Period sections are written by variety of specialists. Contains maps and a glossary-index of museums and monuments, but no bibliography.

1611 Boase, T. S. R. **The Oxford History of English Art.** Oxford, Clarendon Press, 1949- . illus. index.
Comprehensive history of art and architecture in England from prehistoric times to the present. It is planned for eleven volumes, of which the following have appeared to date:
Volume II, *English Art 871-1110*, by D. Talbot Rice (1952)
Volume III, *English Art 1100-1216*, by T. S. R. Boase (1953)
Volume IV, *English Art 1216-1307*, by Peter Brieger (1957)
Volume V, *English Art 1307-1461*, by Joan Evans (1949)
Volume VII, *English Art 1553-1625*, by Eric Mercer (1962)
Volume VIII, *English Art 1625-1714*, by Margaret Winney and Oliver Millar (1957)
Volume IX, *English Art 1714-1800*, by John Burke (1976)
Volume X, *English Art 1800-1870*, by T. S. R. Boase (1959)
Volume XI, *English Art 1870-1940*, by Dennis Farr (1978)
Each volume is well illustrated with plates, plans, drawings and diagrams, and each has a thorough classified bibliography at the end. The standard history of English art and architecture.

1612 Finlay, Ian. **Art in Scotland.** London, Oxford University Press, 1948. 180p. illus. index.
Survey history of art and architecture in Scotland from Celtic times to the early twentieth century.

1613 Frey, Dagobert. **Englisches Wesen in der bildenden Kunst.** Stuttgart, Kohlhammer, 1942. 496p. illus.

Scholarly investigation of national character in English art and architecture from the Middle Ages to the end of the nineteenth century. Extensive bibliography in the notes (pp. 445-71) and list of source material (pp. 495-96). The work of a leading Austrian art historian, Frey's study is one of the best analyses of national art character. See also Pevsner (1619).

1614 Garlick, Kenneth. **British and North American Art to 1900.** New York, Franklin Watts, 1965. 250p. illus. index. LC 65-10268 rev.

Survey history of the painting, drawing, and sculpture of Great Britain and North America from the sixteenth century to 1900. Following a succinct introduction, a biographical section treats the life and works of major British and American painters, with brief literature citations. Illustrated with color and black and white plates.

1615 Harbison, Peter, Homan Potterton, and Jeanne Sheehy. **Irish Art and Architecture from Prehistory to the Present.** London, Thames and Hudson, 1978. 272p. illus. index. LC 78-55034.

Illustrated survey of Irish art and architecture. Contents: I, From Prehistory to 1600; II, The Seventeenth and Eighteenth Centuries; III, The Nineteenth and Twentieth Centuries. Good classified bibliography of books and periodical articles (pp. 265-68).

1616 Jacobs, Michael, and Malcolm Warner. **The Phaidon Companion to Art and Artists in the British Isles.** Oxford, Phaidon, 1980. 320p. illus. index. LC 81-132524.

Topographical handbook of the places important in the lives and works of British artists (mostly painters). Arrangement is by region and then by place. Information is provided concerning the location of places associated with the lives of artists and places depicted by artists. Introductions to the regions sketch the history of artistic life in the region from the eighteenth century to the present. Illustrated with photographs of places and many works of art depicting recognized places and works produced by artists while they were working in certain places. General bibliography, pp. 307-308.

1617 Mullins, Edwin. **The Arts of Britain.** Oxford, Phaidon, 1983. 288p. illus. index. LC 83-190968.

Collection of popular essays on various aspects of art and architecture in Great Britain centered around the theme of "Britishness." List of public collections and general bibliography, pp. 278-82.

1618 Osmond, Edward. **The Arts in Britain, from the Eighth to the Twentieth Centuries.** London, Studio, 1961. 207p. illus. index. LC 62-52391.

Survey history of art and architecture in the British Isles from early medieval times to the present. Good selection of illustrations.

1619 Pevsner, Nikolaus. **The Englishness of English Art.** Harmondsworth, Penguin, 1964. 229p. illus. index. LC NUC65-77133.

Study of English national character in art and architecture from the Middle Ages through the nineteenth century; based on a series of radio lectures broadcast in 1955. Contents: 1, The Geography of Art; 2, Hogarth and Observed Life; 3, Reynolds and Detachment; 4, Perpendicular England; 5, Blake and the Flaming Line; 6, Constable and the Pursuit of Nature; 7, Picturesque England; 8, Conclusion. Bibliographical references in the notes (pp. 207-220). See Frey (1613) as well for a complementary study.

Italy

TOPOGRAPHIC HANDBOOKS

1620 Hootz, Reinhardt, ed. **Kunstdenkmäler in Italien: Ein Bildhandbuch.** Munich, Deutscher Kunstverlag, 1973- . LC 75-113560.

A comprehensive series of illustrated handbooks on the art and architecture of Italy. To date, these have appeared: *Südtirol und Trentino (Trentino-Alto Adige)* (1973); *Venedig, Stadt und Provinz* (1974); *Venetien obne Venedig* (1976). Volumes covering all the major regions of Italy are planned. When completed, it should provide a most needed topographical guide to art and architectural monuments *in situ* in Italy. Does not include works of art in museums. The introductory essay, which sketches the art history of the particular region, is followed by a collection of excellent plates, concise and factual notes on the plates (with plans), and a chronological list of the works illustrated at the end. No bibliography. This will be a valuable reference tool for the advanced student. The small size of the volumes permits their use as field guides for intensive art travel.

1621 Keller, Harald. **Die Kunstlandschaften Italiens.** Munich, Prestel, 1960. 387p. illus. index. LC A61-3518.

Handbook of the regional styles of Italian art and architecture. The art, history, and geography of the various regions of Italy are discussed and coordinated by the use of maps. The pocket edition, published in 1965 by the same publisher, provides a collection of plates as well. Extensive bibliography in the notes. A standard work in the field of art geography.

1622 Ministero della Educazione Nazionale Direzione Generale delle Antichità e Belle Arti. **Inventario degli oggetti d'arte d'Italia.** Rome, La Libreria dello Stato, 1931-1938. 9v. illus. index.

Beginning of an official inventory of art objects in Italy. Does not include architecture. The series consists of:

Bergamo (1931)
Calabria (1932)
Parma (1934)
Aquila (1934)
Pola (1935)
Mantua (1935)
Padua (1936)
Ancona, Ascoli Piceno (1936)
Sondrio (1938)

Within the volumes, objects are arranged by location. Fairly well illustrated, the volumes have descriptive and historical text, with reference in the footnotes to specialized literature.

1623 **Reclams Kunstführer Italien.** Herausgegeben von Manfred Wundram. Stuttgart, Reclam, 1965- . illus. index. LC 72-460989.

Topographical guide to the art and architecture in Italy from prehistoric times to the present. To date, the following have appeared:

Band 1, 1, *Lombardy* (1981)
Band 1, 2, *Piedmont, Liguria, Aosta, Antal* (1981)
Band 2, 1, *Venedig, Brenta-Villen, Chioggia, Murano, Torcello* (2d ed. 1974)
Band 2, 2, *Südtirol, Trentino, Venezia-Giulia, Friaul, Veneto* (3d ed. 1981)
Band 3, *Florenz* (3d ed. 1975)
Band 4, *Emilia-Romagna, Marken, Umbrien* (1971)
Band 5, *Rom und Latium* (4th ed. 1981)
Band 6, *Neapel und Umgebung* (1983)

Arranged by place or site. A brief historical sketch precedes a thorough description of the major buildings and monuments, including their art contents and decoration. Modestly illustrated with plates, liberally provided with plans and diagrams, and well-indexed. No bibliography. The Reclam guides are intended as pocket guides for the serious art tourist, but their thoroughness makes them valuable reference works for the advanced student as well. This is especially so for Italy, where official inventories are lacking or inadequate.

HISTORIES

1624 Alazard, Jean. **L'art italien.** Paris, H. Laurens, 1949-1960. 4v. illus. index. LC A51-2809 rev.

Comprehensive history of art and architecture in Italy from earliest times through the nineteenth century. Contents: Volume 1, *Des origines à la fin du XIV^e siècle*; Volume 2, *Au XV^e siècle, le quattrocento*; Volume 3, *Au XVI^e siècle*; Volume 4, *De l'ère baroque au XIX^e siècle*. Volumes are well illustrated, and there are bibliographies of major books at the end of each volume. A standard history of Italian art.

1625 Ancona, Paolo d'. **Storia dell'arte italiana.** Florence, Marzocco, 1953-1954. 3v. illus. index. LC 60-34627.

History of art and architecture in Italy from ancient Roman times to the present. Volume 1, *Dall antichità classica al romanico*; Volume 2, *L'arte gotica e il quattrocento*; Volume 3, *Dal cinquecento all'arte contemporanea*. These well-illustrated volumes have responsible, factual text, with a bibliography at the end of each volume. A good general history of Italian art and architecture for beginning and advanced students.

1626 **Art Treasures in Italy: Monuments, Masterpieces, Commissions, and Collections.** General eds., Bernard S. Myers and Trewin Copplestone. New York, McGraw-Hill, 1969. 176p. illus. index. LC 72-76756.

Pictorial survey of architecture, painting, sculpture, and the minor arts in Italy from prehistory to the present. Periods are treated by a variety of specialists. Contains maps and a glossary-index of museums and monuments, but no bibliography. For the general reader.

1627 Baumgart, Fritz E. **Italienische Kunst: Plastik, Zeichnung, Malerei.** Berlin, Atlantis, 1936. 171p. illus. LC 37-10460.

Forward by Paul Clemen. Pictorial survey of 128 masterpieces of Italian sculpture, painting, and drawing from the Renaissance through the eighteenth century. Descriptive notes. No bibliography.

1628 Bottari, Stefano. **Storia dell'arte italiana.** Milan, Principato, 1955-1957. 3v. illus. index. LC A55-10697.

History of art and architecture in Italy from ancient Roman times to the present. Volume 1, *Dall'antichità al trecento*; Volume 2, *Il Rinascimento: L'arte del quattrocento*; Volume 3, *Dal cinquecento ai nostri giorni*. The good, classified bibliography (Volume 3, pp. 540-60) lists books in all languages.

1629 Carli, Enzo, and Gian Alberto Acqua. **Profilo dell'arte italiana.** Bergamo, Instituto Italiano d'Arte Grafiche, 1954-1955. 2v. illus. index. LC 56-21289.

Comprehensive history of Italian art and architecture from ancient Roman times to the mid-twentieth century. Selected bibliography of books and periodical articles (v. 2, pp. 647-66).

1630 Chastel, André. **Italian Art.** New York, T. Yoseloff, 1963. 526p. illus. index. LC 63-6134.

Concise history of art and architecture in Italy from the fifth century through the mid-twentieth century. Provides a good annotated and classified bibliography (pp. 403-22). Further specialized literature is given in the biographical and geographical indexes. The best history of Italian art in English.

1631 Mazzariol, Giuseppe, and Terisio Pignatti. **Storia dell'arte italiana.** Milan, Mondadori, 1960-1961. 3v. illus. index. LC 66-34913.

History of art and architecture in Italy from 2000 B.C. to the present. No bibliography. Popular survey history.

1632 Monteverdi, Mario. **Italian Art to 1850.** New York, Franklin Watts, 1965. 433p. illus. index. LC 64-23685.

Pictorial survey of the art and architecture of Italy from the middle of the thirteenth century to 1850. Emphasis is on painting and sculpture. The introduction (which outlines the chief characteristics, schools, and artists) is followed by a substantial section devoted to artists' biographies. The work concludes with a historical sketch of the development of Italian art and architecture. Well illustrated. Brief and inadequate bibliographies at the end of the introduction and in some of the biographies. Awkwardly arranged, but the numerous illustrations and responsible (though somewhat too brief) text make it a useful survey for the general reader.

1633 Salmi, Mario. **Arte italiana.** Florence, Sansoni, 1953. 2v. illus. index. LC 50-55508.

Well-illustrated survey history of Italian art and architecture from ancient Roman times to the present. First volume covers the period from Early Christian times to the end of the Gothic; second volume treats the Renaissance to the present. Introduction in the first volume gives an extensive history of ancient art and architecture as a background to Italian art. Good bibliographies at the end of each chapter.

1634 Toesca, Pietro. **Storia dell'arte italiana.** 2d ed. Turin, Unione Torinese, 1965. 3v. illus index. (Storia dell'Arte Classica e Italiana, v. 3). LC 67-117871.

Comprehensive history of art and architecture in Italy from the early Christian period through the fourteenth century. Well-illustrated with extensive bibliographical references in the footnotes. A standard, scholarly history of Italian medieval art and architecture.

1635 Venturi, Adolfo. **Storia dell'arte italiana.** Milan, Hoepli, 1901-1940. 11v. illus. index. Reprint: New York, Kraus, 1967. 11v. in 25. LC 66-9698.

Comprehensive history of art and architecture in Italy from the Early Christian period through the sixteenth century. Footnotes with bibliography. The standard history of Italian art. Index by J. D. Sisson, (Nendeln, Kraus, 1975. 2v.)

Low Countries

GENERAL WORKS

1636 Hammacher, A. M., and R. Hammacher Vandenbrande. **Flemish and Dutch Art.** New York, Franklin Watts, 1965. 316p. illus. index. LC 64-23686.

Pictorial survey of the art and architecture of the Low Countries from the thirteenth century through Post-Impressionism. Introduction outlines the major characteristics, schools, and artists. This is followed by a substantial section devoted to biographies of major artists. A concluding section, "Influences and Developments," ties the first two parts together in a brief history. Well illustrated. Brief, inadequate bibliographies are given at

the end of the introduction and in some of the biographies. Awkwardly arranged, but the numerous illustrations and the responsible, if brief, text make it a useful survey for the general reader and beginning student.

BELGIUM

Topographic Handbooks and Inventories

1637 Lemaire, Raymond M., ed. **Le patrimoine monumentale de la Belgique.** Liège, Ministère de la Culture Française, 1971- . LC 72-363660.

Inventory of art and architecture of the French-speaking part of Belgium: References to specialized literature throughout. To date, the following have appeared:

Tome 1, *Province de Brabant, Arrondissement de Louvain* (1971)
Tome 2, *Province de Brabant: Arrondissement de Nivelles* (1974)
Tome 3, *Province Liège: Arrondissement Liège* (1974)
Tome 4, *Province de Hainaut: Arrondissement de Mons* (1975)
Tome 5, *Province de Namur: Arrondissement de Namur* (2v. 1975)
Tome 6, *Province de Hainaut: Arrondissement de Tournai* (2v. 1978)

ANTWERP

1638 Donnet, Fernand, and G. Van Doorslaer. **Inventaris der Kunstvoorwerpen bewaard in de openbare gestichten der Provincie Antwerpen.** Antwerp, 1902-1940. 12v. illus. index.

Inventory of works of art in churches and other buildings open to the public in the Belgian province of Antwerp.

1639 Leeman, Hector. **Inventaris van het kunstpatrimonium van de Provincie Antwerpen.** Antwerp, De Nederlandsche Boekh., 1972- .

Inventory of art and architecture in the Belgian province of Antwerp. To date the following has appeared: Deel 1: *Sint Gummarus kerk te Lien* (1972).

BRABANT

1640 **Province de Brabant: Inventaire des objets d'art.** Brussels, 1904-1912. 3v. illus. index.

Inventory of art in the Belgian province of Brabant.

See also: Lemaire (1637).

EAST FLANDERS

1641 Dhannens, Elisabeth. **Inventaris van het Kunstpatrimonium van Oostvlaanderen.** Ghent, Kommisie voor Kulturele Aangelegenheden, 1951- . illus. index.

Inventory of art and architecture in the Belgian province of Oostvlaanderen (East Flanders). Thorough reference to bibliography in the footnotes. Contents:

Volume 1, *Temse* (1951)
Volume 2, *Kanton Kaprijke* (1956)
Volume 3, *Sint-Niklaaskerk, Gent* (1960)
Volume 4, *Dendermonde* (1961)
Volume 5, *Sint-Baafskathedral, Gent* (1965)
Volume 6, *Het retabel van het Lam Gods in de Sint-Baafskathedral te Gent* (1965)

Volumes 9, 10, *De Onze Lieve Vrouwerk van Pamela te Oudenoorde* (1978, 1979)
Volume 12, *Beoren, Doel, Kallo, Kieldrecht, Verrebroek* (1980)
Volumes 14, 15, *De Sint Martinuskerk te Aalst* (1980)
Volumes 16, 17, *De Gemeentenhuizen van Oostvlaandern* (1982)

1642 **Inventaire archéologique de Gand.** Ghent, 1897-1915. 57 fasc. in 3v. illus. index.
Inventory of art and architecture in Ghent.

1643 **Ouheidkundig Inventaris van Oost Vlaanderen.** Ghent, 1911-1915. 11v. illus. index.
Inventory of art and architecture in the Belgian province of East Flanders. In part, superseded by (1641).

HAINAUT

1644 **Inventaire des objets d'art et d'antiquité de la Province du Hainaut.** Mons, 1923-1941. 10v. illus. index.
Inventory of art and architecture in the Belgian province of Hainaut.

See also: Lemaire (1637).

LIÈGE

1645 **Inventaire des objets d'art et d'antiquité de la Province de Liège.** Liège, 1911-1930. 2v. illus. index.
Inventory of art and architecture in the Belgian province of Liège.

See also: Lemaire (1637).

LIMBURG

1646 **Oudheidkundig Inventaris der Kunstvoorwerken in Kerken en openbare Gebouwen van de Provincie Limburg.** Hasselt, 1916-1935. 9v. illus. index.
Inventory of art and architecture in the Belgian province of Limburg. Covers churches and other buildings open to the public. Includes only objects dating before 1830.

NAMUR

See: Lemaire (1637)

WEST FLANDERS

1647 Devliegher, Luc. **Kunstpatrimonium van West-Vlaanderen.** Utrecht, Lannoo, 1968- . LC 70-431740.
Inventory of art and architecture in West Flanders in Belgium. To date, the following have appeared:
Deel 2, *De huizen te Brugge* (1968)
Deel 3, *De huizen te Brugge* (1968)
Deel 4, *De Zwinstreek* (1970)
Deel 5, *Damme* (1971)
Deel 6, *De Onze-Lieve-Vrouwkerk te Kortrijk* (1973)
Deel 7, *De Sint Salvators Kathedral te Brugge: geschedenis in architektur* (1984)
Deel 8, *De Sint Salvators Kathedral te Brugge: inventaris* (1984)
Deel 9, *De Molens in West-Vlaandren* (1984)

Histories

1648 Clemen, Paul. **Belgische Kunstdenkmäler.** Munich, Bruckmann, 1923. 2v. illus. index.
 A collection of essays by various specialists (Clemen, Julius Baum, Greta Ring, etc.) on various aspects of the history of art and architecture in Belgium. Arrangement is chronological; volume one covers the ninth through fifteenth centuries, volume two covers the sixteenth through eighteenth centuries. Together they form a valuable history of art and architecture in Belgium.

1649 Fierens, Paul. **L'art en Belgique du Moyen Age à nos jours.** 3d ed. Brussels, Renaissance du Livre, 1957. 535p. illus. index.
 This history of art and architecture in Belgium is composed of essays, written by specialists, on the development of the various arts from the eleventh century through the early twentieth century. There are occasional footnotes with bibliography.

1650 Fierens, Paul. **L'art flamand.** Paris, Larousse, 1945. 164p. illus. index.
 Concise history of art and architecture in Belgium from the eleventh to the mid-twentieth century. A useful, classified bibliography is included (pp. 156-59). A popular survey history for the general reader and the beginning student. A standard history of Flemish art and architecture.

1651 Francastel, Pierre, ed. **L'art mosan.** Paris, A. Colin, 1953. 227p. illus.
 Collection of essays by European experts on aspects of medieval art and architecture in the Mosan region. Contents: La route de la Meuse et les relations lointaines des pays mosans entre le VIIIe et le XIe siècle (Maurice Lombard); Les arts du métal dans la vallée de la Meuse du Ier au Xe siècle (Faider-Feytmans); Ivoires mosans du haut moyen âge originaires de la région de la Meuse (W. F. Volbach); Les origines de la technique du bronze dans la vallée de la Meuse (Erich Meyer); Manuscrits pré-romans du pays mosan (André Boutemy); Les églises du haut moyen âge et le culte des anges (Paolo Verzone); La chronologie de la cathédrale de Tournai (Elie Lambert); La miniature dans le diocèse de Liège aux XIe et XIIe siècles (J. Stiennon); Les débuts du style roman dans l'art mosan (K. H. Usener); Quelques résultats des expositions de "L'art Mosan" à Liège, à Paris et à Rotterdam, 1951-1952 (J. de Borchgrave d'Altena); Orfèvrerie mosane-Orfèvrerie byzantine (André Grabar); Emaillerie mosane et emaillerie limousine aux XIIe et XIIIe siècles (S. Gauthier); Essai de groupement de quelques émaux autour de Godefroid de Huy (Hubert Landais); Le Chapiteau de pied de croix de Suger à l'abbaye de Saint-Denis (B. de Montesquiou-Fezensac); Influences mosanes dans les émaux anglais (C. Oman); A propos des vitraux de Châlons-sur-Marne. Deux points d'iconographie mosane (Louis Grodecki); L'iconographie du rétable typologique de Nicolas de Verdun à Klosterneubourg (L. Réau); La technique et le style du rétable de Klosterneubourg (Hans Hahnloser); Autour de Nicolas de Verdun (Otto Homburger); Oeuvres inédites d'art mosan en Pologne au XIIe siècle (Marjan Morelowski); La porte de bronze de Gniezno (P. Francastel); Orfèvrerie mosane et Orfèvrerie parisienne au XIIIe siècle (Pierre Verlet); Notes sur la vie et les oeuvres du sculpteur Jean de Liège (Pierre Pradel). Extensive bibliography in the footnotes.

1652 Helbig, Jules, and Joseph Brassinne. **L'art mosan depuis l'introduction du christianisme jusqu'à la fin du XVIIIe siècle.** Brussels, Van Oest, 1906-1911. 2v. illus. index.
 Comprehensive history of art and architecture in the Mosan region from the fifth century A.D. to the end of the eighteenth century. Tome 1: Des origines à fin du XVe siècle; tome 2: Du début du XVIe à la fin du XVIIIe siècle. Bibliographical footnotes.

1653 Leurs, Stan, ed. **Geschiedenis van de Vlaamsche Kunst....** Antwerp, de Sikkel, 1936-1940. 2v. illus. index.
 A history of Flemish art and architecture from the early Middle Ages through the early twentieth century. Sections were written by various specialists, with bibliographies at the end of chapters. Well illustrated with plates, plans, and diagrams.

1654 Rooses, Max. **Art in Flanders.** New York, AMS Press, 1970. 341p. illus. index. LC 79-100819.

 Pictorial history of art and architecture in Belgium from the late Middle Ages to the early twentieth century. For the general reader. Reprint of 1914 volume in the series: "Ars Una: Species Mille."

1655 Souillard, Colette. **Kunst in Belgie van de middeleeuwen tot vandaag. Art in Belgium from the Middle Ages to the Present Day.** Tielt, Lannoo, 1986. 160p. illus. LC 86-214848.

 Pictorial survey of art and architecture in Belgium from the Middle Ages to the present. Emphasis is on painting. Introductory essay and captions to plates in Flemish and English.

NETHERLANDS

Topographic Handbooks

1656 Hootz, Reinhardt. **Kunstdenkmäler in den Niederlanden: Ein Bildhandbuch.** Munich, Deutscher Kunstverlag, 1971. 421p. illus. index. LC 72-306403.

 Illustrated handbook of art and architecture in the Netherlands from the early Middle Ages through the present, arranged by place. An introductory essay sketching the art history of the Netherlands is followed by an excellent collection of plates, with informative notes to the plates (with plans). There is no bibliography. At the end of the volume is a useful chronological list of the works illustrated. Does not cover works of art in museums. Although it is not a substitute for the intensive and extensive coverage of art and architectural monuments in the official Dutch inventory (1657), this work is a most handy and competent reference tool and field guide to the art and architecture *in situ* in the Netherlands.

1657 **De Nederlandsche Monumenten vom Geschiedenis en Kunst.** Utrecht, Oosthoek, 1912- . illus. index. Reprint: Arnhem, Gjsberg and Van Loon, 1974.

 Official inventory of art and architecture in the Netherlands. To date, the following volumes have appeared:

 Deel 1, *De Provincie Noordbrabant. Part 1. Voormalige Baronie van Breda*
 Deel 2, *De Provincie Utrecht. Part 1. Gemeente Utrecht; Part 2. De Dom van Utrecht*
 Deel 3, *De Provincie Gelderland. Part 1. Het Kwartier van Nijmegen* (2v.); *Part 2. Het Kwartier van Zutphen*
 Deel 4, *De Provincie Overijsel. Part 1. Twente; Part 2. Zuid-Salland; Part 3. Noord en Oost-Salland*
 Deel 5, *De Provincie Limburg. Part 1, Gemeente Masstricht; Part 2. Noord-Limburg; Part 3. Zuid-Limburg*
 Deel 6, *De Provincie Groningen. Part 1. Oost-Groningen*
 Deel 7, *De Provincie Zuidholland. Part 1. Leiden en westelijk Rijnland*
 Deel 8, *De Provincie Noordholland. Part 1. Waterland; Part 2. Westfriesland; Part 3. De Gemeente Amsterdam*

Histories

1658 Gelder, Hendrik E. van, and J. Duverger. **Kunstgeschiedenis der Nederlanden van de Middleleeuwen tot onze Tijd....** 3d ed. Utrecht, de Haan, 1954-1956. 3v. illus. index. LC 55-1363.

 General history of art and architecture in the Netherlands and the Flemish part of Belgium from the early Middle Ages to modern times. Sections were written by various specialists. Bibliographical footnotes. Well illustrated. The standard history of Netherlandish art and architecture.

1659 **Guide to Dutch Art.** 3d rev. ed. The Hague, Government Printing and Publishing Office, 1961. 355p. illus. LC 62-5438.

Produced by the Netherlands Department van Onderwijs, Kunsten en Wetenschappen. Handbook to art and architecture in the Netherlands from the Carolingian period through the twentieth century. A historical introduction is followed by essays on the development of the various arts, a good collection of plates, and a useful guide to the principal towns (with maps). Also included are a brief bibliography (pp. 95-96) and a list and description of notable museums (pp. 90-94). A useful handbook for the general reader, the tourist, and the beginning student.

1660 Timmers, J. J. M. **A History of Dutch Life and Art.** Amsterdam, Elsevier, 1959. 201p. illus. index. LC 60-3972. British edition: London, Nelson, 1959. LC 60-427.

Concise survey of the art and architecture of the Netherlands from prehistory through the twentieth century. Although it is chiefly a history of art and architecture, each section is preceded by a brief cultural history of the period under consideration. Well illustrated, it has informative notes to the plates, but no bibliography. A good survey history for the general reader.

Scandinavia

GENERAL WORKS

1661 Kusch, Eugen. **Ancient Art in Scandinavia.** Nuremberg, Carl, 1965. 83p. (text); 176p. (illus.). LC 71-8618.

Pictorial survey of the art and architecture in Denmark, Sweden, and Norway from the Viking period through the sixteenth century. Introductory essay provides a popular history of Scandinavian art, followed by more specific information in the notes to the plates. No bibliography.

1662 Laurin, Carl, ed. **Scandinavian Art.** New York, American Scandinavian Foundation, 1922. 662p. illus. index. (Scandinavian Monographs, V).

Collection of essays by specialists on various aspects of the history of art and architecture in Denmark, Sweden, and Norway from the early Middle Ages through the early twentieth century. Contents: "A Survey of Swedish Art," by Laurin; "Danish Art in the 19th Century," by Emil Hannover; "Modern Norwegian Art," by J. Thiis. No bibliography. Still a useful introduction for the general reader.

DENMARK

Topographical Handbooks

1663 Copenhagen, Nationalmuseet. **Danmarks kirker, udgivet af Nationalmuseet....** v. 1- .Copenhagen, Gad, 1933- . illus. index. LC 36-5424.

Official inventory of the churches of Denmark with detailed descriptions and histories of the major and minor buildings together with their decorations and furnishings. Extensive bibliographical references. To date the following have appeared:

 1: *København.* B. 1-(4, 2), 1945-(1975).
 2: *Frederiksborg amt.* B. 1-4, 1964-1975.
 3: *Københavns amt.* B. 1-4, 1944-1951.
 4: *Holbak amt.* B. 1, 1979.
 5: *Sorø amt.* B. 1-2, 1936-1938.
 6: *Prasto amt.* B. 1-2, 1933-1935.
 6: *Nvneregister: Tillag.* 1955.

7: *Bornholm.* 1954.
8: *Maribo amt.* B. 1-2, 1948-1951.
12: *Tisted amt.* B. 1-2, 1940-1942.
16: *Århus amt.* B. 1-(4, 4), 1968-(1980).
19: *Ribe amt.* B. 1-(1, 6), 1979-(1982).
20: *Sønderjylland: Haderslev amt.* B. 1-2, 1954-1955.
21: *Sønderjylland: Tønder amt.* 1957.
22: *Sønderjylland: Abenrå amt.* 1959.
23: *Sønderjylland: Sønderborg amt.* 1961
Sønderjylland: Tilføjelser og rettelser, Kunsthistorisk oversigt, Registre. 1963.

1664 Zeitler, Rudolf. **Reclams Kunstführer Dänemark.** Stuttgart, Reclam, 1978. 431p. illus. index. LC 78-398048.
Topographical guide to the art and architecture of Denmark from prehistoric times to the present. Arranged by place or site. Each place is introduced by a brief historical sketch that precedes a thorough description of the major buildings and monuments, including their art contents and decoration. Intended as a pocket guide for the serious art tourist, its thoroughness makes it a valuable reference work. No bibliography.

Histories

1665 Beckett, Francis. **Danmarks Kunst.** Copenhagen, Kappel, 1924-1926. 2v. illus. index.
Comprehensive history of Danish art and architecture from prehistoric times to the end of the Gothic period. Bibliographical footnotes and general bibliographies at the end of each volume. Contents: volume 1, *Del Oldtiden og den seldre middelalder*; volume 2, *Gotiken.*

1666 Laurin, Carl G. **Nordisk konst; Danmarks och Norges konst fran 1880 till 1925.** Stockholm, Norstedt, 1925. 413p. illus. index.
History of art and architecture in Denmark and Norway from 1880 to 1925. Bibliographical footnotes.

1667 Noregard-Nielsen, Hans F. **Dansk kunst.** Copenhagen, Guldendal, 1983. 2v. illus. index. LC 84-109631.
History/handbook of art and architecture in Denmark from earliest times to the present. Volume one is a survey history, volume two is a biographical dictionary of major Danish artists.

1668 Norlund, Poul. **Danish Art through the Ages.** Copenhagen, Tidsskrift Danmark, 1948. 90p. illus. LC 49-17841.
This history of Danish art and architecture consists of essays by specialists; coverage extends from the Romanesque period through the twentieth century. No bibliography.

1669 Poulsen, Vagn. **Danish Painting and Sculpture.** Copenhagen, Det Danske Selskab, 1955. illus. index. 2d ed. Copenhagen, Det Danske Selskab, 1976. 234p. LC 77-374931.
Concise history from the twelfth century to 1940, with emphasis on the nineteenth and twentieth centuries. No bibliography.

1670 Poulsen, Vagn, ed. **Dansk Kunsthistorie: Billedkunst og Skulptur.** v. 1- . Copenhagen, Politiken, 1972- . illus. index. LC 73-327315.
History of painting and sculpture in Denmark from the Carolingian period to the middle of the nineteenth century. The fourth and final volume will cover the period 1850 to 1950. Well illustrated, but there is no bibliography and there are no footnotes. Text for the general reader and beginning student; plates useful to the advanced student.

1671 Poulsen, Vagn. **Illustrated Art Guide to Denmark.** Copenhagen, Gyldendal, 1959. 84p. illus. index. LC 59-8958.

Pocket handbook of art and architecture in Denmark with a survey history of Danish art and architecture, a list of museums, and a collection of small illustrations. No bibliography. For the general reader and the tourist.

FINLAND

1672 Hahm, Konrad. **Die Kunst Finnland.** Berlin, Deutscher Kunstverlag, 1933. 36p. illus.

Pictorial survey of art and architecture in Finland. Bibliography of basic books (p. 36).

1673 Lilius, Henrik, and Rudolf Zeitler. **Finnland: Kunstdenkmäler und Museen.** Stuttgart, Reclam, 1985. 343p. illus. index. ISBN 3150103347.

In the series: "Reclams Kunstführer." Topographical handbook of the art and architecture in Finland. Arrangement is by place. Brief history of the place followed by descriptions of the major buildings and their art contents. Museums are listed and briefly described at the end of each place entry. Introductory essays on the language and cultural history of Finland. Chronological table of major events, numerous maps, and glossary of terms.

1674 Okkonen, Onni. **Finnish Art.** Porvoo, Söderström, 1946. 42p. text, 208 plates.

Pictorial survey of Finnish painting and sculpture from the Middle Ages to the twentieth century. Includes medieval architecture. No bibliography.

1675 Ringbom, Sixten. ed. **Konsten i Finland: fran medeltid till nutid.** Helsinki, Schildt, 1978. 360p. illus. index. LC 80-475064

History of art and architecture in Finland from the Middle Ages to the present. Chapters written by various scholars. Bibliography of basic books and articles, pp. 344-51.

1675a **Suomen Kirkot. Finlands Kyrkor.** Suomen Muinaismusitoyhdistyksen puolesta julkaisseet/Utgivna av Finska Fornminnesf reningen genom. Helsinki, Museovirasto, 1950- . illus. index.

Official inventory of the art and architecture of the churches of Finland. Text in Finnish and Swedish. Bibliographies in the footnotes or at the end of the sections. In progress to date (1989) the following have appeared:
1. *Turun arkkihiippakunta I Osa: Vehmaan rovastikunta* (1959)
2. *Turun arkkihiippakunta II Osa: Myn m en rovastikunta* (1961)
3. *Turun arkkihiippakunta III Osa: Turun tuomiorovastikunta I* (1964)
4. *Turun arkkihiippakunta IV Osa: Perni n rovastikunta II* (1966)
5. *Turun arkkihiippakunta V Osa: Perni n rovastikunta I* (1968)
6. *Turun arkkihiippakunta VI Osa: Naantalin rovastikunta* (1972)
7. *Borga Stift Del I: Abolands prosteri I* (1973)
8. *Borga Stift Del II: Abolands prosteri II* (1975)
9. *Turun arkkihiippakunta VII Osa: Loimaan rovastikunta I* (1979)
10. *Turun arkkihiippakunta VIII Osa: Loimaan rovastikunta II* (1980)
11. *Turun arkkihiippakunta IX Osa: Loimaan rovastikunta III* (1982)
12. *Oulun hiippakunta I, Lepin rovastikunta I* (1984)
13. *Turun arkkihiippakunta X Osa: Loimaan rovastikunta IV* (1985)
14. *Oulun Hiippakunta 2: Kamin rovastikunta I* (1987)
15. *Turun arkkihiippakunta XI Osa: Lomaan rovastikunta V* (1988)

GREENLAND

1676 Kaalund, Bodil. **The Art of Greenland: Sculpture, Crafts, Painting.** Berkeley and Los Angeles, University of California Press, 1983. 224p. illus. index. LC 82-45908.

Well-illustrated survey of arts of the indigenous peoples of Greenland. Includes art of Europeans depicting places, events, and persons in Greenland. Excellent, classified bibliography (pp. 218-19).

ICELAND

1677 Eldjárn, Kristján. **Icelandic Art.** New York, Abrams, 1961. 14p. (text); 80p. (illus.). LC 61-5785.

Pictorial survey of painting, sculpture, and the minor arts of Iceland from the twelfth century through the nineteenth century. Brief text sketches the main lines of artistic development in Iceland. No bibliography.

NORWAY

1678 Aars, Harald, et al. **Norsk Kunsthistorie.** Oslo, Gyldendal, 1925. 2v. illus. index.

This history of Norwegian art and architecture consists of essays, written by specialists, on various periods from prehistoric times to the twentieth century. The classified bibliography is arranged by chapters (pp. 661-72). A standard history of Norwegian art and architecture.

1679 Berg, Knut, ed. **Norges kunsthistorie.** Oslo, Gyldendal, 1981-1983. 7v. illus. index. LC 82-719578.

Comprehensive history of art and architecture in Norway from Viking times to the present. Each volume has an extensive bibliography. Contents: volume 1, *Fra Oseberg til Borgund*; volume 2, *Hoymiddelalder og Hansa*; volume 3, *Nedgangstid og ny reisning*; volume 4, *Det unge Norge*; volume 5, *Nasjonal vekst*; volume 6, *Mellom-Krigstid*; volume 7, *Inn i en nytid*. Standard history of Norwegian art and architecture.

1680 Lexow, Einar Jacob. **Norges Kunst.** Oslo, Steenske, 1926. 342p. illus.

Concise history of art and architecture in Norway from prehistoric times to the twentieth century. Brief bibliography of major works (pp. 340-42). No index. A popular history for the general reader.

1681 Ostby, Leif. **Norges kunsthistorie.** Oslo, Gyldendal, 1977. 287p. illus. index. LC 77-550760.

Concise history of art and architecture in Norway from Viking times to the present.

SWEDEN

Topographic Handbooks

1682 **Sveriges Kyrkor. Konsthistoriskt Inventarium.** v. 1- . Stockholm, Generalstabers Litografiska Austalts Forläg, 1912- . Stockholm, Almqvist and Wiksell, 1970- . LC 59-43266.

Official inventory of art and architecture of the churches of Sweden. Summaries are given in German (before 1945) and English (after 1945) at the end of each volume. In recent volumes captions of the illustrations are translated into English. Bibliographies are in footnotes or at the end of sections. In progress, 202 volumes to date (1987), makes

Sveriges kyrkor the largest single art inventory. Up to 1976 all of the regional subseries were broken down into volumes (*Bänder*) and parts (*Häfte*). After 1976 the use of subseries numbering was abandoned for most but not all the regions. To clarify this situation and make it possible to locate a particular place, the individual volumes in *Sveriges kyrkor* are here grouped by region with those not having subseries numbering listed last. The overall series volume (*volym*) number is given following the publication date of the individual volume. The regional groups are listed alphabetically. However, anyone seeking volumes of *Sveriges kyrkor* through database search and interlibrary loan should know that in the early run (before 1976) the regional groups were listed according to a geographical pattern as follows: Uppland (part 1), Gotland (part 2), Västergotland (part 3), Stockholm (part 4), Dalarna (part 5), Östergotland (part 6), Värmland (part 7), Blekinge (part 8), Medelpad (part 9), Dalsland (part 10), Skane (part 11), Gästrikland (part 12), Närke (part 13), Smaland (part 14), Bohusland (part 15), Härjedalen (part 16), Södermanland (part 17), Öland (part 18), Lappland (part 19). In the same database records, the volumes published after 1976 are listed by the overall series volume (*volym*) number. An abbreviated English language subseries was begun in 1968. To date only volume I: *The Churches of Blekinge* (1968) has appeared.

Blekinge
I, 1, *Östra härad* (1926) volume 22
I, 2, *Medelsta härad* (1932) volume 36
II, *Bräkne och Listers häraden* (1941) volume 51
III, 1, *Fredrikskyrkan i Karlskrona* (1946) volume 59
III, 2, *Trefaldighetskyrkan eller Tyska kyrkan i Karlskrona* (1951) volume 65
III, 3, *Amiralitetskyrkan i Karlskrona* (1959) volume 86
IV, 1, *Ronneby kyrkor* (1959) volume 85
IV, 2, *Karlshamn kyrkor* (1960) volume 87
IV, 3, *Sölvesnorgs kyrkor* (1962) volume 93
V, 1, *Översikt av landskapets kyrkokonst* (1961) volume 90
V, 2, *Generalregister till Blekinge Band I-V* (1965) volume 106

Bohuslän
I, 1, *Västra Hisings härad* (1944) volume 57
I, 2, *Inlands Södre härad, sydvästra delen* (1965) volume 104
I, 3, *Ytterby, Kareby och Romelanda, Inlands Södre härad* (1967) volume 112
II, 1, *Inlands Nordre härad, södra delen* (1962) volume 95
III, 1, *Hjärtums och Västerlanda kyrkor* (1968) volume 122
IV, 1, *Kungälvs kyrkor, Inlands Södre härad* (1969) volume 132
IV, 2, *Kyrkorna in Marstrand* (1974) volume 154

Dalarna
I, 1, *Kyrkor i Leksands och Gagnefs tingslag* (1916) volume 6
I, 2, *Kyrkor i Falu Domsagas norra tingslag* (1920) volume 9
I, 3, *Kyrkor i Falu Domsagas södra tingslag* (1932) volume 37
II, 1, *Falu stads kyrkor* (1940) volume 52
Mora tingslag: kyrkorna i Mora (1984) volume 197

Dalsland
I, *Sundals härad* (1931) volume 34

Gästrikland
I, 1, *Gävle stads kyrkor* (1930) volume 39
I, 2, *Landskyrkorna* (1932) volume 44

Gotland
I, 1, *Kyrkor i Lummelunda ting* (1914) volume 3
I, 2, *Tingstäde kyrka* (1925) volume 21
I, 3, *Kyrkor in Bro ting* (1929) volume 31

I, 4, *Kyrkor in Endre ting* (1931) volume 33
I, 5, *Kyrkor i Dede ting* (1931) volume 35
II, *Kyrkor i Rute setting* (1933) volume 42
III, *Kyrkor i Hejde setting* (1942) volume 54
IV, 1, *Kyrkor i Linda ting* (1949) volume 61
IV, 2, *Kyrkor i Halla ting, norra delen* (1952) volume 66
IV, 3, *Kyrkor i Halla ting, södra delen* (1953) volume 68
IV, 4, *Kyrkor i Kräklinge ting, nordvästra delen* (1959) volume 84
IV, 5, *Kyrkor i Kräklinge ting, sydöstra delen* (1963) volume 97
IV, 6, *Samt Register till band IV* (1968) volume 101
V, 1, *Kyrkor pa Gotland; Garde ting södra delen* (1965) volume 105
V, 2, *Alskogs kyrka, Garde ting* (1908) volume 118
V, 3, *Garde kyrka* (1972) volume 145
VI, 1, *Burs kyrka. Burs ting* (1967) volume 115
VI, 2, *Stånga kyrka. Burs ting* (1968) volume 125
VI, 3, *Hems kyrkor, Hemse ting* (1969) volume 131
VI, 4, *Alva kyrka, Hemse ting* (1970) volume 137
VI, 5, *Rone kyrka* (1973) volume 150
VI, 6, *Eke kyrka, Hemse ting* (1974) volume 156
VI, 7, *Lau kyrka, Burs ting* (1975) volume 165
VII, 1, *Lojsta kyrka, Fardhems ting* (1977) volume 171
VII, 2, *Linde kyrka, Fardhems ting* (1981) volume 186
VIII, 2, *Sproge kyrka, Hablinge ting* (1982) volume 191
XI, 1, *Visby Domkyrka: Kyrkobyggnaden* (1978) volume 175
XI, 2, *Visby Domkyrka Inredning* (1986) volume 202
Visby: S Nicolaus och S Clemens (1977) volume 169
Hablinge ting: Eksta Kyrka (1978) volume 178
Visby: Helge Ands ruin och Hospitalet (1981) volume 184

Halland
Viske härad: Väro och Str valla Kyrkor (1979) volume 180
Himle härad: Kyrkorna i Varberg (1980) volume 181

Härjedalen
I, 1, *Kyrkor i Svegs tingslag, norvästra delen* (1961) volume 91
I, 2, *Kyrkor i Svegs tingslag, södra delen* (1965) volume 103
I, 3, *Kyrkor i Svegs tingslag, östra delen* (1966) volume 107

Lappland
I, 1, *Kiruna kyrkor* (1973) volume 153

Medelpad
I, 1, *Njurunda och Sköns tingslag samt Sundsvalls stad* (1929) volume 30
I, 2, *Indals, Ljustorps och Västra Domsagans tingslag* (1939) volume 47

Närke
I, 1, *Örebro stads kyrkor* (1939) volume 46
I, 2, *Kyrkor i Örebro härad* (1949) volume 63
I, 3, *Kyrkor in Glanshammars härad, sydvästra delen* (1961) volume 92
I, 4, *Ödeby kyrka, Glanshammars härad* (1969) volume 129
I, 5, *Lillkyrka och Götlunda kyrkor, Glanshammars härad* (1971) volume 141
I, 6, *Kyrkor i Närke* (1972) volume 147
Kumla kyrkor, Kumla härad (1976) volume 166

Öland
I, 1, *Kyrkor pa Öland Indledning* (1966) volumes 108 & 142
I, 2, *Böda och St. Olof: Akerbo härad* (1968) volume 116

I, 3, *Högby kyrkor: Akerbo härad* (1968) volume 119
I, 4, *Källa kyrkor: Akerbo härad* (1969) volume 128
I, 5, *Persnäs kyrkor: Akerbo Härad* (1970) volume 133
I, 6, *Föra kyrkor* (1972) volume 142
II, 1, *Runstens härad: Långlots Kyrkor* (1973) volume 151
II, 2, *Runstens härad: Löt och Egby* (1975) volume 163
II, 3, *Runstens härad: Gärdslösa Kyrka* (1978) volume 177
II, 4, *Runstens härad: Bredsättra Kyrkor* (1980) volume 183
II, 5, *Runstens härad: Runstens kyrkor* (1982) volume 188
Köpings kyrkor, Slättbo härad (1977) volume 170

Östergotland
I, 1, 2, *Kyrkor i Bankekings härad, norra delen* (1921) volumes 13 & 14
I, 3, *Bankekings härad, mellersta delen* (1963) volume 99
II, *Vreta Klosters kyrka* (1935) volume 43
Vadstena klosterkyrka II: Inredning (1983) volume 193
Vadstena klosterkyrka III: Gravminnen (1985) volume 196
Linköpings domkyrka I: Kyrkobyggnaden (1986) volume 200
Linköpings domkyrka II: Planscher (1986) volume 201

Skäne
I, 1, *Kävlinge kyrkor i Harjagers härad* (1932) volume 38
I, 2, *Barsebäcks och Hofterluds kyrkor* (1972) volume 144
I, 3, *Löddeköping och Höchs kyrkor* (1972) volume 148
II, 1, *Luggude härad, sydvästra delen* (1963) volume 96
II, 2, *Kyrkorna i Vä, Gärds härad* (1971) volume 139

Småland
I, *Jönköpings och Huskvarna kyrkor* (1940) volume 48
II, 1, *Kyrkorna i Sjösås uppvidinge härad* (1967) volume 114
II, 2, *Drews och Hornaryds kyrkor* (1968) volume 120
II, 3, *Dädesjö och Eke kyrkor: Uppvidinge härad* (1969) volume 126
II, 4, *Granhutts och Nottebäcks kyrkor* (1972) volume 149
III, 1, *Kalmar Slots kyrkor* (1968) volume 117
III, 2, *Kalmar Storkyrka* (1974) volume 158
III, 3, *Kalmar Gamla kyrkorgård, Sancta Birgittas* (1976) volume 162
IV, 1, *Växjö domkyrka* (1970) volume 137
IV, 2, *Växjö och Öjaby kyrkor* (1971) volume 143
V, 1, *Kinnevalds härad: Bergunda och Öja kyrkor* (1970) volume 138
V, 2, *Kinnevalds härad: Jäts kyrkor* (1977) volume 173
V, 3, *Vederslövs och Dänningelanda kyrkor, Kinnevalds härad* (1981) volume 185
VI, 1, *Uppvidinge härad: Aseda och Alghults kyrkor* (1974) volume 157
VI, 2, *Uppvidinge härad: Lenhovda och Herråkra kyrkor* (1977) volume 171

Södermanland
I, 1, *Strängnäs domkyrka I, 1: Medeltidens byggnadshistoria* (1968) volume 100
I, 2, *Strängnäs domkyrka 1, 2: Nyare tidens byggnnadshistoria samt beskrivning
 av kyrkog rden och begravningsplatsen* (1969) volume 124
I, 3, *Strängnäs domkyrka 1, 3: Kalkmalningar* (1982) volume 189
II, 1, *Strängnäs domkyrka II, 1: Gravminnen* (1974) volume 159
II, 2, *Strängnäs domkyrka II, 2: Inredning* (1978) volume 176
III, 1, *Soltholms härad: Sorunda kyrka* (1972) volume 146
III, 2, *Soltholms härad: Ösmo kyrka* (1973) volume 152
III, 3, *Soltholms härad: Tyresö kyrka* (1978) volume 179
IV, 1, *Svartlösa härad: Botkyrka kyrkor* (1975) volume 161
V, 1, *Fors kyrka, Villattinge härad* (1976) volume 168
V, 2, *Torshälla kyrka, Västerrekarne härad* (1981) volume 187

Stockholms kyrkor

I, 1, 2, 3, *St. Nikolai eller Storkyrkan* (1925-27) volumes 17, 24, 25
II, 1, 2, *Riddarholmskyrkan* (1928-37) volumes 28, 45
III, 1, *Ulrika Eleonara elle Kungsholm kyrka me St. Görans kapell* (1915) volume 5
III, 2, *Hedvig Eleonara kyrka* (1920) volume 10
IV, 1, 2, *S. Jacobs* (1928-30) volumes 26, 32
IV, 3, *S. Johannes kyrka och S. Stefans kapell* (1934) volume 40
V, 1, *Adolf Fredriks kyrka ochs S. Olovs kapell* (1924) volume 20
V, 2, *Gustav Vasa kyrka* (1943) volume 55
V, 3, *Matteus kyrka* (1946) volume 60
VI, 1, 2, *S. Klara kyrka* (1927) volumes 23, 27
VII, 1, *S. Maria Magdalena kyrka* (1934) volume 41
VII, 2, *Katarina kyrka* (1944) volume 56
VII, 3, *Sofia kyrka* (1961) volume 89
VII, 4, *Högalids kyrka* (1966) volume 109
VIII, 1, *Bromma kyrka och Västerledskyrkan* (1940) volume 49
VIII, 2, *Spanga och Hässelby kyrkor* (1959) volume 83
VIII, 3, *Brännkyrka, S. Sigfrids och Enskede kyrkor* (1964) volume 102
IX, 1, *Skeppsholmskyrkan elle Johanns kyrka* (1942) volume 53
IX, 2, *Oscar kyrka* (1975) volume 160
IX, 3, *Hjorthagen kyrka* (1980) volume 182

Uppland

I, 1, *Kyrkor i Danderyds skeppslag: mellersta delen* (1918) volume 7
I, 2, *Kyrkor i Danderyds skeppslag: östra och västra delen* (1928) volume 29
I, 3, *Kyrkor i Värmdo skeppslag* (1949) volume 62
I, 4, *Kyrkor i Akers skeppslag* (1950) volume 64
II, 1, *Kyrkor i Väddö och Haverö skeppslag* (1918) volume 8
II, 2, *Kyrkor i Bro och Vätö skeppslag* (1940) volume 50
II, 3, *Kyrkor i Fröntuna och Länna skeppslag* (1945) volume 58
II, 4, 5, *Kyrkor i Frösakers härad* (1955-56) volumes 74, 75
III, 1, 2, *Kyrkor i Langshundra härad* (1921-52) volumes 12, 67
III, 3, *Kyrkor i Närdinghundra härad, västra delen* (1953) volume 69
III, 4, *Närdinghundra härad, östra delen* (1953) volume 70
IV, 1, *Kyrkor i Erlinghundra härad* (1912) volume 1
IV, 2, *Kyrkor i Seminghundra härad* (1919) volume 11
V, 1, *Kyrkor i Vallentuna härad, östra delen* (1953) volume 71
V, 2, *Kyrkor i Vallentuna härad, västra delen* (1955) volume 72
V, 3, *Kyrkor i Sjuhundra härad, sydvästra delen* (1956) volume 78
V, 4, *Kyrkor i Sjuhundra härad, nordöstra delen* (1958) volume 80
V, 5, *Kyrkor i Lyhundra härad* (1961) volume 88
V, 6, *Estuna och Sörderby-Karls kyrkor i Uppland* (1966) volume 110
V, 7, *Karls Kyrkoruin* (1967) volume 113
VI, 1-3, *Kyrkor i Farentuna härad* (1954-57) volumes 73, 77, 79
VI, 4, *Kyrkor i Sollentuna härad, södra delen* (1958) volume 81
VI, 5, *Kyrkor i Sollentuna härad, norra delen* (1958) volume 82
VII, 1, *Kyrkor i Bro härad* (1956) volume 76
VII, 2, *Kyrkor i Håbo härad, södra delen* (1962) volume 94
VII, 3, *Kyrkor i Håbo härad, mellersta delen* (1963) volume 98
VIII, 1, *Trögds härad* (1974) volume 155
IX, 1, *Härkeberga kyrka: Trögds härad* (1968) volume 123
IX, 2, *Litslena kyrka* (1969) volume 127
X, *Enköping Kyrkor* (1984) volume 195
XI, 1, *Svinnegarns, Enköpings-Näs och Teda kyrkor* (1966) volume 111
XI, 2, *Tillinge kyrka: Assunda härad* (1969) volume 121

XI, 3, *Sparrsätra och Breds kyrkor, Asunda härad* (1969) volume 130
XII, 1, *Kulla och Hjälsta kyrkor, Lagunda härad* (1970) volume 134
XII, 2, *Fittja kyrka, Lagunda härad* (1970) volume 140
XIII, 1, *Ulriksdal slottskapell* (1976) volume 167
XIII, 2, *Drottningholms slottskyrka* (1977) volume 174

Värmland
I, 1, *Grums härad, norra delen* (1924) volume 18
I, 2, *Grums härad, södra delen* (1924) volume 19

Västergötland
I, 1, *Kallands härad, norra delen* (1913) volume 2
I, 2, *Kallands härad, sydöstra delen* (1915) volume 4
I, 3, *Kallands härad, sydvästra delen I* (1918) volume 15
I, 4, *Kallands härad, sydvästra delen II* (1922) volume 16
II, 1, *Habo kyrka, Vartofta härad* (1969) volume 135
II, 2, *Brandstorps kyrka, Vartofta härad* (1975) volume 164
Varnhems klosterkyrka, Valle härad (1982) volume 190
Läckö slottskyrka (1985) volume 198

Independent of the regional subdivisions
192, *Medeltida träkyrkor I: Småland samt Ydre och Kinda i Östergötland* (1983) volume 192
Medeltida träkyrkor II: Västergotland, Värmland, Närke (1985) volume 199

1683 Zeitler, Rudolf. **Schweden. Kunstdenkmäler und Museen** . Stuttgart, Reclam, 1985. 729p. illus. index. LC 86-107192.
 In the series: "Reclams Kunstführer." Topographical handbook of the art and architecture in Sweden. Arrangement is by place. A brief history of the place is followed by a description of the major buildings and their art contents. Museums are listed and briefly described at the end of the place entries. Introductory essays on the language and cultural history, numerous maps, chronological table of major events in Swedish history and glossary of terms.

Histories

1684 Cornell, Henrik. **Den svenska Konstens Historia**. 2d ed. Stockholm, Aldus/ Bonnier, 1966. 2v. illus. index. LC 67-101872.
 History of art and architecture in Sweden from the Viking period to about 1800. Supplementary chapter covers the graphic arts from 1600 to 1700. Bibliography (pp. 421-32) arranged by chapters. Excellent collection of plates, plans, and diagrams. A standard history of Swedish art, particularly good for the Middle Ages.

1685 Grate, Pontus, ed. **Treasures of Swedish Art, from Pre-Historic Age to the 19th Century**. Malmö, Allhem, 1965. 166p. illus. LC 66-51407.
 Pictorial survey of art and architecture in Sweden from prehistoric times to the nineteenth century. The brief introductory essay, which sketches the development of Swedish art, is followed by a collection of plates with informative notes.

1686 Lindblom, Andreas A. F. **Svensk Konst; från Stenåldern till Rymdåldern**. Stockholm, Norstedt, 1960. 410p. illus. index. LC 60-32013.
 Concise history of art and architecture in Sweden from prehistoric times to the present. No bibliography. A well-illustrated recent survey history for the general reader and the beginning student.

1687 Lindblom, Andreas. **Sveriges Konsthistoria från Forntid till Nutid.** Stockholm, Nordisk Rotogravyr, 1944-1946. 3v. illus. index.
Comprehensive history of art and architecture in Sweden from prehistoric times to the mid-twentieth century. Well-illustrated, but no bibliography. A standard history.

1688 Lindgren, Mereth, et al. **A History of Swedish Art.** Lund, Signum, 1987. 277p. illus. index. ISBN 9185330787.
Well-illustrated survey of art and architecture in Sweden from early Viking times to the present. Contents: 1000-1520 by Mereth Lindgren; 1520-1728 by Birgitta Sandström; 1728-1886 by Anna Greta Wahlberg; 1886-1980 by Louise Lyberg. No bibliography.

1689 Romdahl, Axel L., and Johnny Roosval. **Svensk Konsthistoria.** Stockholm, Aktien-bolaget, 1913. 612p. illus. index.
Comprehensive history of art and architecture in Sweden from the early Middle Ages to the end of the nineteenth century. Chapters are written by various Swedish experts, and each chapter has a brief bibliography at the end.

1690 Roosval, Johnny A. E. **Swedish Art.** Princeton, Princeton University Press, 1932. 77p. illus. (Princeton Monographs in Art and Archaeology, XVIII).
A collection of lectures given at Princeton in 1929 covering most aspects of the history of Swedish art and architecture (with the exception of the eighteenth century). Bibliography in the footnotes.

1691 Serner, Gertrud. **Treasures of Swedish Art, from Earliest Times to the Beginning of the Twentieth Century.** Stockholm, Forum, 1950. 111p. illus.
Pictorial survey of art, excluding architecture, in Sweden from early Viking times to 1900. No bibliography.

Spain and Portugal

TOPOGRAPHIC HANDBOOKS

1692 Gudiol i Ricart, Josep, and Santiago Alcolea. **Hispania guía general del arte español.** Barcelona, Argos, 1962. 2v. illus. index.
Handbook of art and architecture of Spain, arranged by provinces. Includes the Canary Islands. No bibliography.

1693 Milicua, D. José. **Guide artistique de l'Espagne.** Paris, Tisne, 1967. 559p. illus. index.
Handbook of art and architecture in Spain arranged by place. Provides small illustrations and short descriptions, but no bibliography.

1694 **Catálogo monumental de España.** Madrid, Ministerio de Instrucción Pública y Bellas Artes, 1924- . illus. index.
Official inventory of art and architecture in Spain. Volumes are arranged by province and city; to date, the following have appeared:
Provincia de Badajoz (3v. 1925-1926)
La Ciudad de Barcelona (1947)
Provincia de Cáceres (3v. 1924)
Provincia de Cádiz (2v. 1934)
Provincia de Leon (2v. 1925)
Provincia de Palencia (4v. 1946-1951)
Provincia de Salamanca (2v. 1967)
Zaragoza (2v. 1957)
Provincia de Zamora (2v. 1927)

Within volumes, material is arranged by chronological period. Reference to specialized literature is made in the footnotes. This is the standard topographical handbook of art and architecture *in situ* in Spain. It is not yet complete, however, and several regions have been inventoried by local groups; see below.

1695 **Catálogo monumental de la Provincia de Palencia.** Palencia, Imprenta Provincial, 1939-1951. 4v. illus. index.

Topographical inventory of the art and architecture of the province of Palencia (North Central Spain). Emphasis is on architecture, but the chief works of art and decoration in the various buildings are also treated. Reference to specialized literature in the footnotes.

1696 **Catálogo arqueológico y artístico de la Provincia de Sevilla.** v. 1- . Seville, Servicio de Defensa del Patrimonio Artístico Nacional, 1939- . illus. index.

Topographical inventory of the art and architecture in the province of Seville, Spain. Arranged by place, it treats the major architectural monuments, archaeological sites, and the art contents and decorations of the major buildings in the province. Reference to specialized literature is found in the footnotes. Fills a gap, although incompletely, in the official inventory of Spanish art and architecture (1694).

1697 **Catálogo monumental de la Provincia de Toledo.** Toledo, Publicationes de la Excelentisma Diputación Provincial de Toledo, 1959. 413p. illus index.

Topographical inventory of the art and architecture of the province of Toledo. Emphasis is on the architectural monuments, but the art contents and decoration of the major buildings are also covered. Reference to specialized literature is found in the footnotes. Fills a gap in the official inventory of Spanish art and architecture (1694).

1698 **Catálogo monumental de la Provincia de Valladolid.** Valladolid, Editado por la Excelentisma Diputación Provincial de Valladolid, 1960- . 5v. to date. illus. index.

Topographical inventory of the art and architecture in the province of Valladolid, Spain. Arranged by place, it emphasizes the architectural monuments, but the art contents and decoration of the major buildings are also covered. Reference to specialized literature is in the footnotes. Fills a gap in the official inventory of Spanish art and architecture (1694).

1699 **Inventário artístico de Valladolid y su Provincia.** Valladolid, Sever-Cuesta, 1970. 361p. illus. index.

Author: Juan J. M. Gonzalez. Concise inventory of the art and architecture of the city and province of Valladolid. Emphasis is on architecture, with brief notices of works of art and decoration contained within the major buildings. No bibliography.

1700 **Catálogo monumental Diócesis de Vitoria.** Vitoria, Spain, 1967- . 4v. to date. illus. index. LC 71-234343.

Topographical inventory of the art and architecture in the diocese of Vitoria. Arranged by place, it emphasizes the buildings, but the art contents and decoration of the major structures are also covered. Well illustrated, with thorough reference to specialized literature in the footnotes. Fills a gap in the official inventory of Spanish art and architecture (1694).

1701 **Catálogo de monumentos de Vizcaya.** Bilbao, Junta de cultura de Vizcaya,, 1958. 2v. illus. index. LC 63-33570 rev.

Inventory of the art and architecure in the province of Vizcaya. Although the emphasis is on buildings, archaeological sites and the artistic contents of the buildings are also covered. Reference to specialized literature is in the footnotes. Arranged by place. Fills a gap in the official inventory of Spanish art and architecture (1694).

1702 **Inventário artístico de Portugal.** Lisbon, Academia Nacional de Bellas Artes, 1943- . illus. index.

Official inventory of art and architecture in Portugal. The first eight volumes are as follows:

I,	*Distrito de Portalegre* (1943)
II,	*Cidade de Coimbra* (1947)
III,	*Distrito de Santarém* (1949)
IV,	*Distrito de Coimbra* (1952)
V,	*Distrito de Leira* (1955)
VI,	*Distrito de Aveiro* (1959)
VII,	*Concelho de Évora* (2v. 1966)
VIII,	*Distrito de Évora* (2v. 1975)

Each volume is organized by place. A summary of the political and artistic history of the locality is followed by a detailed description of the major buildings and their contents. Specialized literature is referred to in the footnotes. Additional volumes are planned. A standard reference tool.

1703 **Reclams Kunstführer Spanien.** Stuttgart, Reclam, 1986- . ISBN 3150103398.
Topographical guide to the art and architecture of Spain. Arrangement within the volumes is by place and includes museums. To date the following has appeared: *Band 1: Madrid und Zentralspanien,* by G. Noehles-Doerk (1986).

HISTORIES

1704 **Art Treasures in Spain: Monuments, Masterpieces, Commissions, and Collections.** General eds., Bernard S. Myers and Trewin Copplestone. New York, McGraw-Hill, 1969. 175p. illus. index. LC 70-76758.
Pictorial survey of the architecture, painting, sculpture, and the decorative arts in Spain from prehistory to the present. Sections were written by a variety of specialists. Contains maps and a glossary-index of museums and monuments, but no bibliography.

1705 Barreira, João, ed. **Arte portuguesa.** Lisbon, Excelsior, n.d., 3v. in 4. illus. index.
Comprehensive history of Portuguese art and architecture from antiquity to the twentieth century. Tomo 1: *Arquitetura e escultura*; tomo 2: *Pintura*; tomo 3: *Artes decorativas.* Bibliographical footnotes.

1706 Cirici-Pellicer, Alejandro. **Treasures of Spain from Charles V to Goya.** Geneva, Skira; Cleveland, World, 1965. 236p. illus. index. LC 65-24418.
Introduction by F. J. Sánchez Cantón. Pictorial survey of art and architecture in Spain from the sixteenth through the early nineteenth centuries. No bibliography. Excellent color plates.

1707 Dieulafoy, Marcel. **Art in Spain and Portugal.** London, Heinemann, 1913. 376p. illus. index.
In the series, "Ars Una: Species Mille." General survey of art and architecture in Spain and Portugal from Moorish times to the end of the nineteenth century. Has a long introduction tracing the development of Islamic art and architecture from Sassanian times to the conquest of Spain. Last chapter on Portuguese art. No bibliography.

1708 Gaya Nuño, Juan A. **Historia del arte español.** Madrid, Editorial Plus-Ultra, 1946. 478. illus. index.
Concise history of art and architecture in Spain from prehistoric times to the present. Provides a chronological table and a bibliography (pp. 448-50) that lists major books, chiefly in Spanish.

1709 Gudiol i Ricart, Josep. **The Arts of Spain.** Garden City, N.Y., Doubleday, 1964. 318p. illus. index. LC 64-13731.
Survey history of art and architecture in Spain from prehistoric times to the present. Well illustrated and provided with a bibliography (pp. 305-307) of basic books in all languages. A good survey for the general reader.

1710 Gudiol i Ricart, Josep, ed. **Ars Hispaniae: Historia universale del arte hispánico.** Madrid, Plus-Ultra, 1947-1973. 21v. illus. index. LC 51-23057 rev.

Comprehensive history of art and architecture in Spain. Written by specialists, it covers the period from prehistoric art through the twentieth century. Volume XXI is a history of art and architecture in Latin America (exclusive of Brazil) and the Philippine Islands. Each volume has an excellent classified bibliography of books and periodical articles in all languages. Well illustrated. The standard history of Spanish art and architecture.

1711 Hagen, Oskar. **Patterns and Principles of Spanish Art.** Madison, University of Wisconsin Press, 1943. 2d ed. illus. index.

Concise history of Spanish art and architecture from prehistoric times to the present. Bibliographical references in footnotes. This is still a competent survey history for the general reader.

1712 Jiménez-Placer, Fernando, and Alejandro Cirici-Pellicer. **Historia del arte español.** Barcelona, Labor, 1955. 2v. illus. index.

History of art and architecture in Spain from Paleolithic times through the twentieth century. Well illustrated. No bibliography.

1713 Kehrer, Hugo. **Spanische Kunst von Greco bis Goya.** Munich, H. Schmidt, 1926. 364p. illus. index.

Well-illustrated survey of Spanish art and architecture from the sixteenth through the eighteenth centuries. Emphasis is on painting. Bibliographical footnotes.

1714 Kubler, George, and Martin Soria. **Art and Architecture in Spain and Portugal and Their American Dominions: 1500 to 1800.** Harmondsworth, Penguin, 1959. 445p. illus. index. (Pelican History of Art, Z17). LC 60-666.

Comprehensive and scholarly history of art and architecture in Spain, Portugal, and Latin America from 1500 to 1800. Excellent selection of plates, plans, and diagrams. Good classified bibliography of books and periodical articles (pp. 403-416), with further reference to more specialized literature in the extensive footnotes. A standard history of Spanish, Portuguese, and early Latin American art and architecture.

1715 Lambert, Élie. **L'art en Espagne et au Portugal.** Paris, Larousse, 1945. 138p. illus. index. LC AF47-1595.

Concise history of art and architecture in Spain and Portugal from the early Middle Ages to the end of the nineteenth century. Bibliography of books in all languages (pp. 131-33). Series "Arts, Styles et Techniques."

1716 Lozoya, Juan C. **Historia del arte hispánico.** Barcelona, Salvat, 1931-1949. 5v. illus. index.

Comprehensive history of art and architecture in Spain from prehistoric times through the twentieth century. Well-illustrated with plates, plans, and diagrams. Good bibliographies at the end of each chapter, plus a supplementary bibliography for the entire work in volume 5 (pp. 671-83). A standard history.

1717 Pita-Andrade, José M. **Treasures of Spain from Altamira to the Catholic Kings.** Geneva, Skira; Cleveland, World, 1967. 248p. illus. index. LC 67-25118.

Pictorial survey of art and architecture in Spain from prehistoric cave paintings through the fifteenth century. Introduction is by F. J. Sánchez Cantón. Excellent color plates. Popular text for the general reader; the plates are useful to beginning as well as advanced students.

1718 Smith, Bradley. **Spain: A History in Art.** New York, Simon and Schuster, 1966. 296p. illus. LC 66-19432.

General survey of art in Spain, from prehistory to 1931, set in a cultural and historical context. Emphasis is on painting, with some sculpture and almost no architecture. Generously illustrated, all in color. General bibliography (pp. 294-96).

1719 Lacerda, Aarao de, et al. **Historia da arte en Portugal.** Oporto, Potucalense Editora, 1943-1953. 3v. LC 58-35147.

Comprehensive history of art and architecture in Portugal from prehistoric times through the nineteenth century. Volume 1 covers the period from prehistory through the fourteenth century; volume 2 treats the fifteenth and sixteenth centuries; volume 3 covers the seventeenth through nineteenth centuries. Only the first volume has a bibliography (pp. 555-60), which is a good classified list of books and periodical articles. A standard history of Portuguese art and architecture.

1720 Santos, Reynoldo dos. **Historia del arte portugues.** Barcelona, Labor, 1960. 383p. illus. index.

Concise history of art and architecture in Portugal from the pre-romanesque period through the twentieth century. No bibliography.

1721 Smith, Robert Chester. **The Art of Portugal, 1500-1800.** New York, Meredith, 1968. 320p. illus. index. LC 68-31684.

Concise history of art and architecture in Portugal from 1500 to 1800. Well illustrated. Bibliography is provided in the notes to the text (pp. 313-16). A good general history of Portuguese art and architecture in English for the general reader and the beginning student.

See also: Vey and de Salas (1597).

EASTERN EUROPE

General Works

1722 Rhodes, Anthony. **Art Treasures of Eastern Europe.** New York, Putnam, 1972. 280p. illus. index. LC 75-186798.

Pictorial survey of the art and architecture of Yugoslavia, Czechoslovakia, Poland, Hungary, Romania, and Bulgaria from prehistoric times to 1800. Provides a list of major museums in Eastern Europe, brief biographical notes on artists, and a bibliography of general books (p. 273). An attractive pictorial survey for the general reader.

Czechoslovakia

1723 Hootz, Reinhardt. **Bildhandbuch der Kunstdenkmäler Tschechoslowakei.** Munich, Deutscher Kunstverlag, 1978. 2v. illus. index.

Illustrated, topographical handbook of the art and architecture in Czechoslovakia. Collection of plates arranged by place followed by brief descriptive notes. Bibliographies of basic works, chronological list of monuments, and index of artists at end of each volume. Contents: Band 1, *Die Stadt Prag* (1978); Band 2, *Böhmen und Mähren* (1986).

1724 Prokop, August. **Die Markgrafschaft Mähren in Kunstgeschichte Beziehung.** Vienna, R. Spies, 1904. 4v. in 2. illus. index.

Illustrated handbook of art and architecture in Moravia from the Romanesque through the Baroque. Contents: 1, Das Zeitalter des romanischen Stils; 2, Das Zeitalter des gotischen Stils; 3, Das Zeitalter der Renaissance; 4, Das Zeitalter der Barocke. Illustrated with line drawings and lithographs.

1725 Sourek, Karel, ed. **Die Kunst in der Slowakei.** Prague, Melantrich, 1939. 81p. text. 1330 plates.

Illustrated survey of art and architecture in Czechoslovakia from prehistoric times to the end of the nineteenth century. Includes chapters on folk art. Brief introductory essay followed by good collection of plates with descriptive notes. A bibliography.

1726 Wirth, Karel, et al. **La richesse d'art de la Bohême.** Prague, Štenc, 1913. 2v. illus.

Illustrated survey of art and architecture in Bohemia from prehistoric times to the end of the nineteenth century. Introductory text followed by extensive collection of plates, with descriptive notes containing bibliographical references.

Bulgaria

1727 Bozhkov, Atanas. **Bulgarian Art.** Sofia, Foreign Language Press, 1964. 125p. illus. index. LC 64-56569.

Concise history of art and architecture in Bulgaria from the seventh through the twentieth centuries. No bibliography.

1728 Filov, Bogdan D. **Geschichte der altbulgarischen Kunst bis zur Eroberung des bulgarischen Reiches durch die Türken....** Berlin, de Gruyter, 1932. 100p. illus. index. (Grundriss der slavischen Philologie und Kulturgeschichte, 10).

History of Bulgarian art and architecture from 679 to 1393. Bibliographies are given at the end of the chapters. This work, along with (1729) is a standard history of Bulgarian art and architecture.

1729 Filov, Bogdan D. **Geschichte der bulgarischen Kunst unter der türkischen Herrschaft und in der neueren Zeit....** Berlin, de Gruyter, 1935. 94p. illus. index. (Grundriss der slavischen Philologie und Kulturgeschichte, 10).

History of Bulgarian art and architecture from 1393 to 1930. Bibliographies are given at the end of each chapter. Sequel to (1728); together they form a standard history of Bulgarian art and architecture.

1730 Hootz, Reinhardt, ed. **Kunstdenkmäler in Bulgarien.** Munich, Deutscher Kunstverlag, 1983. 412p. illus.

Topographical handbook of the art and architecture of Bulgaria from prehistoric times to the present. Over 300 plates are arranged by place, and are followed by a descriptive catalog with ground plans. General bibliography, pp. 410-12.

1731 Venedikov, Ivan, and Nikolai Todorov. **Kunstdenkmäler in Bulgarien; Prähistorische und Antike.** Sofia, Sofia Press, n.d. 204 plates.

Illustrated history of art and architecture in Bulgaria from prehistoric times to the fourth century A.D. Brief essays on the various cultures and descriptive notes to the plates. No bibliography.

Greece

1732 Hootz, Reinhardt, ed. **Kunstdenkmäler im Griechenland: Ein Bildhandbuch.** Berlin, Deutscher Kunstverlag, 1982-1984. 2v. illus.

Topographical handbook of art and architecture in Greece from ancient times to the present. Collection of 700 plates arranged alphabetically by place with descriptive catalog. Includes archaeological sites and works of art that have been removed to museums outside Greece. Contents: volume 1, *Festland ohne Pelaponnes*; volume 2, *Pelaponnes und Inseln*.

Hungary

TOPOGRAPHIC HANDBOOKS

1733 Hootz, Reinhardt. **Kunstdenkmäler in Ungarn: Ein Bildhandbuch.** 2d ed. Munich, Deutscher Kunstverlag, 1981. 484p. illus. LC 83-175825.

Illustrated, topographical handbook of art and architecture in Hungary from prehistoric times to the present. Good collection of plates, arranged by place, with descriptive notes and ground plans. Bibliography of general works, p. 463.

1734 **Magyarország Müemlekei togográfiája.** Budapest, Akademiai Kiado, 1948- . v. 1- . illus. index.

Official inventory of the art and architecture in Hungary. Full scholarly apparatus includes extensive bibliographical references. Summaries in German at the end of each volume. To date the following have appeared:

v. 1, Esztergom müemlékei (1948)
v. 2, Sopron és környéke müemlékei (1955)
v. 3, Nograd megye müemlekei (1954)
v. 4, Budapest müemlékei (1955)
v. 5, 6, Pest megye müemlékei (1958)
v. 7, 8, 9, Heves megye müemlékei (1969-1977)
v. 10, 11, Szabolcs-Szatmar megye müemlékei (1986-1987)

HISTORIES

1735 Divald, Kornel. **Old Hungarian Art.** London, Oxford University Press, 1931. 228p. illus. LC 32-13251.

General survey of Hungarian art and architecture from prehistoric times to the end of the nineteenth century. No bibliography.

1736 Kampis, Antal. **The History of Art in Hungary.** London, Wellingborough, 1967. 400p. illus. index. LC 67-78512.

Concise history of art and architecture in Hungary from the ninth century through the first decade of the twentieth century. No bibliography.

1737 Németh, Lajos. **Modern Art in Hungary.** Budapest, Corvina, 1969. 187p. illus. LC 72-9780.

Survey history of twentieth century art and architecture in Hungary. Bibliography (pp. 171-72) lists books and periodical articles in all languages.

Poland

TOPOGRAPHICAL HANDBOOKS

1738 Hootz, Reinhardt, ed. **Kunstdenkmäler in Polen: Ein Bildhandbuch. Kraukau und Südostpolen.** Munich, Deutscher Kunstverlag, 1984. 502p. illus. index. LC 85-170616.

Illustrated topographical handbook of architecture and art in Poland covering the city of Cracow and the territory between the Carpathian mountains and the Pilica and Bug rivers. Introduction provides a brief history of art and architecture in the region. Notes to the plates provide basic information. General bibliography, pp. 498-500.

1739 **Katalog Zabytkow Sztuki w Polsce.** Ed. by J. Z. Lozinski and B. Wolff-Lozinska. Warsaw, Polska Akademia Nuk, 1951- .

Official, topographical inventory of the art and architecture of Poland. To date the the following have appeared:

Volume 1, *Wojewodztwo krakowskie* (1953)
Volume 3, *Wojewodztwo kieleckie* (1957-1966)
Volume 4, *Miastro Krakow 1: Wawel (1965)*
Volume 4, *Miastro Krakow 2 & 3: Koscioly i klasztorzy Srodmiescia* (1971, 1978)
Volume 5, *Wojewodztwo poznanskie 21: Powiat rawicki* (1965)
Volume 8, *Wojewodztwo lubelski* (1960-1982)
Volume 10, *Wojewodztwo warszawskie 5: Powiat Grojecki* (1962), *23: Powiat Sierpecki* (1951)
Volume 11, *Wojewodztwo Bydgoskie 1: Powiat aleksandrowski* (1969), *2: Powiat brodnicki* (1969), *12: Powiat rypinski* (1969)
Volume 13, *Wojewodztwo rzeszowskie* (1974)
N. S. volume 1, *Wojewodztwo krosnienskie 1 & 2* (1977-1982)
N. S. volume 5, *Wojewodztwo gdanskie: Pruszcz gdanski i okoliche* (1986)
N. S. volume 7, *Miastro Poznan* (1983)
N. S. volume 9, *Wojewodztwo lomzynskie 1: Lomza i okolice* (1982)

HISTORIES

1740 Kuhn, Alfred. **Die Polnische Kunst von 1800 bis zur Gegenwart.** 2d ed. Berlin, Klinkhardt & Biermann, 1937. 211p. illus.
Survey of Polish art and architecture of the nineteenth and early twentieth centuries. Bibliography of books in all languages (pp. 201-204).

1741 Piotrowska, Irena. **The Art of Poland.** New York, Philosophical Library, 1947. 238p. illus. index. LC 47-3695.
Concise history of art and architecture in Poland from the early Middle Ages through the early twentieth century. Bibliography (pp. 227-28) lists major works in all languages.

1742 Topass, Jean. **L'art et les artistes en Pologne.** Paris, Félix, 1923-1928. 3v. illus.
History of art and architecture in Poland from the beginning of the Middle Ages to circa 1920. Volume 1, *Au moyen âge*; volume 2, *De la prime-renaissance au préromantisme*; volume 3, *Du romantisme à nos jours*. Bibliographies given at the end of each volume list books in Polish, French, and German. Still one of the few histories of Polish art in a Western language.

Romania

1743 Hootz, Reinhardt. **Kunstdenkmäler in Rumanien.** Munich, Deutscher Kunstverlag, 1985. 482p. illus. LC 86-205142.
Illustrated, topographical handbook of art and architecture in Romania from prehistoric times to the present. Collection of plates, arranged by place, is accompanied by descriptive notes with ground plans. Bibliography of general books and specialized literature for major sites, pp. 472-73.

1744 Iorga, Nicolae, and G. Bals. **Histoire de l'art roumain ancien.** Paris, Boccard, 1922. 411p. illus.
History of art and architecture in Romania from the late Middle Ages through the nineteenth century. Contents: L'art roumain du XIVe au XIXe siècle-description et documentation historique; L'architecture religieuse moldave.

Russia

1745 Ainalov, Demetrius. **Geschichte der russischen Monumentalkunst.** Leipzig, De Gruyter, 1932-1933. 2v. illus. index.

In the series, "Grundriss der Slavischen Philologie und Kulturgeschichte." First volume is subtitled: *Geschichte der russischen Monumentalkunst der vormoskovitischen Zeit*; volume two: *Geschichte der russischen Monumentalkunst zur Zeit der Grossfürstentums Moskau.* Comprehensive, scholarly history of art and architecture in Russia from the tenth through the seventeenth centuries. Extensive bibliographical footnotes. Old, standard work.

1746 Alpatov, Mikhail V. **Art Treasures of Russia.** New York, Abrams, 1967. 178p. illus. index. LC 67-12683.

Lavishly illustrated general survey of Russian painting, sculpture, architecture, and liturgical arts from the Middle Ages through the nineteenth century. No bibliography.

1747 Alpatov, Mikhail V., and Nikolai I. Brunov. **Geschichte der altrussischen Kunst.** Augsburg, Filser, 1932. 2v. illus. index. Reprint: New York, Johnson Reprint, 1969. 423p. illus. index. LC 69-19944.

Comprehensive history of art and architecture in Russia from the tenth century through the seventeenth century. Subjects are treated by type: Alpatov writes on architecture, and Bronov on the figurative arts. The reprint has a new preface in English by the authors. The bibliography for the architecture section is on pages 235-36; other bibliographies are at the end of the chapters. An old, but classic history of old Russian art and architecture; still valuable to the advanced student.

1748 **Art Treasures in Russia: Monuments, Masterpieces, Commissions, and Collections.** General eds., Bernard S. Myers and Trewin Copplestone. New York, McGraw-Hill, 1970. 175p. illus. index. LC 71-101167.

Pictorial survey of painting, sculpture, architecture, and the decorative and minor arts in Russia from 2500 B.C. to the present. The various epochs are treated by different specialists. Includes maps and a glossary-index of museums and monuments, but no bibliography.

1749 Auty, Robert, and Dimitri Oblensky, eds. **An Introduction to Russian Art and Architecture.** Cambridge, Cambridge University Press, 1980. 194p. illus. index. (Companion to Russian Studies, 3). LC 75-10691.

Survey history of art and architecture in Russia from 988 to 1972. Divided into four broad periods: 988-1700, 1700-1860, 1860-1917, 1917-1972. Guide to further reading, pp. 173-81, is a good, classified bibliography of basic books in Russian and Western European languages.

1750 Blankoff, Jean. **L'art de la Russie ancienne.** Brussels, Centre National pour l'Étude des Etats de l'Est, 1963. 92p. text, 150 plates. index. LC 64-4041.

Concise history of art and architecture in Russia from the tenth century to the end of the seventeenth century. Contents: Introduction; La Russie de Kiev (Xe-XIIIes.); La Russie de Vladimir-Souzdal (XIIe-XIVes.); Novgorod et Pskov; La Russie moscovite (XIVe-XVIIes.); Conclusion. Bibliography (pp. 77-87) is a good list of books and articles, mostly in Russian with titles transliterated.

1751 Bunt, Cyril G. E. **Russian Art from Scyths to Soviets.** London, Studio, 1946. 272p. illus. index.

Survey history of art and architecture from the pre-Christian period through World War II. Brief and inadequate bibliography (p. 268).

1752 Eliasberg, Alexander. **Russische Kunst; ein Beitrag zur Charakteristik des Russentums.** Munich, R. Piper, 1915. 118p. illus.

Concise history of art and architecture in Russia from the twelfth century to the end of the nineteenth century. Contents: Einleitung; Architektur vom XII. bis zum XVII. Jahrhundert; Altrussische Malerei; Architektur im XVIII. und XIX. Jahrhundert; Die Malerei vom XVIII. Jahrhundert bis zur Gegenwart; Volkskunst. No bibliography. Introduction contains an important, early attempt to characterize Russian national style in the visual arts.

1753 **Geschichte der russischen Kunst.** Dresden, Verlag der Kunst, 1957- . 6v. to date. illus. index.

Collection of essays on various aspects of the art and architecture of Russia, written by Russian specialists and translated into German (Russian title: *Istoriia russkogo iskusstva*). To date, it covers prehistory through the eighteenth century. Good bibliography, with German translations of Russian titles. A standard history of Russian art.

1754 Gibellino-Krasceninnicowa, Maria. **Storia dell'arte russa.** Rome, P. Maglione, 1935-1937. 2v. illus. index. LC 39-20014.

Comprehensive history of art and architecture in Russia from the eleventh century to the 1930s. Contents: tomo 1, Dal sècolo XI al sècolo XVII; tomo 2, Da Pietro il Grande ai tempi nostri. Bibliographies at the end of each volume.

1755 Hamilton, George H. **Art and Architecture of Russia.** 2d ed. London, Penguin, 1976. 342p. illus. index. (Pelican History of Art, Z6). 3d ed. 1983. 482p. LC 81-10583.

Comprehensive history of the art and architecture of Russia from the tenth through the twentieth centuries. Good selection of plates, plans, and diagrams. Bibliography (pp. 295-99) lists books chiefly in Western languages. Reference to further, more specialized literature is in the extensive footnotes. A standard history of Russian art and architecture.

1756 Hare, Richard. **The Art and Artists of Russia.** Greenwich, Conn., New York Graphic Society, 1966. 294p. illus. index. LC 66-16279.

Survey of the history of painting and the minor arts in Russia from the fifteenth to the early twentieth centuries. Selected bibliography (pp. 282-86). Popular survey for the general reader and the collector.

1757 Hootz, Reinhardt. **Kunstdenkmäler in der USSR.** Munich, Deutscher Kunstverlag, 1979- . illus. index.

Illustrated, topographical handbook of art and architecture in the Soviet Union. Collection of plates followed by brief descriptive catalog. Chronological list of monuments, bibliography of basic books, and index of artists at end of each volume. To date the following have appeared:

Band 1, *Moskau und Umgebung* (1978)
Band 2, *Alte russiche Städte* (Gorki, Nishni, Nowgorod, Jaroslawl, Jurjew-Polskoi) (1980)
Band 3, *Leningrad und Umgebung* (1982)
Band 4, *Ukraine und Moldawien* (1984)

1758 Kornilovich, Kira V. **Arts of Russia.** Cleveland, World, 1967-1968. 2v. illus. LC 67-24469 rev.

Pictorial survey of the art and architecture of Russia from the ancient Scythians through the eighteenth century. Popular text with good color plates. No bibliography.

1759 Matthey, Werner von. **Russische Kunst.** Einsiedln, Benzinger, 1948. 115p. illus. index.

Concise history of art and architecture in Russia from the early Middle Ages to the early twentieth century. Bibliography of general works in all languages (p. 110).

1760 Nemitz, Fritz. **Die Kunst Russlands.** Berlin, Hugo, 1940. 130p. illus.
Concise history of architecture, painting, and sculpture in Russia from the eleventh through the nineteenth centuries. Contents: Einführung; Sakrale Baukunst; Das Wunder der Ikone; Russland und Europa. No bibliography.

1761 Réau, Louis. **L'art russe.** Verviers, Belgium, Gerard, 1968. 2v. illus. index. LC 75-408686.
Reissue of the 1921-1922 edition (Paris, Laurens). Survey of art and architecture in Russia from the Greco-Scythian period through the Rococo. No bibliography, but there is occasional reference to further literature in the footnotes. An old, standard history of Russian art and architecture.

1762 Rice, David T. **Russian Art; An Introduction.** London, Gurney and Jackson, 1935. 136p. illus.
Collection of essays by various scholars on aspects of Russian art and literature. Contents: 1, Russian Art—an Appreciation; 2, An Historical Survey; 3, The Periods and Schools of Early Russian Art; 4, Art in the Eighteenth Century; 5, Early Nineteenth Century Painting; 6, Decorative Art, Theatre and Ballet; 7, Textiles; 8, Metalwork and Enamels; 9, Art of the Book; 10, Porcelain. Table of emperors and dates. No bibliography.

1763 Rice, Tamara T. **A Concise History of Russian Art.** New York, Praeger, 1963. 288p. illus. index. LC 63-16653.
Concise history of art and architecture in Russia from the tenth through the twentieth centuries. Provides a brief, unclassified bibliography (pp. 272-73). A good survey history of Russian art and architecture for the general reader.

1764 Wulff, Oskar K. **Die Neurussische Kunst im Rahmen der Kultur-Entwicklung Russlands von Peter dem Grossen bis zur Revolution.** Augsburg, Filser, 1932. 2v. illus. index.
Comprehensive history of art and architecture in Russia from the eighteenth century through the early twentieth century. Volume one, text; volume two, plates. Brief bibliography (p. 350).

Yugoslavia

1765 Bihalji-Merin, Oto, et al. **Art Treasures of Yugoslavia.** New York, Abrams, 1974. 445p. illus. index. LC 72-5237.
Well-illustrated history of art and architecture in Yugoslavia from prehistoric times to the present, consisting of essays by various Yugoslavian scholars. Bibliography (pp. 427-34) provides a good classified list of books and periodical articles in all languages.

1766 Hootz, Reinhardt, ed. **Kunstdenkmäler in Jugoslawien: Ein Bildhandbuch.** Munich, Deutscher Kunstverlag. 1981. 2v. illus. LC 83-107127.
Illustrated, topographical handbook of the architecture and art of Yugoslavia from prehistoric times to the present. Plates, arranged by place, are accompanied by descriptive notes with ground plans. First volume covers place names A through O, the second volume P through Z. Chronological list of monuments, index of artists, and bibliography of basic works, in volume 2, pp. 422-33.

1767 Kasanin, Milan. **L'art yougoslave dès origines à nos jours.** Belgrade, Musée du Prince Paul, 1939. 91p. illus.
Illustrated survey of art in Yugoslavia from prehistoric times to the early twentieth century. Bibliographical footnotes. Collection of plates illustrates works in the Belgrade Museum.

1768 Radojčic, Svetozar. **Geschichte der serbischen Kunst; von den Anfängen bis zum Ende des Mittelalters.** Berlin, De Gruyter, 1969. 126p. illus. index. LC 70-458515.

Concise history of art and architecture in Serbia from prehistoric times to the end of the Middle Ages. Contents: Die älteste serbische Kunst bis zum Ende des 12. Jahrhunderts; Die Anfänge der monumentalen Kunst in Raszien; Der reife raszische Stil (1200-1300); Die Serbische Kunst von Ende des 13. Jahrhunderts bis zur Schlacht an der Marica (1371); Die Kunst des Morava- und Donaugebietes von 1371 bis 1459. Extensive bibliographical footnotes.

11
ORIENTAL ART

GENERAL WORKS

1769 Glaser, Kurt, et al. **Die aussereuropäische Kunst.** Leipzig, Kröner, 1929. 718p. illus. index. (Handbuch der Kunstgeschichte, Band VI).
Comprehensive and scholarly history of the art and architecture of Asia, Oceania, and pre-Columbian America. Bibliography of basic books (p. 694).

1770 Hallade, Madeleine. **Arts de l'Asie ancienne. Thèmes et motifs.** Paris, Presses Universitaires de France, 1954-1956. 3v. illus. index. (Publications du Musée Guimet. Recherches et Documents d'Art et d'Archéologie, Tome V).
Important, scholarly study of the development of the art and architecture of the Indian subcontinent, Southeast Asia, and China from the standpoint of iconography and function. Excellent bibliographies of specialized literature at the end of each chapter.

1771 La Plante, John D. **Asian Art.** Dubuque, Iowa, W. C. Brown, 1968. 185p. illus. index. LC 68-14575.
Survey of the art and architecture of India, China, and Japan from circa 2500 B.C. to the beginning of the twentieth century. Provides useful maps and a modest selection of illustrations in black and white. Bibliography (p. 177) lists major books in English. Designed as an inexpensive text for the beginning student.

1772 Lee, Sherman E. **A History of Far Eastern Art.** 4th ed. Englewood Cliffs, N.J., Prentice-Hall, 1980. 548p. illus. index. LC 81-3603.
Concise history of art and architecture in India, China, Korea, Japan, Central Asia, Southeast Asia, and Indonesia. Excellent selection of plates, plans, and diagrams covering works from the Stone Age through the eighteenth century. The good bibliography (pp. 499-511) of books and periodicals in all languages singles out those of special interest. The standard history of Far Eastern art and architecture.

1773 Theile, Albert. **Aussereuropäische Kunst von den Anfangen bis Heute: ein Überblick.** Cologne, Seemann, 1956. 3v. illus. index. LC A57-4278.
Concise history of non-Western art and architecture from prehistoric times to the present. Band 1, *Die Kunst der Naturvölker: Die altere Kunst Amerikas*; Band 2, *Die neuere Kunst Amerikas; Kunst Australias; Indische Kunst; Die Kunst des Islam*; Band 3, *Die Kunst des Fernen Ostens: China, Korea, Japan.* General bibliography (volume 3, pp. 274-78) lists major books in all languages. A standard German history of non-Western art and architecture.

ISLAMIC WORLD

General Works

1774 Diez, Ernst. **Kunst der islamischen Völker.** Berlin, Athenaion, 1915. 218p. illus. index.
Concise but scholarly history of Islamic art and architecture from the beginnings through the eighteenth century. Bibliography given at the end of the chapters. A volume in the series, "Handbuch der Kunstwissenschaft." An old, but classic history, still of interest to the advanced student.

1775 Glück, Heinrich, and Ernst Diez. **Die Kunst des Islam.** Berlin, Propyläen, 1925. 616p. illus. index. (Propyläen Kunstgeschichte, V).
Comprehensive illustrated handbook of Islamic art and architecture. Introductory essays followed by good corpus of plates with descriptive notes. No bibliography. Superseded by new Propyläen series (1790).

1776 Grabar, Oleg. **The Formation of Islamic Art.** New Haven, Yale University Press, 1973. 233p. illus. index. 2d ed. 1987. LC 87-8200.
Scholarly study of Islamic art and architecture through the tenth century. Contents: 1, The Problem; 2, The Land of Early Islam; 3, The Symbolic Appropriation of the Land; 4, Islamic Attitudes toward the Arts; 5, Islamic Religious Art: the Mosque; 6, Islamic Secular Art: the Palace and City; 7, Early Islamic Decoration: the Arabesque; 8, The Formation of Islamic Art. Excellent annotated bibliography (pp. 217-27).

1777 Grousset, René, et al. **Arts musulmans, Extrême-Orient.** Paris, Colin, 1937. 496p. illus. index.
Concise history of the art and architecture of India, Indochina, Indonesia, China, Japan, Central Asia, and the Islamic world. Well illustrated. Bibliographies at the end of each section. An older but still valuable survey of Oriental art and architecture.

1778 Grube, Ernst J. **The World of Islam.** New York, McGraw-Hill, 1967. 176p. illus. index. LC 66-19271.
General pictorial survey of the architecture, sculpture, architectural decoration, metalwork, and minor and decorative arts throughout Islamic realms. Includes the arts of the Umayyads, Fatimids, Seljuk Turks in Anatolia and Iran, Atabeks, Ayyubids, Mongol period, Mamluk, Nasrid, Timurid, Ottoman Turks, Safavid Iran, and Islamic art in India. Includes maps, plans, and a brief bibliography (p. 171).

1779 Kühnel, Ernst. **Islamic Art and Architecture.** Ithaca, N.Y. Cornell University Press, 1966. 200p. illus. index. LC 66-19223.
Concise history of art and architecture in the Muslim world from earliest times (Umayyad style) to the twentieth century. Well illustrated with plates, plans, and diagrams. Provides a brief but good bibliography (pp. 185-89). Translation of *Die Kunst des Islam* (Stuttgart, 1963). A good survey history for the beginning student and the general reader.

1780 Marcais, Georges. **L'art musulman.** Paris, Presses Universitaires de France, 1962. 186p. illus. index. LC 65-30614.
Concise history of Islamic art and architecture from the eighth century through the eighteenth century. First published in 1946 as *L'art de l'Islam.* Bibliography (pp. 184-86) lists books in all languages.

1781 Migeon, Gaston. **Les arts musulmans.** Paris, Van Oest, 1926. 44p. text, 64 plates.
Pictorial survey of art and architecture in the Islamic world to the middle of the nineteenth century. Bibliography of basic works (p. 43).

1782 Migeon, Gaston. **Manuel d'art musulman: Arts plastiques et industriels.** 2d ed. Paris, Picard, 1927. 345p. illus. index.
Comprehensive handbook of Islamic painting, sculpture, applied, and decorative arts. Bibliographical footnotes.

1783 Otto-Dorn, Katharina. **L'art de l'Islam.** Paris, Michel, 1967. 278p. illus. index. LC 67-107712.
Concise history of Islamic art and architecture from its beginnings through the eighteenth century. Provides glossary of terms, chronological table, and bibliography (pp. 270-75), which lists books in all languages. French edition of the series, "Art of the World."

1784 Papadopoulo, Alexandre. **Islam and Muslim Art.** New York, Abrams, 1979. 611p. illus. index. LC 78-31690.
Sumptuously illustrated history of Islamic art. Contents: Islam and Muslim Civilization, The Muslim Arts, Architecture, The Image as Document, The Principal Sites of Muslim Art, Prayer Halls and Other Interiors. Bibliographical lexicon of artists and architects together with other personalities important to the history of Islamic art, glossary of terms, and classified bibliography of basic works, pp. 615-19.

1785 Papadopoulo, Alexandre. **L'Islam et d'art musulman.** Paris, Mazenod, 1976. 611p. illus. index. LC 78-341485.
Sumptuously illustrated survey of Islamic art and architecture. Chapter on the chief sites of Islamic art. Bibliography (pp. 598-602) provides a good, classified list of books and periodical articles in all languages.

1786 Pijoán y Soteras, José. **Arte islámico.** Madrid, Espasa-Culpe, 1949. 625p. illus. index. (Summa Artis, Historia General del Arte, XII).
Comprehensive history of Islamic art and architecture. Introduction discusses the background of Islamic art, and subsequent chapters are devoted to major periods and nations of Islam, including a lengthy chapter on Islamic art in Spain. Bibliography of basic books (pp. 597-99).

1787 Raymond, Alexandre M. **L'art islamique en Orient.** Paris, Librarie Raymond, 1923. 2v. illus.
Contents: 1 partie: Vielles faiences turques en Asie-mineure et à Constantinople; 2 partie: Fragments d'architecture religieuse et civile. Bibliographical footnotes.

1788 Rice, David T. **Islamic Art.** New York, Praeger, 1965. 286p. illus. index. LC 65-10179.
Concise history of art and architecture in the Muslim world from the seventh through the seventeenth centuries. Good selection of plates; bibliography (pp. 261-63) lists chief books in English, French, and German.

1789 Ry van Beest Holle, Carel J. du. **Art of Islam.** New York, Abrams, 1971. 263p. illus. index. LC 72-92914.
Survey history of the art and architecture of the Islamic world from the time of the Umayyad dynasty through the Safavid dynasty. Includes a chapter on Islamic art of India (Moghul India). The illustrations are well chosen, and the balanced bibliography (pp. 256-58) lists books in all languages. A good survey for the general reader.

1790 Sourdel-Thomine, Janine, and Bertold Spuler. **Die Kunst des Islam.** Berlin, Pro-pyläen, 1973. 426p. (text); 416p. (illus.). index. (Propyläen Kunstgeschichte, Band 4). LC 74-310053.

Comprehensive, illustrated handbook of the art and architecture of the Islamic world from its beginnings through the eighteenth century. Also covers the art and architec-ture of Persia from the sixth century B.C. to the rise of Islam. The introductory essay char-acterizing and sketching the history of Islamic art and architecture is followed by a corpus of excellent plates. Separate essays by a group of international specialists discuss in greater detail the development of the various arts and national styles. Notes to the plates provide basic information and references to specialized literature. The volume concludes with a very good classified bibliography (pp. 401-17) that lists books and periodical articles in all languages. A chronological table coordinates political, religious, cultural, and artistic events in the various regions. A standard handbook.

Egypt

1791 Brunner-Traut, Emma, and Vera Hell. **Ägypten: Kunst und Reiseführer mit Land-eskunde.** 3d ed. Stuttgart, Kohlhammer, 1978. 784p. illus. index.

Exceptionally complete pocket-sized guide book to the art historical sites of Egypt. Introductory chapters survey geography, history, religion, language, culture, and art in ancient times, Coptic and Islamic culture. These are followed by a thorough description of major sites, arranged by broad regions, then by place. Covers the neighboring regions of Libya, Sinai, and Nubia. Chronological table, list of major museums of Egyptian art, and basic bibliography of books in all languages. Also provides helpful practical hints for the modern traveler to Egypt. An admirable art-tourist guide book.

Iran and Afghanistan

1792 Auboyer, Jeanine. **The Art of Afghanistan.** Pelham, England, Hamlyn, 1968. 75p. 136 plates. LC 79-359016.

General survey of art and architecture in Afghanistan from prehistoric times to the present. Introductory essay followed by plates with descriptive notes. Bibliography, pp. 65-70, lists books and periodical articles in all languages.

1793 Belloni, Gian Guido, and Liliana Fedi Dall'Asèn. **Iranian Art.** New York, Praeger, 1969. 29p. (text); 101p. (illus.). LC 70-81992.

Pictorial guide to the art and architecture of Iran from prehistoric times to the seventeenth century. Brief introduction traces the history of art and architecture in Iran with the help of maps and a chronological table; this is followed by a good selection of plates with informative captions. Bibliography (p. 29) lists major books in all languages.

1794 Godard, André. **The Art of Iran.** New York, Praeger, 1965. 358p. illus. index. LC 65-11169.

Comprehensive history of art and architecture in Iran from 2400 B.C. through the first half of the nineteenth century. Well illustrated with plates, plans, diagrams, and useful maps; good classified bibliography (pp. 339-45) lists books and periodical articles in all lan-guages. Scholarly but readable text. Standard history of Iranian art and architecture.

1795 Pope, Arthur U. **An Introduction to Persian Art Since the Seventh Century A.D.** New York, Scribner's, 1931. 256p. illus.

Concise history of art and architecture in Persia from the seventh through the twen-tieth centuries. Provides a list of the principal monuments and a brief bibliography (pp. 252-56). An old, general survey history of Persian art and architecture by a leading expert; still useful reading for the general reader.

1796 Pope, Arthur U., and Phyllis Ackerman, eds. **Survey of Persian Art from Prehistoric Times to the Present.** London, Oxford University Press, 1965. 14v. illus. index. LC NUC67-61802.

Collection of essays by specialists covering all aspects of Persian art from prehistory to the present. Volume 14 contains "New Studies 1938-1960: The Proceedings of the International Congress of Iranian Art and Archaeology, 1960, Part A." Bibliography is in the footnotes. These authoritative, scholarly essays form a standard history of Persian art and architecture.

Turkey

1797 Akurgal, Ekrem. **The Art and Architecture of Turkey.** New York, Rizzoli, 1980. 268p. illus. index. LC 79-56610.

Survey of art and architecture in Turkey from prehistoric times to the Ataturk period. Contents: The Position and Role of Anatolia in World History; Anatolia from the Neolithic Period to the End of the Roman Period; Byzantine Art in Turkey; Anatolia: Seljuk Architecture; Turkish Architecture in Asia Minor in the Period of the Turkish Emirates; Architecture of the Ottoman Period; Architectural Decoration and Minor Arts; Turkish Metalwork; Turkish Miniature Painting.

1798 Akurgal, Ekrem, et al. **Treasures of Turkey.** Geneva, Skira, 1967. 253p. illus. index. LC 66-22488.

Pictorial survey of art and architecture in Turkey from the earliest civilizations of Anatolia through the Islamic period. Excellent color plates. No bibliography. Popular text for the general reader.

1799 Aslanapa, Oktay. **Turkish Art and Architecture.** New York, Praeger, 1971. 422p. illus. index. LC 72-144222.

Concise history of art and architecture in Turkey from pre-Islamic times through the Ottoman period. Well illustrated. Bibliography (pp. 355-99) is an excellent classified list of books and periodical articles in all languages. A standard history of Turkish art and architecture.

1800 Levey, Michael. **The World of Ottoman Art.** New York, Scribner's, 1977. 152p. illus. index. LC 76-40383.

Concise history of Ottoman art and architecture in Turkey. Contents: 1, Early Cities and Style; 2, Istanbul: Creation of a New Capital; 3, The Age of Sinan; 4, Achievement Amid Decline; 5, Intimations of Rococo; 6, The Exotic West. Glossary of terms, brief historical outline, and bibliography (p. 149) of books, chiefly in English.

1801 Restle, Marcell. **Istanbul. Bursa, Edirne, Iznik. Baudenkmäler und Museen.** Stuttgart, Reclam, 1976. 632p. illus. index.

Pocket-sized handbook of the architectural monuments and museums of the Turkish cities of Istanbul (Constantinople), Bursa (Brusa), Edirne (Adrianople), and Iznik (Nicaea). Emphasis is on architecture, but major works of painting and mosaic are mentioned, and the collections of major museums are described. Glossary of terms. Bibliography of books in all languages (pp. 551-57). In the series, "Reclams Kunstführer." Excellent guide for the art tourist but thorough enough for reference work, especially considering the lack of topographic studies for this important ancient, Byzantine, and Islamic region.

INDIA AND CEYLON

1802 Abbate, Francesco, ed. **Indian Art and the Art of Ceylon, Central and South-East Asia.** London, Octopus, 1972. 158p. illus. LC 73-151958.

Brief, pictorial survey of the art and architecture of India, Ceylon, Afghanistan, Nepal, Tibet, Siam, Burma, Cambodia, Vietnam, and Indonesia. Popular text. Brief bibliography (p. 154) and chronological table.

1803 Ahmed, Jalal U. **Art in Pakistan.** 2d ed. Karachi, Pakistan Publications, 1962. 151p. illus. index. LC SA64-1479.

Brief history of art and architecture in Pakistan from the beginning of the Islamic period to the present. No bibliography.

1804 Bussagli, Mario, and C. Sivaramamurti. **5,000 Years of the Art of India.** New York, Abrams, 1971. 355p. illus. index. LC 78-133846.

Illustrated handbook of art and architecture in India from prehistoric times to the present. Excellent plates. For the general reader and beginning student. The corpus of illustrations is useful for the advanced student.

1805 Coomaraswamy, Ananda K. **History of Indian and Indonesian Art.** New York, Dover, 1965. 295p. illus. index. Reprint of 1927 edition.

Concise history of art and architecture in India, Nepal, Tibet, Turkestan, Ceylon, and Indonesia from pre-Mauryan times through the Indian medieval. Bibliography (pp. 214-29) provides a good listing of older books and periodical articles. An older, standard history.

1806 Craven, Roy C. **A Concise History of Indian Art.** New York, Praeger, 1976. 252p. illus. index. LC 76-363147.

Contents: I, Harappan Culture: Beginnings on the Indus; II, Historical and Religious Origins; III, The Mauryan Period; IV, The Shunga Dynasty; V, The Andhra Period; VI, The Kushan Period; VII, The Gupta and Post-Gupta Periods; VIII, South India; IX, The Medieval Period in North India; X, Islamic India; XI, Jain, Rajusthani and Pahari Painting. Good classified bibliography (pp. 246-48).

1807 Diez, Ernst. **Die Kunst Indiens.** Berlin, Athenaion, 1925. 194p. illus. index.

History of art and architecture in ancient and medieval India and of Indian colonial art of the same time in Ceylon, Java, Burma, Cambodia, Thailand, and Laos. Bibliographies at the end of the chapters. A volume in the "Handbuch der Kunstwissenschaft" series. An old, but classic scholarly history of Indian art.

1808 Fischer, Klaus. **Schöpfungen indischer Kunst, von den frühesten Bauten und Bilderns bis zum mittelalterlichen Tempel.** Cologne, DuMont-Schauberg, 1959. 412p. illus. index. LC A60-1155.

Well-illustrated handbook of ancient and medieval art and architecture in India. Contents: 1, Einleitung und Fragestellung; 2, Denkmälerkunde; 3, Leben und Kunst im alten und neuen Indien; 4, Enstehung und Wandlung altindischer Kunstformen (Volk, Geschichte und Kunst in der Vor- und Frühzeit; Die erste Kunst geschichtlicher Zeit; Indische Kunst im Austausch mit der Fremde; Der Beginn des Freibautempels und das Ende der Felskunst; Bauten und Bilder des indischen Mittelalters). Good classified bibliography of books and periodical articles in all languages, pp. 353-84.

1809 Franz, Heinrich G. **Buddhistische Kunst Indiens.** Leipzig, Seemann, 1965. 382p. illus. index. LC 66-75937.

Scholarly history of Buddhist art and architecture in India. Important for its thorough examination of the cult function of Buddhist art and architecture. General works cited (p. 162) and extensive bibliographies of specialized literature at the end of each chapter.

1810 Goetz, Hermann. **The Art of India: Five Thousand Years of Indian Art.** New York, Crown, 1962. 280p. illus. index. LC 59-13434.
 Concise history of art and architecture in India from prehistoric times to the present. Provides a glossary of terms, a chronological table, a map, and a good, select bibliography (pp. 263-69) of books and periodical articles in English. A good survey history for the beginning student and the general reader.

1811 Grünwedel, Albert. **Buddhist Art in India.** London, Quaritch, 1901. 228p. illus. index.
 Concise history of Buddhist art and architecture in India. Contents: I, Introduction; II, Early-Indian Style; III, The Gandhara Sculpture; IV, Representation of Buddha and Bodhisattva. Bibliography (p. 218) lists books and periodical articles. A pioneering history of Indian Buddhist art.

1812 Härtel, Herbert, and Jeanine Auboyer. **Indien und Südostasien.** Berlin, Propyläen, 1971. 408p. (text); 369p. (illus.). index. (Propyläen Kunstgeschichte, Band 16). LC 71-889568.
 Comprehensive, illustrated handbook of the art and architecture of India and Southeast Asia from 3000 B.C. to 1700 A.D. Covers also Afghanistan, East Turkestan, and Central Asia. Introductory essay is followed by a corpus of excellent plates, notes to the plates that provide basic information and specialized bibliography, and separate essays on the development of the various media and national styles by a group of specialists. Provides an excellent, comprehensive bibliography (pp. 330-45) that lists books and periodical articles in all languages and a useful chronological table that coordinates the artistic, political, religious, and general cultural events in the various countries. A basic handbook.

1813 Harle, James C. **The Art and Architecture of the Indian Subcontinent.** Harmondsworth, Middlesex, Penguin, 1986. 597p. illus. index. ISBN 0140560491.
 In the series "Pelican History of Art." Replaces in part the earlier volume in the series by Rowland (1824). Comprehensive history of art and architecture in present day India, Pakistan, Bangladesh, Nepal, and Sri Lanka from prehistoric times to the end of the Mughal period. Contents: 1, Early Indian Art; 2, The Gupta Period; 3, The Post-Gupta Period; 4, The Later Hindu Period; 5, South India; 6, Painting; 7, Indo-Islamic Architecture; 8, Sri Lanka; 9, Nepal. Excellent, classified bibliography, pp. 537-562, and additional bibliography in the notes. A standard history.

1814 Havell, Ernest B. **The Ideals of Indian Art.** London, Murray, 1916. 188p. illus. index.
 History of Indian art, exclusive of architecture. Contents: I, Origin of Indian Art— the Vedic Period; II, The Eclectic or Transition Period; III, The Universities of Northern India and Their Influence on Asiatic Art; IV, The Development of the Divine-Ideal; V, The Trimurti; VI, The Feminine Ideal; VII, The Three Paths; VIII, Historical Development of Indian Art. Bibliographical footnotes.

1815 Iyer, K. Bharatha. **Indian Art: A Short Introduction.** Bombay, Asia Publishing House, 1958. 87p. illus. index. LC 60-2779.
 Brief history of art and architecture in India from earliest times through the eighteenth century. Brief bibliography (pp. 79-80).

1816 Hague, Enamul. **Islamic Art Heritage of Bangladesh.** Dhaka, Bangladesh National Museum, 1983. 255p. illus. index. LC 84-900781.
 Survey of Islamic art and architecture in Bangladesh from the thirteenth century to the present. No bibliography.

1817 Huntington, Susan. **The Art of Ancient India, Buddhist, Hindu, Jain.** New York, Weatherhill, 1985. 786p. illus. index. LC 83-5742.

Comprehensive history of art and architecture in India from 2300 B.C. to 1565. Contents: I, Foundations of Indic Civilizations: Prehistoric and Protohistoric Periods; II, Period of the Early Dynasties; III, Dynasties of the Middle Period; IV, Later Northern Schools; V, Later Schools of the Decan and the South. Bibliography (pp. 659-713) is a comprehensive classified list of English-language books.

1818 Kramrisch, Stella. **The Art of India.** 3d ed. New York, Phaidon, 1965. 230p. illus. index. LC 65-28967. Reprint: Delhi, Motilal Banarsidass, 1987. ISBN 8120801822.

Survey of the art and architecture of ancient and medieval India. Well illustrated, the text concentrates on concepts and characteristics of Indian art. Bibliography (pp. 230-31) lists major works, catalogs of exhibitions, and periodical articles. Still an authoritative introduction to Indian art and architecture.

1819 Kramrisch, Stella. **Grundzüge der indischen Kunst.** Helleran bei Dresden, Avalun-Verlag, 1924. 141p. illus. index.

Concise history of Indian art, with emphasis on sculpture. Contents: Mythus und Form; Natur; Raum; Rhythmus; Entwicklungsmomente. Bibliography of books in all languages (pp. 131-33).

1820 Mukerjee, Radhakamal. **The Culture and Art of India.** New York, Praeger, 1959. 432p. illus. index. LC 59-7976.

History of Indian art, exclusive of architecture, from earliest times to the end of the nineteenth century, with emphasis on the general cultural context. Time chart of Indian civilization. Bibliography of books and periodical articles (pp. 387-94).

1821 Rau, Heimo. **Stilgeschichte der indischen Kunst.** Graz, Akademische Druck- und Verlagsanstalt, 1986. 2v. illus. LC 87-408842.

Comprehensive history of the art and architecture of India from the Bronze Age to the early twentieth century. Emphasis is on development from the archaic period to the Moghul Empire. Classified bibliography, pp. 439-48.

1822 Rawson, Philip. **Indian Art.** New York, Dutton, 1972. 159p. illus. index.

Survey history of art and architecture in India from prehistoric times through the twentieth century. Well illustrated, it provides a brief bibliography (p. 157) of popular works in English.

1823 Rivière, Jean R. **El arte de la India.** Madrid, Espasa-Calpe, 1964. 803p. illus. index. (Summa Artis, Historia General del Arte, XIX). LC NUC65-94883.

Comprehensive history of art and architecture in India from prehistoric times to the end of the Mughal period. Bibliographies at the end of each chapter.

1824 Rowland, Benjamin, Jr. **The Art and Architecture of India: Buddhist, Hindu, Jain.** 3d ed. rev. London, Penguin, 1967. 314p. illus. index. (Pelican History of Art, Z2). LC 67-4077.

Comprehensive history of art and architecture in India from prehistoric times through the period of the Hindu dynasties (nineteenth century). Also covers Romano-Indian art and architecture in Afghanistan, Turkestan, and Kashmir, and Indian art and architecture in Ceylon, Siam, Burma, and Java. Provides a good selection of plates, useful maps, plans, diagrams, a glossary of terms, and a good, classified bibliography (pp. 486-92), which lists books and periodicals in all languages. Reference to specialized literature is in the extensive footnotes. A standard history of Indian art and architecture.

1825 Smith, Vincent A. **A History of Art in India and Ceylon.** 2d ed. rev. by K. de B. Codrington. 3d rev. and enl. ed. by Karl Khandalavala. Bombay, D. B. Taraporevala, 1962. 219p. illus. index. LC SA62-809.
Concise history of art and architecture in India and Ceylon from the Mauryan period to modern times. Covers Indian-inspired art in Central Asia, Tibet, Nepal, and Java. Bibliography (pp. 209-10) lists books in English. Reissue of an older general history.

1826 Sundaram, K. **Monumental Art and Architecture of India.** Bombay, Taraporevala, 1974. 106p. illus. index. LC 75-901577.
Concise survey of Indian architecture and sculpture. Bibliography of basic books (pp. 103-104).

1827 Winstedt, Richard, ed. **Indian Art.** London, Faber and Faber, 1947. 200p. illus. index.
Survey of the art and architecture of India during the ancient and medieval periods. Introductory essay giving the historical background by H. G. Rowlinson. Popular text. No bibliography.

1828 Zimmer, Heinrich R. **The Art of Indian Asia: Its Mythology and Transformation.** 2d ed. Princeton, Princeton University Press, 1955. 2v. illus. index.
A comprehensive conceptual and historical study of the art and architecture of India and Indian Asia from prehistoric times to 1850. Volume one, text; volume two, plates. Provided with maps and a chronological table. Thorough reference to specialized literature is in the notes. A standard work on Indian art and architecture, especially for its chapters on symbolism.

CENTRAL ASIA

1829 Barua, Dipak K. **Buddhist Art of Central Asia.** Calcutta, International Institute of Pali and Prakrit Studies, 1981. 115p. illus. index. LC 84-900617.
Survey of Buddhist art and architecture of the Turkestan region of the Soviet Union. Bibliography (pp. 111-12) is a list of books in English.

1830 Dagyab, Lodan Sharap. **Tibetan Religious Art.** Wiesbaden, Harrassowitz, 1977. 386p. illus. index. (Asiatische Forschungen, Band 52). LC 78-347988.
Scholarly study of Tibetan painting and sculpture, with reference to source of imagery and usage in sacred texts of Tibetan Buddhism. Bibliographical footnotes.

1831 Gordon, Antoinette K. **Tibetan Religious Art.** 2d ed. New York, Paragon, 1963. 104p. illus. index. LC 63-22167.
Concise history of Tibetan painting, sculpture, and the minor arts. Provides bibliography (pp. 99-100) of books and periodical articles in English.

1832 Hrbas, Miloš, and Edgar Knobloch. **The Art of Central Asia.** London, Hamlyn, 1965. 140p. illus. LC 66-71049.
Pictorial survey with brief introductory essay. Bibliography (p. 27) lists works in German and Czech.

1833 Hummel, Siegbert. **Geschichte der tibetischen Kunst.** Leipzig, Harrassowitz, 1953. 123p. (text); 124p. (illus.).
History of art and architecture in Tibet from prehistory to the present. Provides maps, a good selection of plates, and a bibliography (pp. 113-17) that lists books and periodical articles in all languages. A standard history of Tibetan art and architecture.

1834 Pal, Pratapaditya. **The Arts of Nepal.** v. 1- . Leiden, Brill, 1974- . illus. index. LC 75-500108.
Comprehensive history of the art and architecture of Nepal. To date, volume one, covering sculpture, has appeared. Bibliographical footnotes.

1835 Rau, Heimo. **Nepal: Kunst und Reiseführer.** Stuttgart, Kohlhammer, 1984. 316p. illus. index. ISBN 3170079255.
In the series "Kohlhammer Kunst- und Reiseführer". Guide to the artistic sites of Nepal. Geographically arranged by place. Introduction offers advice on travel in Nepal. Good maps, bibliography of basic books in Western languages, pp. 299-301.

1836 Rice, Tamara T. **Ancient Arts of Central Asia.** New York, Praeger, 1965. 288p. illus. index. LC 65-19586.
Concise survey of the art and architecture of Central Asia, including the greater Caucasian area, Russian Central Asia, Afghanistan, and parts of Northern India. Provides a chronological table and a brief bibliography arranged by chapters (pp. 263-64).

1837 Singh, Madanjeet. **Himalayan Art....** New York, Macmillan, 1971. 287p. illus. LC 68-28652.
Survey history of painting and sculpture in the Himalayas including Nepal, Bhutan, Sikkim, and the Siwalik Ranges. Bibliography (pp. 281-82) lists general books in English.

1838 Waldschmidt, Ernst, and Rose Leonore Waldschmidt. **Nepal: Art Treasures from the Himalayas.** New York, Universe, 1970. 160p. illus. index. LC 72-96964.
Pictorial survey of the art and architecture of Nepal from circa 400 A.D. through the eighteenth century. Brief introduction characterizes the geography, people, and religion of Nepal and provides a short sketch of the art history. Excellent collection of plates with informative captions and a brief but useful note (p. 159) referring to the chief sources for bibliography on Nepal.

SOUTHEAST ASIA

General Works

1839 Griswold, Alexander B., and Peter H. Pott. **The Art of Burma, Korea, Tibet.** New York, Crown, 1964. 277p. illus. index. LC 63-20855.
Concise history of the art and architecture of Burma, Korea, and Tibet from 200 B.C. to the nineteenth century. Provides maps, a chronological table, and a good bibliography of books in all languages (pp. 255-63).

1840 Groslier, Bernard Philippe. **The Art of Indochina, including Thailand, Vietnam, Laos and Cambodia.** New York, Crown, 1962. 261p. illus. index. LC 62-11805.
Concise history of art and architecture in Southeast Asia from prehistory to circa 1900. Emphasis is on the architecture and sculpture of the great temples. Provides a useful glossary, a guide to the pronunciation of names, a list of the names of kings, and a bibliography (pp. 240-45) of major books and periodical articles in all languages.

1841 Rawson, Philip S. **The Art of Southeast Asia: Cambodia, Vietnam, Thailand, Laos, Burma, Java, Bali.** New York, Praeger, 1967. illus. index. LC 67-29399.
Survey history of the art and architecture of Cambodia, Vietnam, Laos, Thailand, Burma, Java, and Bali from earliest times to the modern age. Provides a glossary of terms and a select bibliography of books in all languages (pp. 278-83).

Indochina

1842 Bezacier, Louis. **L'art vietnamien.** Paris, Union Française, 1955. 233p. illus. index.
History of art and architecture in Vietnam from prehistoric times to the nineteenth century. Poor illustrations. Bibliography (pp. 211-13) lists books and periodicals, chiefly in French.

1843 Das, Ram R. **Art Traditions of Cambodia.** Calcutta, Mukhopadhyay, 1974. 208p. illus. index.
History of art and architecture in Cambodia. Based upon the premise that India was a chief influence. Bibliography of basic works (pp. i-vi).

1844 Hetjzlar, J. **The Art of Vietnam.** London, Hamlyn, 1973. 262p. illus.
Popular, pictorial survey of art and architecture in Vietnam. One-page bibliography of general works.

1845 Lunet de Lajonquière, Etienne E. **Inventaire descriptif des monuments du Cambodge.** Paris, Leroux, 1902-1911. 3v. illus. index.
Geographical inventory of architecture and sculpture in Cambodia. Arrangement by provinces. Occasional bibliographical footnotes. Well illustrated with plans, elevations, and other drawings.

1846 Parmentier, Henri. **L'art khmer classique; monuments du quadrant nord-est....** Paris, Les Éditions d'Art et d'Histoire, 1939. 2v. illus. index.
Comprehensive handbook of Khmer art and architecture from the ninth to the fifteenth centuries. Geographical arrangement. Glossary of terms and chronological table of major monuments. Bibliographical footnotes. Together with (1847), a standard reference to Cambodian art and architecture.

1847 Parmentier, Henri. **L'art khmer primitif.** Paris, Les Éditions d'Art et d'Histoire, 1927. 2v. illus. index.
Comprehensive handbook of Khmer art and architecture from the seventh to the ninth centuries A.D. Geographical arrangement. Glossary of terms. Chronological table of monuments. A standard reference work.

1848 Parmentier, Henri. **L'art du Laos.** Paris, École Française d'Extrême-Orient, 1954. 2v. illus. index. (Publications de l'École Française d'Extrême-Orient, volume XXXV).
Comprehensive history of art and architecture in Laos. Following introductory chapters is a thorough geographical inventory of the major sites. Summary takes the form of a general survey of the historical development of Laotian art and architecture. Bibliography (pp. 347-48) lists books and periodical articles. Glossary of Laotian terms. A standard work.

Indonesia

1849 Bernet, Kempers, August J. **Ancient Indonesian Art.** Cambridge, Mass., Harvard University Press, 1959. 124p. (text); 353p. (illus.). LC 59-4979.
Comprehensive study of art and architecture in Indonesia from mesolithic times through the early Islamic period (circa 1650). Brief introduction tracing the development is followed by an excellent corpus of illustrations, with detailed and informative notes. Provides an excellent but unclassified bibliography (pp. 109-14) of books and periodical articles in all languages. A standard history of Indonesian art and architecture.

1850 Bezemer, T. J. **Indonesian Arts and Crafts.** The Hague, Ten Hagen, 1931. 168p. illus.
 Pictorial survey of Indonesian sculpture, painting, and decorative arts. No bibliography.

1851 Bodrogi, Tibor. **Art of Indonesia.** Greenwich, Conn., New York Graphic Society, 1972. 140p. (text); 157p. (illus.). LC 76-154331.
 Well-illustrated survey of the art and architecture of Indonesia from paleolithic times to the present. Provides a good bibliography (pp. 109-15) listing books and periodical articles in all languages. A good survey history of Indonesian art for the general reader.

1852 Holt, Claire. **Art in Indonesia: Continuities and Change.** Ithaca, N.Y., Cornell University Press, 1967. 355p. illus. index. LC 66-19222.
 Concise history of art and architecture in Indonesia from prehistoric times to the modern age. Discussion of the legends and literature expressed in the fine arts of Indonesia in the appendices. Bibliography (pp. 331-38) is an unclassified list of books chiefly in English.

1853 Jasper, J. E., and Mas Pirngadie. **Die inlandsche kunstnijverheid in Nederlandsch-Indie.** The Hague, Mouton, 1912-1930. 5v. illus. index.
 Comprehensive handbook of the arts and crafts of Indonesia. Contents: I, *Het Vlechtwerk* (1912); II, *De Weefkunst* (1912); III, *De Batikkunst* (1912); IV, *De Goud en Zilversmeed Kunst* (1930); V, *De Bewerking van Niet-edele Metalen* (1930). Extensive treatment of techniques and materials. Bibliographical footnotes. A standard work.

1854 Loèber, Johannes. **Geillustreerde beschrijvingen van indische kunstnijverheid.** Amsterdam, J. H. de Bussy, 1903-1916. 8v. illus.
 Early illustrated handbook of the arts and crafts of Indonesia. Contents: 1, *Het weven in Nederlandsch-Indie*; 2, *Bamboe in Nederlandsch-Indie*; 3, *Het schelpen-en-Kratenwerk in Nederlandsch-Indie*; 4, *Het bladwerk en zijn versiering in Nederlandsch-Indie*; 5, *Textiele versieringen in Nederlandsch-Indie*; 6, *Leder-en perkamentwerk, schorsbereiding en aardewerk in Nederlandsch-Indie*; 7, *Beenhoorn-en schildpadbewerking en het vlechtwerk in Nederlandsch-Indie*; 8, *Houtsnijwerk en metaalbewerking in Nederlandsch-Indie*.

1855 Wagner, Frits. **Indonesia: The Art of an Island Group.** New York, McGraw-Hill, 1959. 256p. illus. index. LC 59-13943.
 History of art and architecture in Indonesia from the neolithic age through the twentieth century. Excellent chapters on the impact of Indian and Islamic culture on the culture of Indonesia precede the discussion of the major epochs of Indonesian art and architecture. Provides a useful glossary, a chronological table, and a bibliography (pp. 243-45) of books and periodical articles in all languages. An excellent history of Indonesian art and architecture for beginning and advanced students.

Thailand

1856 Döhring, Karl S. **Kunst und Kunstgewerbe in Siam.** Berlin, Band 1, 1925. 2v. illus.
 Pictorial survey of the art of Thailand with emphasis on works in lacquer. Volume of text and volume of plates. *See also* the author's: *Siam.* Munich, G. Müller, 1923. 3v. illus.

1857 Le May, Reginald S. **A Concise History of Buddhist Art in Siam.** 2d ed. Rutland, Vt., Tuttle, 1963. 169p. illus. LC 62-18359.
 Originally published in 1938, this is a survey history of art and architecture in Thailand from the Dvaravati period through the schools of Lopburi and Ayadhya. Bibliography (pp. 155-57) lists major books and periodical articles in all languages.

FAR EAST

General Works

1858 Fontein, Jan, and Rose Hempel. **China, Korea, Japan.** Berlin, Propyläen, 1968. 362p. (text); 256p. (illus.). index. (Propyläen Kunstgeschichte, Band 17). LC 70-426900.
Comprehensive, illustrated handbook of art and architecture of China, Japan, and Korea from 1000 B.C. to the middle of the nineteenth century. Introductory essays on the development of the varous arts in the three countries are followed by an excellent corpus of plates. The very informative notes also supply bibliographical references to specialized literature. The volume concludes with an excellent comprehensive bibliography (pp. 318-37) of books and periodical articles in all languages and a thorough chronological table that coordinates artistic events in the three countries with philosophical, political, religious, and general cultural happenings. The standard illustrated handbook of Far Eastern art.

1859 Kümmel, Otto. **Die Kunst Chinas, Japans und Koreas.** Wildpark-Potsdam, Athenaion, 1929. 198p. illus. index.
Concise history of art and architecture in China, Japan, and Korea from prehistoric times to the Ching and Tokugawa periods. Bibliography is given at the end of the chapters. An old, but scholarly history, still of interest to the advanced student. Part of the series, "Handbuch der Kunstwissenschaft."

1860 Munsterberg, Hugo. **Art of the Far East.** New York, Abrams, 1971. 264p. illus. index. LC 68-26866.
Survey history of art and architecture in China, Korea, and Japan from prehistoric times to the present. Well-chosen illustrations but no plans for the architectural examples. Bibliography (pp. 260-62) lists books in all languages.

1861 Shoten, Kadokawa, ed. **A Pictorial Encyclopedia of the Oriental Arts.** New York, Crown, 1969. 7v. illus. LC 70-93408.
Illustrated handbook of Far Eastern art and architecture, divided by country; two volumes are devoted to China, four to Japan, and one to Korea. Provides broad essays on periods of art and architecture, followed by an extensive collection of plates. No bibliographies. A useful collection of illustrations.

China

1862 **Arts of China.** Tokyo, Kodansha International, 1968-1970. 3v. illus. index.
Illustrated history of Chinese art and architecture, with emphasis on discoveries since the Second World War. Volume 1: *Neolithic Cultures to the T'ang Dynasty*, by T. Akiyama, et al.; volume two: *Buddhist Cave Temples; Recent Discoveries*, by T. Akiyama; volume three: *Paintings in Chinese Museums; New Collections*, by Y. Yonezawa and M. Kanakita.

1863 Ashton, Leigh, and Basil Gray. **Chinese Art.** London, Faber, 1935. 375p. illus. index.
Concise history of art, exclusive of architecture, in China from the pre-Han period (3000 B.C.) to the end of the Ching dynasty. Emphasis is on the minor arts. Bibliography (pp. 360-62) lists major books in English. An old, but valuable survey by leading English scholars. For the beginning student and the collector.

1864 Bachhofer, Ludwig. **A Short History of Chinese Art.** New York, Pantheon, 1946. 139p. illus. index.

Concise history of art and architecture in China from the neolithic period through the eighteenth century. Bibliography is provided in the form of notes to the text (pp. 129-31).

1865 Buhot, Jean. **Chinese and Japanese Art, with Sections on Korea and Vietnam.** New York, Praeger, 1967. 428p. illus. index. LC 67-9244.

Concise history of Chinese and Japanese art and architecture with briefer sections on Korea and Vietnam from prehistoric times through the eighteenth century. Classified bibliography (pp. 335-43), mostly of works in French.

1866 Fenollosa, Ernest F. **Epochs of Chinese and Japanese Art: An Outline History of East Asiatic Design.** New and rev. ed. with copious notes by Professor Petrucci. New York, Dover, 1963. 2v. illus. LC 63-5655.

Reprint of the 1921 edition, first published in 1912. Concise history of art and architecture in China and Japan from prehistoric times through the nineteenth century. Provides a glossary of proper names and some bibliographical references in the footnotes. Early pioneering history of Far Eastern art.

1867 Grousset, René. **Chinese Art and Culture.** New York, Orion Press, 1959. 331p. illus. index. LC 59-13323.

Translation of *La Chine et son art* (Paris, Plon, 1951). Concise history of art and architecture in China from prehistoric times through the Ching dynasty. Sets the arts within the development of Chinese culture. Bibliographical footnotes. A good introduction to Chinese art and its cultural context for the general reader and the beginning student.

1868 Jenyns, R. Soame, ed. **Chinese Art.** New York, Universe, 1960-1965. 4v. illus. LC 60-12415.

Illustrated handbook of Chinese art, exclusive of architecture, covering the period from neolithic times to the end of the Ching dynasty. The volumes consist of a brief introductory essay followed by a good collection of plates. Bibliographies are given at the end of volumes 1, 3, and 4. Contents:

Volume 1, Lion, Daisy, and Jean Claude Moreau-Gebard. *Bronze, Jade, Sculpture, Ceramics* (1960)

Volume 2, Watson, William, and R. Soame Jenyns. *Gold, Silver, Bronze, Cloisonné, Cantonese Enamel, Lacquer, Furniture, Wood* (1962)

Volume 3, Speiser, Werner, Roger Goeppe, and Jean Fribourg. *Painting, Calligraphy, Stone Rubbing, Wood Engraving* (1964)

Volume 4, Jenyns, R. Soame. *Textiles, Glass and Painting on Glass, Carvings in Ivory and Rhinoceros Horn, Carvings in Hardstones, Snuff Bottles, Inkcakes and Inkstones* (1965)

Good collection of plates for the collector and advanced student.

1869 Medley, Margaret. **A Handbook of Chinese Art for Collectors and Students.** London, G. Bell, 1964. 140p. illus. index. LC 64-54900. Reprint: New York, Harper & Row, n.d. LC 74-6765.

Dictionary handbook of Chinese art, exclusive of architecture. Sections cover bronzes, ceramics, decoration, jade and hardstones, and painting. Each section has a brief introduction and a dictionary of terms. Brief bibliographies at the end of each section list books in English. General bibliography (pp. 131-32) lists books in English. Appendix lists societies devoted to the study of Chinese art and culture and chief collections of Chinese art. Useful handbook for the beginning student and the collector.

1870 Munsterberg, Hugo. **The Arts of China.** Rutland, Vt., Tuttle, 1972. 234p. illus. index. LC 70-188012.

Concise history of art and architecture in China from prehistory through the Ching period. Bibliography (pp. 221-23) lists major books in English.

1871 Munsterberg, Hugo. **A Short History of Chinese Art.** New York, Greenwood Press, 1969. 225p. illus. index. LC 70-88990.

Reprint of 1949 edition. General history of Chinese art and architecture from prehistoric times through the Ching dynasty. Bibliography (pp. 21317) lists major works in English.

1872 Prodan, Mario. **Chinese Art: An Introduction.** New York, Pantheon, 1958. 220p. illus. index. LC 58-11711.

Concise history of Chinese art, exclusive of architecture, from prehistoric times through the Ching dynasty. Chapters on bronzes, ceramics, sculpture, painting, ivories, jade, lacquer, textiles, and jewelry. Bibliography (pp. 209-13) is a classified list of books in all languages. A sensitively written survey for the general reader and the collector.

1873 Rawson, Jessica. **Ancient China: Art and Archaeology.** New York, Harper & Row, 1980. 240p. illus. index. LC 79-3674.

History of Chinese art excluding architecture from the Neolithic to the Han dynasty and based upon archaeological material in the British Museum. Thorough, classified bibliography (pp. 221-28).

1874 Rivière, Jean R. **El arte de la China.** Madrid, Espasa-Calpe, 1966. 626p. illus. index. (Summa Artis, Historia General del Arte, XX). LC NUC67-61954.

Comprehensive history of art and architecture in China from prehistoric times to the end of the Manchu dynasty. Good coverage of the applied and decorative arts. No bibliography.

1875 Sickman, Laurence C. S., and Alexander Soper. **The Art and Architecture of China.** 3d ed. Harmondsworth, Penguin, 1968. 350p. illus. index. (Pelican History of Art, Z10). LC 75-422837.

Comprehensive history of art and architecture (treated in separate sections) of China from prehistoric times to the early twentieth century. Excellent selection of plates, maps, plans, and diagrams. Two-part bibliography (pp. 327-34) lists major works in all languages, with an additional note on works that have appeared since the first edition. Further reference to specialized literature is found in the extensive footnotes. Useful glossary of terms. The standard history of Chinese art and architecture.

1876 Silcock, Arnold. **Introduction to Chinese Art and History.** New York, Oxford University Press, 1948. 256p. illus. index.

Concise survey of Chinese art and architecture cast within the general historical development of the country. Provides maps, chronological table of events in China and the West, guide to the pronunciation of Chinese names, and a brief bibliography listing major books and periodicals in English (pp. 244-46). Still a useful survey for the general reader.

1877 Sirén, Osvald. **A History of Early Chinese Art.** London, Benn, 1929-1930. 4v. illus. index.

Comprehensive history of art and architecture in China through the T'ang dynasty. Contents of volume I: *Prehistoric Introduction; the Yin Period; the Chou Period; the Ch'u and Ch'in Period*; volume II: *The Han Period; the Chin and Six Dynasties Period*; volume III: *Sculpture*; volume IV: *Architecture*. Bibliographical footnotes. An older, standard work.

1878 Smith, Bradley, and Wan-go Weng. **China: A History in Art.** Garden City, N.Y., Doubleday, 1973. 296p. illus. index. LC 72-76978.

Elaborately illustrated cultural history of China from ancient times to the present, as illustrated in works of art and architecture. Bibliography (pp. 293-94) lists books in English and Chinese.

1879 Speiser, Werner. **The Art of China: Spirit and Society.** New York, Crown, 1961. 258p. illus. index. LC 61-10700.

Survey history of art and architecture in China from the Shang dynasty to the twentieth century. Provides glossary of terms, chronological table, and bibliography (pp. 247-48) of books in all languages (those works that have bibliographies are singled out).

1880 Sullivan, Michael. **The Arts of China.** 3d. ed. Berkeley and Los Angeles, University of California Press, 1984. 278p. illus. index. LC 82-16027.

New edition of the author's *A Short History of Chinese Art* (1967). Concise history of the art and architecture of China from prehistory through the twentieth century. Good selection of plates, useful chronological table, and bibliography (pp. 271-73) of major works in English. An excellent survey history for the general reader and the beginning student.

1881 Sullivan, Michael. **Chinese and Japanese Art.** New York, Franklin Watts, 1965. 302p. illus. index. LC 65-10271.

A concise history of Chinese and Japanese painting, sculpture, and architecture. Includes an interesting section on influences. Illustrated with color plates and black and white illustrations. A good introduction for beginning students and general readers.

1882 Swann, Peter C. **Art of China, Korea and Japan.** New York, Praeger, 1963. 285p. illus. index. LC 63-18836.

Concise survey of the art and architecture of the Far East from circa 1550 B.C. to the present Bibliography (pp. 274-81) lists books in English.

1883 Tregar, Mary. **Chinese Art.** New York, Oxford University Press, 1980. 216p. illus. index. LC 79-24744.

In the series: The World of Art. Survey of Chinese art excluding architecture from Neolithic times to the 1960s. Bibliography of basic works in English, p. 201.

1884 Watson, William. **Style in the Arts of China.** New York, Universe, 1975. 126p. illus. index. LC 74-193821.

Concise history of art and architecture in China from prehistoric times through the nineteenth century. Brief text with emphasis on stylistic development. Good selection of plates with informative, descriptive captions. Brief bibliography of books in all languages. Series: "Universe History of Art."

1885 Willetts, William. **Chinese Art.** London, Penguin, 1958. 2v. illus. index. LC 59-12349.

History of art and architecture in China from prehistoric times to the present. After an introduction that covers the geography of China and that provides a short history of the country, there are chapters on prehistoric civilization. The rest of the work is divided into sections on the major media. Bibliographical references are in the footnotes. A good history of Chinese art and architecture, in part superseded by the author's later work (1886).

1886 Willetts, William. **Foundations of Chinese Art from Neolithic Pottery to Modern Architecture.** New York, McGraw-Hill, 1965. 456p. illus. index. LC 64-66127.

Illustrated history of art and architecture in China from the neolithic to the present. The text is a revised, abridged, and extensively rewritten version of the author's *Chinese Art* (1885). Provides a very good selection of plates, plans, and diagrams and a good classified bibliography (pp. 437-41). A good survey history of Chinese art and architecture for beginning and advanced students.

Japan

1887 Abbate, Francesco, ed. **Japanese and Korean Art.** London, Octopus, 1972. 158p. illus. LC 72-17182.
Pictorial survey of the art and architecture of Japan and Korea from the seventh century A.D. to the beginning of the twentieth century. All illustrations are in color, but some are poorly reproduced. Inadequate one-page bibliography.

1888 **Arts of Japan.** v. 1- . New York, Weatherhill/Shibundo, 1972- . illus.
Pictorial survey of the pictorial and applied and decorative arts of Japan. Each volume is topical and written by a Japanese expert on the subject. To date, the following have appeared:
1, *Design Motifs*
2, *Kyoto Ceramics*
3, *Tea Ceremony Utensils*
4, *The Arts of Shinto*
5, *Narrative Picture Scrolls*
6, *Meiji Western Painting*
7, *Ink Painting*
Some have been adapted from the original Japanese series (Nihon no Bijutsu) by individual translators. No bibliographies.

1889 Boger, H. Batterson. **The Traditional Arts of Japan: A Complete Illustrated Guide.** Garden City, N.Y., Bonanza, 1964. 351p. illus. index. LC 64-11726.
Comprehensive survey of the many arts of Japan, including painting, sculpture, architecture, landscape design, floral arrangement, tea ceremony and ceremonial objects, pottery, porcelain, lacquerware, and others. Generously illustrated with black and white illustrations plus a color plate section. Includes maps, chronological outline, and a bibliography (pp. 339-40). A good, sensitive survey for beginning and advanced students.

1890 Buhot, Jean. **Histoire des arts de Japon. I. Des origines à 1350.** Paris, Vanoest, 1949. 270p. illus. index. (Annales du Musée Guimet, Nouv. série, V).
Comprehensive and scholarly history of the art and architecture of Japan from prehistoric times to 1350. Provides good selection of plates, diagrams and maps, with thorough reference to specialized literature in the extensive footnotes. A standard history of early Japanese art and architecture.

1891 Gutiérrez, Fernando G. **El arte de Japòn.** Madrid, Espasa-Calpe, 1967. 567p. illus. index. (Summa Artis, Historia General del Arte, XXI). LC NUC68-44791.
Comprehensive history of art and architecture in Japan from pre-Buddhist times to 1926. Glossary of technical terms in Japanese and bibliography of basic books (pp. 547-48).

1892 **Heibonsha Survey of Japanese Art.** v. 1- . New York, Weatherhill, 1972- . illus.
Comprehensive history of Japanese art, architecture, and the applied arts, consisting of volumes devoted to specific subjects. To date, the following have appeared:
1, *Major Themes in Japanese Art*
2, *The Beginnings of Japanese Art*
3, *Shinto Art: Ise and Izumo Shrines*
4, *Asunka Buddhist Art*
5, *Nara Buddhist Art*
6, *The Silk Road and Shoso-in*
7, *Temples of Nara and Their Art*
8, *Art in Japanese Esoteric Buddhism*
9, *Heian Temples: Byodo-in and Chuson-ji*
10, *Painting in the Yamato Style*

11, *Sculpture of the Kamakura Period*
12, *Japanese Ink Painting: Shubun to Sesshu*
13, *Feudal Architecure of Japan*
14, *Momoyama Decorative Painting*
15, *Japanese Arts and the Tea Ceremony*
16, *Japanese Costume and Textile Arts*
17, *Momoyama Genre Painting*
18, *Edo Painting: Sotatsu and Korin*
19, *The Namban Art of Japan*
20, *Edo Architecture*
21, *Traditional Domestic Architecture*
22, *Traditional Woodblock Prints of Japan*
23, *Japanese Painting in the Literati Style*
24, *Modern Currents in Japanese Art*
25, *Japanese Art in World Perspective*
26, *Folk Arts and Crafts of Japan*
27, *The Art of Japanese Calligraphy*
28, *The Garden Art of Japan*
29, *The Art of Japanese Ceramics*

Each volume is written by a Japanese expert and contains bibliographical references.

1893 Newman, Alexander R., and Egerton Ryerson. **Japanese Art: A Collector's Guide.** London, Bell, 1964. 271p. illus. index. LC 65-83470.

Handbook of Japanese art containing chapters on various media (books, ceramics, clocks, etc.) and a section on Japanese dating and periods of art history. Good bibliographies are provided at the end of chapters and sections. A good guide to Japanese art, especially the minor arts of interest to collectors.

1894 Noma, Seiroku. **The Arts of Japan.** Tokyo, Kodansha International, 1966-1967. 2v. illus. LC 65-19186 rev.

Illustrated history of art and architecture in Japan from prehistory to the present day. Volume I: *Ancient and Medieval*; volume II: *Late Medieval to Modern*. Short essays sketch the development of art and architecture by periods; there are excellent color plates with informative captions. A bibliography of works in English is at the end of each volume. An excellent survey for the general reader.

1895 **The Pageant of Japanese Art.** Tokyo, Toto Bunka, 1957-1958. 6v. illus.

Comprehensive history of Japanese art and architecture to the early twentieth century. Contents: Volumes 1-2, *Painting*; volume 3, *Sculpture*; volume 4, *Ceramics and Metalwork*; volume 5, *Textiles and Lacquer*; volume 6, *Architecture and Gardens*. Each volume contains a text tracing the development of the medium, a collection of plates with descriptive notes, a glossary of Japanese terms, and explanatory drawings and diagrams. No bibliography.

1896 Paine, Robert T., and Alexander C. Soper. **Art and Architecture of Japan.** 2d ed. London, Penguin, 1974. 328p. illus. index. (Pelican History of Art, Z8). LC 74-186336.

Comprehensive and scholarly history of art and architecture in Japan from the archaic period to the mid-nineteenth century. Excellent selection of plates, glossary, maps, diagrams, and plans. Bibliography (pp. 293-306) is divided into sections on architecture and art; the first part lists only books in English, while the second part has sections for books in Western languages and those in Japanese. Thorough reference to more specialized literature in the extensive footnotes. The standard history of Japanese art and architecture in English.

1897 Smith, Bradley. **Japan. A History in Art.** Garden City, N.Y., Doubleday, 1964. 295p. illus. LC 64-21410.

Elaborately illustrated cultural history of Japan from the earliest times to the present. One-page bibliography of general books in English.

1898 Swann, Peter C. **The Art of Japan: From Joman to the Tokugawa Period.** New York, Crown, 1966. 238p. illus. index. LC 66-22128.

Concise history of art and architecture in Japan from neolithic times to the mid-nineteenth century. Good selection of color plates, modest supplement of black and white plates; liberally provided with plans and diagrams. Provides useful maps, a chronological table, and a bibliography (pp. 226-28) that lists major works in all languages.

1899 Swann, Peter C. **An Introduction to the Art of Japan.** Oxford, Cassirer, 1958. 220p. illus. index. LC 58-12088.

Concise history of the art, exclusive of the architecture, of Japan from prehistoric times to the Edo period. Bibliography (p. 216) lists books in English.

1900 Tsuda, Noritake. **Handbook of Japanese Art.** Tokyo, Sanseido, 1935. 525p. illus. index.

History and handbook of Japanese art and architecture covering the period from prehistoric times to the twentieth century. Text is arranged by periods. Part II provides a useful topographical guide to temples and museums in Japan. Bibliography (pp. 505-508) lists only books in English. An older history, still useful to the advanced student.

1901 Tsudzumi, Tsuneyoshi. **Die Kunst Japans.** Leipzig, Insel, 1929. 341p. illus. index.

Comprehensive history of art and architecture in Japan from a poetic and aesthetic point of view. Contents: Einleitung; Die Rahmenlosigkeit als Grundbegriff des Japanischen Kunststils; Kunst der Naturgestaltung; Religiöse Kunst; Kunst der Lebengestaltung. No bibliography. Important contribution toward the definition of national character in Japanese art history, albeit from a nationalistic vantage point.

1902 Warner, Langdon. **The Enduring Art of Japan.** Cambridge, Mass., Harvard University Press, 1952. 125p. illus. index.

Concise history of Japanese art and architecture from 794 to circa 1750. Consists of chapters on the major periods of Japanese art and architecture. Bibliography (pp. 111-13) provides a list of major books in English. A useful introduction to the broad outlines of Japanese art history.

1903 Yashiro, Yukio, ed. **Art Treasures of Japan.** Tokyo, Kokusai Bunka Shinkokai, 1969. 2v. illus. LC 63-2165.

Illustrated handbook of Japanese art, exclusive of architecture, from prehistoric times to the present. Consists of essays on the various periods by Japanese specialists, followed by an excellent corpus of illustrations with descriptive notes. Provides a useful chronological chart of the periods of Oriental art history. A standard handbook of Japanese art.

1904 Yashiro, Yukio. **2000 Years of Japanese Art.** New York, Abrams, 1958. 268p. illus. index. LC 58-13478.

Illustrated survey of the art of Japan from prehistoric times to the present, exclusive of architecture. The introductory essay, which characterizes the chief epochs of Japanese art, is followed by a collection of excellent plates with informative captions. No bibliography. A good survey for the general reader.

Korea

1905 Eckardt, Andreas. **A History of Korean Art.** London, Goldston, 1929. 225p. illus. index.

Concise history of art and architecture in Korea from earliest times to the twentieth century. A bibliography is given at the beginning of each section. An older survey history of Korean art and architecture.

1906 Kim, Chae-won. **Treasures of Korean Art: 2000 Years of Ceramics, Sculpture and Jeweled Arts.** New York, Abrams, 1966. 283p. illus. index. LC 66-23402.

Illustrated history of sculpture and the minor arts in Korea from prehistoric times to the middle of the nineteenth century. Bibliography (pp. 261-63) is an unclassified list of major works; further literature is mentioned in the notes to the text. Excellent illustrations, and good (if brief) text. A good survey of the arts of Korea for the beginning student and the collector.

1907 McCune, Evelyn. **The Arts of Korea: An Illustrated History.** Rutland, Vt., Tuttle, 1961. 452p. illus. index. LC 61-11122.

Concise history of the art and architecture of Korea from prehistoric times through the nineteenth century. Good selection of illustrations, chronological table, and brief but well-selected bibliography (pp. 439-42). A standard history of Korean art and architecture.

12
NEW WORLD ART

PRE-COLUMBIAN AMERICA

General Works

1908 Aleina, Franch Jose. **Pre-Columbian Art.** New York, Abrams, 1983. 614p. illus. index. LC 82-20626.
Richly illustrated survey of art and architecture in pre-Columbian Central and South America from paleolithic times to the end of the Aztec civilization. Catalog of principal sites, maps, and classified bibliography.

1909 Anton, Ferdinand, and Frederick J. Dockstader. **Pre-Columbian Art and Later Tribal Arts.** New York, Abrams, 1968. 264p. illus. index. LC 68-11509.
Survey of the art and architecture of pre-Columbian Mexico, Central and South America, and the later tribal arts of the North American Indian. Good choice of illustrations. Bibliography (pp. 258-61) lists books in all languages.

1910 Bushnell, G. H. S. **Ancient Arts of the Americas.** New York, Praeger, 1965. 287p. illus. index. LC 65-20077.
Concise history of the arts of pre-Columbian civilizations of North and South America. Emphasis is on the ancient civilizations of Mexico, Central America, and northern South America, with only brief mention of North American Indian art. Good selection of plates, with maps, a chronological table, and a bibliography (pp. 267-68) of works in English.

1911 Disselhoff, Hans-Dietrich, and Sigvald Linné. **The Art of Ancient America: Civilizations of Central and South America.** New York, Crown, 1966. 270p. illus. index. LC 61-16973.
Concise history of pre-Columbian art and architecture covering Mexico, Central America, the Andean lands, greater Peru, Colombia, and San Agustín from prehistory to the Spanish Conquest. Provides useful chronological tables, glossary of terms, good selection of color plates, and modest supplement of black and white plates. Bibliography (pp. 263-66) lists books and periodical articles in all languages. A good survey of pre-Columbian art and architecture for the beginning student.

1912 Emmerich, André. **Art before Columbus.** New York, Simon and Schuster, 1963. 256p. illus. index. LC 63-16027.
Pictorial survey of the art and architecture in Latin America from the second millennium B.C. to the Spanish Conquest. The brief text is accompanied by a good selection of color and black and white plates. Provides a useful glossary of terms and a good bibliography (pp. 245-47) of books in all languages.

293

1913 Kelemen, Pál. **Art of the Americas, Ancient and Hispanic, with a Comparative Chapter on the Philippines.** New York, Crowell, 1969. 402p. illus. index. LC 72-87163.

Concise history of art and architecture in Central and South America from prehistoric times through the Colonial period. Contains a chapter on art and architecture in the Colonial Philippines. Provides maps, a good selection of plates, and a bibliography (pp. 359-61) that lists books and periodical articles in English.

1914 Kelemen, Pál. **Medieval American Art.** New York, Macmillan, 1943. Reprint: New York, Dover, 1969. 2v. illus. index.

Comprehensive history of the art and architecture of Mexico, Central America, and the Andean region of South America from circa 100 A.D. to the Spanish Conquest. Good selection of plates, plus maps, plans, diagrams, and a chronological table. Bibliography (pp. 385-405) is an unclassified list of books and periodical articles. A dated, but classic treatment of pre-Columbian art and architecture.

1915 Kubler, George. **Art and Architecture of Ancient America.** 3d ed. London, Penguin, 1983. 572p. illus. index. (Pelican History of Art, Z21). LC 81-10525.

Comprehensive history of art and architecture in pre-Columbian South and Central America. Covers the civilizations of Mexican, Mayan, and Andean regions from 1500 B.C. to the Spanish Conquest. Provides good selection of plates, maps, plans, diagrams, and an excellent bibliography (pp. 385-402) that lists the major books and periodical articles in all languages. A standard, scholarly history of ancient American art and architecture.

1916 Lapiner, Alan. **Pre-Columbian Art of South America.** New York, Abrams, 1976. 460p. illus. LC 75-1016.

Illustrated handbook of art and architecture in Peru, Ecuador, Colombia, Venezuela, Bolivia, Argentina, Chile, and Brazil before the Spanish Conquest. Chronological tables, maps, glossary and bibliography of books and periodical articles in all languages (pp. 455-59).

1917 Lothrop, S. K. **Treasures of Ancient America: The Arts of the Pre-Columbian Civilizations from Mexico to Peru.** Geneva, Skira, 1964. 230p. illus. index. LC 64-23255.

Pictorial survey of the art (exclusive of the architecture) of the ancient civilizations of Mexico, Central America, and the Andean region of South America, from pre-Classical times to the Spanish Conquest. The brief text is accompanied by excellent color plates and commentaries. No bibliography.

1918 Pijoán y Soteras, José. **Arte precolombiano Mexicana y Maya.** Madrid, Espasa-Calpe, 1946. 606p. (Summa Artis, Historia General del Arte, X).

Comprehensive history of art and architecture in pre-Columbian Mexico and Central America. Chapters are devoted to individual sites. Bibliography (pp. 585-87) lists general books in all languages.

1919 Willey, Gordon, ed. **Das Alte America.** Berlin, Propyläen, 1974. 392p. text, 228 plates. (Propyläen Kunstgeschichte, XVIII). LC 75-568149.

Comprehensive, illustrated handbook of pre-Columbian art and architecture. Introductory essays by various experts examine the development in major regions and are followed by a good corpus of plates with descriptive notes containing specialized bibliographies. Bibliography (pp. 367-85) is an excellent classified list of books and periodical articles in all languages.

Mesoamerica and Mexico

1920 Anton, Ferdinand. **Ancient Mexican Art.** New York, Putnam, 1969. 309p. illus. index. LC 77-75212.

Illustrated history of art and architecture in Mexico from circa 1500 B.C. to the Spanish Conquest. Brief introductory essay is followed by a good selection of plates and commentaries. Provides a useful chronological table, a map, and a bibliography (pp. 299-301) that lists books and periodical articles in all languages. Good survey history for the general reader and beginning student. Plates form a valuable handbook for the advanced student.

1921 Anton, Ferdinand. **Die Kunst der Goldländer zwischen Mexiko und Peru.** Leipzig, Seemann, 1974. 314p. illus. LC 75-528638.

Illustrated handbook of the art, exclusive of architecture, of pre-Columbian Nicaragua, Costa Rica, Panama, northern Colombia and Venezuela, and pre-Inca Ecuador. Chronological table and bibliography of basic books in all languages (pp. 313-14).

1922 Covarrubias, Miguel. **Indian Art of Mexico and Central America.** New York, Knopf, 1957. 360p. illus. index. LC 57-59203.

History of the art and architecture of the pre-Columbian civilizations of Mexico and Central America, from the Olmec empire through the Aztec empire. Bibliography (pp. 335-60) lists books and periodical articles. Somewhat out of date, but still useful for the advanced student.

1923 Dockstader, Frederick J. **Indian Art in Middle America.** Greenwich, Conn., New York Graphic Society, 1964. 221p. illus. LC 64-21815.

Illustrated handbook of the arts of Central America from earliest times to the present. Covers the ancient cultures of the Aztecs and Mayas as well as the arts of present-day Indians in Central America. Brief introduction sketches the history of art, followed by more detailed comments on the excellent plates. There are maps, a chronological table, and a bibliography (pp. 217-21). Text is directed to the general reader and the beginning student. Plates, especially when combined with the other works by Dockstader (1934, 1939), form a valuable illustrated handbook of Indian art for the advanced student.

1924 Feuchtwanger, Franz. **Art of Ancient Mexico.** London, Thames and Hudson, 1954. 125p. illus. index.

Pictorial survey of the art and architecture of ancient Mexico from 1521 B.C. to 1500 A.D. Brief text with good plates, a map, and a chronological table. No bibliography.

1925 Medioni, Gilbert. **Art Maya du Mexique et du Guatémala.** Paris, Éditions de la Cyme, 1950. 113p. illus.

Scholarly history of art and architecture of the ancient Mayas. Excellent maps, detailed chronological tables, and a bibliography (pp. 109-12).

1926 Miller, Mary E. **The Art of Mesoamerica from Olmec to Aztec.** London, Thames, and Hudson, 1986. 240p. illus. index. LC 85-51916.

Survey history of pre-Columbian art and architecture in Mesoamerica. Good, partly annotated bibliography of basic works (pp. 231-35).

1927 Pasztory, Esther. **Aztec Art.** New York, Abrams, 1983. 335p. illus. index. LC 82-11527.

Comprehensive history of Aztec art and architecture. Contents: Historical and Cultural Background; A Definition of Aztec Art; Aztec Architecture and Cliff Sculpture; The Major Monuments of Tenochtitlan; Codices; Stone Sculpture; Lapidary Arts; Wood Sculpture and Turquoise Mosaic; Featherwork; Terracotta Sculpture; Ceramics. Bibliography (pp. 312-22) is an alphabetical list by author.

1928 Spinden, Herbert J. **A Study of Maya Art. Its Subject Matter and Historical Development.** Cambridge, Mass., Peabody Museum, 1913. 285p. illus. index. Reprint: ("With introduction and bibliography by J. E. S. Thompson") New York, Dover, 1975. 285p. illus. index. LC 74-20300.
 An old, standard handbook of Maya art and architecture. Contents: Introduction; I, General Consideration of Maya Art—the Human Form, the Serpent, the Serpent and Geometric Art, the Serpent in Some of Its Religious Aspects, Other Subjects; II, Consideration of the Material Arts—Architecture, Minor Arts; III, Chronological Sequence; Table of Nomenclature. Bibliography (pp. 263-76) is a list of works cited in the 1913 edition. Bibliography by Thompson in reprint consists of brief list of works by Spinden at end of biographical introduction.

1929 Steirlin, Henri. **Art of the Aztecs and Its Origins.** New York, Rizzoli, 1982. 228p. illus. index. LC 82-50424.
 Well-illustrated survey of the art and architecture of the Aztecs. Contents: From Early Origins to Pre-Classic Art; Teotihuacan and Classic Heyday; From Xochicalco to the Toltecs; The Ritual Esplanade of Monte Alban; The Mixtecs, Writing and Metallurgy; The Gulf Peoples and El Tajin; From Huateca to the Pacific Coast; The Apotheosis of the Aztecs. Select list of basic books, p. 227

1930 Steirlin, Henri. **Art of the Maya: From the Olmecs to the Toltec Maya.** New York, Rizzoli, 1981. 211p. LC 80-54634.
 Well-illustrated survey of art and architecture of Central America from 1000 B.C. to 1200 A.D. Contents: The Olmec Dawn; The Rise of the Maya; Palenque and Western Maya Art; On the Periphery of Yucatan; The Masterpieces of the Punic Style; The Toltec-Maya Renaissance. Many plans, drawings, and maps, and bibliography (p. 205) of basic books and articles.

1931 Toscano, Salvador. **Arte Pre-Columbino de México y de la América Central.** 2d ed. Mexico City, Inst. de Invest. Estéticas, 1952. 2v. illus. index.
 Comprehensive history of art and architecture of pre-Columbian Mexico and Central America from circa 1500 B.C. to the Spanish Conquest. Good bibliographies are given at the end of the chapters. An older but standard history of ancient Maya and Aztec art and architecture.

1932 Winning, Hasso von. **Pre-Columbian Art of Mexico and Central America.** New York, Abrams, 1968. 388p. illus. LC 65-123065.
 Illustrated history of art and architecture in Mexico and Central America from circa 1500 B.C. to the Spanish Conquest. Brief text sketching the history of art and architecture is accompanied by excellent plates, commentaries on the plates, chronological tables, maps, and a bibliography (pp. 386-88), which lists books and periodical articles in all languages. A well-illustrated and concise survey for the general reader.

South America

1933 Anton, Ferdinand. **Alt Peru und seine Kunst.** Leipzig, Seemann, 1962. 127p. illus. LC 62-47873.
 Pictorial survey of the art and architecture of ancient Peru from 3000 B.C. to 1500 A.D. Excellent plates, maps, brief unclassified bibliography (pp. 99-100) of books and periodical articles in all languages. Further literature is mentioned in the footnotes.

1934 Dockstader, Frederick J. **Indian Art in South America: Pre-Columbian and Contemporary Arts and Crafts.** Greenwich, Conn., New York Graphic Society, 1967. 222p. illus. LC 67-19372.
 Illustrated handbook of the arts and crafts of the Indian societies of South America from earliest times to the present. Includes ancient Inca civilizations. Brief introduction,

commentaries on the excellent plates, maps, chronological table, and bibliography (pp. 219-22). Text is directed to the general reader and the beginning student. Especially when combined with the other works by Dockstader (1923, 1939), the plates form a valuable illustrated handbook of Indian art for the advanced student.

1935 Lehmann, Walter, and Heinrich Ubbelohde-Doering. **The Art of Old Peru.** 2d ed. London, Benn, 1957. 68p. (text); 128p. (illus.). Reprint: New York, Hacker, 1975.
Illustrated survey of pre-Columbian art and architecture with a brief introduction and notes to the good plates. Bibliography (pp. 66-68) lists major works in all languages. First published in 1924. Once a standard work, it is now out of date in several respects; nevertheless, it is still a valuable collection of plates.

1936 Steirlin, Henri. **Art of the Incas and Its Origins.** New York, Rizzoli, 1984. 240p. illus. index. LC 80-5474.
Survey of the art and architecture of the Andean cultures from the Valdivia period to that of Machu Picchu. Excellent selection of well-reproduced plates. Unclassified bibliography of books and periodical articles, pp. 233-35.

1937 Ubbelohde-Doering, Heinrich. **The Art of Ancient Peru.** New York, Praeger, 1952. 240p. illus. LC 52-7489.
Illustrated survey of the arts of ancient Peru. A brief introductory essay sketching the history of ancient Peruvian art is followed by a good selection of plates and a bibliography (pp. 53-55) that lists books and articles in all languages. Still useful for its plates.

NORTH AMERICAN INDIAN

1938 Covarrubias, Miguel. **The Eagle, the Jaguar, and the Serpent: Indian Art of the Americas.** New York, Knopf, 1954. 314p. illus. index. LC 52-6415.
History-study of the arts of the North American Indians covering Alaska, Canada, and the continental United States. Chapters sketch the history of North American Indian art, discuss its techniques and aesthetics, and describe the various Indian societies. Bibliography (pp. 298-314) is an unclassified list of books and periodical articles in English. An older, classic study of Indian art, still useful to the advanced student.

1939 Dockstader, Frederick J. **Indian Art in America.** 3d ed. Greenwich, Conn., New York Graphic Society, 1966. 224p. illus. LC NUC67-88306.
Survey of the arts of the North American Indian. Well illustrated, it also has a good bibliography (pp. 222-24), which lists books in all languages. A good pictorial survey for the general reader.

1940 Feder, Norman. **American Indian Art.** New York, Abrams, 1971. 446p. illus. LC 69-12484.
Illustrated survey of the arts of the North American Indian. Part I deals with the origins, materials, and techniques of the Indian artists; part II discusses the arts by culture areas. Covers Indians of the plains, the Southwest, California, the Northwest, the Eastern woodlands, and the Arctic coasts. Excellent plates and a good bibliography (pp. 439-46) that lists major books. A standard illustrated handbook.

1941 Feder, Norman. **Two Hundred Years of North American Indian Art.** New York, Praeger, 1971. 128p. illus. LC 70-176395.
Pictorial survey of the arts of the North American Indian based on an exhibition held at the Whitney Museum of American Art. Brief introduction discusses the Indian artists, the function of Indian art, and techniques and materials. Well illustrated. Provides a good but unclassified bibliography (pp. 121-24). For the general reader and the beginning student.

1942 Feest, Christian F. **Native Arts of North America.** New York, Oxford University Press, 1980. LC 80-14496.

Survey of the art, not including architecture, of the major North American Indian peoples. Contents: Part I: Towards a History, from "Artificial Curiosities" to Art, the Makers, Native Traditions and the European Impact; Part II: Techniques and Styles, Painting and Engraving, Textiles, Sculpture. Bibliography (pp. 198-208) is a comprehensive and partly annotated list of books and periodical articles. In the "World of Art Series."

1943 Furst, Peter J., and Jill Leslie Furst. **North American Indian Art.** New York, Rizzoli, 1982. 343p. LC 82-40343.

Well-illustrated survey of the traditional arts, not including architecture, of the major North American Indian peoples. Geographical arrangement. Bibliography (pp. 231-35) provides a classified list of books and periodical articles.

1944 Haberland, Wolfgang. **The Art of North America.** New York, Crown, 1964. 251p. illus. index. LC 68-15660.

Survey of the arts of the Indians of the continental United States, Canada, Alaska, and Greenland. Initial chapters treat the Paleo-Indian art of North America; the rest of the work is devoted to an examination of the arts of the American Indian by region. Provides a useful group of five chronological tables, maps, and a good classified bibliography (pp. 212-20), which lists books and periodical articles in all languages. A good survey of North American Indian art for the general reader. Series: "Art of the World."

1945 Vaillant, George C. **Indian Arts in North America....** New York, Harper, 1939. 63p. illus.

Survey of North American Indian art. Selected bibliography (pp. 55-63) is arranged by chapters and lists major books and periodical articles. An old, but solid introduction to American Indian art.

NATIONAL HISTORIES AND HANDBOOKS

Latin America

GENERAL WORKS

1946 Angulo Iñiguez, Diego, Enrique M. Dorta, and Mario J. Buschiazzo. **Historia del arte Hispano-Americano.** Barcelona, Salvat, 1945-1956. 3v. illus. index.

Comprehensive history of art and architecture in Latin America from the time of the Spanish Conquest to the present. Bibliographies are at the end of each volume. Well illustrated, standard history of Latin American art and architecture.

1947 Cali, Francis. **L'art des conquistadors.** Paris, Arthaud, 1960. 294p. illus.

Pictorial survey of the art and architecture of Latin America from the conquests by the Spanish until the end of the eighteenth century. No bibliography.

1948 Castedo, Leopoldo. **A History of Latin American Art and Architecture from Pre-Columbian Times to the Present.** New York, Praeger, 1969. 320p. illus. index. LC 69-13421.

Survey history of art and architecture in Latin America from the ancient Toltecs to the present. Fine selection of plates and maps, and a good selected bibliography (pp. 297-99). A good survey of Latin American art and architecture for the general reader.

1949 Keleman, Pál. **Baroque and Rococo in Latin America.** New York, Macmillan, 1951. 302p. illus. index.

History of art and architecture in Latin America during the Colonial period (seventeenth and eighteenth centuries). Good selection of plates, although they are poorly reproduced; the excellent bibliography (pp. 286-94) lists books and periodical articles in all languages. A somewhat out-of-date, but classic history of Colonial Latin American art and architecture.

1950 Solá, Miguel. **Historia del arte hispano-americano.** Barcelona, Labor, 1935. 341p. (text); 51p. (illus.). index.

Concise history of art and architecture in colonial Latin America (sixteenth through eighteenth centuries). Good selection of poorly reproduced plates. Bibliography (pp. 331-34) lists chiefly Spanish books. This old, general history of colonial Latin American art and architecture is still a useful source of information.

ARGENTINA

1951 Brughetti, Rommaldo. **Historia de arte en Argentina.** Mexico City, Pormaca, 1965. 223p. illus. (Colección Pormaca, 17). LC 67-38174.

Concise survey of art and architecture in Argentina from pre-Hispanic times to the present. Nineteenth and twentieth centuries are treated in a series of chapters devoted to major artists. No bibliography.

1952 **Historia general del arte en la Argentina.** Buenos Aires, Academia Nacional del Bellas Artes, 1983. 5v. illus. index. LC 83-191126.

Illustrated survey of art and architecture in Argentina from prehistoric times to the present. Contents: volumes 1-2, *Desde los comienzos hasta finas del siglo XVIII*; volumes 3-4, *Siglo XIX hasta 1876*; volume 5, *Fines del siglo XIX y comienzos del siglo XX*; volume 6, *Fotografia, la creation musical, arquetectura 1880-1980*. Bibliography.

1953 Pagano, José León. **El arte de los argentinos.** Buenos Aires, Editorial y Libreria Concourt, 1981. 231p. index. LC 82-175866.

Abridged and revised version of (1954), without illustrations. Final chapter, "Las ultimas decadas," brings the history from 1944 to 1980.

1954 Pagano, José León. **El arte de los argentinos.** Buenos Aires, Edicion del Autor, 1937-1940. 3v. illus. index. LC 40-2745.

Comprehensive history of art and architecture in Argentina from prehistoric times to the early twentieth century. Contents: I, Desde los arborigenes el periodo de los organizadores; II, Desde la acción innovadora der "Nexus" hasta neustros dias; III, Desde la pintura en Córdoba hasta las expresiones mas recientes; pintura, escultura, gravado.

1955 Pagano, José León. **Historia del arte Argentino.** Buenos Aires, L'Amateur, 1944. 507p. illus. index.

Concise history of art and architecture in Argentina from the pre-Hispanic aborigines to the present. Bibliography is found in the footnotes. A good general history of art and architecture in Argentina.

1956 Schiaffino, Eduardo. **La pintura y la escultura en Argentina.** Buenos Aires, Edicion del Autor, 1933. 418p. illus.

Survey of painting and sculpture in Argentina from the coming of the Spanish to the end of the nineteenth century. Bibliographical footnotes.

BRAZIL

1957 Acquarone, Francisco. **Historia da arte no Brasil.** Rio de Janeiro, Mano, 1939. 276p. illus. LC 40-14555 rev.
Popular account of Brazilian painting and sculpture from Colonial times until the 1930s. No bibliography.

1958 Acquarone, Francisco. **Historia das artes plasticas no Brasil.** Rio de Janeiro, Grafica Editora Americana, 1980. 288p. LC 81-216631.
Survey of architecture, painting, and sculpture in Brazil from early Colonial times to the present. No bibliography.

1959 Bardi, P. M. **História da arte brasileira. Pintura, escultura, arquitetura, outras, artes.** São Paulo, Melhoramentos, 1975. 228p. illus. index.
Pictorial history of fine and decorative arts in Brazil from prehistoric and primitive cultures to the present. No bibliography.

1960 Lemos, Carlos A., et al. **The Art of Brazil.** New York, Harper & Row, 1983. 318p. illus. LC 83-47551.
Well-illustrated history of art and architecture in Brazil from early Colonial times to the present. Chronological table and dictionary of short biographies of major artists and architects. No bibliography.

1961 Mattos, Anibal. **Historia de arte brasileira.** Bela Horizonte, Ediçoes Apollo, 1937. 2v. in 1.
History of art and architecture in Brazil. Contents: I, *Das origens da arte brasileira*; II, *Arte colonial brasileira*. No bibliography.

COLOMBIA

1962 Arbeláez-Camacho, Carlos, and F. Sebastian. **El arte colonial en Colombia.** Bogotá, Sol y Luna, 1968. 223p. illus. LC 78-424470.
Survey history of architecture, sculpture, painting, furniture, and jewelry in Colombia from the sixteenth through the early nineteenth centuries. Bibliographical footnotes and general bibliography (pp. 209-33) lists books and periodical articles.

1963 Barney, Cabrera Eugenio. **Temas para la historia del arte en Colombia.** Bogotá, Universidad Nacional de Colombia, 1970. 210p. illus. LC 72-317694.
Concise history of art and architecture in Colombia from 1500 to the present. Poor illustrations. Bibliography (pp. 142-43).

1964 **Historia del arte Colombiano.** v. 1- . Bogotá, Salvat Editores Colombiana, 1977- . LC 78-105047.
History of art and architecture in Colombia from prehistoric times to the present. Collaborative work by team of Colombian specialists. To date only volume one, covering the pre-Columbian era, has appeared. Bibliography (p. 240) is a list of five books.

CUBA

1965 Castro, Martha de. **El arte en Cuba.** Miami, Ediciones Universal, 1970. 151p. illus. index. LC 72-19190.
Survey of art and architecture in Cuba from early Colonial times to the present. Bibliographies are at the end of chapters.

DOMINICAN REPUBLIC

1966 Palm, Erwin W. **Arquitectura y arte colonial en Santo Domingo.** Santo Domingo, Editora de la Universidad Autonoma de Santo Domingo, 1974. 251p. illus.

History of art and architecture in Santo Domingo in the seventeenth and eighteenth centuries. Contents: Ecos de arquitectura clasica en el nuevo mundo; La Puerta de San Diego en Santo Domingo, u monumento plateresco; El estilo imperial de Felipe II y las edificaciones del siglo XVII en la Espa ola; Rodrigo de Liendo arquitecto en la Espa ola; Dos santuarios dominicanos; Arte colonial en santo domingo siglos XVI-XVIII. Bibliographical footnotes.

ECUADOR

1967 **Historia del arte ecuatoriano.** Quito, Salvat Editores, 1977. 4v. illus. index. LC 78-1520.

Illustrated survey of art and architecture in Ecuador from prehistoric times to the present. First volume covers pre-Columbian art and architecture; volume two, early Colonial art and architecture; volume three, art and architecture of the seventeenth and eighteenth centuries; volume four, twentieth-century art and architecture. No bibliography.

1968 Vargas, José Maria. **El arte ecuatoriano.** Mexico City, Cajica, 1959. 581p. illus. index. LC 61-20250.

History of art and architecture in Ecuador from the sixteenth century through the nineteenth century. No bibliography. A standard history of Ecuadorian art and architecture.

GUATEMALA

1969 Chinchilla, Aguilar E. **Historia del arte en Guatemala 1524-1962: arquitectura, pintura y escultura.** 2d ed. Guatemala City, Ministerio de Educacion Publica, 1965. 261p. illus. index. LC 63-59236

Concise history of art and architecture in Guatemala from 1524 to 1962. Provides an unclassified bibliography (pp. 183-87).

1970 Diaz, Victor M. **Las bellas artes en Guatemala.** Guatemala City, Tipografia Nacional, 1934. 600p. illus.

History of art, architecture, theater, dance, and music in Guatemala from early colonial times to the late nineteenth century. No bibliography.

MEXICO

1971 **Enciclopedia Mexicana del arte.** Mexico City, Ediciones Mexicanas, 1950-1951. 15 parts. illus.

Collection of essays by various Mexican scholars on aspects of Mexican art and architecture from pre-Columbian times to the early twentieth century. Occasional bibliographical footnotes.

1972 Fernandez, Justino. **A Guide to Mexican Art, from its Beginning to the Present.** Chicago, University of Chicago Press, 1969. 398p. illus. index. LC 69-16773.

Concise history of Mexican art and architecture from the time of the ancient Toltecs to the present. There are good bibliographies at the end of the chapters. A good survey for the general reader.

1973 Rojas, Pedro. **The Art and Architecture of Mexico.** London, Hamlyn, 1968. 71p. (text); 146p. (illus.). LC 79-379618.
Pictorial survey of the art and architecture of Mexico from 10,000 B.C. to the present. Provides a chronological table, a map, and notes to the plates. No bibliography.

1974 Rojas, Pedro, ed. **Historia general del arte mexicano.** Mexico, Editorial Hermes, 1962-1964. 3v. illus. index. LC 64-54702.
Comprehensive history of art and architecture in Mexico from pre-Columbian times to the present. Volume I: *Época Prehispánica,* by R. Guerrero; volume 2: *Época Colonial,* by P. Rojas; volume 3: *Época Moderna Y Contemporánea,* by R. Tibol. There are extensive bibliographies at the end of each volume. Well illustrated. The standard history of Mexican art and architecture.

1975 Smith, Bradley. **Mexico: A History in Art.** New York, Harper & Row, 1968. 296p. illus. index. Reprint: New York, Crowell, 1975. LC 75-6016.
Pictorial history of the art of Mexico, exclusive of architecture, from prehistoric times (1700 B.C.) to 1940. Well illustrated. Provides a bibliography (pp. 294-95) that lists major books.

1976 Tablada, José L. **Historia del arte en Mexico.** Mexico City, "Aguilas," 1927. 255p. illus.
Concise history of art and architecture in Mexico from pre-Columbian times through the nineteenth century. No bibliography.

1977 Toussaint, Manuel. **Colonial Art in Mexico.** Austin, University of Texas, 1967. 493p. illus. index. LC 66-15696.
Translation of *Arte Colonial en México* (Mexico City, 1962). Important, comprehensive history of art and architecture in Mexico from the Spanish Conquest to 1821. Extensive bibliography of books and periodical articles (pp. 461-76). A standard work.

1978 Weismann, Elizabeth W. **Art and Time in Mexico from the Conquest to the Revolution.** New York, Harper & Row, 1985. 284p. illus. index. LC 84-48202.
Survey history of art and architecture in Mexico from the coming of the Spaniards to the early nineteenth century. Illustrations based on photographs by Judith Hancock Sandoval. Bibliography of basic books in English, pp. 272-73.

1979 Westheim, Paul, et al. **Prehispanic Mexican Art.** New York, Putnam, 1972. 447p. illus. index. LC 70-142463.
Illustrated survey of art and architecture of Prehispanic Mexico. Contents: Artistic Creation in Ancient Mexico, by Paul Westheim; The Art of Ancient Mexico in Time and Space, by A. Ruz; Volume and Form in Native Art, by P. Armillas; Prehispanic Architecture, by R. de Robina; Painting in MesoAmerica by A. Caso. Chronological table, site plans, maps, and bibliography of pre-Hispanic codices. Bibliography (p. 397) lists books in all languages.

PERU

1980 Cossio del Pomar, Felipe. **Arte del Perú colonial.** Mexico City, Fondo de Cultura Economica, 1958. 153p. illus. index. LC 59-22919.
History of architecture and art in Peru from the sixteenth through the early nineteenth centuries. Bibliographies of specialized literature at the end of each chapter.

1981 Wethey, Harold. **Colonial Architecture and Sculpture in Peru.** Cambridge, Mass., Harvard University Press, 1949. 317p. illus. index.
Scholarly study of architecture and sculpture in Peru during the sixteenth and seventeenth centuries. Bibliographical footnotes and bibliography of books and periodical articles (pp. 281-86). Catalog of monuments in Lima (pp. 246-78).

VENEZUELA

1982 Calzadilla, Juan, ed. **El arte en Venezuela.** Caracas, Circulo Musical, 1967. 239p. illus. LC 67-98176.

Concise history of art and architecture in Venezuela from pre-Spanish aboriginal art to the present. Provides an appendix with biographies of artists and architects (pp. 196-239). No bibliography. The standard history of art and architecture for Venezuela.

United States

1983 Baigell, Matthew. **A Concise History of American Painting and Sculpture.** New York, Harper & Row, 1984. 420p. LC 84-47555.

General history of art, excluding architecture, in the United States from Colonial times to 1982. Bibliography (pp. 397-406) is a good classified list of books and periodical articles, including works on individual artists.

1984 Brown, Milton W. **American Art to 1900.** New York, Abrams, 1977. 631p. illus. index. LC 72-99241.

Comprehensive history of American art from early Colonial times to 1900. Architecture, painting, and sculpture are treated together in four parts: The Colonial Period, The Early Republic, The Jacksonian Era, and Civil War to 1900. Chapter on art associations and museums and one on patronage and the art union are of special interest. Good classified bibliography (pp. 611-17).

1985 Brown, Milton W., et al. **American Art: Painting, Sculpture, Architecture, Decorative Arts, Photography.** New York, Abrams, 1979. 616p. illus. index. LC 78-12866.

Comprehensive history of art and architecture in the United States from the beginning of European settlement to 1970. Based on the author's *American Art to 1900* and Sam Hunter, *American Art of the 20th Century* (1435). Good, comprehensive bibliography, pp. 590-603.

1986 Cahill, Holger, and Alfred Barr, eds. **Art in America: A Complete Survey....** New York, Halcyon, 1939. 162p. illus.

Brief survey of art and architecture in America from Colonial times to the early twentieth century. Consists of essays written by various specialists. Bibliography (pp. 153-62) lists major books and periodical articles. Still a useful survey for the general reader.

1987 Chase, Judith W. **Afro-American Art and Craft.** New York, Van Nostrand, 1972. 271p. illus. index. LC 76-163485.

Survey of Afro-American painting, sculpture, and minor arts. Introductory chapter discusses the African background and early history of Afro-American art. Bibliography (pp. 138-39) provides a classified list of major books. For the general reader and the beginning student.

1988 Dunlap, William. **A History of the Rise and Progress of the Arts of Design in the United States....** New ed., illustrated, edited, with additions by Frank W. Bayley and Charles E. Goodspeed. Boston, Goodspeed, 1918. 3v. illus. First published in 1834. Reprint: New York, Dover, 1969. LC 69-16810.

History of art and architecture in the United States from early Colonial times to the end of the Federal period. Emphasis is on painting. Chapters are chiefly concerned with lives and works of major artists. Bibliography in volume three (pp. 346-77) was compiled by the editors and lists books and periodical articles. A standard early chronical of the arts in the United States.

1989 Goodrich, Lloyd. **Three Centuries of American Art.** New. York, Praeger, 1967. 145p. illus. index. LC 66-26551.
Pictorial survey of art and architecture in America from Colonial times to the present. Brief introductory text accompanies a good selection of plates. No bibliography. For the general reader.

1990 Green, Samuel M. **American Art: A Historical Survey.** New York, Ronald Press, 1966. 706. illus. index. LC 66-16844.
Comprehensive history of art and architecture in America from Colonial times to circa 1960. Fairly well illustrated; has a good glossary of terms, informative notes to the text, and a good classified bibliography (pp. 663-68). Balanced, unbiased text. An excellent survey history of American art and architecture.

1991 Harris, Neil. **The Artist in American Society; The Formative Years, 1790-1860.** Chicago, University of Chicago Press, 1982. 432p. illus. index. LC 81-19752.
First published in 1966. History of the social position of artists in American society from Federal times to the Civil War. Contents: To Aid of Necessity; The Perils of Vision; Art, Luxury and Republicanism; The Burden of Portraiture; Professional Communities: Growing Pains; European Travel: The Immediate Experience; European Travel: From Perceptions to Conceptions; Art and Transcendentalism: Beauty and Self-Fulfillment; Crusades for Beauty; Artist Images: Types and Tensions; The Pattern of Artistic Community; The Artists' Dreams and European Realities; The Final Tribute. Bibliographical footnotes.

1992 LaFollette, Suzanne. **Art in America.** New York, Harper & Row, 1968. 361p. illus. index. LC 72-2187.
Reprint of 1929 edition. Survey history of art and architecture in America from Colonial times to the early twentieth century. No bibliography. For the general reader.

1993 Larkin, Oliver W. **Art and Life in America.** Rev. and enl. ed. New York, Holt, Rinehart and Winston, 1960. 559p. illus. index. LC 60-6491.
General history of art and architecture in America from circa 1600 to the present. Emphasis is on the cultural context of the fine arts. Thorough and useful bibliographical notes (pp. 491-525). For the general reader and the beginning student.

1994 Lewis, Samella. **Art: African American.** New York, Harcourt Brace Jovanovich, 1978. 246p. illus. index. LC 77-78732.
Survey history of the contribution of black artists to the history of art in the United States from 1619 to the 1970s. Does not include architecture. Bibliography of books, exhibition catalogs, and periodical articles, pp. 233-39.

1995 McLanathan, Richard. **The American Tradition in the Arts.** New York, Harcourt, Brace & World, 1968. 492p. illus. index. LC 65-21032.
History of art and architecture in America from Colonial times to the mid-twentieth century. Well illustrated. A classified list of major books is provided in the bibliography (pp. 471-78). For the general reader and the beginning student.

1996 McLanathan, Richard. **Art in America: A Brief History.** New York, Harcourt Brace Jovanovich, 1973. 216p. illus. index. LC 72-92358.
Concise history of art and architecture in America from Colonial times to the present. Good selection of plates. Good, partially annotated bibliography of books and periodical articles (pp. 211-12). A good survey for the general reader.

1997 Mather, Frank J., Charles R. Morey, and William J. Henderson. **The American Spirit in Art.** New Haven, Yale University Press, 1927. 354p. illus. index. (Pageant of America, v. 12).
Illustrated survey of music and the figurative arts in the United States from Colonial times to the early twentieth century.

1998 Mendelowitz, Daniel M. **A History of American Art.** 2d ed. New York, Holt, Rinehart and Winston, 1970. 521p. illus. index. LC 71-111303.

History of art and architecture in America beginning with American Indian art and concluding with American art of the present. Well illustrated. Bibliography (pp. 510-12) lists basic books. A standard history of American art and architecture for the general reader and the beginning student.

1999 Myron, Robert, and Abner Sundell. **Art in America: From Colonial Days through the Nineteenth Century.** New York, Crowell-Collier, 1969. 186p. illus. index. LC 69-10347.

Survey history of art and architecture in America from Colonial times to the end of the nineteenth century. Brief bibliography (p. 183). For the general reader and the beginning student.

2000 Neuhaus, Eugen. **The History & Ideals of American Art....** Stanford, Stanford University Press, 1931. 444p. illus. index.

Survey of art and architecture in the United States from Colonial times to the early twentieth century. Biographical notes for major artists are provided at the end of each chapter. Bibliography of basic works (pp. 427-38).

2001 Pierson, William H., Jr., and Martha Davidson, eds. **Arts of the United States: A Pictorial Survey.** New York, McGraw-Hill, 1960. 452p. illus. LC 60-9855.

Brief survey of art and architecture in America from Colonial times to the present. The eighteen brief essays on various arts at different periods are by a number of specialists. Conceived as an accompaniment to a slide collection at the University of Georgia, the illustrations are postage-stamp-sized reproductions of the slides. No bibliography. With the slides, this is a valuable teaching tool directed to the general reader and the beginning student.

2002 Richardson, Edgar P. **The Way of Western Art, 1776-1914.** Cambridge, Mass., Harvard University Press, 1939; Reprint: New York, Cooper Square, 1969. 204p. illus. index. LC 73-79604.

Survey history of art and architecture in America and Western Europe in the period 1776 to 1914, with emphasis on the interrelationships between European and American art and architecture. No bibliography. Still a valuable study for beginning and advanced students.

2003 Taylor, Joshua C. **America as Art.** Washington, D.C., Smithsonian Institution Press, 1976. 320p. illus. LC 76-4482.

An examination of the changing interpretation of American life in art from Colonial times to the present. Contents: America as Symbol; The American Cousin, the Virtue of American Nature; The Frontier and the Native American; The Image of Urban Optimism; The Folk and the Masses; A Center of Art; Identity from Uniformity.

2004 Taylor, Joshua C. **The Fine Arts in America.** Chicago, University of Chicago Press, 1979. 264p. illus. index. LC 78-23643.

History of art and architecture in the United States from 1670 to 1978. Chronological table which collates events in art with events in other aspects of American culture. Brief bibliographical note, pp. 250-51.

2005 Wilmerding, John. **American Art.** Harmondsworth, Penguin, 1976. 322p. illus. index. (Pelican History of Art, Z40). LC 75-18755.

Scholarly history of American art from 1564 to 1976. Chapters are devoted to the chronological examination of major periods. Specialized literature cited in the footnotes. Bibliography (pp. 271-302) is a good, classified list of books and articles including a section of selected monographs on artists.

2006 Wright, Louis, ed. **The Arts in America: The Colonial Period.** New York, Scribner's, 1966. 360p. illus. index. LC 66-12921.

History of architecture, painting and the decorative arts in the United States up to independence. Introductory essay discusses the general cultural and political background. Bibliography (pp. 353-57) is a classified list of books.

Canada

2007 Burnett, David, and Marilyn Schiff. **Contemporary Canadian Art.** Edmonton, Alta., Hurtig, 1983. 300p. illus. index. LC 84-123925.

Survey of painting and sculpture in Canada from the Second World War to the present. Bibliographical footnotes and classified bibliography of books, pp. 293-97.

2008 Colgate, William G. **Canadian Art, Its Origin and Development.** Toronto, Ryerson, 1943. 278p. illus. index.

Concise survey of the history of art in Canada, exclusive of architecture, from 1820 to 1940. Bibliography (pp. 267-70) provides a useful list of primary sources as well as major books and articles. A good survey history of Canadian national art. For the general reader and beginning student. The bibliography will be of use to the advanced student.

2009 Fulford, Robert. **An Introduction to the Arts in Canada.** Toronto, Copp Clark, 1977. 135p. illus. LC 78-305709.

Popular survey of architecture, painting, sculpture, native arts, literature, music, theater, dance, film, and broadcasting in Canada with emphasis on the period since the Second World War. No bibliography.

2010 Hubbard, Robert H. **An Anthology of Canadian Art.** Toronto, Oxford University Press, 1960. 187p. illus. LC 60-52060 rev.

Concise history of art and architecture in Canada from the founding of New France to the present. Well illustrated. Brief introduction traces the history of art and architecture in Canada, followed by more detailed notes to the plates, a section of artists' biographies, and useful biographical notes (pp. 167-69), which evaluate the state of art historical scholarship in Canadian art. A good survey history of Canadian art and architecture for the general reader and beginning student.

2011 Hubbard, R. H. **The Development of Canadian Art.** Ottawa, National Gallery of Canada, 1967. 137p. illus. index. LC NUC64-19658.

Survey history of Canadian art and architecture from the foundation of New France to the present. Compiled from a series of lectures delivered at the National Gallery in Ottawa. Well illustrated. No bibliography. A good survey of Canadian art and architecture by a leading specialist. For the general reader and the beginning student.

2012 McInnes, Graham C. **Canadian Art.** Toronto, Macmillan, 1950. 140p. illus. index. LC 52-6306 rev.

Survey of the history of art in Canada, exclusive of architecture, beginning with Indian art and ending in 1933. Appendices give lists of principal events in Canadian history, art institutes and museums, and Canadian artists. No bibliography. A balanced if cursory history of Canadian art for the general reader.

2013 Mellen, Peter. **Landmarks of Canadian Art.** Toronto, McClellan and Stewart, 1979. 260p. illus. index. LC 79-305522.

History of painting and sculpture in Canada from before European settlement to the present, centering around 116 works. Bibliography (p. 257) is a classified list of basic books.

13

ART OF AFRICA AND OCEANIA
(WITH AUSTRALIA)

GENERAL WORKS

2014 Abbate, Francesco, ed. **African Art and Oceanic Art.** London, Octopus, 1972. 158p. illus. LC 72-172111.

Very brief pictorial survey of both sub-Saharan African and Oceanian art, most of which is sculpture. All color illustrations. Weak one-page bibliography. For the general reader.

2015 Trowell, Kathleen M., and Hans Nevermann. **African and Oceanic Art.** New York, Abrams, 1968. 263p. illus. index. LC 68-16798.

Pictorial survey of the arts of sub-Saharan Africa and primitive Oceania in the latter case consisting of New Guinea, Melanesia, Micronesia, and Polynesia. The section on Africa is treated according to modes or types of art, with a chapter on the sculpture of some ancient African kingdoms. The art of Oceania is treated by region. Provided with maps and good photographs showing African artists at work. Bibliography (pp. 259-60) lists books and some periodical articles in all languages. For the general reader and the beginning student.

AFRICA

2016 Asihene, Emmanuel V. **Understanding the Traditional Art of Ghana.** London, Associated University Presses, 1978. 95p. illus. index. LC 77-67.

Survey of the traditional arts and crafts of Ghana. Contents: Historicultural Background of Ghana; The Function of Art in Religion; The Traditional Artist in Society; Traditional Art Forms, Techniques, and Designs; The Future of Traditional Arts and Crafts. Bibliography, p. 93.

2017 Bamert, Arnold. **Africa: Tribal Art of Forest and Savanna.** London, Thames and Hudson, 1980. 332p. illus. index. LC 80-50800.

Translation of *Afrika: Stammeskunst in Urwald und Savanne.* Richly illustrated survey of the art of sub-Saharan Africa. Arrangement is by type of art object, and the text consists chiefly of descriptive captions to the plates. Brief bibliography of basic books, pp. 327-29.

2018 Bascom, William. **African Art in Cultural Perspective: An Introduction.** New York, Norton, 1973. 196p. illus. index. LC 73-4680.
 Survey of the traditional art of Africa, with emphasis on the general anthropological context. There is a brief chapter on Egypt and North Africa, though the bulk of the work is devoted to sub-Saharan Africa. Useful maps, rather poorly reproduced; well-chosen illustrations. Bibliography (pp. 189-91) lists books in all languages. A good introduction for the beginning student.

2019 Berman, Esmé. **Art and Artists of South Africa: An Illustrated Biographical Dictionary and Historical Survey of Painters and Graphic Artists since 1875.** Cape Town, A. A. Balkema, 1970. 368p. illus. index. LC 75-54902.
 Two-part handbook of painters and graphic artists in South Africa since 1875. The entries in the first part, the biographical dictionary, give basic biographical information, list of major exhibitions, collections that own the artist's work, and (for the major artists) reference to further literature. The second part is a historical survey of painting and graphic art in South Africa since circa 1850. Basic reference tool to art of South Africa.

2020 Biebuyck, Daniel. **The Arts of Zaire.** Berkeley, University of California Press, 1985. 2v. illus. index. LC 84-21928.
 Important handbook of the traditional arts of Zaire (former Belgian Congo). Arrangement is by region: volume one covers southwestern Zaire, and volume two, eastern Zaire. Within the two broad geographic areas the work is further divided into regions and tribes. The second volume is largely concerened with Bwami art. Each volume has a thorough bibliography.

2021 Bodrogi, Tibor. **Art in Africa.** New York, McGraw-Hill, 1968. 131p. illus. LC 68-12065.
 Introduction to the traditional arts of sub-Saharan Africa. The brief text is followed by a selection of plates and a bibliography (pp. 97-101). For the general reader.

2022 Brain, Robert. **Art and Society in Africa.** London, Longmans, 1980. 304p. illus. index. LC 81-142096.
 Survey of the arts of sub-Saharan Africa from the sociological point of view. Chapters treat African art in relationship to various tribal economies, political structures, religion, magic, role of women, and entertainment. Bibliography (pp. 285-90) is an unannotated list by author.

2023 Delange, Jacqueline. **The Art and Peoples of Black Africa.** New York, Dutton, 1974. 354p. illus. index. LC 74-1179.
 Comprehensive survey of sub-Saharan art and architecture. Contents: Upper and Middle Niger; The Volta Peoples; The Coastal Peoples of Guinea; The Southwest of the Sudanese Savanna and the West Coast of the Atlantic Forest; The Akan; Dahomey; Nigeria; The Fulani; Central and Western Cameroun; The Western Congo; The Central Congo; The Eastern Congo; East Africa; South Africa. Excellent bibliography, by Alexandra Darkowska-Nidzgorska (pp. 315-44) lists books and periodical articles. First published in Paris (Gallimard) in 1967.

2024 Gillon, Werner. **A Short History of African Art.** Harmondsworth, Viking, 1984. 405p. illus. index. ISBN 0670800554.
 Survey of African art and architecture from prehistoric rock art and ancient Nubian art to the traditional tribal arts of sub-Saharan peoples of today. Comprehensive, classified bibliography of books and periodical articles (pp. 375-94) and additional bibliography in the notes.

2025 Jones, G. I. **The Art of Eastern Nigeria.** Cambridge, Cambridge University Press, 1984. 230p. illus. index. LC 83-20894.
Scholarly study of the traditional arts of eastern Nigeria. Contents: 1, The social and historical background; 2, Domestic arts and crafts; 3, Costume and dress; 4, Religion and magic; 5, Secret societies and their masquerades; 6, Mud sculpture and its derivatives; 7, Architecture; 8, Carving in stone, ivory and wood; 9, Sculpture in wood: the main forms and styles; 10, The Lower Niger and the Delta major styles; 11, The Anang (Ibibio) and Cross River major styles and the Ogoni area; 12, The anomalous and unclassified areas. Classified bibliography (pp. 220-22) and references to specialized bibliography in the footnotes.

2026 Laude, Jean. **The Arts of Black Africa.** Berkeley, University of California Press, 1971. 289p. illus. index. LC 71-125165.
Concise history of the arts of sub-Saharan Africa, treating both historical and contemporary traditional arts. Provides a useful comparative chronological table of artistic and cultural events in Africa and Western Europe. Bibliography (pp. 279-84) lists books in all languages. For the beginning student.

2027 Leiris, Michel, and Jacqueline Delange. **African Art.** London, Thames and Hudson, 1968. 460p. illus. index. (The Arts of Mankind, 11). LC 73-353276.
Comprehensive handbook of the traditional arts of sub-Saharan Africa. Well illustrated with plates, plans, and diagrams. Provided with maps, glossary, and bibliography (pp. 385-408), which lists books and periodical articles in all languages. Although the bibliography is unclassified, it is extensive, and the most important works are marked with an asterisk. For beginning and advanced students.

2028 Leuzinger, Elsy. **Africa: The Art of the Negro Peoples.** 2d ed. New York, Crown, 1967. 247p. illus. index. LC 60-13819.
Concise study of the traditional arts of sub-Saharan Africa. part one gives a general introduction; part two discusses the regional styles of African art. Includes useful maps, a table of cultures, a glossary of terms, and a good selected bibliography (pp. 228-32) of books and periodical articles. A good survey for the general reader and the beginning student.

2029 Leuzinger, Elsy. **The Art of Black Africa.** Greenwich, Conn., New York Graphic Society, 1972. 378p. illus. index. LC 72-172085.
Pictorial handbook of the arts of sub-Saharan Africa. Introduction discusses the geography, function, materials, and techniques of art in Africa. This is followed by an excellent collection of plates arranged according to stylistic regions; there are a map and a succinct summary introduction for each region. The select bibliography (pp. 363-69) is an excellent classified list of books and periodical articles in all languages. A good introduction for the general reader and the beginning student. The excellent plates make it of value to the advanced student as well.

2030 McLeod, Malcolm. **Treasures of African Art.** New York, Abbeville, 1980. 136p. illus. LC 79-92343.
Pictorial survey of the traditional arts of black Africa, using examples from the collections in the Museum of Mankind, British Museum, London. Brief list of books for further reading, p. 136.

2031 Rachewiltz, Boris de. **Introduction to African Art.** New York, New American Library, 1966. 200p. illus. index. LC 66-18260.
Concise survey and history of sub-Saharan African art from prehistoric times to the present. Provides a good, classified bibliography (pp. 161-92). For the general reader and the beginning student.

2032 Wassing, René S. **African Art, Its Background and Traditions.** New York, Abrams, 1968. 285p. illus. index. LC 68-28387.
 The traditional arts of sub-Saharan Africa are covered, with emphasis on their relationship to social life, economics, religion, and technology. Introductory chapter: "The African and His Environment." Well illustrated. Bibliography (pp. 274-75) is a brief alphabetical listing of major books. For the general reader and the beginning student.

2033 Willett, Frank. **African Art: An Introduction.** New York, Praeger, 1971. 288p. illus. index. LC 76-117394.
 Concise history of the art and architecture of sub-Saharan Africa from the earliest times to the present. Provides a good selection of plates, many useful maps, diagrams, and a few plans. Bibliography (pp. 275-79) is an unclassified list of major books and periodical articles in all languages. The footnotes provide further reference to specialized literature. A good general survey for the beginning student and the general reader.

OCEANIA

2034 Ambesi, Alberto C. **Oceanic Art.** Feltham, England, Hamlyn, 1970. 159p. illus. index. LC 78-563041.
 Pictorial survey of the arts of Melanesia, Micronesia, Polynesia, New Zealand, and Hawaii. No bibliography. For the general reader.

2035 Barrow, Terrence. **Maori Art of New Zealand.** Paris, A. H. & A. W. Reed and the UNESCO Press, 1978. 108p. illus. LC 78-368496.
 Survey of the art and architecture of the Maoris of New Zealand. Contents: The Perspective of Maori Art; Village Society and the Craftsman; Arts of Personal Adornment; Maori Religion and the Arts; Symbols of the Woodcarvers' Art; Tools and Techniques of the Woodcarver; Surface Decoration and the Local Styles of Sculpture; The Arts of Work, Home and Leisure; Art in the Service of the Dead. Selected bibliography, pp. 102-103.

2036 Barrow, Tui T. **Art and Life in Polynesia.** Wellington, New Zealand, A. H. & A. W. Reed, 1972. 191p. illus. index. LC 72-77509.
 Well-illustrated handbook of Polynesian art. Part one is devoted to the cultural background with many illustrations of historical significance; part two is a catalog of works of art arranged by geographical centers. Glossary of Polynesian terms, maps, and bibliography (pp. 181-84) listing recent works in English.

2037 Bodrogi, Tibor. **Oceanian Art.** Budapest, Corvina, 1959. 43p. (text); 170p. (illus.). LC 60-36105.
 Pictorial survey of the arts of Melanesia, Micronesia, Polynesia, and Indonesia. Illustrations of works in the Ethnographical Museum in Budapest. Provides a list of principal collectors and collections of Oceanic art, and a brief bibliography (pp. 39-40) of major works in all languages. For the general reader.

2038 Brake, Brian. **Art of the Pacific.** New York, Abrams, 1980. 230p. illus. index. LC 79-17411.
 Illustrated survey of the traditional tribal arts of Melanesia, Micronesia, Polynesia, and New Zealand. Text consists of descriptive captions to the plates and "conversations" based on tape recordings of interviews with various native inhabitants of the South Pacific. No bibliography.

2039 Bühler, Alfred, Terry Barrow, and Charles P. Mountford. **The Art of the South Sea Islands, including Australia and New Zealand.** New York, Crown, 1962. 249p. illus. index. LC 62-11806.
Survey of the arts of Melanesia, Micronesia, Polynesia, as well as the aboriginal arts of Australia and the Maori art of New Zealand. Introductory chapters discuss the geographical setting and the religious, social, and technological factors. These chapters are followed by excellent characterizations of the major regional styles. Bibliography (pp. 235-40) provides a thorough list of major books and periodical articles in all languages. A good survey for beginning and advanced students.

2040 Chauvet, Stephen. **Les arts indigènes en Nouvelle-Guinée.** Paris, Société d'Éditions Géographiques Maritimes et Coloniales, 1930. 350p. illus.
Comprehensive handbook of the arts of the indigenous peoples of New Guinea, arranged by the old Colonial divisions. Bibliographical footnotes to specialized literature and general bibliography (pp. 314-16). A standard work.

2041 Guiart, Jean. **The Arts of the South Pacific.** New York, Golden Press, 1963. 461p. illus. index. (The Arts of Mankind, 4). LC 63-7331.
Well-illustrated study of the native arts of Australia, Torres Straits, New Guinea, Melanesia, Micronesia, Polynesia, and Hawaii. Provided are a glossary-index, maps, and a bibliography (pp. 419-38), which is an alphabetical list of major books and periodical articles in all languages. A good illustrated handbook for beginning and advanced students.

2042 Kooijman, S. **De Kunst van Nieuw-Guinea.** The Hague, Servire, 1955. 135p. illus. index.
Concise survey of the arts of New Guinea. Arrangement is by regions. Bibliography (pp. 125-30) is a thorough, classified list of books and periodical articles in all languages.

2043 Schmitz, Carl A. **Oceanic Art: Myth, Man and Image in the South Seas.** New York, Abrams, 1971. 405p. illus. index. LC 69-12797.
Comprehensive study of the native arts of New Guinea, Melanesia, Polynesia, and Micronesia. The general introduction sketches the history of art in Oceania from prehistoric time to the present. Sumptuously illustrated. Bibliography (pp. 402-405) lists books and periodical articles. For the general reader and the beginning student.

2044 Tischner, Herbert. **Oceanic Art.** New York, Pantheon, 1954. 32p. (text); 96p. (illus.).
Pictorial survey of the arts of Melanesia, Micronesia, Polynesia, and New Zealand. Brief text, with notes to the plates. Bibliography (pp. 17-20) lists books and periodical articles. For the general reader and the beginning student.

2045 Wingert, Paul S. **Art of the South Pacific Islands.** New York, Beechhurst, 1953. 64p. illus.
Brief survey of the arts of Melanesia, Micronesia, Polynesia, New Zealand, and Hawaii. Short bibliography (p. 46) of major books. For the beginning student.

2046 Wingert, Paul S. **An Outline of the Art of the South Pacific.** New York, Columbia University Press, 1946. 61p. illus.
Brief guide to the art of Melanesia, Micronesia, Polynesia, Australia, and New Zealand. Text is in outline form. Appendix gives lists of American museums that have collections of Oceanic art. Good classified bibliography of books and articles (pp. 45-57). An older, but useful introduction for the beginning student.

AUSTRALIA

2047 Berndt, Ronald M., ed. **Australian Aboriginal Art.** New York, Macmillan, 1964. 117p. illus. index. LC 64-12214.

This survey of the art of the Australian aborigines deals with pre-Colonial rock paintings as well as with the more recent traditional aboriginal arts. Consists of a collection of essays by specialists. Well-chosen illustrations and a good bibliography (pp. 108-12), which lists books and periodical articles in all languages. A good introduction for the general reader and the beginning student.

2048 Burke, Janine. **Australian Women Artists: 1840-1940.** Collingwood, Victoria, Greenhouse Publications, 1980. 188p. illus. index. LC 82-100864.

History of women artists, excluding architects, in Australia from 1840-1940. Bibliography.

2049 Hughes, Robert. **The Art of Australia.** Rev. ed. Harmondsworth, Penguin, 1970. 331p. illus. index. LC 72-18946.

History of art and architecture in Australia from prehistoric times to the present. Well illustrated. Bibliography (pp. 317-20) is a good list of books and periodical articles. A standard history of Australian art and architecture for the general reader and the beginning student.

2050 Moore, William. **The Story of Australian Art, from the Earliest Known Art of the Continent to the Art of Today.** Sydney, Angus & Robertson, 1934. 2v. illus. index.

Survey of art and architecture in Australia from prehistoric times to the early twentieth century. Provides a dictionary of Australian artists (pp. 155-234). For the general reader and the beginning student.

2051 Smith, Bernard W. **Place, Taste, and Tradition: A Study of Australian Art since 1788.** Sydney, Smith, 1945. 287p. illus. index. LC 46-1408 rev.

Concise history of art and architecture in Australia in the nineteenth and twentieth centuries. Emphasis is on the general cultural climate. Bibliography (pp. 272-75) lists books and periodical articles. For the general reader and the beginning student.

Reference is to entry number. Both main entries and those authors and titles mentioned in annotations have been included.

Dictionnaire biographique des artistes contemporains, 1910-1930, 402

Dictionnaire critique et documentaire des peintres, sculpteurs, dessinateurs et graveurs..., 352

Dictionnaire d'archeologie chretienne et de liturgie, 387

Dictionnaire de la mythologie grecque et romaine, 618

Dictionnaire de l'art contemporain, 400

Dictionnaire des antiquites grecques et romaines d'apres les textes et les monuments, 375

Dictionnaire des artistes de l'ecole francaise au XIXe siecle..., 426

Dictionnaire des artistes et ouvriers d'art de la France, 423

Dictionnaire des artistes et ouvriers d'art de la Franche-Comte, 421

Dictionnaire des artistes et ouvriers d'art du Lyonnais, 418

Dictionnaire des artistes et ouvriers d'art du Tarn du XIIIe au XX siecle, 431

Dictionnaire des attributs, allegories, emblemes et symboles, 545

Dictionnaire des civilizations africaines, 531

Dictionnaire des eglises de France, 1521

Dictionnaire des monogrammes, marques, figurees, lettres, initiales, noms abreges..., 364

Dictionnaire des peintures et sculpteurs provencaux, 1880-1950, 422

Dictionnaire des symboles: mythes, reves, coutumes, gestes, formes, figures..., 541

Dictionnaire des symbols chretiens..., 591

Dictionnaire encyclopedie des marques et mono-grammes, chiffres, lettres, initiales, signes figuratifs..., 370

Dictionnaire general des artistes de l'ecole francaise depuis l'origine des arts du dessin jusqu a nos jours, 419

Dictionnaire historico artistique du Portugal..., 479

Dictionnaire iconographique des figures, legendes et actes des saints..., 599

Dictionnaire iconographique des monuments de l'antiquite chretienne et du moyen age..., 389

Dictionnaire polyglotte des terms d'art et d'archeologie, 348

Didron, A., 564

Diehl, C., 1037

Dieulafoy, M., 170, 812

Diez, E., 813, 1774-75, 1807

Dilly, H., 658

Dimensions of the 20th Century: 1900-1945, 1398

Directory of Art Libraries and Visual Resource Collections in North America, 295

Directory of World Museum, 296

Disselhoff, H. D., 1911

Dittich, E., 179-80

Dittmann, L., 659

Divald, K., 1735

Dizionario critico Monteverdi. Pittori e scultori contemporanei, 462

Dizionario degli artisti bresciani, 458

Dizionario degli artisti contemporanei, 463

Dizionario degli artisti italiani viventi, pittori, scultori e architetti..., 461

Dizionario degli scultoris e architetti italiani, 448

Dizionario dei simboli, emblemi, attributi, allegorie, immagini degli dei ecc., 555

Dizionario della storia dell'arte in Italia con duecento illustrazioni..., 457

Dizionario di artisti Veneti, 451

Dizionario di termini artistici, 343

Dlabac, J. B., 415

Dobai, J., 98

Dockstader, F. J., 748, 1909, 1923, 1934, 1939

Documentary History of Taste in Britain, 1278

Documents pour servir a l'etude de l'art egyptien..., 766

Dodwell, C. R., 1081

Doering, O., 565

Dohme, R., 1536

Dohring, K. S., 1856

Dohrn, T., 905

Dolling, R., 1063

Donin, K., 1538

Donnet, F., 1638

Doorslaer, G. van, 1638

Dorig, J., 865

Dorta, E. M., 1946

Dove, J., 15

Drake, M., 597

Drake, W., 597

Dreyfous, M., 1356

Driot, E., 770

Droulers, E., 545

Du Bourguet, P., 1003, 1057

Du Colombier, P., 1224-25

Du Peloux de Saint Roman, C., 401

Dube, W. D., 1470

Duby, G., 967

Ducati, P., 851, 931

Ducati, Pericle, 906

Dumbarton Oaks Bibliography Based on Byzantinische Zeitschrift, 75

Dumbarton Oaks Research Library, Harvard University, *Dictionary Catalogue of the Byzantine Collection of the Dumbarton Oaks Research Library*, 243

Duncan, A., 1513

Dunlap, W., 1988

Duplessis, G., 16

Durer-Bibliographie, 127

Durliat, M., 1116

Dussieux, L. E., 425

Dutch Art and Architecture: 1600 to 1800, 1285

Duval, P. M., 954

Duverger, J., 469, 1658

Dvorak, M., 683, 1192

RILA. Repertoire international de la litterature de l'art. International Repertory of the Literature of Art, 33
Rinascimento e Barocco, 1170
Ringbom, S., 1675
Ris-Paquot, O. E., 370
Riviere, J., 1823, 1874
Rivista dell'Istituto d'Archeologia et Storia dell'Arte, 80
Robert Goldwater Library, Metropolitan Museum of Art, New York City, *Catalog of the Robert Goldwater Library*, 240
Roberts, L. P., 503
Robertson, J., 272
Robertson, M., 889
Rococo Age, Art and Civilization of the Eighteenth Century, 1260
Rodenwaldt, G., 854
Roeder, H., 608
Roh, F., 1419, 1535
Rohault de Fleury, C., 583-84
Rojas, P., 1973-74
Roman Art, 937, 946
Roman Art. A Modern Survey of the Art of Imperial Rome, 936
Roman Art; Some of Its Principles and Their Application to Early Christian Painting..., 950
Roman Art and Architecture, 949
Romanesque Art, 1135
Romanesque Art in Belgium: Architecture, Monumental Art, 1113
Romanesque Art in Europe, 1122
Romanesque Art in France, 1118
Romanische Kunst, 1107
Romanische Kunst in Osterreich, 1106
Romanische Kunst in Polen, der Tschecho-slovakei, Ungarn, Rumanien, Jugoslawien, 1126
Romantic Art, 1369
Romantic Rebellion, 1375
Romanticism, 1370, 1372, 1379
Romantics and Romanticism, 1374
Romantisme et l'art, 1371
Romdahl, A. L., 1689
Rome, Bibliotheca Hertziana, *Kataloge der Bibliotheca Hertziana in Rome*, 238a
Rome, Deutsches Archaologisches Institut, *Kataloge der Bibliothek des Deutschen Archaologischen Instituts, Rom*, 242
Rome, the Center of Power: Roman Art to A.D. 200, 924
Rome, the Late Empire: Roman Art A.D. 200-400, 925
Romische Kunst, 940, 941
Romische Weltreich, 942
Ronchetti, G., 555
Rooses, M., 1654
Roosval, J., 1689-90
Roscher, W. H., 624
Rose, B., 1436

Rosenberg, J., 1285
Rosenblum, R., 1334, 1366, 1466
Rosenfeld, A., 746
Roskill, M., 666
Ross, N. W., 646
Rostovtsev, M. I., 830-31
Rotenberg, J., 1257
Rothenstein, J. K., 1423
Rounds, D., 63
Rowland, B., 161, 1824
Rowland, K., 1408
Rowland, M., 1250
Royal Commission on the Ancient and Historical Monuments in Scotland, *An Inventory of Ancient Monuments*, 1606
Royal Commission on the Ancient and Historical Monuments of Wales, *An Inventory of Ancient Monuments*, 1608
Royal Commission on the Ancient and Historical Monuments of England, *An Inventory of Ancient Monuments*, 1607
Royal French Patronage in the Fourteenth Century: An Annotated Bibliography, 78
Royal Institute of British Architects, London, *Catalogue of the Library*, 233
Rubin, W. S., 1508
Rumanian Art 1800 to Our Days, 1324
Rumpf, A., 855, 945
Runciman, S., 1048
Runes, D., 326
Ruskin, A., 749, 856, 1176, 1258
Russian Art; An Introduction, 1762
Russian Art from Scyths to Soviets, 1751
Russian Constructivism, 1476
Russian Experiment in Art, 1863-1922, 1325
Russische Kunst, 1759
Russische Kunst; ein Betrag zur Charakteristik des Russentums, 1752
Ry van Beest Holle, C. J. van, 800, 1789
Rye, J., 1488
Ryerson, E., 1893
Ryerson Library, Art Institute of Chicago, *Index to Art Periodicals*, 256

Sachs, H., 585
Sacred and Legendary Art, 573
Sacred Symbols in Art, 568
Safflund, G., 853
Saggio di bibliografia etrusca, 60
Saglio, E., 375
Sahai, B., 647
Saints and Their Attributes: With a Guide to Localities and Patronage, 608
Saints and Their Emblems, 597
Saints in Art, 610
Saints in Italy: A Book of Reference to the Saints in Italian Art and Decoration..., 606
Salas, X. de, 1597
Salerno, L., 667
Salet, Fr., 1158

SUBJECT INDEX

Reference is to entry number. Topics included cover both main entry titles and titles cited in the annotations. This provides quick access to very specific subject designations, especially the individual locations of the complex inventories of art in Europe, which are not included in the classification system of the bibliography.

Aachen (Germany), art in, 1564
Aalst (Belgium), art in, 1641
Aargau (Switzerland), art in, 1600-1601
Abruzzi (Italy), artists' dictionary, 449
Abstract art (twentieth century), 1474-75, 1477-78, 1480
Adelsheim (Baden, Germany), art in, 1552
Adolf Prediks kyrka (Stockholm, Sweden), art in, 1682
Aegean Art. *See also* Cyclades; Minoan art; Mycenean art
 bibliographies, 61, 64
 histories & handbooks, 762, 832-48
Afghanistan
 bibliographies, 171
 histories & handbooks, 1792
Africa. *See also individual countries*
 bibliographies, 43-46, 214-16, 218-19, 221
 dictionaries, 531
 histories & handbooks, 720-26, 748-53, 2014-33
 twentieth-century art, 1413
Ahaus (Westfalen, Germany), art in, 1567
Ahrweiler (Rheinland-Pfalz, Germany), art in, 1564
Aichach (Bavaria, Germany), art in, 1551
Aigues-Mortres Canton (France), art in, 1523
Ain-Gironde (France), art in
 bibliographies, 113
Akerbo harad (Oland, Sweden), art in, 1682
Akers skeppslag (Uppland, Sweden), art in, 1682
Albania
 bibliographies, 73
Alfeld (Hannover, Germany), art in, 1568
Alghults kyrkor (Smaland, Sweden), art in, 1682
Alinari Photo Archive, catalog, 274
Alsace (France). *See also individual places*
 artists' dictionary, 427
 topographical handbooks, 1525
Alskog kyrka (Gotland, Sweden), art in, 1682
Altena (Westfalen, Germany), art in, 1567
Altenkirchen (Rheinland-Pfalz, Germany), art in, 1564

Alto Adige. *See* South Tirol
Alt-Otting (Bavaria, Germany), art in, 1551
Alva kyrka (Gotland, Sweden), art in, 1682
Alzenau (Bavaria, Germany), art in, 1551
Amberg (Bavaria, Germany), art in, 1551
American art. *See* Indians of Middle America and Mexico; Indians of North America; Indians of South America; *individual countries*
American School of Classical Studies (Athens), library catalog, 241
Amiralitetskyrkan i Karlskrona (Blekinge, Sweden), art in, 1682
Anatolia (ancient)
 histories & handbooks, 818-22
Ancient art. *See also* Ancient Near East; Classical art; Egypt; Greek art; Roman art
 bibliographies, 47-69
 dictionaries, 373-85
 histories & handbooks, 754-63
 library catalogs, 241-42
Ancient Near East. *See also individual regions and cultures*
 bibliographies, 50, 53, 63, 66, 159
 dictionaries, 374, 377
 histories & handbooks, 758, 761-62, 786-802
Ancona (Italy), art in, 1622
Angermunde (Brandenburg, Germany), art in, 1585
Angevin (France), artists' dictionary, 430
Anglesey (Wales), art in, 1608
Anglo-Saxon art
 bibliographies, 71, 74, 88
 histories & handbooks, 1080-81, 1084-85, 1094
Annaberg (Saxony, Germany), art in, 1583
Anthropology and art, 695
Antiques
 dictionaries, 346
 directories, 298
Antwerp (Belgium)
 art in, 1638-39
 artists' dictionary, 472

Furtenberg (Mecklenburg, Germany), art in, 1578
Futurism, 1464, 1481-90
 bibliographies, 93, 100

Gadebusch (Mecklenburg, Germany), art in, 1577
Gagnefs tignslag (Dalarna, Sweden), art in, 1682
Gallo-roman art, 953, 958
Galloway (Scotland), art in, 1606
Gandershein (Braunschweig, Germany), art in, 1569
Gard (France), Canton Aigues-Mortres, art in, 1523
Gardelegen (Thuringia, Germany), art in, 1580
Gards harad (Skane, Sweden), art in, 1682
Gardslosa (Oland, Sweden), art in, 1682
Garmisch (Bavaria, Germany), art in, 1551
Gastrikland (Sweden), art in, 1682
Gavle stads kyrkor (Gastrikland, Sweden), art in, 1682
Gdansk (Poland), art in, 1588, 1590
Geilenkirchen (Nordrhein-Westfalen, Germany), art in, 1564
Gelderland (Netherlands), art in, 1657
Geldern (Nordrhein-Westfalen, Germany), art in, 1564
Gelnhausen (Hessen, Germany), art in, 1560
Gelsenkirchen (Westfalen, Germany), art in, 1567
Gemunden (Bavaria, Germany), art in, 1551
Geography and art, 706
Gera Bezirk (Germany), art in, 1549
German Democratic Republic
 bibliographies, 120, 123
German expressionism. *See* Expressionism
German-speaking countries. *See also individual countries*
 histories, 1534-37
Germanic art, 951, 955, 958, 961-65, 1064
Germany. *See also individual regions and places*
 Baroque & Rococo art, 1273-75, 1277
 bibliographies, 90-91, 116-27
 dictionaries, 432-37
 Gothic art, 1140
 histories, 1592-98
 Impressionism, 1387
 indexes, 259
 medieval art, 984-86, 1593, 1596
 modern art (nineteenth & twentieth centuries), 1317, 1343, 1417-20
 Neoclassicism, 1367
 Renaissance art, 1228-31, 1596
 Romanesque art, 1110
 topographical handbooks, 1548-91
Germersheim (Pfalz, Germany), art in, 1563
Gerolzhofen (Bavaria, Germany), art in, 1551
Ghana, art in, 2016

Ghent (Belgium)
 altarpiece by Jan van Eyck, 1641
 art in, 1641
 art in, 1642
Giessen (Hessen, Germany), art in, 1558
Gifhorn (Hannover, Germany), art in, 1568
Glanshammars harad (Narke, Sweden), art in, 1682
Glauchau (Saxony, Germany), art in, 1583
Gloucestershire (England), art in, 1607
Gnoein (Mecklenburg, Germany), art in, 1577
Goldberg (Mecklenburg, Germany), art in, 1577
Gondrecourt-le-Chateau Canton (France), art in, 1523
Goslar (Hannover, Germany), art in, 1568
Gothic art, 1136-67. *See also individual countries*
Gotland (Sweden), art in, 1682
Gotlunda (Narke, Sweden), art in, 1682
Grabow (Mecklenburg, Germany), art in, 1577
Grafenau (Bavaria, Germany), art in, 1551
Granhutts kyrkor (Smaland, Sweden), art in, 1682
Graubunden (Switzerland), art in, 1600-1601
Graudenz (West Prussia), art in, 1590
Graz (Austria), art in, 1540
Great Basin, prehistoric art, 41
Great Britain. *See also individual regions and places*
 Baroque & Rococo art, 1278
 bibliographies, 98, 128-30
 dictionaries, 438-46
 histories, 1609-19
 medieval art, 987-89
 museum publications, 260
 Neoclassicism, 1360
 nineteenth-century art, 1344-45
 prehistoric art, 38
 topographical handbooks, 1606-8
 twentieth-century art, 1421-24
Greece, art in, 1732. *See also* Greek art
Greek art. *See also* Classical art
 bibliographies, 47, 49, 51, 54-55, 63, 65, 67
 dictionaries, 373, 375-76, 378, 380, 382-85
 geometric, 884, 895
 histories & handbooks, 758, 761-62, 861-98
Greenland, art of, 1676, 1944
Grevenbroich (Nordrhein-Westfalen, Germany), art in, 1564
Grevesmuhlen (Mecklenburg, Germany), art in, 1577
Griesbach (Bavaria, Germany), art in, 1551
Grimma (Saxony, Germany), art in, 1583
Groningen (Netherlands), art in, 1657
Grossenhain (Saxony, Germany), art in, 1583
Grums harad (Varmland, Sweden), art in, 1682
Guatemala,
 histories & handbooks, 1969-70
 Pre-Columbian art, 1925
Guebwiller Canton (France), art in, 1523
Gummersbach (Nordrhein-Westfalen, Germany), art in, 1564